Fine Arts

Fine Arts

A Bibliographic Guide to Basic Reference Works, Histories, and Handbooks

Second Edition

Donald L. Ehresmann

University of Illinois Chicago

Copyright ©1979, 1975 Donald L. Ehresmann All Rights Reserved Printed in the United States of America

No part of this publication may be reproduced, stored in a retrieval system, or transmitted, in any form or by any means, electronic, mechanical, photocopying, recording, or otherwise, without the prior written permission of the publisher.

LIBRARIES UNLIMITED, INC. P.O. Box 263 Littleton, Colorado 80160

Library of Congress Cataloging in Publication Data

Ehresmann, Donald L 1937-Fine arts.

Includes indexes.
1. Art-Bibliography. I. Title.
Z5931.E47 1979 [N7425] 016.7 79-9051
ISBN 0-87287-201-7

This book is bound with James River (Scott) Graphitek®—C Type II nonwoven material. Graphitek—C meets and exceeds National Association of State Textbook Administrators' Type II nonwoven material specifications Class A through E.

For Sibylle and now Amalia

TABLE OF CONTENTS

Preface and Acknowledgments	15
PART I-REFERENCE WORKS	
CHAPTER ONE-BIBLIOGRAPHIES	21
Introduction	21
Research and Library Manuals	24
General Systematic Bibliographies	25
General Series Bibliographies	27
Specialized Bibliographies	29
Prehistoric	29
Primitive	30
Europe	31
Periods of Western Art History	31
Ancient, 31; Medieval and Byzantine, 34; Modern (19th and	
20th Centuries), 36	
European National and Area Dionographics	37
Belgium, 37; Denmark, 37; France, 38; German-Speaking Countries,	
38; Great Britain, 40; Hungary, 40; Italy, 41; Netherlands, 42;	
Russia, 43; Spain and Portugal, 43; Sweden, 43; Switzerland, 44	
Orient	44
General Works	44
Islamic World	44
India and Ceylon	45
Central Asia	46
Far East	46
New World	47
Pre-Columbian America	47
North American Indian	48
Latin America	49
General Works, 49; Argentina, 49; Brazil, 49; Colombia, 49;	
Mexico, 49; Santo Domingo, 49	
United States	50
Africa	50
CHAPTER TWO-LIBRARY CATALOGS	52
Introduction	52
General Fine Arts Libraries	52
North America	52
Europe	54

CHAPTER TWO-LIBRARY CATALOGS (cont'd)	
Specialized Art Libraries	55
Ancient	55
Byzantine	55
Renaissance	56
Modern	56
Oriental	57
American	57
CHAPTER THREE-INDEXES	58
Introduction	58
Periodical Literature	58
Museum Publications	59
Specialized Indexes	60
Indexes to Illustrations	61
	01
CHAPTER FOUR-DIRECTORIES	64
CHAPTER FIVE-DICTIONARIES AND ENCYCLOPEDIAS	67
Introduction	67
General Dictionaries and Encyclopedias	68
Dictionaries of Terminology	71
General Biographical Dictionaries	73
Dictionaries of Marks and Signatures	75
Specialized Dictionaries and Encyclopedias	76
Prehistoric	76
Europe	76
Periods of Western Art History	76
Ancient, 76; Medieval and Byzantine, 78; Renaissance,	
80; Modern (19th and 20th Centuries), 80	
European National Dictionaries and Encyclopedias	82
Austria, 82; Czechoslovakia, 82; Denmark, 82; France, 83;	
Germany, 85; Great Britain, 86; Italy, 87; Low Countries, 89;	
Portugal, 90; Spain, 91; Sweden, 92; Switzerland, 93	
Orient	93
New World	94
Pre-Columbian	94
Latin America	94
United States and Canada	95
Africa	97
Australia	97
CHAPTER SIX-ICONOGRAPHY	98
Introduction	98
Bibliographies	99
General Dictionaries	100

CHAPTER SIX—ICONOGRAPHY (cont'd)	
Christian Iconography	102
General Works	102
Dictionaries of Saints	107
Western Profane Iconography	110
Classical Mythology and Iconography	110
Non-Western Mythology and Iconography	111
Holl-Western Mythology and teoriography	
PART II—HISTORIES AND HANDBOOKS	
CHAPTER SEVEN-PREHISTORIC AND PRIMITIVE ART	119
General Works	119
Prehistoric	120
Primitive	123
CHAPTER FIGHT REPLACE OF WESTERN ART HISTORY	124
CHAPTER EIGHT-PERIODS OF WESTERN ART HISTORY	124
Ancient	
General Works	124
Egyptian	125
Ancient Near Eastern	128
General Works	128
Mesopotamia	131
Iran	132
Anatolia	133
Scythia	134
Aegean	135
Classical	137
General Works	137
Greek	138
Etruscan	144
Roman	146
Germanic and Celtic	150
Medieval and Byzantine	153
General Works	153
Austria	155
France	155
Germany	155
	156
Great Britain	156
Italy	
Scandinavia	156
Switzerland	157
Eastern Europe	157
Early Christian	157
Byzantine	162

C	HAPTER EIGHT-PERIODS OF WESTERN ART HISTORY (cont'd)	
	Medieval and Byzantine (cont'd)	
	Coptic	166
	Early Medieval	167
	General Works	167
	Pre-Carolingian	169
	Carolingian and Ottonian	171
	Romanesque	173
	Gothic	178
	Renaissance (including Mannerism)	183
	General Works	183
	Mannerism	185
	Italian Renaissance	186
	Northern Renaissance	190
	General Works	190
	France	191
		192
	Germany and Austria Spain	192
		192
	Eastern Europe	192
	Baroque and Rococo	
	General Works	193
	France	197
	Germany and Austria	198
	Italy	199
	Low Countries	200
	Spain and Portugal	200
	Eastern Europe	201
	Modern (19th and 20th Centuries)	201
	General Works	201
	Austria	204
	Belgium	204
	France	205
	Germany	205
	Italy	205
	Japan	206
	Mexico	206
	Romania	206
	Russia	206
	Sweden	206
	United States	207
	19th Century	207
	General Works	207
	Austria	208
	Belgium	209
	Denmark	209
	Germany	209

CHAPTER EIGHT—PERIODS OF WESTERN ART HISTORY (cont'd)	
Modern (19th and 20th Centuries) (cont'd)	
19th Century (cont'd)	
Italy	209
Mexico	209
Sweden	209
United States	210
Neoclassicism	210
Romanticism	212
Realism	214
Impressionism, Post-Impressionism, and	-1.
Neo-Impressionism	214
20th Century	216
General Works	216
Africa	218
Austria	218
China	218
Czechoslovakia	219
Germany	219
	219
Great Britain	220
Hungary	220
Japan	220
Mexico	220
Netherlands	220
United States	
Art Nouveau	221 223
Fauvism	223
Cubism	
Expressionism	224
Constructivism and Abstraction	225
Futurism	226
De Stijl	227
Dada and Surrealism	227
Art in Mid-Century	229
The second secon	
CHAPTER NINE—NATIONAL HISTORIES AND HANDBOOKS	221
OF EUROPEAN ART	231
Western Europe	231
France	231
Topographic Handbooks	231
Histories	233
German-Speaking Countries	234
General Works	234
Austria	234
Topographic Handbooks, 234: Histories, 236	

CHAPTER NINE-NATIONAL HISTORIES AND HANDBOOKS	
OF EUROPEAN ART (cont'd)	
Western Europe (cont'd)	
German-Speaking Countries (cont'd)	
Germany	237
Topographic Handbooks, 237; Inventories of Art and	201
Architecture, 239; Histories, 251	
Switzerland	252
Topographic Handbooks, 252; Histories, 254	232
Great Britain and Ireland	254
Topographic Handbooks	254
Histories	256
Italy	258
Topographic Handbooks	258
Histories	259
Low Countries	261
General Works	261
Belgium	261
Topographic Handbooks and Inventories, 261; Histories, 263	201
Netherlands	265
Topographic Handbooks, 265; Histories, 265	203
Scandinavia	266
General Works	266
Denmark	266
Finland	267
Iceland	267
Norway	268
Sweden	268
Topographic Handbooks, 268; Histories, 271	200
Spain and Portugal	272
Topographic Handbooks	272
Histories	274
Eastern Europe	277
General Works	277
Czechoslovakia	277
Bulgaria	278
Hungary	278
Poland	279
Romania	279
Russia	279
Yugoslavia	282
i ugosiavia	202
CHAPTER TEN-ORIENTAL ART	283
General Works	
Islamic World	283
General Works	284
Egypt	284
Iran and Afghanistan	286
Turkey	286
	287

CHAPTER TEN-ORIENTAL ART (cont'd)	
India and Ceylon	288
Central Asia	291
Southeast Asia	
General Works	293
Indochina	293
Indonesia	294
Thailand	295
Far East	296
General Works	296
China	
Japan	
Korea	
Roll	
CHAPTER ELEVEN-NEW WORLD ART	305
Pre-Columbian America	305
General Works	305
Mesoamerica and Mexico	
South America	
North American Indian	
National Histories and Handbooks	
Latin America	
General Works	
Argentina	
Brazil	
Colombia	
Cuba	
Ecuador	
Guatemala	
Mexico	
Peru	
Venezuela	
United States	
Canada	
Canada	01,
CHAPTER TWELVE-ART OF AFRICA AND OCEANIA	
(WITH AUSTRALIA)	319
General Works	
Africa	
Oceania	
Australia	
Australia	323
Index	325
HIMOA	040

PREFACE AND ACKNOWLEDGMENTS

The first edition of *Fine Arts* was written in response to the needs of students in my classes on methods of art historical research at the University of Illinois for a supplement that would expand and update the list of general reference works, histories, and handbooks in the twenty-year-old *Guide to Art Reference Works* by Mary Chamberlin. The continuing growth in fine arts publishing in the past five years has added many titles to the list of those available, and it is now more obvious than ever that a comprehensive bibliography of art history is needed, a bibliography that presents the general literature of the fine arts and also the literature of the history of art in individual media: architecture, sculpture, painting and drawing, the graphic arts, and the applied and decorative arts. Only a multi-volume series of bibliographies can accommodate this need.

This second edition of *Fine Arts* is expanded, updated, and revised and is intended to be one of four bibliographies on the arts. *Applied and Decorative Arts:* A Bibliographic Guide (Libraries Unlimited, 1977) is another one of the four. Work is in progress on an architecture bibliography. The fourth book is to cover the fields of painting, sculpture, and the graphic arts. At this time, no firm date has been set for the publication of the latter two books. The plan is for each bibliography to cover those major books written in Western European languages, published in the past one hundred years, and available in the major libraries of the United States.

The first edition of *Fine Arts* depended on Chamberlin for coverage of pre-1958 titles. In the second edition, this is no longer the case. All titles in Chamberlin that correspond to the scope of this volume have been reexamined, and all but the most ephemeral have been incorporated here, together with 322 pre-1958 titles overlooked by Chamberlin. Finally, the addition of 147 books published since 1973 brings the coverage forward some five years. These changes and enlargements increase the number of titles by more than fifty percent over the number appearing in the first edition. A number of reference works on specific media that appeared in the first edition of *Fine Arts* will reappear in the reference sections in volumes two and three of the series. In all, the second edition of *Fine Arts* contains over 1670 entries.

BIBLIOGRAPHIC SCOPE OF THIS VOLUME

To be included in *Fine Arts*, a work must treat two or more of the major media: architecture, sculpture, and painting. The majority, in fact, treat all three, and often the applied and decorative arts as well. The exact coverage of each item is mentioned in the annotations. The cutoff date for inclusion is September 1, 1978.

The reference works covered in part I include both periodical articles and books published after 1830, the *terminus ad quem* for the basic bibliography of early writings on art history, Julius von Schlosser's *Die Kunstliteratur* (19). Generally, coverage stops at the level of national and period works. However, also included is a selection of titles dealing with the art of some provinces that have in themselves been important centers of European art. With few exceptions, reference works that are not strictly art historical in nature have been excluded. The chief exceptions to this practice are in areas such as ancient art and pre-Columbian art, where archaeological works, which are of special value to art historians, have been listed and described.

The general histories and handbooks in part II are books published after 1875. Histories and handbooks have been defined here to exclude very specialized and theoretical studies. As with reference works in part I, coverage stops at national histories, except for those multi-volume topographical handbooks of various European countries, which extend coverage to the level of major provinces and regions. Dissertations and exhibition and museum catalogs are not included. Coverage is restricted to works in Western European languages; and where multi-lingual editions of the same work exist, preference is given first to the English, then to the French, and then to the German edition. If translation into English is anticipated, this is mentioned in the annotation. Although every reasonable effort has been made to compile a comprehensive bibliography of books that will be of interest to a variety of users, the author does not commit the folly of claiming completeness.

CLASSIFICATION SYSTEM

Reference works are arranged according to publication type. In areas where works are used in a similar fashion but appear in different categories, cross references are provided in the annotations and at the end of sections. Histories and handbooks are arranged by period and geographical area. The history of Western art is classified by standard period and style designations. National histories and handbooks are grouped into four broad cultural areas: Europe, the Orient, the New World, and Africa and Oceania. Topographical handbooks or inventories are given special attention and are further classified by province. Here, too, cross references are used to provide access to related works in the period and geographical sections. It should be borne in mind, however, that the cross references are intended to refer the reader to similarly specific titles, not to more general works.

CITATIONS

The author's full last and first names are given, with initial(s) supplied for middle name(s). Full title is supplied together with publication data. Only numbered series are listed with the citation. Where pertinent to the description of a title, other non-numbered series are mentioned in the annotations. Although a separate search was not made for reprints, the major ones have been included. Library of Congress card numbers are provided for single titles published between 1957 and 1977.

ANNOTATIONS

The annotations are intended to be descriptive and, where warranted, critical comments appear. The repetitive and often redundant nature of many titles in the category of period histories is reflected in the equally repetitive annotations for those titles. Works of unusual completeness or approach have been accorded fuller annotations, some with a list of their contents. Particular attention has been given to the description of special features, such as glossaries, chronological charts, especially good illustrations, and bibliographies.

INDEX

A new, expanded index has been compiled for this edition. Besides authors, editors and main entry titles, the index also includes numbered series titles. The subject indexing has also been greatly expanded. It now provides access to the broad and specific divisions of the classification system and to other subjects taken from the annotations—in particular, the subdivisions of the complex national art inventories. Thus it is possible to use the index to locate, for instance, books on the art and architecture of Bavaria or Westmoreland. Ascending references have been kept to a minimum and descending references have, wherever possible, been accomplished by *See also* references.

ACKNOWLEDGMENTS

Numerous colleagues in the academic and museum worlds have assisted the author with generously given advice. But without the editorial labors of my wife, Julia M. Ehresmann, and the practical support of the staff of the Library of the Art Institute of Chicago, it would have been impossible to contemplate or compile this bibliography.

D.L.E.

CHAPTER ONE BIBLIOGRAPHIES

INTRODUCTION

The history of fine arts bibliography reaches back beyond the eighteenth century. Although some of those early bibliographies are valuable sources for specialized studies in the historiography of the fine arts, nearly all are bibliophilic efforts. For that reason, they are chiefly of antiquarian interest today. Scientific bibliography in the fine arts does not begin until the early years of the present century. At that time, two trends in fine arts bibliography appeared that, in differing proportions, continue to characterize the field of fine arts bibliography to the present. One trend was toward the production of international serial bibliographies that cataloged, if they did not annotate, the major literature in books and periodical articles on a regular (usually annual) basis. This was a direct response to the tremendous increase in far-reaching art historical research that characterized the first quarter of the twentieth century. In international bibliography, the first such serial was produced in Germany (25); it continues, in a somewhat changed form, in the annual bibliography published in the German art historical periodical, Zeitschrift für Kunstgeschichte (31). It was followed soon after by the Répertoire d'Art et d'Archéologie (27), produced by the University of Paris. The Répertoire remains today the chief representative of the international serial bibliography, but it was joined in 1975 by a promising newcomer, the Répertoire international de la littérature de l'art, known as RILA (28). Initiated by the College Art Association of America, RILA is modeled on the new computer-assisted bibliography of musicology, Répertoire international de la littérature musicale, and features lengthy abstracts for many entries and a detailed computer-generated subject index. Art history has high hopes in RILA, for it promises to provide more information on major current titles than any other bibliographic tool.

The second trend—that of specifically delimited national and regional retrospective and serial fine arts bibliographies—began very modestly in the form of Hermann Sepp's bibliography of Bavarian art (97). It grew rapidly, however, in the years between the two world wars. Today it is the dominant trend in fine arts bibliography. Although it is still far from being represented in the majority of the countries that produce the major scholarship, it has been of sufficient magnitude to threaten the trend towards international serial bibliographies. In 1969, the Centre National de la Recherche Scientifique: Sciences Humaines (Paris) sponsored a colloquium on fine arts bibliography, one of the purposes of which was to explore the possibility of coordinating the increasing activity

in national fine arts bibliography with the production of the chief international bibliography, the *Répertoire*. Although until recently little that was concrete had been advanced in that direction, the Paris colloquium did point out the need for both types of fine arts bibliography. Interest in national, regional, and ethnic art has increased tremendously in the past quarter century, and the literature directed to that interest has increased correspondingly. The nature of such literature, often locally produced and distributed, makes it quite clear that only regional bibliographies can handle this aspect of the study of the fine arts. But at the same time, increasing internationality in travel, culture, and study has developed a heightened appetite for information on the art of other nations and cultures. The mass of detailed and locally significant literature covered by national and regional bibliographies frustrates this appetite. There is a continuing need for a critically selective international serial bibliography that provides access to this information.

A major obstacle to the attainment of this possibly utopian goal is the conspicuous lack of national bibliographies for most countries of the world. This is true even if one restricts the task to Western art. This imperfect state of bibliographic coverage is most likely to be with us through the remaining years of this century. Therefore, it is essential that the serious student and conscientious librarian be aware of the strengths and weaknesses of the current situation in fine arts bibliography.

The only truly international fine arts bibliographies are the now obsolete retrospective bibliographies compiled by Lucas (12) and Chamberlin (8). The two serial bibliographies mentioned above (25 and 27) were of broader scope when they began than they are now; both restrict themselves to Western art from the end of the ancient world to the twentieth century. Access to literature on non-Western art is seriously hampered by this, for to date, only a few special bibliographies have appeared to fill the gap. Those that have appeared give excellent access to Islamic art, African art, and the art of ancient Greece and Rome. Far Eastern art and the art of pre-Columbian America have only weak and spotty bibliographic coverage, which has been an impediment to serious scholarship.

If Western art is tolerably served by serial bibliographies, serious study in many areas of Western art history is frustrated by uneven coverage at the national level. Only the German-speaking countries (Germany, Austria, Switzerland), Denmark, and Sweden are thoroughly covered by retrospective bibliographies; the entire Pan-German sphere is covered by the most exhaustive, classified, and annotated serial bibliography in the field of the fine arts (88). Denmark and Sweden both have excellent retrospective bibliographies and have recently instituted serial bibliographies on the German model. The rest of Europe has approached the task of fine arts bibliography less systematically. Italy has a fine retrospective bibliography (105) but has had uneven success with serial bibliography. Considering the great importance of Italian art in the history of Western art, this situation is lamentable. Spain has a good retrospective bibliography and has gradually increased the thoroughness of the serial bibliography published in the Archivo español (115). The Netherlands has concentrated on painting and the graphic arts, but it has recently begun a serial bibliography of more universal scope in its periodical, Simiolus (109). The weakest links in the chain of Western European countries are France and Britain. France has no national bibliography, although much of the literature is covered by the international serial, Répertoire (27). England began a serial fine arts bibliography in the 1930s but discontinued it in 1957. Retrospective and serial bibliographies for these important countries are much needed. Only

a few of the East European countries have attempted fine arts bibliographies. Most surprising of all, however, considering American accomplishments in international fine arts bibliography, there are no American national serial fine arts bibliographies comparable to the European productions. However, beginnings have recently been made toward filling the need for a retrospective bibliography (159, 161), and if all goes according to schedule, the Smithsonian Institution's four-volume bibliography of American art and architecture will be available soon.

A third approach to fine arts bibliography that promises to be a fertile area for bibliographic contribution has been concerned with preparing bibliographies devoted to periods of Western art. Most of these have been concentrated at the two ends of the time spectrum (ancient art and art of the nineteenth and twentieth centuries), which is explained by the fact that most international and many national bibliographies omit these periods. In the case of the bibliography on nineteenth century art by Hilda Lietzmann (82), these period bibliographies have provided a great impetus to scholarship. The bibliography of the German archaeological institute (41) provides specialists in ancient art with an incomparable bibliographic tool. It is conceivable that this type of fine arts bibliography will increase in the future, as will compilations from national bibliographies.

Lastly should be mentioned several contributions in the field of special subject bibliography within the fine arts. Iconography, the study of subject matter in the visual arts, cuts across all periods and nations and has been a growing subsidiary of art history. Until recently, however, there has been little access to literature on this subject. The situation has been dramatically changed by the appearance of a number of excellent dictionaries of iconography, with separate bibliographies, and the serial bibliography of symbolism edited by Manfred Lurker (420). Lurker's bibliography is to be praised not only for its scope but for the thoroughness of its annotations, which were written by specialists in the field of symbolism. Because of the great importance of bibliographies to any serious study in the fine arts, I have endeavored in this section to be as complete as has been practicable. International, national, and regional fine arts bibliographies are included; so are bibliographies dealing with specific periods, civilizations, and subjects. In addition to the fairly well-known serial and retrospective bibliographies published as books, I have included another class of bibliographies that is seldom included in retrospective bibliographies. These are the important short bibliographies that usually deal with a small area in the fine arts and often with critical commentary appearing from time to time in various fine arts periodicals. Some of these bibliographies are the sole bibliographic resource for a special area of study; others, as previously mentioned, amount to extremely comprehensive national serial bibliographies. Their inclusion here should provide the student and librarian with access to a full panorama of bibliographic aids. The fullness will be even greater if the user bears in mind that excellent bibliographies, often classified and occasionally annotated as well, can be found in basic histories and handbooks. These are listed in part II; those that provide bibliographies are noted in the annotations.

^{1.} K. Steinitz, "Early Art Bibliographies. Who Compiled the First Art Bibliography?" Burlington Magazine 114, 1972, pp. 829-37.

RESEARCH AND LIBRARY MANUALS

- 1 Carrick, Neville. How to Find Out about the Arts: A Guide to Sources of Information. Oxford, Pergamon, 1965. 164p. illus. index. LC 65-19834. Guide for the general reader and the undergraduate student in how to use basic reference tools in the fine arts. Chapter on tracing art information has illustrations of actual pages from reference works like Bénézit (268) and Thieme-Becker (276). Chapters with introductory essays cover the major reference tools and basic histories by period, nation, and media. Includes chapters on theater and photography.
- Goldman, Bernard. Reading and Writing in the Arts: A Handbook.
 Detroit, Wayne State University Press, 1972. 163p. index. LC 73-165938.

 Guide for undergraduate students to researching and writing papers. Part 2 is a reference key by subject that serves as an index to the classified bibliography of 403 reference works, general books, and periodicals listed in part 3. The major entries in part 3 have descriptive annotations. Part 4 provides guidance to writers of research papers and a brief section on writing for publication.
 - Jones, Lois S. Art Research Methods and Resources: A Guide to Finding Art Information. Dubuque, Iowa, Kendall/Hunt, 1978. 243p. illus. index. LC 77-93281.

Comprehensive guide for the student and librarian in the use of fine arts reference works. Part I deals with research methods; part II surveys the basic sources. Part III gives practical advice on obtaining reference materials. Emphasis is on English-language materials, but a French, German, and Italian dictionary of art terms is provided. Treats how-to-do materials as well as art history reference tools. Useful feature is the use of facsimilies of pages from major reference sources as guides to their use.

4 Muehsam, Gerd. Guide to Basic Information in the Visual Arts. Santa Barbara, Calif., ABC-Clio, 1978. 266p. index. LC 77-17430.

A reader's and librarian's guide to basic literature on the history of Western art and architecture. Divided into four major sections: "Core Materials," "Periods of Western Art," "Art Forms and Techniques," "National Schools of Art." Each discusses English-language works in essay form. Bibliography (pp. 199-247) lists 1,045 titles discussed in alphabetical order. Because of language restrictions, this guide concentrates on general works, but it is effective in demonstrating how much information can be obtained from these relatively accessible works.

Pacey, Philip, ed. Art Library Manual. A Guide to Resources and Practice. London and New York, R. R. Bowker, 1977. 423p. index.

Collection of essays by 21 experts (mostly British) in the field of art librarianship on such topics as: art bibliographies, museum and gallery publications, exhibition catalogs, sales catalogs, periodicals and serials, abstracts and indices, microforms, slides, film strips, and photographs. Each chapter is provided with a bibliography. Although the emphasis is chiefly on the technical handling of the materials from the librarian's standpoint, in earlier chapters there is much valuable information on the use of reference materials.

GENERAL SYSTEMATIC BIBLIOGRAPHIES

Bachmann, Donna G., and Sherry Piland. Women Artists: An Historical, Contemporary and Feminist Bibliography. Metuchen, N.J. and London, Scarecrow Press, 1978. 323p. illus. LC 78-19182.

Annotated bibliography of women painters, sculptors, photographers, and architects from the Middle Ages through the twentieth century. A 46-page section on general works—which includes slide sets and microfilm collections, dissertations, and exhibition catalogs—precedes literature on 167 individual women artists, 69 of whom are twentieth-century figures. A brief biographical sketch opens each individual entry.

Besterman, Theodore. Art and Architecture: A Bibliography of Bibliographies. Totowa, N.J., Rowman and Littlefield, 1971. 216p. LC 74-29568.

Reissue of the sections on art and architecture in the author's World Bibliography of Bibliographies, 4th ed. (1965-1966). Classified bibliography of bibliographies.

8 Chamberlin, Mary W. Guide to Art Reference Books. Chicago, American Library Association, 1959. 418p. index. LC 59-10457.

Classified and annotated bibliography of 2,489 books on the fine arts. Covers reference tools, basic histories and handbooks, periodicals, documents and sources, and series publications. Includes only books written in Western languages. General index. Although no longer up to date, it is still an indispensable reference tool for students and librarians. A useful feature is the appendix, with a descriptive list of art reference libraries in the United States and Europe.

9 Crouslé, Maurice, comp. L'art et les artistes. 2nd ed. Paris, Hachette, 1961. 343p. illus. index. LC 63-20786.

Classified trade bibliography of some 5,000 books in French on the fine arts. Lists chiefly general and popular books; gives a physical description of the book, place of publication, publisher (but not date of publication), and price. Although it is now out of date, it is still a useful compilation for the reference librarian.

10 Dove, Jack. Fine Arts. London, Clive Bingley, 1966. 88p. index. (The Readers Guide Series). LC 64-27927.

Classified and annotated bibliography of a small selected group of books. Title and subject index. Good basic bibliography for the general reader and the art collector.

Duplessis, Georges. Essai d'une bibliographie générale des beaux-arts; biographies individuelles, monographies, biographies générales. Paris, Rapilly, 1866. 144p.

List of early artists' biographies and monographs. Contents: section I, Biographies individuelles, Monographies (alphabetically by artist's name); section II, Biographies générales (chronologically by date of publication). No indexes.

Lucas, Edna Louise. Art Books: A Basic Bibliography of the Fine Arts. Greenwich, Conn., New York Graphic Society, 1968. 245p. index. LC 68-12364.

Classified bibliography of fine arts books covering basic reference tools, period and medium histories, and monographs on artists. Author, artist, and title index. Based on the author's *Harvard List of Books on Art* (last published in 1952) and designed as a selection guide for college libraries. As such, it includes only the books then readily obtainable, so there are many important omissions, particularly in reference categories. Its most useful feature is its bibliography of artist monographs.

Lucas, Edna Louise. Books on Art: A Foundation List. 2nd ed. Cambridge, Mass., Fogg Museum, Harvard University, 1938. 84p. index. (Harvard-Radcliffe Fine Arts Series).

Classified list of books selected for the needs of a small college library. Now out of date. Author index.

- Lucas, Edna Louise. Guides to the Harvard Libraries, No. 2: Fine Arts. Cambridge, Mass., Harvard University Library, 1949. 54p.
 Guide to the Fine Arts collections of the Harvard libraries. Useful list of basic reference tools in the appendix.
- Mayer, Leo A. Bibliography of Jewish Art. Ed. by Otto Kurz. Jerusalem, Hebrew University Press, 1967. 374p. index. LC B 67-14948. Bibliography of books and periodical articles that treat art by Jews between 70 and 1830 A.D. and that were published up to 1965. The 3,016 entries are arranged alphabetically. Subject, artist, and author index.
 - Podszus, Carl O. Art: A Selected Annotated Art Bibliography. New York, n.p., 1960. 111p. LC 60-1621.

General bibliography of approximately 1,000 items covering all aspects of the visual arts, with particular emphasis on studio practice. Small section on history of art. Intended for schools, it should be useful for beginning students interested in the practice and the history of the fine arts.

- 17 Reisner, Robert G. Fakes and Forgeries in the Fine Arts: A Bibliography. New York, Special Libraries Association, 1950. 58p. index. Bibliography of books and periodical articles on fine arts fakes and forgeries published from 1848 to 1948. Special feature is the list of articles on fakes published in the *New York Times* from 1897 to 1950.
- Rosenthal, T. G. European Art History. Cambridge, Cambridge University Press, 1960. 32p. (Reader's Guide Fourth Series, No. 4). Classified bibliography of books on European art, exclusive of architecture, for the general reader. Includes only books then in print.
 - 19 Schlosser, Julius von. La letteratura artistica: Manuale delle fonti della storia dell'arte moderna. 3 ed. italiana aggiornata da Otto Kurz. Florence, "La Nuova Italia," 1964. 766p. Reprint: Florence, 1977.

Originally published as *Die Kunstliteratur* (Vienna, Schroll, 1924). Scholarly classified bibliography of books on art published up to the early nineteenth century. Basic reference tool for advanced students of art history. Additions by Kurz are in brackets. Artist and author index.

Timmling, Walter. Kunstgeschichte und Kunstwissenschaft: Kleine Literaturführer. Leipzig, Koehler & Volckmar, 1923. 303p.

Classified and annotated bibliography of German books and periodical articles on all aspects of art history. The annotations are directed to the needs of the student. At the time it was published, it was most useful. A supplement, Die Kunstliteratur der neuesten Zeit, was published in Leipzig, 1928.

Vinet, Ernest. Bibliographie méthodique et raisonnée des beaux-arts. . . Paris, Firmin-Didot, 1874-77. 2v. Reprint: Hildesheim, Olms, 1967. 288p. Classified and annotated bibliography of books published before 1870 on all aspects of the fine and applied arts. Although the classification system is rather broad, the descriptive annotations make Vinet's one of the most useful of the nineteenth-century bibliographies. Based on Brunet's Manuel du libraire et de l'amateur de livres.

See also: Indexes (191-200).

GENERAL SERIES BIBLIOGRAPHIES

22 Art/Kunst: International Bibliography of Art Book[s], 1972—. Basel, Helbing & Lichtenhahn, 1973—. index.

Classified list of in-print art books submitted by major art book publishers. As a trade list, it is useful for the librarian and the beginning student.

Bibliographie zur kunstgeschichtlichen Literatur in Ost und Südösteuropaischen Zeitschriften. 1960–. Munich, Zentralinstitut für Kunstgeschichte, 1964–. LC 72-623917.

Classified annual bibliography of articles in Slavic-language periodicals on the history of art. From 1960 to 1971, titled: *Bibliographie zur kunstgeschichtlichen Literatur in slawischen Zeitschriften*. Titles are translated into German, and annotations indicate which articles have summaries in Western European languages. Extremely useful guide to much otherwise inaccessible material in Eastern European periodicals.

- Delogu, Giuseppe, comp. Essai d'une bibliographie internationale d'histoire de l'art, 1934/35. Bergamo, Ist. Ital. d'Arti Grafiche, 1936. index. 176p. Published by the Comité Internationale d'Histoire de l'Art. Defunct. Intended to be a classified bibliography of books on art and music published in German, French, English, Spanish, Italian, Polish, Czech, Romanian, Swedish, and Hungarian. Thorough coverage of exhibition and sales catalogs. Author index.
- Internationale Bibliographie der Kunstwissenschaft, 1902-1917/18.
 Berlin, Behr, 1903-1920. index. 15v. in 14.
 Classified bibliography of books, periodical articles, and book reviews published in all major languages. Outline of classification given at the beginning. Although

defunct, it is a most thorough and comprehensive bibliography of the period 1903 to 1918. Author and subject indexes.

26 Kunstgeschichtliche Anzeigen. Neue Folge. Jahrg. 1–, 1955–. Graz, Cologne. Böhlaus. 1955–.

Continues Kunstgeschichtliche Anzeigen (Innsbruck, 1904-1913) and Kritische Berichte zur kunstgeschichtlichen Literatur (Leipzig, 1927-38). Published by the Kunsthistorisches Institut der Universität Wien. This is a periodical devoted to the scholarly criticism of art historical literature. Each issue is devoted to one or more periods or fields of art historical research. A basic reference tool for all serious students of art history. The important issues are listed in this volume under the appropriate period and civilization headings.

27 Répertoire d'art et d'archéologie; dépouillement des périodiques et des catalogues de ventes, bibliographie des ouvrages d'art français et étrangers. T. 1-. 1910-. Paris, Morancé. 1910-. index.

Since 1965, there has been a Nouvelle Série with the title Répertoire d'art et d'archéologie (de l'époque paléochrétienne à 1939). Classified and annotated annual bibliography of books and periodical articles on all aspects of Western art. In the original series—that is, until 1965—antiquity was covered. In the new series, the bibliography begins with Early Christian art. The material is arranged in large categories subdivided by nation. An outline of classification and a list of serials consulted are given at the beginning of each volume. A basic reference tool for serious study in the history of Western art. The most comprehensive international series bibliography that attempts to cover both periodical articles and books as well as exhibition and museum catalogs. Coverage has varied over the long history of this work. Up to 1945, it included aesthetics, folk art, prehistoric art, primitive art, and pre-Columbian art, Islamic, Far Eastern art, and ancient art were covered until 1964. The coverage of these areas was taken over by Bulletin signalétique, Nrs. 521, 525, and 526 (entries 37, 34, and 123) in 1970. In 1972, coverage of artists born after 1920 and works of art produced after 1940 were dropped. Since 1973, the Répertoire has been computer assisted, and a new, highly detailed subject index has been added. Unfortunately this has been accompanied by a significant reduction in the number of periodicals covered. Nonetheless, the Répertoire still indexes more periodicals than RILA (28) and, except for American art, than the Art Index (192). The standard bibliographic tool for art history.

28 RILA. Répertoire international de la littérature de l'art. International Repertory of the Literature of Art. v. I-. Williamstown, Mass., RILA Abstracts, 1975—.

A new, international, computer-assisted series bibliography covering books and periodical literature on post-classical European art and post—conquest American art. Coverage includes museum and exhibition catalogs, congress papers, Fest-schriften and dissertations. Áppears twice a year. The bibliographic scope, classification system, and indexes are similar to the *Répertoire d'art et d'archéologie* (RAA; see no. 27) since 1973. Unlike RAA, RILA provides lengthy abstracts, many written by the authors, for most entries. Excellent computer-assisted subject indexing. Titles of foreign entries are translated. At present, RILA

indexes some 190 periodicals, a fraction of the number indexed by RAA and the *Art Index* (192), but it indexes some not indexed by RAA, notably, American periodicals and newspapers. Since it greatly depends on author abstracting, RILA's coverage of books is slower and less complete than RAA's. Should be used together with RAA and *Art Index* for any comprehensive bibliographic search.

29 The Worldwide Art Book Syllabus: A Select List of In-Print Books on the History of Art and Archaeology. v. 1—. New York, Worldwide Books, 1966—.

Classified and annotated bibliography of fine arts books available from Worldwide Books. Gives book reviews and prices. Trade list useful to the librarian and general student.

The Worldwide Art Catalogue Bulletin. v. 1—. New York, Boston, Worldwide Books, 1963—.

List of museum and exhibition catalogs, annotated and listed by country. Prices are given. Useful trade list of art catalogs available through Worldwide Books.

31 "Literaturbericht zur Kunstgeschichte," in: Zeitschrift für Kunstgeschichte. Bd. 1—. Munich, Berlin, Deutscher Kunstverlag, 1932—. Beginning with vol. 12, this periodical publishes in its August issue a classified bibliography of books and periodical articles on art published in the previous year, covering all major Western languages. A most useful and thorough current bibliography.

See also: Indexes (191-196).

SPECIALIZED BIBLIOGRAPHIES

PREHISTORIC

32 Bibliographie annuelle de l'âge de la pierre taillée (paléolithique et mésolithique). No. 1-, 1955/56-. Paris, Bureau de Recherches Géologiques et Minières, 1958-.

Annual bibliography of books and periodical articles on all aspects of prehistoric civilization including prehistoric art. Succeeds *Old World Bibliography* (36).

Bonser, Wilfrid. A Prehistoric Bibliography. Extended and ed. by June Troy. Oxford, Blackwell, 1976. 425p. index.

Comprehensive, classified bibliography covering books and periodical articles on all aspects of prehistoric culture in Great Britain published before 1973. Section on art, pp. 330-335. Brief descriptive annotations.

Bulletin Signalétique. Série 525: Préhistoire. v. 24—. Paris, Centre National de la Recherche Scientifique, 1970—. LC 74-263853.

Annual bibliography of books and periodical articles on all aspects of prehistory, including prehistoric art. Titles are translated into French and abstracts in French are provided for the more complex entries. A valuable reference work for advanced students and scholars of prehistoric art.

Eppel, Franz. "In den Jahren 1954 bis 1959 erschienene Werke zur urgeschichtlichen Kunst," in: Kunstgeschichtlichen Anzeigen, Neue Folge, Jahrg. 4, 1959/60, pp. 57-105.

Critical examination of the major publications on prehistoric art published between 1954 and 1959. The works discussed are listed at the beginning of the

article. See (26) for series annotation.

36 Old World Bibliography: Recent Publications Mainly in Old World Palaeolithic Archaeology and Palaeo-Anthropology. Cambridge, Mass., Peabody Museum, American School of Prehistoric Research, v. 1-8, 1948-1955.

Annual bibliography of books and periodical articles on all aspects of prehistoric archaeology and anthropology including prehistoric art. Defunct; succeeded by *Bibliographie annuelle de l'âge de la pierre taillée* (32).

PRIMITIVE

37 Bulletin Signalétique. Série 521: Sociologie-Ethnologie. v. 21 – . Paris, Centre National de la Recherche Scientifique, 1967 – .

Annual bibliography of books and periodical articles on all aspects of sociology and

Annual bibliography of books and periodical articles on all aspects of sociology and ethnology, including the arts of primitive peoples throughout the world. A valuable reference work for advanced students and scholars of primitive art.

Haselberger, Herta. "In den Jahre 1961 bis 1964 erschienene Werke zur ethnologischen Kunstforschung," in: Kunstgeschichtliche Anzeigen, Neue Folge, Jahrg. 7, 1965/66, pp. 62-92.

Critical examination of the major works on primitive art published between 1961 and 1964. The works discussed are listed at the beginning of the article. See (26) for series annotation.

New York City. Museum of Primitive Art. Library. Primitive Art Bibliographies. New York, Museum of Primitive Art, 1963—.

Series of separate classified bibliographies of books and periodical articles on the art of various primitive cultures. To date, they include:

No. 1, Douglas Fraser, *Bibliography of Torres Strait Art* (New York, 1963; 6p.)

No. 2, Julie Jones, Bibliography of Olmec Sculpture (New York, 1963; 8p.)

No. 3, Herbert M. Cole and Robert F. Thompson, *Bibliography of Yoruba Sculpture* (New York, 1964; 11p.)

No. 4, Douglas Newton, *Bibliography of Sepik District Art, Annotated for Illustrations, Part 1* (New York, 1965; 20p.)

No. 6, Paula Ben-Amos, *Bibliography of Benin Art* (New York, 1968; 17p.)

No. 8, Allen Wardwell and Lois Lebov, Annotated Bibliography of Northwest Coast Indian Art (New York, 1970; 25p.)

No. 9, Valerie Chevrette, Annotated Bibliography of the Pre-Columbian Art and Archaeology of the West Indies (New York, 1971; 18p.)

EUROPE

Periods of Western Art History

Ancient

44

Annual Egyptological Bibliography, 1947—. Leiden, Brill, 1948—. Bibliography of books and periodical articles on all aspects of ancient Egyptian civilization including the fine arts. Straight alphabetical listing. Entries have full annotations, some by leading specialists. Standard reference work for all serious study of ancient Egyptian art and architecture.

41 Archäologische Bibliographie: Beilage zum Jahrbuch des Deutschen Archäologischen Instituts, v. 1-. 1932-. Berlin, 1932-. Preceded by Bibliographie zum Jahrbuch des Archäologischen Instituts (Berlin. 1913-1931) and Archäologischer Anzeiger zum Jahrbuch des Archäologischen Instituts (Berlin, 1889-1912). Classified bibliography of books and periodical articles on all aspects of classical archaeology, including art. With its predecessor series, the Archäologische Bibliographie is the most important bibliographical tool for specialists in the history of ancient art.

- 42 Berghe, Louis van den. Bibliographie analytique de l'Assyriologie et de l'archéologie du Proche-Orient, v. 1-. Leyden, Brill, 1956-. Comprehensive, classified, and annotated bibliography of books and periodical articles on all aspects of the ancient civilizations of the Near East. Does not cover Egypt. Contains a valuable section on art and architecture. Basic reference tool for advanced students and scholars of Ancient Near Eastern art and archaeology.
- 43 Coulson, William D. An Annotated Bibliography of Greek and Roman Art, Architecture and Archaeology, New York, Garland, 1975, 135p. (Garland Reference Library of the Humanities, 28). LC 75-24081. Annotated and classified bibliography of basic books on the subject. Would be most useful for students and instructors at the undergraduate level. All were in print at the time of publication, and most are paperbacks. Arranged in two main groups: books useful as texts or supplementary reading; additional books costing under \$10.00. Appendices list major books in German and French then in print.
- Defosse, Pol. Bibliographie étrusque. Brussels, Latomus, 1976-. (Collection Latomus, 144). LC 76-457244. A planned three-volume retrospective bibliography of books and periodical literature on all aspects of Etruscan civilization. To date, Tome II, covering the period 1927 to 1950, has been published. Contains extensive coverage of fine and

applied arts in addition to history, language, religion, and geophysical matters. Thoroughly indexed. Standard reference work for Etruscan art history.

45 Ellis, Richard S. A Bibliography of Mesopotamian Archaeological Sites. Wiesbaden, Harrassowitz, 1972. 113p. index. LC 72-170748. Bibliography of books and periodical literature on ancient sites in pre-Islamic Mesopotamia. Provides quick access to basic archaeological literature on many sites important to the history of ancient art.

46 Fasti Archaeologici . . . Annual Bulletin of Classical Archaeology, v. 1-, 1946-. Florence, Sansoni, 1948-.

Published by the International Association of Classical Archaeology. Issued annually. Classified bibliography of books and periodical articles on all aspects of classical archaeology, including art, from prehistoric to Early Christian times; includes works in English, French, German, and Italian. Also contains bulletins of archaeological discoveries throughout the ancient classical world. A basic reference tool for specialists in ancient art. Author index at the end of each volume.

Kenner, Hedwig. "In den Jahren 1957 bis 1959 erschienene Werke zur griechischen Kunst," in: Kunstgeschichtliche Anzeigen, Neue Folge, Jahrg. 4, 1959/60, pp. 140-59.

Critical examination of the major works on Greek art published between 1957 and 1959. The works discussed are listed at the beginning of the article. See (26) for series annotation.

Kenner, Hedwig. "In den Jahren 1957 bis 1959 erschienene Werke zur keltischen und etruskischen Kunst," in: Kunstgeschichtliche Anzeigen, Neue Folge, Jahrg. 4, 1959/60, pp. 160-64.

Critical examination of the major works on Celtic and Etruscan art published from 1957 to 1959. The works discussed are listed at the beginning of the article. See (26) for series annotation.

Kenner, Hedwig. "In den Jahren 1957 bis 1959 erschienene Werke zur provinzialrömischen Kunst," in: Kunstgeschichtliche Anzeigen, Neue Folge, Jahrg. 4, 1959/60, pp. 178-84.

Critical examination of the major works on Roman provincial art published from 1957 to 1959. The works discussed are listed at the beginning of the article. See (26) for series annotation.

Kenner, Hedwig. "In den Jahren 1957 bis 1959 erschienene Werke zur römischen Kunst," in: Kunstgeschichtliche Anzeigen, Neue Folge, Jahrg. 4, 1959/60, pp. 165-77.

Critical examination of the important publications on Roman art appearing from 1957 to 1959. The works discussed are listed at the beginning of the article. See (26) for series annotation.

Kenner, Hedwig. "In den Jahren 1957 bis 1959 erschienene Werke zur spätantiken Kunst," in: Kunstgeschichtliche Anzeigen, Neue Folge, Jahrg. 4, 1959/60, pp. 185-94.

Critical examination of the major works on late Roman art published from 1957 to 1959. The works discussed are listed at the beginning of the article. See (26) for series annotation.

52 Lopez Pegna, Mario. Saggio di bibliografia etrusca. Florence, Sansoni, 1953.

Classified bibliography of books and periodical articles on all aspects of Etruscan art.

Moon, Brenda E. Mycenaean Civilization Publications since 1935; A Bibliography. London, University of London Institute of Classical Studies, 1957. 77p. (Bulletin of the Institute of Classical Studies, University of London, Supplement, no. 3).

Unclassified bibliography of books and periodical articles on all aspects of Minoan Crete published between January 1936 and June 1956. Subject index, pp. 68-77.

Porter, Bertha, and Rosalind L. B. Moss. Topographical Bibliography of Ancient Egyptian Hieroglyphic Texts, Reliefs and Paintings. 2nd ed. Oxford, Clarendon, 1960. 7v. LC 60-1989.

Comprehensive classified bibliography of books and periodical articles dealing with ancient Eqyptian hieroglyphic inscriptions, reliefs, and paintings. Does not cover architecture or free-standing sculpture. Contents:

- I. Theban Necropolis
- II. Theban Temples
- III. Memphis
- IV. Lower and Middle Egypt
- V. Upper Egypt: Sites
- VI. Upper Egypt: Temples
- VII. Nubia, the Deserts and Outside Egypt

A basic reference tool for advanced study in ancient Egyptian painting and relief sculpture.

Sarne, Berta. "In den Jahren 1955 bis 1961 erschienene Werke zur kretisch-mykenischen Kunst," in: Kunstgeschichtliche Anzeigen, Neue Folge, Jahrg. 7, 1965/66, pp. 7-61.

Critical examination of the major works on Aegean art published from 1955 to 1961. The works discussed are listed at the beginning of the article. See (26) for series annotation.

Swoboda, K. M. "In den Jahren 1950 bis 1956 erschienene Werke zur griechischen Kunst," in: **Kunstgeschichtliche Anzeigen,** Neue Folge, Jahrg. 3, 1958, pp. 9-44.

Critical examination of the major works on ancient Greek art published from 1950 to 1956. The works discussed are listed at the beginning of the article. See (26) for series annotation.

57 Swoboda, K. M. "In den Jahren 1950 bis 1957 erschienene Werke zur Kunst der Spätantike," in: Kunstgeschichtliche Anzeigen. Neue Folge, Jahrg. 3, 1958, pp. 80-137.

Critical examination of the major works on late Roman art published from 1950 to 1957. The works discussed are listed at the beginning of the article. See (26) for series annotation.

Swoboda, K. M. "In den Jahren 1950 bis 1957 erschienene Werke zur römischen Kunst," in: Kunstgeschichtliche Anzeigen. Neue Folge, Jahrg. 3, 1958, pp. 57-59.

Critical examination of the major literature on Roman art published from 1950 to 1957. The works discussed are listed at the beginning of the article. See (26) for series annotation.

Swoboda, K. M. "In den Jahren 1950 bis 1954 erschienene Werke zur Kunst der prähistorie und alten Orients," in: Kunstgeschichtliche Anzeigen, Neue Folge, Jahrg. 1, 1955/56, pp. 3-77.

Critical examination of the major works on prehistoric art and the art of the Ancient Near East published from 1950 to 1954. The works discussed are listed at the beginning of the article. See (26) for series annotation.

Medieval and Byzantine

60 **Bibliographie de l'art byzantin et post-byzantin, 1945-1969.** Athens, Comité National Hellenique de l'Association Internationale d'Etudes du Sud-Est Européen, 1970. 115p. LC 72-318821.

Classified bibliography of books and periodical articles on all aspects of Byzantine and derivative art forms in Eastern Europe published between 1945 and 1969. Brings up to date the various special bibliographies published in *Orient et Byzance* and *Byzantion* in the 1930s and 1940s.

- Bonser, Wilfrid. An Anglo-Saxon and Celtic Bibliography (405-1087).

 Berkeley and Los Angeles, University of California Press, 1957. 2v. index.

 A general classified bibliography of Anglo-Saxon and Celtic culture. Includes a good section (pp. 480-574) on art, which includes books and periodical articles published up to 1953. Author and subject indexes in vol. 2.
 - Dumbarton Oaks Bibliographies Based on Byzantinische Zeitschrift. Series I: Literature on Byzantine Art 1892-1967. Volume 1: By Location. Volume 2: By Categories. Ed. by Jelisaveta S. Allen. London, Mansell, 1973, 1976.

Classified and annotated bibliography of books and periodical articles on all aspects of Byzantine art. The entries are derived from the annual bibliography published since 1892 in the periodical *Byzantinische Zeitschrift*, the leading scholarly journal for Byzantine studies.

- 63 Filov, B. "Die Erforschung der altbulgarischen Kunst seit 1914," in:

 Zeitschrift für slavische Philologie, VII, 1931, pp. 131-43.

 Critically annotated bibliography of scholarly literature on the history of medieval Bulgarian art which appeared between 1914 and 1930. Of interest to students of Byzantine art.
- Grabar, André, and K. Mijatev. "Bibliographie de l'art byzantin: Bulgarie," in: Orient et Byzance, IV, 2, 1930, pp. 417-26.
 Classified bibliography of books and periodical articles on the Byzantine phase of

art in Bulgaria. Part of a series of bibliographies in this periodical covering most Slavic schools of Byzantine art.

Millet, Gabriel, and N. A. Il'in. "Bibliographie de l'art byzantin chez les Russes," in: Orient et Byzance, V, 1932, pp. 439-90.
Classified bibliography of books and periodical articles on the Byzantine phase of Russian art. Part of a series of specialized bibliographies in this periodical covering the major Slavic schools of Byzantine art.

Monneret de Villard, U. "Saggi di una bibliografia dell'arte cristiana in Egitto," in: Rivista dell'Istituto d'Archeologia e Storia dell'Arte, I, 1922, pp. 20-34.

Classified and annotated bibliography of books and periodical articles on Coptic art and architecture published before 1920.

- 67 Sotiriou, G. A. "Bibliographie de l'art byzantin; Bulgarie, Serbie, Roumanie," in: Orient et Byzance, IV, 1930, pp. 417-54.

 Classified bibliography of books and periodical articles on the Byzantine phase of art in Bulgaria, Serbia, and Romania. Part of a series of specialized bibliographies in this periodical covering the major Slavic schools of Byzantine art.
 - Stein, Frauke. "In den Jahren 1957 bis 1962 erschienene Werke zur Kunst der frühen Mittelalters," in: Kunstgeschichtliche Anzeigen, Neue Folge, Jahrg. 6, 1963/64, pp. 105-133.

Critical examination of the major works on early medieval art published from 1957 to 1962. The works discussed are listed at the beginning of the article. See (26) for series annotation.

- 69 Swoboda, K. M. "In den Jahren 1950 bis 1961 erschienene Werke zur byzantinischen und weiteren ostchristlichen Kunst-Figurenkunst," in:

 Kunstgeschichtliche Anzeigen, Neue Folge, Jahrg. 5, 1961/62, pp. 9-183.

 Critical examination of the major works on Byzantine art exclusive of architecture published from 1950 to 1961. The works discussed are listed at the beginning of the article. See (26) for series annotation.
 - Swoboda, K. M. "In den Jahren 1950 bis 1956 erschienene Werke zur Kunst des frühen Mittelalters," in: Kunstgeschichtliche Anzeigen, Neue Folge, Jahrg. 3, 1958, pp. 138-94.

Critical examination of the major works on early medieval art (i.e., pre-Carolingian) published from 1950 to 1956. The works discussed are listed at the beginning of the article. See (26) for series annotation.

- Swoboda, K. M. "In den Jahren 1950 bis 1957 erschienene Werke zur byzantinischen und weiteren ostchristlichen Kunst-Architektur," in: Kunstgeschichtliche Anzeigen, Neue Folge, Jahrg. 4, 1959/60, pp. 34-56. Critical examination of the major works on Byzantine and East Christian architecture published from 1950 to 1957. The works discussed are listed at the beginning of the article. See (26) for series annotation.
 - Swoboda, K. M. "In den Jahren 1950 bis 1957 erschienene Werke zur Kunst der karolingische Zeit," in: Kunstgeschichtliche Anzeigen, Neue Folge, Jahrg. 4, 1959/60, pp. 1-33.

Critical examination of the important literature on Carolingian art published from 1950 to 1957. The works discussed are listed at the beginning of the article. See (26) for series annotation.

Wulff, Oscar K. Bibliographisch-Kritischer Nachtrag zu altchristliche und byzantinische Kunst. Potsdam, Athenaion, 1937. 88p.

Classified bibliography of books and periodical articles on all aspects of early Christian and Byzantine art. Supplement to the author's *Altchristliche und byzantinische Kunst*... (Berlin, Athenaion, 1918) in the series "Handbuch der Kunstwissenschaft."

Modern (19th and 20th Centuries)

Andreoli-de Villers, Jean-Pierre. Futurism and the Arts: A Bibliography. 1959-1973. Toronto and Buffalo, University of Toronto Press, 1975. 189p. index.

Chronologically arranged bibliography of 1,895 books, catalogs, and periodical articles on all aspects of Futurism. Introduction lists eighteen locations in Italy, France, and North America with collections of documents relating to Futurism. Section on periodicals of Futurism.

75 Arntz-Bulletin; Dokumentation der Kunst des 20. Jahrhunderts. v. 1–. Haag, Oberbayern, Arntz-Winter, 1968–.

Annual bibliography that aims at covering all the oeuvre catalogs of major twentieth century artists. Arranged more or less alphabetically, the entries are annotated, and corrections and additions to the catalogs are presented by the compiler. In 1975, a Sonderband, Werkkataloge zur Kunst des 20. Jahrhunderts, appeared that lists catalogues raisonnées printed since 1945, without annotations. Emphasis is on major European painters, sculptors, and graphic artists.

- Annual bibliographies Modern, v. 1—. Santa Barbara, ABC-Clio Press, 1969—. Annual bibliography of books and periodical articles on twentieth century art. Volume 1 was titled *L.O.M.A. Literature on Modern Art*; it was published in London by Lund and Humphries and was based on material in the Victoria and Albert Museum Library, Courtauld Institute Library, and the Library of the Lanchester Polytech. Subsequent volumes have been greatly expanded. First section is arranged alphabetically by artist, second section by subject. A valuable bibliographical tool for modern art.
- 77 Bibliographie 1925: Cinquantenaire de l'exposition de 1925. Paris, Société des Amis de la Bibliotheque Forney, 1976. 166p. index. Comprehensive bibliography of 1,494 books, exhibition and museum catalogs and periodical literature on all aspects of the 1925 Art Deco exposition. Classified by media. Includes theater and the decorative arts.
 - 78 Edwards, Hugh. Surrealism and Its Affinities: The Mary Reynolds Collection. A Bibliography. 2nd ed. Chicago, The Art Institute of Chicago, 1973. 147p. illus. index.

Annotated bibliography of works by Surrealist artists and writers assembled by patroness Mary Reynolds: a bibliography of source materials rather than of literature on Surrealism. Includes books and monographs, Surrealist periodicals, and such miscellanea as catalogs, posters, and broadsides.

Gershman, Herbert. A Bibliography of the Surrealist Revolution in France. Ann Arbor, University of Michigan Press, 1969. 57p. LC 68-31128.

Unannotated and unclassified list of books and periodical articles on all aspects of Surrealism in France, meant as a companion to the author's *The Surrealist Revolution in France* (Ann Arbor, University of Michigan Press, 1969).

80 Grady, James. "Bibliography of Art Nouveau," in: Journal of the Society of Architectural Historians, XIV, 1955, pp. 18-27.

Classified and annotated bibliography of books and periodicals in all languages on Art Nouveau, with particular emphasis on architecture. Sections are devoted to literature on major Art Nouveau architects.

81 Kempton, Richard. Art Nouveau: An Annotated Bibliography. Los Angeles, Hennessey & Ingalls, 1977. 303p. index. (Art and Architecture Bibliographies, 4).

Classified bibliography of books and periodical articles on all aspects of Art Nouveau in continental Europe. Major entries are annotated.

Lietzmann, Hilda. Bibliographie zur Kunstgeschichte des 19. Jahrhunderts: Publikationen der Jahre 1940-1966. Munich, Prestel, 1968. 234p. illus. index. (Studien zur Kunst des neunzehnten Jahrhunderts, Bd. 4). LC 68-133420.

Classified bibliography of books and periodical articles on all aspects of nineteenth century art published from 1940 to 1966. General index. A thorough bibliography basic to serious research in European art of the nineteenth century.

European National and Area Bibliographies

Belgium

"Bibliographie de l'histoire de l'art national. Bibliografie van de nationale Kunstgeschiedenis," 1973—, in: Revue belge d'archéologie et d'histoire de l'art, XLIII, 1974—.

Annual classified bibliography of books and periodical articles on all aspects of art and architecture in Belgium. Appears at the end of the last number in each year. Long-awaited companion to the annual bibliography on Dutch art and architecture published in *Simiolus* (109).

Denmark

84 **Bibliografi over Dansk Kunst**, 1971–. Copenhagen, Kunstakademiets Bibliotek, 1972–.

Annual, classified bibliography of books and periodical articles on all aspects of Danish fine arts. Includes foreign-language literature as well as literature in Danish. Does not include works on archaeology, folk art, costume, numismatics, or photography. A retrospective bibliography covering the literature on Danish art published between 1933 and 1970 is planned to fill the gap between the *Bibliografi over*

Dansk Kunst and Bodelsen and Marcus (85). A basic reference tool for any serious study of Danish art.

Bodelsen, Merete, and Aage Marcus. Dansk Kunsthistorisk Bibliografi. Copenhagen, Reitzel, 1935. 503p.

Classified bibliography of books and periodical articles on Danish art. Includes both Danish and foreign-language publications.

France

Lebel, Gustave. Bibliographie des revues et périodiques d'art parus en France de 1746 à 1914. Paris, New York, 1951. (Gazette des Beaux-Arts, janv.-mars 1951, 6^e per. t. 38).

List of periodicals of art published in France between 1746 and 1914, by title. Gives date of first issue, frequency, editors, and the location of copies (either Bibliothèque Nationale or University of Paris Libraries). Some are annotated. Chronological index. Useful tool for students of eighteenth and nineteenth-century French art history. See *Répertoire d'art*...(27).

German-Speaking Countries

General Works

87 Literaturbericht zur Kunstgeschichte: deutschsprachige Periodika. 1971. Berlin, Mann and Deutscher Verein für Kunstwissenschaft, 1975. 186p. index.

Very comprehensive classified bibliography of articles on all aspects of art history published in German-language periodicals during 1971. The 2,546 articles are provided with abstracts, many written by the authors. Excellent author, artist, topographical, and subject index. Since German scholarship is central to many areas of art historical research, this work (assuming that subsequent volumes can appear at reasonable intervals) is potentially one of the major bibliographical reference tools for art history.

88 Schrifttum zur deutschen Kunst. Jahrg. 1–. Berlin, Deutscher Verein für Kunstwissenschaft, 1934–.

Published by the Deutscher Verein für Kunstwissenschaft and, since 1961, "zusammengestellt von der Bibliothek des Germanischen Nationalmuseums" in Nuremberg. One of the most thorough and comprehensive of national art bibliographies. Classified and annotated bibliography of books, periodical articles, exhibition catalogs, and book reviews on all aspects of art in German-speaking countries. Author, artist, and place indexes.

Austria

89 **Bibliographie zur Kunstgeschichte Osterreichs.** Zusammengestellt im Kunsthistorischen Institut der Universität Wien. Lehrkanzel für Österreichische Kunstegeschichte, 1965–. Vienna, Schroll, 1966–.

Classified bibliography of books and periodical articles on all aspects of Austrian art. Issued as a supplement to Österreichische Zeitschrift für Kunst und Denkmalpflege, XX-XXV (1966-1971). Continues the bibliographic coverage of Austrian art in Mitteilungen der Gesellschaft für vergleichende Kunstforschung in Wien, I (1948)— XV (1963).

Germany

- Beyrodt, Wolfgang. Westfälische Kunst bis zum Barock: Ein Literaturverzeichnis. Bielefeld, Stadtbibliothek Bielefeld, 1970. 63p. Classified bibliography of books and periodical articles on all aspects of art in Westphalia from the early Middle Ages through the baroque.
 - 91 Deutsche Akademie der Wissenschaft zu Berlin, Arbeitsstelle für Kunstgeschichte. Schriften zur Kunstgeschichte. Berlin, Akademie-Verlag, 1960-1974. 6v.

Bibliography of books and periodical articles on all aspects of art in the German Democratic Republic (East Germany). Issued in volumes devoted to separate regions: No. 4, *Bibliographie zur sächsischen Kunstgeschichte*, by Walter Hentschel (1960; 273p.); No. 7, *Bibliographie zur brandenburgischen Kunstgeschichte*, by Edith Neubauer and Gerda Schlegelmilch (1961; 231p.); No. 8, *Bibliographie zur Kunstgeschichte Mecklenburg und Vorpommern*, by Edith Fründt (1962; 123p.); No. 9, *Bibliographie zur Kunstgeschichte von Sachsen-Anhalt*, by Sibylle Harksen (1966; 431p.); No. 13, *Bibliographie zur Kunstgeschichte von Berlin und Potsdam*, by Sibylle Badstübner-Groger (1968; 320p.); and No. 16, *Bibliographie zur thüringischen Kunstgeschichte*, by Helga Mobius (1974; 227p.).

92 Deutscher Kunstrat. Schrifttum zur deutschen Kunst des 20. Jahrhunderts: eine Bibliographie des deutschen Kunstrates e. V. Bearb. von Ernst Thiele. v. 1 – . Cologne, Oda 1960 – . LC 61-47348.

assified and annotated bibliography of books periodical articles exhibition

Classified and annotated bibliography of books, periodical articles, exhibition catalogs, and book reviews published in Germany on German art of the twentieth century. Supplements *Schrifttum zur deutschen Kunst* (88), which does not include art after Art Nouveau.

- 93 Gruhn, Herbert. Bibliographie der schlesischen Kunstgeschichte. Breslau, Korn, 1933. 357p. (Schlesische Bibliographie, 6, 1). Classified bibliography of books and periodical articles on all aspects of art and architecture in the former German province of Silesia.
- Krienke, Gisela. Bibliographie zu Kunst und Kunstgeschichte; Veröffenlichungen im Gebiet der Deutschen Demokratischen Republik. V. 1, 1945-1935; V. 2, 1945-1957. Berlin, VEB, 1956, 1961. index.
 Classified bibliography of books and periodical articles published in the German Democratic Republic (East Germany). Includes unpublished dissertations. Vol. 2 has supplement to Vol. 1. Indexes by periodical, artist, place, names, subjects, and authors.

- 95 Kügler, Hans Peter. Schrifttum zur deutsch-baltischen Kunst. Berlin, Deutscher Verein für Kunstwissenschaft, 1939. 42p.

 Issued as a supplement to the Schrifttum zur deutschen Kunst (88). Classified bibliography of books and periodicals on German art in the former German Baltic provinces.
- 96 Schrifttum zur rheinischen Kunst von den Anfängen bis 1935. Berlin,
 Deutscher Verein für Kunstwissenschaft, 1949. 284p.
 Classified and annotated bibliography of books and periodical articles on all
 aspects of the fine arts in the Rhineland. Covers material published up to 1935,
 when the Schrifttum zur deutschen Kunst (88) takes over the indexing of
 literature on Rhenish art.
- Sepp, Hermann. Bibliographie der bayerischen Kunstgeschichte bis Ende 1905. Strasbourg, Heitz, 1906. 345p. index. (Studien zur deutschen Kunstgeschichte, Bd. 67). Nachtrag für 1906-1910. Strasbourg, Heitz, 1912. 208p. index. (Studien zur deutschen Kunstgeschichte, Bd. 67/155). Classified and annotated bibliography of books and periodical articles on all aspects of art in Bavaria. Covers material published up to 1905, with the Nachtrag treating the literature between 1906 and 1910. Continued by Wichmann (98); together, they ensure that Bavaria is the most thoroughly bibliographized fine arts region in the world.
- Wichmann, Hans. **Bibliographie der Kunst in Bayern**. Wiesbaden, Harrassowitz, 1961-1973. 4v. LC 63-59310.

Classified and annotated bibliography of books and periodical articles on all aspects of art in Bavaria. Covers only works published in the twentieth century, hence it complements Sepp (97). The most thorough of regional bibliographies thus far produced for the fine arts; includes nearly 70,000 items. Matthias Mende's *Sonderband: Dürer-Bibliographie* (Wiesbadan, Harrassowitz, 1971) classifies and annotates over 10,000 items dealing with the art of Albrecht Dürer and is also a model of an exhaustive artist bibliography.

Great Britain

49 London. University. Courtauld Institute of Art. Annual Bibliography of the History of British Art, v. 1-6, 1934-1948. Cambridge, University Press, 1936-1957. index.

Classified bibliography of books and periodical articles. Includes Celtic and Viking but not Roman art. Index in each volume. Useful tool for the study of British art, unfortunately discontinued.

Hungary

Biró, Béla. A Magyar Müsvészettörténeti Irodalom Bibliográfiája; Bibliographie der ungarischen kunstgeschichtlichen Literatur. Budapest, Képzömüvészeti alap Kiadóvállata, 1955. 611p. index. Classified bibliography of books and periodical articles on Hungarian art and Hungarian writings on art history from the eighteenth century to 1954. Table of contents and foreword are in Hungarian and German. Author and artist indexes.

Boskovits, Miklos, ed. L'art du gothique et la Renaissance, 1300-1500: Bibliographie raisonnée des ouvrages publiées en Hongrie. Budapest, Comité National Hongrois d'Histoire de l'Art, 1965. 2v. index. LC 68-37621.

Classified and annotated bibliography of books and periodical articles on Gothic and Renaissance art published in Hungary. Contains 2,858 entries. Author index.

Italy

- 102 "Bibliografia dell'arte veneta," in: Arte Veneta, Anno I, 1947—. Classified bibliography of books and periodical articles appearing annually on all aspects of art and architecture in Venice and its environs.
- Bibliografia del libro d'arte italiano, v. 1–, 1940–. Rome, Bestetti, 1952–. LC A-53-9809 rev.

Classified bibliography of books on Italian art including congresses, catalogs, and guides. Vol. 1, "Cura die Erardo Aeschlimann." Author, title, artist indexes.

"Bollettino bibliografico," in: Commentari: Rivista di Critica e Storia dell'Arte, Anno 2-, 1951-.

Loosely classified list of books and periodical articles on Italian art and architecture appearing in each quarterly issue. By no means an exhaustive bibliography, it is useful in catching major current publications.

Borroni, Fabia. "Il Cicognara": Bibliografia dell'archeologia classica e dell'arte italiana, v. 1, t. 1-v. 2, t. 7-. Florence, Sansoni, 1954-1967. (Biblioteca Bibliografica Italica, v. 6-).

Classified and annotated bibliography of books on classical and Italian art. Arranged in classes and listed chronologically. Illustrates the title pages of earlier works. A basic reference tool for students of classical and Italian art.

106 Ceci, Giuseppe. Bibliografia per la storia delle arti figurative nell'Italia meridonale... Naples, Presso la R. Deputazione, 1937. 2v. index. Comprehensive classified bibliography of books and periodical articles on south Italian art. Arranged chronologically, volume 1 lists works published before 1742; volume 2, those published after that date. Material is best located by means of the author, artist, and place indexes in volume 2. An excellent regional fine arts bibliography.

Geck, Francis J. Bibliography of Italian Art..., v. 5-10. Boulder, Colo., University of Colorado Book Store, 1932-1941.

Volumes 1-4 were never published. Classified bibliography of books on Italian history, customs, and literature as well as art and architecture. Emphasis is on books in English. Contents:

- Vol. 5 Italian Gothic Art 1200-1420
- Vol. 6 Italian Early Renaissance Art—Quattrocento
- Vol. 7 Italian High Renaissance Art-Cinquecento
- Vol. 8 Italian Late Renaissance Art—Cinquecento
- Vol. 9 Italian Baroque Art-Il Seicento
- Vol. 10 Italian Rococo Art

Popular work for the general reader and beginning student.

Istituto Nazionale per le Relazioni Culturali con l'Estero. Archeologia, arti figurative, musica. Rome, I.R.C.E., 1941. 498p. (Bibliografie del Ventennio). index.

Classified bibliography covering archaeology, art, theater, cinema, and music in Italy. Books and exhibition catalogs published between 1922 and 1941. Author index. Supplements Bestetti (103).

Netherlands

"Bibliografisch Overzicht van in Nederland in 1966-verschenen Publicaties op het Gebied van de Kunstgeschiedenis en Enkele Aanverwante Wetenschappen," in: Simiolus, Jaargang 1-, 1966/67-.

Annual, classified bibliography of books and periodical literature published in the Netherlands on all aspects of the history of art.

Hall, H. van. Repertorium voor de Geschiedenis der Nederlandsche Schilder- en Graveerkunst sedert het Begin der 12de Eeuw... 's Gravenhage, Nijhoff, 1936-1949, 2v. index.

Classified bibliography of books and periodical articles on Dutch painting and engraving from the twelfth century to 1946. Belgian painting and engraving until 1500 included. Author index.

Netherlands. Rijksbureau voor Kunsthistorische Documentatie. **Bibliography of the Netherlands Institute for Art History**. v. 1–, 1943–. The Hague, 1943–.

Classified bibliography of books and periodical articles on Dutch painting and graphic arts. Continuation of Hall (110).

Repertorium betreffende Nederlandse Monumenten van Geschiedenis en Kunst. The Hague, 1940-1962. 3v. index.

Classified bibliography of periodical articles on all aspects of art and architecture in the Netherlands from the early Middle Ages to the present. The period from 1901 to 1940 is covered in the first two volumes; the period 1941 to 1950 is in the last volume. Subsequent volumes are planned. A basic reference tool for all serious study of Dutch art and architecture.

Repertorium van Boekwerken betreffende Nederlandse Monumenten van Geschiedenis en Kunst. The Hague, 1950. 169p. index.

Classified bibliography of books on all aspects of art and architecture in the Netherlands from the early Middle Ages to the present. Entries are short and give neither the place of publication, number of pages, nor illustrations. Edited

by the Koninklijke Nederlandse Oudheidkundige Bond. Includes books published to 1940. Periodical literature is treated in (112). A basic reference tool for any serious study of Dutch art and architecture.

Russia

Alpatov, Mikhail V., and Nikolai I. Brunov. "Die altrussische Kunst in der wissenschaftlichen Forschung seit 1914," in: Zeitschrift für slavische Philologie, II, 1925, pp. 474-505; III, 1926/27, pp. 387-408.

Classified bibliographies of books and periodical articles on Russian medieval art, published between 1914 and 1925.

Spain and Portugal

"Aportaciones recientes a la historia del arte español," in: Archivo español del Arte, Tomo 22-, 1949-.

Annual, classified bibliography of books and periodical articles on all aspects of Spanish art. Appears at the end of the "Bibliografia" section in last number in each year. The basic bibliographical tool for the study of Spanish art.

López Serrano, Mathilde. **Bibliografía de arte español y americano 1936- 1940...** Madrid, Gráficas Uguina, 1942. 243p. index.

Classified bibliography of books and periodical articles on art and archaeology of Spain, Latin America, and the Philippines published from 1936 to 1940.

Oliveira, Arnaldo Henriques de. Bibliografia artistia portuguesa. Lisbon, 1944. 320p.

Classified bibliography of books on all aspects of Portuguese art in the library of Luiz Xavier da Costa. Lists 2,930 titles.

Zamora Lucas, Florentino, and Eduardo Ponce de Leon. Bibliografía española der arquitectura (1526-1850)... Madrid, Asoc. de Libreros y Amigos del Libro, 1947. 205p. illus. index.

Classified bibliography of books on Spanish architecture from the period 1526 to 1850. Arranged chronologically by centuries.

Sweden

Lundqvist, Maja. Svensk Konsthistorisk Bibliografi: Sammanställd ur den Tryckta Litteraturen till och med år 1950. Bibliography to Swedish History of Art: Literature Issued up to and including 1950. Stockholm, Almqvist and Wiksell, 1967. index. 432p. (Stockholm Studies in History of Art, 12). LC 67-103402.

Classified bibliography of books and periodical articles on Swedish art and writings on art history in Swedish. Preface and table of contents in Swedish, and English index.

"Svensk Konsthistorisk Bibliografi," 1959–, in: Konsthistorisk Tidskrift, XXIX, 1960).

Classified bibliography of books and periodical articles on Swedish art and writings in Swedish on art history in general. Compiled by Gunhild Osterman and Karin Melin-Fravolini. With (119), the standard bibliographical tool for study of Swedish art history.

Switzerland

Haendcke, Berthold. Architecture, sculpture et peinture . . . Berne, Wyss, 1892. 100p. index. (Bibliographie nationale suisse, fasc. 6^{a-c}). Classified bibliography of books and periodical literature on the history of Swiss art. Index is an alphabetical list of artists' monographs.

ORIENT

General Works

- "Bibliography," in: Oriental Art, XVI, No. 3 (Autumn, 1970—). Classified bibliography of books and periodical articles on all aspects of Oriental art and architecture. Divided into sections (Islamic and India, China and Japan) that reflect separate quarterly issues. Not annotated and not classified within the subsections. A valuable serial bibliography for students of Oriental art and architecture. For serious study, it should be used with *Bulletin Signalétique*, *Série 526* (123).
 - Bulletin Signalétique. Série 526: Art et Archéologie: Proche-Orient, Asie, Amérique. v. 25–. Paris, Centre National de la Recherche Scientifique, 1971–. LC 70-287578.

Annual bibliography of books and periodical articles on all aspects of the art and archaeology of the Near East, Asia, and the Americas. Covers those areas not treated in the *Répertoire* (27). Most entries have annotations or abstracts in French. A valuable reference work for all serious study of Oriental art and architecture.

Rowland, Benjamin, Jr. The Harvard Outline and Reading Lists for Oriental Art. 3rd ed. Cambridge, Harvard University Press, 1967. 77p. LC 67-22872.

Classified bibliography of books on Oriental art. Periodical articles included when no books on a particular subject exist. Useful to the beginning student of Oriental art.

Islamic World

125 Creswell, Keppel A. C. A Bibliography of the Architecture, Arts and Crafts of Islam to 1960. New York, Oxford University Press, 1961. 1330p. LC 62-3352. Supplement 1960, 1972. Cairo, 1973.

Classified bibliography of books and periodical articles on all aspects of Islamic art with the exception of numismatics. Part 1 lists works on architecture classified by country; part 2 treats arts and crafts, each subdivided by country. A most thorough and comprehensive bibliography. A basic research tool for any serious

study of Islamic art. Incorporates the material in the author's A Provisional Bibliography of Mohammadan Architecture in India (1922) and A Bibliography of Painting in Islam (1953).

Ettinghausen, Richard, ed. A Selected and Annotated Bibliography of Books and Periodicals in Western Languages Dealing with the Near and Middle East with Special Emphasis on Medieval and Modern Times. Washington, D.C., Middle East Institute, 1952. 111p.

General classified and annotated bibliography on the Islamic world with a section on art and archaeology. Useful to the beginning student and general reader.

127 Kühnel, Ernst. "Kritische Bibliographie islamischer Kunst. 1914-1927," in: **Der Islam**, XVII, 1928, pp. 133-248.

One of the greatest scholars of Islamic art discusses the major publications on Islamic art published between 1914 and 1927.

- Mayer, L. A. Annual Bibliography of Islamic Art and Archaeology, India Excepted . . . , v. 1-3. Jerusalem, Divan Pub. House, 1935-37. Classified bibliography of books and periodical articles on all aspects of Islamic art, with the exception of Islamic art in India.
- Swoboda, K. M. "In den Jahren 1950 bis 1955 erschienene Werke zur Kunst Asiens vor den Islam," in: Kunstgeschichtliche Anzeigen, Neue Folge, Jahrg. 1, 1955/56, pp. 81-142.

Critical examination of the major works on Near and Middle Eastern art before the time of Islam published from 1950 to 1955. The works discussed are listed at the beginning of the article. See (26) for series annotation.

Swoboda, K. M. "In den Jahren 1950 bis 1956 erschienene Werke zur Kunst Islams," in: Kunstgeschichtliche Anzeigen, Neue Folge, Jahrg. 2, 1957, pp. 63-112.

Critical examination of the major works on Islamic art published from 1950 to 1956. The works discussed are listed at the beginning of the article. See (26) for series annotation.

India and Ceylon

Annual Bibliography of Indian Archaeology . . . , 1926— . Leyden, Brill, 1928— . illus.

Classified and annotated bibliography of books and periodical articles on all aspects of Indian archaeology, including art. Each volume has a useful introduction describing recent excavations. Basic reference tool for students of Indian art.

132 Coomaraswamy, Ananda K. Bibliographies of Indian Art. Boston, Museum of Fine Arts, 1952. 54p.

Classified bibliography of books on Indian art drawn from the catalog of the Indian collection of the Museum of Fine Arts; 1,250 entries. Useful to the beginning student and the general reader.

Mitra, Haridas. Contribution to a Bibliography of Indian Art and Aesthetics. Santiniketan, Visva-Bharati, 1951. 240p.

Classified bibliography of writings in Sanskrit on Indian architecture, sculpture, and painting. Introduction has useful chapter on iconography and a chronology of the masters of Indian art.

Rau, Heimo. "In den Jahren 1960 bis 1965 erschienene Werke zur indischen Kunst," in: Kunstgeschichtliche Anzeigen, Neue Folge, Jahrg. 7, 1965/66, pp. 93-108.

Critical examination of the major works on Indian art published from 1960 to 1965. The works discussed are listed at the beginning of the article. See (26) for series annotation.

Central Asia

Bernier, Ronald M. A Bibliography of Nepalese Art. Khatmandu, Voice of Nepal, 1970. 46p. LC 74-915230.

Classified bibliography of books and periodical articles on art of Tibet, Sikkim, Bhutan, and Nepal.

Jettmar, Karl. "In den Jahren 1955 bis 1962 erschienene Werke zur frühen nomaden Kunst der asiatischen Steppen," in: Kunstgeschichtliche Anzeigen, Neue Folge, Jahrg. 5, 1961/62, pp. 184-97.

Critical examination of the major works on Central Asiatic nomadic art published from 1955 to 1962. The works discussed are listed at the beginning of the article. See (26) for series annotation.

Rau, Heimo. "In den Jahren 1955 bis 1960 erschienene Werke zur Kunst Indiens und Zentralasiens," in: **Kunstgeschichtliche Anzeigen**, Neue Folge, Jahrg. 4, 1959/60, pp. 122-39.

Critical examination of the major literature on the art of India and Central Asia published between 1955 and 1960. Works discussed are listed at the beginning of the article. See (26) for annotation of the series.

Far East

Borton, Hugh, comp. A Selected List of Books and Articles on Japan in English, French and German. Rev. and enl. ed. Cambridge, Mass., Harvard-Yenching Institute, 1954. 272p. index.

Books and periodical articles on art are listed on pages 195 and 222. Classified bibliography. Author, title, and subject indexes.

Dittich, Edith. "In den Jahren 1956 bis 1964 erschienene Werke zur Kunst Ostasiens/Japan," in: Kunstgeschichtliche Anzeigen, Neue Folge, Jahrg. 6, 1963/64, pp. 61-82.

Critical examination of the major works on Japanese art published between 1956 to 1964. The works discussed are listed at the beginning of the article. See (26) for series annotation.

Dittich, Edith. "In den Jahren 1957 bis 1962 erschienene Werke zur Kunst Ostasiens/China," in: Kunstgeschichtliche Anzeigen, Neue Folge, Jahrg. 6, 1963/64, pp. 1-37.

Critical examination of the major works on Chinese art published from 1957 to 1962. The works discussed are listed at the beginning of the article. See (26) for series annotation.

141 Kokusai Bunka Shinkokai, ed. K.B.S. Bibliography of Standard Reference Books of Japanese Studies with Descriptive Notes. Tokyo, 1959.
Volume 3, A: Arts and Crafts.

Volume on the fine arts in a ten-volume guide to reference works on Japanese studies. A classified and annotated retrospective bibliography of major works on Japanese fine arts and crafts. The titles are romanized and the annotations are in English. Useful guide to major works in Japanese and other languages on Japanese art and architecture for the advanced student.

Swoboda, K. M. "In den Jahren 1950 bis 1956 erschienene Werke zur Kunst Ostasians," in: **Kunstgeschichtliche Anzeigen**, Neue Folge, Jahrg. 2, 1957, pp. 5-46.

Critical examination of the major literature on the art of East Asia published from 1950 to 1956. The works discussed are listed at the beginning of the article. See (26) for series annotation.

Vanderstappen, Harrie, ed. The T. L. Yuan Bibliography of Western Writings on Chinese Art and Archaeology. London, Mansell, 1975. 606p. index. LC 76-356246.

Comprehensive, thoroughly classified bibliography of over 15,000 items written in English, German, Dutch, Scandinavian languages, Slavic languages, and Romance languages on all aspects of the art and archaeology of China. Covers material published between 1920 and 1965. Books are listed separately from periodical articles. A reference tool of major importance to the history of Far Eastern art as it covers material not found in any other bibliography.

NEW WORLD

Pre-Columbian America

Bernal, Ignacio. Bibliografia de arqueologia y etografia: Mesoamérica y Norte de Mexico. Mexico City, Instituto Nacional de Antropologia e Historia, 1962. 634p. LC 63-39894.

Comprehensive, retrospective bibliography of books and periodical articles on all aspects of the archaeology and ethnology of Central America and Mexico, including art and architecture. Covers material published between 1514 and 1960. Standard reference tool for the serious student of pre-Columbian art and architecture.

Kendall, Aubyn. The Art and Archaeology of Pre-Columbian Middle
 America: An Annotated Bibliography of Works in English. Boston,
 G. K. Hall, 1977. 334p. index. LC 77-14146.

Comprehensive bibliography of books and periodical literature on all aspects of the art, architecture, and archaeology of Mexico, Guatemala, El Salvador, Honduras, Belize (British Honduras), Costa Rica, Nicaragua, and Panama. Books and periodical articles are listed alphabetically in separate sections. Subject access index is inadequate. Good descriptive annotations. Appendix with list of doctoral dissertations. Use together with Bernal (144) and Valle (147).

146 Kendall, Aubyn. The Art of Pre-Columbian Mexico: An Annotated Bibliography of Works in English. Austin, University of Texas at Austin Press, 1973. 115p.

Selected bibliography of basic books and periodical articles on pre-Columbian art and architecture of Mexico. Books and periodical articles listed alphabetically in separate sections. Descriptive and occasionally critical annotations.

Valle, Rafael H. Bibliografía maya. Mexico City, D. F., 1937-41. 404p. LC 46-42185. Reprint: New York, Burt Franklin, 1971. 404p. (Burt Franklin Bibliography and Reference Series, 436). LC 75-144831.

Comprehensive bibliography of books and periodical literature in all languages and on all aspects of ancient Mayan culture. Issued as an appendix to the *Boletin bibliográfico de antropologia americana* (v. 1-5, 1937-41). Many entries have extensive descriptive annotations. Contains much material on Mayan art and architecture. However, the work is an unclassified alphabetical list, and there is no index to facilitate access to specific subject material.

See also: Bulletin Signalétique. Série 526. (123).

North American Indian

Dawdy, Doris O. Annotated Bibliography of American Indian Painting. New York, Museum of the American Indian, 1968. 27p. (Contributions from the Museums of the American Indian Heye Foundation, vol. 21, pt. 2). LC 78-8195.

A useful bibliography of books and periodical articles on North American Indian painting.

Harding, Anne, and Patricia Bolling. Bibliography of Articles and Papers on North American Indian Art. Washington, D.C., 1938. 365p.
 Classified bibliography of periodical articles and scholarly papers on North American Indian art, with 1,500 entries. An important source for the early scholarly literature on this field.

See also: Bulletin Signalétique. Série 521 (37); Primitive Art Bibliographies (39).

Latin America

General Works

Handbook of Latin American Studies, v. 1—. Cambridge, Mass., Harvard University Press, 1936—.

Each volume contains a classified and annotated bibliography of books on Latin American art compiled by a specialist in the field.

Smith, Robert Chester, and Elizabeth Wilder. A Guide to the Art of Latin America... Washington, D.C., U.S. Govt. Printing Office, 1948. 480p. (U.S. Library of Congress Latin American Series, No. 21).

Classified and annotated bibliography of a selective list of books and periodical articles on Latin American art published before 1943. Source library given for each entry. Although old, it is still a valuable reference tool for the study of Latin American art.

Argentina

Buschiazzo, Mario José. Bibliografía de arte colonial argentino. Buenos Aires, 1947. 150p.

Classified and annotated bibliography of the colonial arts in Argentina. Entries for 843 books.

Brazil

Valladares, José. Estudos de arte Brasileira publicações de 1943-1958: Bibliografia selectiva e comentada. Salvador, 1960. 193p. (Museu do Estado da Bahia. Publicação No. 15). LC 64-43893.

Classified and annotated bibliography of books on Brazilian art published from 1943 to 1958, 693 entries.

Colombia

Giraldo Jaramillo, Gabriel. **Bibliografía selecta del arte en Colombia**. Bogota, Editorial A B C, 1956. 147p.

Classified and annotated bibliography of books on art in Colombia.

Mexico

Ocampo, María Luisa, and María Mediz Bolio. Apuntes para una bibliografía del arte en Mexico. Mexico, Secretaria de Educacion Publica, 1957. 194p. LC 68-43120.

Classified bibliography of books on Mexican art, with 1,031 entries.

Santo Domingo

Florén Lozano, Luis. Bibliografía de las bellas artes en Santo Domingo. Bogotá, Antares, 1956. 53p. Classified bibliography of books and periodical articles on the art of Santo Domingo.

United States

157 Chase, Frank H. A Bibliography of American Art and Artists Before 1835. Boston, 1918. 32p.

Short bibliography of 600 titles, chiefly periodical articles on the colonial and federal periods of art in the United States. Still useful to the specialist.

Garrett, Wendell D., and Jane N. Garrett. The Arts in Early American History. Chapel Hill, University of North Carolina Press, 1965. 170p. index. LC 65-53132.

Classified and annotated bibliography of books and periodical articles on American art up to 1826. Introductory essay, "An Unexploited Historical Resource," by Walter Muir Whitehill.

Keaveney, Sydney S., ed. Art and Architecture Information Guide Series. Detroit, Gale, 1974—.

Series of annotated bibliographies dedicated to a variety of subjects in the fine and applied arts. Thus far, among others, four volumes treating the history of American art have appeared: volume 1: American Painting, by Sydney S. Keaveney (1974); volume 3: American Architects from the Civil War to the First World War, by Lawrence Wodehouse (1976); volume 4: American Architects from the First World War to the Present, by Lawrence Wodehouse (1977); volume 5: American Sculpture, by Janis Ekdahl (1977). Although coverage in these four volumes is somewhat uneven and the information provided by the annotations is not consistent, the Keaveney series begins to fill the need for bibliographical guidance to the history of American art.

McCausland, Elizabeth. "A Selected Bibliography on American Painting and Sculpture from Colonial Times to the Present," in: American Art Journal, v. 36, 1947, pp. 611-53.

Classified bibliography of books and periodical articles on American painting and sculpture. Most useful for access to artist monographs.

Sokol, David M. American Architecture and Art. A Guide to Information Sources. Detroit, Gale, 1976. 341p. index. LC 73-17563.

Classified and annotated bibliography of 1,590 books and periodical articles on all aspects of American art and architecture. Ranges from general histories to articles on individual artists. More complete coverage is provided by Keaveney (159).

AFRICA

Gaskin, Guy. A Bibliography of African Art Compiled at the International African Institute. London, International African Institute, 1965. 120p. index. LC 66-70409.

Classified bibliography of 4,827 books on African art, arranged by region. Author, geographical, ethnic, and subject indexes.

- Hassel, Herta. "In den Jahren 1954 bis 1960 erschienene Werke zur Kunst der ethnologischen Völker, besonders Negerafrikas," in: Kunstgeschichtliche Anzeigen, Neue Folge, Jahrg. 4, 1959/60, pp. 106-121.
 Critical examination of the major works on primitive art, particularly the art of Black Africa. The works discussed are listed at the beginning of the article. See (26) for series annotation.
- 163a Mirvish, Doreen Belle. South African Artists, 1900-1958: Bibliography. Cape Town, University of Cape Town, 1959. 41p. LC 61-21936. Bibliography of books and periodical articles on South African artists published between 1900 and 1958.
- 163b Western, Dominique C. A Bibliography of the Arts of Africa. Waltham, Mass., African Studies Association, Brandeis University, 1975. 123p. index. Classified bibliography of books and periodical articles published in Western European languages before 1974 on Sub-Saharan African art, architecture, oral literature, drama, and music. Major entries are annotated. Section on art and architecture, pp. 1-49, is classified by region and tribal group.

CHAPTER TWO LIBRARY CATALOGS

INTRODUCTION

A decade ago, library catalogs were not important reference tools in the study of the fine arts. Only a few European libraries had issued printed catalogs, and most of these were not kept up to date. With the improvement of the photomechanical process of reproducing actual library catalog cards, however, this situation changed rapidly. Today the majority of major fine arts libraries have had their card catalogs reproduced and made available to libraries around the world, with supplements issued regularly to keep them up to date.

It is essential for those who use these catalogs to be aware of the limitations of photomechanically reproduced library catalogs. Since the cards in the libraries' files are simply reproduced as they exist and bound in pages as they are filed, without any attempt at further or supplementary classification, the user must be familiar with the system used in the original library catalog. Classification systems differ from library to library, and many of the older European libraries follow systems unfamiliar to the average American user. This seldom poses a problem with author listings. But if one wants to use these catalogs for their subject listings—and it is their potential use as subject bibliographies that is a most worthwhile aspect of these catalogs—the idiosyncracies and limitations of the subject classifications become a major restriction. But with perseverance and knowledge of classification (and occasionally of paleography as well), the modern catalogs can be very valuable bibliographic tools.

GENERAL FINE ARTS LIBRARIES

NORTH AMERICA

Cambridge, Mass. Harvard University. Catalogue of the Harvard University Fine Arts Library. The Fogg Art Museum. Boston, Hall, 1971. 16v. Photomechanical reproduction of the author-subject card catalog of the combined holdings in the fine arts of the Widener Library and the Fogg Museum Library. Volume 16 is a separate catalog of the collection of sales catalogs. Harvard has one of the largest fine arts libraries in the United States; consequently, this reproduction of the card catalog with its thorough subject classification is a basic bibliographical tool.

New York City. Columbia University. Avery Architectural Library. Catalog of The Avery Memorial Architectural Library of Columbia University. 2nd ed., enl. Boston, Hall, 1968. 19v.

Columbia University. Avery Architectural Library. Catalog of The Avery Memorial Architectural Library of Columbia University. First Supplement, 1972. 4v.

A union list of books and periodical titles on art and architecture in the extensive Columbia University Library system, as well as 10,000 original drawings in library collections. The catalog of an important American art library, especially strong in architecture.

New York City. Metropolitan Museum of Art. Library. Library Catalog. Boston, Hall, 1960. 25v. First Supplement, 1962; Second Supplement, 1965; Third Supplement, 1968; Fourth Supplement, 1970.

Photomechanical reproduction of the dictionary card catalog of this important collection. Vols. 1-23: books and periodical holdings; Vols. 24-25: sales catalogs. Supplements list accessions since 1960.

167 New York City. New York Public Library. Research Libraries. A Dictionary Catalogue of the Art and Architecture Division. Boston, Hall, 1975. 30v.

Photomechanical reproduction of the author, title, and subject card catalogs of all material cataloged through 1971 in the NYPL Art and Architecture Division; plus material in the General Research and Humanities Division; Cyrillic, Oriental and Hebraic material in the Language Divisions; source material in the Rare Book Division; and important architectural books in the Spencer Collection. Important catalog of one of America's largest art libraries (over 100,000 volumes). Very valuable supplements have been published since 1974 (168).

New York City. New York Public Library. Research Libraries. Art and Architecture Division. Bibliographic Guide to Art and Architecture. 1975—. Boston, Hall, 1976—.

A volume for 1974 was published under the title, Art and Architecture Book Guide (Boston, Hall, 1975). Comprehensive listing of all material cataloged during the year by the Art and Architecture Division of the New York Public Library, with additional titles from the Library of Congress MARC tapes. Multiple access points through main entries, added entries, titles, series, and subject headings. Serves to update the Dictionary Catalog of the Art and Architecture Division (167), and because of the Library of Congress entries, is a valuable series bibliography.

Ottowa, Ontario. National Gallery of Canada. Catalogue of the Library of the National Gallery of Canada, Ottawa. Boston, Hall, 1973. 8v. Photomechanical reproduction of the author-subject card catalog of the more than 35,000 volumes in the Canadian National Gallery Library, Useful tool for research into the visual arts in Canada.

EUROPE

170 Amsterdam. Rijksmuseum. Kunsthistorische Bibliotheek. Catalogus der Kunsthistorische Bibliotheek in het Rijksmuseum te Amsterdam. Amsterdam, Dept. van Onderwijs, 1934-36, 4v.

A classified list of the books and periodicals in this important center for the research of Dutch art history. Outline of the classification at the beginning of each volume. Volume 4 contains author, artists, subject, place, collectors, and dealers indexes.

Brussels. Académie Royale des Beaux-Arts et École des Arts Décoratifs. Catalogue annoté de la Bibliothèque artistique et litéraire. Brussels, Guyot, 1903. 1170p. index.

Thoroughly classified and annotated catalog of books. Author and title index. Particularly useful for the history of Flemish art.

- Hague. Koninklijke Bibliotheek. Catalogus van schoone kunsten en kunstnijverheid. The Hague, Belinfante, 1905, 986p. index. Classified bibliography of the holdings on fine arts in this great Dutch central library. Thoroughly indexed by author, artists, subjects, and locations.
- 173 Leipzig. Anstalt für Kunst und Literatur. Kunstkatalog..., by Rudolf Weigel. Leipzig, 1837-1866. 35 parts in 5v.

 Classified catalog of books and prints in the Anstalt für Kunst und Literatur, listing over 25,000 titles and 3,832 prints (mostly portraits of artists). Index at end of each volume and general index at end of volume five. A standard reference tool for nineteenth century literature on the fine arts.
- London. Royal Institute of British Architects. Library. Catalogue of the Library. London, Royal Institute of British Architects, 1937-38. 2v.
 Volume 1 (1,138p.) is an author catalog of books and manuscripts in the collection. Volume 2 (514p.) contains a classified index and an alphabetical subject index.
 - London. University. Library. Catalogue of Books on Archaeology and Art and Cognate Works Belonging to the Preedy Memorial Library and Other Collections in the University Library... London, University of London Press, 1935-37. 2v. Supplement 1937 (1937). 25p.

Classified bibliography of some 3,000 books covering all aspects of archaeology and the history of art in all languages. Index by author.

176 London. Victoria and Albert Museum. National Art Library Catalogue. Boston, Hall, 1972. 11v. LC 73-153208.

The author catalog of a great art reference library. Volume 10 lists titles written before 1890; volume 11 lists 50,000 exhibition catalogs.

Modena. Annuario bibliografico di storia dell'arte. Anno 1-, 1952-. Modena, Soc. Tipo. Modenese, 1952-. index.

A classified list of the books and periodicals acquired by the Biblioteca dell' Instituto Nazionale d'Archeologia e Storia dell'Arte in Rome. Short abstracts are given for most entries. Index of names. Very useful bibliographical tool for the study of Italian art. Material arranged in three chief classes: I, Arte; II, Artisti; III, Paesi.

- Paris. Bibliothèque Forney. Catalogue des catalogues de ventes d'art, Bibliothèque Forney, Paris. 2v. Boston, Hall, 1972. LC 72-226228. Photomechanical reproduction of the card catalog of the important collection of sales catalogs in the Bibliothèque Forney in Paris.
 - Paris. Bibliothèque Forney. Catalogue Matières: arts-decoratifs, beauxarts métiers, techniques. Paris, Société des Amis de la Bibliothèque Forney. 1970-74. LC 75-574191. 4v.

Photomechanical reproduction of the subject catalog of this famous French library of nearly 100,000 volumes and 1,350 periodicals devoted to the applied arts. Particularly valuable for bibliographical information on art techniques.

Vienna. Österreichisches Museum für Kunst und Industrie. Bibliothek. Katalog... Vienna, n.p., 1902-1904. 5v.

Classified catalog of books; especially rich in material on applied and decorative arts.

SPECIALIZED ART LIBRARIES

ANCIENT

- Athens. American School of Classical Studies at Athens. Genadius Library. Catalogue. Boston, Hall, 1968. 7v. LC 70-3154.

 Photomechanical reproduction of the author and subject card catalog of the Genadius Library at the American School of Classical Studies at Athens, a library of some 50,000 volumes devoted to the history of Greek culture from earliest times to the present.
 - 182 Rome. Deutsches Archäologisches Institut. Kataloge der Bibliothek des Deutschen Archäologischen Instituts, Rom. Boston, Hall, 1969. 13v.

Photomechanical reproduction of the card catalogs of books and card index to periodical articles in the German Archaeological Institute in Rome. Part one is author and periodical title catalog; part two, the subject catalog; part three, the special author index to periodical articles, begun in 1956. The holdings of this famous archaeological library cover the ancient civilizations of the entire Mediterranean basin from prehistory through the early Christian period.

BYZANTINE

Washington. Dumbarton Oaks Research Library. Harvard University. Dictionary Catalogue of the Byzantine Collection of the Dumbarton Oaks Research Library. Boston, Hall, 1975. 12v.

Photomechanical reproduction of the author, title, and subject card catalog of an 82,000-volume library dedicated to research on all aspects of Byzantine civilization. See also the *Dumbarton Oaks Byzantine Bibliographies* (62) and *Catalogue* of the Genadius Library (181).

RENAISSANCE

Florence. Harvard University Center for Italian Renaissance Studies.

Catalogues of the Berenson Library of the Harvard University Center for Italian Renaissance Studies at Villa I Tatti, Florence, Italy. Boston, Hall, 1972. 4v.

The total holdings of about 70,000 volumes are disposed in a two-volume author catalog and a two-volume subject catalog. The photomechanically reproduced cards are old and lack reliable orthography.

Florence. Kunsthistorisches Institut. Bibliothek. Catalog of the Institute for the History of Art, Florence, Italy. Katalog des Kunsthistorischen Instituts in Florenz. Boston, Hall, 1964. 9v. First Supplement, 1968, 2v. Second Supplement, 1972, 2v.

Photomechanical reproduction of the alphabetical catalog (author and key word). The Institut is the most important center for Italian Renaissance studies in Europe. Thus, the holdings of its library are of great interest to students of Italian Renaissance art. The handwritten cards are a formidable obstacle to its use by the inexperienced.

London. Warburg Institute. Catalogue of the Warburg Institute Library. 2nd ed. Boston, Hall, 1967. 12v. First Supplement, 1971.

Photomechanical reproduction of the author and subject card catalog of a collection of over 100,000 volumes, with special emphasis on the survival of the classical tradition. Particularly valuable for research into classical iconography in medieval, Renaissance, and Baroque art.

MODERN

Amsterdam. Stedelijk Museum. Bibliotheek. Catalogus. Amsterdam, n.p., 1957. 179p. index.

Classified catalog of the holdings, as of 1956, of the Library of Modern Art in the Municipal Museum of Amsterdam. Introductory text in English as well as Dutch, German, and French. Thorough indexes.

New York City. Museum of Modern Art. Catalog of the Library of the Museum of Modern Art. Boston, Hall, 1976, 14v.

Photomechanical reproduction of the author, title, and subject card catalogs of 30,000 books and 700 periodical titles covering all aspects of twentieth century art. Particularly valuable is the indexing of periodical articles, many not in *Art Index* (192) or *Répértoire* (27). Includes material in the Latin American Archives and the exhibition and artists files.

ORIENTAL

Washington. Smithsonian Institution, Freer Gallery of Art. Dictionary Catalogue of the Library of the Freer Gallery of Art, Smithsonian Institution, Washington, D.C. Boston, Hall, 1967. 6v.

Photomechanical reproduction of the dictionary catalog of books, pamphlets, and periodicals in this important research library (40,000 volumes) devoted to Far Eastern art. Part one lists works in Western languages; part two, works in Chinese and Japanese.

AMERICAN

Winterthur, Delaware. Winterthur Museum Libraries. The Winterthur Museum Libraries Collection of Printed Books and Periodicals. Wilmington, Del., Scholarly Resources Inc., 1974. 9v. LC 73-88753.

Photomechanical reproduction of the card catalog of the Winterthur Museum Library, an outstanding reference collection devoted to early American civilization and to American art to 1913. Particularly good for primary source material. Contains the general author, title, and subject catalog, the rare book catalog, auction catalog, and Shaker collection.

CHAPTER THREE INDEXES

INTRODUCTION

Included in this section are all reference works that index a limited body of material. In the fine arts, these fall into two broad categories: indexes of literature on the fine arts and indexes to illustrations. In both categories there are important works for the general reader and the advanced student; illustration indexes comprise some of the reference librarian's most used tools.

Like library catalogs, indexes in the fine arts have increased substantially in number during the past decade, and the trend appears to be binal. There are indexes to illustrations in popular periodicals and books, directed to the needs of librarians. And there are indexes to special bodies of scholarly literature, made possible through the photomechanical process used to reproduce library card catalogs; these are designed for the advanced student of the history of art. These bibliographical indexes are especially important and deserve to be singled out. The *Art Index* (192) is one of the oldest and most used of bibliographical tools in the fine arts. It indexes a large number of art periodicals and gives special attention to the more accessible and popular English language journals. It is one of the mainstays of reference librarians. It has been supplemented by the reproduction of the Ryerson Library index (193) and, for specialized periodical literature, by the Avery Architectural Library index (194) and the very valuable catalog of the Bibliothèque Forney (195), which indexes often-ignored articles on the decorative arts.

PERIODICAL LITERATURE

191 Art Bibliographies Current Titles. v. 1— . Santa Barbara, ABC-Clio Press, 1972— .

Monthly index to the articles in approximately 250 current fine arts periodicals. Consists of photomechanical reproductions of the periodicals' tables of contents. Since 1973, it no longer appears in July and August. List of periodicals indexed is given in each number, and a complete list is published twice a year. The selection of periodicals is international and includes some museum bulletins and annuals. A useful index for keeping up with current periodical literature. Produced by the American Bibliographical Center in Santa Barbara. Unfortunately, does not index articles by subject.

192 Art Index: A Cumulative Author and Subject Index to a Selected List of Fine Arts Periodicals and Museum Bulletins. v. 1-, 1929-. New York, Wilson, 1933-.

Issued quarterly with annual and three-year cumulations. Classified bibliography of periodical articles and articles in museum bulletins. Coverage varies; museum bulletins included only through 1957. Periodical articles are listed under author and subject, book reviews under the author reviewed and subject, exhibitions under artist. A basic reference tool, especially for material in English-language periodicals. Should be supplemented with the Ryerson index (193) for more complete coverage.

193 Chicago. Art Institute, Ryerson Library. Index to Art Periodicals. Boston, Hall, 1962. 11v. First Supplement, 1974.

Photomechanical reproduction of the library's card file, which was begun in 1907. Over 300 periodicals are indexed, covering serial titles not indexed in Wilson's *Art Index* (192). Arranged by subject and artist.

New York City. Columbia University, Avery Architectural Library. Avery Index to Architectural Periodicals. 2nd ed. Boston, Hall, 1973. First Supplement, 1975. Second Supplement, 1977. LC 74-152756.

Photomechanical reproduction of the card index to articles in the architectural periodicals held by the Avery Library. The index, begun in 1934, covers architecture in the widest sense so as to include interior decoration, city planning, housing, etc. Articles are listed by subject. Supplements were issued yearly from 1965 to 1968, every two years since then. The Avery index is the most comprehensive index to periodical literature on architecture.

Paris. Bibliothèque Forney. Catalogue d'articles des périodiques—arts décoratifs et beaux-arts. Catalog of Periodical Articles—Decorative and Fine Arts. Boston, Hall, 1972. 4v. LC 72-221666.

Photomechanical reproduction of the card index to articles dealing with the decorative arts in the Bibliothèque Forney in Paris. Articles are arranged by subject. Analyzes the articles on the decorative arts in 1,347 periodicals, 325 of them current. The most comprehensive index of its kind; supplements the other major periodical indexes (192, 193).

196 Prause, Marianne. Verzeichnis der Zeitschriftbestände in den kunstwissenschaftlichen Spezialbibliotheken der Bundesrepublik Deutschland und West-Berlin. Berlin, Mann, 1973.

Comprehensive list of the art and cultural historical periodicals held by art libraries in West Germany and West Berlin. Arranged by periodical title, the entries give the runs held by the various libraries. General bibliography of periodical reference works (pp. 613-21).

MUSEUM PUBLICATIONS

197 Clapp, Jane. Museum Publications. Part I: Anthropology, Archaeology and Art. New York, Scarecrow, 1962. 434p. LC 62-10120.

A classified list of publications available from 276 museums in the United States and Canada, including books, pamphlets, and other monographs and some serial reprints. Now out of date.

198 Lambert, Jean, ed. The Bibliography of Museum and Art Gallery Publications and Audio-Visual Aids in Great Britain and Ireland. Cambridge, Chadwyck and Healey, 1978. 372p. index.

Lists 811 currently available publications, arranged by place and institution. Provides addresses and prices.

Museum Media. A Biennial Directory and Index of Publications and Audiovisuals Available from United States and Canadian Institutions. Detroit, Gale Research, 1973. 455p. index. LC 73-16335.

Alphabetical listing of 732 museums of all kinds in the United States and Canada, with the publications and audiovisual materials currently available from them. Gives complete citations and prices for publications. Provided with an exhaustive title and keyword index. A most useful reference tool for the librarian.

Tümmers, Horst-Johs. Kataloge und Führer der Berliner Museen. Berlin, Mann, 1975. 189p. index. (Verzeichnis der Kataloge und Führer Kunstund Kulturgeschichtlicher Museen in der Bundesrepublik Deutschland und in Berlin [West], Band 1).

Comprehensive, retrospective bibliography of catalogs and guides published by the art and cultural museums of West Berlin before 1971. Two introductory chapters treat works published before 1918. Those published between 1918 and 1971 are arranged alphabetically by institution. The contents of the major catalogs are provided in annotations. First in a series that will eventually cover all of West Germany and provide that country with fine bibliographical coverage of its art catalogs.

SPECIALIZED INDEXES

- Clapp, Jane. Art Censorship: A Chronology of Proscribed and Prescribed Art. Metuchen, N.J., Scarecrow, 1972. 582p. illus. LC 76-172789.

 An index to acts of censorship against art, recorded in 641 selected sources. The acts of censorship are arranged chronologically; each entry gives the date of the incident, reference to one of the sources, and a brief quotation from the source. General index (pp. 425-582).
 - Havlice, Patricia P. Index to Artistic Biography. Metuchen, N.J., Scarecrow, 1974. 2v.

Index of biographies of major artists in 611 reference works, mainly readily available titles in English. However, a rather capricious selection of foreign-language works is also indexed, but not the standard works by Bénézit (268) or Thieme-Becker (276). Entries give basic biographical data, nationality, and media for each artist.

Lugt, Frits. Répertoire des catalogues de ventes publiques intéressant d'art ou la curiosité...v. 1—. The Hague, Hijhoff, 1938—.

Chronological list of catalogs of art sales held throughout Europe from circa 1600 to 1860. Each entry gives date of the sale; place of sale; name of the collector, artist, or merchant; the contents of the sale; number of lots; names of auctioneers; number of pages in the sales catalog; and library source for copies of the catalog. Volume 1 covers period from 1600 to 1825; volume 2, 1826 to 1860; volume 3, 1861 to 1900. Index of collectors and names of collections. Basic reference work for the history of art sales.

New York City. Columbia University, Avery Memorial Architectural Library. Avery Obituary Index of Architects and Artists. Boston, Hall, 1963, 338p. LC 64-7017.

Photomechanical reproduction of the card index to obituaries of architects and artists published in periodicals and newspapers. A valuable source for biographical material on many lesser-known architects.

Rave, Paul O. Kunstgeschichte in Festschriften. Berlin, Mann, 1962. 314p. LC 63-43690.

Classified index of art historical essays that appear in Festschriften published up to 1960. Thoroughly indexed by title, author, artist, and place. For serious students of art history, an extremely valuable reference tool to give access to important material not usually included in other bibliographies. Access to more recent Festschriften is through Otto Leistner. Internationale Bibliographie der Festschriften (International Bibliography of Festschriften); Osnabrück, 1976.

INDEXES TO ILLUSTRATIONS

- 206 A.L.A. Portrait Index to Portraits Contained in Printed Books and Periodicals . . . Washington, D.C., Library of Congress, 1906. 1601p. An index to portraits illustrated in a large set of books and periodicals published before 1905. Arranged by subject. 120,000 portraits of nearly 45,000 persons. Entries give dates of the subject, name of artist and/or engraver, and source for illustrations.
- Bertran, Margaret. A Guide to Color Reproductions. 2nd ed. Metuchen, N.J., Scarecrow, 1971. 625p.

Index of separate-sheet color reproductions of works of art. Lists only those available in the United States, giving the source and price. Part I lists the reproductions by artist; part II, by title or subject.

208 Cirker, Hayward, and Blanche Cirker. Dictionary of American Portraits: 4045 Pictures of Important Americans from Earliest Times to the Beginning of the Twentieth Century. New York, Dover, 1967. 756p. illus. LC 66-30514.

An illustrated index of portraits of Americans, arranged by subject. A short caption to each illustration gives artist and/or source. Index by profession.

209 Clapp, Jane. Art in Life. New York, Scarecrow, 1959. 504p. LC 65-13552. Index to pictures of art published in *Life* magazine from 1936 to 1956. Arranged by artist, title, and/or subject. Supplement (covering years 1957 to 1963) published in 1965.

210 Clapp, Jane. Art Reproductions. New York, Scarecrow, 1961. 350p. LC 61-8714.

Index to art reproductions available from 95 sources in the United States and Canada. Arranged by medium. Entries give the dates of the artist, subject, dimensions, price, and source. Useful source for popular and easily accessible fine art reproductions.

Ellis, Jessie Croft. Index to Illustrations. Boston, F. W. Faxon, 1966. 682p. LC 66-11619.

General index to illustrations of almost everything except nature. Uses a small group of illustration sources, mostly popular magazines.

Havlice, Patricia P. Art in Time. Metuchen, N. J., Scarecrow, 1970. 350p. illus. LC 76-14885.

Index to all pictures in the art section of *Time* magazine, arranged by artist, title, and/or subject. Entries give the dates of the artist, the medium of the work, whether the illustration is in black and white or color, and the source in *Time*. Useful for ready access to important reviews and criticisms of modern art.

Hewett-Woodmere Public Library. Index to Art Reproductions in Books.
Metuchen, N.J., Scarecrow, 1974. 322p. LC 74-1286.

Index to reproductions in a selected group of books published between 1950 and 1971. Two-part index: one under the name of the artist, the other by title of the work of art. Good for the small library, as the 65 books indexed are readily available.

Lee, Cathbert. **Portrait Register**, v. 1–. Asheville, N.C., Biltmore Press, 1968–. LC 73-3014.

Index to some 8,000 painted portraits in private and public collections in the United States. Listed by subject and painter.

215 Morse, John D. Old Masters in America: A Comprehensive Guide; More than Two-Thousand Paintings in the United States and Canada by Forty Famous Artists. Chicago, Rand McNally, 1955. 192p.

Index of paintings by forty famous "old masters" in American collections, arranged by artist. A short biographical note is given with each entry. Index by state and city. Handy tool for quick location of famous paintings.

Munro, Isabel Stevenson, and Kate M. Munro. Index of American Paintings. New York, Wilson, 1948. 731p. First Supplement, 1964. 480p.

Index to illustrations of American paintings in a group of easily accessible books and periodicals; indexed by artist, title, and subject. Basic biographical data and location of the paintings are given.

- Munro, Isabel Stevenson, and Kate M. Munro. Index to Reproductions of European Paintings. New York, Wilson, 1956. 668p. LC 55-6803. Index to illustrations in 328 books and periodicals by artist, title, and subject. Entries give the dates of artists and the locations of the paintings. A valuable reference tool for easy access to illustrations of major European paintings. The sources used are generally available in small libraries.
- Paris, Leroux, 1897-1930. 6v. in 8. illus.

 An illustrated index to ancient Greek and Roman statues, arranged by subject. Index at end of each volume and general index in vol. 5. Still a useful tool for
- 219 Reinach, Salomon. Répertoire de reliefs grecs et romains . . . Paris, Leroux, 1909-12. 3v. illus.

the study of classical iconography.

An illustrated index to ancient Greek and Roman reliefs, arranged by subject. General index in vol. 3. Still a useful tool for the study of classical iconography.

- Fine Art Reproductions, Old and Modern Masters. 9th ed. Greenwich, Conn., New York Graphic Society, 1972. 550p. illustindex. LC 72-85864. Index of the reproductions marketed by the New York Graphic Society, one of the largest manufacturers of fine art reproductions in the United States. Each entry is illustrated and has a caption giving size, reproduction medium, and price.
 - 221 Singer, Hans W. Allgemeiner Bildniskatalog. Leipzig, Hiersemann, 1930-1936. 14v. LC 31-15244. Neuer Bildniskatalog. . . Leipzig, Hiersemann, 1937-38. 5v. index. LC AC 37-1659 rev.

Index to engraved portraits of all times and countries represented in seventeen public collections in Germany. The approximately 180,000 portraits, arranged by subject, give the name of the artist, medium, and location. Separate artist and profession indexes in each volume, general index in volume 14. The *Neuer Bildniskatalog* is an index to painted and sculptured portraits and some early photographic portraits. Same format as the earlier index. Volume 1 has list of sources, and volume 5 has general index by artist and profession. These two Singer indexes are the most comprehensive guides to portraits made up to 1929.

CHAPTER FOUR

DIRECTORIES

- American Architects Directory. 3rd ed. New York, Bowker, 1970. 1126p. Directory of registered architects in the United States, listed alphabetically and by state and city. Also gives the membership of the American Institute of Architects and an appendix listing the National Council of Architectural Registration Boards.
 - 223 American Art Directory. 47th ed. New York, Bowker, 1978. 455p. LC 99-1016.

Directory of American art organizations covering museums, foundations, organizations, university and college art departments, and art schools. Revised biennially.

Art Libraries Society of North America. Directory of Art Libraries and Visual Resource Collections in North America. Santa Barbara, Calif., American Bibliographical Center—Clio Press, 1978. 298p. index. LC 78-61628.

Directory, arranged by state, of art libraries and special collections of visual materials such as photographs and slides. Information provided is similar to that given in *American Art Directory* (223), but coverage is much more extensive for smaller libraries and collections. Thoroughly indexed by institution and subject.

- Hudson, Kenneth, and Ann Nichols, eds. The Directory of World Museums.

 New York, Columbia University Press, 1975. 864p. index. LC 74-21772.

 Directory of approximately 25,000 museums around the world. Excluded are zoos and botanical gardens as well as museums and galleries without permanent collections. Arrangement is by country and place, with place names most often entered in anglicized form. Names of museums are also anglicized, which leads to some confusion. Entries provide addresses, guide to the collections, and opening times. There is a classified list of collections within major museums, glossary of museum terms, and a selected bibliography of museum directories. Does not provide as much information, nor is it as easy to use, as Museums of the World (229).
 - 226 Internationales Kunst-Adressbuch. International Directory of Arts. Annuaire international des beaux-arts. 13th ed., 1977/78. Berlin, Deutsche Zentraldruckerei, 1978. 2v.

Directory of addresses of museums, art galleries, art libraries, art associations, universities, colleges and art academies, auctioneers, restorers, art dealers, booksellers, art publishers, and collectors. Arranged by country. The standard address directory for the fine arts.

- International Who's Who in Art and Antiques. Cambridge, London and Dartmouth, Melrose Press Ltd., 1972. 679p. illus. LC 79-189269. Directory of artists, art educators, gallery and museum directors, heads of art associations, art and antique dealers, auctioneers, art publishers, and restorers in 58 countries. Five appendices list art schools, museums and galleries, art publishers, art associations, and art scholarships and grants by country. Not as thorough as (226), but it has the advantage of a single alphabetical list of persons.
- Kloster, Gudrun B. Handbook of Museums: Germany, Austria, Switzerland. Munich, Verlag Dokumentation, 1972. 2v. index.

 Comprehensive directory of some 3,050 museums in Germany, Austria, and Switzerland. Entries give address, telephone numbers, names of the professional staff, hours of opening, entrance fees, summary history of the museum, description of the buildings, collections, archives, and library, and sketch of the future plans of development and bibliography. Introduction in German and English; entries in German. Very thorough and useful directory.
 - Museums of the World/Museen der Welt: A Directory of 17,000 Museums in 148 Countries, Including a Subject Index. Eleanor Braun, comp. 2nd ed. Pullach bei München, Verlag Dokumentation; New York, Bowker, 1975. 762p. index.

A geographically arranged listing of all kinds of museums. Contains a useful classified subject index and an alphabetical listing by name.

- Official Museum Directory 1977: United States and Canada. New York, National Register, 1977. 1173p. index. LC 79-144808.

 Lists, by state and province, over 6,000 museums of all kinds in the United States and Canada. Gives names and specialties of museum curatorial staff, address of the museum, and a list of the museum's publications. Thorough alphabetical index. Standard American museum directory. Revised every two years.
- Ploetz, Gerhard. Bildquellen-Handbuch; der Wegweiser für Bildsuchende. Wiesbaden, Chmielorz, 1961. 611p. illus. index. LC 61-49194. Directory of photographic illustrations and their sources. Part I is an index of photographs by subject, country, place, persons, artists, etc., giving reference to sources in the approximately 4,000 photographic archives listed by country in parts II-V. A useful directory with emphasis on sources of original photographs.
 - UNESCO. Répertoire international des archives photographiques d'oeuvres d'art. International Directory of Photographic Archives of Works of Art. 2v. Paris, 1950-1954.

Directory of photographic archives throughout the world. The archives are arranged by place; descriptions include subject specialty, if any; size of the collection; nature or purpose of the archive; hours of opening; and the price charged for copies. Useful, although no longer current.

233 Who's Who in American Art. v. 1-. New York, Bowker, 1936-. Issued by the American Federation of Arts. Directory of artists, art historians, art critics, art editors, museum personnel, art educators, and lecturers in the

United States and Canada. Gives short biography and address. Geographical index and necrology at end of each volume. Standard directory for fine arts in America. Back issues are useful source for biographical information of lesser American modern artists.

234 Who's Who in Art. v. 1-. London, Art Trade Press, 1927-. Directory of artists, designers, craftsmen, critics, writers, teachers, collectors, and museum personnel. Appendices with necrology and list of artists' marks and signatures. Useful chiefly for Great Britain.

CHAPTER FIVE

DICTIONARIES AND ENCYCLOPEDIAS

INTRODUCTION

There is no better testimony to the increased interest in the fine arts than the prodigious growth in dictionaries, both serious and popular, since World War II. Most of this activity has been concentrated in the production of biographical dictionaries. It would appear that the completion of the magnum opus of Thieme and Becker (276) in 1950 was a signal, and in many cases the basis, for the publishing of numerous national biographical dictionaries, so that today the majority of European countries and several Western hemisphere nations have competent dictionaries of their artists. There are notable exceptions. France, for example, still lacks a national biographical fine arts dictionary. So does Spain, and the United States still awaits a comprehensive dictionary of its artists. But in some countries, coverage is so broad that specialized biographical dictionaries have appeared concentrating on small periods and, in some cases, on regions.

In contrast, the production of general dictionaries of the fine arts—in particular, those dealing with terminology—has lagged. Only very recently has the German-French *Glossarium Artis* (256) begun to replace our dependence on such

old-fashioned works as Adeline's dictionary (252).

Encyclopedias devoted exclusively to the fine arts are very recent phenomena. Although general encyclopedias dealing with various epochs or periods of history have existed for well over a century, the first art historical encyclopedia was begun in 1937, with the publication of the first volume of the Reallexikon zur deutschen Kunstgeschichte (341), a work of truly encyclopedic scope and scholarly exactness that has in the intervening 44 years reached the letter "F" in six double-column volumes. In the past twenty years, other works have appeared, most notably the Italian-American Encyclopedia of World Art (237). With the possible exception of the advent of national bibliographies in the fine arts, these works have become the most important contributions to the field of fine arts reference tools since the last war. They provide the general reader and the student with access to a vast array of information and expert opinion that was previously known only to specialist-scholars. Since most provide excellent bibliographies, encyclopedias in the fine arts are now the first step in any serious study. Because of the close association of art history and archaeology in the study of the fine arts of prehistoric, ancient, and medieval cultures, the standard general encyclopedias and dictionaries for these periods have been included.

GENERAL DICTIONARIES AND ENCYCLOPEDIAS

Das Atlantisbuch der Kunst; eine Enzyklopädie der bildenden Künste. Zürich, Atlantis, 1952. 897p. illus. index.

One-volume encyclopedia of the visual arts; articles are signed and include bibliographies. Arranged by broad subject areas: 1, Vom Wesen der Kunst; 2, Die Künstlerischen Techniken und ihre Anwendung; 3, Epochen der Kunst in Europa; 4, Die Kunst der aussereuropäischen Völker; 5, Kunstpflege. Well illustrated. Particularly useful are the sections devoted to European styles and periods and to the art of non-Western peoples.

Demmin, Auguste F. Encyclopédie historique, archéologique, biographique, chronologique et monogrammatique des beaux-arts plastiques, architecture et mosaïque, céramique, sculpture, peinture et graveur . . . Paris, Furne, Jouvet, 1873-74. 3v. in 5. illus.

One of the most comprehensive nineteenth-century fine arts encyclopedias. Arranged in broad categories with lists of artists in each. Numerous engraved illustrations. General index at end of volume 3.

237 Encyclopedia of World Art. New York, McGraw-Hill, 1959-1968. 15v. illus. index (v. 15). LC 59-134333.

Comprehensive encyclopedia of the art and architecture of all peoples and periods. Signed articles cover major artists, styles, periods, countries, civilizations, and media. Articles range in length from moderately long biographies of major artists to long articles on civilizations, countries, and periods. All have extensive bibliographies, classified and arranged by date of publication, covering books and periodical articles in all languages. Each volume has a corpus of excellent plates, and the articles are liberally provided with plans and diagrams. First appeared in an Italian edition (Florence, Sansoni), which has adversely affected the alphabetical arrangement in the English edition. In compensation, it is necessary to use the index volume. Only major artists are included; for secondary artists consult Thieme-Becker (276) or Myers (243). A standard reference work in the fine arts, although the quality of the entries varies with the contributor. The bibliographies are excellent guides to further study.

Harper's Encyclopedia of Art: Architecture, Sculpture, Painting, Decorative Arts... New York, Harper, 1937. 2v. illus.

Short-entry encyclopedia of the visual arts covering artists, styles, and periods.

Short-entry encyclopedia of the visual arts covering artists, styles, and periods. Some entries have short bibliographies. Based on the French encyclopedia of Louis Hourticq (Paris, 1925). Older, popular art encyclopedia.

Herder Lexikon: Kunst. Ed. by Ursula Böing-Häusgen. Freiburg im Breisgau, Herder, 1974. 238p. illus. LC 75-527557.

Comprehensive dictionary of world art containing 2,200 entries of various lengths covering major artists, periods, styles, media, techniques, and general terminology. Selected bibliography of basic works, chiefly in German (p. 239).

240 Jahn, Johannes. Wörterbuch der Kunst. 6th ed. rev. and enl. Stuttgart, Kröner, 1962. 749p. illus. LC A45-4462.

General fine arts dictionary of artists, terms, styles, periods, and civilizations. Illustrated with line drawings. Short but excellent bibliographies given at the end of the larger entries. Thoroughly cross referenced. One of the best one-volume art dictionaries.

Lexikon der Kunst. Architektur, bildende Kunst, angewandte Kunst, Industrieformgestaltung, Kunsttheorie. Ed. by Ludger Alscher, et al. Leipzig, Seemann, 1968–. Band I–. LC 78-423729.

Comprehensive encyclopedia covering the fine arts, applied and decorative arts, industrial design, and art theory. Entries are written by various German specialists; some, particularly those dealing with the philosophy of art, show Marxist bias. Major entries have good bibliographies of specialized literature. Particularly useful for technical aspects of art.

Murray, Peter, and Linda Murray. Dictionary of Art and Artists. 3rd ed., Harmondsworth, Penguin, 1972. 467p. illus. LC 73-154752.

General fine arts dictionary containing artist biographies, definitions of terms and techniques, and articles on styles, periods, and schools of art. Excellent illustrations, but no bibliographies. Good general dictionary for the beginning student and general reader. Particularly useful for terms and techniques. Does not deal with non-Western art.

Myers, Bernard S., and Shirley D. Myers, eds. McGraw-Hill Dictionary of Art. New York, McGraw-Hill, 1969. 5v. illus. LC 68-26314.

Comprehensive dictionary of the visual arts covering artists, periods, styles, terms, monuments, museums, places, and countries. Articles range in length from short entries defining terms to long articles on major artists, styles, periods, etc. Larger articles are signed. The larger entries have separate bibliographies. Well illustrated. One of the best all-purpose art encyclopedias in English for the general reader and beginning student.

New International Illustrated Encyclopedia of Art. New York, Greystone, 1967-1971. 23v. illus. LC 67-24201.

Pictorial dictionary of the art and architecture of all peoples and periods. Entries cover artists, countries, media, and such subjects as urban planning. All illustrations are in color. No bibliography. For the general reader.

Osborne, Harold. **The Oxford Companion to Art.** New York, Oxford University Press, 1970. 1277p. illus. LC 71-526168.

A comprehensive general dictionary of the visual arts. Articles range in size from short definitions of terms and brief biographies of major artists to lengthy articles on periods, styles, civilizations, and special aspects of the study of the fine arts (such as preservation and conservation). Also includes places, major buildings, and museums. Entries have bibliographical references to the nearly 3,000 items in the general bibliography at the end of the volume. The best all-round fine arts dictionary in English.

- Parow, Rolf, and H. E. Pappenheim. Kunststile: Lexikon der Stil Begriffe. 2nd ed. Munich, Kunst und Technik, 1958. 332p. illus. LC 58-19045.
 General dictionary of art styles, schools, movements, and forms. Second part is a polyglot dictionary of the terms in German, English, and French. Bibliography (pp. 149-50). Useful dictionary for students confronted with the task of reading German art historical literature.
- Dutton, 1978. 704p. illus. LC 77-89312. One-volume condensation of the *Praeger Encyclopedia of Art* (249). Entries have been abbreviated and the bibliographies eliminated.

Phaidon Encyclopedia of Art and Artists. Oxford, Phaidon; New York,

- 248 Pierce, James S. From Abacus to Zeus: A Handbook of Art History. 2nd ed. Englewood Cliffs, N.J., Prentice-Hall, 1977. 131p. illus. Pocket-size dictionary of general art terminology and iconography intended as a companion to H. W. Janson's *A History of Art*, a standard American college text book. Illustrated with line drawings and provided with maps locating major art centers of the world. References are made to illustrations in Janson's text.
- Praeger Encyclopedia of Art. New York, Praeger, 1971. 5v. illus. index. LC 75-122093.
 Comprehensive encyclopedia-dictionary covering the art and architecture of all

Comprehensive encyclopedia-dictionary covering the art and architecture of all nations, civilizations, and periods. Covers artists, styles, schools, movements, and some terms. Most entries are short, but there are some 1,000 longer survey articles that cover major styles and periods. Based on the *Dictionnaire universel de l'art et des artistes* published by Hazan in Paris (1967), the work of a number of Continental specialists. A good reference work for the general reader and student with useful bibliographies attached to the major entries.

Schaffran, Emerich. Dictionary of European Art. New York, Philosophical Library, 1958. 283p.

General fine arts dictionary of artists, terms, techniques, periods, styles, etc. No bibliographies. Popular dictionary with very short entries, uneven in coverage. Restricted to European art.

Sormani, Giuseppe. **Dizionario delle arti.** 2nd ed. rev. and enl. Milan, Sormani, c. 1953. 974p. illus.

General fine arts dictionary with entries arranged under broad subjects and movements. Index of names. The unusual arrangement is advantageous for quick reference to styles, schools and movements, particularly in Italian and modern art.

Visual Dictionary of Art. General editor, Ann Hill. Greenwich, Conn., New York Graphic Society, 1973. 640p. illus. index. LC 73-76181. General dictionary of art, both Eastern and Western, covering civilizations, periods, styles, schools, movements, and artists as well as terms, techniques, and materials. Thoroughly illustrated. An unusual and useful feature is the collection of short essays on major periods and civilizations preceding the alphabetical entries. The brevity of the entries and the limited bibliography restrict its usefulness to the general reader.

DICTIONARIES OF TERMINOLOGY

Adeline, Jules. Adeline's Art Dictionary. New York, Appleton, 1927; repr. Ann Arbor, Mich., Edwards, 1953. 422p.

General fine arts dictionary with short definitions of terms, techniques, materials, subjects, and objects. Illustrated with line drawings. Although old, it is still useful for definitions of many terms, especially those encountered in antiquarian literature.

Bilzer, Bert. Begriffslexikon der bildenden Künste. Die Fachbegriffe der Baukunst, Plastik, Malerei, Graphik und des Kunsthandwerks. Reinbek bei Hamburg, Rororo, 1971. 2v. illus. LC 78-596414.

Dictionary of terms used in architecture, sculpture, painting, graphic arts, and the applied and decorative arts. Covers stylistic and iconographical terms, objects, structures, techniques, style, and movements. Well illustrated with black and white and color plates plus line drawings. No bibliography.

255 Ehresmann, Julia M. Pocket Dictionary of Art Terms. Boston, New York Graphic Society, 1979. 156p. illus.

Concise dictionary of terminology of the fine and decorative arts, photography, and some architecture. Includes media, techniques, and styles but not artists. Twelve line drawings illustrate certain classes of terms. Selected bibliography of standard, available books on art at the end of the volume.

Fairholt, Frederick W. A Dictionary of Terms in Art... London, Virtue, Hall & Virtue, 1854. 474p. illus.

Covers terms used in sculpture, painting, graphic arts, and applied and decorative arts. Used in the preparation of the English translation of Adeline (253).

Glossarium Artis. Deutsch-Französisches Wörterbuch zur Kunst. fasc. 1—. Tübingen and Strasbourg, Niemeyer, 1972—. illus.

German-French dictionary of art terms arranged in fascicles by types of art works. To date, the following fascicles have appeared:

- 1. Der Wehrbau, L'Architecture-militaire, 152p.
- 2. Liturgische Geräte, Kreuze und Reliquiare der christlichen Kirchen. Objets liturgiques, croix et reliquaires des églises chrétiennes. 159p.
- 3. Bogen und Arkaden, Arcs et arcades, 167p.
- 4. Paramente und liturgische Bücher der christlichen Kirchen. Parements et livres liturgiques des églises chrétiennes. 203p.
- 5. Treppen und Rampen. Escaliers et rampes. 269p.
- 6. Gewölbe und Kuppeln, Voutes et Couples. 249p.

Each term is illustrated by a line drawing and briefly defined. Arranged under the German name with the French equivalent at the end of each entry. Synonyms and homonyms given as well. Each fascicle contains a comprehensive bibliography of the subject. General indexes are planned. The most scholarly and comprehensive dictionary of art terms. When complete, it will be the standard work in the field.

Haggar, Reginald G. Dictionary of Art Terms. New York, Hawthorn Books, 1962. 415p. illus. LC 62-8288.

General dictionary of art terms. Illustrated with line drawings. General bibliography (pp. 411-15). Chiefly useful for succinct definitions of art techniques, styles, and subjects.

259 Lemke, Antje B., and Ruth Pleiss. Museum Companion: A Dictionary of Art Terms and Subjects. New York, Hippocrene, 1974. 211p. illus. index. LC 73-76377.

Defines some 700 movements, styles, subjects, and techniques of Western art. Provides pronunciations of terms, a list of major museums in Europe and North America, and a classified bibliography of selected books.

Linnenkamp, Rolf. Begriffe der modernen Kunst. Munich, Heyne, 1974.
 203p. illus. index. (Heyne Bücher, 4431). LC 74-342487.

Dictionary of some 1,300 entries, covering all aspects of twentieth-century art. Part one covers terms and subjects, and part two, short biographies of major artists. Consult Walker (267) also.

Lützler, Heinrich. Bildwörterbuch der Kunst. Bonn, Dummer, n.d. (c. 1950). 626p. illus.

Comprehensive dictionary covering terms from all aspects of art history, together with a few major biographies. Illustrated with line drawings.

Masciotta, Michelangelo. Dizionario di termini artistici. Florence, Le Monnier, 1967. 269p. LC 68-100571.

General Italian dictionary of art terms consisting of brief definitions. No bibliography. Useful tool for students who are reading extensively in Italian art historical literature.

Mayer, Ralph. A Dictionary of Art Terms and Techniques. New York, Crowell, 1969. 447p. illus. index. LC 69-15414.

General fine arts dictionary of terms and techniques, intended chiefly for the practicing artist and general reader. Particularly useful for definitions of materials and techniques.

Mollett, John W. An Illustrated Dictionary of Words Used in Art and Archaeology . . . Boston, Houghton Mifflin, 1883. 350p. illus. Reprint: New York, American Archives of World Art, 1966.

Well-illustrated nineteenth century dictionary covering architecture, sculpture, painting, graphic arts, and applied and decorative arts. Includes a few Far Eastern terms.

O'Dwyer, John, and Raymond Le Mage. A Glossary of Art Terms. London and New York, Nevill, 1950. 148p.

Popular dictionary of terms, techniques, styles, and schools of Western art. Includes some foreign terms with English translations. For the general reader.

Réau, Louis. Dictionnaire polyglotte des termes d'art et d'archéologie. Paris, Presses Universitaires de France, 1953; repr. Osnabrück, Ohms, 1974. 247p.; 2nd ed., Osnabrück, Ohms, 1977. 961p.

Polyglot dictionary of fine arts terms, consisting of one alphabetical listing under the French name of the term. Equivalents are given in Greek, Latin, Italian, Spanish, Portuguese, Romanian, English, German, Dutch, Swedish, Czech, Polish, and Russian. Greek and Russian names are transliterated into Latin alphabet. Second edition has additions to German, English, and Italian terminologies.

Walker, John A. Glossary of Art, Architecture and Design since 1945. 2nd ed., London, Linnet Books, 1977. 352p.

Dictionary of terms relating to the fine arts since 1945. Brief entries give definition and source when known. General bibliography useful for definitions of the most avant-garde art terms. See Linnenkamp (260), as well.

See also: General Dictionaries, above.

GENERAL BIOGRAPHICAL DICTIONARIES

Bénézit, Emmanuel. Dictionnaire critique et documentaire des peintres, sculpteurs, dessinateurs et graveurs . . . Paris, Gründ, 1948-1955; repr. Paris, 1957. 8v. illus. index; Nouv. éd., Paris, 1976. 10v. illus. index. Dictionary of painters, sculptors, and graphic artists of all times and nations. Entries vary from a few lines to several paragraphs. In addition to the basic biographical data, longer entries list prizes won by the artist and museums where his works can be found. Facsimiles of signatures are given and monograms are listed at the end of each letter of the alphabet. Author index and general bibliography in final volume. Directed to the general reader and collector rather than the scholar.

Darmstaedter, Robert. Künstlerlexikon: Maler, Bildhauer, Architekten. Bern and Munich, Francke, 1961. 527p. LC 62-43121.

General dictionary of artists' biographies covering all periods and peoples. Each entry gives basic biography, characterization of the artist's style, list of major works, and a separate bibliography. The most comprehensive and reliable one-volume dictionary of artists. The bibliographies are especially useful.

270 Kaltenbach, Gustave Emile. Dictionary of Pronunciation of Artists'
Names. 2nd ed. Chicago, The Art Institute of Chicago, 1938. 74p.
Alphabetical list of 1,500 artists' names with their birth and death dates, nationality, and pronunciation of their names. A useful and reliable guide.

Lodovici, Sergio. Storici, teorici e critici delle arti figurative (1800-1940). Rome, E.B.B.I., Istituto Editoriale Italiano, 1942. 412p. illus. (Enciclopedia Biografia e Bibliographica "Italiana," ser. IV).
Dictionary of art historians, theoreticians, and critics active between 1800 and 1940. Each biography gives a list of the writer's major works and a discussion of that person's theories; a portrait of the writer is often included.

272 Meyer, Julius, ed. Allgemeines Künstler-Lexikon . . . Leipzig, Engelmann, 1872-85. 3v.

Planned revision and expansion of Nagler's *Neues allgemeines Künstler-Lexikon* (276), which reached only as far as "Bezzuoli." Excellent signed entries by leading German scholars of the last quarter of the nineteenth century.

Müller, Hermann A., and Hans W. Singer. Allgemeines Künstler-Lexikon. Leben und Werke der berühmtesten bildenden Künstler. 5th ed. Frankfurt am Main, Rütten & Loening, 1921-22. 6v.

Unrevised reprint of the 3rd edition, published in 1891-1901, with a supplement and corrections in the sixth volume. Short, unsigned biographical entries cover major artists of all periods and countries. No bibliographies.

Nagler, Georg K. Neues allgemeines Künstler-Lexicon . . . Leipzig, Schwarzenberg & Schumann, 1924, 25v.

Reprint of the first edition, published 1835-1852. Comprehensive dictionary of fine and applied artists of all periods and countries. Entries discuss both the life and work of the artist but give no bibliographies or references to sources. The most important of the early nineteenth-century artists' dictionaries, it laid the foundation for, and was superseded by, Thieme-Becker (276).

Spooner, Shearjashub. A Biographical History of the Fine Arts; or, Memoirs of the Lives and Works of Eminent Painters, Engravers, Sculptors, and Architects... New York, Bouton, 1865. 2v. illus.

First published in 1853 as a dictionary of painters and engravers. Brief biographical entries on major artists of all periods and countries. Section devoted to major copyists and imitators, arranged under the master whose works they copied. Together with Bryan's *Dictionary of Painters and Engravers* (London, 1816), the chief English nineteenth-century artists dictionary.

276 Thieme, Ulrich, and Felix Becker. Allgemeines Lexikon der bildenden Künstler von der Antike bis zur Gegenwart . . . Leipzig, Seemann, 1907-1950. 37v.

The most comprehensive biographical dictionary of artists from antiquity to the present. Entries are signed and vary in length depending on the artist. All have separate bibliographies. Larger entries have thorough discussions of the stylistic development of the artist and lists of works with locations. Volume 37, entitled *Meister mit Notnamen und Monogrammisten*, contains biographies of anonymous artists known by substitute names or monograms. Artists active chiefly in the twentieth century are not included; equivalent biographies of these are found in Vollmer (265). A reference work of outstanding scope and scholarship. The standard biographical source for the fine arts.

Waters, Clara Erskine Clement. Women in the Fine Arts: From the Seventh Century B.C. to the Twentieth Century A.D. Cambridge, Mass., Houghton Mifflin, 1904. 395p. illus. Reprint: New York, Hacker, 1974. LC 73-92107.

Biographical dictionary of female artists in all media. Brief entries give biographical data together with list of major works. Bibliographical references to a list of basic reference works.

See also: Havlice, Index to Artistic Biography (202).

DICTIONARIES OF MARKS AND SIGNATURES

Brulliot, Franz. Dictionnaire des monogrammes, marques figurées, lettres initiales, noms abrégés etc. . . . Nouv. éd. Munich, Cotta, 1832-34. 3v. illus. index.

Comprehensive dictionary of marks, monograms, and initials of artists of all schools and periods, illustrated with facsimiles. Figurative marks appear as appendices in the first two volumes. Indexes of artists' names in each volume; general index at end of last volume. Superseded by Nagler (283).

- Caplan, H. H. The Classified Directory of Artists' Signatures, Symbols and Monograms. London, George Prior, 1976. 738p. illus. LC 77-356200. General dictionary of marks and signatures, with emphasis on European painters and graphic artists (and a few Far Eastern or American artists). Arranged in four sections: alphabetical by artist's name, monograms by first letter, illegible or misleading signatures by first legible letter, and symbols classified by shape. Entries give facsimiles of the marks and signatures plus basic biographical data for the artist. No bibliography.
- Goldstein, Franz. Monogrammlexikon: Internationales Verzeichnis der Monogramme bildender Künstler seit 1850. Berlin, de Gruyter, 1964.
 931p. LC 65-47949.

Dictionary of the monograms of artists active since 1850, arranged alphabetically by the initial letters. Entries give the dates of the artist, media worked in, and bibliographical reference to either Thieme-Becker, Vollmer, Bénézit, or *Dresslers Kunsthandbuch*. The standard reference tool for the monograms of modern artists. Complements Nagler (283).

- Haslam, Malcolm. Marks and Monograms of the Modern Movement 1875-1930. New York, Scribner's, 1977. 192p. illus. index. LC 76-26189. Dictionary of marks and monograms of modern artists working in the graphic, applied, and decorative arts. Arrangement is by media: ceramics, glass, metalwork and jewelry, graphics, furniture, and textiles. Entries provide a facsimile of the mark and basic biographical data for the artist.
- 282 Lampe, Louis. Signature et monogrammes des peintres de toutes les écoles; guide monogrammiste . . . Brussels, Castaign, 1895-98. 3v. Dictionary of signatures and monograms of Western painters of all periods and schools. Arranged by the subject depicted and then alphabetically by artists. Short biographical entries with facsimiles of signatures and monograms. Still a useful dictionary.
 - Nagler, Georg Kaspar. Die Monogrammisten und diejenigen bekannten und unbekannten Künstler aller Schulen . . . Munich, Franz, 1858-79. 5v. illus. index. General-Index zu G. K. Nagler die Monogrammisten . . . Munich, Hirth, 1920. 109p. (Reprint: Nieuwkoop, De Graaf, 1966. 6v. illus. index.).

Comprehensive dictionary of the monograms of artists in all media and from all periods. In addition, it includes printers' and collectors' marks and marks on

metalwork and ceramics. Arranged by the chief initials in the monogram. Facsimiles of the marks are given, with a short biography of the artist and a discussion of where the mark is found. Each volume has a supplement (Nachtrag) and index at the end. Volume six contains a general index and bibliography. The standard work on monograms. For the monograms of modern artists—i.e., active since 1870—see Goldstein (280).

284 Ris-Paquot, Oscar E. Dictionnaire encyclopédique des marques et monogrammes, chiffres, lettres, initiales, signes figuratifs . . . Paris, Laurens, 1893. 2v. illus. index.

Comprehensive dictionary of artist's marks, initials, monograms, and signs, with particular attention to those found in various works of applied and decorative arts. Arranged by broad classes and illustrated with facsimiles. General index of artists' names (pp. 579-609) in volume two. Useful inclusion of marks of collectors, museums and libraries.

SPECIALIZED DICTIONARIES AND ENCYCLOPEDIAS

PREHISTORIC

Ebert, Max, ed. **Reallexikon der Vorgeschichte**. Berlin, de Gruyter, 1924-32. 15v. in 16. illus. index.

Comprehensive and scholarly encyclopedia of signed articles covering all aspects of prehistoric archaeology. The long articles are accompanied by separate and extensive bibliographies and many excellent illustrations. The standard reference tool for prehistoric archaeology.

Filip, Jan, ed. Enzyklopädisches Handbuch zur Ur- und Frühgeschichte Europas. Stuttgart, Kohlhammer, 1966-69. 2v. illus. LC 67-101201. Encyclopedia covering all aspects of European civilization during prehistoric and early historic times. Articles cover objects, sites, regions, and styles that are directly related to the study of prehistoric, Germanic, and Celtic art. Articles are occasionally illustrated with line drawings and plans; each major article is accompanied with an extensive bibliography of specialized literature. A standard reference tool for all serious study of early European art.

EUROPE

Periods of Western Art History

Ancient

Avery, Catherine B., ed. The New Century Handbook of Greek Art and Architecture. New York, Appleton-Century-Crofts, 1972. 213p. illus. LC 72-187738.

Dictionary of ancient Greek art and architecture covering artists, objects, monuments, places, styles, and schools. The entries are derived from the *New Century Classical Dictionary* and in some instances have been expanded to reflect more recent archaeological findings. For the general reader and beginning student.

Bianchi Bandinelli, Ranuccio, ed. Enciclopedia dell'arte antica; classica e orientale. Rome, Istit. della Enciclopedia Italiana, 1958-1973. 8v. illus. index. LC 58-37080.

Comprehensive encyclopedia of ancient art covering the period from prehistory to 500 A.D. Long signed articles by specialists with separate bibliographies and good illustrations. Treats classical antiquity including the ancient civilizations of the Near East, Egypt, and the prehistoric cultures of Northern Europe. Volume 8 contains an atlas. Excellent reference tool for ancient art. A 951-page supplement was published in 1973.

Daremberg, Charles V., and Edmond Saglio. Dictionnaire des antiquités grecques et romaines d'après les textes et les monuments. Paris, Hachette, 1873-1919. 5v. illus. index. Reprint: Graz, Akademische Druck und Verlagsanstalt, 1962-63. 5v. in 10. LC 64-44287.

Scholarly encyclopedia covering all aspects of classical culture including the visual arts. Long signed articles by recognized specialists with separate bibliographical references. Does not include biography. One of the standard reference tools for classical studies. For greater depth and for classical biography and literature see Pauly-Wissowa (296).

290 Dictionary of Ancient Greek Civilization. London, Methuen, 1967. 491p. illus.

General dictionary covering all aspects of ancient Greek civilization, with articles on artists, art centers, major buildings, and subjects.

- 291 Ebeling, Erich, and Bruno Meissner, eds. Reallexikon der Assyriologie.
 v. 1— ("A" through "Hazazu"). Berlin, de Gruyter, 1928—. illus.
 Comprehensive encyclopedia covering all aspects of the ancient civilizations of the ancient Near East. Long signed articles illustrated with line drawings and plans, plus extensive bibliographies. Most of the entries are in German, but some are in French and English. A standard reference work for the advanced student and scholar of ancient Near Eastern art and architecture.
- Hammond, N. G. L., and H. H. Scullard, eds. The Oxford Classical Dictionary. 2nd ed. Oxford, Clarendon, 1970. 1176p. LC 73-18819.
 Comprehensive dictionary of all aspects of classical Greek and Roman civilizations. Entries are signed and supply separate bibliographies. Useful for students of ancient art for quick reference on places, major artists, religious and mythological subjects, and literary subjects. The standard classical dictionary in English.
 - Helck, Wolfgang, and Eberhard Otto, eds. Lexikon der Ägyptologie. Bd. I-. Wiesbaden, Harrassowitz, 1972-.

The first volume of a comprehensive encyclopedia covering all aspects of ancient Egyptian civilization. Six volumes are planned. Entries are signed and provide excellent bibliographies. Should become a standard reference work for advanced students and scholars of ancient Egyptian art and architecture.

294 Lamer, Hans. Wörterbuch der Antike mit Berücksichtigung ihres Fortwirkens. 8th ed., expanded and improved by P. Kroh. Stuttgart, Kröner, 1976. 832p. illus.

General dictionary of Greek and Roman civilization covering terms, persons, places, objects, and subjects. Major entries have separate bibliographies. One of the best pocket-sized classical dictionaries; particularly useful for its attention to the continuation of classical traditions in later periods.

295 Lexikon der alten Welt. Zürich and Stuttgart, Artemis, 1965. 3524 columns. LC 67-105898.

Comprehensive dictionary covering all aspects of ancient civilization. Long signed articles cover places, persons, objects, and subjects. There are excellent separate bibliographies. An excellent classical dictionary.

Pauly, August Friedrich von. Pauly's Real-Encyclopädie der classischen Altertumswissenschaft; neue Bearbeitung begonnen von Georg Wissowa, unter Mitwirkung zahlreicher Fachgenossen Herausgegeben von Wilhelm Kroll und Karl Mittelhaus. Stuttgart, Metzler, 1894-1968. 44v.

Appeared in two series and eleven volumes of supplements. Additional supplements are planned. Scholarly encyclopedia covering all aspects of classical civilizations. Long signed articles, with separate bibliographies, cover biography, antiquities, literature, mythology, religion, sites, and historical events. The standard classical encyclopedia. A basic reference tool for advanced students of classical art.

Praeger Encyclopedia of Ancient Greek Civilization. New York, Praeger, 1967. 491p. illus. LC 67-25162.

General dictionary with brief signed articles covering all aspects of ancient Greek civilization, including art and architecture. A useful reference work for the general reader and the beginning student.

Stillwell, Richard, ed. The Princeton Encyclopedia of Classical Sites.
Princeton, N.J., Princeton University Press, 1976. 1019p. LC 75-30210.
Dictionary of basic information on sites important during classical antiquity, i.e., between the eighth century B.C. and the sixth century A.D. Does not include Early Christian sites. Entries describe the locations and their material remains and include valuable bibliographies of specialized literature that often note art historical references.

Medieval and Byzantine

Aressy, Pierre. Abrégé de l'art roman, suivi d'un lexique des termes employés en art roman. Montpellier, Causse et Castelnau, 1967. 143p. illus. LC 68-76605.

Part II (pp. 85-121) is a dictionary of terms used in the history of Romanesque art. Part I gives a short but useful history of Romanesque art in France. Useful handbook for the student of medieval art.

300 Cabrol, Fernand. Dictionnaire d'archéologie chrétienne et de liturgie . . . Paris, Letouzey et Ané, 1907-53, 15v. illus.

Volumes 3-14 "publié par le Rme. dom Fernand Cabrol . . . et le R. P. dom Henri Leclercq." Illustrated with line drawings. Scholarly encyclopedia covering all aspects of Christian culture of the period from the early Christians through the Carolingians. The long signed articles have separate bibliographies and are of particular importance to students of Christian art seeking information on sites, archaeological and liturgical artifacts, and iconographical subjects. In the latter category, the work's usefulness extends far beyond its period of specialty.

301 Gay, Victor, and Henri Stein. Glossaire archéologique du moyen-âge et de la Renaissance. Paris, Société Bibliographique, 1887-1928; repr. Nendeln, Kraus, 1967. 2v. illus.

Dictionary of terms encountered in the study of medieval and Renaissance art. Major entries give quotations from literary or documentary sources. Illustrated with line drawings.

Guénebault, Louis J. Dictionnaire iconographique des monuments de l'antiquité chrétienne et du moyen âge depuis le bas-empire jusqu'a la fin du seizième siècle indiquant l'état de l'art et de la civilisation a ces diverses époques. Paris, Leleux, 1843-1845. 2v.

Comprehensive dictionary of the art and architecture of the Early Christian period and the Middle Ages. Entries treat countries, provinces, sites, objects, structures, techniques, and iconographic subjects. For an old book, information supplied is impressive. The extensive references to early literature make it a useful special tool.

Klauser, Theodor. Reallexikon für Antike und Christentum; Sachwörterbuch zur Auseinandersetzung des Christentums mit der Antiken Welt...
 Bd. I. Stuttgart, Hiersemann, 1950. illus.

Scholarly encyclopedia covering all aspects of the culture of the late Roman and Early Christian period. It is designed to investigate the interrelationship between Christianity and late antiquity. Consists of long signed articles with separate and exhaustive bibliographies on a broad variety of subjects, many of which are of direct interest to art historians of the period. Particularly valuable for information on iconography, architecture, sites, and personalities of the Early Christian period. Each volume has a table of contents in German, English, French, and Italian.

304 Laag, D. Heinrich. Wörterbuch der altchristlichen Kunst. Kassel, Stauda, 1959. 166p. illus. LC A66-3623.

General dictionary of terms, persons, subjects, and places encountered in the study of Early Christian art and architecture. Illustrated with line drawings. A very useful, pocket-sized dictionary for the student of Early Christian art.

305 Lexikon des Mittelalters. Band I—. Munich and Zurich, Artemis Verlag, 1977—.

Planned five-volume encyclopedia covering all aspects of medieval civilization, including art and architecture. Entries are written by experts from various countries, are illustrated, and include valuable bibliographies of specialized literature. Of

particular interest to art historians are the articles on major works of art, artistic personalities, and iconographical subjects.

Vogüe, Melchior de, Jean Neufville, and Wenceslas Bugara. Glossaire de terms techniques à l'usage des lecteurs de "La Nuit des Temps." Paris, Zodiaque, 1965. 473p. illus. index. LC 67-81381.

Dictionary of art and architectural terms used in the study of Romanesque and Gothic art. Very thorough dictionary is accompanied by numerous plates, plans, and diagrams, many with the terms included. An excellent dictionary of French terms for the advanced student of medieval art and architecture.

Wessel, Klaus, ed. Reallexikon zur byzantinischen Kunst. v. 1–. Stuttgart, Hiersemann, 1966–. illus. LC 76-446105.

Comprehensive and scholarly encyclopedia of all aspects of Byzantine art and architecture. Recognized specialists prepared the lengthy articles, which are well illustrated with plans and drawings and which have extensive separate bibliographies. Standard reference tool for the study of Byzantine art.

Renaissance

308 Avery, Catherine B., ed. The New Century Italian Renaissance Encyclopedia. New York, Appleton-Century-Crofts, 1972. 978p. illus. LC 76-81735.

Comprehensive dictionary of all aspects of the Italian Renaissance, including articles on artists and writers, résumés of literary works, subjects, and some terms dealing with the fine arts. The entries are brief, without bibliographies. Useful reference work for the general reader and the beginning student.

Modern (19th and 20th Centuries)

309 Busse, Joachim. Internationales Handbuch aller Maler und Bildhauer des 19. Jahrhunderts. Wiesbaden, Busse Verlag, 1977. 1200p. illus. LC 77-481499.

Comprehensive, computer-assisted index of 89,000 painters, sculptors, and graphic artists still alive after 1806 or born before 1880. Emphasis is on European artists. Arranged alphabetically by artist's name and set in table form, the following information is provided chiefly through abbreviations: birth and death dates, nationality, place of work, techniques used and subjects most often represented, and reference to twelve reference sources, including sales catalogs. The work is designed for quick reference by collectors and others seeking basic information on less well-known artists of the nineteenth century, particularly Continental.

Charmet, Raymond. Dictionnaire de l'art contemporain. Paris, Larousse, 1965, 320p. illus. LC 66-72421.

This pocket-sized dictionary of twentieth century art and architecture provides brief biographies of artists and architects, with entries on schools, styles, terms, and places relative to modern art. No bibliography.

311 Du Peloux de Saint Romain, Charles. Répertoire biographique et bibliographique des artistes du XVIIIe siècle français... Paris, Champion, 1930-41. 2v.

Biographical dictionary and bibliography on French artists of the eighteenth century. Volume 1 contains the dictionary; volume 2, the bibliography of about 4,000 titles of books and periodical articles published in the decade between 1930 and 1940.

Edouard-Joseph, René. Dictionnaire biographique des artistes contemporains, 1910-1930 . . . Paris, Art et Edition, 1930-34. 3v. illus. index. Supplément. Paris, 1936. 162p. illus.

Dictionary of artists active in France from 1910 to 1930. In addition to basic biographical data, it also lists when and where the artist exhibited and the awards won by each artist. List of important works given for major artists. Index of monograms at end of vol. 3.

Maillard, Robert, ed. New Dictionary of Modern Sculpture. New York, Tudor, 1971. 328p. illus. LC 70-153118.

Biographical dictionary of modern sculptors. Signed entries with illustrations, no bibliographies. Index of photographers.

Myers, Bernard S., and Shirley D. Myers. Dictionary of 20th Century Art. New York, McGraw-Hill, 1974. 440p. illus. LC 74-4200.

Entries on twentieth century art and architecture from the McGraw-Hill Dictionary of Art (243). Bibliography, pp. 435-440, lists basic books in English.

Naylor, Colin, and Genesis P-Orridge, eds. Contemporary Artists. London, St. James Press, 1977. 1077p. illus. LC 76-54627.

Dictionary of some 1,300 internationally known artists who were alive in 1930. For inclusion, an artist has to have had at least five years as a career professional, one-person shows, participation in a large-scale museum-type survey show, and have works in the permanent collections of major museums. Entries are quite comprehensive, giving biographical data, list of one-person and group exhibitions, collections possessing the artist's work, publications on and by the artist, and a brief statement (sometimes by the artist) of the character and intention of the artist's work. Most entries have illustrations. Partially fills the need for a dictionary of contemporary artists that includes the less well-known.

Phaidon Dictionary of Twentieth-Century Art. 2nd ed. London and New York, Phaidon, 1977. 420p. illus. LC 77-81957.

General dictionary of twentieth century art, including artists' biographies, artists' groups, schools, styles, and a few terms. There are short bibliographies for most entries. Particularly useful for quick reference to modern art styles and movements.

Vollmer, Hans. Allgemeines Lexikon der bildenden Künstler des XX.

Jahrhunderts. Leipzig, Seemann, 1953-62. 6v. LC 54-19064.

Biographical dictionary of twentieth century artists in all media. Conceived as a supplement to Thieme-Becker (276), it emphasizes artists born after 1870. In the case of those artists that are also treated in Thieme-Becker, Vollmer gives

additional information. Volumes 5 and 6 are supplement volumes; additional supplement volumes are planned. The entries vary in length, are signed, and have separate bibliographies. The standard biographical dictionary for twentieth century artists.

Waters, Clara E., and Laurence Hutton. Artists of the 19th Century and Their Works . . . 3rd ed. Boston, Osgood, 1885. 2v. in 1. index. First published in 1870. Brief biographical entries of some 2,050 American and European artists active in the nineteenth century. Useful feature is the inclusion of quotations from contemporary critics.

See also: Avery Obituary Index (205).

European National Dictionaries and Encyclopedias

Austria

- Schmidt, Rudolf. Österreichisches Kunstlerlexikon. Von den Anfängen bis zur Gegenwart. Band 1—. Vienna, Tusch, 1975—. LC 75-566515.

 Comprehensive dictionary of Austrian artists of all media and from earliest times to the present. In progress, the most recent volume (III) has reached "Buzzi-Quattrini." Entries are very thorough, giving full biographies, a list of major works, and a bibliography of specialized literature.
- 320 Wastler, Josef. Steirisches Künstler-Lexicon. Graz, "Leykam," 1883. 198p. index.

 Biographical dictionary of artists born in or active in the Austrian province of Styria. Major entries have references to sources listed on p. ix. Geographical

Czechoslovakia

index (pp. 192-97).

Dlabač, Jan B. Allgemeines historisches Künstler-Lexikon für Böhmen und zum Theil auch für Mähren und Schlesien. Prague, Hasse, 1815. 3v. in 1. Comprehensive dictionary of artists, architects, and musicians in Bohemia from the Middle Ages to the end of the eighteenth century. Entries include references to archival material. Also includes some artists active in Moravia and Silesia.

Denmark

- Gelsted, Otto. Kunstner Leksikon, med 1100 biografier af Danske Billedhuggere, Malere, Grafikere og Dekorative Kunstnere fra 1900-1942.
 Copenhagen, Jensen, 1942. 197p.
- Short-entry biographical dictionary of Danish artists active between 1900 and 1942.
 - Weilbach, Philip. Kunstnerleksikon; udgivet af en Komite med Støtte af Carlsbergfondet. Redaktion: Meret Bodelsen og Povl Engelstoft. Copenhagen, Aschehoug, 1947-1952. 3v. illus. index. LC 50-24719 rev.

Biographical dictionary of signed entries for Danish artists and foreign artists active in Denmark. Good bibliographies at the end of each entry. Supplement at end of volume 3. Indexes. Standard reference tool for Danish artists.

France

Bellier de Chavignerie, Émile. Dictionnaire général des artistes de l'école française depuis l'origine des arts du dessin jusqu'à nos jours . . . Paris, Renouard, 1882-85. 2v.

Biographical dictionary of artists who were admitted three times to the French Salon. Includes architects, painters, sculptors, and graphic artists. Entries list the works and dates exhibited. Supplement published in 1887 brought the information up to the 1882 Salon. Useful "Table topographique des artistes français" listing artists by province and city of birth in the supplement.

Bérard, André. Dictionnaire biographique des artistes français du XI^e au XVII^e siècle, suivi d'une table chronologique et alphabétique comprenant en vingt classes les arts mentionnés dans l'ouvrage . . . Paris, Dumoulin, 1872. 864 columns.

Limited-edition dictionary of French painters, sculptors, graphic, and applied artists. Reference is made to 206 sources listed at the beginning. Chronological list of artists at end.

326 Camard, Jean P., and Anne M. Belfort. Dictionnaire des peintres et sculpteurs provencaux, 1880-1950. Ile de Bendor, Éditions Bendor, n.d. (1975?). 444p. LC 75-504752.

Biographical dictionary of some 700 painters and sculptors active in Provence between 1880 and 1950. Entries give basic biographical data, where the artist exhibited and locations of works.

Dictionnaire des artistes et ouvriers d'art de la France. Paris, Bibliothèque d'Art et d'Archéologie, 1912-1919. 3v. illus. index.

Unfinished series of biographical dictionaries intended to cover all the provinces of France. Each volume has an introduction outlining the art history of the region, a biographical dictionary of artists of the region who died before 1900, and a bibliography. Contents: *Franche-Comté*, par l'Abbé Paul Brunne (1912); *Lyonnais*, par M. Audin et E. Vial (1918-1919; 2v.).

Du Peloux de Saint Romain, Charles, Vicomte. Répertoire biographique et bibliographique des artistes du XVIII^e siècle français... Paris, Champion, 1930-41. 2v.

Dictionary of French artists of the eighteenth century arranged by media in the first volume. Second volume contains: "notices historiques sur l'art français dans les pays scandinaves, les manufactures particulières de faïence, de porcelaine et de tapisseries." Comprehensive bibliography of books and periodical articles in all languages and on all aspects of eighteenth century French art published before 1940 is found both in first volume (pp. 329-449) and in second volume (pp. 38-97). Valuable list of art societies, collectors and public auctions in the

eighteenth century (v. 1, pp. 288-328). A standard reference tool for eighteenth-century French art.

Dussieux, Louis E. Les artistes français à l'étranger . . . 3rd ed. Paris, Lecoffre, 1876. 643p.

First published in 1852. Comprehensive dictionary of French artists and foreign artists active in France, arranged by country, then province. Brief biographical entries. No bibliographies.

- Gabet, Charles H. J. Dictionnaire des artistes de l'école française au XIXe siècle. Peinture, sculpture, architecture, gravure, dessin, lithographie et composition musicale... Paris, Vergne, 1831. 709p. illus. Biographical dictionary of French artists, architects, and musicians to the end of the eighteenth century. Some references to sources listed on page two. Engraved illustrations.
- Gérard, Charles. Les artistes de l'Alsace pendant le moyen âge. Paris and Nancy, Berger-Levrault, 1872-1873. 2v. index.

 Dictionary of artists born and active in Alsace from the seventh through the sixteenth centuries. Arrangement is by centuries, then alphabetically by artist's name. No bibliographies.
- Giraudet, Eugène. Les artistes tourangeaux: architects, armuriers, brodeurs, émailleurs, graveurs, orfèvres, peintres, sculpteurs, tapissiers de haute lisse... Tours, Rouillé-Ladevèze, 1885. 419p. illus. index.

 Dictionary of artists active in the Tours region of France. Entries have bibliographical footnotes referring to documentary and other source material. Introduction sketches the history of the fine arts in the Touraine.
 - Leblond, Victor. Les artistes de Beauvais et du Beauvaisis au XVIe siècle et leurs oeuvres. Beauvais, Imprimerie Départmentale de l'Oise, 1922. 56p.

Handbook of architects and sculptors in Beauvais and vicinity during the sixteenth century. Includes chapter on glass-workers. List of families of artists (pp. 49-51) and "contracts d'apprentissage" (pp. 51-56).

Port, Célestin. Les artistes angevins, peintres, sculpteurs, maîtres d'oeuvre, architects, graveurs, musiciens, d'après les archives angevins . . . Paris, Baur, 1881. 334p.

Alphabetically arranged dictionary of artists active in the Angevin region of France, with references to archival material.

Portal, Charles. Dictionnaire des artistes et ouvriers d'art du Tarn du XIIIe au XXe siècle. albi, Chez L'Auteur, 1925. 332p. illus. index. Biographical dictionary of artists of the Tarn region, covering the period from the thirteenth to the twentieth centuries. Introduction gives the sources for the work.

Germany

Merlo, Johann J. Kölnische Künstler in alter und neuer Zeit. Rev. and exp. ed., edited by Eduard Firmenich-Richartz and Hermann Keussen. Düsseldorf, Schwann, 1895. 1206 columns. illus. (Publikationen der Gesellschaft für Rheinische Geschichtskunde, IX).

First published in 1850. Dictionary of architects, sculptors, painters, and graphic artists active in Cologne. Alphabetically arranged, the entries for the major artists contain references to documentary sources and additional bibliography. One of the most comprehensive dictionaries of regional artists.

Mithoff, H. Wilhelm H. Mittelalterliche Künstler und Werkmeister Niedersachsens und Westfalens . . . 2nd ed. Hannover, Helwing, 1885. 462p.

Comprehensive dictionary of artists and architects active in Lower Saxony and Westphalia up to 1600. Following the alphabetical artist list are sections on: organizations of artists and architects, "Rolle der Maler und Glaseramts zu Lüneburg," artists' coats of arms, handling of artists and architects in the documents, "Morgensprache," patron saints of artists and artisans, and glossary of Lower German words used in medieval documents pertaining to artists.

Müller, Hermann A., and Oskar Mothes. Illustriertes archäologisches Wörterbuch der Kunst des germanischen Altertums, des Mittelalters und der Renaissance . . . Leipzig & Berlin, Spamer, 1877. 2v. illus.

Comprehensive dictionary of terms in German, English, and French applicable to the study of the art history of antiquity, the Middle Ages, and the Renaissance. Covers stylistic terms, techniques for both the fine and applied arts, iconography, heraldry, epigraphy, and iconography. Illustrated with line drawings. The German equivalent to Adeline's dictionary (252) but more complete.

Nagel, Gert K. Schwäbische Maler, Bildhauer und andere Künstler; ein illustriertes Lexikon von Künstler der letzten 200 Jahre. Stuttgart, Kunsthaus Fritz Vogel, 1975. 176p. illus. LC 76-460749.

Biographical dictionary of some 1,600 artists active in Swabia during the last 200 years. Bibliographies provided for the major entries.

Neumann, Wilhelm. Lexikon baltischer Künstler. Riga, Jonck & Poliewsky, 1908; repr. Hannover-Döhren, von Hirschheydt, 1972. 171p. LC 72-366260.

Biographical dictionary (in German) of Baltic artists of all media and times. Covers artists born and/or active in the former German province of East Prussia and in Estonia, Latvia, and Lithuania. Major entries have separate bibliographical references. Standard biographical dictionary of Baltic area artists.

341 Schmitt, Otto, ed. Reallexikon zur deutschen Kunstgeschichte. Bd. 1–. Stuttgart, Metzler, 1937–. illus.

Comprehensive and scholarly encyclopedia of German art history. Long signed articles by leading specialists are accompanied by many illustrations and extensive bibliographies. Covers all aspects except biography. Many subjects not covered in

other reference tools are treated with impressive scholarly thoroughness. This is especially true in the areas of iconography, materials, structures, and objects. Although the work is progressing slowly (at present, only the beginning of the letter "F" has been reached) and is technically limited to German art, the Reallexikon is of almost universal value. Information and bibliography on subjects that cut across periods (such as apse, altarpiece, and brick architecture) can be quickly and confidently obtained from this work. One of the finest reference tools in the field of art history.

342 Zülch, Walther K. Frankfurter Künstler, 1223-1700. Frankfurt am Main, Diesterweg, 1935. 670p. index.

Biographical handbook of artists active in Frankfurt am Main from 1223 to 1700. Arranged chronologically, entries give archival sources as well as thorough reference to recent literature. List of artists by media (pp. 601-629); alphabetical list of artists (pp. 629-54). An excellent regional biographical dictionary.

Great Britain

- 343 Cunningham, Allan. The Lives of the Most Eminent British Painters, Sculptors, and Architects . . . London, Murray, 1830-1833. 6v. illus. Biographical essays on 47 major British artists. Engraved portrait of the artist precedes each chapter.
- 344 Dictionary of British Artists 1880-1940. An Antique Collectors Club Research Project, London, Antique Collectors' Club, 1976, 567p. Short-entry dictionary of some 4,000 British artists active 1880 to 1940. Starred entries are artists whose work sold for more than 100 pounds at auctions 1970-1975. Selected book list (p. 16).
- 345 Graves, Algernon. Dictionary of Artists Who Have Exhibited in the Principal London Exhibitions from 1760 to 1893. 3rd ed. London, Graves, 1901. Reprint: Bath, Kingsmead, 1973. 314p. List of over 16,000 painters, graphic artists, medalists, sculptors, and architects in tabular form, giving the town from which the artist came, dates of first and last exhibits, speciality, and symbols indicating to which societies the artist belonged.
- 346 Hall, Henry C. Artists and Sculptors of Nottingham and Nottinghamshire, 1750-1950. Nottingham, H. Jones, 1953. 95p. Biographical dictionary of artists in Nottingham and surrounding region, arranged in three parts: Artists of the past (pp. 11-67); Contemporary artists (pp. 71-85);
- 347 Redgrave, Samuel. A Dictionary of Artists of the British School: Painters, Sculptors, Architects, Engravers and Ornamentists; with Notices of Their Lives and Work . . . 2nd ed. London, Bell, 1878. 497p. Dictionary of artists and architects born in and active in the British Isles. For

major artists, brief biographical entries supply list of chief works. No

Sculptors (pp. 89-95). Brief biographical notes, bibliography.

bibliography.

Rees, Thomas M. Welsh Painters, Engravers, Sculptors (1527-1911)... Carnarvon, Welsh Pub. Co., 191?. 188p. illus.

Brief biographical entries with reference to list of standard sources.

349 Strickland, Walter G. A Dictionary of Irish Artists . . . Dublin, Maunsel, 1913. 2v. illus. index.

Comprehensive dictionary of artists born and active in Ireland from the earliest times to the twentieth century. Appendix to second volume provides a discussion of Irish artists' societies and art institutions.

Waters, Grant M. Dictionary of British Artists Working 1900-1950.
Eastbourne, Eastbourne Fine Arts, 1975. 368p. illus. LC 75-325140.
Dictionary of some 5,500 British artists active between 1900 and 1950. Entries provide brief biography, list of works, and society affiliation. Good for secondary artists.

Italy

Alizeri, Federigo. Notizie dei professori del disegno in Liguria dalla Fondazione dell' Accademia. Genoa, Tip. Luigi Sambolino, 1864-66. 3v. illus. index.

Dictionary of painters, sculptors, and graphic artists active in the Italian province of Liguria during the eighteenth and nineteenth centuries. Artists are listed by media. Introduction sketches the history of art in Liguria.

Bessone-Aurelj, Antonietta M. Dizionario degli scultori e architetti italiani. Genoa, Dante Alighieri, 1947. 523p.

General biographical dictionary of Italian sculptors and architects. Complements the author's dictionary of Italian painters. Very short entries. No bibliographies.

Bolognini Amorini, Antonio. Vite dei pittori ed artefici bolognesi. Bologna, Tip. Governativi alla Volpe, 1848. 5v. illus.

Collection of lives of major Bolognese artists and architects; intended as an expansion of the work by Malvasia (Carlo Cesare Malvasia, Felsina pittrice; vite pittori bolognesi alla measta christianissima di Lvigi XIII . . . , Bologna, Barbieri, 1678). Lists of artists covered at the end of each volume.

Brenzoni, Raffaello. Dizionario di artisti Veneti. Florence, Olschki, 1972. 304p. LC 72-336512.

Comprehensive dictionary of artists of all periods who were active in Venice and the surrounding province of the Veneto. Entries provide an extensive vita including a discussion of the artist's major work. Each entry is provided with a thorough, chronologically arranged bibliography. Standard dictionary of Venetian artists.

Calvi, Girolamo L. Architetti, scultori e pittori che fiorirono in Milano durante il governo dei Visconti e degli Sforza. Milan, Ronchetti, 1859-1869. 3v. index. Reprint: Bologna, Forni, 1975.

Collection of biographies of major artists and architects active in Milan during the Visconti and Sforza periods. Bibliographical references and references to sources in the footnotes.

- 356 Campori, Giuseppe, ed. Gli artisti italiani e stranieri negli stati estensi . . . Modena, Camera, 1855. 537p. Reprint: Rome, Multigrafica Editrice, 1969. Comprehensive dictionary of artists working in all media and active in the former territory of the Este family. Entries are extensive; many have excerpts from archival material. Bibliographical footnotes.
- Campori, Giuseppe. Memorie biografiche degli scultori, architetti, pittori, ec. nativi di Carrara . . . Modena, Vincenzi, 1873. 466p.

 Dictionary of artists active in Carrara and the surrounding province of Massa as well as artists from elsewhere who came to Carrara to select marble for their work. Bibliography of sources, (pp. 375-430). Thoroughly indexed.
- Centofanti, L. Tanfani. Notizie di artisti tratte dai documenti pisani.
 Pisa, Spoerri, 1897. 583p. index. Reprint: Bologna, Forni, 1972.
 Comprehensive dictionary of artists in all media active in Pisa from the Middle Ages to the middle of the nineteenth century. Occasional bibliographical footnotes; frequent reference to archival material.
- Coddé, Pasquale. Memorie biografiche posté in forma di dizionario dei pittori, scultori, architetti e incisori mantovani. Mantua, 1837. 174p. index. Reprint: Bologna, Forni, 1972.

Dictionary of painters, sculptors, architects, and graphic artists born or active in Mantua from earliest times to the end of the eighteenth century. Reference is made to appendix with excerpts from original documents.

- Corna, Andrea. Dizionario della storia dell'arte in Italia con duecento illustrazioni... 2nd ed. Piacenza, Tarantola, 1930. 2v. illus.
 First published in 1919. Biographical dictionary of Italian architects, sculptors, painters, graphic artists, and applied artists.
- Fenaroli, Stefano. Dizionario degli artisti bresciani. Brescia, Tip. Editrice del Pio Istituto Pavoni, 1877. 317p. index.

 Dictionary of architects, sculptors, painters, and some applied and decorative artists active in Brescia. List of sources (pp. 263-89).
- Gubernatis, Angelo de, Conte. Dizionario degli artisti italiani viventi, pittori, scultori e architetti . . . Florence, Le Monnier, 1889. 640p. Biographical dictionary of Italian artists and architects living in 1888.
- Monteverdi, Mario. Dizionario critico Monteverdi. Pittori e scultori italiani contemporanei. Milan, Editrice Selearte Moderna, 1975. 852p. illus.

Dictionary of twentieth-century Italian artists. Brief biography is followed by a critical description of the artist's work. No bibliography.

Padovano, Ettore. Dizionario degli artisti contemporanei. Milan, Istituto Tip. Editoriale, 1951. 403p. illus. index. Dictionary of twentieth-century Italian artists and architects. Uneven coverage, no bibliography: superseded by Monteverdi (363).

Schede Vesme. L'arte in Piemonte dal XVI al XVIII sécolo. Turin, Società Piemontese di Archeologia e Belle Arte, 1963. 3v. index.

Comprehensive dictionary of artists working in all media and active in Piedmont from the sixteenth through the eighteenth century. Entries refer to, and often give excerpts from, documentary sources.

366 Valgimigli, Gian M. Dei pittori e degli artisti Faentini de'secoli XV. e XVI. 2nd ed. Faenza, Conti, 1871.

Collection of biographical sketches on individual painters, and four sculptors, active in Faenza in the fifteenth and sixteenth centuries. Life and works are discussed, with occasional bibliographic references in the footnotes. Chiefly of historical interest, the work contains neither illustrations nor index.

367 Zannandreis, Diego. Le vite dei pittori, scultori e architetti veronese . . . Verona, Franchini, 1891. 559p.

Comprehensive dictionary of artists working in all media and active in Verona. Entries emphasize documentary sources, which are summarized (pp. xxvii-xxxv).

Low Countries

Duverger, Jozef. De Brusselsche steenbikkeleren: Beeldhouwers, bouwmeesters, metselaars enz. der XIVe en XVe eeuw met een aanhangsel over Klaas Sluter en zijn Brusselsche medewerkers te Dijon. Ghent, Vyncke, 1933. 134p. index.

Dictionary of architects, sculptors, and stonemasons active in Brussels during the fourteenth and fifteenth centuries. Chapter on primary documents and on the work of Claus Sluter in Brussels. Index of names (pp. 77-130).

Immerzeel, Johannes, Jr. De levens en werken der hollandsche en vlaamsche kunstschilders, beeldhouwers, graveurs en bouwmeesters . . . Amsterdam, van Kestern, 1842-43. 3v. illus. Reprint: Amsterdam, B. M. Israël, 1974. 305p.

Dictionary of Dutch and Flemish painters, sculptors, graphic artists, and architects active between 1400 and 1840. Short biographies are usually followed by list of major works. Dictionary of monograms (pp. 265-307). No bibliographies.

370 Kramm, Christiaan. De levens en werken der Hollandsche en Vlaamsche kunstschilders, beeldhouwers, graveurs en bouwmeesters, van den vroegsten tot op onzen tijd . . . Amsterdam, Diederichs, 1857-64. 6 parts and supplement in 3v.

Biographical dictionary of Dutch and Flemish painters, sculptors, graphic artists, and architects from the earliest then known to the date of publication. The work is based on Immerzeel (369). Supplement is a separate list of additional masters.

371 Lerius, Théodore F. X. van. Biographies d'artistes anversois. Antwerp, Kockx, 1880-81. 2v. (Maatschappij der Antwerpsche Bibliophilen, uitgave, 8, 11).

Comprehensive dictionary of artists of all media active in Antwerp. Entries on major personalities contain excerpts from documents. Bibliographical footnotes.

372 Scheen, Pieter. Lexicon nederlandse beeldende Kunstenaars, 1750-1950. 's Gravenhage, Scheen, 1969-70, 2v. illus.

Biographical dictionary of Dutch painters active between 1750 and 1950. Expansion of the same author's *Honderd Jaren Nederlandsche Shilder- en Teekenkunst* 1750-1850 (The Hague, 1946). Separate bibliographies after each entry; general bibliography at end of volume 2. Supplement in volume 2. Illustrations arranged by subject.

Wurzbach, Alfred. Niederländisches Künstler Lexikon . . . Vienna, Halm, 1906-1911. 3v.

Biographical dictionary of Dutch and Flemish artists. Biographies give facsimiles of signatures, lists of major works, and separate bibliographies. Volume 3 is devoted to anonymous artists and monogrammists. Standard reference tool for artists from the Netherlands.

Portugal

- Andrade, Arsénio S. de. Dicionário histórico e biografico de artistas e technicos portugueses. Lisbon, Minerva, 1959. 278p. illus. index.
 Concise dictionary of artists and architects, critics of art, engineers, musicians, and composers in Portugal from the fourteenth century to the middle of the twentieth century. Emphasis on modern. Bibliography of basic works in Portuguese (pp. 273-76).
- Machado, Cyrillo V. Collecção de memorias relativa as vidas dos pintores, e escultores, architetos, e gravadores portuguese e dos estrangeiros, que estiverão em Portugal... Coimbra, Imprensa da Universidade, 1922. 295p. (Subsidios para a historia da arte portuguesa, 5). Reprint of first edition, Lisbon, 1823.

Biographical dictionary of Portuguese architects, sculptors, painters, and graphic artists.

Pamplona, Fernando de. Dicionário de pintores e escultores Portugueses ou que trabalharam em Portugal. Lisbon, Santo Silva, 1954-59. 4v. illus. LC 55-28095 rev.

Biographical dictionary of Portuguese painters and sculptors. Entries include facsimiles of signatures and separate bibliographies for major artists. Basic reference tool for Portuguese artists.

Raczyński, Atanazy. Dictionnaire historico artistique du Portugal, pour faire suite à l'ouvrage ayant pour titre: Les arts en Portugal, lettres adressées à la Société artistique et scientifique de Berlin et accompagnées de documens... Paris, Renouard, 1847. 306p. illus.

Biographical dictionary of artists and architects active in Portugal from the late Middle Ages through the early nineteenth century. Entries are brief but contain references to sources. Companion to the author's *Les arts en Portugal* (Paris, Renouard, 1846).

Spain

Campoy, Antonio M. Diccionario critico del Arte Español contemporaneo.
Madrid, Iberico Europea de Ediciones, 1973. 489p. illus.

Dictionary of Spanish twentieth-century architects, sculptors, painters, and graphic artists. Entries are in the form of narrative biographies. No bibliography.

379 Ceán Bermúdez, Juan A. Diccionario histórico de los más ilustres profesores de las bellas artes en España . . . Madrid, Ibarra, 1800. 6v.

Biographical dictionary of Spanish artists, architects, and applied artists. Last volume contains a supplement (pp. 55-91) and index tables by chronology, media, and geography. A standard early dictionary of Spanish artists. See Viñaza (389) for continuation and supplement.

380 Elias de Molins, Antonio. Diccionario biográfico y bibliográfico de escritores y artistas catalanes del siglo XIX. Barcelona, Administración, 1889. 2v. illus.

Comprehensive dictionary of Catalan writers and artists active during the nineteenth century. Bibliographical references are supplied for the larger entries.

Furió, Antonio. Diccionario histórico de los ilustres professores de las bellas artes en Mallorca. Palma, Mallorquina, 1946. 337p. (Biblioteca Balear, 10).

Biographical dictionary of painters, sculptors, and architects in Majorca from the thirteenth century to the nineteenth century. Introduction (pp. 13-84) is a history of art of the Balearic Islands. Occasional bibliographical references in the footnotes to the dictionary entries.

Gestoso y Pérez, José. Ensayo de un diccionario de los artifices que florecieron en Sevilla desde el siglo XIII al XVIII inclusive . . . Seville, Oficina de la Andalucia Moderna, 1899-1909. 3v. illus. index.

Biographical dictionary of artists active in Seville from the thirteenth through the eighteenth centuries. Alphabetical arrangement; facsimiles of twenty signatures in third volume.

Orellana, Marcos A. de. Biografia pictória valentina . . . 2nd ed., prepared by Xavier de Salas. Valencia, Ayuntamiento de Valencia, 1967. 654p. index. LC 76-277651.

Biographical dictionary, in chronological order, of Valencian painters, sculptors, graphic artists, and architects from the fourteenth through eighteenth centuries. Entries treat life and works, with bibliographical references in the footnotes to individual entries.

Ossorio y Bernard, Manuel. Galeria biografica de artistas espagnoles del siglo XIX. Madrid, Gaudi, 1975. 749p. illus.

Reprint of work originally published in 1883. Dictionary of some 3,000 Spanish nineteenth century painters, sculptors, and graphic artists. Illustrated with line drawings. No bibliography.

Ráfols, José F., ed. Diccionario biográfico de artistas de Cataluna desde la epoca romana hasta nuestros dias . . . Barcelona, Millá, 1951-1954. 3v. illus. index.

Comprehensive dictionary of architects and artists working in all media and active in the province of Catalonia from the Romanesque to the mid-twentieth century. No bibliography. Index of artists by media.

Ramiréz de Arellano, Rafael. Diccionario biográfico de artistas de la provincia de Córdoba. Madrid, Perales y Matinez, 1893. 535p. (Colección de documentos inéditos para la historia España . . . t. CVII).

Biographical dictionary of artists and architects active in the Spanish province of Córdoba. Alphabetical arrangement with tables indexing the entries by time and media. Appendix with documents pertaining to artists in Córdoba.

Saltillo, Miguel Lasso de la Vega, y Marqués del López de Tejada.

Artistas y artífices sorianos de los siglos XVI y XVII (1509-1699).

Madrid, Editorial Maestre, 1948. 476p. illus. index.

Biographical dictionary of artists, architects, and musicians in the Spanish province of Soria during the sixteenth and seventeenth centuries.

Stirling-Maxwell, William. Annals of the Artists of Spain . . . 2nd ed. London, Nimmo, 1891. 4v. illus. index.

Biographies of major Spanish artists, arranged in the form of a narrative history. Covers from the Romanesque to 1800. Material on anonymous figures is included in the chapters treating various sites. Bibliographical footnotes. Anecdotal in style.

Viñaza, Cipriano Muñoz, y Conde de la Manzano. Adiciones al Diccionario histórico de los más ilustres profesores de las bellas artes en España de D. Juan Agustín Ceán Bermúdez . . . Madrid, Tip. de los Huérfanos, 1889-1894. 4v. in 2.

Supplement to Ceán Bermúdez (379). Contents: t. 1, Edad media . . . ; t. 2-4, Siglos XVI, XVII y XVIII. Within the volumes, arrangement is alphabetical by name of artist. Covers artists and architects. References to sources.

Sweden

Engman, Bo, ed. Konstlexikon. Svensk konst under 100 år. 2500 konstnärer, 1500 konsttermer. Stockholm, Natur och Kultur, 1972. 379p. illus. LC 73-318300.

Comprehensive dictionary of Swedish art history, covering artists, styles, periods, and general terminology.

- 391 Svensk Konstnärs Lexikon. Malmö, Allhems, 1952-1967. 5v. illus. Comprehensive biographical dictionary of Swedish artists. Larger entries are signed and have separate bibliographies. Standard reference guide to Swedish artists.
 - Svenska konstnärer; biografisk handbok. New ed. Stockholm, Eden, 1974. 561p. illus. LC 75-410307.

Biographical dictionary of Swedish artists and architects. Bibliographical references provided for the major entries.

Switzerland

Brun, Carl. Schweizerisches Künstler Lexikon; Dictionnaire des artistes suisses. Frauenfeld, Huber, 1905-1917. 4v.

Biographical dictionary of Swiss artists of all periods and all media as well as foreign artists active in Switzerland. Articles are signed, and longer entries have separate bibliographies. Volume 4 contains a supplement. A standard reference work on Swiss artists. For the twentieth century, see Plüss (394).

394 Plüss, Eduard, and Hans C. von Tavel. Künstler Lexikon der Schweiz XX. Jahrhundert. Frauenfeld, Huber, 1958-67. 2v.

Comprehensive and scholarly dictionary of Swiss artists of the twentieth century. Thorough biographies include lists of exhibitions and works in museums, and very good separate bibliographies. Standard reference tool for modern Swiss artists.

ORIENT

- 395 Encyclopaedia of Islam, v. 1-. New ed. Leiden, Brill, 1960-. Comprehensive encyclopedia of long signed articles covering all aspects of Islamic civilization both past and present. Articles have thorough bibliographies of specialized literature. Entries cover places, persons, objects, and subjects. Of great value to the advanced student and scholar of Islamic art and architecture.
 - Hansford, Sidney Howard. A Glossary of Chinese Art and Archaeology. 2nd. rev. ed. London, China Society, 1961. 104p. illus. (China Society Sinological Series No. 4).

A general dictionary of terms pertaining to most media; particularly useful for technical terms related to ceramics, lacquer, and other minor arts. Terms are given in Chinese characters, with transliteration and English translation.

Roberts, Laurence P. A Dictionary of Japanese Artists: Painting, Sculpture, Ceramics, Prints, Lacquer. London, New York, Weatherhill, 1976. 330p. illus. LC 76-885.

Comprehensive dictionary of Japanese pictorial artists who were either born before 1900 or who died before 1972. The 3,000 entries provide biographical data, summary of the artist's career, list of major works, characterization of style, and bibliographical references to works in English and Japanese. There is an index to alternate names and an index of the artists in Kanji characters. Additional aids include: glossary of Japanese art terms; list of art organizations and institutions; chronological table of art periods of Japan, Korea, and China; and directory of Japanese provinces and prefectures. An excellent, long-awaited reference work on Japanese art.

NEW WORLD

Pre-Columbian

Muser, Carl. Facts and Artifacts of Ancient Middle America: A Glossary of Terms and Words Used in the Archaeology and Art History of Pre-Columbian Mexico and Central America. New York, Dutton, 1978. 212p. illus. LC 77-79799.

Popular but useful dictionary covering terms relating to pre-Columbian art and architecture. Covers objects, subjects, places, and styles and is illustrated with drawings and a few plates. Good maps that show locations of ancient sites, chronological tables, and bibliography, by Allan Chapman (pp. 207-212) provides an annotated list of basic works in English.

Latin America

- 399 Cavalcanti, Carlos, ed. **Dicionário Brasileiro de artistas plásticos**. v. 1—. Brasilia, Ministerio da Educação e Cultura, 1973—. LC 74-219639. Comprehensive dictionary of Brasilian painters, sculptors, and graphic artists, with emphasis on modern. Numerous illustrations but no bibliography.
- 400 Enciclopedia de arte en América. Buenos Aires, Bibliographica OMEBA, 1969. 5v. illus. LC 72-236036.

General encyclopedia of Latin American art and architecture, edited by Vicente Gesauldo. Volumes 1 and 2 provide a general history of Latin American art and architecture. Volumes 3 to 5 comprise a biographical dictionary of Latin American artists. Brief bibliographies given at the end of the major entries. A standard but popular encyclopedia of Latin American art and architecture.

Merlino, Adrián. Diccionario de artistas plasticos de la Argentina, siglos XVIII-XIX-XX. Buenos Aires, 1954. 433p. illus.

Biographical dictionary of artists in Argentina, covering the period from the beginning of the eighteenth to the middle of the twentieth centuries. Each entry gives basic biographical data, list of prizes and exhibitions, and a list of museums owning the artist's work. Provides a general bibliography (pp. 408-414).

Ortega Ricaurte, Carmen. Diccionario de artistas en Colombia. Bogota, n.p., 1965. 448p. illus. index. LC 66-56385.

Biographical dictionary of painters, sculptors, graphic artists, architects, caricaturists.

Biographical dictionary of painters, sculptors, graphic artists, architects, caricaturists, ceramicists, and metalsmiths of Colombia to the present. Entries give outline of artist's life, works, and bibliographic citations.

Pontual, Roberto. Dicionário das artes plasticas no Brasil. Rio de Janeiro, Civilização Brasileira, 1969. 559p. illus. LC 76-464169. General biographical dictionary of Brazilian artists. Most entries are short and have abbreviated bibliographies. Illustrations are given for the most important artists. Basic reference tool for Brazilian art.

Vargas, Ugarte R. Ensayo de un diccionario de artifices coloniales de la America meridional. Lima, Baiocco, 1947. 391p. index. Apendice. Lima, Baiocco, 1955. 118p.

Biographical dictionary of Latin American artists arranged by centuries. No

bibliography.

United States and Canada

Britannica Encyclopedia of American Art. Chicago, Encyclopaedia Britannica Educational Corp., 1973; distr. New York, Simon and Schuster. 669p. illus. LC 73-6527.

Dictionary covering architecture and all the arts in America from pre-Colonial times to the present. Respected specialists prepared the articles, which are signed. Numerous color and black and white illustrations. A list of entries according to the various arts (pp. 622-27), is an effective index by media. Contains a guide to major American museums and collections, a four-page glossary of terms, and a two-part bibliography (pp. 638-68): part I, a good general classified bibliography of American arts; and part II, a bibliography according to entries in the main body of the work. A sound reference tool in the field of American art.

- Cederholm, Theresa D., ed. Afro-American Artists: A Bio-Bibliographical Directory. Boston, Boston Public Library, 1973. 348p. LC 73-84951.
 Biographical dictionary of some 2,000 Afro-American artists. Gives basic biographical data, education, exhibition awards, and bibliographical references. A very useful tool for an otherwise neglected area of art biography.
- 407 Creative Canada: A Biographical Dictionary of Twentieth-Century Creative and Performing Artists, v. 1—. Toronto and Buffalo, University of Toronto Press, 1971—.

Biographical dictionary of performing and visual artists in Canada in the twentieth century. Does not include architects and designers. Each volume covers about 500 visual artists, chiefly painters and sculptors. Uneven coverage.

408 Cummings, Paul. Dictionary of Contemporary American Artists. 3rd ed. New York, St. Martin's, 1977. 545p. illus.

Biographical dictionary of short entries. In addition to basic biographical data, it tells where the artist taught, his one-man and group shows, and the collections owning works. Good general bibliography (pp. 315-31). The best reference tool for prominent modern American artists.

Dawdy, Doris O. Artists of the American West: A Biographical Dictionary. Chicago, Swallow Press, 1974, 275p. LC 72-91919.

Dictionary of 1,300 pictorial artists born before 1900 who depicted subjects or scenes from the West (the sixteen states roughly west of the 95th meridian). Most entries are very brief, but 300 artists have been selected—somewhat arbitrarily—for longer narrative description of their careers. Bibliographical references are made to a very basic list of books; only an occasional monograph is noted.

Fielding, Mantle. Dictionary of American Painters, Sculptors and Engravers . . . Enl. ed., Green Farms, Conn., Modern Books and Crafts, 1975. 455p.

Reprint of 1926 edition with addendum containing corrections and additional material. Short biographies of approximately 10,500 American artists. Bibliography.

Groce, George C., and David H. Wallace. The New York Historical Society's Dictionary of Artists in America, 1564-1860. New Haven, Yale University Press, 1957. 759p.

Biographical dictionary of approximately 10,000 artists (professional and amateur, native or foreign-born) active in the present continental limits of the United States between 1564 and 1860. Key to sources (pp. 713-59). Standard reference guide to early American artists.

Macdonald, Colin. A Dictionary of Canadian Artists. v. 1—. Ottawa, Canadian Paperbacks, 1967—. LC 67-8044.

Comprehensive dictionary of Canadian artists and architects. Concise biographies give list of major works and reference to specialized literature.

Mallett, Daniel T. Mallett's Index of Artists: International and Biographical... New York, Bowker, 1935. 493p. Supplement. 1940. 319p. (Reprint: New York, Smith, 1948, 2v.; Bath, England, 1976, Supplement, 1977).

Index to biographical information on painters, sculptors, and graphic artists in 24 standard reference books and 957 additional sources. Entries give nationality, birth and death dates, medium, residence (if artist was then living), and reference to sources for further information. Supplement concentrates on contemporary artists. Useful index for the general reader seeking further information on major artists and lesser-known American artists of the first half of the present century. Inaccuracies severely limit its value as a source for biographical data.

Samuels, Peggy, and Harold Samuels. The Illustrated Biographical Encyclopedia of Artists of the American West. Garden City, N.Y., Doubleday, 1976. 580p. illus. LC 76-2816.

Dictionary of artists of all nationalities who depicted subjects and scenes of the West, both in the United States and Canada. The 1,700 entries provide basic biographical data, brief sketch of the artist's career, and his relationship to the West. Bibliographical references are given to a list of basic books, and note is made of recent auction records. More complete and accurate than Dawdy (409).

Schwab, Arnold T. A Matter of Life and Death: Vital Facts About Selected American Artists. New York, Garland, 1977. 64p. LC 76-52694. (Garland Reference Library of the Humanities, v. 90).

About 580 artists active in the United States in the twentieth century are listed in tabular form, together with basic biographical data. Most of those included appear to be associated with the MacDowell Colony or mentioned by James Gibbon Huneker.

416 Smith, Ralph C. A Biographical Index of American Artists... Baltimore, Williams & Wilkins, 1930. 102p. Reprint: Detroit, Gale, 1976. LC 79-167186.

Alphabetical index of about 4,700 American artists giving basic biographical data and reference to a collection (listed on p. ix) of basic reference works. Useful for lesser-known American artists established before 1929.

Young, William, ed. A Dictionary of American Artists, Sculptors and Engravers from the Beginnings to the Turn of the Twentieth Century. Cambridge, Mass., Young, 1968. 515p. illus. LC 68-37333.

Short biographical entries covering native-born painters, sculptors, and graphic artists. Does not provide information concerning the artist's training. No bibliography.

AFRICA

418 **Dictionnaire des civilisations africaines.** Paris, Hazan, 1968. 448p. illus. General dictionary covering all aspects of sub-Saharan African civilization, including useful articles on places, media, objects, and subjects of importance to the study of African art. Thoroughly illustrated with plates of African art. No bibliography.

AUSTRALIA

McCulloch, Alan. Encyclopedia of Australian Art. New York, Praeger, 1969. 668p. illus. LC 69-17079.

One-volume encyclopedia of Australian art from 1770 to the present. Covers all aspects including biography. The majority of entries give separate bibliographies.

CHAPTER SIX ICONOGRAPHY

INTRODUCTION

Questions concerning the subject matter depicted in the fine arts pose special problems for the student and the reference librarian. The general reader and beginning student are often looking for an accurate identification and succinct explanation of a theme or subject encountered in a painting or sculpture. The advanced student, particularly in medieval and ancient art, frequently also needs information about the literary sources for the subject and its significance and place in the historical development of iconography. Until fairly recently, this need for iconographical information was poorly met by reference works, and in many areas, it is still inadequately served. Christian iconography, the most complex and the most intensely studied field of iconography, has seen the appearance of two major reference tools in the last ten years: G. Schiller's Handbook of Christian Iconography (465) and the Reallexikon der christlichen Ikonographie, produced under the editorship of the late Engelbert Kirschbaum (455). Both are products of German scholarship. The former is being translated into English, and the latter is not only well organized but also equipped with a polyglot index so that it is accessible to anyone with a modest knowledge of German. These two works should finally retire to the antiquarian shelves two old standards: Anna B. Jameson's The History of Our Lord as Exemplified in Works of Art ..., (450) and Adolphe N. Didron's Christian Iconography (444).

The field of classical iconography has been well served by comprehensive dictionaries and encyclopedias on classical civilization. Some recent works, like Hunger's dictionary (356), have condensed the subject into even more accessible form. Non-Western iconography—especially the subject matter of Chinese and Japanese art, which has become increasingly popular in recent years—is most inadequately served by reference tools. Here it is necessary to fall back on general dictionaries of Asiatic mythology, which are included in this section in order to avoid the shortcomings of the few dilettante specialized works that do exist. Mention should be made of the Bibliographie zur Symbolkunde (421), a work being compiled under the editorship of Manfred Lurker. An annual bibliography of books and periodical articles on all aspects of symbolism, including iconography, its annotations were written by major scholars from around the world, so it is a reference tool of great value to any serious study of iconography.

Included in this section are reference works—i.e., bibliographies, encyclopedias, dictionaries, and handbooks. Studies and histories of special subjects are not

included.

BIBLIOGRAPHIES

419a Iconclass, an Iconographic Classification System, devised by H. van de Waal, completed and edited by L. D. Couprie with R. H. Fuchs and E. Tholen. Amsterdam, North-Holland Publishing Co. for the Royal Netherlands Academy of Arts and Sciences, 1973—.

A system of classification of works of art by subject matter with accompanying bibliographies. Seventeen volumes are planned: seven volumes for the system, seven for the bibliographies, and three volumes of indexes. To date, four classification volumes and four bibliography volumes have appeared. These cover subjects pertaining to nature and man. The bibliographies cover both books and periodical articles in all Western languages. The classification is of interest to slide librarians and others compiling lists of works of art by subject. The bibliographies will be very valuable to all advanced students and scholars interested in iconography.

420 Lurker, Manfred, ed. Bibliographie zur Symbolik, Ikonographie und Mythologie, Jahrg. 1—. Baden-Baden, Heitz, 1968—.

Classified and annotated bibliography of books and periodical articles on all aspects of symbolism, iconography, and mythology, including their manifestation in the visual arts. Each entry has a descriptive annotation in the language of the entry.

421 Lurker, Manfred. Bibliographie zur Symbolkunde. Baden-Baden, Heitz, 1964-1968. 3v. (Bibliotheca Bibliographica Aureliana, XII-XIV). index. LC 67-100109.

Classified and annotated retrospective bibliography of books and periodical articles on all aspects of symbolism, including the representation of symbols and subjects in the fine arts of all periods, nations, and cultures. Literature published since 1964 is indexed in the same author's annual bibliography on symbolism (420). Standard reference tool for all serious students and scholars of iconography. A work of amazing scope, containing more than 11,000 entries. Indexes by subject and author.

422 Pöschl, Viktor. Bibliographie zur Antiken Bildersprache. Heidelberg, C. Winter, 1964. 674p. (Heidelberger Akademie der Wissenschaften, Bibliothek der klassischen Altertumswissenschaften, N.F. 1. Reihe). LC 66-55568.

Classified bibliography of special studies of imagery in classical literature. Part I lists the studies by author; part II is an index to the first part arranged according to imagery of themes. This will be of direct value to classicists and art historians who wish to find the literary sources for images that are common in classical art.

Warburg Institute. A Bibliography of the Survival of the Classics. London, Cassell, 1934-38. 2v.

Classified and descriptively annotated bibliography of books dealing with all aspects of the survival of the classics in European civilization after antiquity. Continues Richard Newald's bibliography, "Nachleben der Antike," in *Jahresbericht über die Fortschritte der klassischen Altertumswissenschaft* 232 (1931) and 250 (1935). Valuable bibliography for the specialist.

GENERAL DICTIONARIES

Bernen, Satia, and Robert Bernen. Myth and Religion in European Painting 1270-1700: The Stories As the Artists Knew Them. New York,
 Braziller, 1973. 280p. illus. LC 72-96070.

Dictionary of short entries covering religious subject matter in European painting. A popular dictionary with very brief bibliography of sources and no reference to special iconographic literature.

Cirlot, Juan E. A Dictionary of Symbols. New York, Philosophical Library, 1962. 400p. illus. LC A63-289.

General dictionary of sacred and profane symbols. Does not include narrative subjects. Bibliographical references are made to a list of 61 reference books. A popular work for the general reader and beginning student.

Cooper, J. C. An Illustrated Encyclopedia of Traditional Symbols.
London, Thames and Hudson, 1978. 207p. illus. LC 78-55429.

General dictionary of world symbolism in the visual arts. Entries give the meaning of common symbols in the various cultures. No reference to sources or specialized bibliography. Glossary of terms and bibliography (pp. 203-207) listing books in all languages.

Daniel, Howard. Encyclopedia of Themes and Subjects in Painting. New York, Abrams, 1971. 252p. illus. LC 74-153493.

Dictionary of short entries covering all aspects of subject matter in Western painting. A well-illustrated, popular iconographic dictionary. Of limited usefulness to advanced students because it lacks bibliography and specific reference to literary sources.

- Droulers, Eugene, pseud. Seyn, Eugéne. Dictionnaire des attributs, allégories, emblèmes, et symboles. Turnhout, Brepols, (1948). 281p. illus. Dictionary of symbols, including symbolic objects and personages, in a single alphabetical listing. Brief definitions with no references to sources. However, a chronological list of sources and works of scholarship on symbolism is provided (pp. 276-81). Illustrated with engravings and line drawings.
- 4 '9 Errera, Isabelle. **Répertoire abrégé d'iconographie...** Wetteren, de Meester, 1929-1938. 3v.

Completed only through letter "C." Attempts to provide a dictionary of Christian, classical, and profane iconography in Western art. Entries give brief definition together with list of major works of art in which symbol of the personage is depicted. Bibliography (pp. ix-xxiv) lists basic books in all languages.

430 Hall, James. Dictionary of Subjects and Symbols in Art. New York, Harper & Row, 1974. 345p. illus. LC 74-186426.

Comprehensive dictionary of sacred and profane iconography of Western art. Treated in a single alphabetical list are: signs, attributes, symbols, narrative subjects, and allegories. Major literary sources are both referred to in the entries

and listed (pp. xix-xxiv). Only occasional reference to actual works of art. The best modern single-volume dictionary of iconography in English.

Henkel, Arthur, and Albrecht Schöne. Emblemata: Handbuch zur Sinnbildkunst des XVI. und XVII. Jahrhunderts. 2nd ed. Stuttgart, Metzler, 1976. 2196 cols. illus.

Comprehensive dictionary of sixteenth and seventeenth century emblems and their meanings. Classified by groups, illustrated with facsimiles of engraved emblems. There is a list of the emblem books used and an excellent bibliography. The standard scholarly reference work on emblems. First edition (1967) has been updated to equal second edition by a supplement volume (1976), which contains a much enlarged bibliography.

Jobes, Gertrude. Dictionary of Mythology, Folklore and Symbols. New York, Scarecrow, 1962. 3v. index. LC 61-860.

Short definitions of a comprehensive range of symbolic figures, objects, and concepts. Third volume is an index in two parts. Part A is a tabular index of deities, heroes, and personalities; part B is a tabular index of mythological affiliations, supernatural forms, values, and objects. A long but unclassified and unannotated bibliography at the end of volume 2 (pp. 1736-59).

433 Koch, Willi A. Musisches Lexikon: Künstler, Kunstwerke und Motive aus Dichtung, Musik und bildender Kunst. 2nd ed. Stuttgart, Kröner, 1964. 1250p. illus. index. LC 65-69991.

Dictionary of music, literature, and the fine arts, covering biography and works of literature, music, and art, as well as the subjects depicted in the three arts. Most useful for tracing parallel treatments of some major subjects in literature, music, and the fine arts.

Pigler, Andor. Barockthemen, eine Auswahl von Verzeichnissen zur Ikonographie des 17. und 18. Jahrhunderts. 2nd ed. Budapest, Akadémiai Kiadó, 3v. illus. index.

A classified list of subjects, both secular and religious, depicted in seventeenthand eighteenth-century art. Volume one lists religious subjects; volume two, secular subjects. Useful for tracing and comparing baroque iconography.

Ronchetti, Giuseppe. Dizionario illustrato dei simboli, emblemi, attributi, allegorie, immagini degli dei ecc. Milan, Hoepli, 1922. 1009p. illus. Comprehensive dictionary of signs, emblems, attributes, and symbols in all aspects of iconography. Although individuals are included as simple symbols, narrative subjects are not covered. Illustrated with line drawings. Unfortunately, no bibliography or references to sources.

Todd, Alden, and Dorothy Weisbord. Favorite Subjects of Western Art. New York, Dutton, 1969. 224p. illus. LC 68-55032.

Short-entry dictionary of secular and religious subjects commonly depicted in Western art. This popular work is of little use to the advanced student, since it lacks reference to literary sources and to further literature.

- Waters, Clara (Erskine) Clement. A Handbook of Legendary and Mythological Art... Boston and New York, Houghton, Mifflin, 1892. 23rd ed. 575p. illus. index. Reprint: Detroit, Gale, 1969. LC 68-26616.
 First published in 1871. Popular handbook of classical and Christian iconography. Contents: Symbolism in Art; Legends and stories illustrated in art; Legends of Place; Ancient Myths which have been Illustrated in Art. Appendix with supplementary material and list of paintings mentioned in the text.
- Whittlesey, E. S. Symbols and Legends in Western Art: A Museum Guide. New York, Scribner's, 1972. 367p. illus. LC 71-162764.

 Dictionary of short entries covering religious and non-religious subject matter in Western art. Reference is made to works of art in collections in the United States. An inadequate one-page bibliography limits its usefulness to advanced students.

CHRISTIAN ICONOGRAPHY

GENERAL WORKS

439 Aurenhammer, Hans. Lexikon der christlichen Ikonographie. v. 1–. Vienna, Hollinek, 1959–.

Comprehensive dictionary of Christian iconography, arranged alphabetically by subject; to date, it has reached the entry "Christus und die vierundzwanzig Ältesten." Each entry gives a thorough description of the subject, discussion of the literary sources, a sketch of the development of the subject, and a thorough bibliography of specialized literature. No illustrations. A valuable, scholarly dictionary of Christian iconography. Unfortunately, it is progressing very slowly. For the advanced student and scholar.

- Barbier de Montault, Xavier. Traité d'iconographie chrétienne . . . Paris, Vivès, 1890. 2v. illus. index.
- General handbook of Christian iconography. Contents: I, Les anges et les démons; II, Dieu; III, L'ancien testament; IV, Le monde païen; V, Le Christ; VI, La Sainte vierge; VII, Les apôtres; VIII, Les evangélistes et les docteurs; IX, Les saints; X, Les erreurs contre la foi catholique. No bibliography. Illustrated with line drawings by Henri Nodet.
- Champeaux, Gérard de. Introduction au monde des symboles. Paris, Zodaique, 1966. 470p. illus. (Introductions à la nuit des temps, 3). General handbook of broad aspects of Christian iconography common in early medieval art. Contents: 1, Le ciel; 2, Figures simples; 3, Temple et cosmos; 4, L'ascension et les hauteurs; 5, L'homme; 6, L'arbre; 7, Le tetramorphie. Bibliographical footnotes.
- Child, Heather, and Dorothy Colles. Christian Symbols, Ancient and Modern: A Handbook for Students. New York, Scribner's, 1972. 270p. illus. index. LC 72-2769.

Popular handbook of Christian iconography. Subjects are arranged in broad categories, such as the cross, trinity, images of Christ, etc. Bibliography (pp. 256-259) is an inadequate list of very general and many obsolete works.

Detzel, Heinrich. Christliche Ikonographie. Freiburg im Breisgau, Herder, 1894-96. 2v. illus. index.

Comprehensive handbook of Christian iconography. First volume covers the iconography of God, trinity, Mary, good and evil, the life of Christ, death of Mary, and the Last Judgment. Second volume is devoted to the iconography of the saints. Bibliographical footnotes.

Didron, Adolphe N. Christian Iconography; or, the History of Christian Art in the Middle Ages... London, Bell, 1886. 2v. illus. index. Reprint: New York, Ungar, 1963. LC 65-23577.

Contents: Part I: Nimbus or Glory; II, History of God; III, Trinity, Angels, Devils, Death, The Soul, The Christian Scheme. Appendix has useful translation of the late Byzantine *Guide to Painting* and the text of the *Biblia pauperum*. First published in 1845 as *Manuel d'iconographie chrétienne*, grecque et latine.

Doering, Oskar. Christliche Symbole. 2nd ed. Freiburg im Breisgau, Herder. 1940. 147p. illus. index.

Pocket-size handbook of Christian iconography covering symbolism of the trinity, heaven, the cross, Mary, angels, evangelist, the church, the mass, seven sacraments, virtues and vices, the Last Judgment, the devil, numbers, colors, flowers, the liberal arts, the elements, time. Bibliographical footnotes.

446 Ferguson, George W. Signs and Symbols in Christian Art, with Illustrations from Paintings of the Renaissance. New York, Oxford University Press, 1954, 346p, illus, index.

Handbook of Christian symbols and subjects in classified arrangement. Illustrations of works of Renaissance painting in American museums. Popular work with no bibliography and few references to specific literary sources.

Forstner, Dorothea. Die Welt der Symbole. 3rd ed. Innsbruck, Vienna, and Munich, Tyrolia, 1977. 456p. illus. index.

Handbook of Christian symbolism in the fine arts. Subjects are arranged in broad classes and the entries refer to literary and biblical sources as well as to specialized iconographical literature. General bibliography. Indexed by subject. An excellent one-volume handbook of Christian symbols. More useful for information on small subjects and symbols than for its complicated biblical narratives.

Goldsmith, Elizabeth E. Sacred Symbols in Art. 2nd ed. New York, London, Putnam, 1912. 296p. illus. index.

Popular handbook of Christian iconography based on the works of Jameson (450), Didron (444), and with additional material from the *Golden Legends*. Chapters cover: emblems of the saints, color and number symbolism, trinity, angels and archangels, Virgin Mary, St. John the Baptist, the four evangelists, apostles, the Last Supper, Mary Magdalen, Latin fathers, patron saints, legends of the saints, and the monastic orders.

Hulme, Frederick E. The History, Principles and Practice of Symbolism in Christian Art. 6th ed. New York, Macmillan, 1910. 234p. illus. index. (The Antiquarian Library, 2).

First published in 1891. Contents: Introduction; II, Number and Color Symbolism; III, The Trinity; IV, Sacred Monograms and Other Attributes of God; V, The Cross; VI, Soul of Man. Reference to literary sources in text and footnotes.

Jameson, Anna Brownell (Murphy). The History of Our Lord as Exemplified in Works of Art... 4th ed. London, Longmans, Green, 1881. 2v. illus. index.

Older, popular handbook of the iconography of the life of Christ and the principal Old and New Testament types. Volume one covers Old Testament figures, the childhood and ministry of Christ; volume two, the Passion and the Last Judgment. Inadequate bibliography and reference to sources. Superseded by first three volumes of Schiller (465).

Jameson, Anna Brownell (Murphy). Legends of the Madonna As Represented in the Fine Arts... Cor. and enl. ed. Boston, Houghton Mifflin, 1891. 483p. illus. index.

First published in 1848. Forms third series to her Sacred and Legendary Art (453). Popular handbook of the iconography of the Virgin Mary. Contents: Introduction, Virgin without the Child, Virgin with the Child, Symbols and Attributes of the Virgin, Life of the Virgin. Illustrated with line drawings. Inadequate bibliography and reference to sources.

Jameson, Anna Brownell (Murphy). Legends of the Monastic Orders as Represented in the Fine Arts... 6th ed. London, Longmans, Green, 1880. 461p. illus. index.

First published in 1850. Forms second series to her Sacred and Legendary Art (453). Chapters devoted to the various religious orders of Western Christendom, describing the history, habits, attributes, chief churches, and legends of the various saints associated with each order. Includes the Jesuits. As with all the works of Mrs. Jameson, inadequate references to literary sources.

Jameson, Anna Brownell (Murphy). Sacred and Legendary Art...
Edited with Additional Notes by Estelle M. Hurll... Boston, New York,
Houghton Mifflin, 1896. 2v. illus. index. Reprint: New York, AMS Press,
1970. LC 71-12594.

First published in 1848. Popular handbook of the iconography of Christian saints and other holy personages. First volume covers angels, archangels, apostles, doctors of the church, the three Marys, Lazarus, Maximin, Marcella, Mary of Egypt, and the Holy Penitents. Second volume covers patron saints, virgin patronesses, martyrs, bishops, and hermits. As with all work by Mrs. Jameson, inadequate attention was paid to accurately documenting the information and ideas.

Keller, Hiltgart I. Reclams Lexikon der heiligen und der biblischen Gestalten. Stuttgart, Reclam, 1968. 571p. illus. LC 76-393012. Dictionary of short entries covering Christian subject matter, with special emphasis on the iconography of the saints. A good one-volume dictionary-handbook of Christian iconography. Its valuable appendixes include attributes of the saints, glossary of terms dealing with costume, a calendar of saints' days, and a good representative bibliography.

- Kirschbaum, Engelbert, ed. Lexikon der christlichen Ikonographie.
 Freiburg im Breisgau, Herder, 1968-76. 8v. illus. index. LC 71-386111.
 Comprehensive encyclopedia covering all aspects of Christian iconography. Signed entries, arranged alphabetically, range in size from short entries on simple symbols to lengthy and exhaustive articles on major subjects. All entries give a list of literary sources, description of the subject, history of the representation in Christian art, and a thorough bibliography listing special iconographical literature. Volume four gives a list of entries for the entire work in English and French with the German equivalents. Volumes 5 through 8 comprise a comprehensive dictionary of iconography of Christian saints. This is now the standard work on Christian iconography.
- Knipping, John B. Iconography of the Counter Reformation in the Netherlands. Nieuwkoop, de Graaf, 1974. 2v. illus. index. LC 73-85234. Comprehensive, scholarly study of the effect of the Counter Reformation on the iconography of art in the Catholic Netherlands. Expanded translation of *De iconographie van de contra-reformatie in de Nederlanden*... (Hilversum, Brand, 1939-1940). Contents: I, Netherlands and the Counter Reformation; II, Humanism and the Counter Reformation; The New Ascetism; IV, New Devotions; V, The Bible; VI, The Saint in Cult and Culture; VII, Christian Love as Life; VIII, The Militant Church; IX, Form and Content; X, The Great Stream of Tradition. Comprehensive list of books and periodical articles in all languages (pp. 497-503).
- Künstle, Karl. Ikonographie der christlichen Kunst... Freiburg im Greisgau, Herder, 1926-1928. 2v. illus. index.

A comprehensive handbook of Christian iconography. Volume two covers the iconography of the saints in dictionary form; all other Christian subjects are covered in volume 1, where they are arranged in classes. Each chapter has a separate bibliography with many references to specific literature. A standard handbook on Christian iconography, although it is somewhat out-of-date in certain areas.

Lipffert, Klementine. Symbol-Fibel: Eine Hilfe zum Betrachten und Deuten mittelalterlicher Bildwerke. 4th ed. Kassel, Stauda, 1964. 159p. illus. index. LC 65-106537.

Handbook of Christian symbolism arranged by classes (i.e., animals, plants, colors, persons, inanimate objects, initials). Bibliography (pp. 158-60). Useful for quick reference on simple Christian symbols.

459 Lurker, Manfred. Wörterbuch biblischer Bilder und Symbole. Munich, Kösel, 1973. 434p. index.

Dictionary of biblical subjects and symbols. The thorough entries discuss the meaning of the subject with references to scriptural passages. Very useful bibliographies citing specialized literature follow each entry. General bibliography (pp. 386-91). Provides a comprehensive index of meanings and scriptural passages. A valuable tool for anyone seeking the meaning of biblical subjects found in the fine arts.

460 Molsdorf, Wilhelm. Christliche Symbolik der mittelalterlichen Kunst. 2nd ed. rev. and enl. Leipzig, Hiersemann, 1926; repr. Graz, Akademischen Druck-und Verlagsanstalt, 1969. 284p. illus. index. LC 73-390272. Handbook of Christian subject matter found in medieval art, arranged by classes. Entries have reference to further illustrations and to specific literature. Still a useful one-volume handbook to Christian iconography. Well indexed.

461 Réau, Louis. Iconographie de l'art chrétien . . . Paris, Presses Universitaires de France, 1955-59. 3v. in 6. illus. Reprint: Nendeln, Kraus, 1974.

Comprehensive handbook of Christian iconography covering both Eastern and Western traditions. Arranged by classes. Volume one gives a general introduction; volume two covers biblical subjects; volume three, the iconography of the saints. A general bibliography is given (pp. 21-26 in volume one), and separate bibliographies follow each chapter. A particularly useful feature is the list of examples at the end of each chapter or class of subject. A standard handbook; Schiller (465) and Kirschbaum (455) are now more thorough.

Rohault de Fleury, Charles. L'évangile; études iconographiques et archéologiques . . . Tours, Mame, 1874. 2v. illus. index.

Guide to the iconography of the life of Christ, arranged according to the texts of the Gospels. Major passages of scripture are followed by section on iconography and archaeology that discusses the visualization of the text in art and the physical evidence associated with the original event. Bibliographical footnotes; illustrated

with engravings.

Rohault de Fleury, Charles. La messe: études archéologiques sur ses monuments continuées par son fils . . . Paris, Morel, 1883-1889. 8v. illus.

Iconographical and archaeological history of the Mass from Early Christian times to the end of the Middle Ages. Illustrated with line drawings. Occasional bibliographical footnotes. Still an important work in a neglected area of Christian iconography.

Sachs, Hannelore, Ernst Badstübner and Helga Neumann. Christliche Ikonographie im Stichworten. Leipzig, Koehler und Amelang, 1973. 371p. illus.

Comprehensive dictionary covering all aspects of Christian iconography from broad narrative subjects to simple symbols.

Schiller, Gertrud. Ikonographie der christlichen Kunst. v. 1—.
 Gutersloh, Mohn, 1966—. English translation: Iconography of Christian
 Art. v. 1—. Greenwich, Conn., New York Graphic Society, 1969—.
 illus. index. LC 76-132965.

A comprehensive handbook of Christian iconography, arranged by broad categories. Volume one covers the subjects related to the childhood of Christ; volume two, His Passion; volume three, His Resurrection and Ascension. Volume four, part one (1976), covers the symbolism of the church, Pentecost, and the Catechism. A very thorough and scholarly treatment of Christian iconography. If completed and translated, it would provide the best coverage available in English. Very well illustrated. Each volume has a good selected bibliography that partly compensates for the lack of separate bibliographies after the major sections. The only index at present is to scriptural passages. Presumably,

the final volume will have a subject index that will greatly increase the work's usefulness.

466 Sill, Gertrude G. A Handbook of Symbols in Christian Art. New York, MacMillan, 1975. 241p. illus. index. LC 75-26557.

Popular handbook covering signs, symbols, narrative subjects, and allegories of Christian art. Arrangement is not strictly alphabetical; instead, subjects are grouped under broad categories like angels, beasts, initials, etc. Except for occasional scriptural quotes, literary sources are not given. No references to specialized literature. Inadequate one-page bibliography of popular works in English.

- Urech, Édouard. Dictionnaire des symbols chrétiens. Neuchâtel, Delachaux & Nestlé, 1972. 192p. illus. LC 72-368448.
 Concise dictionary of Christian symbols. Bibliographical references are to a list of basic works (p. 187).
- Webber, Frederick R. Church Symbolism; An Explanation of the More Important Symbols of the Old and New Testament, the Primitive, the Mediaeval and the Modern Church . . . 2nd ed. rev. Cleveland, Jansen, 1938. 413p. illus. index. Reprint: Detroit, Gale, 1971.
 First published in 1927. Popular handbook of Christian iconography covering: Old Testament figures, trinity, sacred monogram, cross, nimbus, and emblems of the saints. Does not cover narrative subjects. No bibliography.
- Timmers, J. J. M. Symboliek en Iconographie der Christelijke Kunst...
 Roermond-Maaseik, Romen & Zonen, 1947. 1125p. illus. index.
 Comprehensive handbook of Christian iconography. Subjects are arranged in broad classes similar to Künstle (457). Bibliography (pp. 1015-30). Indexed by subjects, people, and places. Excellent Dutch handbook of iconography, with a good, concise history of Christian symbolism as an introduction.

See also: Mâle (901, 902, 988), Weisbach (1000).

DICTIONARIES OF SAINTS

Braun, Joseph. Tracht und Attribute der Heiligen in der deutschen Kunst. Stuttgart, Metzler, 1943; repr. Stuttgart, Druckenmüller, 1964. 854p. illus. index. LC 65-16573.

Dictionary of the saints found in German art. First part lists the saints alphabetically; each entry gives a short life of the saint and a thorough description of how the saint is represented in art, with reference to and occasional illustrations of works of German art. Excellent references to literary sources and specific iconographical literature. Second part deals with the costume and attributes of the saints. One of the finest iconographical dictionaries of the saints.

Cahier, Charles. Caractéristiques des saints dans l'art populaire enumerées et expliquées . . . Paris, Poussielgue, 1867. 2v. illus. index. Older, comprehensive dictionary of the saints and their attributes. Arrangement is alphabetical, with saints, their attributes, and their symbols listed together.

Entries under each saint's name give quite thorough descriptions of the chief legends. Bibliographical footnotes.

- Drake, Maurice, and Wilfred Drake. Saints and Their Emblems . . . London, Laurie, 1916; repr. New York, Franklin, 1971. 235p. illus. General dictionary of saints and their attributes. Part one is a dictionary of saints, with brief biographies; part two is a list of their attributes; part three lists and describes other religious personages. An excellent general dictionary of the saints.
 - Guénebault, Louis J. Dictionnaire iconographique des figures, légendes et actes des saints, tant de l'ancienne que de la nouvelle loi, et répertoire alphabétique des attributs . . . Paris, Chez l'Éditeur, 1850. 1232 columns. (Encyclopédie théologique, tome 45).

Early dictionary of saints and their attributes. First part is an alphabetically arranged dictionary of the lives of the saints; second part is a dictionary of saints' attributes. Bibliographical references to list of sources (cols. 1070-1220).

Holweck, Frederick G. A Biographical Dictionary of the Saints, with a General Introduction on Hagiology . . . St. Louis, Herder, 1924.
 1053p. Reprint: Detroit, Gale, 1969. LC 68-30625.
 Comprehensive dictionary of the saints, with occasional reference to their

Comprehensive dictionary of the saints, with occasional reference to their attributes.

- Husenbeth, Frederick C. Emblems of Saints: By Which They Are
 Distinguished in Works of Art... 3rd ed. Norwich, Norfolk and Norwich Archaeological Society, 1882. 426p. illus. index.

 Divided into two parts. First lists saints and their emblems together with sources, i.e., usually works of art depicting the saint. In the second part, emblems are listed first. Also includes patron saints of various trades and professions, countries and cities. Appendix discusses the iconography of the sibyls and sacred heraldry.
- Kaftal, George. Iconography of the Saints in Central and South Italian Painting. Florence, Sansoni, 1965. illus. index. LC 67-42343. Specialized dictionary of saints found in Central and South Italian painting of the fourteenth and fifteenth centuries. Follows the plan of the author's dictionary of Tuscan saints (477). Scholarly reference tool for the specialist.
- Kaftal, George. Iconography of the Saints in Tuscan Painting. Florence, Sansoni, 1952. 1274p. illus. index. LC A53-2358.

 Specialized dictionary of saints found in Tuscan painting of the fourteenth and fifteenth centuries. Each entry gives short life and a description of how the saint is represented, with reference to specific works of Tuscan painting, literary sources, and special bibliography. Thoroughly indexed by attribute, painters, place, and saints. A scholarly dictionary of amazing thoroughness. A basic reference tool for the study of Italian painting.

- Menzies, Lucy. The Saints in Italy: A Book of Reference to the Saints in Italian Art and Decoration . . . London, Medici Society, 1924. 496p. Dictionary of saints found in Italian art. Entries give dates, short life, and description of how the saint is represented in art. List of attributes and description of the habits of the monastic orders (pp. 465-96). This popular dictionary is still useful for quick reference, but it lacks sources and bibliography as well as reference to specific works of art.
 - 479 Ricci, Elisa. Mille santi nell'arte . . . Milan, Hoepli, 1931. 734p. illus. index.

A general dictionary of saints in art. Brief entries give description of the saint and reference to works of art in which the saint is depicted. Index of attributes (pp. 687-99). A good, well-illustrated dictionary of the saints in art.

- Roeder, Helen. Saints and Their Attributes: With a Guide to Localities and Patronage. London, Longmans, Green, 1955. 391p. illus. index. General dictionary of saints arranged by their attributes. Death date, main locality of veneration, and day of commemoration are given for each saint. Indexed by saints and by localities. A good general dictionary of saints, but it lacks specific bibliography and reference to works of art.
 - Rohault de Fleury, Charles. Archéologie chrétienne. Les saints de la messe et leurs monuments . . . Paris, Libraires Impremeries Réunies, 1893-1900. 10v. illus.

Older handbook of the iconography of major Christian saints. Entries give basic biographical facts and list of works of art and architecture associated with each saint. Illustrated with line drawings, plans, and elevations. Contents: I, Les vierges; II, Vierges et martyrs; III, Papes; IV, Ministres sacrés; V, Diacres, médecins; VI, Saint Pierre; VII, Saint Pierre, Saint Paul, Saint Philippe, Saint Jacques Mineur; VIII, Saint Jean Évangéliste, Saint Jacques-le-Majeur; IX, Saint Barthélemy, Saint Matthieu, Saint Thomas; X, Saint André, Saint Simon et Saint Jude, Saint Mathias, Saint Barnabé, Saint Jean-Baptiste, Agneau de Dieu. Bibliographical footnotes. Useful chiefly for its information on early cult associations of the saints.

Waters, Clara (Erskine) Clement. Saints in Art. Boston, Houghton Mifflin, 1907. 428p. illus. index. Reprint: Detroit, Gale, 1974.
 LC 77-89303.

Popular old handbook of the iconography of the saints. Covers the four evangelists, twelve apostles, fathers of the church, patron saints, virgin saints, and other saints. No bibliography.

Wimmer, Otto. Die Attribute der Heiligen. 3rd ed. Innsbruck, Vienna, and Munich, Tyrolia, 1975, 185p. LC 75-507508.

Dictionary of the saints in art, arranged in two lists: by the name of the saint, and by the attribute of the saint. Gives a brief life of each saint. Popular pocket dictionary of the saints in art.

WESTERN PROFANE ICONOGRAPHY

Marle, Raimond van. Iconographie de l'art profane au moyen-âge et à la Renaissance, et la décoration des demeures . . . The Hague, Nijhoff, 1931-32. 2v. illus.

Comprehensive handbook of secular iconography in the art of the Middle Ages and the Renaissance. Arranged in broad classes; entries relating to everyday life are grouped in volume one, while volume two covers secular allegories and symbols. A standard work on secular subject matter. Lack of an index makes it difficult to use for quick reference.

Tervarent, Guy de. Attributs et symboles dans l'art profane, 1450-1600. Geneva, Droz, 1958-1964. 3v. LC 60-32005.

Dictionary of symbols and subjects found in works of non-religious art between 1450 and 1600. Entries give literary sources for the subject and references to specific works of art that depict the symbol or subject. Although restricted essentially to the Renaissance period, many of the secular subjects treated in this dictionary occur in earlier and later periods. Should be consulted by any serious student pursuing a secular subject.

CLASSICAL MYTHOLOGY AND ICONOGRAPHY

486 Brommer, Frank. Denkmälerlisten zur griechischen Heldensage. Marburg, Elwert, 1971-76. 4v. index.

Alphabetical list of personages, objects, and subjects from ancient Greek mythology, with references to works of ancient Greek and Roman art that depict the subjects. Gives location of the works, short description of the object, and references to sources of illustrations and further information. Does not include works of ancient vase painting, which are indexed in a separate list (487). A very useful index for advanced students interested in classical iconography.

- Brommer, Frank. Vasenlisten zur griechischen Heldensage. 3rd ed. Marburg, Elwert, 1973. 646p. LC 74-305619.
 Index to subjects from Greek mythology depicted in works of ancient Greek vase painting. Follows the arrangement of (486). A very useful index for advanced students interested in classical iconography.
- Grant, Michael, and John Hazel. Who's Who in Classical Mythology.
 London, Weidenfeld & Nicolson, 1973. 447p. illus. LC 73-177715.

 Dictionary of classical mythology; well-illustrated with works of art. Entries give concise summaries of the lives and exploits of the chief mythological figures, with references to major Greek and Latin authors. The entries do not, however, refer specifically to iconography. Useful genealogical charts, maps, and list of classical authors used as sources.
 - Grimal, Pierre. Dictionnaire de la mythologie grecque et romaine. 3rd ed. Paris, Presses Universitaires de France, 1963. 578p. illus. index. LC 64-22572.

Dictionary of ancient Greek and Roman mythology. Each entry has a collection of bibliographical footnotes that refer chiefly to source material. A competent classical mythology dictionary, though it does not refer specifically to depiction of the subjects in the fine arts.

Hunger, Herbert. Lexikon der griechischen und römischen Mythologie:
 Mit Hinweisen auf des Fortwirken antiker Stoffe und Motive in der bildenden Kunst, Literatur und Musik des Abendlandes bis zur Gegenwart. 5th ed. Vienna, Hollinek, 1959. 387p. illus. LC 59-33741.
 Reprint: Reinbek bei Hamburg, 1974 (Rororo Handbuch, 6178).

Comprehensive dictionary of ancient Greek and Roman mythological subjects in Western art, literature, and music to the present day. Each entry provides numerous bibliographical references, a short account of the subject according to original sources, a discussion of the meaning of the subject, and a description of the subject's use in later Western art, literature, and music. Excellent general bibliography (pp. 383-87) with section on classical iconography. Very useful tool for students interested in classical mythology.

Overbeck, Johannes. Griechische Kunstmythologie. Leipzig, Engelmann, 1871-1889. 3v. illus. index. Reprint: Osnabrück, Biblio Verlag, 1964. LC NUC 71-49134.

Detailed examination of the major deities in ancient Greek art. Contents: Band 1: Zeus; Band 2: Hera, Poseidon, Demeter und Kora; Band 3, Apollon. Bibliographical footnotes. Still valuable for its thorough treatment of literary sources.

Roscher, Wilhelm H. Ausführliches Lexikon der griechischen und römischen Mythologie. Leipzig, Teubner, 1884-1927. 6v. plus Supplements (3v. in 5). illus.

Comprehensive dictionary of ancient Greek and Roman mythology. The entries give very thorough discussions of the myths, their literary sources and cult significance, and their representation in the fine arts. A standard dictionary of classical mythology; basic to all serious research on classical iconography.

Tripp, Edward. Crowell's Handbook of Classical Mythology. New York, Crowell, 1970. 631p. index. LC 74-127614.

Comprehensive dictionary of Greek and Roman mythology. Entries are fuller than in Grant (488) and give more comprehensive reference to literary sources. No references to art. Pronouncing index.

NON-WESTERN MYTHOLOGY AND ICONOGRAPHY

Banerjea, Jitendra N. The Development of Hindu Iconography. 2nd rev. and enl. ed. Calcutta, University of Calcutta, 1956. 653p. illus. index.

Scholarly history of the early development of Hindu iconography in Indian art, chiefly sculpture. Contents: I, Study of Hindu Iconography; II, The Antiquity of Image-Worship in India; III, The Origin and Development of Image-Worship in India; IV, Brahmanical Divinities and Their Emblems on Early Indian Coins;

V, Deities and Their Emblems on Early Indian Seals; VI, Iconoplastic Art in India—Factors Contributing to Its Development; VII, Iconographic Terminology; VIII, Canons of Iconometry; IX, Cult Icons-Vyantara Devatas; X, Cult Icons-Visnu and Surya; XI, Cult Icons-Siva and Sakti; XII, Miscellaneous and Syncretistic Icons. Selected bibliography (pp. 627-32).

- Bhattacharyya, Benoytosh. The Indian Buddhist Iconography, Mainly Based on the Sādhanamālā and Other Cognate Tāntric Texts of Rituals...

 London, New York, Milford, Oxford University Press, 1924. 220p. illus. index. 2nd rev. ed. Calcutta, Mukhopadhyay, 1958. 478p. illus. index. Scholarly, comprehensive handbook of Buddhist iconography in India. Chapters treat various classes of symbols and emphasis is placed on textual sources. Glossary of terms, selected bibliography of books and articles in all languages (pp. xxx-xxxiii). A standard work.
- Bonnet, Hans. Reallexikon der ägyptischen Religionsgeschichte. Berlin, de Gruyter, 1952. 883p. illus. LC A52-9962.
 Comprehensive dictionary of ancient Egyptian religion. Covers deities and other personages, places, objects, and subjects. Each entry has a separate bibliography of specialized works. Standard reference work on ancient Egyptian religion. Invaluable for all serious study of ancient Egyptian iconography.
- Coomaraswamy, Ananda K. Elements of Buddhist Iconography. Cambridge, Mass., Harvard University Press, 1935. 95p. text, 15 plates.
 Handbook of basic Buddhist symbolism. Contents: Part I, Tree of Life, Earth-Lotus, Word-Wheel; Part II, The Place of the Lotus-Throne. Plates have descriptive notes with bibliographical footnotes.
- 497 Getty, Alice. The Gods of Northern Buddhism; Their History, Iconography and Progressive Evolution through the Northern Buddhist Countries. 2nd ed. rev. Oxford, Clarendon Press, 1928. 220p. illus. index.
 Introduction sketches the development of Buddhism and Buddhist art. Subsequent chapters deal with a major deity. Glossary of Oriental terms used in the text (pp. 183-203). Bibliography of books and periodical articles in all languages (pp. 203-207).
- 498 Gopinātha Rau, T. A. Elements of Hindu Iconography . . . Madras, Law Printing House, 1914-1916. 2v. in 4. illus. index.

 Scholarly, comprehensive handbook of Hindu iconography, with emphasis on textual sources. Literary sources in Sanskrit and English translation provided throughout. Thoroughly indexed and good corpus of plates. A standard work.
- Gordon, Antoinette K. The Iconography of Tibetan Lamaism. 2nd ed. New York, Paragon, 1967. 131p. illus. index. LC 67-711.
 Little changed from first edition of 1938. Dictionary of subjects of Tibetan Lamaism. Arranged in classes with descriptions and illustrations. General bibliography (pp. 111-18). Popular work, yet still important to serious student.

500 Grey, Louis H., and John A. MacCulloch, eds. Mythology of All Races. Boston, Jones, 1916-1932. 13v. illus. index.

Comprehensive handbook of world mythology. Arranged by broad cultures with subject index in vol. 13. Good bibliographies at the end of each volume. The most comprehensive dictionary of mythology in English. A valuable aid to the study of non-Western iconography.

Gupte, Ramesh. Iconography of the Hindus, Buddhists, and Jains.
Bombay, Taraporevala, 1972. 201p. illus. LC 72-907859.
Comprehensive handbook of the iconography of traditional Indian art. The basic subjects of Hindu, Buddhist, and Jainistic art are discussed, together with the relevant literary tests.

Hackin, Joseph, *et al.* **Asiatic Mythology**. London, Harrap, 1932; repr. New York, Crowell, 1963. 459p. illus. index. LC 63-20021.

A collection of articles by specialists on the mythology of Persia, the Kafirs, Buddhism, Lamaism, Indochina, Central Asia, modern China, and Japan. Responsible collection of myths found in Oriental art, but the lack of bibliography and specific references to literary sources limits its usefulness for the serious student.

Haussig, Hans Wilhelm, ed. Wörterbuch der Mythologie. I. Abteilung:
 Die Mythologie der alten Kulturvölker. Lieferung 1-. Stuttgart,
 E. Klett, 1961-. illus. index.

Comprehensive dictionary of the mythology of all ancient cultures of the world. Consists of a series of separate dictionaries of the mythologies, in five categories: Ancient Near East (includes Egypt), Ancient Europe, the Iranian Peoples, Central and East Asia, and Ancient America. Thus far, the first and second parts have been published. A second section, covering the mythology of primitive peoples, is being planned. Each dictionary has a valuable introduction with an historical survey of the mythology concerned. The entries cover gods, ideas, cults, etc., and have thorough cross references and excellent separate bibliographies attached to the major entries. A collection of plates, maps, and chronological tables is provided. The basic, scholarly reference tool for the study of mythology. Essential for any serious study of non-Christian iconography; of special value to the specialist in non-classical archaeology.

Joly, Henri L. Legend in Japanese Art: A Description of Historical Episodes, Legendary Characters, Folk-Lore, Myths, Religious Symbolism Illustrated in the Arts of Old Japan. Rutland, Vt., Tuttle, 1967. 623p. illus. LC 67-16411.

Reissue of 1908 edition. This dictionary of Japanese iconography explains the mythology, but without specific reference to literary sources or specialized literature. Bibliography (pp. 596-609) lists, for the most part, works that are older and that are in Japanese.

505 Kirfel, Willibald. Symbolik des Hinduismus und des Jinismus. Stuttgart, Hiersemann, 1959. 167p. illus. index. (Symbolik der Religionen, 4). Concise survey of Hindu and Jain symbolism, with reference to literature and visual arts. Bibliographical footnotes.

Kirfel, Willibald. **Symbolik des Buddhismus**. Stuttgart, Hiersemann, 1959. 128p. illus. index. (Symbolik der Religionen, 5).

Concise survey of Buddhist symbolism, with particular reference to the visual arts. Bibliographical footnotes.

- 507 Lurker, Manfred. Symbole der alten Ägypter: Einführung und kleines Wörterbuch. Weilheim, O. W. Barth, 1964. 152p. illus. LC 66-93601. Dictionary of ancient Egyptian symbols. The alphabetical part, covering signs, signets, gods, and goddesses, is preceded by a brief account of ancient Egyptian mythology and its representation in the visual arts. A useful dictionary for the advanced student.
- Mensching, Gustav. Buddhistische Symbolik . . . Gotha, Klotz, 1929. 52p. text. 68 plates. index.

 Illustrated survey of basic Buddhist symbolism in architecture, sculpture, and painting. Bibliography (pp. 51-52).
 - Ross, Nancy Wilson. Three Ways of Asian Wisdom: Hinduism, Buddhism, Zen and Their Significance for the West. New York, Simon & Schuster, 1966. 222p. illus. index. LC 66-11065.

British edition titled *Hinduism*, *Buddhism*, *Zen: An Introduction to Their Meaning and Their Arts* (London, Faber, 1968). A handbook of the subject matter of Hinduism, Buddhism, and Zen religions. There are separate chapters for each religion, with sub-sections on the representation of their subjects in the fine arts. Adequate illustrations, with descriptive captions. Bibliography (pp. 199-207) lists chiefly works on religion. A general and popular treatment, it is still useful because of the lack of other substantial works in the field.

- Sahai, Bhagwant. Iconography of Minor Hindu and Buddhist Deities.

 New Delhi, Abhinav Publications, 1975. 295p. illus. index.

 Scholarly handbook, arranged by type, i.e., Vedic, Saiva deities, etc. Thorough reference to textual sources and good use of works of art as examples of the various subjects. Extensive bibliographical footnotes. Emphasis on Indian material. Supplements Bhattacharyya (495) and Gopinātha Rāu (498).
 - Stutley, Margaret, and James Stutley. A Dictionary of Hinduism: Its Mythology, Folklore and Development 1500 B.C.-A.D. 1500. New York, Harper, 1977. 372p. LC 76-9999.

Comprehensive dictionary of Hinduism, with particular reference to literary sources. Although few references to the visual arts are made, this work is very useful to study of Hindu iconography. Bibliography (pp. 353-68) lists books and periodical articles in all languages.

Werner, Edward T. C. A Dictionary of Chinese Mythology. New York, Julian Press, 1961. 627p. illus. LC 61-17239.

Reprint of 1932 edition. Comprehensive dictionary of characters, objects, and

subjects of Chinese mythology. Longer entries have references to sources and occasionally to specialized literature. Bibliography (pp. 625-27) lists books in

Chinese and Western languages. A standard dictionary of Chinese mythology. Essential for all serious study of Chinese pictorial art.

Williams, Charles Alfred S. Encyclopedia of Chinese Symbolism and Art Motives: An Alphabetical Compendium of Legends and Beliefs as Reflected in the Manners and Customs of the Chinese Throughout History. New York, Julian, 1960. 468p. illus. index. Reprint: Rutland, Vt., Tuttle, 1974. LC 73-90237.

Reissue of *Outlines of Chinese Symbolism and Art* (1931). Dictionary of Chinese iconography. Chinese characters are given after the main English heading. Very useful dictionary. Longer entries have bibliographies of specialized literature.

TARTS OF THE MEDICAL SECTION OF THE STATE OF

erte protes and manage of the first first protes and the protes and the second second protes and the second protes and the second protest and the second protest

CHAPTER SEVEN

PREHISTORIC AND PRIMITIVE ART

GENERAL WORKS

514 Adam, Leonhard. Primitive Art. New York, Barnes and Noble, 1963. 250p. illus. index. LC 64-6042.

Actually covers both prehistoric and primitive art of Africa, Asia, Oceania, Australia, and the arts of the American Indian. Introductory chapters cover primitive art and the artists of the West, primitive art and psychoanalysis, etc. Appendixes give a good annotated bibliography of general literature and a very useful section on primitive art in museums.

515 Christensen, Erwin O. Primitive Art. New York, Crowell, 1955. 384p. illus. index. LC 55-11109:

Survey of the arts of the primitive peoples of Africa and Alaska; the American Indian; the pre-Columbian societies of Central and South America, Oceania, and Australia; and the prehistoric art of Europe. Provides maps, a fair selection of plates, and a bibliography (pp. 367-76), which lists books and periodical articles chiefly in English.

Cossío, Manuel B., and José Pijoán y Soteras. Arte de los pueblos aborigenes. Bilbao and Madrid, Espasa-Calpe, 1931. 526p. illus. index. (Summa Artis, Historia General del Arte, I).

Comprehensive survey of all of the arts of primitive peoples and certain prehistoric cultures, namely, pre-Columbian. Treats the art of children and the arts of Oceania, Melanesia, tribal Africa, and North American Indians—the last with special thoroughness. Brief bibliographies of books at the ends of chapters.

Kühn, Herbert. **Die Kunst der Primitiven** . . . Munich, Delphin, 1920. 240p. illus. index.

Survey of prehistoric and primitive art covering Paleolithic and Neolithic art of Europe, American rock pictures, European Bronze Age art, and the art of sub-Saharan Africa. Emphasis is on socioeconomic relationship between art and society. Bibliography of basic works in all languages (pp. 178-222).

Lommel, Andreas. Prehistoric and Primitive Man. New York, McGraw-Hill, 1966. 176p. illus. index. LC 66-15836.

Concise survey of the arts of prehistoric and primitive cultures in Europe, Asia, Indonesia, Oceania, the Americas, and Africa. Includes maps and a general reading list (pp. 171-72).

519 Pericot-Garcia, Luis, John Galloway, and Andreas Lommel. Prehistoric and Primitive Art. New York, Abrams, 1968. 340p. illus. index. LC 68-26867.

Handbook of European prehistoric art to the Bronze Age and the arts of the primitive societies of Africa, Oceania, and the American Indian. Excellent bibliography (pp. 326-33), which covers the major general works; numerous footnotes give reference to more specialized literature. Well illustrated.

520 Sydow, Eckhart von. Die Kunst der Naturvölker und der Vorzeit . . . Berlin, Propyläen, 1923. 569p. illus. index.

Covers prehistoric art of Europe, primitive art of Africa and Oceania, art of ancient America, and Germanic art of the migrations and Viking periods. General bibliography (pp. 551-58). Still a useful one-volume handbook of primitive and prehistoric art.

PREHISTORIC

- Bandi, H. G., et al. The Art of the Stone Age. London and New York, World, 1961. 242p. illus. index. LC 52-13999.
 Covers paleolithic art in Europe, north and south Africa, and Australia. Balanced bibliography of general works and glossary of terms.
- Brown, Gerard B. The Art of the Cave Dweller; A Study of the Earliest Artistic Activities of Man... London, Murray, 1928. 280p. illus. index. Comprehensive survey of prehistoric art of Europe, with good coverage of the major cave painting sites. Cultural-historical emphasis. Bibliographical footnotes.
 - Cossío, Manuel B., and José Pijoán y Soteras. El arte prehistórico europeo. Bilbao and Madrid, Espasa-Calpe, 1935. 592p. illus. index. (Summa Artis, Historia General del Arte, VI).

Comprehensive survey of the arts and artifacts of prehistoric Western cultures, from Neolithic to Celtic, and including Mycenaean and Minoan art and architecture. Brief lists of books in Western languages at the ends of chapters.

Giedion, Siegried. The Eternal Present: The Beginnings of Art. New York,
 London, Bollingen, 1962. 588p. illus. index. (Bollingen Series, XXXV,
 6.1). LC 62-7942.

Influential study of prehistoric art; first presented as the 1957 Mellon Lectures at the National Gallery in Washington. Chapters extensively treat the formalistic and symbolic qualities of "primeval art." List of works cited (pp. 552-62) is a fairly extensive list of books and periodical articles in all languages.

Grand, Paule M. Prehistoric Art: Paleolithic Painting and Sculpture.
 Greenwich, Conn., New York Graphic Society, 1967. 103p. illus. index.
 (Pallas Library of Art, v. III). LC 67-28690.

Pictorial survey of paleolithic art in Europe, Africa, and Australia. Well illustrated with plates, line drawings, and diagrams; also included are a useful selection of maps and a select but well-chosen bibliography (p. 101) of basic books in all languages.

526 Graziosi, Paolo. Palaeolithic Art. New York, McGraw-Hill, 1960. 278p. (text); 306p. (illus.). index. LC 59-13435.

Comprehensive and scholarly study of European paleolithic sculpture and painting. One chapter is an excellent introduction to the study of paleolithic art. Excellent selection of plates. Bibliography (pp. 221-36) is unclassified but is a thorough list of books and periodical articles. A standard handbook.

Hoernes, Moritz, and Oswald Menghin. Urgeschichte der bildenden Kunst. 3rd ed. Vienna, Schroll, 1925. 864p. illus. index.

Comprehensive handbook-history of prehistoric art, chiefly in Europe, from neolithic through La Tène periods. Thorough reference to specialized literature in the footnotes. Illustrated chiefly with line drawings. An old but classic history of European prehistoric art.

Kühn, Herbert. Die Kunst Alteuropas. 3rd ed. Stuttgart, Kohlhammer, 1958. 251p. illus. index. LC 59-52274.

Concise history of art of Europe from the Ice Age through the early Middle Ages. Attempts to trace a continuous stylistic development from prehistoric through ancient and medieval times. Most useful for the earlier chapters on art up to the first millenium. Good classified bibliography (pp. 235-42), with mention of additional literature in the notes to the plates.

- Laming-Emperaire, Annette. La signification de l'art rupestre paléolithique; Methodes et applications. Paris, Picard, 1962. 424p. illus. index. Important, scholarly study of paleolithic art in Europe, expressing an influential opinion on the function of prehistoric art. Contents: I, L'art rupestre paléolithique; II, Hypothèses et théories sur la signification de l'art rupestre paléolithique; III, Une methode d'etude de la signification de l'art rupestre paléolithique et ses applications; IV, Documents. The last chapter offers a complete catalog of the major cave sites in France. Excellent annotated bibliography (pp. 360-94). A standard work.
- Leroi-Gourhan, André. Treasures of Prehistoric Art. New York, Abrams, 1967. 543p. illus. index. LC 67-22851.

Comprehensive study of and handbook for paleolithic art. Provides chronological tables, maps, lists of works of art that are reliably dated, list of cave sites, analysis of cave art by style, etc. General bibliography (p. 527) is followed by specialized bibliography, arranged by site (pp. 528-37). A standard work on paleolithic art; fully documented.

Maringer, Johannes, and Hans Georg Bandi. Art in the Ice Age. London, New York, Praeger, 1953. 167p. illus. index.

Concise survey of paleolithic art in Europe. Bibliography (pp. 164-65) of major works.

- Mellink, Machteld J., and Jan Filip. Frühe Stufen der Kunst. Berlin,
 Propyläen, 1974. 371p. illus. index. (Propyläen Kunstgeschichte, 13).
 Comprehensive illustrated scholarly handbook of prehistoric art in Europe through the La Tène period, and in the eastern Mediterranean and the Near East until the emergence of Sumerian civilization. Also includes prehistoric art of North Africa. Text consists of essays by various European scholars; detailed notes to the excellent corpus of plates, with special bibliographic references. Chronological table and excellent classified bibliography of books and periodical articles in all languages (pp. 349-62). A standard handbook for prehistoric art.
- Müller-Karpe, Hermann. Das Vorgeschichte Europa. Badan-Baden, Holle, 1968. 223p. illus. index. LC 74-497422.

 Concise history of European prehistoric art. Provides a glossary, a chronological table, and a good, classified bibliography (pp. 194-99), which lists books and periodical articles in all languages. German edition of the series "Art of the World."
- Nougier, Louis R. L'art préhistorique. Paris, Presses Universitaires de France, 1966. 186p. illus. LC 67-72072.

 Survey of prehistoric art in Europe with a brief chapter on America and Africa. Good selection of plates; bibliography (pp. 185-86) lists books in all languages.
- Powell, Thomas George E. Prehistoric Art. New York, Praeger, 1966. 284p. illus. LC 66-12991.

 Treats the art of prehistoric Europe through La Tène Celtic. Bibliography (pp. 263-69) lists only recent publications, chiefly those in English. Popular work for the general reader and beginning student.
- Sandars, Nancy K. Prehistoric Art in Europe. Harmondsworth, Penguin, 1968. 350p. illus. index. (Pelican History of Art Z30). LC 79-352957. Art of prehistoric Europe through La Tène Celtic. Good bibliography of general works and extensive bibliographical footnotes to specialized literature. A standard work on prehistoric art.
- Torbrügge, Walter. Prehistoric European Art. New York, Abrams, 1968. 260p. illus. index. LC 68-28390.

 Concise history of prehistoric art in Europe from paleolithic times through La Tène. Well illustrated; provided with useful maps, chronological tables, and a bibliography (pp. 255-56) that lists major books in all languages.
- Ucko, Peter J., and Andrée Rosenfeld. Palaeolithic Cave Art. New York, Toronto, McGraw-Hill, 1967. 256p. illus. index. LC 66-16481.

 Survey of European and African prehistoric cave art, concentrating on painting but also reviewing sculpture, with emphasis on the function of prehistoric art. Chapter three summarizes past interpretations of paleolithic art; chapter four postulates ethnographic explanation for the function of cave art, together with a critical evaluation of the ideas of Leroi-Gourhan (530) and Laming (529). General and specialized literature covered in the notes (pp. 240-51).

Waage, Frederick O. Prehistoric Art. Dubuque, Iowa, W. C. Brown, 1967. 113p. illus. index. LC 67-22709.

Survey of prehistoric art from paleolithic times through the Levant style of Spanish rock art. Bibliography (pp. 109-110) provides a short list of books in English. Designed as an inexpensive text for the beginning student.

PRIMITIVE

- Batterberry, Michael, and Ariane Ruskin. Primitive Art. New York, McGraw-Hill, 1972. 192p. illus. index. LC 72-2295.
 Pictorial survey of the arts of primitive Africa, Oceania, Australia, and pre-Columbian America. No bibliography.
- Boas, Franz. **Primitive Art.** New York, Dover, 1955. 372p. illus. index. Reprint of 1927 edition. Conceptual study of primitive art, with emphasis on the art of the Northwest Coast Indians of America. Bibliography in the footnotes. An old but classic study.
- Fraser, Douglas. Primitive Art. Garden City, N.Y., Doubleday, 1962. 320p. illus. index. LC 62-13342.

 Survey of the arts of the primitive cultures of Africa, Asia, Oceania, and America. The American section covers both the pre-Columbian civilizations of Central and South America and the arts of the North American Indian. Bibliography (pp. 313-16) is a good selection of the major works in this broad field.
- Wingert, Paul S. Primitive Art: Its Traditions and Styles. New York, Oxford University Press, 1962. 421p. illus. index. LC 62-20161.

 Treats the arts of the primitive societies of Africa, Oceania, and the American Indian. Illustrated in black and white, with a selection of maps. Selected bibliography (pp. 387-94). A workmanlike handbook on the main aspects of primitive art.

CHAPTER EIGHT

PERIODS OF WESTERN ART HISTORY

ANCIENT

GENERAL WORKS

Byvanck, Alexander Willem. **De Kunst der Oudheid** . . . Leiden, Brill, 1946-65. 5v. illus. index. LC 46-2532.

Comprehensive Dutch history of art and architecture in the ancient world from Egypt to Mesopotamia through Rome. Well illustrated with plates, plans, and diagrams and provided with good bibliographies at the end of each volume. A respected history of ancient art.

- Curtius, Ludwig. Die Antike Kunst. Berlin and Potsdam, Athenaion, 1923, 1938; repr. Hildesheim, Olms, 1959. 2v. illus. index.

 Comprehensive history of the art and architecture of ancient Egypt, the ancient Near East, ancient Greece and Rome. Bibliographies are given at the end of each chapter. Once a standard handbook-history, it is still valuable for the force of the author's language and ideas. Original series: "Handbuch der Kunstwissenschaft."
- Groenewegen-Frankfort, Henriette A., and Bernard Ashmole. Art of the Ancient World. New York, Abrams, n.d. 529p. illus. index. LC 77-113722. Survey history of the art and architecture of the major civilizations of the ancient Mediterranean from ancient Egypt and Mesopotamia through Roman civilization. Has a brief bibliography of selected English language works (pp. 509-514), and the extensive footnotes give access to more specialized literature. Well illustrated. One of the best histories of ancient art in English.
- Huyghe, René, ed. Larousse Encyclopedia of Prehistoric and Ancient Art. London, Hamlyn, 1966. 415p. illus. index. LC 67-85568.

 Collection of essays by French experts on various aspects of the arts of prehistoric and primitive man, plus the art and architecture of ancient Egypt, the ancient Near East, and Asia to 1000 A.D. Historical summaries are given at the end of each major section. Provides maps and chronology but no bibliography. For the general reader and beginning student.
 - Leroy, Alfred. Évolution de l'art antique . . . Paris, Horizons de France, 1945. 316p. illus.

Concise survey of ancient art, exclusive of architecture, from ancient Egypt and the Near East through late Roman. Chronological table, maps of art centers, and bibliography of basic books in all languages (pp. 307-316).

Otto, Walter, ed. Handbuch der Archäologie, im Rahmen des Handbuchs der Altertumswissenschaft... Munich, Beck, 1939-1953. 4v. illus. index. (Handbuch der Altertumswissenschaft, 6.Abt.).

Comprehensive handbook of ancient art and archaeology. Volume one covers the ancient civilizations of Egypt and the Near East; volume two, the Stone and Bronze Ages of Europe; volumes three and four the ancient civilizations of Greece and Rome. Die griechische Plastik, by G. Lippold (v. 3, part 1), and Malerei und Zeichnung, by A. Rumpf (v. 4, part 1), are classics in the field.

550 Perrot, Georges, and Charles Chipiez. Histoire de l'art dans l'antiquité. Paris, Hachette, 1882-1914. 10v. illus. index.

Old standard, comprehensive history of art and architecture in the ancient world. Contents: v. l, L'Égypte; v. 2, Chaldée et Assyrie; v. 3, Phénicie, Cypre; v. 4, Judée, Sardaigne, Syrie, Cappadoce; v. 5, Perse, Phrygie, Lydie et Carie, Lycie; v. 6, La Grèce primitive: l'art mycénien; v. 7, La Grèce de l'épopée, la Grèce archaïque (le temple); v. 8, La Grèce archaïque, la sculpture; v. 9, La Grèce archaïque, la glyptique, la numismatique, la peinture, la céramique; v. 10, La Grèce archaïque, la céramique d'Athènes. An English translation of the first six volumes (issued in twelve volumes) was published in London by Chapman and Hall, 1883-1894.

Powell, Ann. The Origins of Western Art. New York, Harcourt, Brace, 1973. 224p. illus. index. LC 74-183245.

General survey history of art in Europe from the Stone Age through the late Roman Empire. Glossary, chronological table, and a bibliography (pp. 219-20) that lists recent books in English. For the general reader and the beginning student.

EGYPTIAN

Aldred, Cyril. The Development of Ancient Egyptian Art from 3200-1315 B.C. 3v. New York, Transatlantic, 1952. LC 52-14926. One-volume ed.: London, Tiranti, 1962.

Survey history of the fine arts of ancient Egypt, excluding architecture, from predynastic times through the eighteenth dynasty. Suggestions for further reading at the end of each volume. Informative notes on the black and white plates. For the general reader and beginning student.

Capart, Jean. Documents pour servir à l'étude de l'art égyptien . . . Paris, Les Éditions du Pégase, 1927-31. 2v. illus. index.

Collection of plates of major Egyptian works of art in various museums and collections around the world. Brief text accompanies each plate, and a selected bibliography is appended to each volume. General indexes in each volume.

Capart, Jean. Egyptian Art: Introductory Studies . . . New York, Stokes, 1923. 179p. illus. index.

Concise handbook of ancient Egyptian art, with bibliographies at the end of each chapter. Once a standard work for the beginning student, it is now obsolete; nevertheless, it is still worthwhile because of its organization and its succinct language.

- 555 Capart, Jean. L'art égyptien. 2v. Brussels, Vromant, 1909-1911. An illustrated handbook of the art and architecture of ancient Egypt from predynastic times through the Greco-Roman period. The notes to the plates offer very thorough bibliographies. This old standard illustrated handbook is still useful to the advanced student because it provides access to older literature.
 - Cossío, Manuel B., and José Pijoán y Soteras. El arte egipcio hasta la conquista romana. Bilbao and Madrid, Espasa-Calpe, 1932. 555p. illus. index. (Summa Artis, Historia General del Arte, III).

Comprehensive history of Egyptian art and architecture from predynastic times through the Roman conquest in the first century B.C. Brief bibliographies of books in all languages at the ends of chapters.

- Driot, Étienne. Egyptian Art. New York, Arts, Inc., 1951. 161p. illus. Brief survey of the fine arts in ancient Egypt from prehistoric times through the Greco-Roman period. A pictorial survey for the general reader.
- Hamann, Richard. Ägyptische Kunst, Wesen und Geschichte. Berlin, T. Knaur, 1944. 314p. illus.

Well-written history of art and architecture in ancient Egypt from prehistoric times to the Ptolemaic period.

Lange, Kurt. Egypt. Photographs by Max Hirmer. 4th ed., rev. and enl. New York and London, Phaidon, 1968. 559p. illus. index. 5th ed., in German, published by Hirmer in 1975.

The brief introductory survey of ancient Egyptian art is followed by many excellent photographs and informative notes. General bibliography (pp. 548-49). A standard illustrated handbook for the beginning and advanced student.

Maspero, Gaston C. C. Manual of Egyptian Archaeology and Guide to the Study of Antiquities in Egypt... New York, Putnam, 1926. 385p. illus. index.

Translation of *L'archéologie égyptienne* (Paris, 1887). Survey of ancient Egyptian fine and applied arts. Media treated in separate chapters. Occasional bibliographic footnotes.

Michalowski, Kazimierz. The Art of Ancient Egypt. New York, Abrams, 1969. 600p. illus. index. LC 68-26865.

A comprehensive and richly illustrated history of the fine arts in ancient Egypt. Useful chronological tables, glossaries, and bibliography of general works. Most useful parts are the section on archaeological sites arranged by regions and the bibliographies of specialized literature given at the end of the various chapters. A standard handbook-history.

- Poulsen, Vagn. Egyptian Art. Greenwich, Conn., New York Graphic Society, 1968. 184p. illus. index. LC 69-15492.
 Pictorial survey of ancient Egyptian art and architecture. Brief bibliography.
- Excellent illustrations. For the general reader.
- Rachewiltz, Boris de. An Introduction to Egyptian Art. New York, Viking, 1960. 255p. illus. index. LC 60-11232.

Concise survey of the history of art and architecture in ancient Egypt from predynastic times through the Roman period. Provides maps; a useful chapter on chronology; modest but intelligent selection of plates, diagrams, and plans; and a well-classified and selected bibliography of major books and periodical articles in all languages (pp. 233-50).

- Schäfer, Heinrich. Von ägyptischer Kunst: eine Grundlage. 4th ed. Wiesbaden, Harrassowitz, 1963. 462p. illus. index. LC 65-49119.
 History of ancient Egyptian art and architecture from predynastic times through the New Kingdom. Well illustrated and with excellent bibliography in the notes (pp. 368-94). A standard handbook-history.
 - Schäfer, Heinrich, and Walter Andrea. Die Kunst des alten Orients. 3rd ed. Berlin, Propyläen, 1942. 686p. illus. index. (Propyläen Kunstgeschichte, II).

A pictorial handbook of the art and architecture of ancient Egypt and Mesopotamia, and the Hittite and Aramaic cultures. Brief introductory essays precede the large collection of plates. No bibliography. Still a useful collection of illustrations, although it is being superseded by volumes in the new *Propyläen Kunstgeschirhte* (567, 584).

- Smith, William S. Art and Architecture of Ancient Egypt. London, Penguin, 1958. 301p. illus. index. (Pelican History of Art, Z14). Scholarly history of the fine arts in ancient Egypt from the predynastic period through the Saitic period. Bibliography of general works (pp. 289-90). Thorough coverage of specialized literature in the numerous footnotes. The standard history of Egyptian art and architecture in English.
 - Vandersleyen, Claude. Das alte Ägypten. Berlin, Propyläen, 1975. 457p. text, 440 plates. (Propyläen Kunstgeschichte, 15).

Comprehensive illustrated handbook of ancient Egyptian art and architecture from prehistoric times through the Roman period. Text consists of essays by European experts on various media and periods and detailed notes to the plates, which provide bibliographies of specialized literature. Chronological table. Excellent classified bibliography of books and periodical articles in all languages (pp. 436-45). A standard handbook.

Vandier, Jacques. Manuel d'archéologie égyptienne. Paris, Picard, 1952-55. 6v. illus. index. LC 68-77571.

Handbook of ancient Egyptian art and architecture from predynastic times through the New Kingdom. Contents: Tome I, Les époques de formation (2v.); Tome II, Les grandes époques: Ancien, Moyen et Nouvel Empire 2v.); Tome III, La

statuaire (2v.). Excellent bibliographies at the end of each tome and extensive bibliographical references in the text footnotes. A standard handbook of ancient Egyptian art and archaeology.

- Westendorf, Wolfhart. Painting, Sculpture and Architecture of Ancient Egypt. New York, Abrams, 1969. 260p. illus. index. LC 68-2839. Survey history of fine arts in ancient Egypt from prehistoric times through the Coptic (12th century A.D.). Chronological table and brief bibliography (pp. 255-56). Designed for the general reader, this work discusses literature, religions, and history as well as the fine arts.
- Woldering, Irmgard. The Art of Egypt: The Time of the Pharaohs. New York, Crown, 1963. 260p. illus. index. LC 62-20055.

 Survey history of ancient Egyptian art and architecture from prehistory through the Ptolemaic period. Each period has a separate chapter on history and culture. Chronological table, glossary, and brief bibliography of general works (pp. 248-49).
- Woldering, Irmgard. Gods, Men and Pharaohs: The Glory of Egyptian Art. New York, Abrams, 1967. 275p. illus. index. LC 67-26468. Survey of art and architecture in ancient Egypt from predynastic times to the end of the New Kingdom. Bibliography (pp. 247-50) lists major books in all languages. For the general reader and the beginning student.
- Wolf, Walter. The Origins of Western Art: Egypt, Mesopotamia, the Aegean. New York, Universe, 1971. 207p. illus. index. LC 72-134760. Survey history of ancient art and architecture of Egypt, Mcsopotamia, and the Aegean Islands. Does not cover Iran or Asia Minor. Brief bibliography (pp. 202-203). Excellent condensation for the beginning student. There are many appropriate illustrations, with informative captions.

ANCIENT NEAR EASTERN

General Works

Bossert, Helmuth T. Altsyrien: Kunst und Handwerk in Zypern, Syrien, Palästina, Transjordanien und Arabien von den Anfängen bis zum volligen Aufgehen in der griechisch-römischen Kultur. Tübingen, Wasmuth, 1951. 407p. illus. index. LC A51-10617.

Illustrated handbook and history of the art and architecture of ancient Syria, Cyprus, Palestine, Jordan, and Arabia from prehistoric times to the second century B.C. Expecially good coverage of the minor arts. A standard handbook and survey history concentrating on an area often slighted in other surveys of ancient Near Eastern art and architecture.

Burney, Charles. The Ancient Near East. Ithaca, N.Y., Cornell University Press, 1977. 224p. illus. index. LC 76-55483.

Survey of art and civilization in the ancient Near East from Neolithic times to the end of the Assyrian Empire. Bibliography of basic works in English is arranged by chapters of the text (pp. 205-212).

575 Christian, Viktor. Altertumskunde des Zweistromlandes von der Vorzeit bis zum Ende der Achämenidenherrschaft . . . v. 1– . Leipzig, Hiersemann, 1940– .

Comprehensive, scholarly handbook of archaeological sites in Mesopotamia. Planned to cover the period from prehistory to the end of the Achaemenian dynasty, but only first part appeared. Covers ancient Mesopotamia from prehistoric times through the third dynasty of Ur. Geographical arrangement with detailed descriptions of the finds at various levels at the major sites. Extensive bibliographical references throughout.

576 Contenau, Georges. L'art de l'asie occidentale ancienne. Paris and Brussels, Van Oest, 1928. 119p. illus.

Concise survey of art and architecture in the ancient Near East from the beginnings to the third century A.D.

Contenau, Georges. Arts et styles de l'Asie antérieure (d'Alexandre le Grand a l'Islam). Paris, Larousse, 1948. 125p. illus.

Survey history of ancient Near Eastern art and architecture under the Seleucid, Parthian, and Sassanian dynasties. Chronological table, map of chief archaeological sites, and classified bibliography of basic books in all languages (pp. 115-17).

- 578 Contenau, Georges. Manuel d'archéologie orientale depuis les origines jusqu'à l'époque d'Alexandre. Paris, Picard, 1927-47. 4v. illus. index. Volumes 1-3 trace the history of art and architecture in Mesopotamia, Iran, Anatolia, the Levant, and Arabia from prehistoric times to the time of Alexander the Great. Fourth volume discusses important archaeological discoveries made between 1930 and 1939 and relates these to the overall history of ancient Near Eastern art. Bibliographies for each chapter, plus general bibliographies at end of each volume.
 - Cossío, Manuel B., and José Pijoán y Soteras. Arte del Asia occidental. Bilbao and Madrid, Espasa-Calpe, 1931. 554p. illus. index. (Summa Artis, Historia General del Arte, II).

Comprehensive history of the arts of ancient Near Eastern cultures: Sumerian, Babylonian, Assyrian, Hittite, Phoenician, Persian, Parthian, Sassanian, and Scythian. Includes architecture, textiles, pottery, and other artifacts with sculpture and painting.

Frankfort, Henri. The Art and Architecture of the Ancient Orient. 4th rev. ed. Harmondsworth, Penguin, 1970. 465p. illus. (Pelican History of Art, PZ7). LC 70-128007. (Revised paperback edition of the 1954 hardcover edition.)

Comprehensive and scholarly history of art and architecture in the ancient Near East from Sumerian times to the end of the Achaemenian Empire. Covers Mesopotamia, Anatolia, Iran, and the Levant. Good selection of plates, many plans and diagrams. Bibliography (pp. 413-36) is an excellent classified list of books and periodical articles in all languages; it has been brought up to date by an additional bibliography edited by Helene Kanter. The standard history of ancient Near Eastern art and architecture.

581 Garbini, Giovanni. **The Ancient World**. New York, McGraw-Hill, 1966. 176p. illus. index. LC 66-19270.

Historical survey of the art of Mesopotamia (Sumeria, Akkadia, Neo-Sumeria, Babylonia, the Kassites, Assyria, Neo-Babylonia), Palestine, Anatolia, plus the Hittites, Syria, Persia, Phoenicia, Egypt (pre-dynastic through Saite dynasty), Nubia, South Arabia, Ethiopia, and Carthage. Includes chronological tables, glossary, maps, and a general bibliography (p. 172).

- Goossens, Godefroy. L'art de l'Asie antérieure dans l'antiquité; les époques. Brussels, Office de Publicité, 1948. 90p. illus.
 Brief survey of the history of ancient Near Eastern art and architecture from ancient Sumer to the advent of Islam. Occasional bibliographic footnotes.
- Lloyd, Seton. The Art of the Ancient Near East. New York, Praeger, 1961. 303p. illus. index. LC 61-15605.

 Survey of the art and architecture of the ancient Near East covering Mesopotamia, Egypt, and Iran from prehistoric times to the Persian Empire. Architecture is surveyed in a separate chapter. Brief bibliography (p. 283).
- Orthmann, Winfried. Der alte Orient. Berlin, Propyläen, 1975. 520p. text, 480 plates. index. (Propyläen Kunstgeschichte, 14).

 Comprehensive illustrated handbook of the art and architecture of the ancient Near East from the beginnings of Sumerian civilization through pre-Islamic Persian culture. Covers all major cultures of Mesopotamia, Iran, Anatolia, the Levant, and Cyprus. Text consists of essays by leading European scholars and detailed notes to the excellent corpus of plates. The notes to the plates have very useful bibliographies of specialized literature. Chronological table coordinates events in the various regions. Good classified bibliography of basic books and periodical articles in all languages (pp. 542-57).
- Potratz, Johannes M. H. Die Kunst des alten Orient: Babylonien und Assyrien, Alt-Syrien, Alt Anatolien und das Alten Persien. Stuttgart, Kröner, 1961. 438p. illus. index. LC 67-55551.

Concise history of art and architecture of the ancient Near East including Mesopotamia, Iran, Syria, and Anatolia. Covers the period from circa 3100 B.C. to 330 B.C. Although it is a pocket-sized book, it is well provided with plates, plans, diagrams, a useful chronological table, and an excellent classified bibliography (pp. 404-417), which lists books and periodical articles in all languages. An excellent handbook-history of ancient Near Eastern art and architecture for the advanced student.

Ry van Beest Holle, Carel J. du. Art of the Ancient Near and Middle East.
New York, Abrams, 1970. 264p. illus. index. LC 78-92910.
Concise history of art and architecture in the Near and Middle East from 9000
B.C. to the third century A.D. Covers Mesopotamia, Anatolia, Iran, Syria, Jordan, Palestine, and Arabia. Good selection of color illustrations, maps, and chronological tables. Has a good chapter on the discovery of ancient Near Eastern civilization.
Bibliography (pp. 258-60) lists major books in all languages.

587 Speiser, Werner. Vorderasiatische Kunst. Berlin, Safari-Verlag, 1952. 301p. illus. LC A53-2037.

Survey history of art and architecture in the Near East from prehistoric times to the Parthians. Bibliography of basic books (p. 296).

Woolley, Charles Leonard. The Art of the Middle East Including Persia, Mesopotamia and Palestine. New York, Crown, 1961. 259p. illus. index. LC 61-16972.

A survey history of the fine arts in the ancient Near East from Elam and Sumeria to the Greco-Roman period covering Mesopotamia, Iran, Anatolia, Syria, and Palestine. Provides maps, chronological tables, glossary, and brief bibliography (pp. 247-50).

Mesopotamia

Moortgart, Anton. The Art of Ancient Mesopotamia: The Classical Art of the Near East. London and New York, Phaidon, 1969. 356p. illus. index. LC 69-12789.

Comprehensive history of the art and architecture of ancient Mesopotamia from Sumerian through Neo-Babylonian times. General bibliography and notes (pp. 329-40). Survey with emphasis on stylistic development.

Parrot, André. The Arts of Assyria. New York, Golden Press, 1961. 380p. illus. index. (The Arts of Mankind, 2). LC 61-11170. Pictorial survey of the art and architecture of Mesopotamia and Iran from the Assyrian period through the Achaemenian period to the death of Alexander the Great. Part two has an interesting section on Mesopotamian techniques, literature, and music. Provides maps, glossary-index, and good bibliography (pp. 343-59). Informative notes to the plates. Sequel to (592).

Parrot, André. Sumer, the Dawn of Art. New York, Golden Press, 1961. 396p. illus. index. (The Arts of Mankind, 1). LC 61-6746. Pictorial survey of art and architecture in ancient Mesopotamia from prehistoric times through the Kassite and Elamite periods. Provides a glossary-index, maps, and good bibliography (pp. 361-70). Richly illustrated, there is often more information in the notes to the illustrations than in the overly condensed text. For the general reader and the beginning student.

592 Schmökel, Hartmut. Ur, Assur und Babylon; Drei Jahrtausende im Zweistromland. Stuttgart, Kilpper, 1955. 301p. illus. index. (Grosse Kulturen der Frühzeit, Band 2). LC A55-5641.

Survey of Mesopotamian art and architecture from prehistoric times to the Neo-Babylonians. Good selection of plates. Bibliography (pp. 291-94) lists books and periodical articles in all languages.

593 Strommenger, Eva. 5000 Years of the Art of Mesopotamia. New York, Abrams, 1964. 480p. illus. index. LC 64-15231.

A comprehensive illustrated handbook of the art and architecture of ancient Mesopotamia from the Sumerian through the late Babylonian periods. A concise and well-written introduction is followed by a section of 280 superlative plates

by Max Hirmer, and very informative notes on the plates with references to specialized literature. Chronology proposed is somewhat controversial. General bibliography (pp. 465-69) includes an excellent section on excavation reports. Standard illustrated handbook for ancient Mesopotamian art.

594 Unger, Eckhard. Assyrische und Babylonische Kunst. Breslau, F. Hirt, 1927. 140p. illus.

Concise survey of Assyrian and Babylonian art with particular emphasis on stele sculpture. Bibliography (pp. 72-75).

Woolley, Charles L. The Development of Sumerian Art... London, Faber and Faber, 1935. 140p. illus. index. LC 36-3991.

Older survey history of Sumerian art and architecture from the Al Ubaid period through the third dynasty of Ur, by famous excavator of the royal tombs of Ur. Bibliographical note at the end of each chapter.

596 Zervos, Christian. L'art de la Mésopotamie de la fin du quatrième millénaire au XVe siècle avant notre ère . . . Paris, Cahiers d'Art (1935). 264p. illus.

Pictorial survey of the art and architecture of ancient Mesopotamia from Sumerian through Akkadian times.

Iran

597 Colledge, Malcom A. Parthian Art. Ithaca, N.Y., Cornell University Press, 1977. 200p. illus. index.

Survey of ancient Parthian art and architecture. Introduction provides a history of the Parthians. Special chapters on techniques, iconography, and style. Appendixes with principal scripts, chronological table of eras, list of kings. Bibliography (pp. 172-92) is an unclassified list of basic books and periodical articles.

Dieulafoy, Marcel A. L'art antique de la Perse. Paris, Librairie Centrale d'Architecture, 1884-89. 5v. illus.

Collection of plates and accompanying descriptive text of major works and sites of Achaemenian, Parthian, and Sassanian Persia. Partie 1: Monuments de la Vallée de Polvar-Roud; 2: Monuments de Persépolis; 3: La sculpture persépolitaine; 4: Les monuments vouté de l'époque achéménide; 5: Monuments parthes et sassanides. Bibliographic footnotes.

- 599 Diez, Ernst. Iranische Kunst. Vienna, Andermann, 1944. 238p. illus. index. Survey history of art and architecture in Iran from prehistoric times through the sixteenth century A.D. Bibliographical footnotes (pp. 233-35). Useful for the discussion of transition from ancient to Islamic Persian art.
 - Ghirshman, Roman. The Arts of Ancient Iran from Its Origins to the Time of Alexander the Great. New York, Golden Press, 1964, 439p. illus. (The Arts of Mankind, 5). LC 64-13072.

History of art and architecture in Iran from the prehistoric period through Achaemenian times. In addition to Iranian art and architecture, it covers Irano-Urartian and Scythian art. Provides a glossary-index, maps, chronological table, and a good bibliography (pp. 405-417), which lists books and periodical articles in all languages. Well illustrated.

Ghirshman, Roman. Persian Art: The Parthian and Sassanian Dynasties.
 New York, Golden Press, 1962. 344p. illus. index. (The Arts of Mankind,
 3). LC 62-19125.

Pictorial survey of the art and architecture of ancient Iran from 249 B.C. to 651 A.D. Provides a glossary-index, maps, and good annotated bibliography (pp. 369-77). Numerous plans, chronological tables, and reconstructions are used throughout.

Porada, Edith. The Art of Ancient Iran: Pre-Islamic Cultures. New York, Crown, 1965. 279p. illus. index. LC 65-15839.

Concise history of the art and architecture of ancient Iran from the Elamites through the Sassanians. Provides useful glossary of terms, map, chronological table, and a good basic bibliography (pp. 262-67). An excellent survey history for the general reader as well as for the beginning and advanced student.

Sarre, Friedrich P. T. Die Kunst des alten Persien. Berlin, Cassirer, 1922. 150p. illus. (Die Kunst des Ostens, Band V).

Survey history of Persian art and architecture from circa 550 B.C. to circa 636 A.D. Also includes material on the applied and decorative arts. Bibliography of basic books (pp. 57-59).

See also: Belloni (1459), Godard (1460), Pope (1462).

Anatolia

Akurgal, Ekrem. The Art of the Hittites. New York, Abrams, 1962. 315p. illus. index. LC 62-11624.

History of Hittite art and architecture from 2500 to 700 B.C. Excellent illustrations and a good, comprehensive bibliography (pp. 306-312) of books and periodical articles in all languages. A standard history of Hittite art and architecture. For the beginning and advanced student. The latter should be aware of translation errors and should consult the German original (Munich, 1961).

Akurgal, Ekrem. Die Kunst Anatoliens von Homer bis Alexander. Berlin, de Gruyter, 1961. 350p. illus. index.

Scholarly history of art and architecture of the Greeks, Phrygians, Lydians, Urartians, Persians, and other societies in Anatolia from circa 1000 B.C. to the middle of the fourth century B.C. Extensive footnotes with reference to specialized literature. Informative notes to the black and white plates, with further bibliography. Standard history of one phase of ancient Anatolian art.

Bittel, Kurt. Les Hittites. Paris, Gallimard, 1976. 332p. illus. index. (L'Universe des Formes, 24). LC 76-489568.

Translation of *Die Hethiter* (Munich, Beck, 1976). Well-illustrated survey of the art and architecture of ancient Anatolia from the end of the third to the beginning

of the first millenium B.C., with emphasis on Hittite civilization. Chronological table correlates events in Anatolia with those in other areas of the ancient Mediterranean. Maps and excellent classified bibliography of books and periodical articles in all languages (pp. 309-316).

- Bossert, Helmuth T. Altanatolien: Kunst und Handwerk in Kleinasien von den Anfängen bis zum volligen Aufgehen in der griechische Kunst.
 Berlin, Wasmuth, 1942. 112p. (text); 160p. (illus.). index. LC A47-2988. Illustrated handbook of the art and architecture of ancient Asia Minor from prehistoric times to the middle of the fourth century B.C. A standard survey and handbook with emphasis on the minor arts.
 - Vieyra, Maurice. Hittite Art 2300-750 B.C. London, Tiranti, 1955.
 91p. illus. LC A55-10301.

Series: "Chapters in Art." Pictorial survey of Hittite art and architecture. Bibliography of basic works in all languages (pp. 55-58).

Scythia

Artamonov, M. I. The Splendor of Scythian Art. New York, Praeger, 1966. 296p. illus. index. LC 68-31440.

Pictorial survey of the arts of the ancient Scythians from the sixth through the fourth century B.C., with emphasis on the remains from Russian tombs. Bibliography is brief and listed by the various Russian barrows.

Borovka, Grigorii I. Scythian Art . . . London, Benn; New York, Stokes, 1928. 111p. illus. index.

Brief survey of Scythian art illustrated chiefly with examples in Soviet collections. Bibliography of basic books and articles (pp. 12-14). Once a standby, it is now superseded by Artamonov (609).

Charrière, Georges. L'art barbare scythe. Paris, Éditions Cercle d'Art, 1971. 263p. illus. LC 75-865997.

Pictorial survey of the arts of the ancient Scythians. Provides a glossary of terms, informative notes to the plates, and brief bibliography (p. 259).

Jettmarr, Karl. Art of the Steppes. New York, Crown, 1967. 272p. illus. index. LC 67-17700.

Concise history of art of the ancient peoples of the Russian steppes. Covers the Scythians, Sarmatians, and societies of Eastern and Central Soviet Union from circa 900 B.C. to 200 A.D. Provides a valuable chronological table, maps, good color plates and an excellent classified bibliography of books in all languages (pp. 242-58). An excellent history of this complex and slighted area of ancient art history. For the beginning and advanced student.

Rice, Tamara T. The Scythians. London, Thames & Hudson, 1957. 255p. illus. index. LC A57-4905.

Concise survey of the arts of the ancient Scythians, with emphasis on their relationship to the general culture of the Scythians. Provides a chronological table, list of

major burial sites, and a useful bibliography of books (pp. 201-208), arranged by language.

Rostovtsev, Mikhail I. The Animal Style of South Russia and China . . . Princeton, Princeton University Press, 1929. 112p. illus. (Princeton Monographs in Art and Archaeology, XIV).

A survey of the arts of the ancient Scythians and Sarmatians, with an exploration of the relationship of these arts to Chinese art of the Han and Chou dynasties. Bibliographical footnotes. An old but still influential study.

Rostovtsev, Mikhail I. Iranians and Greeks in South Russia. Oxford, Clarendon Press, 1922. 260p. illus. index.

History of the arts of the major ancient civilizations of Southern Russia including the Scythians, Cimmerians, Sarmatians, and Greeks from the eighth century B.C. through the Roman period. Good bibliography (pp. 223-38). A standard work.

AEGEAN

Boardman, John. Pre-Classical: From Crete to Archaic Greece. Harmondsworth, Penguin, 1967. 186p. illus. index. LC 67-99818.

Concise history of art and architecture of the ancient Mediterranean from circa 3000 to 500 B.C. Covers the art of the Minoans, Mycenaeans, Etruscans, Scythians, and Greeks from the Geometric period through the Archaic period. Modest but well-chosen selection of plates. Bibliography (pp. 183-84) lists and annotates major books in English. Series: "Style and Civilization."

Bossert, Helmuth T. The Art of Ancient Crete, from the Earliest Times to the Iron Age . . . 3rd ed. London, Zwemmer, 1937. 44p. text, 304 illus. LC 38-15038.

Illustrated survey with notes to the plates. Some bibliographical references in the notes; chronological table of ancient Aegean civilizations.

- Demargne, Pierre. The Birth of Greek Art. New York, Golden Press, 1964. 446p. illus. index. (The Arts of Mankind, 6). LC 64-21312. Pictorial handbook-history of art and architecture in the Aegean including Minoan, Mycenaean, and Greek art of the early Archaic period. Richly illustrated and equipped with maps, plans, and reconstructions, plus a useful glossary-index and an extensive bibliography (pp. 421-30) with its own index.
 - Hafner, German. Art of Crete, Mycenae and Greece. New York, Abrams, 1969. 264p. illus. index. LC 68-28392.

Concise history of art and architecture in the ancient Aegean area and Greece from circa 2800 B.C. to 146 B.C. Covers Helladic, Cretan-Mycenaean, and Greek art and architecture. The introduction, which traces the main outlines of the development, is followed by a good collection of illustrations, arranged chronologically, and a brief introduction to the major periods. The illustrations have informative notes as well as captions. There are no plans for the architectural examples, but the work does provide a useful chronological table, a map, and a good, classified bibliography (pp. 258-60), which lists major books in all languages.

Higgins, Reynold A. Minoan and Mycenaean Art. New York, Praeger, 1967. 216p. illus. index. LC 67-27569.

Survey history of the art and architecture of ancient Crete, the Cyclades and mainland Greece to the late Bronze Age. Selected bibliography (pp. 195-96). A few brief bibliographical footnotes.

Marinatos, Spyridon. Crete and Mycenae. New York, Abrams, 1960. 177p. illus. index. LC 60-8399.

Survey history of the art and architecture of the ancient civilizations of Minoan Crete and Mycenaean Greece. Bibliography is found in notes to the plates and notes to the text. A good survey, with photographs by Max Hirmer.

- Matz, Friedrich. The Art of Crete and Early Greece: The Prelude to Greek Art. New York, Crown, 1962. 260p. illus. index. LC 62-20056. Survey history of art and architecture in the Aegean Islands and the Greek mainland from the Neolithic through the Mycenaean periods. Provides maps, glossary, chronological tables, and selected bibliography (pp. 248-50).
- Spiteris, Tony. The Art of Cyprus. New York, Reynal, 1970. 215p. illus. index. LC 75-128117.
 Illustrated survey of art of ancient Crete from Neolithic times to circa 58 B.C. Good plates. Maps, chronological table, and selected list of books (p. 215).
- Thimme, Jürgen, ed. Art and Culture of the Cyclades in the Third Millenium B.C. Chicago, University of Chicago Press, 1977. 617p. illus. index. LC 77-84340.

Comprehensive illustrated handbook of art, exclusive of architecture, of the Cyclades during the third millenium B.C. Based on an exhibition held in Karlsruhe. Consists of papers on various aspects of Cycladic art by internationally known experts, extensive catalogue to the excellent plates (with bibliographical references), glossary, maps, and good, classified bibliography of books and periodical articles in all languages (pp. 598-607). A standard work.

- Zervos, Christian. L'art de la Créte néolithique et minoenne. Paris, Éditions Cahiers d'Art, 1956. 523p. illus. index.

 Illustrated survey of ancient art and architecture of Neolithic and Minoan Crete, with excellent corpus of plates. Brief introductory text with useful chapter on major excavations on Crete.
- Zervos, Christian. L'art des Cyclades du début à fin de l'âge du bronze . . . Paris, Éditions Cahiers d'Art, 1957. 278p. illus. index.

 Comprehensive survey of the art of the Cycladic Islands from circa 2500 B.C. to circa 100 B.C. Includes chapters on major excavations and religion. Brief list of basic books in all languages (p. 271). Further references to specialized literature in the footnotes.

See also: Cossío and Pijoán (523).

CLASSICAL

General Works

627 Becatti, Giovanni. The Art of Ancient Greece and Rome: From the Rise of Greece to the Fall of Rome. New York, Abrams, 1967. 441p. illus. index. LC 67-12684.

Comprehensive history of the art and architecture of ancient Greece and Rome from the Archaic period through the late Roman period. Well illustrated with plates, plans, and reconstructions. Provides a glossary of terms and an excellent comprehensive bibliography (pp. 401-423). A standard history of classical art.

Bohr, Russel LeRoi. Classical Art. Dubuque, Iowa, W. C. Brown, 1967. 158p. illus. index. LC 67-21302.

Survey history of art and architecture of ancient Greece and Rome from the Stone Age through Constantinian Roman art. Provides maps on the end papers, tables of major works of art (with phonetic spelling), and a brief bibliography of basic works in English (pp. 149-52). Designed for the beginning student.

- Ducati, Pericle. L'arte classica. 3rd ed. Turin, Ed. Torinese, 1944. 829p. illus. index. (Storia dell'Arte Classica e Italiana, v. 1).

 History of art and architecture in ancient Greece and Rome. Well illustrated, it provides a useful chronological table, list of major museums and collections of classical art, and a bibliography (pp. 789-802), which lists major works in all languages. A standard Italian history of classical art and architecture.
- Kasper, Wilfried. Bruckmann's Handbuch der antiken Kunst. Munich, Bruckmann, 1976. 287p. illus. index. LC 77-456436. Well-illustrated handbook of ancient Greek and Roman art and architecture. The text supplies a good summary of the main outlines in the development of classical art.
- Kjellberg, Ernst, and Gosta Säfflund. Greek and Roman Art, 3000 B.C. to A.D. 550. New York, Crowell, 1968. 250p. illus. index. LC 68-20758. A survey history of art and architecture from the Aegean period through late Roman. Chronological table, glossary, and bibliography of major works in English (pp. 222-28). A general history and guide to classical art for the general reader and tourist.
- Rodenwaldt, Gerhart. Die Kunst der Antike; Hellas und Rom. 4th ed. Berlin, Propyläen, 1944. 770p. illus. index. (Propyläen Kunstgeschichte, III).

Comprehensive illustrated handbook of ancient Greek and Roman art and architecture. Introductory essays on the development of art in classical antiquity are followed by good corpus of plates with descriptive notes. Superseded by two volumes in the new Propyläen series (665, 708).

Rumpf, Andreas. Die griechische und römische Kunst. 4th ed. Leipzig, Teubner, 1931. 106p. (Einleitung in die Altertumswissenschaft, II, 3).

Survey history of the art and architecture of classical antiquity from Minoan Crete to the beginning of the fourth century A.D. Bibliographies at the end of each chapter. No illustrations.

634 Ruskin, Ariane. Greek and Roman Art. Adapted by Ariane Ruskin and Michael Batterberry. New York, McGraw-Hill, 1968. 192p. illus. index. LC 73-96242.

Pictorial survey of the architecture, sculpture, and painting of the ancient world, from Crete and Mycenae through the Roman Empire.

635 Strong, Donald E. **The Classical World.** New York, McGraw-Hill, 1965. 166p. illus. index. LC 65-21594.

Survey of the architecture, painting, sculpture, and minor arts of Greek and Roman civilizations, from Bronze Age Crete through late Roman art. Includes glossary, general bibliography (p. 169), and chronological table.

636 Zinserling, Gerhard. Abriss der griechischen und römischen Kunst. Leipzig, Reclam, 1970. 606p. illus. index. (Reclams Universal-Bibliothek, Band 435). LC 72-581110.

Concise history of art and architecture in ancient Greece and Rome from the second millennium B.C. to the middle of the fourth century A.D. A pocket-sized aid for students, it provides many useful assists: glossary of terms, chronological table, list of principal excavations, list of major museums of ancient art, and an excellent classified bibliography listing books and periodical articles. Additionally, there are special sections for periodicals and books of reference in fields relating to the study of ancient art and architecture.

Greek

- Akurgal, Ekrem. The Art of Greece: Its Origins in the Mediterranean and the Near East. New York, Crown, 1968. 258p. illus. index. LC 75-548860. A survey of the art and architecture of Archaic Greece and the neighboring cultures (Neo-Assyrian, Babylonian, Aramaean, Neo-Hittite, Phoenician, and Syrian). Provides glossary of terms, chronological tables, maps, and general bibliography. Useful survey of this otherwise slighted group of Eastern cultures that influenced the early development of Greek art.
- Arias, Paolo Enrico. L'arte della Grecia. Turin, Unione Torinese, 1967.
 951p. illus. index. (Storia universale dell'Arte, v. 2, t. 1). LC 68-109179.
 Comprehensive history of ancient Greek art and architecture from the Geometric period through the Hellenistic period. Well illustrated and provided with a good, classified bibliography (pp. 895-930) of books and periodical articles in all languages.
 - Beazley, John D., and Bernard Ashmole. Greek Sculpture and Painting to the End of the Hellenistic Period . . . 2nd ed. Cambridge, Cambridge University Press, 1966. 111p. illus. index.

General survey first published in 1932, here accompanied with a two-page appendix that is inadequate to bring the excellent older work up to date.

640 Boardman, John. Greek Art. Rev. ed. New York, Praeger, 1973. 286p. illus. index. LC 90-414.

Concise survey of art and architecture in ancient Greece from the Geometric period through the Hellenistic period. Chronological table and selected bibliography (pp. 271-72). Best for early periods, i.e., Geometric through Archaic.

641 Boardman, John, José Dörig, and Werner Fuchs. The Art and Architecture of Ancient Greece. New York, Abrams, 1967. 600p. illus. index. LC 67-22850.

Comprehensive, well-balanced handbook of the art and architecture of ancient Greece, richly illustrated with photographs by Max Hirmer and numerous plans, maps, and reconstructions. Selected, general bibliography (pp. 587-88), and extensive bibliographical references in the notes to the text.

Brilliant, Richard. Arts of the Ancient Greeks. New York, McGraw-Hill, 1973. 406p. illus. index. LC 72-14098.

Concise history of the art and architecture of ancient Greece from Mycenaean times through the Hellenistic period. Excellent selection of plates, plans, and diagrams. Bibliographies at the end of each chapter list major books and periodical articles in all languages.

Brunn, Heinrich. Geschichte der griechischen Künstler. Stuttgart, Ebner
 & Seubert, 1889. 2v. illus.

Important, early history of ancient Greek art and architecture from the Ancient period through the Hellenistic, with emphasis on major personalities. First volume covers sculptors; the second, painters, architects, and applied and decorative artists. Bibliographical footnotes.

Brunn, Heinrich. Griechische Kunstgeschichte. Munich, Bruckmann, 1893-1897. 2v. illus. index.

First parts of an uncompleted comprehensive history of ancient Greek art and architecture. Contents: Band I: Die Anfänge und die älteste decorative Kunst; Band II: Die archäische Kunst. Bibliographical footnotes.

645 Chamoux, François. Greek Art. Greenwich, Conn., New York Graphic Society, 1966. 97p. illus. index. LC 65-21746.

Pictorial survey of the art and architecture of ancient Greece from Mycenaean times through Hellenistic. Excellent plates. Brief bibliography of recent works in English. For the general reader.

Charbonneaux, Jean, Roland Martin, and François Villard. Archaic Greek Art (620-480 B.C.). New York, Braziller, 1971. 437p. illus. index. (The Arts of Mankind, 14). LC 78-13166.

Pictorial history of ancient Greek art and architecture during the Archaic period, particularly strong on influences of the ancient Near East. Provides a useful glossary-index, maps, plans, and reconstructions, and a very thorough bibliography (pp. 385-95) with its own index. With the sequel volumes (647 and 648) by the same authors, it forms a good pictorial handbook of ancient Greek art and architecture.

647 Charbonneaux, Jean, Roland Martin, and François Villard. Classical Greek Art (480-330 B.C.). New York, Braziller, 1972. 422p. illus. index. (The Arts of Mankind, 16). LC 72-80015.

Pictorial history of art and architecture in ancient Greece during the classical period. Richly illustrated. Provides useful chronological table, glossary-index, maps, and good bibliography (pp. 367-77). Sequel to (457). Together with other volumes in the series (646 and 648), it forms a valuable pictorial handbook.

Charbonneaux, Jean, Roland Martin, and François Villard. Hellenistic Art (330-50 B.C.). New York, Braziller, 1973. 421p. illus. index. (The Arts of Mankind, 18). LC 72-89850.

Excellent, well-balanced pictorial history of art and architecture in ancient Greece during the Hellenistic period. Richly illustrated. Provides chronological table, glossary-index, maps, and good bibliography (pp. 371-82). Sequel to (647). Together with other volumes in the series (646 and 647), it forms a valuable pictorial handbook for advanced students, while the texts are concise enough for the general reader and beginning student.

649 Carpenter, Rhys. Greek Art: A Study of the Formal Evolution of Style. Philadelphia, University of Pennsylvania Press, 1962. 256p. illus. index. LC 61-6619.

Survey of art and architecture in ancient Greece from the Archaic through Hellenistic periods, with an emphasis on stylistic development. No bibliography.

- Cook, Robert M. Greek Art: Its Development, Character and Influence. New York, Farrar, Straus, Giroux, 1973. 277p. illus. LC 72-84781. Handbook-history of ancient Greek art, arranged by media. Contains a brief but usefully annotated bibliography (pp. 261-66). Good glossary and useful section on Greek art in museums. Good, workmanlike handbook; similar to but more up-to-date than Richter (661). Lacks bibliographical references for more serious study.
- Cossío, Manuel B., and José Pijoán y Soteras. El arte griego hasta la toma de Corinto por los romanos (146 A.J.C.). Bilbao and Madrid, Espasa-Calpe, 1932. 591p. illus. index. (Summa Artis, Historia General del Arte, IV).
 Comprehensive history of Greek art and architecture from the post-Mycenaean period to 146 B.C., when the Romans took Corinth. Brief bibliographies of books in all languages at the ends of chapters.
- Hamann, Richard. Griechische Kunst; Wesen und Geschichte. Munich,
 Droemersche Verlagsanstalt, 1949. 459p. illus. index.
 History of art and architecture of ancient Greece from Minoan times through the Hellenistic period. Combines stylistic history with form concept analysis. Bibliography (pp. 456-59) lists books in all languages.
 - 653 Havelock, Christine M. Hellenistic Art: The Art of the Classical World from the Death of Alexander to the Battle of Actium. Greenwich, Conn., New York Graphic Society, 1970. 282p. illus. index. LC 79-85795.

Illustrated handbook of Hellenistic art and architecture. Introductory essay followed by notes to the plates with bibliographical references. Emphasizes sculpture.

Holloway, R. Ross. A View of Greek Art. Providence, R.I., Brown University Press, 1973. 213p. illus. index. LC 72-187947.

History of ancient Greek art and architecture, with an emphasis on the purpose or use. Covers the periods from Archaic through Hellenistic and deals chiefly with monumental art. A brief bibliographical note (p. 203), maps, and chronological table of the periods of ancient Greek art and architecture round it out.

655 Homann-Wedeking, Ernst. The Art of Archaic Greece. New York, Crown, 1968. 224p. illus. index. LC 68-16898.

Concise survey of the art and architecture of ancient Greece during the Archaic period, circa 600-480 B.C. Provides a useful glossary, map, and chronological table. General bibliography (pp. 209-211) and further bibliographical references in the notes to the text. Together with the sequel volumes in the same series (637, 664, and 671), it forms a good history of the art and architecture of ancient Greece.

656 Klein, Wilhelm. Geschichte der griechischen Kunst. Leipzig, Verlag von Veit & Comp., 1904-1907. 3v. illus. index.

Comprehensive history of ancient Greek art and architecture from the Archaic period through the first century B.C. Chapters are devoted to periods, regions, artists and architects, and major monuments. Extensive bibliographical footnotes. A standard, older work with thorough coverage of the earlier literature.

Lübke, Wilhelm, and Erich Pernice. Die Kunst der Griechen . . . 17th ed. Vienna, Neff, 1948. 464p. illus. index. (Grundriss der Kunstgeschichte, Band 1).

Latest edition, reworked by Berta Sarne, of the volume of ancient Greek art and architecture from the standard, older, multi-volume history of art. Contents: Vorgeschichte (Troja, Kykladen, Kreta, Mykenä); Die griechische Architektur; Plastik; Kunsthandwerk; Malerei. One-page bibliography of basic books in German. A good stylistic history.

658 Matz, Friedrich. Geschichte der griechischen Kunst; I, Die geometrische und früharchaische Form. Frankfurt/Main, Klostermann, 1949. 2v. illus. index.

The only volume to appear in a projected comprehensive history of ancient Greek art and architecture. Covers the Geometric and early Archaic periods. Volume one, text; volume two, plates (which are excellent). Thorough bibliography (pp. 511-38) lists books and periodical articles in all languages. Even though it is incomplete, it is a major work for the advanced student.

Pollitt, J. J. Art and Experience in Classical Greece. London, Cambridge University Press, 1972. 205p. illus. index. LC 74-160094.

A history of art and architecture in ancient Greece from circa 480 to 323 B.C., with emphasis on the interrelationship of the fine arts and the general cultural

climate. Bibliography (pp. 199-202) is a useful commentary on the major scholarly interpretations of classical Greek art.

- Richter, Gisela M. A. Archaic Greek Art against Its Historical Background; A Survey. New York, Oxford University Press, 1949. 226p. illus. index. History of Greek art from circa 650 to circa 480 B.C. Bibliography of books and periodical articles given with the abbreviations (pp. xiii-xviii). A standard work, but should be used together with Charbonneaux and Homann-Wedeking (646, 655).
- Richter, Gisela M. A. A Handbook of Greek Art: A Survey of the Visual Arts of Ancient Greece. 6th ed. London and New York, Phaidon, 1969. 431p. illus. index. LC 75-443770.

Handbook-history of ancient Greek art from the Archaic period through the Hellenistic period. Treats the various arts separately by type, with good attention to the minor arts. Provides glossary, maps, tentative chronology of Greek sculptural work, and a good bibliography of basic literature (pp. 399-410). Further reference to specialized literature in the notes. A standard handbook of Greek art and architecture that emphasizes sculpture.

- Robertson, Martin. A History of Greek Art. Cambridge, Cambridge University Press, 1975. 2v. illus. index. LC 73-79317.

 Comprehensive history of Greek art, excluding architecture, from Geometric and Orientalizing periods through the Hellenistic period. Volume of text and volume of plates. Written as a continuous history in which the various media are treated together. Reference to specialized literature in the notes; general, unclassified bibliography of basic works (pp. 740-59).
- Salis, Arnold von. Die Kunst der Griechen . . . 4th ed. Zurich, Artemis-Verlag, 1954. 328p. illus. index.
 First published in 1919. Influential, formalistic history of ancient Greek art, exclusive of architecture, from the Geometric through the Hellenistic periods.
 Bibliography (p. 327) is a brief list of basic books in German.
- Schefold, Karl. The Art of Classical Greece. New York, Crown, 1967. 294p. illus. index. LC 67-17705.

History of the art and architecture of ancient Greece during the Classical period, circa 480-330 B.C. Provides a useful glossary of terms, a map, and a chronological table. General bibliography (pp. 236-45) and further bibliography in the notes to text. Together with other volumes in the series (637, 655, and 671), it forms a good history of art and architecture in ancient Greece.

Schefold, Karl. Die Griechen und ihre Nachbarn. Berlin, Propyläen, 1967. 372p. (text); 432p. (illus.). index. LC 67-109553.

Comprehensive illustrated handbook of the art and architecture of ancient Greece from the Geometric period through the Hellenistic period, and the art and architecture of the neighboring civilizations in the Near East (Phrygian, Lydian, Scythian, Iranian to the Seleucids) and the western Mediterranean (Phoenician and Iberian, and Italy before Rome). The introductory essay is by Schefold, and

there are additional essays on the development of the various arts by leading European specialists. Excellent illustrations, numerous plans and elevations in the notes. Long, very informative notes to the illustrations (with references to specialized literature) and a very good comprehensive bibliography (pp. 343-55). The finest handbook for ancient Greek art.

- Schoder, Raymond V. Masterpieces of Greek Art. Greenwich, Conn.,
 New York Graphic Society, 1965. 121p. illus. LC 65-6508.
 Brief pictorial survey of ancient Greek art and architecture. Excellent illustrations.
 For the general reader.
- 667 Schuchhardt, Walter H. Greek Art. New York, Universe, 1972. 189p. illus. index. LC 70-17860.

Concise history of art and architecture in ancient Greece from the Archaic through the Hellenistic periods. Brief bibliography of major works (pp. 186-87). Excellent condensed history for the beginning student, with many well-chosen illustrations and informative captions.

Schweitzer, Bernard. Greek Geometric Art. New York, Phaidon, 1971. 352p. illus. index. LC 71-111066.

Detailed examination of the history of ancient Greek art of the Proto- and Geometric periods. Chapters are devoted to individual media and major classes of art objects. Chapter on architecture is less comprehensive. Extensive bibliographic footnotes.

Seltman, Charles. **Approach to Greek Art.** New York, Dutton, 1960. 143p. illus. index.

Unusual survey of ancient Greek art from Archaic times through the Hellenistic period. Emphasizes the dominant role of celature, i.e., the art of embossing on metal, most notably in the creation of coins. Brief bibliography of basic books (p. 122).

- Vermeule, Emily. Greece in the Bronze Age. Chicago, University of Chicago Press, 1964. 406p. illus. index. LC 64-23427.
 Reprinted in 1972. Cultural history of ancient Greece from the end of the Stone Age to the end of Mycenaean and Minoan civilizations. Good bibliography of books and periodical articles in all languages (pp. 351-83). Glossary of terms.
- Webster, Thomas Bertram L. The Art of Greece: The Age of Hellenism. New York, Crown, 1966. 243p. illus. index. LC 66-26188.

 Concise history of the art and architecture of ancient Greece during the Hellenistic period, circa 330-50 B.C. Provides a useful glossary of terms, a map, and a chronological table. General bibliography (pp. 224-32) and further bibliography in the notes to the text. Together with other volumes in the series (637, 655, and 664), it forms a good history of ancient Greek art.

Etruscan

- 672 Bianchi Bandinelli, Ranuccio, and Antonio Giuliano. Etruschi e Italici prima del dominio di Roma. Milan, Rizzoli, 1973. 437p. illus. index. Pictorial history of the art and architecture of the Etruscan and ancient Italians. Richly illustrated. Provides useful chronological table, glossary-index, maps, and good, classified bibliography of books and periodical articles in all languages (pp. 389-98).
- 673 Bloch, Raymond. Etruscan Art: A Study. Greenwich, Conn., New York Graphic Society, 1966. 103p. illus. index. LC 65-22674.

 Brief history of Etruscan art and architecture. Good illustrations.
- Busch, Harold, ed. Etruskische Kunst. Frankfurt am Main, Umschau Verlag, 1969. 59p. text, 134 plates. LC 71-579548.
 Illustrated survey of Etruscan art and architecture. Introductory essay by W. Zchietzschmann traces the outlines of Etruscan art and architecture. A good corpus of black and white illustrations follows.
- Dohrn, Tobias. Grundzüge etruskischer Kunst. Baden-Baden, Grim, 1958. 64p. illus. (Deutscher Beiträge zur Altertumswissenschaft, Heft 8). Scholarly analysis of the basic stylistic character of ancient Etruscan art, exclusive of architecture. Important chapters on the process of absorbtion of Greek influences by Etruscan art and the Etruscan contribution to Roman art. Bibliographic footnotes.
- Ducati, Pericle. Storia dell'arte etrusca. Florence, Rinascimento del Libro, 1927. 2v. illus. index.

Comprehensive history of Etruscan art and architecture. Volume one is text; volume two is plates. Good bibliographies given at the end of each chapter. Once a standard history, it is now out of date. Nevertheless, it is still useful to the advanced student for its plates and its bibliography of older literature.

- 677 Frova, Antonio. L'arte etrusca. Milan, Garzanti, 1957. 110p. illus. index. Illustrated survey of Etruscan art and architecture. Selected bibliography of books in all languages (pp. 104-108).
- 678 Giglioli, Giulio Q. Arte Etrusca. Milan, Treves, 1935. 95p. illus. index. LC 36-14223.

Pictorial handbook to ancient Etruscan art and architecture. Still a valuable collection of illustrations for the beginning and advanced student.

Hess, Robert. Das etruskische Italien; Entdeckungsfahrten zu den Kunststätten und Nekropolen der Etrusker. Cologne, DuMont-Schauberg, 1974. 285p. illus. index. LC 73-345438.

Comprehensive, pocket-sized handbook to the major Etruscan archaeological sites. Introductory chapters survey Etruscan history and art and are followed by a geographically arranged description of the major sites. Bibliography (pp. 267-71) lists basic books in all languages.

Mansuelli, Guido Achille. The Art of Etruria and Early Rome. New York, Crown, 1965. 255p. illus. index. LC 65-24336.

Concise, well-illustrated history of Etruscan art and architecture and the art and architecture of the Republican period of Rome. Provides a useful glossary of terms, a map, a chronological table, and an appendix on the Etruscan tombs. General bibliography (pp. 240-46) is excellent except that it does not note English translations of certain key titles.

Martha, Jules. L'art étrusque. Paris, Firmin-Didot, 1889. 635p. illus. index. LC F-3664.

Older, once standard handbook of Etruscan art and architecture. Illustrated with line drawings. Bibliographical footnotes.

Matt, Leonard von. The Art of the Etruscans. Photos by Leonard von Matt. Text by Mario Moretti and Guglielmo Maetzke. New York, Abrams, 1970. 252p. illus. index. LC 70-125781.

Illustrated handbook of the art and architecture of the ancient Etruscans, arranged by place. For the general reader, the beginning student, and the tourist.

Mühlestein, Hans. Die Etrusker im Spiegel ihrer Kunst. Berlin, Deutscher Verlag der Wissenschaften, 1969. 324p. illus. LC 71-423275.

Part one covers Etruscan history; part two surveys the history of Etruscan art exclusive of architecture. Extensive bibliographic footnotes. One of the best cultural histories of the ancient Etruscans.

Pallottino, Massimo. The Etruscans. Baltimore, Penguin, 1956. 295p. illus. index. LC 56-53.

History of Etruscan civilization, with strong emphasis on its art and architecture. Good selection of plates. Brief bibliography (pp. 281-82) lists major books in all languages. A standard cultural history.

Pallottino, Massimo, and Martin Hürlimann. Art of the Etruscans. New York, Vanguard, 1955. 154p. illus. LC 56-39.

Pictorial survey of the art and architecture of the ancient Etruscans. Emphasis is on painting and sculpture; only tomb architecture is included. Brief but sensible text is followed by a fine collection of plates with informative notes. Provides a map, a chronological table, and a brief bibliography (p. 29) that lists major books in all languages.

Richardson, Emeline Hill. The Etruscans, Their Art and Civilization. Chicago, University of Chicago Press, 1964. 285p. illus. index. LC 64-15817.

History of the arts and civilization of the ancient Etruscans from the prehistoric period through the Hellenistic period. Good general bibliography (pp. 251-63) and further reference to specialized literature in the notes to the plates. One of the best surveys of Etruscan art, except for paucity of illustrations. Reprinted (1976) by publisher.

687 Riis, Poul J. An Introduction to Etruscan Art. Copenhagen, Munksgaard, 1941. 144p. illus. index.

Collection of lectures on various aspects of Etruscan art and architecture, some out of date, others still useful to the beginning student. Bibliographical references are given at the end of each chapter.

See also: Cossío and Pijoán (697), Hafner (702), Kraus (708).

Roman

Andreae, Bernard. The Art of Rome. New York, Abrams, 1978. 656p. illus. index. LC 75-8855.

Sumptuously illustrated history and handbook of ancient Roman art and architecture. Part one, City to Empire to World Spirit, traces the development of art and architecture within the general cultural context. Part two, The Image as Document, provides an extensive collection of illustrations chronologically arranged to demonstrate the continuity and evolution of style. Part three is a catalog of descriptions of major archaeological sites, with bibliographies of specialized literature. Glossary of terms, genealogical tables of the Roman emperors, chronological table of major events in Roman history. Color plates of exceptional quality.

- 689 Becatti, Giovanni. L'arte romana. Milan, Garzanti, 1962. 139p. illus. Concise history of ancient Roman art and architecture from its beginnings to the end of the fourth century A.D. Glossary of terms, brief bibliography of books in Italian.
- 690 Bertman, Stephen. Art and the Romans. A Study of Roman Art as a Dynamic Expression of Roman Character. Lawrence, Kansas, Coronado Press, 1975. 83p. illus. index.

Sketchy attempt to discern manifestations in Roman art and architecture of such broad themes as war and peace, conquest of space, and Rome and Jerusalem. Suggestions for further reading (pp. 75-81).

Bettini, Sergio. L'arte alla fine del mondo antico. Padua, Editorial Liviana, 1948. 139p. illus. index. LC 50-17294.

Concise history of Roman art and architecture of the third through the fifth centuries A.D. No bibliography.

692 Bianchi Bandinelli, Ranuccio. Rome, the Center of Power: Roman Art to A.D. 200. New York, Braziller, 1970. 455p. illus. index. (The Arts of

Mankind, 15). LC 79-526920.

Illustrated history of Roman art and architecture from Republican times to 200 A.D. Provides excellent illustrations, numerous maps, plans, reconstructions, and chronological and genealogical tables. A good comprehensive bibliography (pp. 391-96). Together with vol. 16 and 17 in the series (by the same author), it forms a good pictorial handbook-history.

693 Bianchi Bandinelli, Ranuccio. Rome, the Late Empire: Roman Art A.D. 200-400. New York, Braziller, 1971. 463p. illus. index. (The Arts of Mankind, 16). LC 71-136167.

Illustrated history of the art and architecture of ancient Rome during the third and fourth centuries A.D. Provides a glossary-index, a chronological table, numerous plans and reconstructions, and a good bibliography (pp. 411-21). Together with another volume in the series (692), it forms a good pictorial handbook-history of ancient Roman art and architecture.

Brilliant, Richard. Roman Art from the Republic to Constantine. London, New York, Phaidon, 1974. 288p. illus. index. LC 74-1527.

Well-illustrated survey of Roman art and architecture. Part one treats major themes in Roman art; part two, the history of period styles in Roman art. Chronological table and bibliography arranged by chapters (pp. 269-72) provides a good overview of the major books and articles in all languages.

695 Chapot, Victor. Les styles du monde romain. Paris. Larousse, 1943, 144p. illus. index.

Concise stylistic history of ancient Roman art and architecture from Republican times to the end of the Empire. Chapter on architectural construction. Glossary, topographic index with summaries of the monuments, and bibliography (pp. 139-40) listing basic books in all languages. Volume in the series, "Arts, Styles, et Techniques."

696 Charbonneaux, Jean. L'art au siècle d'Auguste. Lausanne, Guilde du Livre, 1948. 108p. text, 101 plates. LC 49-27633.

Survey of the art of ancient Rome from the middle of the first century B.C. to the middle of the first century A.D. Good collection of plates. Bibliographical

footnotes.

697 Cossío, Manuel B., and José Pijoán y Soteras. El arte romano hasta la muerte de Diocleciano. Arte etrusco y arte helenístico después de la toma de Corinto. Bilbao and Madrid, Espasa-Calpe, 1934. 591p. illus. index. (Summa Artis, Historia General del Arte, V).

Comprehensive survey of Roman art and architecture, including both Roman Hellenistic and Etruscan aspects. Brief lists of books at the end of chapters.

Ducati, Pericle. L'arte in Roma dalle origini al sec. VIII . . . Bologna, Cappelli, 1938. 500p. illus. index.

History of art and architecture in ancient Rome from early Republican times through the eighth century. Well illustrated and provided with a good annotated bibliography (pp. 421-36).

Essen, Carel C. van. **De kunst van het oude Rome.** The Hague, Servire, 1954. 105p. illus. index. LC A55-4049.

Concise history of Roman art by a leading Dutch scholar. Emphasis on contribution of Italy. Bibliography of basic books (p. 106).

- Essen, Carel C. van. Précis d'histoire de l'art antique en Italie. Brussels, Latomus, 1960. 151p. index. (Collection Latomus, 42).

 Unusual attempt to trace the history of art and architecture in Italy, as a regional phenomenon, from circa 200 B.C. to circa 700 A.D. Extensive hibliographic
- Unusual attempt to trace the history of art and architecture in Italy, as a regional phenomenon, from circa 900 B.C. to circa 700 A.D. Extensive bibliographic footnotes.
 - Frova, Antonio. L'arte di Roma e del mondo romano. Turin, Unione Torinese, 1961. 947p. illus. index. (Storia Universale dell'Arte, v. 2, t. 2). LC 61-49278.

Comprehensive history of Roman art and architecture from Etruscan times through the fourth century A.D. Well illustrated and provided with a good classified bibliography (pp. 839-93) that lists books and periodical articles in all languages.

Hafner, German. Art of Rome, Etruria and Magna Graecia. New York, Abrams, 1969. 264p. illus. index. LC 71-92911.

Concise history of art and architecture of the Etruscans and ancient Romans from the eighth century B.C. through the fourth century A.D. An introduction sketching the main outlines of the development is followed by a good selection of illustrations, arranged chronologically, and a brief introduction to the chief periods of ancient Etruscan and Roman art. The plates are accompanied by informative notes in addition to the captions. Unfortunately, there are no plans for the architectural examples. Does have a good chronological table, maps, and a good, classified bibliography (pp. 257-59) that lists books in all languages.

703 Hanfmann, George M. A. Roman Art. A Modern Survey of the Art of Imperial Rome. New York, New York Graphic Society, 1964. 328p. illus. index. LC 64-21814.

Pictorial survey arranged by media. Introductory essay and short essays on periods of Roman art. Notes to the plates give some references to specialized literature. Bibliography of basic books (pp. 53-55).

704 Heintze, Helga. Roman Art. New York, Universe, 1971. 200p. illus. index. LC 79-134759.

Concise history of art and architecture of the ancient Romans from 600 B.C. to 500 A.D. Good selection of plates, plans, and diagrams. Succinct and informative text and illustration captions. Bibliography (pp. 193-95) lists major books in all languages. A good survey of Roman art and architecture for the beginning student.

Kähler, Heinz. The Art of Rome and Her Empire. New York, Crown, 1963. 262p. illus. index. LC 63-14558.

Concise history of art and architecture in ancient Rome from the time of Augustus to that of Constantine. Provides a useful glossary of terms, a chronological table, a map, and a bibliography of basic works (pp. 216-24). Mansuelli's volume (680) in the same series treats earlier Roman art. Useful chapter on fundamental characteristics of Roman art.

Kaschnitz von Weinberg, Guido. Römische Kunst. Reinbek bei Hamburg, Rowohlt, 1961-1963. 4v. illus. index. LC NUC66-84856.

Comprehensive history of the art and architecture of ancient Rome, beginning with Republican times and ending with the fourth century. Volume one is a general introduction that explores the concept of Roman art, the problem of Roman art form, the origins of Roman art, and the general historical background to Roman art. Volume two is a history by types of Roman sculpture; volumes three and four cover the history of Roman architecture. Provides a chronological table, brief bibliography at the end of each volume, and an index at the end of volume four. A basic work for advanced students. Emphasizes form in the tradition of Alois Riegl.

707 Koch, Herbert. Römische Kunst. 2nd ed. Weimar, Böhlaus, 1949. 160p. illus. index.

Concise history of art and architecture in ancient Rome from early Republican times through the fifth century. Chronological outline (pp. 151-54) and selected bibliography (pp. 145-50). A brief but well-written general history of Roman art and architecture.

Kraus, Theodor. Das Römische Weltreich. Berlin, Propyläen, 1967.
 336p. (text); 414p. (illus.). index. (Propyläen Kunstgeschichte, 2).
 LC 68-70295.

Comprehensive illustrated handbook of the art and architecture of ancient Rome and its dominions from late Etruscan times through the fifth century. Introductory essay is followed by sections on the development of the various arts, written by a number of specialists. Excellent illustrations, numerous plans and elevations, and very informative notes to the illustrations, with references to specific bibliography. Good comprehensive bibliography (pp. 305-319). One of the finest handbooks of ancient Roman art.

Lübke, Wilhelm, and Ernst Pernice. Die Kunst der Römer. New edition reworked by Berta Sarne. Vienna, Neff, 1958. 455p. illus. index. (Grundriss der Kunstgeschichte, Band 1). LC 59-5011.

Comprehensive history of ancient Roman art and architecture from its beginnings to the end of the fourth century A.D. Chapter on architecture is particularly thorough, treating the basic systems of construction and the development of the major building types. Bibliography (pp. 450-54) provides a good, classified list of books and periodical articles in all languages. Latest edition of the volume on Rome in an older, standard multi-volume history of art.

Riegl, Alois. Spätrömische Kunstindustrie. 2nd ed. Vienna, Österreichischen Staatsdruckerei, 1927. 422p. illus. index. Reprint: Darmstadt, Wissenschaftliche Buchgesellschaft, 1964.

First published in 1901. Highly influential history and analysis of the art and architecture of the third through the sixth centuries A.D. Introduction examines the past attitudes to late Roman and Early Christian art. Separate chapters are devoted to the analysis of architecture, sculpture, painting, and the minor arts. Conclusion summarizes the basic qualities of late Roman art. Riegl's work was one of the first to seriously reevaluate a period that was previously seen only as one of artistic decline. Bibliographical footnotes. Classified bibliography of basic books and periodical articles (pp. 413-16). Appendix with important essay on Riegl by Otto Pächt.

711 Rumpf, Andreas. Stilphasen der spätantiken Kunst; Ein Versuch. Cologne, Westdeutsche Verlag, 1957. 52p. text, 40p. illus. (Arbeitsgemeinschaft für Forschung des Landes Nordrhein-Westfalen. Geisteswissenschaften. Abhandlung 44).

Scholarly history of the development of late Roman art, exclusive of architecture, from the fourth through the sixth centuries. Based on lectures delivered in Copenhagen and Bonn in 1953. Extensive bibliographical footnotes. A standard work; see also Kitzinger (796).

Strong, Donald. Roman Art. Harmondsworth, Penguin, 1976. 256p. illus. index. (Pelican History of Art, Z 39).

Scholarly history of Roman art exclusive of architecture, which is treated in a separate volume in the same series, *Etruscan and Roman Architecture* by Axel Boëthius and J. B. Ward-Perkins (1970). Strong covers the period from early Republican times through the fourth century A.D. Lacks detailed footnotes due to author's death. Bibliography (pp. 175-84) compiled by Jocelyn Toynbee. Not as comprehensive a work as the companion volume on architecture, but still an important history.

Strong, Eugénie. Art in Ancient Rome . . . New York, Scribner's, 1928.
 2v. illus. index. Repr.: Westport, Conn., Greenwood Press, 1970. 220p. illus. index. LC 72-109858.

Handbook of ancient Roman art from the early Republican period through the fifth century A.D. Does not cover architecture. Once a standard history, it is still valuable for its succinct stylistic analysis and its organization.

- Toynbee, Jocelyn M. C. The Art of the Romans. New York, Praeger, 1965. 271p. illus. index. (Ancient People and Places, v. 43). LC 65-20080. Concise history of the art but not the architecture of ancient Rome from the sixth century B.C. to the end of the fifth century A.D. General bibliography (pp. 183-89) and further references to specialized literature in the footnotes and notes to the plates. One of the best modern surveys of Roman art.
- 715 Wheeler, Robert Eric Mortimer. Roman Art and Architecture. New York, Praeger, 1964. 250p. illus. index. LC 64-22933.

 Concise history of art and architecture in ancient Rome from Republican through late Roman times with emphasis on architecture. The arts are surveyed separately by medium. Short bibliography (p. 237).
- Wickhoff, Franz. Roman Art; Some of Its Principles and Their Application to Early Christian Painting . . . London, Heinemann; New York, Macmillan, 1900. 198p. illus. index.

General survey history of Roman art as the background to the art of the Early Christian and Early Byzantine periods, with special reference to the "Vienna Genesis." An influential work in its time. Bibliographic footnotes.

GERMANIC AND CELTIC

717 Adama van Scheltema, F. Die altnordische Kunst: Grundprobleme vorhistorischer Kunstentwicklung. 2nd ed. Berlin, Mauritius, 1924. 252p. illus. index.

Comprehensive history of the art of Europe from paleolithic times through the Iron Age art of the Germanic peoples. Illustrated with line drawings and a few plates. Extensive bibliography in the footnotes. In many aspects, out of date and still controversial in approach, yet a classic study of the development and significance of prehistoric and migration art in Europe.

Allen, John R. Celtic Art in Pagan and Christian Times. 2nd ed. London, Methuen, 1912. 315p. illus. index.

Survey of Celtic art, with emphasis on the British Isles, from the early Bronze age to circa 1100 A.D. Bibliographic footnotes. For its time, a remarkably comprehensive and well-illustrated survey.

719 Déchelette, Joseph. Manuel d'archéologie préhistorique celtique et gallo-romaine. Paris, Picard, 1908-1934. 6v. illus. index. Reprint of first two volumes: Farnborough, Gregg, 1971.

Handbook of Celtic and Gallo-Roman archaeology. Useful information on the fine arts. Volume one covers prehistoric archaeology; volumes two through four, Celtic archaeology; the remaining volumes, Gallo-Roman archaeology. Each volume has extensive bibliographies. A standard handbook.

- Duval, Paul-Marie. Les celtes. Paris, Gallimard, 1977. 323p. illus. index. Pictorial survey of Celtic art on the European continent and the British Isles from 450 B.C. to the fourth century A.D. Richly illustrated. Provides useful chronological table, maps, glossary-index, and excellent bibliography (pp. 299-307) listing 356 books and periodical articles in all languages. List of principal museums with collections of Celtic art.
- Paris, Michel, 1965. 263p. illus. index. LC 66-56194.

 Concise history of the art of the ancient Celts and Germanic peoples from 500 B.C. through the fifth century A.D. Also covers provincial Roman art in Gaul. Provides excellent color plates, a supplementary collection of black and white plates, maps, diagrams, drawings, a chronological table, and a good classified bibliography of major works in all languages (pp. 241-49). This is the French edition of the "Art of the World Series"; it may soon be translated into English. A good survey history of a period otherwise neglected in the general literature.
- Fettich, Nándor. Die altungarische Kunst. Berlin, Kupferberg, 1942. 54p. text; 60p. illus. (Schriften zur Kunstgeschichte Südösteuropas, I). Brief but still useful survey of the art of the migrations period in Hungary. Bibliography of books and periodical articles (pp. 53-54).
 - Finlay, Ian. Celtic Art: An Introduction. London, Faber and Faber, 1973. 183p. illus. index. LC 72-89198.

Concise history of Celtic art in Europe, exclusive of architecture, from the Hallstatt period through the fourteenth century. Good selection of plates and a brief, unclassified bibliography (pp. 174-75).

724 Grenier, Albert. Manuel d'archéologie gallo-romaine. v. 1—. Paris, Picard, 1931—. illus. index.

Comprehensive handbook of Gallo-Roman archaeology with much information on Celtic and Gallo-Roman art and architecture. Continues Déchelette (495). Contents: Tome 1, *Généralités: travaux militaires*; Tome 2, *Archéologie du sol*; Tome 3, *L'architecture*; Tome 4, *Les monuments* (2v.). A basic handbook.

Holmqvist, Wilhelm. Germanic Art During the First Millenium A.D. Stockholm, Almquist & Wiksell, 1955. 89p. illus. (Kungl. Vitterhets Historie och Antikvitets Akadiemiens Handlingar, Del. 90).
 Survey of Germanic art from late Roman times to the end of the Viking period.
 Bibliography (pp. 79-84) is an unclassified list of books and periodical articles in all languages. Further reference to specialized literature in the footnotes. A

standard work on Germanic art.

Jacobsthal, Paul. Early Celtic Art. Oxford, Clarendon Press, 1970. 2v. illus. index. LC 73-16002.

Reissue of the 1944 edition. Comprehensive study of Celtic art of the third through the early second century B.C. Does not cover Celtic art in Spain and Portugal. The excellent selection of plates is accompanied by a catalog with reference to specialized literature. A standard history-handbook of Celtic art.

- Jenny, Wilhelm Albert von. Die Kunst der Germanen im frühen Mittelalter. Berlin, Deutsche Kunstverlag, 1940. 151p. illus. History of the arts of the Germanic peoples from the first through the tenth centuries. Covers the arts of the North Germans through the Viking period as well as the arts of the various migrating Germanic tribes. Well illustrated. Good bibliography (pp. 77-86), which lists books and periodical articles in all languages. A standard history of Germanic art.
- Kühn, Herbert. Die vorgeschichtliche Kunst Deutschlands. Berlin, Propyläen, 1935. 611p. illus. index. (Propyläen-Kunstgeschichte, Ergänzungsband 8).

Comprehensive handbook of art in Germany from earliest times through the period of migrations. Introductory essay followed by good collection of plates with descriptive notes. Good classified bibliography of books and periodical articles (pp. 571-81).

- László, Gyula. The Art of the Migration Period. Coral Gables, Fla.,
 University of Florida Press, 1974. 135p. illus. LC 70-171454.
 Pictorial survey of the arts of the pre-Christian Germans, Huns, Avars, Slavs, and Hungarians during the period of the migrations. Well illustrated. Brief bibliography (pp. 141-44) of books and periodical articles. One of the few recent surveys of the art of the migrations period.
- 730 Megaw, J. V. S. Art of the European Iron Age. New York, Harper, 1970. 195p. illus. index. LC 78-115868.

 Concise history of the arts of barbarian Europe from the eighth century B.C. to

the second century A.D. Concentrates chiefly on Celtic art but does not cover

Celtic art in Iberia or the Iron Age cultures in the Balkans and East Hallstatt region. The catalog of plates provides excellent bibliographical references. A basic history.

Salin, Bernhard. Die altgermanische Thierornamentik... New edition. Stockholm, Wahlström & Widstrand, 1935. 387p. illus. index.

First published in Swedish in 1904. Detailed, scholarly study of the evolution of Germanic decorative style from the late Roman period through the Viking style. Salin describes a series of zoomorphic styles of ornament in Germanic art that form the basis (although controversy on the points exists) for all later study of Germanic art. Bibliography in the footnotes. A standard work.

MEDIEVAL AND BYZANTINE

GENERAL WORKS

Focillon, Henri. The Art of the West in the Middle Ages. 2nd ed. New York, Phaidon, 1963. 2v. illus. index. LC 63-4333.

Comprehensive survey of art and architecture in Western Europe during the Roman-

comprehensive survey of art and architecture in Western Europe during the Romanesque and Gothic periods. Good collection of black and white plates; emphasis is on architecture, with less on sculpture and little on painting. Good bibliographies are at the end of the chapters, with further bibliography in the informative footnotes, some brought up to date by editor Jean Bony. Not strictly a factual history, but a highly individualistic interpretation of medieval art that emphasizes the metamorphosis of forms.

- Huyghe, René, ed. Larousse Encyclopedia of Byzantine and Medieval Art. New York, Prometheus, 1963. 416p. illus. index. LC 63-12755. Collection of essays by French specialists on the art and architecture of the early Christian through the Gothic periods. Includes Asian art and architecture of the same time span. No bibliography.
 - 734 Kidson, Peter. The Medieval World. New York, McGraw-Hill, 1967. 176p. illus. index. LC 67-11796.

Pictorial survey of the art and architecture of the Western Middle Ages from Hiberno-Saxon and Carolingian times through the Gothic. Provides a glossary, chronological tables, maps, succinct captions to the illustrations, and a brief list of books for further reading.

735 Lethaby, William R. Medieval Art, from the Peace of the Church to the Eve of the Renaissance, 312-1350. Rev. by David T. Rice. New York, Philosophical Library, 1950; repr. New York, Greenwood, 1969. 223p. illus. index. LC 71-97315.

Survey history of the art and architecture of the Middle Ages from 312 to 1350. Also covers Byzantine art and architecture. Few bibliographical references in the footnotes. Originally published in 1904 and long a standard history, this useful work has been brought up to date by Rice, chiefly through the addition of supplementary footnotes.

Mâle, Émile. Art et artistes du moyen âge. 4th ed. Paris, A. Colin, 1947. 328p. illus. index.

Survey of Western medieval art and architecture from Early Christian through Gothic, consisting of chapters on major monuments such as Mont-Saint-Michel, Rheims, Córdoba; artists such as Jean Bourdichon; media such as French late Gothic ivories. Interesting chapter on Rodin and the French cathedrals. Bibliographical footnotes.

737 Morey, Charles R. Medieval Art. New York, Norton, 1942. 412p. illus. index.

Survey of art and architecture from the early Christian through the late Gothic periods. Brief reading list (p. 395). Illustrated with black and white plates and line drawings. Some bibliographical references given in footnotes. Once a standard history of medieval art, it is now quite out of date. Nevertheless, it is still useful to the general reader and beginning student for its effective organization and succinct language.

738 Schlosser, Julius von. Die Kunst des Mittelalters. Berlin, Neubabelsburg, 1923. Reprinted as: L'arte del medioevo. Turin, Einaudi, 1961. 134p. illus.

Survey of medieval art and architecture in Western Europe with emphasis on evolution of form within the overall cultural context. Still an influential interpretation of medieval art. No bibliography.

739 Smith, Norris Kelly. Medieval Art: An Introduction to the Art and Architecture of Europe, A.D. 300-A.D. 1300. Dubuque, Iowa, W. C. Brown, 1967. 111p. illus. index. LC 67-22712.

Concise survey of the art and architecture in Eastern and Western Europe from 300 to 1300. Includes Byzantine art and architecture. General, unclassified bibliography (pp. 113-14).

740 Strong, Donald E., *et al.* Origins of Western Art. New York, Franklin Watts, 1965. 246p. illus. index. LC 64-23542.

Pictorial survey of the art and architecture of Europe from late Roman times through the thirteenth century. Consists of essays on late Roman, early Christian, Byzantine, early Medieval, Romanesque, and Gothic art and architecture by specialists. Well illustrated. Provides brief bibliography (p. 15) of books in English.

741 Zarnecki, George. Art of the Medieval World: Architecture, Sculpture, Painting, the Sacred Arts. New York, Abrams, 1975. 476p. illus. index. LC 75-25576.

Survey history of art and architecture from the fourth century A.D. to the middle of the fourteenth century A.D. Includes Byzantine art and architecture. Chronological table correlating persons and events with artists and their works. Glossary of terms and classified bibliography of basic books and periodical articles in all languages (pp. 462-67). Intended as a college text.

AUSTRIA

See: Feuchtmüller (1243), Ginhart (1244).

FRANCE

Evans, Joan. Art in Medieval France, 987-1498. 1st ed., 3rd impression with additional bibliography. Oxford, Clarendon Press, 1969. 325p. illus. index. LC 70-430545.

History of art and architecture in medieval France cast in the context of the cultural environment. Some bibliography in the text footnotes; unclassified bibliography (pp. 293-300). Useful and readable history of the arts and general culture of medieval France. Particularly valuable are the chapters on the monastic orders.

Réau, Louis, and Gustave Cohen. L'art du moyen âge: art plastique, arts litteraires et la civilization française. Paris, Albin Michel, 1935. 468p. illus, index. Reprinted 1951.

Survey history of French medieval literature and fine arts during the Middle Ages. The two art forms are treated in separate sections, but the text makes frequent cross references. Good classified bibliography of basic books (pp. 429-43).

See also: Schneider (1234).

GERMANY

Mâle, Emile. L'art allemand et l'art français du moyen âge. 4th ed. Paris, Colin, 1922. 328p. illus. index. LC 17-28856.

Survey of the art of France and Germany from Carolingian times through the Gothic, with emphasis on the interrelationships between the two countries. Bibliographic footnotes.

745 Schardt, Alois J. Die Kunst des Mittelalters in Deutschland. Berlin, Rembrandt-Verlag, 1943. 668p. illus. index. (Geschichte der Kunst, Band II, Teil 1). LC 46-2267.

Comprehensive history of art and architecture in Germany from the time of Charlemagne to the end of the fifteenth century. No bibliography.

Schmitz, Hermann. Die Kunst des frühen und hohen Mittelalters in Deutschland. Munich, Bruckmann, 1924. 272p. illus.

Concise survey of the history of art and architecture in the German-speaking countries from prehistoric times through the late Romanesque (mid-thirteenth century). Includes a brief, unclassified bibliography of German books (pp. 268-69). Although now out of date in the details, it is still a well-written survey of German medieval art.

See also: Dehio (1287), Pinder (1290).

GREAT BRITAIN

747 Saunders, O. Elfrida. A History of English Art in the Middle Ages. Oxford, Clarendon Press, 1932; repr. Freeport, N.Y., Books for Libraries, 1969. 272p. illus. index. LC 70-103658.

Concise history of art (exclusive of architecture) in England, beginning with Saxon period and ending the the late Gothic. General bibliography (pp. 260-62) in addition to the bibliographies at the ends of chapters. An old survey history that is still of interest to the general reader.

748 Stoll, Robert. Architecture and Sculpture in Early Britain: Celtic, Saxon, Norman. New York, Viking, 1967. 356p. illus. index. LC 67-7107. Pictorial survey of architecture and sculpture in Britain during the early Middle Ages, from the seventh century through the Romanesque. The short introductory essay is followed by a collection of black and white plates (chiefly of architecture) and notes to the plates. No bibliography.

See also: Boase (1305).

ITALY

Lavagnino, Emilio. L'arte mediaevale. 2nd ed. Torino, Unione Tipografico Editrice Torinese, 1960. 942p. illus. index. (Storia dell'Arte Classica e Italiana, v. 2).

Survey of art and architecture in Italy from the Early Christian through the Gothic periods. Gothic section includes the Trecento. Good annotated bibliography (pp. 880-89). First published in 1936; still a good, well-illustrated history of medieval art and architecture in Italy.

Vitzthum, Georg von, and Wolfgang F. Volbach. Die Malerei und Plastik des Mittelalters in Italien. Wildpark-Potsdam, Athenaion, 1924. 339p. illus. index.

Older, comprehensive history of painting and sculpture in Italy from the seventh through the fourteenth centuries. Arrangement is chronological by region. Bibliographical references are provided at the beginning of each chapter.

See also: Ancona (1316), Venturi (1326).

SCANDINAVIA

Anker, Peter, and Aron Andersson. The Art of Scandinavia. London, Hamlyn, 1970. 2v. illus. index. LC 79-21555.

Comprehensive history of art and architecture in Scandinavia during the Middle Ages. Well illustrated with plates, plans, and diagrams. Bibliographical footnotes. This is a translation of the French edition, titled *La Pierre-qui-vire* (Zodiaque, 1968-69). An excellent history of Scandinavian medieval art and architecture. The first volume is especially valuable as a thorough treatment of Viking art.

Rácz, István. Art Treasures of Medieval Finland. New York, Praeger, 1967. 252p. illus. LC 67-15670.

Pictorial survey of art and architecture in Finland during the fourteenth and fifteenth centuries. Introduction and notes on the plates by Riitta Pylkkänen. No bibliography.

Rácz, István. Norsk Middelalderkunst. Oslo, Cappeln, 1970. 224p. illus. index. LC 79-574133.

Survey history of medieval art and architecture in Norway. Well illustrated. No bibliography.

See also: Lindblom (916), Poulsen (1356).

SWITZERLAND

See: Gantner (1297).

EASTERN EUROPE

Grabar, André. L'art du moyen âge en Europe orientale. Paris, Michel, 1968. 243p. illus. index. LC 71-363370.

Concise history of the art and architecture in Eastern Europe, covering the Balkans, Romania, Russia, and Greece from the tenth to the seventeenth century. Provides maps, chronological tables, and a classified bibliography of books in all languages (pp. 229-31). A good survey history of a neglected area of medieval art history.

Millet, Gabriel, ed. L'art byzantin chez les slaves; L'ancienne russie, les slaves catholiques. Paris, Geuthner, 1932. 535p. illus. index.

Collection of scholarly essays on Slavic Byzantine art and architecture. Three parts: Monuments byzantins de Chersonèse; L'ancienne Russie; Les Slaves catholiques. Extensive bibliographical footnotes and excellent classified bibliography of basic books and periodical articles compiled by Millet (pp. 439-90). A standard work.

Voyce, Arthur. The Art and Architecture of Medieval Russia. Norman, University of Oklahoma Press, 1966. 432p. illus. index. LC 66-13433. History of art and architecture in Russia from the pre-Christian era (Scythians, etc.) to 1600. Provides a chronological table, a useful glossary of Russian art terms, maps, and good bibliography of general works (pp. 405-416). A standard history of medieval Russian art and architecture.

See also: Alpatov (1416), Filov (1404), Radojčic (1435).

EARLY CHRISTIAN

Beckwith, John. Early Christian and Byzantine Art. Harmondsworth, Penguin, 1970. 211p. illus. index. (Pelican History of Art). LC 79-23592.

History of Early Christian art from the early third century and Byzantine art to the middle of the fifteenth century. Does not cover architecture, which is treated in the same series by R. Krautheimer's *Early Christian and Byzantine Architecture*. Provides a glossary of terms, maps, and a brief bibliography of general works (pp. 191-92). Specialized literature is mentioned in the notes to the text. A basic history of Early Christian and Byzantine art.

- Brenk, Beat. Spätantike und frühes Christentum. Berlin, Propyläen, 1977. 351p. text, 400 plates. (Propyläen-Kunstgeschichte, Ergänzungsband I). Comprehensive illustrated handbook of Early Christian art and architecture covering the third through the fifth centuries. Introductory essays by various European scholars discuss the evolution of Early Christian art. Excellent corpus of plates with detailed descriptive notes that include bibliographic references to specialized literature. Includes chronological table correlating political, religious, and artistic events. Good classified bibliography of books and periodical articles in all languages. A standard handbook.
- Cossío, Manuel B., and José Pijoán y Soteras. Arte cristiano primitivo. Arte bizantino, hasta el saqueo de Constantinopla por los cruzados el año
 1204. Bilbao and Madrid, Espasa-Calpe, 1935. 592p. illus. index. (Summa Artis, Historia General del Arte, VII).

Comprehensive survey of Early Christian art and architecture and also Byzantine art to 1204. Does not treat contemporary Germanic arts (these are given consideration in number 523). Brief lists of books at the ends of chapters.

Du Bourguet, Pierre. Early Christian Art. New York, Reynal, 1971. 219p. illus. LC 77-151935.

Comprehensive history of Early Christian art and architecture from circa 200 to the end of the fourth century A.D. Excellent illustrations, useful plans and maps, and a good classified bibliography (pp. 216-17), which lists books and periodical articles in all languages. A good survey history.

Francia, Ennio. **Storia dell'arte paleocristiana**. Milan, Martello, 1969. 209p. illus. index. LC 78-434554.

Concise history of early Christian art and architecture from the early second century A.D. through the fifth century. Good selection of plates. Bibliography (pp. 147-54) lists books and periodical articles in all languages.

Garrucci, Raffaele. Storia della arte cristiana nei primi otto secoli della chiesa . . . Prato, Guasti, 1872-81. 6v. illus.

Collection of line drawings illustrating Early Christian painting and sculpture, chiefly in Rome. Contents: v. 1, Teorica, Annali; v. 2, Pitture cimiteriali; v. 3, Pitture non cimiteriali; v. 4, Musaici cimiteriali; v. 5, Sarcofagi ossia sculture cimiteriali; v. 6, Sculture non cimiteriali. Still occasionally consulted by the specialist scholar.

Gerke, Friedrich. Spätantike und frühes Christentum. Baden-Baden, Holle, 1967. 279p. illus. index. LC 68-114559.

Concise history of Early Christian art and architecture from the pre-Constantinian art through the time of Heraclius. Provides a useful glossary of terms, a map, and a brief bibliography (pp. 251-52).

Gough, Michael. The Origins of Christian Art. London, Thames & Hudson, 1973. 216p. illus. index. LC 73-8233.

Concise history of art and architecture in Europe from pre-Constantinian Christian art of the third century A.D. through Hiberno-Saxon art and architecture of the eighth century. Covers Byzantine art and architecture through the seventh century. Good choice of illustrations, plans, and diagrams. Bibliography (pp. 203-204) lists major books in Western languages.

Grabar, André. Early Christian Art: From the Rise of Christianity to the Death of Theodosius. New York, Odyssey, 1969. 325p. illus. index. (The Arts of Mankind, 9). LC 68-110414.

British edition is *The Beginnings of Christian Art*, 200-395. This is an illustrated history of the art and architecture of the Early Christian period from circa 200 to 395 A.D. Provides chronological tables, maps, useful glossary, index, an excellent section on documents in translation, and good bibliography (pp. 307-313).

Hutter, Irmgard. Early Christian and Byzantine Art. New York, Universe, 1971. 191p. illus. index. LC 75-122018.

Concise survey history of the art and architecture of the Early Christian and Byzantine periods beginning with the third century and ending with the thirteenth century. Balanced, well-chosen illustrations with informative captions. Brief bibliography (pp. 186-87).

767 Kaufmann, Carl M. Handbuch der christlichen Archäologie, Einführung in die Denkmälerwelt und Kunst des Urchristentums. 3rd ed. Paderborn, Schöningh, 1922. 683p. illus. index.

First published in 1905. Scholarly handbook of Early Christian art and architecture from the third century through the sixth century. Arranged by media, each chapter provides a bibliographical note at the beginning and bibliographical footnotes throughout the text. A once-standard handbook.

768 Lassus, Jean. The Early Christian and Byzantine World. New York, McGraw-Hill, 1967. 176p. illus. index. LC 67-11797.

Survey of the architecture, mosaics, sculpture, and minor arts of these two epochs. Includes a chronological table, a glossary, maps, and a general bibliography (p. 172).

769 Laurent, Marcel. L'art chrétien primitif. Brussels, Vromant, 1911. 2v. illus. index. LC 11-18988.

Contents: Tome 1, L'art des catacombes, statues et sarcophages, églises et baptistères; Tome 2, la mosaïque, les arts industriels, l'art chrétien primitif en orient, Ravenne, l'art préroman. Bibliographical footnotes. A standard, older history of Early Christian art by a leading Belgian scholar. Reissued as: L'art chrétien des origines à Justinien (Brussels, Laclercq, 1957) in one volume.

773

775

- Leclercq, Henri. Manuel d'archéologie chrétienne depuis les origines jusqu'au VIIIe siècle. Paris, Letouzev et Anne, 1907. 2v. illus. Older, comprehensive handbook of Early Christian art and architecture, illustrated with line drawings. Good coverage of the applied and decorative arts and considerable useful information on the techniques of Early Christian art and architecture. Bibliography at the end of each chapter.
- Leroy, Alfred. Naissance de l'art chrétien des origines à l'an mil. Paris, A. Fayard, 1956. 123p. illus. LC 57-30497. Concise survey of Christian art and architecture from its beginnings to the year 1000, seen from the point of view of a clergyman. Bibliographical references at the end of each chapter.
- Lowrie, Walter. Art in the Early Church. 2nd rev. ed. New York, Harper, 1965. 229p. illus. index. LC 67-11797. Survey of Early Christian art and architecture, beginning with the pre-Constantinian art of the catacombs and ending with a discussion of the influence of Early Christian art on early medieval art. Provides a chronological table and a good selective, annotated bibliography of the older literature. An enthusiastic study and interpretation of Early Christian art for the general reader and the beginning student.
- Marucchi, Orazio. Éléments d'archéologie chrétienne . . . Paris, Rome, Lefebvre, 1899-1903, 3v. illus, index. Older, comprehensive handbook of Early Christian art, chiefly that in Rome. First volume provides an overall sketch; second volume covers the catacombs of Rome and Naples; volume three treats the chief Early Christian basilicas of Rome. Illustrated with line drawings, maps, and plans.
- 774 Meer, Frederik van der. Early Christian Art. London, Faber, 1967. 149p. illus. index. LC 67-114396. Concise survey of the art and architecture of the early Christian period from the

catacombs through the sixth century. Good chapter on the discovery of Early Christian art. No bibliography. Good appreciative survey of Early Christian art.

University Press, 1953. 282p. illus. index. History of Early Christian art, beginning with the Hellenistic background and ending with the eighth century. Does not cover architecture. Informative notes to the plates. Bibliography is included in the footnotes. Once a standard history, it is now out of date. Nevertheless, it is still useful to the advanced student because of the author's original approach in dealing with the origins of Early Christian art and because of its bibliographical footnotes.

Morey, Charles R. Early Christian Art. 2nd ed. Princeton, Princeton

Neuss, Wilhelm. Die Kunst der alten Christen. Augsburg, Filser, 1926. 155p. illus.

An important survey of Early Christian art and architecture from the third to the sixth century, with emphasis on the religious content and sacred function. Extensive bibliographical footnotes.

777 Rice, David T. The Beginnings of Christian Art. London, Hodder & Stoughton, 1957. 223p. illus. index.

Concise survey of the development of Christian art and architecture from the third to the twelfth century, including Byzantine art and architecture. Brief bibliographies at the end of each chapter.

- 778 Sas-Zaloziecky, Wilhelm. Die altchristliche Kunst. Frankfurt am Main, Ullstein, 1963. 157p. illus. index. (Ullstein Kunstgeschichte, 7).
 Concise history of Early Christian art and architecture from the early third century to the end of the fifth century A.D. Bibliography of basic works in all languages (pp. 155-56).
 - 779 Stryzygowski, Josef. Orient oder Rom; Beiträge zur Geschichte der spätantiken und frühchristlichen Kunst. Leipzig, Hinrich, 1901. 159p. illus. index.

Influential and controversial study of the stylistic origins of Early Christian and late Roman art and architecture. Chapters treat individual monuments (like the tomb of ca. 259 in Palmyra and the sarcophagus from Sidamarra in Berlin) as well as broader topics like Coptic textiles and Constantinian building in the Holy Land. Bibliographical footnotes. Strzygowski's thesis is the preeminence of Near Eastern sources over Roman sources for the direction of Late Antique style.

- Sybel, Ludwig von. Christliche Antike; Einführung in die altchristliche Kunst. Marburg, Elwert, 1906-1909. 2v. illus. index. LC 24-28938.

 Older, scholarly handbook of Early Christian art and architecture. First volume examines the religious content with special emphasis on the subject matter of the Roman catacomb paintings. Here the examination of such subjects as the feast of the saints and the theme of salvation are classics of early scholarship in Christian antiquity. Second volume is a remarkably complete summary of what was then known about the development of architecture, sculpture, and painting in the Early Christian period.
- 781 Sybel, Ludwig von. Frühchristliche Kunst. Leitfaden ihrer Entwicklung. Munich, Beck, 1920. 55p. illus. index.
 Concise history of Early Christian art and architecture from Hadrian to Theodosius.
 Bibliographical footnotes.
- 782 Syndicus, Eduard. Early Christian Art. New York, Hawthorn Books, 1962.
 186p. illus. index. (Twentieth Century Encyclopedia of Catholicism, v. 121, Section 12; Catholicism and the Arts). LC 62-11412.
 Concise history of art and architecture from the early third century A.D. to the end of the Carolingian period. Emphasis is on the content of Early Christian art

concise history of art and architecture from the early third century A.D. to the end of the Carolingian period. Emphasis is on the content of Early Christian art and its interrelationship with the world of late antiquity. The selection of plates is modest, but the book is liberally provided with plans and diagrams. Brief bibliography (pp. 187-88) lists major books in all languages. A good survey written from the standpoint of the church.

Volbach, Wolfgang F. Early Christian Art. New York, Abrams, 1962. 363p. illus. index. LC 61-8333.

Illustrated handbook of Early Christian art and architecture. Short introductory essay is followed by 158 excellent plates (with informative notes), containing plans, elevations, reconstructions, and references to specialized literature. A basic handbook.

784 Wulff, Oskar K. Altchristliche und byzantinische Kunst. 2v. Berlin, Athenaion. 1918. illus. index.

Comprehensive history of the art and architecture of the Early Christian period of Byzantium. Volume one covers Early Christian art and architecture from pre-Constantinian times through the fifth century; volume two, Byzantine art and architecture from the sixth through the fourteenth centuries. Extensive bibliographies are given at the end of chapters. A third volume, containing a critical bibliography, appeared in 1939 and is annotated elsewhere in this bibliography (73). This old standard handbook is still useful to the advanced student and the scholar.

BYZANTINE

- 785 Bayet, C. L'art byzantin. Paris, Quantin, n.d. 320p. illus. Older history of Byzantine art and architecture from the sixth through the fourteenth century. Engraved illustrations. Bibliographical footnotes.
 - 786 Beckwith, John. The Art of Constantinople: An Introduction to Byzantine Art, 330-1453. 2nd ed. New York, Phaidon, 1968. 184p. illus. index. LC 68-18908.

History of Byzantine art (but not architecture) from 330 to 1453, with emphasis on the contribution of Constantinople. Chronological table, glossary of terms, and thorough reference to and discussion of the literature of Byzantine art in the footnotes. Well-chosen illustrations.

- 787 Number not used.
- Bon, Antoine. Byzantium. London, Barrie and Jenkins, 1973. 222p. illus. index. LC 73-165988.

Cultural history of the Byzantine Empire, with special emphasis on art and architecture of the period from the ninth through the middle of the fifteenth century. Chronological table; selected bibliography of books in all languages (pp. 193-202).

789 Bréhier, Louis. L'art byzantin . . . Paris, Laurens, 1924. 203p. illus. index.

Survey history of Byzantine art and architecture, with a useful chapter on the centers of Byzantine art (pp. 188-200). No bibliography.

790 Dalton, Ormonde M. Byzantine Art and Archaeology . . . Oxford, Clarendon, 1911. 727p. illus. index.

Older, comprehensive handbook of Byzantine art, but not including architecture. Introduction gives a geographical overview. Useful chapter on iconography with references to material illustrated elsewhere in the text. Thorough bibliographical references in the footnotes. Still a valuable guide to the older literature.

Dalton, Ormonde M. East Christian Art, a Survey of the Monuments.
Oxford, Clarendon, 1925. 396p. illus. index.
Geographical survey of Byzantine art and architecture, a somewhat more popular

Geographical survey of Byzantine art and architecture, a somewhat more popular version of the author's *Byzantine Art and Archaeology* (790). Bibliographical footnotes.

- Delvoye, Charles. L'art byzantin. Paris and Grenoble, Arthaud, 1967. 462p. illus. index. (Collection Art et Paysages, 27). LC 68-80779. Well-illustrated survey of Byzantine art and architecture, with a good classified bibliography of books and periodical articles in all languages (pp. 407-426).
 - 793 Diehl, Charles. Manuel d'art byzantin . . . 2nd ed. Paris, Picard, 1925-26. 2v. illus. index.

History of Byzantine art and architecture from the sixth century through the middle of the fifteenth century. Extensive references to specialized literature in the footnotes; bibliographical note (pp. xiii-xv) discusses major works in all languages. Has a useful iconographical index. An old but still useful handbook.

- Grabar, André. The Art of the Byzantine Empire: Byzantine Art in the Middle Ages. New York, Crown, 1966. 216p. illus. index. LC 66-21147. Survey history of the art and architecture in the Byzantine Empire from the Iconoclastic period (mid-eighth century) to the fifteenth century. Provides a chronological table and a brief, general bibliography (pp. 209-210). A good survey history of later Byzantine art for the beginning and advanced student.
 - Grabar, André. The Golden Age of Justinian, from the Death of Theodosius to the Rise of Islam. New York, Odyssey, 1967. 408p. illus. index. (The Arts of Mankind, 10). LC 66-29363.

British edition is titled *Byzantium*, from the Death of Theodosius.... Illustrated history of the art and architecture of Byzantium from the early sixth through the fifteenth century. Treats the various arts separately by type. Provides plans, maps, chronological tables, informative notes to the plates, and a good bibliography (pp. 383-92).

- 796 Kitzinger, Ernst. Byzantine Art in the Making... Cambridge, Mass., Harvard University Press, 1977. 175p. illus. index. LC 77-73578. Scholarly study of the stylistic development of Early Christian and early Byzantine art from the late third through the seventh centuries. Emphasis is on the roles played by various centers and regions. Extensive bibliographical references in the notes (pp. 129-53).
- Concise history of Byzantine art and architecture from the sixth through the middle of the fifteenth century. Introduction sketches the overall historical

development and a concluding chapter summarizes the influence of Byzantine art on the West. Glossary of terms and topographical index with summaries of the major monuments. Bibliography (p. 127) lists French books. In the series, "Arts, Styles et Techniques."

798 Mathew, Gervase. Byzantine Aesthetics. New York, Viking, 1963. 189p. illus. index. LC 64-12098.

History of Byzantine art and architecture from the third century to the middle of the fifteenth century, with emphasis on the record in contemporary documents. Thorough bibliographical coverage of primary sources in the notes; bibliography (pp. 179-80) lists only major books published since 1945. An important documentary history.

799 Micheles, Panayotis A. An Aesthetic Approach to Byzantine Art. London, Batsford, 1955. 284p. illus. index.

Historical study of the distinctive character of Byzantine sacred art and architecture. Contents: Part one, The Aesthetic Character of Christian Art; part two, The Sublime in Byzantine Art; part three, The Aesthetic Approach to the History of Art. The latter part is a critique of Wöllflin's methodology. Bibliographical footnotes. Although not consistently convincing, this contains much valuable material, particularly in the liturgical use of Byzantine architecture and painting.

800 Peirce, Hayford, and Royall Tyler. L'art byzantin . . . Paris, Libraire de France, 1932-34, 4v. illus, index.

Illustrated handbook of Byzantine art, exclusive of architecture, from the fourth century through the sixth century. Each volume has a brief introductory cssay sketching the development of the various media, followed by a good collection of plates with informative notes. No bibliography. Still valuable to the advanced student for its illustrations.

Rice, David T. The Art of Byzantium. London, Thames and Hudson, 1959. 339p. illus. index. LC 60-1215.

Illustrated handbook of Byzantine art and architecture from the time of Justinian to the middle of the fifteenth century. Brief introductory survey is followed by an excellent collection of plates; the informative notes to the plates include bibliographical references. A standard illustrated handbook.

Rice, David T. The Art of the Byzantine Era. New York, Praeger, 1963. 286p. illus. index. LC 63-16444.

Survey history of art and architecture in Byzantium from the early sixth to the mid-fifteenth centuries. Includes Coptic, Palestinian, and Syrian art. Provides maps, a chronological table, and a brief bibliography of major works (pp. 267-68).

Rice, David T. Byzantine Art. Rev. and expanded ed. Harmondsworth, Penguin, 1968. 580p. illus. index. LC 75-356968.

Survey of the art and architecture of Byzantium from the early sixth through the middle of the fifteenth century. The various arts are treated separately. Provides maps, an excellent selection of illustrations, and a good, annotated bibliography (pp. 563-70). An excellent survey for the general reader and the beginning student.

Runciman, Steven. Byzantine Style and Civilization. Harmondsworth, Penguin, 1975. 238p. illus. index. LC 75-330373.

History of Byzantine civilization from the fourth to the middle of the fifteenth century, with emphasis on the art and architecture of Constantinople. Contents: The Triumph of the Cross; The Sixth-century Synthesis; The Triumph of the Image; The Full Programme; The Changing World; The Last Splendor; Conclusion. An annotated guide to further reading (pp. 227-29). Valuable bibliographical references to more specialized literature are contained in the catalog of illustrations (pp. 213-26). Series: "Style and Civilization."

805 Sas-Zaloziecky, Wilhelm. Die byzantinische Kunst. Frankfurt am Main, Ullstein, 1963. 157p. illus. index. (Ullstein Kunstgeschichte, 8). LC 65-98284.

Concise history of Byzantine art and architecture, with a good chapter on the spread of Byzantine art to Slavic Europe. Bibliography (pp. 154-55) lists books in all languages.

Schug-Wille, Christa. The Art of the Byzantine World. New York, Abrams, 1971. 263p. illus. index. LC 75-92912.

Concise history of art and architecture from pre-Constantinian times (circa 200 A.D.) through the art and architecture of Russia during the fifteenth and sixteenth centuries. Well-chosen illustrations and useful maps, but no plans for architectural examples. Provides a balanced bibliography (pp. 257-59) that lists books in all languages.

Schweinfurth, Philipp. Die byzantinische Form; Ihr Wesen und ihre Wirkung. Berlin, Kupferberg, 1943. 162p. illus. index.
 Stylistic history of Byzantine art and architecture from the sixth through the fourteenth century. Chapter on the importance of Byzantine art to the development of Western art. Bibliographical footnotes.

Stern, Henri. L'art byzantin. Paris, Presses Universitaires de France, 1966. 186p. illus. index. LC 67-91757.

In the series, "Les Neuf Muses." Concise history of Byzantine art and architecture from the time of Justinian to the fall of Constantinople in 1453. Chapter on the influence of Byzantine art in Slavic Europe. Bibliography (pp. 183-86) lists books and periodical articles in all languages.

809 Stryzgowski, Josef. L'ancien art chrétien de Syrie, son caractère et son évolution . . . Paris, Boccard, 1936. 215p. illus. index.

History of art and architecture in Syria during the Early Christian period. A controversial work in its day, it is now out of date but the only general survey of the subject. Bibliographic footnotes.

Volbach, Wolfgang F., and Jacqueline LaFontaine-Dosgne. Byzanz und der christliche Osten. Berlin, Propyläen, 1968. 366p. (text); 432p. (illus.). index. (Propyläen Kunstgeschichte, Band 3). LC 70-377738.

Comprehensive illustrated handbook of the art and architecture of Byzantium and the Christian art and architecture of Syria, Egypt, Nubia, Ethiopia, Armenia,

Georgia, Russia, Romania, Bulgaria, Yugoslavia, and Greece from the sixth through the fifteenth century. Introductory essay is followed by a corpus of excellent illustrations, essays on the development of the various arts and national subdivisions, extensive and informative notes to the plates, and plans and elevations. A chronological table comparing the artistic developments with political and religious developments is provided, and there is an excellent classified bibliography (pp. 380-98). Specialized literature is noted in the notes to the plates. A standard and basic illustrated handbook.

COPTIC

Badawy, Alexander. Coptic Art and Archaeology: The Art of the Christian Egyptians from the Late Antique to the Middle Ages. Cambridge, Mass., MIT Press, 1978, 416p. illus, index. LC 77-25101.

History of Coptic art and architecture. Chapters treat the historical-cultural background, the development of the major and minor art forms and significance and influences of Coptic art. Good bibliography of books and periodical articles (pp. 364-73).

Du Bourguet, Pierre. The Art of the Copts. New York, Crown, 1971. 234p. illus. index. LC 78-147350.

Concise history of the art and architecture of the Copts from pre-Coptic times through the twelfth century. Provides maps, a chronological table, a good classified bibliography (pp. 224-27), and bibliographical footnotes to the text. Excellent history of Coptic art and architecture for the beginning and advanced student.

Effenberger, Arne. Koptische Kunst: Ägypten in spätantiker, byzantinischer und frühislamischer Zeit. Leipzig, Koehler und Amelang, 1975. 277p. illus. index. LC 77-461908.

Well-illustrated survey of Coptic art and architecture from the fourth century through the eighth century A.D. Bibliography of basic books and periodical articles (pp. 251-59).

- Gayet, Albert J. L'art copte: École d'Alexandrie—architecture monastique—sculpture—peinture—art somptuaire . . . Paris, Leroux, 1902. 334p. illus. Comprehensive history of Coptic art and architecture. Illustrated with line drawings. Bibliographical footnotes. An old, standard history of Coptic art; should be known by the advanced student.
- Grüneisen, Wladimir de. Les caractéristiques de l'art copte. Florence, Alinari, 1922. 193p. illus.

Illustrated survey of Coptic art and architecture. Good selection of plates. Provides a brief bibliography (pp. 27-29), with reference to more specialized literature in the footnotes. An older survey, still useful to the advanced student because of the plates.

Zalosser, Hilde. Die Kunst im christlichen Ägypten. Vienna and Munich, Schroll, 1974. 191p. illus. index. LC 75-530475.

Concise survey of Coptic art and architecture from Hellenistic times to the advent of Islam. Bibliography of books and periodical articles in all languages (pp. 177-88).

Wessel, Klaus. Coptic Art. New York, McGraw-Hill, 1965. 247p. illus. index. LC 65-19075.

Survey of the art of Early Christian Egypt. Does not include architecture. Maps, good selection of plates, and brief unclassified bibliography (pp. 238-37). A useful but controversial history of Coptic art.

EARLY MEDIEVAL

General Works

Backes, Magnus, and Regine Dölling. Art of the Dark Ages. New York, Abrams, 1971. 263p. illus. index. LC 70-90886.

Concise survey of the art and architecture of the early Middle Ages from the period of the migrations through the Ottonian period. A short introduction is followed by explanations of the plates. Brief bibliography (pp. 258-59).

- 819 Bréhier, Louis. L'art en France des invasions barbares à l'époque romane . . . Paris, La Renaissance du Livre, 1930. 210p. illus.

 Concise history of the art and architecture of France in the Merovingian, Carolingian, and pre-Romanesque periods. Illustrated with facsimiles and rather weak plates. Bibliography (pp. 107-108) lists major works. An old, but still valuable study of a neglected period in French medieval art history.
- Busch, Harald, and Bernd Lohse. Pre-Romanesque Art. New York, Macmillan, 1966. 217p. illus. LC 66-16924.
 Pictorial survey of art and architecture of Western Europe from the fourth through the middle of the eleventh century. Introduction by Louis Grodecki; informative notes to the plates by Eva Wagner. No bibliography.
- Fillitz, Hermann. Das Mittelalter, I. Berlin, Propyläen, 1969. 350p. (text); 420p. (illus.). index. (Propyläen Kunstgeschichte, Band 5). LC 71-484515.

Comprehensive illustrated handbook of the art and architecture of the early Middle Ages. Covers the period from the late eighth century through the Romanesque period (circa middle of the twelfth century). Introductory essay is followed by a corpus of excellent illustrations with extensive and highly informative notes and separate essays on the development of the various arts. There is a chronological table comparing the developments in the arts with those in political and religious history, and an excellent classified bibliography (pp. 292-327). Specialized literature is mentioned in the notes to the illustrations. A standard and basic illustrated handbook.

Hautmann, Max. Die Kunst des frühen Mittelalters. Berlin, Propyläen, 1929. 756p. illus. index. (Propyläen-Kunstgeschichte, VI). LC 30-8339. Comprehensive, illustrated handbook of the art and architecture of Western Europe and Byzantium from the time of Constantine through the twelfth century.

Introductory essay followed by good corpus of plates with descriptive notes. No bibliography. Superseded by a volume (821) in the new Propyläen series.

Henderson, George. Early Medieval. Harmondsworth, Penguin, 1972. 272p. illus. index. LC 72-171390.

Concise history of art and architecture in Western Europe from the eighth century through the middle of the eleventh century. Emphasis is placed on the relationship between the fine arts and the general culture of the early Middle Ages. Well-chosen illustrations with informative notes and some with bibliographical references. Bibliography (pp. 165-68) is a helpful annotated list of major literature in all languages. Contents: Introduction; The Barbarian Tradition; An Habitation of Dragons; The Uses of Antiquity; Story-telling; De Laudibus Sanctae Crucis.

Holländer, Hans. Early Medieval Art. New York, Universe, 1974. 192p. illus. index. LC 72-91633.

Series: "Universe History of Art." Concise history of art and architecture in Western Europe from the seventh century to the middle of the eleventh century. Emphasis is on development of style. Brief text accompanied by good selection of plates of major works with informative captions. Bibliography (pp. 188-89) lists books in all languages.

- Hubert, Jean. L'art pré-roman... Paris, Éditions d'Art et d'Histoire, 1938. 202p. illus. index. Reprint: Chartres, Laget, 1974. LC 76-471633. Concise history of the art and architecture of France from the fifth to the tenth century. Bibliographical references in the footnotes. Illustrated with plates, plans, and diagrams. A standard history.
- Kayser, Felix. Kreuz und Rune; langobardisch-romanische Kunst in Italien. Stuttgart, Urachhaus, 1964. 2v. illus. index. LC 67-85057.
 History of the art and architecture of the Lombards in Italy from the sixth century through the twelfth century. Good plates and plans. General bibliography (pp. 138-40) and further reference to more specialized literature in the footnotes.
 A standard history of Lombardic art and architecture.
- Lasko, Peter. Ars Sacra: 800-1200. Baltimore, Penguin, 1972. 338p. illus. index. (Pelican History of Art, Z36). LC 73-162318.
 Comprehensive history of ivory carving, metalwork, enamels, and bronze sculpture from the Carolingian through the Romanesque periods. Good selection of plates.
 Bibliography (pp. 315-17) is a selected list of major works in all languages. Further reference to more specialized literature in the notes.
- Lantier, Raymond, and Jean Hubert. Les origines de l'art français. Paris,
 Le Prat, 1947. 180p. illus.
 Concise history of art and architecture in France from prehistory through

Carolingian era. Brief bibliography (p. 180). The good selection of plates makes this work valuable for this neglected period of French art and architecture.

Mahr, Adolf. Christian Art in Ancient Ireland. Dublin, Stationery Office, 1932-41. 2v. illus. index. Reprint: New York, Hacker, 1977. LC 75-11058. Concise history of art and architecture in Ireland from the seventh century to the time of the Anglo-Norman conquest. Bibliography (pp. 169-76) of books and periodical articles. An older, general history of Irish medieval art and architecture.

- Michel, André, ed. Des débuts de l'art chrétien à la fin de la période romane. Paris, Colin, 1905. 440p. illus. (Histoire de l'Art . . . tome I). Comprehensive history of art, architecture, and the applied arts in Europe from the third to the end of the twelfth centuries. Chapters are written by various French scholars. Bibliographies of basic literature at the end of each chapter.
- Palol Salellas, Pedro de. Early Medieval Art in Spain. New York, Abrams, 1967. 500p. illus. index. LC 66-26609.

 Illustrated handbook of art and architecture in Spain from the Visigothic through the Romanesque periods. Genealogical tables, maps, and excellent plates. Bibliog-

raphy in the notes to the plates.

Picton, Harold W. Early German Art and Its Origins from the Beginnings to About 1050. London, Batsford, 1939. 148p. illus. index.

A survey of the development of the art and architecture of the Germanic peoples from neolithic times through the Ottonian period. A pan-Germanic survey that treats Germanic art of the migrations epoch and the early Middle Ages in Eastern Europe, Italy, Spain, France, and the British Isles, as well as Central Europe. This provocative work is out of date in many of its conclusions, but it is still valuable for the advanced student.

Pijoán y Soteras, José. Arte bárbaro y pre-románico desde el siglo IV hasta el año 1000. Bilbao and Madrid, Espasa-Calpe, 1942. 569p. illus. index. (Summa Artis, Historia General del Arte, VIII). Comprehensive survey of Germanic art and the art and architecture of the Western Middle Ages to the year 1000. Conventional arrangement, but thorough treatment. Brief bibliographies at the end of chapters.

834 Strzygowski, Josef. Die altslavische Kunst. Augsburg, Filser, 1929. 296p. illus. index.

Scholarly history of the art and architecture of the Slavic peoples during the early Middle Ages. Excellent plans and diagrams, good illustrations of rarely reproduced works, and thorough reference to specialized literature in the footnotes. Like all works by Strzygowski, this one is still controversial; but it remains one of the standard histories of early Slavic art and architecture.

Pre-Carolingian

Brown, Gerard B. The Arts in Early England . . . London, Murray, 1903-37. 6v. illus. index.

Contents: v. 1, The Life of Saxon England in Its Relationship to the Arts; v. 2, Ecclesiastical Architecture in England from the Conversion of the Saxons to the Norman Conquest; v. 3-4, Saxon Art and Industry in the Pagan Period; v. 5, The Ruthwell and Bewcastle Crosses, the Gospels of Lindesfarne and other Christian Monuments in Northumbria; v. 6, pt. 1, Completion of the Study of

the Monuments of the Great Period of the Art of Anglican Northumbria; v. 6, pt. 2, Anglo-Saxon Sculpture. As a survey history of early medieval art in the British Isles superseded by Kendrick (839). Volume 6, part 2, is still the basic history of Anglo-Saxon sculpture.

Henry, Françoise. Irish Art in the Early Christian Period to 800 A.D. 3rd rev. enl. ed. Ithaca, New York, Cornell University Press, 1965. 256p. illus. index. LC 65-22854 rev.

Concise history of art and architecture in Ireland from the fifth century to 800 A.D. Good bibliographical footnotes in the text. A standard history of early medieval art and architecture in Ireland.

Hubert, Jean, Jean Porcher, and W. F. Volbach. Europe of the Invasions. New York, Braziller, 1969. 387p. illus. (The Arts of Mankind, 12). LC 75-81858.

Illustrated history of art and architecture of Western Europe from the fifth through the eighth centuries. Covers the art of the migrating Germanic tribes, the last manifestations of Early Christian art in Italy, and the art and architecture of the established Germanic kingdoms in Western Europe and the British Isles. The arrangement by types of works of art does not give clarity to the complex history of art in this transitional time. Provides numerous plans, elevations, reconstructions, maps, notes to the plates, and a good but unclassified bibliography (pp. 331-35). One of the few books in English on this crucial period.

Kendrick, Thomas D. Anglo-Saxon Art to A.D. 900. London, Methuen, 1938. 227p. illus. index.

Concise history of art and architecture in England from the Roman period to 900 A.D. Bibliographical references in the footnotes. A standard history.

Kendrick, Thomas D. Late Saxon and Viking Art. London, Methuen, 1949. 152p. illus. index. Reprint: London and New York, Barnes and Noble, 1974. LC 74-193181.

Concise history of the art and architecture of England in the tenth century and Scandinavian art of the ninth and tenth centuries. Bibliographical references in the footnotes. This is a sequel to (838); together they form a standard history of the arts of the early Middle Ages in England with reference to contemporary Scandinavian art.

- Klindt Jensen, Ole, and David Wilson. Viking Art. Ithaca, Cornell University Press, 1966. 173p. illus. index. LC 66-13813 rev.
 Concise history of Scandinavian art of the Viking period, 800-1100. The chapter on Scandinavian art before the Vikings adds to the usefulness of this survey. A standard work in English.
- Kutzli, Rudolf. Langobardische Kunst. Die Sprache der Flachbänder.
 Stuttgart, Urachhaus, 1974. 256p. illus. index. LC 75-572228.
 History of art of the Lombards in Italy, with special emphasis on metalwork and relief sculpture. Well-illustrated.

Palol Salellas, Pedro de. Arte hispanico de la epoca Visigoda. Barcelona, Ediciones Poligrafia, 1968. 237p. illus. LC 72-620.

Pictorial survey of Visigothic art and architecture in Spain. Text in Spanish, English, and French. Brief bibliography (p. 221). Useful pictorial survey for the general reader and beginning student.

Puig y Cadafalch, José. L'art wisigothique et ses survivances. Paris, de Nobelle, 1961. 204p. illus. index. LC 64-36324.

History of art and architecture of the Visigoths in Spain with chapters on the survival and influence of Visigothic art and architecture in Carolingian art, Mozarabic art, and the early Romanesque in Spain. Excellent bibliography (pp. 189-98). Standard history of Visigothic art.

Schaffran, Emerich. Die Kunst der Langobarden in Italien. Jena, Diederich, 1941. 196p. illus. index.

History of the art and architecture of the Lombards in Italy during the seventh and eighth centuries. Access to further literature through the numerous footnotes in the text.

Stokes, Margaret M. Early Christian Art in Ireland . . . Dublin, Stationery Office, 1928. 2v. illus. index.

First published in 1887 as a handbook for the South Kensington Museum. General survey of early medieval Irish architecture, sculpture, manuscript illumination, and metalwork. Chronological table, bibliographies in each chapter.

Verzone, Paolo. The Art of Europe: The Dark Ages from Theodoric to Charlemagne. New York, Crown, 1968. 276p. illus. index. LC 68-9069. Concise history of art and architecture in Western Europe from circa 425 to 800 A.D. Emphasis on Italian developments. Provides glossary of terms, chronological table, and brief bibliography (pp. 259-60. A useful, if somewhat complicated, history of a period on which little has been written for the beginning student.

See also: Kuhn (728).

Carolingian and Ottonian

Beckwith, John. Early Medieval Art. New York, Praeger, 1964. 270p. illus. index. LC 64-19953.

Concise history of the art and architecture of Western Europe from the early ninth through the middle of the twelfth centuries. Excellent critical bibliographical references in the notes to the text. Well-chosen illustrations.

Braunfels, Wolfgang. Die Welt der Karolinger und ihre Kunst. Munich, Callwey, 1968. 402p. illus. index. LC 70-364845.

History of art and architecture of the Carolingian period. Well illustrated; the descriptive notes to the plates contain bibliographical references to specialized literature. General bibliography (pp. 392-95).

849 Grodecki, Louis, and Florentine Mütherich. La siècle de l'an mil. Paris, Gallimard, 1973. 442p. illus. index. (Univers des formes 20). LC 74-161053.

History of art and architecture in Europe during the Ottonian and early Romanesque period (tenth through middle of the eleventh century). Provides good selection of plates, plans, diagrams, a glossary-index, and a good comprehensive bibliography of books and periodical articles. German edition in the series, "The Arts of Mankind."

- Henry, Françoise. Irish Art During the Viking Invasions, 800-1020. Ithaca, Cornell University Press, 1967. 236p. illus. index. LC 67-15300. Concise history of the art and architecture in Ireland, 800-1020. Good selection of plates and maps. Bibliographical references in the footnotes to the text. Sequel to (836); together with (871), it is a standard history of Irish medieval art.
- Hinks, Roger P. Carolingian Art. Ann Arbor, Mich., University of Michigan Press, 1962. 226p. illus. index. LC 62-52487.

First published in 1935 (London, Sidgwick and Jackson). Survey of Carolingian art, excluding architecture. Adequate bibliographical references in the footnotes in the text, plus a general bibliography (pp. 215-18). Although it is very much out of date, the beginning student will find the section on form and structure of Carolingian art to be informative reading.

Hubert, Jean, Jean Porcher, and W. F. Volbach. The Carolingian Renaissance. New York, Braziller, 1970. 381p. illus. (The Arts of Mankind, 13). LC 72-99513.

Illustrated handbook of Carolingian art and architecture. Provides chronological table, glossary-index, and good comprehensive bibliography (pp. 321-35) with its own index by subject. Collection of plans, elevations, reconstructions, and maps.

Jantzen, Hans. Ottonische Kunst. Reinbek bei Hamburg, Rowohlt, 1959. 175p. illus. index. LC AF99-455.

First published in 1947 (Munich, Münchner Verlag). History of the art and architecture in the Ottonian period covering the development within and outside Germanic lands. Separate chapters on the various arts. Unclassified bibliography of major works (pp. 166-67). A standard history of Ottonian art.

- Kubach, Hans Erich, and Victor Elbern. Das frühmittelalterliche Imperium. Baden-Baden, Holle, 1968. 308p. illus. index. LC 79-378251. Concise history of the art and architecture of the Carolingian and Ottonian periods. Treats the arts separately by type. Provides a chronological table, a map, and a good classified bibliography (pp. 280-93). An excellent history for the advanced student.
 - Messerer, Wilhelm. **Karolingische Kunst.** Cologne, DuMont-Schauberg, 1973. 236p. illus. index. LC 73-342249.

Scholarly handbook of Carolingian art, architecture, and applied arts. Introductory chapter defines Late Antique, Germanic, Carolingian, and Ottonian styles by a comparison of four metal and ivory bookcovers. Subsequent chapters examine

the state of research, the concept of *Renovatio*, styles and schools, iconographic development, architecture, and the influence of Carolingian art. Work concludes with a collection of excerpts from the work of major experts in the field (von den Steinen, Schnaase, Koehler, Otto, Schöne, and Porcher). Extensive bibliography in the notes.

ROMANESQUE

Aubert, Marcel. L'art français à l'époque romane, architecture et sculpture. Paris, Morancé, 1929-1951. 4v. illus. index.

Pictorial survey of Romanesque architecture and architectural sculpture in France. Volume one: Ile-de-France, Champagne, Alsace, Normandie, Vallée de la Loire; volume two: Poitou, Saintonge, Angoumois, Périgord, Nivernais, Auvergne, Velay; volume three: Bourgogne; and volume four: Provence, Languedoc. A collection of plates with short introductions but with useful bibliographies at the end of each volume. Basic compendium of illustrations for the advanced student.

Aubert, Marcel, ed. L'art roman en France . . . Paris, Flammarion, 1961. 464p. illus. index. LC 62-32085.

History of art and architecture of the Romanesque period in France. Consists of essays by specialists on the various regional styles. Well illustrated, but no bibliography.

Baldass, Ludwig, Bruno Buchowiecki, and Wilhelm Mrazek. Romanische Kunst in Österreich. Vienna and Hanover, Forum, 1962. 119p. (text); 96p. (illus.).

History of Romanesque art and architecture in Austria from the early eleventh century through the twelfth century. Well illustrated and provided with a good bibliography (pp. 115-16) that lists books and periodical articles.

- Bonet, Blas. El movimento románico en España. The Romanesque Movement in Spain... Barcelona, Poligrafia, 1967. 307p. illus. LC 68-74678. Survey history of art and architecture in Spain from the fifth through the twelfth centuries. Text in Spanish, French, English, and German. No bibliography.
 - Brehier, Louis. Le style roman. Paris, Larousse, 1942. 125p. illus. index. LC 46-35343.

Concise survey history of Romanesque art and architecture. Emphasis is on France, with a final chapter that briefly outlines the development of the Romanesque in other countries of Western Europe. Chapter on the applied and decorative arts. Glossary of terms and useful topographic index with brief descriptions of the major monuments. One-page bibliography of basic books.

Busch, Harald. Germania Romanica; die hohe Kunst der romanischen Epoche in mittleren Europa. Vienna, Schroll, 1963. 316p. illus. LC 65-66409.

Pictorial survey of art and architecture of the Romanesque period in the Germanspeaking countries, with emphasis on architecture. A brief introductory essay is followed by a selection of black and white plates, with notes to those plates. No bibliography. Selections from this work are found in (873).

Colas, René. Le style roman en France dans l'architecture et la décoration des monuments. Paris, Colas, 1927. 59p. text. 144 plates.
 Pictorial survey of French Romanesque architecture, architectural sculpture, and

painting. No bibliography.

863 Collon-Gevaert, Suzanne, et al. A Treasury of Romanesque Art: Metalwork, Illuminations and Sculpture from the Valley of the Meuse. London, Phaidon, 1972. 327p. illus. index. LC 76-161220.

Translation of Art roman dans la vallée de la Meuse aux XIe et XIIe siècles (Brussels, 1962). Well-illustrated survey of the figurative arts of the eleventh and twelfth centuries in the Meuse region of Belgium and the Netherlands. Part one provides a historical background; part two discusses metalwork; and part three, works in other media. Good classified and annotated bibliography of books (pp. 309-316).

Courtens, André. Romanesque Art in Belgium: Architecture, Monumental Art. Brussels, M. Vokaer, 1969. 111p. (text); 125p. (illus.). index. LC 75-572505.

Pictorial survey of architecture and monumental sculpture in Belgium of the Romanesque period. The short introductory essay is followed by a collection of black and white plates (chiefly of architecture), notes to the plates, and a classified bibliography of general works (pp. 104-106).

Crozet, René. L'art roman. Paris, Presses Universitaires de France, 1962.
 186p. illus. index. LC 63-38107.

Survey history of art and architecture of the Romanesque period, with an emphasis on France. A brief chapter called "Universalité de l'art Roman," sketches the history of Romanesque art and architecture outside France. Bibliography (pp. 185-86) lists chiefly books in French.

Decker, Hans. Romanesque Art in Italy. New York, Abrams, 1959. 82p. (text); 240p. (illus.). LC 59-5999.

Pictorial survey of the Romanesque art and architecture in Italy. Emphasis is on architecture and its decoration. Text discusses the material by region. Bibliography (p. 82) lists a few major works in all languages. Good collection of plates. Text is for the general reader and the beginning student; plates are useful to the advanced student as well.

Durliat, Marcel. L'art roman en Espagne. Paris, Braun, 1962. 86p. (text);
 248p. (illus.). LC 64-46252.

Pictorial survey of the art and architecture of Romanesque Spain, with the emphasis on architecture. The short introductory essay is followed by a good selection of black and white plates (also with emphasis on architecture), notes to the plates, and a brief, unclassified bibliography (pp. 88-89).

Franz, Heinrich G. Spätromanik und Frühgotik. Baden-Baden, Holle, 1969. 283p. illus. index. LC 75-452952.

Concise history of late Romanesque and early Gothic art and architecture. Good color plates with a modest supplement of black and white plates, plans, and diagrams, plus a good classified bibliography (pp. 245-68) of major books and periodical articles in all languages. For the beginning and advanced student. German edition in the series "The Art of the World."

Gantner, Joseph, and Marcel Pobé. Romanesque Art in France. London, Thames & Hudson, 1956. 80p. (text); 271p. (illus.). index. LC A57-3028.

Pictorial survey of Romanesque art and architecture in France. Chief emphasis is on architecture, with less on monumental sculpture and little on painting. Introductory essay, notes on the plates, and general bibliography (p. 78).

870 Gomez Moreno, Manuel. El arte románico español. Madrid, Blass, 1934. 173p. illus. index.

Concise history of Romanesque art, architecture, and applied arts in Spain from the late eleventh through the twelfth century. Good corpus of plates. Geographical arrangement. Bibliographical footnotes.

Henry, Françoise. Irish Art in the Romanesque Period, 1020-1170.

3rd rev. enl. ed. Ithaca, New York, Cornell University Press, 1970. 240p. illus. index. LC 76-82117.

Concise history of art and architecture in Ireland, 1020-1170. Good selection of plates and maps. Bibliographical references in the footnotes to the text. Sequel to (836 and 837); together they form a standard history of Irish medieval art.

Kubach, Hans E., and Peter Bloch. L'art roman, de ses débuts à son apogée. Paris, Michel, 1966. 297p. illus. index. LC 67-42768.

History of Romanesque art and architecture from the middle of the eleventh to the middle of the twelfth century. Good selection of color plates, modest but well-chosen supplement of black and white plates; liberally provided with plans and diagrams. Also provides map and chronological table and an excellent classified bibliography (pp. 245-68), which lists books and periodical articles in all languages. French edition of the series "The Art of the World." An excellent history of Romanesque art and architecture.

Künstler, Gustav, comp. Romanesque Art in Europe. Greenwich, Conn., New York Graphic Society, 1969. 327p. illus. index. LC 69-18001. Pictorial survey of the art and architecture of Romanesque Europe, consisting of a selection of text and illustrations from a six-volume series published between 1955 and 1968 by Schroll Verlag of Vienna. These volumes, three of which have been translated into English, are annotated separately in this bibliography (748, 861, 864, 866, 869, and 884). Short introductory essays, selection of black and white plates (with emphasis on architecture), notes on the plates, and maps and plans; no bibliography.

Lefrançois, Louis Pillon. L'art roman en France: architecture, sculpture, peinture, arts mineurs. Paris, Le Prat, 1943. 118p. illus.

Concise history of art and architecture in France during the Romanesque period. No bibliography.

Mâle, Émile. Religious Art in France, the Twelfth Century: A Study of the Origins of Medieval Iconography. Princeton, N.J., Princeton University Press, 1978. 460p. illus. index. (Bollingen Series, XC. 1).

Translation of the 6th ed. (Paris, A. Colin, 1953) of L'art religieux du XIIe siècle en France; étude sur les origines de iconographie du moyen âge. . . . First published in 1922. Important scholarly study of the iconography of French figurative arts of the twelfth century. In this edition, supplemental material published as addenda in the 1953 edition has been incorporated into the text. Brought up to date through additions to the notes by Louis Grodecki. Introduction sketching and evaluating Mâle's career by Harry Bober. Contents: I, The Birth of Monumental Sculpture: the Influence of Manuscripts; II, The Complexity of Twelfth Century Iconography: Its Hellenistic, Syrian and Byzantine Origins; III, Eastern Iconography Modified by Our Artists; IV, Enrichment of Iconography: the Liturgy and Liturgical Drama; V, Suger and His Influence; VI, The Saints; VII, The Pilgrimage Road in Italy; VIII, The Pilgrimage Road in France and Spain; IX, Encyclopedic Trends in Art; X, The Monastic Imprint; and XI, Twelfth Century Historiated Portals: Their Iconography. Unclassified, but comprehensive, updated bibliography of books and periodical articles in all languages (pp. 517-46). A standard work.

Merhautova-Livorova, Anezka. Romanische Kunst in Polen, der Tschechoslovakel, Ungarn, Rumanien, Jugoslawien. Vienna, Munich, Schroll, 1974. 318p. illus. index. LC 75-530497.

Concise survey of art and architecture in Eastern Europe during the Romanesque. Brief text summarizes the developments in each country, followed by good collection of plates.

Pijoán y Soteras, José. El arte románico. Siglos XI y XII. Bilbao and Madrid, Espasa-Calpe, 1944. 612p. illus. index. (Summa Artis, Historia General del Arte, IX).

Comprehensive survey of European Romanesque art and architecture. Brief lists of books at the ends of chapters.

Rey, Raymond. L'art roman et ses origines. Paris, Didier, 1945. 511p. illus. index.

History of Romanesque art and architecture in France. Traces its origin back to Gallo-Roman and Germanic art. Bibliographical footnotes. A good survey of Romanesque art and architecture in France for the advanced student.

Santos, Reynoldo dos. O románico em Portugal. Lisbon, Editorial SUL, 1955. 151p. text, 144 plates. index.

Concise history of Portuguese Romanesque architecture and architectural sculpture, arranged by place. Introductory chapter surveys the pre-Romanesque background. Occasional bibliographical footnotes.

880 Souchal, François. Art of the Early Middle Ages. New York, Abrams, 1968. 263p. illus, index. LC 68-27428.

Brief survey of the art and architecture of the Romanesque period. A short introductory essay is followed by explanations of the plates. Provides chronological tables and a brief bibliography (pp. 258-59).

Swarzenski, Hanns. Monuments of Romanesque Art: The Art of Church Treasures in North-Western Europe. 2nd ed. Chicago, University of Chicago Press, 1967. 102p. (text); 238p. (illus.). index. LC 67-85931.

Comprehensive illustrated handbook of manuscript painting, metalwork, bronze sculpture, ivory carving, and enamels from France, Germany, the Low Countries, and England dating from the ninth century through the middle of the thirteenth century. The introduction, which traces the history of these arts, is followed by detailed notes on the plates with thorough reference to specialized literature. The excellent plates form an invaluable corpus of early medieval minor arts. A standard handbook.

882 Swoboda, Karl M. Die Epoche der Romanik. Munich and Vienna, Schroll, 1976. 236p. illus. index. LC 77-480452. (Geschichte der bildenden Kunst, Band 1).

History of art and architecture in Western Europe from the fourth century through the twelfth century. Emphasis is on the evolution of early medieval form. Bibliographies of specialized literature at the beginning of each chapter and a classified bibliography of general works (pp. 226-27). A good, balanced modern survey.

Timmers, J. J. M. A Handbook of Romanesque Art. London, Nelson, 1969. 240p. illus. index. LC 79-80800.

Concise handbook of Romanesque art and architecture in Italy, France, Germany, Spain, British Isles, Scandinavia, the Low Countries, and Eastern Europe. After an introduction that traces its origins, Romanesque art is divided into national groupings. Excellent maps, good selection of plates, and general, unclassified bibliography (pp. 234-35). A good handbook for beginning and advanced students.

Tuulse, Armin. Scandinavia Romanica: Die hohe Kunst der romanischen Epoche in Dänemark, Norwegen, und Schweden. Vienna, Schroll, 1968. 35p. (text); 96p. (illus.). LC 73-281685.

Pictorial survey of Romanesque sculpture and architecture in Denmark, Norway, and Sweden. Short introductory essay is followed by a collection of black and white plates, with notes; emphasis is on architecture. There are a few ground plans and elevations. Selections from this work are contained in (873).

885 Zarnecki, George. Romanesque Art. New York, Universe, 1971. 196p. illus. index. LC 75-122322.

Concise history of the art and architecture of the Romanesque period. Well-chosen illustrations with informative captions. Bibliography of general works (pp. 190-92). Series: "Universe History of Art."

GOTHIC

Aubert, Marcel. The Art of the High Gothic Era. New York, Crown, 1965. 227p. illus. index. LC 64-24750.

"With the collaboration of J. A. Schmoll-gen. Eisenwerth and contributions by Hans H. Hofstätter." Concise history of art and architecture in Western Europe, 1220-1350. Provides maps, glossary, chronological tables, and good classified bibliography (pp. 196-207). A good survey history of the climax of Gothic art in France and its spread to the rest of Europe. Series: "Art of the World."

887 Bachmann, Erich, ed. Gothic Art in Bohemia. New York, Praeger, 1977. 96p. text, 249 plates. index. LC 75-111067.

Comprehensive, scholarly history of art and architecture in Bohemia from the thirteenth through the fifteenth centuries. Translation of *Gotik in Böhmen* (Munich, Prestel, 1969). Chapters treating the development of architecture, painting and sculpture are written by German specialists. Bibliography of basic books and periodical articles (pp. 90-92).

Bialostocki, Jan. **Spätmittelalter und beginnende Neuzeit.** Berlin, Propyläen Verlag, 1972. 474p. (text); 468p. (illus.). index. (Propyläen Kunstgeschichte, Band 7). LC 72-373268.

Comprehensive illustrated handbook of Western European art and architecture of the fifteenth century. The introductory essay is followed by a body of excellent plates, essays by specialists on the development of the various arts, informative notes on the plates with additional plans and reconstructions, and valuable bibliographical references. Excellent, classified bibliography (pp. 430-52). A standard handbook.

Bouffard, Pierre. L'art gothique en Suisse. Geneva, Mazenod, 1948. 90p. illus.

Illustrated survey of art and architecture throughout Switzerland during the thirteenth, fourteenth, and fifteenth centuries. Series: "Les Nouvelles Éditions d'Art."

890 Busch, Harald. Deutsche Gotik. Vienna and Munich, Schroll, 1969. 124p. illus. LC 76-487048.

Pictorial survey of Gothic art and architecture in Germany. Emphasis is on architecture and its sculptural and painted decoration. Consists of brief introductory sketch followed by a good selection of plates with informative notes. No bibliography. Useful collection of plates.

891 Decker, Heinrich. Gotik in Italien. Vienna, Schroll, 1964. 308p. illus. LC 65-66821.

Illustrated survey of Gothic art and architecture in Italy. Introductory essay discusses the development of Gothic in the various regions of Italy, followed by a good collection of plates with emphasis on architecture and its decoration. No bibliography.

892 Deuchler, Florens. Gothic Art. New York, Universe, 1973. 184p. illus. index. LC 72-85081. Concise history of Gothic art and architecture from the mid-twelfth century through the fifteenth century in Northern Europe. The treatment of the Italian development ends with the thirteenth century. Well-chosen illustrations, many plans and elevations, and a balanced bibliography of general works (pp. 178-80). A good survey history for beginning and advanced students. Series: "Universe History of Art."

Fischer, Friedhelm W., and J. J. M. Timmers. Spätgotik; zwischen Mystik und Reformation. Baden-Baden, Holle, 1971. 283p. illus. index. LC 74-570646.

Concise and well-balanced history of the art and architecture of Germany, France, the Low Countries, and England during the fourteenth and fifteenth centuries. Provides a good selection of color plates, plans, and diagrams, a glossary of terms, and a classified bibliography of books in all languages (pp. 264-71). This work is part of the German edition of the series "The Art of the World," and may be translated in the near future.

Harvey, John H. The Gothic World, 1100-1600: A Survey of Architecture and Art. New York, Harper & Row, 1969. 160p. illus. index. LC 69-12465.

Concise survey of art and architecture in Western Europe during the Gothic period. Sets the history of art within the general context of cultural history, with good chapters on the methods and techniques of the Gothic artists and architects. Chief attention is given to architecture. Brief classified bibliography (pp. 133-36) and further bibliography in the footnotes. Rather poor illustrations, but useful maps and plans.

Henderson, George D. S. Gothic. Harmondsworth, Penguin, 1967. 223p. illus. index. (Style and Civilization). LC 67-9741.

An exploration of the factors that brought about the Gothic style in Europe, with chapters on the Gothic artists, the relation of theology to form, the development of Gothic style, and art and mysticism. Short but helpfully annotated bibliography (pp. 217-19).

Hofstätter, Hans H. Art of the Late Middle Ages. New York, Abrams, 1968. 264p. illus. index. LC 68-18131.

Brief survey of the art and architecture of the thirteenth through the midsixteenth centuries. Provides chronological tables of painting, sculpture, and architecture and a brief general bibliography (p. 253).

Jantzen, Hans. Kunst der Gotik. Reinbek bei Hamburg, Rowohlt, 1957. 174p. illus. index.

Scholarly history of French architecture, portal sculpture, and stained glass of the late twelfth and thirteenth centuries. Chapter on the rediscovery of the Middle Ages and the state of research into Gothic architecture. Glossary of terms and bibliography of basic books in all languages (pp. 166-67).

Karlinger, Hans. Die Kunst der Gotik. 3rd ed. Berlin, Propyläen, 1927. 726p. illus. index. (Propyläen Kunstgeschichte, VII).

Comprehensive illustrated handbook of Gothic art and architecture throughout Europe. Covers the period from the beginning of the Gothic style in France in the mid-twelfth century to the end of the fifteenth century. Includes the applied and decorative arts and graphic arts. Introductory essay surveys development, followed by a good corpus of plates with descriptive notes. No bibliography. Superseded by the new Propyläen series (911).

Lambert, Elie. L'art gothique en Espagne. Paris, Laurens, 1931. 314p. illus. index. Reprint: New York, B. Franklin, 1971. LC 72-156386.
 Concise history of art and architecture in Spain during the twelfth and thirteenth centuries. Good selection of plates, plans, and diagrams. Annotated bibliography (pp. 291-98). Standard history of Spanish Gothic art.

900 Lefrancois-Pillon, Louis, and Jean Lafond. L'art du XIVe siècle en France. Paris, Albin Michel, 1954. 254p. illus. index.

Comprehensive history of art and architecture in France during the fourteenth century. Chapters discuss the various media separately. Appendix with discussion of the iconography of fourteenth-century illuminated manuscripts. Bibliographical footnotes and brief list of basic books (p. 238).

901 Mâle, Émile. L'art religieux de la fin du moyen âge en France. 5th ed. Paris, A. Colin, 1949.

First published in 1908. Important iconographic history of French late Gothic art. Contents: I, L'iconographie française et l'art italien; II, L'art et le theatre religieux (an influential essay); III, L'art religieux traduit des sentiments nouveaux—le pathétique; IV,—la tendresse humaine; V,—les aspects nouveaux du culte des saints; VI, L'ancien et le nouveau symbolisme; Partie II, 1, L'art et la destinée humaine—la vie humaine—le vice et la vertu; 2,—, la mort; 3,—le tombeau; 4,—la fin du monde—le jugement dernier—les peines et les recompenses; 5, Comment l'art du moyen âge a fini. Bibliographical footnotes. A standard work.

Mâle, Émile. Religious Art in France of the Thirteenth Century; A Study in Mediaeval Iconography and Its Sources of Inspiration. New York, Dutton, 1913. 415p. illus. index. Reprinted as: The Gothic Image: Religious Art in France of the Thirteenth Century. New York, Harper, 1958. LC 58-10152.

Translation of the third edition (Paris, Leroux, 1898); the most recent, the eighth edition, was published by Colin in Paris (1948). Scholarly study of the iconography of French figurative arts of the thirteenth century. Contents: I, General Characteristics of Mediaeval Iconography; II, Method Used in This Study of Mediaeval Iconography—the Mirrors of Vincent of Beauvais; Book I, The Mirror of Nature; Book II, The Mirror of Instruction; Book III, The Mirror of Morals; Book IV, The Mirror of History. The Old Testament; The Gospels; Apocryphal Stories; The Saints and the Golden Legend; Antiquity. Secular History; The Close of History—The Apocalypse—The Last Judgment; Conclusion. Appendix with list of works devoted to the Life of Christ. Extensive bibliographical footnotes and comprehensive, but unclassified bibliography (pp. 407-410). Index is to works of art mentioned, not to subjects. Until a new translation appears in the Bollingen series (875), serious

students should use this edition together with the eighth French edition. A standard work.

903 Martindale, Andrew. Gothic Art. New York, Praeger, 1967. 287p. illus. index. LC 67-28194.

Concise history of Gothic art and architecture from the twelfth to the fifteenth century. Includes Italian art and architecture of the fourteenth century. Provides a chronological table, a glossary of terms, and a select bibliography (pp. 272-73).

904 Mayer, August L. Gotik in Spanien. Leipzig, Klinkhardt und Biermann, 1928. 299p. illus. index.

History of art and architecture in Spain from the early thirteenth century to the end of the fifteenth century. Chapters treat major monuments, artists, schools, and regions. Inadequate bibliographical footnotes.

905 Michel, André, ed. Formation, expansion et évolution de l'art gothique. Paris, Colin, 1907. 2v. illus. (Histoire de l'Art..., tome II).

Comprehensive history of art, architecture, and the applied arts in Western Europe during the thirteenth and fourteenth centuries. Chapters written by various French scholars discuss the development of these media in the various countries with emphasis on France and Italy. Bibliographies of basic literature at the end of each chapter.

906 Pijoán y Soteras, José. Arte gótico de la Europa occidental, siglos XIII, XIV y XV. Madrid, Espasa-Calpe, 1947. 615p. illus. index. (Summa Artis, Historia General del Arte, XI).

Comprehensive history of art and architecture in Western Europe during the thirteenth, fourteenth, and fifteenth centuries. Introductory chapters discuss the background and definition of Gothic style. Arrangement of the remaining chapters is by country, then chiefly by major building. Bibliography of general books (pp. 595-97).

907 Réau, Louis. L'art gothique en France: architecture, sculpture, peinture, arts appliqués. Rev. and exp. ed. Paris, Le Prat, 1968. 170p. illus. LC 79-373657.

Concise history of art and architecture in France during the Gothic period. Provides a one-page glossary of terms and brief bibliography (p. 170).

908 Salet, François. L'art gothique. Paris, Presses Universitaires de France, 1963. 186p. illus. LC 66-46706.

Concise history of Gothic art and architecture, chiefly in France, from 1125 to 1540. Bibliography (pp. 185-86) chiefly lists works in French.

909 Scheffler, Karl. Der Geist der Gotik. Leipzig, Insel, 1917. 111p. illus. Analysis of the development of form in medieval art. Contents: Die Lehre von Ideal; Die beiden Formenwelten der Kunst; Der Weg der Gotik. No bibliography. For a similar approach, see Worringer (917).

910 Schmarsow, August. Italienische Kunst im Zeitalter Dantes. Augsburg, Filser, 1928. 2v. illus.

Important, comprehensive history of Italian art and architecture during the thirteenth and fourteenth centuries. Contents: I, Niccolò Pisano; II, Giovanni Pisano; III, Die Gotik in Mittelitalien; IV, Rhythmik der Innenraum; V, Raumdarstellung der Maler; VI, Giotto in Padua und in Florenz; VII, Die Bronzetur des Andrea Pisano; VIII, Reliefskulpturen des Domfassade von Orvieto; IX, Sienesische Malerei; and X, Der Schrein des SS. Corporale in Orvieto. No bibliography.

911 Simson, Otto von. **Das Mittelalter II**: **Das Hohe Mittelalter**. Berlin, Propyläen, 1972. 475p. (text); 472p. (illus.). index. (Propyläen Kunstgeschichte, Band 6). LC NUC73-87529.

Comprehensive illustrated handbook of art and architecture in Western Europe from the mid-twelfth century through the fourteenth century. Introductory essay by von Simson is followed by a corpus of excellent plates; essays by specialists on the development of the various arts in France, Germany, England, and Italy; informative notes on the plates with valuable bibliographical references; and an excellent comprehensive and classified bibliography (pp. 437-56). A standard handbook.

- 912 Stalley, R. A. Architecture and Sculpture in Ireland, 1150-1350. New York, Barnes & Noble, 1971. 149p. illus. LC 72-197179.

 Well-illustrated survey of architecture and architectural sculpture in Ireland during the Gothic period. Introductory chapter on patrons and craftsmen is followed by chapters devoted to particular building types. Maps; no bibliography.
- Swaan, Wim. The Late Middle Ages: Art and Architecture from 1350 to the Advent of the Renaissance. Ithaca, N.Y., Cornell University Press, 1977. 232p. illus. index. LC 77-77552.

Well-illustrated survey of art and architecture outside Italy from 1350 to circa 1500. Introduction analyzes the "Tenor of the Age," and subsequent chapters concentrate on the development of art and architecture in the various nations. Excellent photographs by the author. Classified bibliography, chiefly of books (pp. 224-27).

- Swoboda, Karl M. Die Gotik von 1150-1300. Munich and Vienna, Schroll, 1977. 234p. illus. index. (Geschichte der bildenden Kunst, Band 2). History of Gothic art and architecture 1150 to 1300. Introductory chapters discuss the state of research on Gothic art and stylistic and formalistic ramifications of the Gothic mode. Subsequent chapters are devoted to the evolution of Gothic in the various nations of Western Europe. Specialized literature is contained in bibliographies at the beginning of each chapter, and general works are presented in a classified list (pp. 226-27). A good, balanced, modern stylistic survey.
- 915 Swoboda, Karl M. Die Spätgotik. Munich and Vienna, Schroll, 1978.
 228p. illus. index. (Geschichte der bildenden Kunst, Band 3).
 History of art and architecture in Italy during the fourteenth century and in the rest of Western Europe during the fourteenth and fifteenth centuries. Introduction analyzes the concept of Late Gothic, and subsequent chapters trace the evolution of style in the various countries. Bibliographies of specialized literature at the

beginning of each chapter and a classified bibliography of more general works (pp. 216-17). A good, balanced, modern stylistic survey.

916 Walle, A. J. L. van de. Gothic Art in Belgium. Brussels, M. Vokaer, n.d. 239p. illus. index. LC 72-360090.

Pictorial survey of architecture and monumental sculpture from the Gothic period in Belgium. Includes examples from the thirteenth through the fifteenth centuries. Introductory essay is concerned chiefly with the history of architecture in Belgium during the Gothic period. Plates that follow include works of sculpture as well as architecture. Brief, unclassified bibliography (pp. 77-78). For the general reader and the beginning student; however, the introductory essay is sufficiently detailed to be of value to the advanced student of medieval architecture.

Worringer, Wilhelm. Form in Gothic. Revised edition. London, Tiranti, 1957. 180p. illus. Reprinted: New York, Schocken, 1964. LC 63-22688. First published in 1910 as Formprobleme der Gotik. Highly influential study of the psychology of Gothic art and architectural form. Based upon the ideas of the German aesthetician, Theodor Lipps, in analyzing aesthetic empathy (Einfühlung). Worringer sees Gothic form as a fundamental desire for abstraction derived from the spirituality of the age. A classic work in the psychology of art history.

RENAISSANCE (INCLUDING MANNERISM)

GENERAL WORKS

918 Adama van Scheltema, Frederik. Die Kunst der Renaissance. Stuttgart, Kohlhammer, 1957. 210p. illus. index. (Die Kunst des Abendlandes, Band 3). LC A58-273.

Survey history of art and architecture of the fifteenth and sixteenth centuries in both Northern and Southern Europe. Bibliographical footnotes.

919 Batterberry, Michael, adapter. Art of the Early Renaissance. New York, McGraw-Hill, [c. 1968]. 191p. illus. index. LC 79-115138.

Pictorial survey of the art and architecture of Northern and Southern Europe from Giotto to Botticelli and Van Eyck to Bosch. No bibliography. For the general reader.

920 Battisti, Eugenio. Rinascimento e Baròcco. Turin, Einaudi, 1960. 328p. illus. LC 62-42100.

History of European art and architecture from the early fourteenth century through the middle of the eighteenth century. Emphasis is on Italian developments. Extensive bibliographical footnotes. A standard Italian history of Renaissance and baroque art and architecture.

921 Baumgart, Fritz-Erwin. Renaissance und Kunst des Manierismus. Cologne, DuMont Schauberg, 1963. 232p. illus. index. LC 64-43125.

History and investigation of the meaning of the High Renaissance and Mannerism in Western Europe. Provides a most useful collection of excerpts (translated into

German) from documents relating to the Renaissance and Mannerism, from Serlio

to Erwin Panofsky. Bibliography (pp. 217-22) lists major works on the period in chronological order. A scholarly definition and history of the High Renaissance and Mannerism.

922 Gilbert, Creighton. History of Renaissance Art: Painting, Sculpture, Architecture throughout Europe. New York, Abrams, 1973. 460p. illus. index. LC 72-4791.

Concise history of art and architecture of the Renaissance in Western Europe. Emphasis is on painting, beginning with Cimabue and ending with the late sixteenth century. Chronological chart of artists and classified bibliography of works in English (pp. 423-36).

- Huyghe, René, ed. Larousse Encyclopedia of Renaissance and Baroque Art. New York, Prometheus, 1964. 444p. illus. index. LC 64-13787. Concise history composed of brief essays by specialists on the art and architecture of Western Europe from the end of the Middle Ages through the baroque (actually nineteenth century). No bibliography.
 - Waufmann, Georg. Die Kunst des 16. Jahrhunderts. Berlin, Propyläen, 1970. 468p. (text); 408p. (illus.). index. (Propyläen Kunstgeschichte, Band 8). LC 75-551182.

Comprehensive illustrated handbook of the art and architecture of Europe in the sixteenth century. The introductory essay by Kauffmann is followed by a body of excellent plates, essays by a number of specialists on the development of the various arts, informative notes to the plates (with plans and diagrams), and valuable references to specialized literature. Excellent classified bibliography of books and periodical articles (pp. 405-441). Chronological table provides synopsis of events in political history, the various arts, philosophy, literature, and cultural history. A standard handbook.

Martindale, Andrew. Man and the Renaissance. New York, McGraw-Hill, 1966. 186p. illus. index. LC 66-15837.

Art historical survey of the Renaissance in Italy and Northern Europe in a cultural context. Treats architecture, sculpture, and painting. Enhanced by maps, a chronological table, brief biographical glossary and a general reading list (p. 167).

Ruskin, Ariane. Art of the High Renaissance. New York, McGraw-Hill, 1968. 189p. illus. index. LC 76-110961.

Pictorial survey of art and architecture from Leonardo to El Greco. Covers both Northern and Southern Europe. No bibliography. For the general reader.

Wolf, Robert E., and Ronald Millen. Renaissance and Mannerist Art. New York, Abrams, 1968. 263p. illus. index. LC 68-18132.

Concise survey of the art and architecture in Italy, Spain, Portugal, France, the Low Countries, Germany, and England during the fifteenth and sixteenth centuries. Well illustrated and with a brief, classified bibliography of books in English and foreign languages (pp. 258-60).

Wundram, Manfred. Art of the Renaissance. New York, Universe, 1972. 196p. illus. LC 73-175861.

Concise history of art and architecture in all of Western Europe during the fifteenth and sixteenth centuries. Very good selection of plates with informative captions, liberally provided with plans and diagrams. Bibliography (pp. 190-92) lists major books in all languages. Concise but balanced and factual text with emphasis on the development of style in Renaissance art and architecture. A good survey for the general reader and the beginning student. Series: "Universe History of Art."

MANNERISM

- 929 Hauser, Arnold. Mannerism: The Crisis of the Renaissance and the Origin of Modern Art. New York, Knopf, 1965. 2v. illus. index. LC 65-11130. Volume one, text; volume two, plates. This scholarly study of the art and architecture of mannerism provides a good historical survey of the style and an investigation of the concept of mannerism and its relationship to contemporary culture. No separate bibliography, but the extensive footnotes provide thorough reference to literature on mannerism. A standard work.
- 930 Hocke, Gustav R. Die Welt als Labyrinth, Manier und Manie in der europäischen Kunst: Beiträge zur Ikonographie und Formgeschichte der europäischen Kunst von 1520 bis 1620. Hamburg, Rowohlt, 1957. 252p. illus. index. LC 59-25248.

Five-part text discusses subject matter and style of European mannerism. Important theoretical analysis of manneristic spatial concepts. Classified bibliography of basic works in all languages (pp. 229-33).

931 Shearman, John K. G. Mannerism. Harmondsworth, Penguin, 1967. 216p. illus. index. LC 67-98470.

Handbook of the art and architecture of mannerism in both Northern and Southern Europe. Not a history of mannerist art but an investigation of the meaning of the style in relationship to other arts and cultural developments. Chapter five gives an excellent account of the term mannerism in art history. A brief but useful bibliography of books and periodical articles in all languages (pp. 207-208). Further literature is noted in the catalog of illustrations. For beginning and advanced students. This is one of the best analyses of the mannerist style in English.

- Weise, Georg. Il manierismo. Bilancio critico del problema stilistico e culturale. Florence, Olschki, 1971. 236p. illus. index. LC 72-325759. (Accademia Toscana di Scienze e Lettere "La Colombaria," Studi XX). Collection of essays on the nature of mannerism. Part one treats formal problems in the development of manneristic style; part two examines broad ideas and cultural phenomena of mannerism. Unclassified list of books and periodical articles in all languages (pp. 213-19).
 - Würtenberger, Franzsepp. Mannerism, the European Style of the Sixteenth Century. New York, Holt, Rinehart and Winston, 1963. 246p. illus, index. LC 63-18066.

Comprehensive history of the art and architecture of mannerism in Western Europe. Treats art, architecture, and the minor arts. Excellent illustrations and a good classified bibliography (pp. 230-38), which lists books and periodical articles in all languages. A standard history and study of mannerism.

ITALIAN RENAISSANCE

934 Battisti, Eugenio. Hochrenaissance und Manierismus. Baden-Baden, Holle, 1970. 255p. illus. index. LC 79-508918.

Concise history of Italian art and architecture of the High Renaissance and mannerism. Good selection of color plates, modest supplement of black and white illustrations. Bibliography (pp. 214-44) provides a good classified list of books and periodical articles in all languages. German edition of the series, "Art of the World."

- Bode, Wilhelm von. Die Kunst der Frührenaissance in Italien. Berlin, Propyläen, 1923. 624p. illus. index. (Propyläen Kunstgeschichte, VIII). Illustrated survey of fifteenth-century art and architecture in Italy. Introduction discussing the fourteenth-century background is followed by chapters devoted to major regional schools. Superseded by a new Propyläen series volume (888), but the text here, by one of the greatest experts on the Italian Renaissance, is still worth reading.
 - Odyssey Press, 1965. 384p. illus. index. (The Arts of Mankind, 7). LC 65-27309.

History of art and architecture in Italy from circa 1460 to 1530 with a section on the spread of Italian Renaissance style to the rest of Europe. Provides maps and chronological tables; the bibliography of books in all languages (pp. 359-67) has its own subject index. With its companion volume (630), it forms a useful pictorial handbook to Italian Renaissance art and architecture for the advanced student. The somewhat confused arrangement by schools, types, etc., will frustrate the beginning student, who would otherwise benefit most from the text.

937 Chastel, André. Studios and Styles of the Italian Renaissance. New York, Odyssey Press, 1966. 417p. illus. index. (The Arts of Mankind, 8). LC 66-18997.

Survey history of the art and architecture of the fifteenth century in Italy, arranged by type, with an emphasis on workshops and local schools. Provides a glossary-index that treats artists, terms, and places; there are also maps and a good bibliography of books in all languages (pp. 387-98). See (936) as well.

Decker, Heinrich. The Renaissance in Italy. New York, Viking, 1969. 338p. illus. index. LC 68-23210.

Pictorial survey of the art and architecture of Italy in the fifteenth and sixteenth centuries. After a short introductory essay the plates are arranged by geographical region, with informative notes. No bibliography.

Dvořák, Max. Geschichte der italienischen Kunst im Zeitalter der Renaissance . . . Munich, Piper, 1927-28. 2v. illus. index.

Comprehensive and scholarly history of art and architecture in Italy during the fourteenth, fifteenth, and sixteenth centuries. Well-illustrated with plates and plans. Volume one covers the fourteenth and fifteenth centuries; volume two, the sixteenth century. Bibliography in the footnotes. An old but classic history of Italian Renaissance art by one of the greatest specialists.

Eglinski, Edmund. The Art of the Italian Renaissance. Dubuque, Iowa,W. C. Brown, 1968. 104p. illus. index. LC 68-14576.

Brief survey of the art and architecture of Italy during the fifteenth and sixteenth centuries. Short bibliography of books in English (pp. 100-102). For the beginning student.

941 Hartt, Frederick. History of Italian Renaissance Art: Painting, Sculpture and Architecture. New York, Abrams, 1969. 636p. illus. index. LC 74-95193.

Comprehensive history of art and architecture in Italy from the late twelfth to the late sixteenth century. Excellent choice of illustrations, plans, and diagrams, very useful glossary of terms and subjects, chronological chart of artists and monuments, and classified bibliography of works in English (pp. 608-613). A standard history of Italian Renaissance art and architecture for beginning and advanced students.

942 Heydenreich, Ludwig H. Italie, 1400-1460: Éclosion de la Renaissance. Paris, Gallimard, 1972. 452p. illus. index. LC NUC74-111761. History of art and architecture in Italy from 1400 to 1460. Provides a good selection of plates, plans, and diagrams; a glossary-index; and a good comprehensive bibliography of books and periodical articles. French edition in the series "The Arts of Mankind."

943 Heydenreich, Ludwig H., and Gunther Passavant. Le temps des génies; Renaissance italienne 1500-1540. Paris, Gallimard, 1974. 462p. illus. index. (L'Univers des Formes, 22). LC 74-759.

History of art and architecture in Italy during the High Renaissance. Provides good selection of plates, plans, and diagrams; a glossary-index; and a good comprehensive bibliography of books and periodical articles. French edition of the series "The Arts of Mankind."

944 Hoffmann, Heinrich. Hochrenaissance, Manierismus, Frühbarock. Die Italienische Kunst des 16. Jahrhunderts. Zurich, Leipzig, Gebr. Leeman, 1938. 187p. illus.

Formalistic analysis and survey of art and architecture in Italy during the sixteenth century. One of the first books to recognize the intermediary role played by mannerism in the development from High Renaissance to Baroque. Classified bibliography of basic books in all languages (pp. 184-87).

945 Keller, Harald. The Renaissance in Italy: Painting, Sculpture, Architecture. New York, Abrams, 1969. 394p. illus. index. LC 69-12485.

History of art and architecture in Italy from the early fourteenth century through mannerism. Good selection of black and white and color plates, plans, and diagrams,

and a balanced, classified bibliography (pp. 375-79). An excellent history for beginning and advanced students.

Levey, Michael. Early Renaissance. Harmondsworth, Penguin, 1967.224p. illus. index. LC 68-88043.

History and analytical study of Italian art and architecture of the fifteenth century. Emphasis is on the idea of the Renaissance and the relationship of the fine arts to the general culture. Provides a good annotated bibliography (pp. 217-19) of books in English.

947 Michel, André, ed. La renaissance. Paris, Colin, 1909-1911. 2v. illus. (Histoire de l'Art . . . , tome IV).

Comprehensive history of art, architecture, and graphic and applied arts in Italy, France, Spain, and Portugal during the sixteenth century. Chapter on painting of the Low Countries at the end of the sixteenth century. Bibliographies of basic literature at the end of each chapter.

948 Michel, André, ed. Le réalisme les débuts de la renaissance. Paris, Colin, 1907-1908. 2v. illus. (Histoire de l'Art..., tome III).

Comprehensive history of art, architecture, and the graphic and applied arts in Italy and France during the fifteenth century. Chapters, written by various French scholars, sketch the development of the media. Concluding chapter: "L'art chrétien d'orient du milieu du XIIe au milieu du XVIe siècle," by G. Millet. Bibliography of basic literature at the end of each chapter.

949 Murray, Linda. The High Renaissance. New York, Praeger, 1967. 213p. illus. index. LC 67-18404.

Concise survey of the art and architecture of Italy in the first three decades of the sixteenth century. Selected bibliography of books in English (pp. 195-97). Series: "World of Art Library."

950 Murray, Linda. The Late Renaissance and Mannerism. New York, Praeger, 1967. 215p. illus. index. LC 67-25566.

Concise survey of the art and architecture of Western Europe from circa 1530 to 1580. Short bibliography (pp. 200-202) of books in English. Series: "World of Art Library."

Murray, Peter, and Linda Murray. The Art of the Renaissance. New York, Praeger, 1963. 286p. illus. index. LC 63-18834.

Survey history of the art and architecture of Western Europe of the fifteenth century. Good selection of illustrations and readable text, but no bibliography. Series: "World of Art Library."

Paatz, Walter. The Arts of the Italian Renaissance. Englewood Cliffs, N.J., Prentice-Hall, 1974. 277p. illus. LC 73-21965.

Concise history-handbook of art and architecture in Italy from the beginning of the fifteenth century until 1530. Treats the various arts separately. Excellent introductory chapters on the concept and definition of the Renaissance. Thorough bibliographical references in the footnotes of the text.

Pijoán y Soteras, José, and Juan A. Gaya Nuño. Arte del periodo humanístico trecento y cuartrocento. Madrid, Espasa-Calpe, 1950. 641p. illus. index. (Summa Artis, Historia General def Arte, XIII).

Comprehensive history of art and architecture in Italy during the fourteenth and fifteenth centuries. Chapters are chiefly dedicated to major personalities and schools. Bibliography (pp. 611-13) lists general books in all languages.

954 Pijoán y Soteras, José. Renacimiento Romano y Veneciano siglo XVI. Madrid, Espasa-Calpe, 1951. 711p. illus. index. (Summa Artis, Historia General del Arte, XIV).

Comprehensive history of Italian art and architecture of the sixteenth century with emphasis on Rome and Venice. Chapters are dedicated to major personalities, schools, and major buildings. Bibliography of general books (pp. 667-69).

- Schubring, Paul. Die Kunst der Hochrenaissance in Italien. Berlin, Propyläen, 1926. 614p. illus. index. (Propyläen-Kunstgeschichte, IX). Illustrated survey of Italian art and architecture of the first half of the sixteenth century. Brief introductory essay followed by corpus of plates. No bibliography. Superseded by new Propyläen series volume (924).
- Smart, Alastair. The Renaissance and Mannerism in Italy. New York, Harcourt Brace Jovanovich, 1971. 252p. illus. index. LC 76-113711. Survey of the art and architecture of Italy from the early fifteenth to the late sixteenth century. Emphasis is on painting and sculpture, although architecture is treated. Bibliography (pp. 245-46) lists only books in English.
- 957 Stokes, Adrian D. The Quattro Cento; A Different Conception of the Italian Renaissance. New York, Schocken, 1968. 230p. illus. index. LC 68-28902.

First published in 1932. Collection of essays on various aspects of the fifteenth century in Italy, particularly the relationship between Verona and Florence. Eccentric. No bibliography.

958 White, John. Art and Architecture in Italy: 1250 to 1400. Baltimore, Penguin, 1966. 449p. illus. index. (Pelican History of Art, Z28). LC 67-5664.

Comprehensive history of art and architecture in Italy from 1250 to 1400. Good selection of plates, plans, and diagrams; a good, classified bibliography (pp. 419-27) of books in English and foreign languages, with additional references to specialized literature in the notes to the text. A standard history.

Wölfflin, Heinrich. Classic Art, an Introduction to the Italian Renaissance. 2nd ed. New York, Phaidon, 1953. 297p. illus. index.

History of painting and sculpture in Italy during the period of the High Renaissance. A preliminary survey outlines the development of Italian art during the fifteenth century; this is followed by a detailed analysis of the artistic development of Leonardo, Michelangelo, Raphael, Fra Bartolommeo, and Andrea del Sarto. The work concludes with a formalistic investigation of the style of Italian Renaissance art. Bibliographical footnotes. A classic of art historical analysis, more important

for its highly influential methodology than for its history of Italian Renaissance art.

Wölfflin, Heinrich. Die Kunst der Renaissance: Italien und das deutsche Formgefühl. Munich, Bruckmann, 1931. English translation: The Sense of Form in Art. New York, Chelsea Publishing Co., 1958. 230p. illus. LC 57-12877.

Not a history of Renaissance art, but a detailed comparison of the formalistic qualities of Italian and German art and architecture of the sixteenth century. One of the most influential studies in contrasting national art styles. No bibliography.

See also: Alazard (1315), Bottari (1319), Venturi (1326).

NORTHERN RENAISSANCE

General Works

Benesch, Otto. The Art of the Renaissance in Northern Europe. 2nd ed. New York and London, Phaidon, 1965. 195p. illus. index. LC 64-13171. History of art (exclusive of architecture) of Germany, France, and the Low Countries during the sixteenth century, with an emphasis on the interrelationship between the visual arts and the general intellectual climate of the times. Treats mannerist styles as well as Renaissance. Thorough bibliography of books and periodical articles in the notes to the text (pp. 169-85). A basic study for the advanced student.

Glück, Gustav. Die Kunst der Renaissance in Deutschland, der Niederlanden, Frankreich . . . 2nd ed. Berlin, Propyläen, 1928. 657p. illus. index. (Propyläen-Kunstgeschichte, X).

Comprehensive illustrated handbook of art and architecture outside of Italy during the sixteenth and seventeenth centuries. Introductory essay outlining the development of style is followed by a good corpus of plates, with descriptive notes containing occasional bibliographical references. Superseded by new Propyläen series (924).

963 Michel, André, ed. La renaissance dans les pays du nord; Formation de l'art classique moderne. Paris, Colin, 1912-1915. 2v. illus. (Histoire de l'Art..., tome V).

Comprehensive history of art, architecture, and the graphic and applied arts in Germany, the Low Countries, and England during the fifteenth and early sixteenth centuries. Chapters, written by various French scholars, trace the development of the media in the various countries. Concluding chapter on enamels by P. de Vasselot. Bibliographies of basic literature at the end of each chapter.

Osten, Gert von der, and Horst Vey. Painting and Sculpture in Germany and the Netherlands: 1500 to 1600. Baltimore, Penguin, 1969. 403p. illus. index. (Pelican History of Art, Z31). LC 73-8246.

Comprehensive history of painting and sculpture in Germany and the Netherlands in the sixteenth century. Good selection of plates; an unclassified bibliography in the form of a list of abbreviations (pp. 375-78) is supplemented by reference to specific literature in the notes to the text. A standard history.

Pijoán y Soteras, José. El arte renacimiento en el norte y el centro de Europa. Madrid, Espasa-Calpe, 1952. 696p. illus. index. (Summa Artis, Historia General del Arte, XV).

Comprehensive history of art and architecture in the Low Countries, Germany, Austria, and Switzerland during the fifteenth and sixteenth centuries. Chapters are chiefly devoted to the art of a major personality. Bibliography of general works (pp. 630-34).

966 Smart, Alastair. The Renaissance and Mannerism outside Italy. New York, Harcourt Brace Jovanovich, 1972. 224p. illus. index. LC 70-165326.

Survey of art and architecture in France, Spain, the Low Countries, Portugal, and Germany from the early fifteenth century to the end of the sixteenth century. Emphasis is on painting and sculpture. Bibliography (pp. 218-20) is restricted to books in English.

967 Stokstad, Marilyn J. Renaissance Art outside Italy. Dubuque, Iowa, W. C. Brown, 1968. 113p. illus. index. LC 68-14577.

Survey of art and architecture in Spain, France, Germany, and the Low Countries during the Renaissance. Brief bibliography (pp. 107-108) lists major books in English. Designed as an inexpensive text for beginning students.

See also: Bialostocki (888)

France

Blunt, Anthony. Art and Architecture in France: 1500-1700. 3rd ed.
 Baltimore, Penguin, 1970. 315p. illus. index. (Pelican History of Art, Z4).
 LC 70-521859.

Comprehensive history of art and architecture in France during the sixteenth and seventeenth centuries. Good selection of plates, plans, and diagrams. Bibliography (pp. 289-94), with further, more specialized literature mentioned in the extensive footnotes. A standard history.

969 Columbier, Pierre du. L'art de la renaissance en France. 2nd ed. Paris, Le Prat, 1950. 133p. illus.

Brief survey of the art and architecture in France during the late fifteenth and sixteenth centuries. Text arranged by media. No bibliography.

Olombier, Pierre du. Le style Henri IV et Louis XIII. Paris, Larousse, 1941. 124p. illus. index.

In the series "Arts, Styles et Techniques." Concise history of art, architecture, and the decorative arts in France during the reigns of Henry IV and Louis XIII. Bibliography of books and periodical articles (pp. 119-22) and index with artists' biographies.

971 Gébelin, François. Le style renaissance en France. Paris, Larousse, 1942. 129p. illus.

Brief history of art and architecture in France during the sixteenth century. Brief bibliography (pp. 126-29) and an appendix of short biographies of artists.

972 Weese, Arthur. Skulptur und Malerei in Frankreich vom 15. bis 17.

Jahrhundert. Berlin, Athenaion, 1927. 220p. illus. index.

Comprehensive history of sculpture and painting in France from the early fifteenth through the seventeenth centuries. Some bibliographical references in the footnotes.

See also: Schneider (1234).

Germany and Austria

Baldass, Peter von, Rudolf Feuchtmüller, and Wilhelm Mrazek. Renaissance in Österreich. Vienna and Hanover, Forum, 1966. 11p. (text); 96p. (illus.). index. LC 67-77758.

History of art and architecture in Austria during the sixteenth century. Chapters treat the major media of architecture, painting, and sculpture, as well as the minor arts. Well illustrated. Provides a good bibliography (pp. 107-109) that lists books and periodical articles.

973a Jahn, Johannes. Deutsche Renaissance: Architektur, Plastik, Malerei, Graphik, Kunsthandwerk. Vienna and Munich, Schroll, 1969. 50p. (text); 158p. (illus.). LC 70-471461.

Pictorial survey of the art and architecture of the Renaissance in Germany, Austria, and Switzerland. Short essays on the development of the various arts are followed by a collection of good plates and descriptive notes. No bibliography.

See also: Pinder (1290).

Spain

974 Saló Marco, Antonio. El estilo renacimiento español. Barcelona, Serrahima y Urpi, n.d. (1931). 480p. illus.

Comprehensive handbook of Spanish Renaissance art, with emphasis on the applied and decorative arts. Contents: Mobiliario; Cerámica y vidrieras; Hierros forjados; Techos artesonados, puertas labrados; Orfebreria, plateria, esmaltes; Bordados, tejidos, cueros repujados; Conjunto de interiores; Altares, retablos, púlpitos; Arquitectura; Patios, zaguanes y jardines. Each chapter ends with a summary. No bibliography.

See also: Gudiol y Ricart (1387).

Eastern Europe

975 Bialostocki, Jan. The Art of the Renaissance in Eastern Europe. Ithaca, N.Y., Cornell University Press, 1976. 312p. illus. index. LC 75-38429. Based on the Wrightsman Lectures at the Institute of Fine Arts in New York in 1975. Themalogical survey of art in Poland, Czechoslovakia, and Hungary during the sixteenth century. Contents: Humanism and Early Patronage; the Castle; the Chapel; the Tomb; the Town; Classicism, Mannerism and Vernacular. Comprehensive but unclassified bibliography, with Slavic titles translated into English (pp. 281-306). Major work by a leading Polish art historian on a neglected area.

975a Kozakiewiczowie, Helena, and Stefan Kozakiewiczowie. The Renaissance in Poland. Warsaw, Arkady, 1976. 330p. illus. index.

Illustrated survey of art and architecture in Poland (including the former German territories presently under Polish administration) from 1545 to 1640. Selected bibliography (pp. 323-25) lists works in Polish.

See also: Alpatov (1417), Geschichte der russischen Kunst (1422).

BAROOUE AND ROCOCO

GENERAL WORKS

976 Andersen, Liselotte. Baroque and Rococo Art. New York, Abrams, 1969. 264p. illus. index. LC 79-75041.

A survey history of painting, sculpture, architecture, and the decorative and minor arts of the Baroque and Rococo in Northern and Southern Europe. Includes chronological tables and a general bibliography (pp. 258-59).

Bazin, Germain. Baroque and Rococo. New York, Praeger, 1964. 288p. illus. index. LC 64-22488.

Survey history of the art and architecture of the seventeenth and eighteenth centuries in Italy, Spain, Portugal, France, the Low Countries, Germany, Austria, Scandinavia, Great Britain, and Eastern Europe. Brief, but annotated bibliography of books in all languages (pp. 273-75).

978 Brinckmann, Albert E. **Die Kunst des Rokoko**. Berlin, Propyläen, 1940. 671p. illus. index. (Propyläen-Kunstgeschichte, XIII).

Comprehensive illustrated handbook of Rococo architecture, sculpture, and painting throughout Europe. Geographical survey introduces a good corpus of plates, with descriptive notes and some bibliographical references. First edition by Max Osborn (Berlin, Propyläen, 1929. 659p.). Superseded in function by the new Propyläen series (984), but the introductory essay by one of the great experts on eighteenth-century art is still worth reading.

979 Hausenstein, Wilhelm. Vom Genie des Barock. Munich, Prestel, 1962. 104p. illus. LC 57-2274.

Scholarly analysis of the Baroque style in European art and architecture. Particularly valuable for the text and illustrations examining the quality of space in Baroque painting and architecture. No bibliography.

980 Hautecoeur, Louis. L'art baroque. Paris, Formes et Reflets, 1958. 146p. illus. index.

Illustrated survey of art and architecture of the seventeenth century in Western Europe. No bibliography.

981 Held, Julius S., and Donald Posner. 17th and 18th Century Art: Baroque Painting, Sculpture, Architecture. New York, Abrams, 1971. 439p. illus. index. LC 79-127417.

History of art and architecture in Italy, France, Spain, Portugal, the Low Countries, Germany, Austria, and England during the seventeenth and eighteenth centuries. Provides a chronological chart of artists and a brief selected bibliography of books chiefly in English (pp. 424-27). Reference to specialized literature is made in the notes to the text.

982 Hubala, Erich. Baroque and Rococo Art. New York, Universe, 1976. 196p. illus. index. LC 73-88459.

Concise stylistic history of art and architecture in Western Europe during the seventeenth and eighteenth centuries. Good selection of plates with informative captions. Bibliography (pp. 192-93) offers a classified list of books in all languages. In the series, "Universe History of Art," and originally published in German as a volume in the "Belser Stilgeschichte."

983 Hubala, Erich. Die Kunst des 17. Jahrhunderts. Berlin, Propyläen, 1970. 387p. (text); 408p. (illus.). (Propyläen Kunstgeschichte, Band 9). LC 79-518135.

Comprehensive illustrated handbook of the art and architecture of Europe in the seventeenth century. Introductory essay is followed by an excellent corpus of illustrations, specialists' commentaries on the development of the various arts, very informative notes to the plates (with plans, diagrams, and excellent bibliographies of specialized literature). Provides a very good classified bibliography (pp. 347-58) of books and periodical articles in all languages. A standard handbook.

Weller, Harald. Die Kunst des 18. Jahrhunderts. Berlin, Propyläen, 1971. 479p. (text); 436p. (illus.). index. (Propyläen Kunstgeschichte, Band 10). LC 77-884403.

Comprehensive, illustrated handbook of the art and architecture of Europe and the New World in the eighteenth century. Introductory essay by Keller is followed by an excellent corpus of plates, short commentaries on the evolution of the arts in various countries, informative notes to the plates (with plans, diagrams, and very valuable bibliographies of specialized literature). An excellent, comprehensive, classified bibliography of books and periodical articles in all languages (pp. 446-56). A standard handbook.

Kimball, S. Fiske. The Creation of the Rococo. New York, Norton, 1964. 242p. illus. index. Reprint of 1943 edition.

Scholarly history of Rococo architecture and architectural decoration. Bibliographical references in the extensive footnotes; the numerous illustrations are poorly reproduced in this reprint. A standard work on Rococo architectural decoration for the advanced student.

986 Kitson, Michael. The Age of the Baroque. New York and Toronto, McGraw-Hill, 1966. 175p. illus. index. LC 65-21591.

Pictorial survey of the architecture, painting, sculpture, and decorative and minor arts in all of Europe in the seventeenth and eighteenth centuries. Includes maps, chronological tables, and short biographical notes on baroque artists and architects.

987 Lübke, Wilhelm, and Max Semrau. Die Kunst der Barockzeit und des Rokoko. 4th ed. Stuttgart, Neff, 1921. 435p. illus. index. (Grundriss der Kunstgeschichte, IV).

Older, comprehensive history of art and architecture in Europe during the seventeenth and eighteenth centuries. Contents: Architektur des Barocks, Die bildenden Kunst im Zeitalter des Barocks; Die niederländische Malerei im 17. Jahrhundert; Die spanische Malerei und Plastik im 17. Jahrhundert; Die Kunst des Rokoko und des Klassismus. Bibliographical footnotes.

Mâle, Émile. L'art religieux de la fin du XVI^e siècle et du XVIII^e siècle; étude sur l'iconographie après le concile de Trente: Italie, France, Espagne, Flandres. 2nd ed. rev. and corrected. Paris, A. Colin, 1951. 532p. illus. index. LC A51-5112.

First published in 1932 as L'art religieux après le concile de Trente.... Scholarly study of the iconography of the figurative arts in Catholic Europe from the end of the sixteenth through the eighteenth century. Contents: I, L'art et les artistes après le concile de Trent; II, L'art et le Protestantisme; III, Le martyr; IV, V, La vision et l'extase; VI, L'iconographie nouvelle; VII, Les devotions nouvelles; VIII, Les survivances de passé, persistance de l'esprit du moyen âge; IX, Les survivances du passé, persistance de l'esprit du XVIe siècle, L'allegorie; X, La decoration des églises, les églises des ordres religieux. Extensive bibliographical footnotes. A standard work.

989 Martin, John R. Baroque. New York, Harper and Row, 1977. 367p. illus. index. LC 76-12059.

Scholarly analysis of Baroque art and architecture. Contents: 1, The Question of Style; 2, Naturalism; 3, The Passions of the Soul; 4, The Transcendental View of Reality and the Allegorical Tradition; 5, Space; 6, Time; 7, Light; 8, Attitudes to Antiquity. Appendix with translations of documents pertaining to Rubens, Paul Fréart de Chatelon, Arnold Houbraken, Francisco Pacheo, and Philippe de Champaigne. Books for further reading (pp. 305-309) has a critical discussion of basic works.

990 Michel, André, ed. L'art en Europe au XVII^e siècle. Paris, Colin, 1921-1922. 2v. illus. (Histoire de l'Art..., tome VI).

Comprehensive history of art and architecture in Europe during the seventeenth century. Chapters, written by various French scholars, sketch the development of the various media in the countries of Western Europe. Does not cover Eastern Europe. Bibliographies of basic literature at the end of each chapter.

991 Michel, André, ed. L'art en Europe au XVIII^e siècle. Paris, Colin, 1924-1925. 2v. illus. (Histoire de l'Art..., tome VII).

Comprehensive history of art, architecture, the graphic, applied and decorative arts in Europe during the eighteenth century. Chapters, written by various French scholars, cover the development of the various media in the countries of Western Europe. Bibliographies of basic literature at the end of each chapter.

992 Pignatti, Terisio. The Age of Rococo. London, Hamlyn, 1969. 157p. illus. LC 76-434709.

Pictorial survey of art and architecture in Western Europe during the eighteenth century. Emphasis on the Italian scene. All illustrations in color. No bibliography.

993 Pijoán y Soteras, José. Arte barroco en Francia, Italia y Alemania. Madrid, Espasa-Calpe, 1957. 578p. illus. index. (Summa Artis, Historia General del Arte, XVI).

Comprehensive history of art and architecture of the seventeenth and eighteenth centuries in Italy, France, and Germany. Chapters are arranged by countries, then by major personalities and schools. A few chapters are dedicated to major buildings, such as Versailles. Bibliography of general books (pp. 539-41).

Posterier, Jewsej. Die Kunst des 17. Jahrhundert in Europa. Dresden, VEB Verlag, 1978. 307p.

First published in Russian in 1971. History of art and architecture throughout Europe during the seventeenth century. Introduction expounds a Marxist interpretation of history. Bibliography (pp. 287-95) is particularly useful for its listing of Eastern European publications.

Ruskin, Ariane. 17th and 18th Century Art. New York, McGraw-Hill, 1969. 191p. illus. index. LC 69-17190.

Pictorial survey of the art and architecture in Italy, Spain, France, the Netherlands, and Germany during the seventeenth and eighteenth centuries. All illustrations are in color. No plans for the architectural examples. No bibliography. For the general reader.

Sewter, A. C. Baroque and Rococo. New York, Harcourt Brace Jovanovich, 1972. 224p. illus. index. LC 73-152765.

Concise, popular survey of art and architecture in Europe during the seventeenth and eighteenth centuries. Bibliography (pp. 218-21) lists basic books in English and includes some artists' monographs.

Soehner, Halldor, and Arno Schönberger. The Rococo Age, Art and Civilization of the Eighteenth Century. New York, McGraw-Hill, 1960. 394p. illus. index. LC 60-11310.

Survey of the art of Europe (exclusive of architecture) during the eighteenth century, with emphasis on the general cultural context. Informative notes to the plates, but no bibliography.

998 Stinson, Robert E. Seventeenth and Eighteenth Century Art: An Introduction to Baroque and Rococo Art in Europe from A.D. 1600 to A.D. 1800. Dubuque, Iowa, W. C. Brown, 1969. 149p. illus. LC 68-14580.

Brief survey of the art and architecture of Western Europe from 1600 to 1800. Brief bibliography of books in English (pp. 143-44).

Tapie, Victor Lucien. The Age of Grandeur: Baroque Art and Architecture... New York, Praeger, 1961. 305p. illus. index. LC 61-17028. Survey of the art and architecture of the seventeenth century in Italy, Spain, Portugal, France, Germany and Austria, the Low Countries, Eastern Europe, and the New World colonies. Classified bibliography (pp. 285-97) of books in all languages; further literature is referred to in the notes to the text.

1000 Weisbach, Werner. Der Barock als Kunst der Gegenreformation. Berlin, Cassirer, 1921. 232p. illus. index.

Important, scholarly examination of the role of the Counter Reformation in the formation of the style of Baroque art and architecture in Catholic Europe, particularly in Italy and Spain. Contents: Historische und psychologische Grundlage; Elemente der gegenreformatorischen Kunst; Die gegenreformatorische Kunst und das Heilige. Bibliographical references in the footnotes.

Weisbach, Werner. Die Kunst des Barock in Italien, Frankreich, Deutschland und Spanien. Berlin, Propyläen, 1924. 536p. illus. index. (Propyläen Kunstgeschichte, XI).

Comprehensive illustrated handbook of art and architecture of the seventeenth century in Italy, France, Germany, and Spain. Concise historical sketch serves as an introduction to the good corpus of plates, with descriptive notes. No bibliography. Superseded by the new Propyläen series (983, 984).

FRANCE

Hildebrandt, Edmund. Malerei und Plastik des 18. Jahrhunderts in Frankreich. Berlin, Athenaion, 1924. 212p. illus. index.

Comprehensive history of painting and sculpture in France during the eighteenth century. Extensive bibliographies of books and periodical articles given at the end of the sections. An old but standard treatment of the subject.

Kalnein, Wend Graf, and Michael Levey. Art and Architecture of the Eighteenth Century in France. Harmondsworth, Penguin, 1972. 443p. illus. index. (Pelican History of Art). LC 73-167862.

Comprehensive history of art and architecture in France during the eighteenth century. Part one, dealing with painting and sculpture, is by Levey; part two, on architecture, is by Graf Kalnein. Does not cover the minor arts. Good selection of plates. Bibliography (pp. 405-417) lists books in all languages. Further reference to more specialized literature is made in the extensive footnotes. A standard history of French eighteenth century art and architecture.

Mauricheau-Beaupré, Charles. L'art au XVII^e siècle en France. Paris, Le Prat, 1946-47. 2v. illus. index.

History of architecture, sculpture, painting, and the applied arts in France during the seventeenth century. Tome 1: Premiere période, 1594-1661; tome 2: Deuxieme période, 1661-1715. No bibliography.

1005 Réau, Louis. L'art au XVIIIe siècle en France: Style Louis XVI. Paris, Le Prat, 1952. 2v. illus. LC 56-23929.

Illustrated survey of art and architecture in France during the reign of Louis XVI. Emphasis is on interior design and decorative arts.

1006 Verlet, Pierre. Le style Louis XV. Paris, Larousse, 1942. 154p. illus. index. In the series, "Arts, Styles et Techniques." Concise history of art, architecture, and the applied and decorative arts during the reign of Louis XV. Introductory chapter sketches the historical background to and formulates a characterization of the Louis XV style. Bibliography of basic books and periodical articles (pp. 148-49).

Weigert, Roger. Le style Louis XIV. Paris, Larousse, 1942. 127p. illus. index.

In the series, "Arts, Styles et Techniques." Concise history of art, architecture, and the decorative arts in France during the reign of Louis XIV. Introductory chapter examines the origins and character of the Louis XIV style. Concluding chapter on the importance of foreign artists then in France. Bibliography of books in all languages (pp. 120-23). Index with biographies of major artists.

See also: Colombier (970), Mâle (988), Weese (972).

GERMANY AND AUSTRIA

Feulner, Adolf. Skulptur und Malerei des 18. Jahrhunderts in Deutschland. Wildpark-Potsdam, Athenaion, 1929. 268p. illus. index. LC 30-2560.

Volume in the series, "Handbuch der Kunstwissenschaft." Scholarly history of painting and sculpture in the German-speaking countries during the eighteenth century. The two media are treated in the chronological sequence of styles: Spätbarock, Rokoko, Louis XVI, übergang zum Klassismus. Bibliographical footnotes and general bibliography (p. 255). Although out of date in parts, still a standard work by one of the great experts.

Grimschitz, Bruno, Wilhelm Mrazek, and Ruppert Feuchtmüller. Barock in Österreich. Vienna and Hanover, Forum, 1960. 95p. (text); 92p. (plates). index.

History of art and architecture in Austria during the seventeenth and eighteenth centuries. Consists of essays on developments in the major media. No bibliography. Well illustrated.

Hempel, Eberhard. Baroque Art and Architecture in Central Europe. Baltimore, Penguin, 1965. 370p. illus. index. (Pelican History of Art, Z22). LC 65-28970.

Comprehensive and scholarly history of art and architecture in Germany, Austria, Switzerland, Hungary, Czechoslovakia, and Poland. Painting and sculpture are treated from the early seventeenth through the eighteenth century; architecture, from the beginning of the sixteenth century through the eighteenth century. Excellent selection of plates, maps, plans, and diagrams. Good, well-classified

bibliography of books and periodical articles in all languages (pp. 335-43). Further reference to specialized literature in the notes to the text. A standard history.

1011 Riesenhuber, Martin. Die kirchliche Barockkunst in Österreich. Linz, Verlag Christlichen Kunstblätter, 1924. 670p. illus. index.

Comprehensive and scholarly history of religious architecture, sculpture, painting, and the applied arts in Austria during the seventeenth and eighteenth centuries. Contents: I, Einleitung; II, Literatur; III, Allgemeines über die Barocke; IV, Die Ausstattung der Barockkirchen; VII, Baumeister und Bauten der Barockzeit; VIII, Die barocke Plastik; IX, Die Malerei des 17. und 18. Jahrhunderts; and X, Nachträge. Thoroughly indexed. Detailed, annotated bibliography of books and periodical articles (pp. 6-15).

1012 Schmitz, Hermann. Kunst und Kultur des 18. Jahrhunderts in Deutschland. Munich, Bruckmann, 1922. 379p. illus.

Comprehensive history of art, architecture, and culture in general in Germany and Austria during the eighteenth century. No bibliography.

ITALY

1013 Golzio, Vincenzo. Seicento e Settecento. 3rd ed. Turin, Unione Torinese, 1968. 2v. illus. index. (Storia dell'Arte Classica e Italiana, 4). LC 75-522328.

Comprehensive history of art and architecture in Italy during the seventeenth and eighteenth centuries. Well illustrated with good, selected bibliography of books (pp. 919-26). A standard and scholarly history for the advanced student.

1014 Griseri, Andreina. Le metamorfosi del barocco. Turin, Einaudi, 1967. 383p. illus. index. LC 68-105433.

History of Baroque art and architecture in Italy from its background in late mannerism to the mid-eighteenth century. Extensive bibliography in the footnotes. Good selection of plates.

1015 Lees-Milne, James. Baroque in Italy. London, Batsford, 1959. 216p. illus. LC 60-20309.

Concise history of art and architecture in Italy from mannerism through the late baroque (circa 1775). Emphasis is on architecture and its decoration. Bibliography (pp. 205-209) lists books and periodical articles in all languages. For the general reader and the beginning student.

Wittkower, Rudolf. Art and Architecture in Italy: 1600 to 1750. 3rd rev. ed. Harmondsworth, Penguin, 1973. 485p. illus. index. (Pelican History of Art, Z16). LC 75-128578.

Comprehensive history of art and architecture in Italy, 1600 to 1750. Good selection of plates, plans, and diagrams, good classified bibliography (pp. 415-52), and further reference to specialized literature in extensive footnotes. A standard work.

LOW COUNTRIES

1017 Ackere, Jules van. Baroque & Classic Art in Belgium (1600-1789).
Brussels, Marc Vokaer, 1972. 244p. illus. index. LC 73-167677.
Illustrated survey of architecture and monumental sculpture in Belgium, 1600-1789. Chapter on interior decoration. Well illustrated. Specialized literature in the notes; list of general books (p. 238).

1018 Gerson, Horst, and E. H. ter Kuile. Art and Architecture in Belgium: 1600 to 1800. Baltimore, Penguin, 1960. 236p. illus. index. (Pelican History of Art, Z18). LC 60-3193.

Comprehensive history of art and architecture in Belgium from 1600 to 1800. Excellent selection of plates, plans, diagrams, and maps. Provides a good, classified bibliography of major works (pp. 197-217) and thorough reference to specialized literature in the extensive footnotes. The standard history of Flemish art in the Baroque and Rococo periods.

1019 Rosenberg, Jakob, and Seymour Slive. Dutch Art and Architecture: 1600 to 1800. London, Penguin, 1966. 330p. illus. index. (Pelican History of Art, Z27). Rev. paperback ed. Harmondsworth, Penguin, 1972.

Comprehensive history of art and architecture in the United Netherlands from 1600 to 1800. Contains an excellent selection of illustrations (though they are poorly reproduced), useful plans, diagrams, and maps. A good, classified bibliography (pp. 279-308) lists references to more specialized literature in the extensive footnotes. The standard history of Dutch Baroque and eighteenth century art and architecture.

SPAIN AND PORTUGAL

Bonet Correa, Antonio, and Victor M. Villegas. El barroco en España y en Mexico. Mexico City, M. Porrúa, 1967. 244p. illus. index. LC 78-321763.

Popular, illustrated survey of Spanish and Mexican Baroque art, with emphasis on architecture. Chapter on Baroque *retablos*. Introduction by George Kubler and René Taylor. Bibliography of Spanish books (p. 247).

Lees-Milne, James. Baroque in Spain and Portugal, and Its Antecedents.
 London, Batsford, 1960. 224p. illus. index. LC 61-1109.
 Pictorial survey of architecture and art of the Baroque in Spain and Portugal, with emphasis on architecture and its decoration. For the general reader and the beginning student.

Weisbach, Werner. Spanish Baroque Art. Cambridge, England, Cambridge University Press, 1941. 65p. illus.

Series of three lectures on Spanish Baroque architecture, painting, and sculpture. Concentrates on the chief artistic personalities. No bibliography.

EASTERN EUROPE

1023 Angyal, Endre. Die slawische Barokwelt. Leipzig, Seemann, 1961. 321p. illus. LC 61-37650.

Concise history of art and architecture of the Baroque in the Slavic countries. Good chapter treating the research on Slavic Baroque. Bibliographical footnotes.

Blažiček, Oldřich J. Baroque Art in Bohemia. Feltham, Hamlyn, 1968. 195p. illus. LC 77-370432.

Pictorial survey of art and architecture in Bohemia from the middle of the seventeenth to the end of the eighteenth century. Specialized literature in the footnotes; bibliography (p. 181) lists basic books and articles in all languages.

Swoboda, Karl M., ed. Barock in Böhmen. Munich, Prestel, 1964. 359p. illus. index.

Comprehensive, scholarly history of art, architecture, and the applied arts in Bohemia from the early seventeenth to the late eighteenth centuries. Chapters on the individual media are written by various Austrian scholars. Well illustrated. Extensive bibliographical coverage in the notes.

See also: Alpatov (1417), Geschichte der russischen Kunst (1422).

MODERN (19th AND 20th CENTURIES)

GENERAL WORKS

Arnason, H. H. History of Modern Art: Painting, Sculpture, Architecture. 2nd ed. Englewood Cliffs, N.J., Prentice-Hall; New York, Abrams, 1977. 740p. illus. index.

Comprehensive history of art and architecture in Europe and America from the Impressionists through the many movements of the 1960s. Arranged according to movements, the text centers on important artists, using their lives and art as distillations of the movements and periods covered. With copious black and white and color illustrations. Good classified bibliography of books (pp. 631-43). A standard history.

Bowness, Alan. Modern European Art. New York, Harcourt Brace Jovanovich, 1972. 224p. illus. index. LC 77-183243.

Concise history of art in Europe from Manet to the inheritors of abstract expressionism. Emphasis is on painting; arrangement is by movements. Separate chapters are devoted to modern European sculpture and architecture. Illustrated in black and white, with some color plates. Classified bibliography of books (pp. 217-20).

Brizio, Anna M. Ottocento; Novecento. Turin, Unione Torinese, 1939. 571p. illus. index. (Storia Universale dell'Arte, vol. 6).

Comprehensive history of art and architecture in the West from Neoclassicism to circa 1930. Bibliography (pp. 549-58) lists books and periodical articles in all languages. A standard Italian history of nineteenth-century art and architecture.

1029 Canaday, John. Mainstreams of Modern Art. New York, Holt, Rinehart and Winston, 1959. 576p. illus. index. LC 59-8693.

Comprehensive history of Western painting, graphics, and sculpture from David to Surrealism. An appendix gives a short history of modern architecture. No bibliography. A good survey history for the general reader.

1030 Evers, Hans Gerhard. The Art of the Modern Age. New York, Crown, 1970. 270p. illus. index. LC 72-125038. British title: The Modern Age: Historicism and Functionalism (1970).

Concise history of painting, sculpture, and architecture in Europe and America from the late nineteenth century to the mid-twentieth century. Chronological table of political history, art, literature, and science and technology, but no bibliography. A good balanced survey.

- Galloway, John C. Modern Art: The Nineteenth and Twentieth Centuries. Dubuque, Iowa, W. C. Brown, 1967. 149p. illus. index. LC 67-22713. Survey of painting and sculpture in Europe and America during the nineteenth and twentieth centuries (only twentieth century American art is covered). Bibliography (pp. 131-39) lists major books and periodical articles chiefly in English.
- Hamilton, George H. 19th and 20th Century Art: Painting, Sculpture, Architecture. New York, Abrams, 1970. 583p. illus. index. LC 70-100401. Comprehensive history of art and architecture in Europe and America during the nineteenth and twentieth centuries. Good selection of plates, diagrams, and plans. Bibliography (pp. 459-64) lists books in English.
- Hamilton, George H. Painting and Sculpture in Europe, 1880 to 1940. Rev. and corrected ed. Baltimore, Penguin, 1972. 624p. illus. index. (Pelican History of Art, Z29). LC 71-128577.

Comprehensive and scholarly history of painting and sculpture in Europe from 1880 to 1940. Excellent choice of illustrations. Provides a good, classified bibliography (pp. 391-419) that lists books in all languages. Further bibliographical references are to be found in the extensive footnotes. A standard history.

Hildebrandt, Hans. Die Kunst des 19. und 20. Jahrhunderts. Berlin, Athenaion, 1924. 460p. illus. index.

Comprehensive history of art and architecture in Europe from 1800 to 1920. The scholarly text is amplified by a large selection of plates and plans, but there is no bibliography. A volume in the series, "Handbuch der Kunstwissenschaft." An older, but classic history of nineteenth-century and early twentieth-century art and architecture.

Huyghe, René, ed. Larousse Encyclopedia of Modern Art, from 1800 to the Present Day. New York, Prometheus, 1965. 444p. illus. index. LC 65-19759.

Not a true encyclopedia, but a general survey of modern painting, sculpture, and architecture amplified by summary discussions of parallel developments in history, literature, and music. Written by a variety of specialists, the sections cover a range

of subjects from Classicism and Romanticism to action painting and abstract expressionism. Includes a large section on "Later Eastern Arts" (Oriental art from 1200 onward), which treats periods that are judged to have been influential on modern art.

Huyghe, René, and Jean Rudel, eds. L'art et le monde moderne. Paris, Larousse, 1969-70. 2v. illus. index. LC 75-518560.

Comprehensive history of modern art and architecture from 1880 to the present. Includes the minor arts and the cinema. Consists of a group of essays by French specialists. Well illustrated and provided with a useful chronological table, but no bibliography. A useful illustrated survey for the beginning and advanced student.

Lübke, Wilhelm, and Friedrich Haack. Die Kunst des XIX. Jahrhunderts und der Gegenwart. 6th ed. Stuttgart, Neff, 1922-25. 2v. illus. index. (Grundriss der Kunstgeschichte, Bände 5-6).

Comprehensive history of art and architecture in Western Durope during the nineteenth and early twentieth centuries. Text is divided into four major divisions: Klassizismus, Romantik, Renaissancismus, and Moderne. Bibliographical footnotes.

Lynton, Norbert. The Modern World. New York, McGraw-Hill, 1965. 175p. illus. index. LC 65-21593.

The text of this pictorial survey covers painting, sculpture, and architecture from the first half of the nineteenth century to just after 1940. Includes a glossary of terms, a chronological table (inside the covers), and a general bibliography (pp. 170-71).

Meier-Graefe, Julius. Entwicklungsgeschichte der modernen Kunst. 3rd ed. Munich, Piper, 1966. 2v. illus. index. LC 67-81601.

Comprehensive history of modern European art, chiefly painting, from Neoclassicism through Les Fauves and German Expressionists. No bibliography. A recent edition of an old, but classic study of the development of modern art.

Michel, André, ed. L'art en Europe et en Amerique au XIX^e siècle et au début du XX^e siècle. Paris, Colin, 1925-1929. 3v. illus. (Histoire de l'Art..., tome VII).

Comprehensive history of art, architecture, and the graphic, applied, and decorative arts in Europe and America during the nineteenth and early twentieth centuries. Chapters are written by various French scholars and cover the development of the various media in the countries of Western Europe, Hungary, the Balkan countries, Poland, Russia, Latin America, the United States, and Canada. Concluding chapter by Louis Réau discusses the development of the decorative arts at the end of the nineteenth century. Bibliographies of basic literature at the end of each chapter.

1041 Pijoán y Soteras, José. Arte europeo de los siglos XIX y XX. Madrid, Espasa-Calpe, 1967. 591p. illus. index. (Summa Artis, Historia General del Arte, XXIII).

Comprehensive history of art and architecture in Europe during the nineteenth and first half of the twentieth centuries. Chapters treat the various styles from

Neoclassicism to abstract expressionism. Bibliography (pp. 553-56) lists basic books in all languages.

Wilenski, Reginald H. The Modern Movement in Art. London, Faber and Faber, 1945. 210p. illus.

Critical examination of the development of European art and architecture in the late nineteenth and early twentieth century. Contents: I, Character of the Movement; II, Degenerate Nineteenth Century Art; III, Technique of the Movement; IV, Relative Values. Bibliographical footnotes.

Zervos, Christian. Histoire de l'art contemporain. Paris, Cahiers d'Art,1938. 498p. illus.

Comprehensive history of modern European painting and sculpture from Les Fauves to the Dadaists. Numerous but poorly reproduced illustrations and no bibliography. An older history of European Post-Impressionist art.

AUSTRIA

Feuchtmüller, Ruppert, and Wilhelm Mrazek. Kunst in Österreich, 1860-1918. Vienna and Hanover, Forum, 1964. 130p. (text); 100p. (plates). index.

History of art and architecture in Austria from 1860 to 1918. Consists of essays on the development of various media. Well illustrated, with a good bibliography (pp. 123-26) that lists general studies, artist monographs, and periodicals. A standard history of Austrian art and architecture of the late nineteenth century.

1045 Karpfen, Fritz. Österreichische Kunst. Leipzig, Literaria Verlag, 1923. 212p. illus. index. (Gegenwarts Kunst, III).

Journalistic treatment of Austrian painting, sculpture, and graphic arts of the late nineteenth and early twentieth centuries. No bibliography.

1046 Sotriffer, Kristian. Modern Austrian Art: A Concise History. New York, Praeger, 1965. 140p. illus. index. LC 65-25389.

Concise history of Austrian painting, sculpture, and graphic art from the late nineteenth century to the 1960s. Includes two biographical dictionaries: the first is of sixty artists mentioned in the text, with literature citations; and the second is of fifty artists not mentioned. Includes a short, selective bibliography (pp.136-37).

BELGIUM

1046a Fontaine, André. L'art belge depuis 1830; art et esthétique. Paris, Felix Alcan, 1925. 168p. illus.

Survey history of Belgian art and architecture from Neoclassicism through Art Nouveau. Occasional bibliographical footnotes.

1047 Lambotte, Paul, *et al.* **Histoire de la peinture et de la sculpture en Belgique**, **1830-1930**. Brussels, Van Oest, 1930. 203p. illus.

Contents: I, La Renaissance de l'art Belge apres 1830; II, Le Romantisme; III, L'epoque de la societé libre des Beaux-Arts; IV, Les peintres de genre et

d'intérieurs; V, Les paysagistes; VI, Les marinistes; VII, Les animaliers; VIII, Les graveurs; IX, Les peintres actuels; and X, Les sculpture. No bibliography.

FRANCE

Fontainas, André, et al. Histoire générale de l'art français de la révolution à nos jours. Paris, Librarie de France, 1922. 3v. illus.

Concise history of French art and architecture from the Revolution to the early twentieth century. Volume 1 covers painting and graphic arts; volume 2, architecture and sculpture; volume 3, decorative arts. No bibliography.

See also: Schneider (1234).

GERMANY

Gurlitt, Cornelius. Die deutsche Kunst seit 1800. Ihre Ziele und Taten. 4th ed. Berlin, Bondi, 1924. 535p. illus. index.

Comprehensive history of German art, exclusive of architecture, from Neoclassicism through Expressionism. Contents: I, Das Erbe; II, Die Klassiker; III, Die alten Schulen; IV, Die Landschaft; V, Die Romantiker; VI, Die Historische Schule; VII, Das Streben nach Wahrheit; VIII, Die Kunst aus Eigenem; IX, Der Kampf um den Stil; X, Der Realismus und Impressionismus; and XI, Der Expressionismus. No bibliography.

See also: Dehio (1287).

ITALY

1050 Argan, Giulio Carlo. L'arte moderna, 1770/1970. Florence, Sansoni, 1970. 774p. illus. index. LC 79-564092. Comprehensive history of art and architecture in Italy from 1770 to 1970. Well illustrated; has some bibliographical footnotes.

1051 Carrieri, Raffaele. Avant-Garde Painting and Sculpture (1890-1955) in Italy. Milan, Domus, 1955. 318p. illus. index.

History of Italian painting and sculpture from 1890 to 1955. Consists of chapters on movements and major artists. No bibliography.

Lavagnino, Emilio. L'arte moderna dai neoclassici ai contemporaei. Turin, Edit. Torinese, 1956. 2v. illus. index. (Storia dell'Arte Classica e Italiana, 5).

Comprehensive history of art and architecture in Italy from the nineteenth century to the middle of the twentieth century. Well illustrated with plates, plans, and diagrams. Bibliography (pp. 1263-78) is a balanced list of books and periodical articles. The standard history of Italian nineteenth- and twentieth-century art.

Maltese, Corrado. Storia dell'arte in Italia, 1785-1943. Turin, Einaudi, 1960. 471p. illus. index. LC A61-5671.

History of art and architecture in Italy from Neoclassicism to mid-twentieth century abstraction. Well illustrated, but no bibliography.

JAPAN

Munsterberg, Hugo. The Art of Modern Japan: From the Meiji Restoration to the Present. New York, Hacker, 1978. 159p. illus. index. Popular pictorial survey of Japanese art and architecture from 1868 to 1968. Bibliography of basic books (pp. 153-54).

MEXICO

Fernández, Justino. El arte moderno y contemporaneo en Mexico.

Mexico City, Imprenta Universitaria, 1952. 522p. illus. index.

Comprehensive history of art and architecture in Mexico from the early nineteenth century to the middle of the twentieth century. Numerous but poor illustrations; good but unclassified bibliography (pp. 505-512). A standard history of modern Mexican art and architecture.

ROMANIA

Oprescu, George. Rumanian Art 1800 to Our Days. Malmö, Malmö
 Ljustrycksanstalt, 1935. 192p. illus. index.

 Concise history of Romanian art of the nineteenth and early twentieth centuries.
 No bibliography.

RUSSIA

1057 Gray, Camilla. The Russian Experiment in Art, 1863-1922. New York, Abrams, c. 1962; reissued in new format, 1970. 296p. illus. index. LC 76-106290.

Concise history of painting and sculpture in Russia from the 1860s to 1922. Bibliography (pp. 280-82).

1058 Lozowick, Louis. Modern Russian Art. New York, Museum of Modern Art, 1925. 60p. illus.

Concise history of Russian art, exclusive of architecture, in the late nineteenth and early twentieth centuries. Contents: Introduction; The First Moderns; The Cubists; The Suprematists; The Constructivists; The Expressionist Strain; Others; Art Criticism; Present Standing. No bibliography.

SWEDEN

Strömböm, Sixten G. M. Konstnärsförbundets historia: Med företal av Prins Eugen. Stockholm, Bonnier, 1945-1965. 2v. illus. index. Comprehensive, scholarly history of Swedish painting and sculpture, with emphasis on artists' associations and academies. Volume one: Till och med 1890; volume two: Nationalromantik och radikalism (to circa 1920). Extensive bibliography in footnotes. A standard work.

UNITED STATES

1060 Cahill, Holger, and Alfred H. Barr, Jr. Art in America in Modern Times. Freeport, N.Y., Books for Libraries, 1969. 110p. illus. LC 69-17569. Reprint of 1934 edition.

Survey history of art and architecture in America from 1865 to 1934. Covers photography, film, and stage design as well as architecture, painting, and sculpture. Brief bibliographies (pp. 107-110) list major books.

Myron, Robert, and Abner Sundell. Modern Art in America. New York, Crowell-Collier, 1971. 218p. illus. index. LC 76-153760.

Survey of art and architecture in America from circa 1870 to 1970. Modest selection of black and white plates and brief bibliography of popular books (p. 214).

19TH CENTURY

General Works

Hansen, Hans Jürgen. Late Nineteenth Century Art: Architecture and Applied Art of the "Pompous Age." New York, McGraw-Hill, 1972. 264p. illus. index. LC 72-148989.

Pictorial survey of art and architecture in Europe and the United States during the second half of the nineteenth century. Emphasis is on Victorian art and architecture and its equivalents in Germany and France. Consists of essays on the various arts, written by specialists. Provides a bibliography (pp. 257-60) that lists major books in all languages.

Hofmann, Werner. Art in the Nineteenth Century. London, Faber & Faber, 1960. 435p. illus. index.

History of art and architecture in Europe and America, with an emphasis on the relationship between the fine arts and the general culture. Bibliographical references in the footnotes. An important study of nineteenth-century art for beginning and advanced students.

1064 Lankheit, Klaus. **Révolution et Restauration**. Paris, Michel, 1966. 286p. illus, index. LC 66-51780.

Concise history of art and architecture in Europe and America from Neoclassicism through Realism. Good selection of color plates, modest supplement of black and white illustrations, plans, and diagrams. Provides a good bibliography (pp. 253-63) that lists books and periodical articles in all languages. French edition of the series "Art of the World."

Novotny, Fritz. Painting and Sculpture in Europe: 1780 to 1880.
Baltimore, Penguin, 1960. 288p. illus. index. (Pelican History of Art, Z20). LC 60-51441.

Comprehensive history of painting and sculpture in Europe from Neoclassicism through Impressionism. Good selection of plates and good classified bibliography (pp. 253-69), which lists books and periodical articles in all languages. Further

reference to specialized literature can be found in the extensive footnotes. A standard history of nineteenth-century painting and sculpture.

Scheffler, Karl. Die europäische Kunst im neunzehnten Jahrhundert. Berlin, Cassirer, 1926-1927. 2v. illus. index.

Important, comprehensive history of painting and sculpture in Western Europe during the nineteenth century and early twentieth century. Band 1: Geschichte der europäische Malerei von Klassizismus bis zum Impressionismus; Band 2: Geschichte der europäischen Malerei vom Impressionismus bis zur Gegenwart, Geschichte der europäischen Plastik in neunzehnten und zwanzigsten Jahrhundert. No bibliography.

Schultze, Jürgen. Art of Nineteenth Century Europe. New York, Abrams, 1972. 264p. illus. index. LC 79-92913.

Concise history of art and architecture in Europe during the nineteenth century. Begins with Neoclassicism and hence reaches back into the mid-eighteenth century. Good selection of illustrations, mostly in color. No plans are given for the architecture. Provides a useful chronological table that coordinates events in the fire arts with events in literature, music, politics, and science and technology. Good bibliography (pp. 253-55) lists books in all languages. A good survey of nineteenth-century art and architecture for the general reader.

Vogt, Adolf M. Art of the Nineteenth Century. New York, Universe, 1973. 189p. illus. index. LC 72-85082.

Concise history of art and architecture in Europe during the nineteenth century. A concluding chapter treats the influence of foreign cultures on nineteenth-century Western art. Good selection of plates, informative captions, and a good, balanced bibliography (pp. 184-86) of books and periodical articles in all languages.

Zeitler, Rudolf W. Die Kunst des 19. Jahrhunderts. Berlin, Propyläen, 1967. 411p. (text); 440p. (illus.). index. (Propyläen Kunstgeschichte, Band 11). LC 67-104178. LC 67-104178.

Comprehensive illustrated handbook of the art and architecture of the nineteenth century in Europe and America. The introductory essay by Zeitler is followed by essays on various styles and media by different specialists, an excellent corpus of plates, very informative notes to the plates with reference to specialized literature, and a very good, comprehensive, and classified bibliography (pp. 373-83) of books and periodical articles in all languages. A standard handbook of nineteenth-century art and architecture.

Austria

Hevesi, Ludwig. Österreichische Kunst im 19. Jahrhundert. Leipzig, Seemann, 1903. 2v. illus. index. (Geschichte der Modernen Kunst, II). Older, comprehensive history of art and architecture in the Austro-Hungarian Empire from 1800 to 1900. No bibliography.

Belgium

Hymans, Henri S. Belgische Kunst des 19. Jahrhunderts. Leipzig, Seemann, 1906. 253p. illus. index.

General history of art and architecture in Belgium during the nineteenth century. No bibliography. Still valuable for illustrations.

1072 Vanzype, Gustave. L'art belge du XIXe siècle. Paris and Brussels, Van Oest, 1923. 2v. illus. index.

Illustrated survey of Belgian painting and sculpture during the nineteenth century; based upon an exhibition held in Brussels in 1922. Chapters are dedicated to major artists. No bibliography.

Denmark

Hannover, Emil. Dänische Kunst des 19. Jahrhunderts. Leipzig, Seemann, 1907. 168p. illus. index.

General history of art and architecture in Denmark during the nineteenth century. No bibliography. Still valuable for illustrations.

Germany

1074 Beenken, Hermann T. Das neunzehnte Jahrhundert in der deutschen Kunst. Munich, Bruckmann, 1944. 563p. illus. index. LC 46-12460. A comprehensive history of art and architecture in Germany during the nineteenth century. Bibliographical references in the footnotes. A standard history.

Italy

Willard, Ashton R. History of Modern Italian Art... 2nd ed. New York, Longmans, Greene, 1900. 713p. illus. index.
 Older, popular history of Italian art and architecture from Canova to the end of the nineteenth century. No bibliography.

Mexico

Fernández, Justino. El arte del siglo XIX en México. 2nd ed. Mexico City, Imprenta Universitaria, 1967. 256p. text, 343 illus., 23 color plates. index. History of painting, sculpture, architecture, graphic arts, and popular graphics from colonial Baroque times to the mid-twentieth century. Bibliography (pp. 228-32) is a selected, unclassified list of books and periodical articles, mostly in Spanish.

Sweden

1077 Nordensvan, Georg G. Schwedische Kunst des 19. Jahrhunderts. Leipzig, Seemann, 1904. 140p. illus.

General survey of art and architecture in Sweden in the nineteenth century. No bibliography. Still valuable for illustrations.

Nordensvan, Georg G. Svensk konst och svenska konstnärer i nittonde århundradet... Stockholm, Bonnier, 1925-1928. 2v. illus. index. Scholarly history of Swedish art from the late eighteenth through the nineteenth centuries. Contents: V. 1, Från Gustav III till Karl XV; v. 2, Från Karl XV till sekelslutel. Bibliography of books and periodical articles (v. 2, pp. 511-13). A standard work.

United States

1079 Garrett, Wendell D., *et al.* The Arts in America: The Nineteenth Century. New York, Scribner's, 1969. 412p. illus. index. LC 78-852.

History of art and architecture in the United States during the nineteenth century. Good coverage of the minor and decorative arts. Bibliography (pp. 385-90) lists major books. A good survey of nineteenth-century American art and architecture for the general reader.

Neoclassicism

Benoit, François. L'art français sous la révolution et l'empire. Paris, L.-H. May, 1897. illus. index.

History of French painting, sculpture, and architecture from the beginning of the French Revolution to the end of the Empire (1789-1815). Part 1 deals with influences of theory, of traditional art, and of the government and public. Part 2 treats artists both as a class and as individual masters. Classified bibliography of books, mostly French (pp. 441-46).

Dreyfous, Maurice. Les arts et les artistes pendant la période révolutionnaire (1789-1795). Paris, Paclot, 1906. 471p. illus.

Comprehensive history of the visual and performing arts in France during the Revolution. Contents: I, Le vandalisme révolutionnaire; II, Les fondations artistiques; III, Les travaux et les projets artistiques; IV, Les arts plastiques; V, Les arts du théatre; VI, La musique révolutionnaire; VII, L'art des corteges. Bibliography of books and periodical articles (pp. 467-71).

1082 Francastel, Pierre. Le style empire. Paris, Larousse, 1944. 104p. illus. index.

In the series, "Arts, Styles et Techniques." Concise history of French art and architecture of the Empire style. Includes chapter on applied and decorative arts and the role of foreigners in French Empire style. Bibliography (pp. 99-100) lists basic works in French.

Hautecoeur, Louis. L'art sous la révolution et l'empire en France, 1789-1815. Paris, Le Prat, 1953. 130p. illus.

Pictorial survey of art, architecture, and applied arts in France from 1789 to 1815. No bibliography.

Honour, Hugh. Neo-classicism. Harmondsworth, Penguin, 1968. 221p. illus. index. LC 71-384062.

In the series, "Style and Civilization." History of Neoclassical art and architecture in Europe, with special reference to the general cultural context of the style. Bibliographical footnotes and critically annotated bibliography of basic works (pp. 209-212).

1085 Irwin, David. English Neoclassical Art: Studies in Inspiration and Taste. London, Faber, 1966. 230p. illus. index. LC 68-10513.

History of British art, exclusive of architecture, in the Neoclassical style. Contents: Introduction; II, The Antique: Leaders of Taste; III, The Antique: A Fashionable Phase or Imagination Supreme; IV, The Gothic Muse; V, 'Sublime' and 'Wicked' in Renaissance and Baroque Art; VI, Poetry and Further Romantic Tendencies; VII, The Contemporary Scene; VIII, Conclusion. Good bibliography of books and periodical articles and including source material (pp. 171-212).

Landsberger, Franz. Die Kunst der Goethezeit: Kunst und Kunstanschauung von 1750 bis 1830. Leipzig, Insel-Verlag, 1931. 319p. illus. index.

History of Realism, Neoclassicism, and Romanticism, with their antecedents in Germany from 1750 to about 1830. Arranged by chronological periods and treating painting, sculpture, and architecture. Good classified bibliography (pp. 304-315) and a name index.

Pariset, François G. L'art néo-classique. Paris, Presses Universitaires de France, 1974. 184p. illus. index. LC 74-178185.

Concise history of art and architecture in Europe from 1780 to 1820. Contents: I, L'Italie jusque vers 1800; II, Le néo-classicisme Anglo-Saxon jusque vers 1780; III, La France; IV, L'Italie néo-classique aprés 1800; V, Le néo-classicisme anglais; VI, L'Europe centrale; VII, Le néo-classicisme slave. Bibliography (pp. 180-84) provides a good classified list of books in all languages. In the series, "Les neuf muses."

Pauli, Gustav. Die Kunst des Klassizismus und des Romantik. Berlin, Propyläen, 1925. 527p. illus. index. (Propyläen Kunstgeschichte, XIV). Comprehensive illustrated handbook of European Neoclassical and Romantic art and architecture. Introductory essay sketches the development of the various media and is followed by a good corpus of plates with descriptive notes. No bibliography. Superseded by the new Propyläen series (1069).

1089 Praz, Mario. On Neoclassicism. London, Thames & Hudson, 1969. 400p. illus. index. LC 70-386455.

First published as *Gusto neoclassico* (Florence, Sansoni, 1940). Translation of the second revised edition (1959). Important, scholarly, and controversial analysis of Neoclassical art and architecture. Chapters treat major literary and artistic figures, national manifestations of Neoclassicism and major works of art and architecture. Extensive bibliography in the notes.

1090 Pückler-Limpurg, Siegfried L. J. Der Klassizismus in der deutschen Kunst. Munich, Heimatbucher-Verlag, 1929. 261p. illus. index. History of Neoclassicism in the art and architecture of German-speaking countries. Includes the applied and decorative arts. Bibliographical footnotes.

1091 Rosenblum, Robert. Transformations in Late Eighteenth Century Art. Princeton, N.J., Princeton University Press, 1967. 203p. illus. index. LC 66-21841.

Scholarly examination of the development of Neoclassical art and architecture in Europe. Contents: I, Neoclassicism: Some Problems of Definition; II, The Exemplum Virtutis; III, Aspects of Neoclassic Architecture; IV, Toward the Tabula Rasa. Extensive bibliographical footnotes. A major work on the development of early Neoclassicism.

1092 Sydow, Eckart von. Die Kultur des deutschen Klassizismus. Leben/Kunst/Weltanschauung. Berlin, Grote, 1926. 264p. illus. index.

Comprehensive history and analysis of Classicism in Germany, with particular emphasis on art and architecture. First chapter summarizes the political background, the second describes the general cultural life, the third provides an expansive examination of Neoclassical art and architecture, and the fourth presents an influential analysis of "die klassizistische Weltauffassung." Bibliography (pp. 262-64) lists books in German. The standard work on German Neoclassicism.

Romanticism

Brion, Marcel. Art of the Romantic Era: Romanticism, Classicism, Realism. New York, Praeger, 1966. 285p. illus. index. LC 65-20070.
Concise history of art and architecture in Europe and the United States during the period 1750-1850 (American art and architecture to circa 1900). Good selection of illustrations. Bibliography (pp. 267-68) lists major books in all languages.

Brion, Marcel. Romantic Art. New York, McGraw-Hill, 1960. 239p. illus. index. LC 60-12761.

Pictorial history of Romantic art and architecture in Western Europe and the United States. Architecture and sculpture are treated in a brief chapter; the rest of the book consists of essays and notes, with plates of Romantic painting in the various countries. No bibliography.

Hautecoeur, Louis, *et al.* Le romantisme et l'art. Paris, Laurens, 1928. 320p. illus.

Collection of essays on various aspects of French Romantic art and literature. Contents: Les origines du romantisme (Louis Hautecoeur); La sculpture romantique (Paul Vitry); Le romantisme et le moyen age (Marcel Aubert); Gros-Géricault (Robert Rey); Delacroix (Paul Jamot); Les manuscrits d'Eugene Delacroix (André Joubin); Chassériau ou les deux romantismes (Henri Focillion); Le paysage romantique (René Schneider); Les peintres romantiques et la peinture étrangére (M. Rouches); La gravure romantique (Léon Rosenthal); L'orient romantique (René Lanson); Berlioz et le romantisme (Adolphe Boschot); and Le livre, l'illustration et la relieure a l'époque romantique (Henri Girard). Bibliographical footnotes.

Husarski, Vaslav. Le style romantique. Paris, Éditions du Trianon, 1931. 145p. illus. index.

Concise history of European art and architecture in the period of Romanticism. No bibliography.

Newton, Eric. The Romantic Rebellion. New York, St. Martin's Press, 1962. 224p. illus. index. Reprint: New York, Schocken, 1964. LC 63-9417.

Examination of the history of Romanticism, with particular emphasis on the visual arts. Contents: 1, Romanticism in the Visual Arts; 2, Central and Centrifugal; 3, Distance and Direction; 4, Romantic States of Mind; 5, Romanticism of Mystery—Pre-Nineteenth Century Romantics; 6, Romanticism of Mystery, the Nineteenth Century; 7, The Pre-Raphaelite Brotherhood; 8, The Romanticism of the Abnormal; 9, Conflict; 10, Romanticism in the Twentieth Century—Picasso; 11, Romanticism in the Twentieth Century—Paul Klee; Conclusion. No bibliography.

1098 Ráfols, José F. El arte romántico en España. Barcelona, Juventud, 1954. 284p. illus. index.

Comprehensive history of Spanish Romantic art and architecture, with chapter on the literary background. Brief biographies of major personalities (pp. 245-80).

1099 Réau, Louis. L'art romantique. Paris, Garnier, 1930. 228p. illus. General history of painting and sculpture of the Romantic movement, mostly in France, which concentrates on individual masters and some general phenomena like landscape and the decorative arts. General, classified bibliography of mostly French books (pp. 220-23).

1100 Réau, Louis. L'ére romantique: Les arts plastiques. Paris, Michel, 1949. 301p. illus. index.

Written in conjunction with two other volumes (by other authors) treating literature and music of the Romantic movement. Contents: Introduction; part I, Preromanticism in northern and southern Surope; part II, Romanticism in France—painting, sculpture, architecture and decorative arts; part III, Romanticism in England, the United States, Germany, Latin countries, Scandinavia, and Slavic countries; Epilogue, Postromanticism. Classified bibliography (pp. 277-87) and index of artists.

1101- Numbers not used.

1111 Vaughan, William. Romanticism. New York and Toronto, Oxford University Press, 1978. 288p. illus. index.

Series: "World of Art Library." Comprehensive history of European art and architecture in the Romantic style, with emphasis on the general cultural context. Contents: I, Attitudes and Ambiguities; 2, Hope and Fear; 3, The Heroic Era; 4, The Medieval Revival; 5, Transcendent Landscapes; 6, "Natural painture"; 7, Sensation; 8, Romanticizing the World. Brief list of sources and bibliography of basic books, chiefly in English (pp. 281-82).

Realism

- Nochlin, Linda. Realism. Baltimore, Penguin, 1971. 283p. illus. index. Study of Realist art and architecture of the nineteenth century. Emphasis is on the relationship of Realism to contemporary culture and the nature of Realist style rather than its historical development. Provides a good annotated bibliography (pp. 271-74) that lists books and periodical articles in all languages.
- Waldmann, Emil. Die Kunst des Realismus und des Impressionismus im 19. Jahrhundert. Berlin, Propyläen, 1927. 652p. illus. index. (Propyläen Kunstgeschichte, 15).

Comprehensive, illustrated handbook of European painting, sculpture, and graphic arts in the second half of the nineteenth century. Introductory essay outlines the development of Realism and Impressionism and is followed by a good corpus of plates with descriptive notes. No bibliography. Superseded by new Propyläen series (1069), but Waldmann's text is still a valuable introduction.

Impressionism, Post-Impressionism, and Neo-Impressionism

Bowness, Alan, ed. Impressionists and Post-Impressionists. New York, Franklin Watts, 1965. 296p. illus. index. LC 65-10269.

Pictorial history of painting and sculpture in Europe and America in the second half of the nineteenth century, with an emphasis on the Impressionist and Post-Impressionist phases. The brief introduction, which sketches the chief characteristics of the period, is followed by a substantial section devoted to artists' biographies. The work concludes with a succinct historical sketch of the development of late nineteenth-century art. Well illustrated, with portraits of most of the artists discussed. Brief and inadequate bibliographies at the end of the introduction and in some of the biographies. Although it is awkwardly arranged, its numerous illustrations and its responsible (if too brief) text make it a useful survey for the general reader and the beginning student.

1115 Clay, Jean. De l'impressionisme à l'art moderne. Paris, Hachette Réalités, 1975. 318p. index. illus. LC 76-478369.

History of painting and sculpture from Impressionism to the present. Contents: Avant-Propos; Les signes et les hommes; I, La couleur; II, La deformation; III, L'objet pulvérisé; IV, La frontalité; V, L'objet réel; VI, Le mouvement. No bibliography.

Hamann, Richard, and Jost Hermand. Impressionismus. Berlin, Akademie-Verlag, 1960. 414p. illus. index. (Deutsche Kunst und Kultur von der Gründerzeit bis zum Expressionism, Band III). LC 61-40068.

Comprehensive history of German art and architecture during the last decade of the nineteenth and first decade of the twentieth century, with emphasis on the general cultural context. Brief bibliographical note (p. 406). Together with other volumes in the series, it forms a good history of German art for the period 1870 to 1930.

Hamann, Richard, and Jost Hermand. Naturalismus. Berlin, Akademie-Verlag, 1959. 336p. illus. index. (Deutsche Kunst und Kultur von der Gründerzeit bis zum Expressionismus, Band II). LC 60-2589.

Comprehensive history and analysis of German art and architecture in the 1880s with an emphasis on the general cultural context. Excellent chapter on Naturalism as a stylistic principle in nineteenth century art history. Brief bibliographical note (p. 330). Together with other volumes in the series, it forms a good history of German art for the period 1870 to 1930.

1118 Leymarie, Jean. Impressionism. Cleveland, World; Geneva, Switzerland, Skira, 1955. 2v. illus. index. LC 55-7701.

Survey history of French Impressionist painting. Handsomely illustrated. The bibliography in volume 1 (pp. 127-29) lists books and periodical articles in all languages.

1119 Lucie-Smith, Edward. Symbolist Art. New York, Praeger, 1972. 216p. illus. index. LC 72-77068.

Concise history of Symbolist art since its origin in the Symbolist movement of the late nineteenth century through its heirs in the twentieth century. Illustrated in black and white, with some color plates. Brief bibliography (p. 209). For the general reader and the beginning student, a good survey of the subject.

Mathey, François. The Impressionists. New York, Praeger, 1961. 289p. illus. index. LC 61-5759.

Pictorial survey of French Impressionist painting. Good selection of illustrations.

Pool, Phoebe. Impressionism. New York, Praeger, 1967. 282p. illus. index. LC 67-25263.

Concise history of Impressionistic painting in Europe and America. Good selection of plates. Bibliography (pp. 270-72) lists major books in all languages. For the general reader.

- Rewald, John. The History of Impressionism. 4th ed. Greenwich, Conn., New York Graphic Society, 1973. 672p. illus. index. LC 68-17468. Comprehensive history of French Impressionist painting. Thoroughly illustrated and provided with a useful chronological table of events and an excellent annotated bibliography (pp. 608-652) of books and periodical articles in all languages. A standard history of impressionism.
- Rewald, John. Post-Impressionism, from Van Gogh to Gauguin. New York, Museum of Modern Art, 1956. 614p. illus. index. LC 56-14105. History of French Post-Impressionist painting from 1886 to 1893. Well illustrated; the good bibliography (pp. 551-95) lists books and periodical articles in all languages. A standard history of the early phase of Post-Impressionism in France.

20TH CENTURY

General Works

1124 Argan, Giulio C., ed. Die Kunst des 20. Jahrhunderts 1880-1940. Berlin, Propyläen, 1977. 420p. text, 400 plates. index. (Propyläen Kunstgeschichte, XII).

Comprehensive illustrated handbook of art and architecture of Europe and America from 1880 to 1940. Introductory essays by various scholars are followed by excellent corpus of plates, with descriptive notes provided with good bibliographies of specialized literature. Chronological table, and classified bibliography of basic works (pp. 415-19).

Batterberry, Michael. Twentieth Century Art. New York, McGraw-Hill, 1969. 191p. illus. index. LC 70-76821.

A pictorial survey of modern painting and sculpture beginning with Matisse and Les Fauves and ending with the New York School of the 1950s. No bibliography.

1126 Carroll, Donald, and Edward Lucie-Smith. Movements in Modern Art.
New York, Horizon Press, 1973. 208p. illus. index. LC 73-77640.
History of the art and architecture of Europe and America in the twentieth century. Text takes the form of a conversation between the two authors. Contents:
I, Cubism/Futurism; II, Surrealism/Dadaism; III, The Rise of Abstract Art; IV,
Abstract Expressionism; V, Pop Art; and VI, The Contemporary Avant-Garde.
No bibliography.

1127 Cirlot, Juan E. Arte de siglo XX. Barcelona Labor, 1972. 2v. illus. index. LC 72-334275.

Concise survey of European art and architecture during the twentieth century, with emphasis on Spain. Volume one covers architecture and sculpture; volume two, painting. Bibliography of general books (volume 2, p. 645).

Delevoy, Robert L. Dimensions of the 20th Century: 1900-1945.
Geneva, Switzerland, Skira, 1965. 223p. illus. index. LC 65-24417.

A conceptually treated survey of modern art, demonstrated by examples of painting, sculpture, and architecture. Exceptionally good tipped-in color plates. Indexed by names of artists. Includes a general bibliography (pp. 215-16).

Einstein, Carl. **Die Kunst des 20. Jahrhunderts.** 3rd ed. Berlin, Propyläen, 1951. 575p. illus. index.

Illustrated handbook of painting and sculpture during the first half of the twentieth century. Excellent collection of plates, brief text, and informative notes to the plates. No bibliography. Even with the new "Propyläen Kunstgeschichte" volume covering the twentieth century (1124), this is still a useful handbook for beginning and advanced students.

Grohmann, Will. Bildende Kunst und Architektur. Berlin, Suhrkamp, 1953. 551p. illus. index. (Zwischen den Beiden Kriegen, Dritter Band).

Comprehensive history of European and American art and architecture between the two world wars. Provides a useful chronological table of events from 1890 to 1950 and a good classified bibliography (pp. 521-26) of books and periodical articles. A good history of art and architecture of the 1920s and 1930s for the advanced student.

Haack, Friedrich. Die Kunst des XX. Jahrhunderts und der Gegenwart. 6th ed. Esslingen, Neff, 1922-25. 2v. illus.

Comprehensive history of European art and architecture of the nineteenth and early twentieth centuries. First published in 1905, it was one of the first attempts to trace systematically the stylistic development of nineteenth-century art and architecture. Despite its age, it should be known by the advanced student.

Heise, Carl G., ed. Die Kunst des 20. Jahrhunderts. Munich, Piper, 1957. 3v. illus. LC 57-38885 rev.

Comprehensive history of art, architecture, and the applied arts from 1900 to 1950. Contents: Band 1, Malerei, by H. Platte; Band 2, Plastik, by H. Platte; Band 3, Bau, Raum, Gerät, by W. Fischer. Bibliography (v. 3, pp. 287-88) is chiefly a list of German books.

Hunter, Sam, and John Jacobus. Modern Art; From Post-Impressionism to the Present: Painting, Sculpture, Architecture. New York, Abrams, 1977. 351p. illus. index. LC 76-14611.

Survey history of European and American art and architecture from the late nine-teenth century to the present. Good, classified bibliography of books in English (pp. 341-47).

1134 Langui, Emile. 50 Years of Modern Art. New York, Praeger, 1959. 335p. illus. LC 59-7300.

Illustrated survey of painting and sculpture from Fauvism to non-representational art. Good collection of illustrations and useful section of artists' biographies. No bibliography.

- Lucie-Smith, Edward. Art Now: From Abstract Expressionism to Superrealism. New York, Morrow, 1977. 504p. illus. index. LC 77-76724. Comprehensive, well-illustrated history of American and European art, exclusive of architecture, from the 1930s to the present. Contents: Birth of Modernism; Abstract Expressionism; Postwar Europe; Assemblage and Neo-Dadaism; Pop Art in America; Pop Art as an International Style; Op Art and Kinetic Art; Post-Painterly Abstraction; Sculpture in the Post-war Period; Happenings and Environments; Earth Art and Concept Art; Superrealism. The bibliography (p. 501) lists books in English.
- 1136 Richardson, Tony, and Nikos Stangos, eds. Concepts of Modern Art.
 New York and Evanston, Harper & Row, 1974. 281p. illus. index.
 Concise history of modern art, exclusive of architecture, from 1900 to the present.
 Consists of essays by specialists on the various "isms" of modern art, beginning with Fauvism and ending with minimal art. Provides a good classified bibliography of major literature in all languages.

1137 Rowland, Kurt. A History of the Modern Movement: Art, Architecture, Design. New York and London, Van Nostrand-Reinhold, 1973. 240p. illus. index. LC 73-7117.

Contents: Arts & Crafts; The New Art; The New World; The Periphery; Expressions; The New Reality; Art and Industry; The Machine; Anti-Art; The Machine (2); The New Style; The New Society; The New Education. No bibliography.

Schug, Albert. Art of the Twentieth Century. New York, Abrams, 1972. 264p. illus. index.

Concise history of twentieth-century European and American painting, sculpture, architecture, and graphic arts, arranged according to movements. Illustrated with black and white and color plates. Includes a chronological table of the arts, political history, and science and technology. There is a general bibliography (pp. 258-60), which is heavily European in the citations.

- Sylvester, David, ed. Modern Art, from Fauvism to Abstract Expressionism. New York, Franklin Watts, 1965. 296p. illus. index. LC 65-10270. Survey history of modern painting, drawing, graphic art, and sculpture, from Matisse to the abstract expressionists. Following a succinct introduction, a biographical section treats the lives and works of important modern artists, with brief literature citations. Illustrated with color and black and white plates.
- Thomas, Karin. Bis Heute: Stilgeschichte der bildenden Kunst im 20. Jahrhundert. 3rd ed. Cologne, DuMont-Schauberg, 1975. 384p. illus. index. LC 76-457921.

Survey of art, exclusive of architecture, in Western Europe and America from 1885 to 1971. Chapters are devoted to the major styles: Expressionism, Cubism, Dada, Surrealism, Abstract. Concluding chapter treats trends since mid-century. Selected bibliography of books in German (pp. 374-75).

Africa

Beier, Ulli. Contemporary Art in Africa. New York, Praeger, 1968. 173p. illus. index. LC 68-19432.

Survey of mid-century painting and sculpture in Black Africa, with an emphasis on West African artists. Well illustrated. No bibliography.

Austria

Feuerstein, Günther, et al. Moderne Kunst in Österreich. Vienna and Hanover, Forum, 1965. 119p. (text); 114p. (illus.). index.

History of art and architecture in Austria from 1918 to 1964. Consists of essays on the development of the various media. Well illustrated. The good bibliography (pp. 120-23) lists books and periodical articles.

China

Sullivan, Michael. Chinese Art in the Twentieth Century. Berkeley and Los Angeles, University of California Press, 1959. 110p. illus. index.

History of Chinese art, exclusive of architecture, from 1912 to 1950. Provides a good selection of plates, a biographical index of modern Chinese artists, and a bibliography (p. 98), which lists books and periodicals in Chinese and Western languages. A good survey of modern Chinese art.

Czechoslovakia

Nebeskýi, Václav. L'art moderne tschécoslovaque. Paris, Alcan, 1937. 186p. illus.

Illustrated survey of painting and sculpture in Czechoslovakia from 1905 to 1933. Chapters concentrate on major personalities. No bibliography.

Germany

Haftmann, Werner, et al. German Art of the Twentieth Century. New York, Museum of Modern Art, 1957. 240p. illus. index. Reprint: New York, Arno Press, 1972. LC 78-169303.

History of painting, sculpture, and the graphic arts in the German-speaking countries during the twentieth century. Good bibliography (pp. 227-235) by Nancy Riegen lists books, catalogs, and periodical articles.

Roh, Franz. German Art in the 20th Century. Greenwich, Conn., New York Graphic Society, 1968. 516p. illus. index. LC 68-12367. Comprehensive history of art and architecture in Germany from Jugendstil to the present. Additional chapters on developments since 1955 have been written by Juliane Roh. Good selection of plates. No bibliography.

1147 Thoene, Peter. Modern German Art. Harmondsworth, Penguin, 1938. 108p. illus.

Survey history of German painting and sculpture from Impressionism through the abstract styles of the 1930s. No bibliography. An older survey, still valuable for the advanced student because of its comments on the state of German modern art at the time of the Nazi campaign on "degenerate" art.

Great Britain

Read, Herbert. Contemporary British Art. Harmondsworth, Penguin, 1957. 46p. text, 64 plates.

Concise survey of painting and sculpture in Britain during the 1940s and 1950s by a major critic. List of books (pp. 45-46).

1149 Rothenstein, John K. M. British Art Since 1900, an Anthology. London, Phaidon, 1962. 181p. illus. LC 62-51567.

Pictorial survey of painting and sculpture in Britain from 1900 to 1955. Brief introductory essay and biographical notes to the plates. No bibliography.

Hungary

Németh, Lajos. Modern Art in Hungary. Budapest, Corvina, 1969. 187p. illus. LC 72-9780.

Concise survey of painting, sculpture, and the graphic arts in Hungary from 1900 to 1965. Bibliography (pp. 171-72) lists books and periodical articles in all languages.

Japan

1151 Kung, D. The Contemporary Artist in Japan. Honolulu, East-West Center Press, 1966. 187p. illus. LC 66-31499.

Survey of Japanese painting and sculpture since the last war. Introduction on the development of modern Japanese art is followed by biographies of leading artists. No bibliography.

Mexico

Schmeckebier, Laurence E. Modern Mexican Art. Westport, Conn., Greenwood, 1971. 191p. illus. index. LC 70-141418.

Reprint of 1939 edition. Survey history of painting and sculpture in Mexico during the first three decades of the twentieth century. Poor illustrations. Provides a section of artists' biographies and a brief selected bibliography (pp. 181-83).

Netherlands

Kersten, Wim. Moderne Kunst in Nederland. Amsterdam, de Bussy, 1969. 140p. illus. index. LC 76-485611.

Survey of modern art and architecture in the Netherlands from the early twentieth century to the present. No bibliography.

1154 Loosjes-Terpstra, Aleide B. Moderne Kunst in Nederland, 1900-1914. Utrecht, Dekker & Gambert, 1959. 352p. illus. index. (Orbis Artium, Utrechtse Kunsthistorische Studiën, 3). LC 61-34142.

Comprehensive study of art and architecture in the Netherlands from 1900 to 1914. Bibliographical footnotes. A good study.

United States

Cambridge, Mass., Harvard University Press, 1958. 170p. illus. index.

Survey of painting and sculpture in the United States during the first half of the twentieth century. The introductory chapter, which traces the main outlines of the development of modern American art, is followed by chapters investigating the various movements. Concluding chapters discuss the position of the artist in modern society and attempt to characterize what is American in contemporary art. Bibliographical references in the footnotes. A standard study of modern American art.

1156 Goodrich, Lloyd, and John I. H. Baur. American Art of Our Century. New York, Praeger, 1961, 309p. illus. index.

Concise history of painting and sculpture in the United States from 1900 to 1960. Consists of short essays on the major phases. Designed as a guide to the collections in the Whitney Museum of American Art; thus, all examples illustrated are from that collection. Provides a catalog of the Whitney Collection and a list of the exhibitions and books published by the Museum.

Hunter, Sam. American Art of the 20th Century. New York, Abrams, 1972. 487p. illus. index. LC 72-3634.

Comprehensive history of American painting and sculpture of the twentieth century. Copiously illustrated with black and white and color illustrations. The excellent classified bibliography (pp. 437-70) is in two sections: literature to 1959, by Bernard Karpel; and literature since 1959, by Roberta Smith and Nicole Metzner. A standard history suitable for all levels.

Rose, Barbara. American Art Since 1900: A Critical History. 2nd ed. New York, Praeger, 1975. 320p. illus. index. LC 72-83563.

This concise history of modern American art centers on painting but includes a chapter each for sculpture and architecture. Illustrated in black and white, with some color plates. General bibliography (pp. 289-92) is supplemented by the notes to the text.

Art Nouveau

- Abbate, Francesco, ed. Art Nouveau: The Style of the 1890's. London and New York, Octopus, 1972. 158p. illus.

 Pictorial survey of the art and architecture of Art Nouveau. All illustrations are in color; brief popular text. Inadequate one-page bibliography.
- Ahlers-Hestermann, Friedrich. Stilwende: Aufbruch der Jugend um 1900. 2nd ed. Berlin, Mann, 1956. 116p. illus. LC 57-44770.

 History of Art Nouveau art and architecture throughout Europe. Contents: Einleitung; Das neunzehnte Jahrhundert; England: Art Nouveau; Deutschland: Die Münchener Gruppe; Henry van de Velde, kritische und wegweisende Stimmen; Ausbreitung der Bewegung; Buchkunst; Wien und Darmstadt: Das Folkwang-Museum, Die Schotten; Wendung zur Sachlichkeit; Traditions-und Neuform; Malerei und Plastik. No bibliography.
- Amaya, Mario. Art Nouveau. New York, Dutton, 1966. 168p. illus. index. Brief history of Art Nouveau art and architecture in Britain, America, Spain, Belgium, Holland, France, Germany, and Austria. No bibliography.
- Barilli, Renato. Art Nouveau. London, Hamlyn, 1969. 157p. illus. Pictorial survey of Art Nouveau art and architecture. All illustrations are in color. Popular text. No bibliography.

- 1163 Champigneulle, B. L'art nouveau. Paris, Somogy, 1972. 288p. illus. index. Surveys Art Nouveau art and architecture in all countries. Poor illustrations. No bibliography.
- 1164 Cremona, Italo. Il tempo dell'art nouveau. Florence, Vallecchi, 1964. 230p. illus. index.

Survey of Art Nouveau art and architecture throughout Europe. Provides a biographical dictionary of major Art Nouveau artists and architects, but no bibliography.

Lenning, Henry F. The Art Nouveau. The Hague, Nijhoff, 1951. 142p. illus. index.

History of Art Nouveau art and architecture in Europe, with special emphasis on Belgium. Contents: I, The Art Nouveau; II, Henry van de Velde-1; III, Henry van de Velde-2; IV, Expositions and Salons; V, Architecture; VI, Interiors and Furnishings; VII, The Art Nouveau—the Style. Bibliography (pp. 131-35) lists books and periodical articles, including source material, in all languages.

1166 Madsen, S. Tschudi. Art Nouveau. New York, McGraw-Hill, 1967. 256p. illus. index. LC 66-24159.

Concise history of Art Nouveau art and architecture in Europe and America. Brief bibliography (pp. 247-48), and further reference to specialized literature in the footnotes.

1167 Rheims, Maurice. The Age of Art Nouveau. London, Thames and Hudson, 1966. 450p. illus. index. LC 66-66903.

First published as L'art 1900 (Paris, 1965). Well-illustrated history of art and architecture in the Art Nouveau style throughout Europe.

Schmutzler, Robert. Art Nouveau. New York, Abrams, 1964. 322p. illus. index. LC 64-10765.

Comprehensive history of Art Nouveau art and architecture. Traces the origin of the style to proto-Art Nouveau art of the earlier nineteenth century and its development to late Art Nouveau of the 1920s. Good selection of plates, and excellent bibliography (pp. 299-307), which lists books and periodical articles in all languages. There are special sections on literary sources. A standard history of Art Nouveau.

Seling, Helmut. **Jugendstil**: **Der Weg ins 20. Jahrhundert.** Heidelberg and Munich, Keyser, 1959. 459p. illus. index.

Comprehensive history of Art Nouveau art and architecture, consisting of essays by German specialists on the development of the various arts. Good coverage of the minor arts. Good bibliographies at the end of each chapter. Also provides a useful dictionary of artists' biographies. A standard work for the advanced student.

1170 Selz, Peter. Art Nouveau: Art and Design at the Turn of the Century.
New York, Doubleday, 1960. 192p. illus. index. LC 60-11987.
Survey of Art Nouveau art and architecture, consisting of a group of essays by various specialists. Designed to accompany an exhibition formed by the Museum

of Modern Art in New York. Provides an excellent bibliography (pp. 152-61), compiled by James Grady.

See also: Grady (80), Kempton (81).

Fauvism

1171 Crespelle, Jean-Paul. The Fauves. Greenwich, Conn., New York Graphic Society, 1962. 351p. illus. index.

Illustrated survey of the painting and graphics of the Fauves. Well illustrated and provided with a bibliography (pp. 349-51) that lists books and periodical articles.

Leymarie, Jean. Fauvism, Biographical and Critical Study. Paris and New York, Skira, 1959. 163p. illus. index. LC 59-7255.

Survey of painting of the Fauves with emphasis on the major personalities. Bibliography (pp. 149-52) lists major books and periodical articles in English and French.

- Muller, Joseph E. Fauvism. New York, Praeger, 1967. 260p. illus. index. History of French Fauves, with emphasis on the movement's influence on such major painters as Matisse and Dufy. Well illustrated. A good survey for the general reader and the beginning student.
- 1174 Rewald, John. Les Fauves. New York, Museum of Modern Art, 1952. illus. index.

Survey of Fauvism designed to accompany an exhibition at the Museum of Modern Art in New York. Good selection of illustrations, and good bibliography.

Cubism

Barr, Alfred H. Cubism and Abstract Art. New York, Museum of Modern Art, 1936. 250p. illus. index.

Survey of the history of Cubist painting and sculpture in Europe and America. Good selection of illustrations and good bibliography (pp. 234-49) of books and periodical articles, compiled by B. Newhall.

- 1176 Fry, Edward. Cubism. New York, McGraw-Hill, 1966. 200p. illus. index. This study consists of a history of Cubism and an extensive collection of documentary texts related to Cubism. Provides an excellent bibliography (pp. 176-83), which lists books and periodical articles in all languages, and a useful listing of Cubist exhibitions. A standard work on Cubism.
- 1177 Golding, John. Cubism: A History and an Analysis. New York, Wittenborn, 1959. 207p. illus. index. LC 59-4201.

Important, scholarly history and analysis of Cubism. Contents: The History and Chronology of Cubism; II, Picasso and Braque 1907-1912; III, Picasso, Braque and Gris, 1912-1914; IV, The Influence of Cubism in France, 1910-1914. Bibliography covers sources, books, and periodical literature. A standard work on Cubism.

Habasque, Guy. Cubism: Biographical and Critical Study. Paris and New York, Skira, 1959. 170p. illus. index.

Survey of Cubist painting in Europe. Color illustrations. Provides a good bibliography (pp. 154-57), which lists books on and sources for Cubism in all languages.

1179 Kozloff, Max. Cubism/Futurism. New York, Charterhouse, 1973. 243p. illus. LC 72-84221.

Study and concise history of Cubism and Futurism. Bibliography (pp. 221-22) provides a selected list of books in English.

- 1180 Pierre, José. Cubism. London, Heron, 1970. 207p. illus. LC 70-598812. Survey of Cubism with emphasis on French Cubist painting. Bibliography (p. 204) lists major books in French and English.
- Rosenblum, Robert. Cubism and Twentieth Century Art. 3rd ed. New York, Abrams, 1976. 347p. illus. index.

History and analysis of Cubism from Picasso and Braque to circa 1939. Emphasis is on painting. Provides a chronological table and a good critical bibliography (pp. 312-17). A good scholarly study of Cubism for beginning and advanced students.

1182 Schwartz, Paul W. Cubism. New York, Praeger, 1971. 216p. illus. index. LC 70-100034.

Survey of Cubist painting and sculpture, along with literature and the theater. Brief, selected bibliography (pp. 203-204) of books in all languages.

Expressionism

1183 Cheney, Sheldon. Expressionism in Art. Rev. ed. New York, Boni, 1958. 415p. illus. index.

Survey of Expressionist elements in European and American art of the nineteenth and twentieth centuries. Bibliographical footnotes.

Dube, Wolf D. Expressionism. New York, Praeger, 1973. 215p. illus. index. LC 72-79505.

Concise history of German Expressionist painting and graphic arts from its origins to the late 1920s. Provides a section (pp. 208-213) of artists' biographies, with bibliographies of major monographs. A good survey of Expressionism for the general reader and the beginning student.

Kuhn, Charles L. German Expressionism and Abstract Art: The Harvard Collections. Cambridge, Mass., Harvard University Press, 1957. illus. index.

History of German Expressionist painting and sculpture, with emphasis on the pieces in the Harvard University Collections.

Myers, Bernard S. The German Expressionists: A Generation in Revolt. New York, Praeger, 1957.

Survey history of German Expressionist painting and graphic arts. Good selection of illustrations. Bibliography provides a good list of major books in all languages.

Willett, John. Expressionism. New York, McGraw-Hill, 1970. 256p. illus. index. LC 70-96434.

Survey history of Expressionist art and literature from its beginnings to 1945. Good selection of illustrations and a useful, annotated bibliography (pp. 248-52), which lists books in all languages. For the general reader and the beginning student.

Constructivism and Abstraction

Blok, Cor. Geschichte der abstrakten Kunst 1900-1960. Cologne, DuMont-Schauberg, 1975. 190p. illus. LC 76-472868.

Comprehensive handbook of American and European abstarct painting and sculpture. Contents: I, Von den Anfängen bis 1944; II, Die Nachkriegszeit; II, Abstrakte Kunst in der Perspektive. Specialized literature in the notes; selected bibliography of books in all languages (pp. 177-78). Useful chronological list of styles with brief summaries. In the series, "DuMont Dokumente."

- Brion, Marcel. Art abstrait. Paris, Albin Michel, 1956. 315p. illus. Survey of twentieth-century abstract art in Europe and America. Bibliographical footnotes.
- Poensgen, Georg, and Leopold Zahn. Abstrakte Kunst: Eine Weltsprache. Baden-Baden, Woldemar, 1958. 224p. illus.

Survey of painting and sculpture in the abstract style throughout the world. Introductory essay on the nature and development of abstract art is followed by a series of artists' biographies, which are accompanied by excellent illustrations and short bibliographies. The bibliography (p. 125) deals with the documentary sources of abstract art in the twentieth century.

Rickey, George. Constructivism: Origins and Evolution. New York, Braziller, 1967. 305p. illus. index. LC 67-24210.

Concise history of the Constructivist movement from its origins in the early twentieth century to movements and persons still working under Constructivist influence. Black and white illustrations. Includes a chronology of Constructivist events, a table of museum holdings of major artists, and a good classified, annotated bibliography (pp. 247-301).

Vallier, Dora. Abstract Art. New York, Orion, 1970. 342p. illus. index. LC 75-86121.

Translated from the French *L'art abstrait* (1967). Concise history of abstract sculpture and painting, beginning with Kandinsky and including abstract art after 1945. The idea of abstraction is discussed at length in the introduction. In addition to a chronology of events, there is a good general bibliography (pp. 322-30). A straightforward and responsible work.

Futurism

1193 Baumgarth, Christa. Geschichte des Futurismus. Reinbek bei Hamburg, Rowohlt, 1966. 313p. illus. index.

Comprehensive history of Futurism, covering the period from 1905 to the influence of Futurist art in the mid-twentieth century. Covers art and architecture. Provides a collection of documents (translated into German), a section of further source material, and a good bibliography (pp. 299-306) of books and periodical articles in all languages.

1194 Carrieri, Raffaele. Futurism. Milan, Milione, 1963. 183p. (text); 163p. (illus.).

Concise history of Futurism in Italian art and literature. Provides a good bibliography (pp. 171-77), which lists books and periodical articles on Futurism; there is also a list of writings, manifestoes, and exhibitions of Futurism. A definitive work.

1195 Clough, Rosa T. Futurism, The Story of a Modern Art Movement: A New Appraisal. New York, Philosophical Library, 1961. 297p. illus. index. LC 60-15952.

Reprint of (1196), with the addition of part II: A New Appraisal. Updated bibliography (pp. 283-90).

1196 Clough, Rosa T. Looking Back at Futurism. New York, Philosophical Library, 1942. 297p. illus.

Based on dissertation at Columbia University, this is a history of Futurism. Contents: Revolt Against the Past; Literature; Painting; Sculpture; Architecture; Post-War Futurism. Bibliographical footnotes and selected works (pp. 205-207). See also (1195).

1197 Martin, Marianne W. Futurist Art and Theory. 1909-1915. Oxford, Clarendon Press, 1968. 228p. illus. index. Reprint: New York, Hacker, 1978. LC 75-44910.

History of Futurist sculpture and painting from 1909 to 1915, with special reference to the literature of Futurist theory. Appendix on Futurists' controversies. Bibliography (pp. 207-213) is an unclassified but comprehensive list of books and articles in all languages. Reprint has new introduction by the author.

1198 Rye, Jane. Futurism. London, Studio Vista, 1972. 159p. illus. index. LC 72-170798.

Survey of Futurist literature, art, and architecture in and outside Italy. Brief bibliography (p. 156). For the general reader.

Taylor, Joshua. Futurism. New York, Museum of Modern Art, 1961. 153p. illus.

Survey of Futurist painting and graphics. Provides a collection of excerpts from Futurist writings and a useful chronology of events in the Futurist movement. Good bibliography (pp. 148-51).

Tisdall, Caroline, and Angelo Bozzella. Futurism. New York and Toronto, Oxford University Press, 1978. 216p. illus. index. LC 77-76819.

Comprehensive history of Futurism, covering literature, theater, and music as well as painting and sculpture. Contents: 1, The Means of Futurism; 2, The Roots of Futurism; 3, Painting and Sculpture up to 1913; 4, Literature and Theatre; 5, Futuristic Music; 6, The Futuristic City; 7, Photodynamism and Futurist Cinema; 8, Futurism and Women; 9, Lacerba; 10, Art of the War Years and After; 11, Futurism and Fascism. Brief bibliography and list of sources (p. 210).

De Stijl

1201 Jaffe, Hans. De Stijl, 1917-1931. Amsterdam, Meulenhoff, 1956. 293p. illus.

Comprehensive history of Dutch art and architecture from 1917 to 1931. Discusses the origin, character, and influence of De Stijl. Good selection of plates and excellent bibliography (pp. 269-91). A standard work on De Stijl.

Overy, Paul. De Stijl. New York, Dutton, 1969. 167p. illus. index. Brief history of modern Dutch art and architecture from 1895 to 1930. Provides a short bibliography (p. 164) of books in all languages. For the general reader.

Dada and Surrealism

1203 Abastado, Claude. **Introduction au surréalisme**. Paris, Bordas, 1971. index. LC 72-316405.

Concise history of many aspects of Surrealism, including the visual arts. Part one treats the causes of the Surrealist revolt; part two discusses philosophical and intellectual expressions; part three covers literature, painting, sculpture, cinema and theater; part four, "Vision du monde," thematically treats "Le moi," "L'amour," and "Le monde." Includes a good chronological table of events and creations; lists of source materials, exhibitions and revues; Surrealist films; and a concise biographical dictionary of personalities. Excellent classified bibliography (pp. 218-27).

- 1204 Abastado, Claude. Le surrealisme. Paris, Hachette, 1975. 320p. illus. Comprehensive handbook of Surrealist art and literature. Contents: I, L'action; II, Théorie de la connaissance; III, Les oeuvres; IV, Surrealisme sans frontiéres. Bibliographical footnotes and excellent classified bibliography of sources and critical studies (pp. 269-314).
- Barr, Alfred H. Fantastic Art: Dada, Surrealism. 2nd ed. New York, Museum of Modern Art, 1937. 271p. illus. index.

 Collection of essays on fantastic art, Dada, and Surrealism; designed to accompany an exhibition at the Museum of Modern Art. Well illustrated and provided with a good bibliography (pp. 263-67) of books and periodical articles.
- 1206 Gascoyne, David. A Short Survey of Surrealism. London, Cass, 1970. 162p. illus. index. LC 77-571396.

Brief survey of Surrealism, with a section containing translations of major works of Surrealist poetry. Poor illustrations and no bibliography.

1207 Gaunt, William. **The Surrealists.** London, Thames and Hudson, 1972. illus. index. LC 72-75027.

Survey of Surrealist painting in Europe. Well illustrated and provided with a bibliography listing major books and periodical articles in all languages.

Haslam, Malcomb. The Real World of the Surrealists. London, Weidenfeld and Nicolson, 1977. 272p. illus. index. LC 78-102303.

Journalistic account of the lives and times of major Surrealist artists. Many contemporary photographs, together with good illustrations on major works of art and a useful chronology of Surrealist events from 1917 to 1939. One-page bibliography of basic works.

Nadeau, Maurice. The History of Surrealism. New York, Macmillan, 1965. 351p. illus. index. LC 65-23834.

Translation of second edition of *Histoire du surréalism* (Paris, Éditions du Seuil, 1964). First published in 1945. Important early history of Surrealist art, including theater and literature. Contents: I, The Elaboration; II, The Heroic Period, 1923-1925; III, The Analytical Period, 1925-1930; IV, The Period of Automony, 1930-1939; V, Epilogue; VI, Famous Manifestos and Documents. Bibliography (pp. 319-35) lists sources and a classified list of books and periodical articles on Surrealism. Short biographical notes to the principal artists (pp. 337-43).

Passeron, René. Encyclopédie du surréalisme. New ed. Paris, Somogy, 1977. 288p. illus. index. LC 76-459040.

Contents: Introduction; Les précurseurs; Les surréalistes; Index conceptuel et technique; Les groupes; Les revues; Les expositions. Dictionary arrangement followed in each section. Bibliography (pp. 274-76) is an unclassified list of books and articles in all languages.

Picon, Gäetan. Surrealists and Surrealism, 1919-1939. New York, Rizzoli, 1977. 231p. illus. index. LC 76-62889.

Sumptuously illustrated history of European Surrealism from 1919 to 1939. Contents: 1, 1919, The Discovery; 2, 1920-1924, From Dada to Surrealism; 3, 1924, The Year 1; 4, 1925-1929, The Surrealist Revolution; 5, 1930, Back to First Principles; 6, 1931-1939, Dream and Revolution. Bibliography pp. (193-206) provides a comprehensive list of books and periodical articles, including artist monographs and sources.

Pierre, José. A Dictionary of Surrealism. London, Methuen, 1974. 168p. illus. LC 74-183172.

Covers personalities, concepts, major works of art, and techniques of Surrealism. No bibliography.

1213 Read, Herbert. Surrealism . . . New York, Harcourt, Brace, 1936. 251p. illus.

Survey history and conceptual study of Surrealist art. Contents: Introduction, by Herbert Read; "Limits Not Frontiers of Surrealism," by André Breton; "Surrealism at This Time and Place," by Hugh S. Davies; "Poetic Evidence," by Paul Éluard; "1870-1936," by George Hugnet. A standard collection of essays on Surrealism.

Richter, Hans. Dada: Art and Anti-Art. New York, McGraw-Hill, 1965. 246p. illus. index. LC 65-19077.

History of Dada in Europe and America. Divided into "schools" of Dada (Zurich Dada, New York Dada, etc.), with a chapter on Dada's influence on art since 1923. Appendix provides a translation of the Zurich Dada *Chronicle*. Good bibliography (pp. 229-37) lists works on Dada as well as literary works by major Dada figures. A standard history of Dada.

Rubin, William S. Dada and Surrealist Art. New York, Abrams, [1968]. 525p. illus. index. LC 68-13064.

Comprehensive history of Dada and Surrealist art in Europe and America. Excellent selection of plates, thorough and scholarly text. Provides a comprehensive chronology (pp. 453-72) by Irene Gordon and an excellent bibliography (pp. 492-512) listing books, periodical articles, and editions of writings by Dada and Surrealist artists and writers. A standard study.

1216 Schneede, Uwe M. Surrealism. New York, Abrams, 1975. 144p. illus. index. LC 74-2302.

Pictorial survey of Surrealist painting, sculpture, and film. Contents: Dada—"A Mental Attitude"; Proto-Surrealism; Breton's 1924 Manifesto; Activities and Disagreements 1924-1929; The Second Manifesto 1929; Unconscious Notation—The Principle of Metamorphosis; The Verism of the Impossible; Max Ernst the Individualist; Films; The Situation between 1930 and 1939; Surrealism in Exile; Chronology. Good classified bibliography includes monographs on artists.

1217 Verkauf, Willy, ed. Dada: Monograph of a Movement. New York, Wittenborn, 1957. 188p. illus. index.

Collection of essays on various aspects, phases, and media of Dada. Provides a useful bibliography (pp. 176-83) arranged by artists. A standard work on Dada.

1218 Waldberg, Patrick. Surrealism. Cleveland, Skira-World, 1962. 140p. illus. index. LC 62-10989.

Brief history of Surrealism. Good color plates. Select bibliography (p. 135) lists major works in all languages. Also has a useful chronological survey of events in Surrealism and a list of the major writings by Surrealist authors. For the beginning student.

See also: Edwards (78), Gershman (79).

Art in Mid-Century

1219 Brion, Marcel, *et al.* Art Since 1945. New York, Washington Square Press, 1962. 336p. illus.

This survey history of modern art since 1945 comprises essays by ten specialists on painting and sculpture in the following countries: France, Spain, Italy, Yugoslavia, Poland, Germany, Austria, Switzerland, Great Britain, Holland, Scandinavia, and the United States. No bibliography and no index. A regional approach for the beginning student.

Haftmann, Werner, et al. Art Since Mid-Century: The New Internationalism. Greenwich, Conn., New York Graphic Society, 1971. 2v. illus. index. LC 70-154332.

Collection of essays by various experts; covers the development of European and American painting and sculpture since the end of the Second World War. First volume covers abstract styles; second volume, figurative styles. Each volume concludes with short statements by the artists considered. No bibliography.

Hunter, Sam, et al. New Art around the World: Painting and Sculpture.
New York, Abrams, 1966. 509p. illus. index. LC 66-29665.
History of painting and sculpture in the major art-generating countries around the world between 1945 and 1965. Consists of essays by various specialists on the art of United States, Paris, Great Britain, Italy, Spain, The Netherlands, Scandinavia, Belgium, Japan, South America, Greece, Israel, Poland, Czechoslovakia, Yugoslavia, Germany, Austria, and Switzerland. No bibliography.

Lucie-Smith, Edward. Late Modern: The Visual Arts since 1945. New York, Praeger, 1969. 288p. illus. index. LC 74-92585.
 Survey history of painting and sculpture since 1945 with sections on Abstract Expressionism, the European scene, Pop Art, Op Art, kinetic art, sculpture, and environments. General reading list (p. 275).

CHAPTER NINE

NATIONAL HISTORIES AND HANDBOOKS OF EUROPEAN ART

WESTERN EUROPE

FRANCE

Topographic Handbooks

1223 Dictionnaire des églises de France. Paris, Laffont, 1966-1971. 5v. illus. index. LC 67-73940.

Topographical guide to the art and architecture of the churches of France, Belgium, Luxembourg, and French Switzerland. Volume one is a history of church art and architecture in the above countries with bibliographies at the end of sections and a glossary of terms at the end of the volume. Volumes two through five treat the churches (by region and place), giving attention to the art contents along with the architecture of the major buildings. Contents: vol. 2, Centre et Sud-Est; vol. 3, Sud-Ouest; vol. 4, Ouest et Ile-de-France; vol. 5, Nord et Est, Belgique, Luxembourg, Suisse. The entry for each church has a brief bibliography. Although not the in-depth coverage of an official inventory, this is still a valuable reference work for beginning and advanced students.

1224 Guide artistique de France. Paris, Hachette, 1968. 1240p. index. LC 68-122321.

Pocket-size guide to the art and architecture of France, including collections of major museums. Geographical arrangement. Good classified bibliography of books in French (pp. 1023-45).

1225 Inventaire général des monuments et des richesses artistiques de la France. Paris, Imprimerie Nationale, 1969—.

Published by the Ministère des Affaires Culturelles. Official inventory of the art and architecture in France, arranged by region. To date, the following have appeared:

Finistère: Canton Carhaix-Plouguer (1969; 2v.) Haut-Rhin: Canton Guebwiller (1972; 2v.) Landes: Canton Pevrehorade (1973: 2v.)

Gard: Canton Aigues-Mortres (1973; 2v.)

Bretagne: Morbihan, Cantons Le Faouet et Gourin (1975) Haute Normandie: Eure, Canton Lyon-la-Forêt (1976) Côte d'Or: Canton Sombernon (1977) Bretagne: Morbihan, Canton Belle-Ile-en-Mer (1978)

Each section is introduced with a chapter on the pertinent archival sources and a sketch of the local history and art history. The inventory of the monuments and their contents is arranged by place. For each section, a volume of plates accompanies the inventory text. Two sub-series are attached to the Inventaire: the first is "Répertoire des inventaires," 1970-, which is a series of bibliographies on the art and architecture of the major regions of France. To date, the following volumes have appeared: Région Nord (1970), Limousin (1970), Languedoc-Roussillon (1970), Lorraine (1973), Poitou-Charentes (1975), and Auvergne (1977). The other sub-series is "Principes d'analyse scientifique," 1971-, which consists of illustrated glossaries of the terminology used in the description of the various arts. Volumes that have appeared to date are: Tapisserie (1971), Architecture (1972: 2v.). The *Inventaire* and its sub-series are intended, when complete, to replace the old and incomplete inventory. They will fill a long-standing gap in the information on art and architecture in situ in France. The volumes of the sub-series deserve to be better known as reference tools in their own right. The Répertoire has the potential of becoming the long-needed retrospective bibliography on French art and architecture. The volumes of the "Principes d'analyse scientifique" are excellent dictionaries of art terminology.

Olivier-Michel, Françoise, *et al.* A Guide to the Art Treasures of France. London, Methuen, 1966. 555p. illus. index. LC 66-74412.

Topographical guide to the art and architecture of France. Arrangement is by region, then by place. Includes art in museums as well as *in situ*. Text consists of brief descriptions accompanied by numerous small illustrations. No bibliography. Too large to be used in the field, but it can be used for quick reference to illustrations of the major works.

1227 Keller, Harald. Die Kunstlandschaften Frankreichs. Wiesbaden, F. Steiner, 1963. 100p. illus. index. LC 64-44002.

Handbook of the regional styles of French art and architecture on the model of

the same author's work on Italian art (870). Modest selection of plates, good maps, and extensive bibliographical footnotes. For the advanced student.

Reclams Kunstführer Frankreich. Herausgegeben von Manfred Wundram. Stuttgart, Reclam, 1967—. illus. index. LC 78-413637.

Topographical guide to the art and architecture of France, including all major works from prehistoric times to the present. The two volumes that have appeared to date are: Band I, Paris und Versailles (1970); Band II, Provence; Côte d'Azur; Dauphiné; Rhône-Tal (1975). Within the volumes, arrangement is by place and, in the case of Paris, by city quartier. Each place is introduced by a historical sketch, followed by a thorough description of the major buildings, their art contents and decoration, sites and monuments. Major museums and their buildings and collections are also included. Modestly illustrated with plates; liberally provided with plans and diagrams. No bibliography. Designed as pocket guides for the serious art tourist, the thoroughness of the Reclam guides makes them valuable reference tools.

Histories

- Art Treasures in France: Monuments, Masterpieces, Commissions, and Collections. General eds., Bernard S. Myers and Trewin Copplestone. New York and Toronto, McGraw-Hill, 1969. 176p. illus. index. LC 69-13326. Pictorial survey of the architecture, painting, sculpture, and decorative and minor arts in France from prehistory to the present. Written by a variety of period specialists. Contains maps and a glossary-index of museums and monuments in France, but no bibliography.
- Hourticq, Louis. Histoire générale de l'art—France. Paris, Hachette, n.d. (1912). 476p. illus.

 Survey of art and architecture in France from Gallo-Roman times to the end of the nineteenth century. No bibliography. Series: "Ars Una; Species-Mille."
- Laclotte, Michel. French Art from 1350 to 1850. New York, Franklin Watts, 1965. 249p. illus. index. LC 65-10267.

 Pictorial survey of art and architecture in France from 1350 to 1850, with an emphasis on painting and sculpture. The introduction, which outlines the chief characteristics, schools, and artists of France, is followed by a substantial section devoted to artists' biographies. The work concludes with a brief historical sketch of the development of art and architecture in France. Well illustrated. Brief and inadequate bibliographies are found at the end of the introduction and in some of the biographies. It is awkwardly arranged, but its numerous illustrations and responsible, if too brief, text make it a useful survey for the general reader.
- Mâle, Émile. Religious Art from the Twelfth to the Eighteenth Century. New York, Pantheon, 1949. 208p. illus. index. Reprinted: New York, Noonday, 1958. LC 49-10882.

Translation of the second edition (Paris, A. Colin, 1946) of *L'art religieux du XIIe au XVIIIe siècle: etraits choisis par l'auteur*. Collection of passages, chosen by the author, from his four-volume history of the iconography of French art (875, 901, 988). No bibliography.

1233 Réau, Louis. Histoire de l'expansion de l'art français . . . Paris, Laurens, 1924-33. 3v. illus. index.

History of French art and architecture in other countries and the influence of French art and architecture in other countries. Contents: vol. 1, Le monde latin—Italie, Espagne, Portugal, Roumanie, Amérique du Sud; vol. 2, pt. 1, Belgique et Hollande, Suisse, Allemagne et Autriche, Bohème et Hongrie; vol. 2, pt. 2, Pays scandinaves, Angleterre, Amérique du Nord; vol. 3, Le monde slave et l'Orient. Each volume provides a list of documents and bibliography.

1234 Schneider, René. L'art français . . . Paris, Laurens, 1925-30. 6v. illus. index.

General history of art and architecture in France from the early Middle Ages to the early twentieth century. Popular text, but there are good bibliographies at the end of each volume.

GERMAN-SPEAKING COUNTRIES

General Works

1235 **Deutsche Kunstgeschichte.** Munich, Bruckmann, 1942-1956. 6v. illus. index.

Comprehensive history of art and architecture in the German-speaking countries from Carolingian times through the twentieth century. Band I, *Baukunst*, by Eberhard Hempel; Band II, *Plastik*, by Adolf Feulner and Theodor Müller; Band III, *Malerei*, by Otto Fischer; Band IV, *Zeichnung und Graphik*, by Otto Fischer; Band V, *Kunstgewerbe*, by Heinrich Kohlhaussen; Band VI, *Die Kunst des 20. Jahrhunderts*, by Franz Roh. Good, classified bibliographies at the end of each volume. Excellent illustrations. A standard history of German art and architecture.

1236 Geschichte der deutschen Kunst... Berlin, Grote, 1887-1891. 5v. illus. index.

Comprehensive history of art and architecture in German-speaking countries. Contents: Band 1, Robert Dohme, Geschichte der deutschen Baukunst; Band 2, Wilhelm Bode, Geschichte der deutschen Plastik; Band 3, Heinrich Janitschek, Geschichte der deutschen Malerei; Band 4, Carl von Lützow, Geschichte des deutschen Kupferstiches und Holzschittes; Band 5, Jakob von Falke, Geschichte des deutschen Kunstgewerbes. Only occasional bibliographical footnotes. An old, standard history; superseded by Bruckmann's Deutsche Kunstgeschichte (1235).

1237 Grisebach, August. Die Kunst der deutschen Stämme und Landschaften. Vienna, Neff, 1946. 367p. illus. index. LC A49-92.

Important attempt to delineate the various regional styles in the art and architecture of the German-speaking countries. Contents: Einleitung; Franken; Schwaben; Die Alemannen am Oberrhein; Bayern und Österreich; Köln und der Niederrhein; Westfalen und Niedersachsen; Lübeck und die Kunst an der Ostsee; Thüringen und Sachsen; Schlesien und der Nordosten; Berlin; Schlusswort. Artists index. No bibliography.

Austria

Topographic Handbooks

Dehio-Handbuch: Die Kunstdenkmäler Österreichs. Vienna, Schroll, 1953– . illus. index.

Edited by the Bundesdenkmalamt and Institut für österreichische Kunstforschung. This is the fourth and fifth editions of the original work by Georg Dehio, *Handbuch der deutschen Kunstdenkmäler* . . . 2. *Abteilung: Österreich* . . . (Berlin, 1933-35), expanded, rearranged, and rewritten by a team of specialists. List of volumes to date: *Wien*, by Justus Schmidt and Hans Tietze; *Niederösterreich*, by Richard Kurt Donin; *Oberösterreich*, by Erwin Hainisch; *Salzburg*, by Franz Martin; *Steiermark*, by Eberhard Hempel and Eduard Andorfer; *Tirol*, by Heinrich Hammer *et al.*; *Kärnten*, by Karl Ginhart, *et al.* Additional volumes covering the remaining provinces are planned. Topographical handbook of the art and architecture of Austria, divided by province and arranged by place. A short history of the place with

reference to documents is followed by a thorough description and discussion of the major architectural monuments of Austria. Does not include works in museums. Intended as a field guide, it is also a major reference tool for the advanced student.

Hootz, Reinhardt. Kunstdenkmäler in Österreich: Ein Bildhandbuch. Munich, Berlin, Deutscher Kunstverlag, 1965-1968. 4v. illus. index. LC 67-96968.

Illustrated handbook of the art and architecture of Austria. Volume one covers the provinces of Salzburg, Tirol and Vorarlberg; volume two, Carinthia and Styria; volume three, Upper and Lower Austria and Burgenland; volume four, the city and county of Vienna. Each volume has an introductory essay on the history of art and architecture in the particular regions, followed by an excellent collection of plates arranged by place. Informative notes to the plates give dates, attribution, plans, etc. There is a chronological listing of the works illustrated. A standard handbook for beginning and advanced students.

1240 Österreichische Kunsttopographie. Band I- . Vienna, Schroll, 1907- . illus. index.

Official inventory of art and architecture in Austria. After 1918 it was published by Deutschösterreiches Staatsdenkmalamt, and after 1924 by Bundesdenkmalamt. Between 1937 and 1945 the name changed to *Ostmärkische Kunsttopographie*. In progress. To date the following volumes have appeared:

Band I, Bezirk Krems (1907)

Band II, Stadt-Wien (XI-XXI Bezirk) (1908)

Band III, Bezirk Melk (1909)

Band IV, Pöggstall (1910)

Band V, Bezirk Horn (1911)

Band VI, Bezirk Waidhofen a.d. Thaya (1911)

Band VII, Benediktiner-Frauen-Stift Nonnberg in Salzburg (1911)

Band VIII, Bezirk Zwettl (ohne Stift Zwettl) (1911)

Band IX, Stadt Salzburg-Kirchliche Denkmale der Stadt Salzburg (1912)

Band X, Bezirk Salzburg (1913)

Band XI, Bezirk Salzburg (1916)

Band XII, Stift St. Peter in Salzburg (1913)

Band XIII, Profanen Denkmale der Stadt Salzburg (1914)

Band XIV, Hofburg in Wien (1914)

Band XV, Kunsthistorischer Atlas Wien (1916)

Band XVI, Die Kunstsammlungen der Stadt Salzburg (1919)

Band XVII, Urgeschichte des Kronlandes Salzburg (1918)

Band XVIII, Bezirk Baden (1924)

Band XIX, Stift Heiligenkreuz (1926)

Band XX, Bezirk Hallein (1927)

Band XXI, Bezirk Schärding (1927)

Band XXII, Bezirk Tamsweg (1929)

Band XXIII, St. Stephansdom in Wien (1931)

Band XXIV, Bezirk und Städte Eisenstadt und Rust (1932)

Band XXV, Bezirk Zell am See (1933)

Band XXVI, Volkskunde des Burgenlandes (1935)

Band XXVII, Vorgeschichtlichen Vorarlbergs (1937)

Band XXVIII, Landkreise Bischofshofen (1940)

Band XXIX, Zisterzienserkloster Zwettl (1940)

Band XXX, Bezirk Braunau (1947)

Band XXXI, Benediktinerstift St. Lambert (1971)

Band XXXII, Bezirk Feldkirch (1958)

Band XXXIV, Bezirk Lambach (1959)

Band XXXV, Bezirk Murau (1964)

Band XXXVI, Die Linzer Kirchen (1964)

Band XXXVII, Benediktinerstift St. Paul im Lavnattal (1969)

Band XXXVIII, Die Profanen Kunstdenkmäler der Stadt Innsbruck (1972)

Band XXXIX, Gerichtsbezirk Oberwölz (1973)

Band XL, Bezirk Oberwalt (1974)

Band XLI, Wien, Die Kirche des III. Bezirks (1974)

Band XLIII, Benediktinerstiftes Kremsmünster (2v., 1977)

Band XLIV, Die Profanen Kunstdenkmäler von Linz (1976)

Each volume devoted to a region is introduced by an historical sketch of the area followed by a description of major buildings (including their art contents and decoration), monuments, archaeological sites, and other *in situ* remains. The history of major places and monuments is discussed in detail, with thorough reference to documentary sources and to specialized literature in the footnotes. Well and extensively illustrated with plates, plans, and diagrams.

Oettinger, Karl, ed. **Reclams Kunstführer Österreich**. Stuttgart, Reclam, 1961. 2v. illus. index. LC 78-407658.

Topographical guide to the art and architecture of Austria. Divided into regions and arranged by place. Band I, Wien, Niederösterreich, Oberösterreich, Burgenland (3rd ed., 1961; 703p.); Band II, Salzburg, Tirol, Vorarlberg Kärnten, Steiermark (2nd ed., 1961; 895p.). Each place is introduced with a historical sketch, followed by a description and discussion of the major buildings. Although emphasis is on architecture, the art contents of the buildings are briefly discussed. Illustrated with plates and plans of the major buildings. Volume one has a useful glossary of terms; each volume has an index by place and by artist-architect. Designed as a comprehensive, pocket-sized field guide, this work is remarkably thorough, but not as detailed as the Dehio-Handbuch (1238) or as definitive as the official inventories (1240).

Histories

Benesch, Otto. Kleine Geschichte der Kunst in Österreich. Vienna, Globus, 1950. 65p. illus. LC A51-2497.

Concise history of Austrian art and architecture from the earliest times to the middle of the twentieth century. No bibliography.

Feuchtmüller, Rupert. Kunst in Österreich vom frühen Mittelalters bis zur Gegenwart. v. 1–. Vienna, Hanover, and Basel, Forum, 1972–. illus. index. LC 75-315996.

Comprehensive history of art and architecture in Austria from the early Middle Ages to the present. Volume one covers the Middle Ages. Bibliographical references are given at the end of each section. Well illustrated with plates, plans, and diagrams.

1244 Ginhart, Karl, ed. Die bildende Kunst in Österreich. Baden bei Wien, R. M. Rohrer, 1936-1943. 6v. illus, index. LC 39-10657.

Comprehensive and scholarly history of art and architecture in Austria from prehistoric times to the 1940s. Contents: Band 1, Voraussetzungen und Anfänge (von der Urzeit bis zum 600 N.Chr.); Band 2, Vorromanische und Romanische Zeit (von etwa 600 bis zum 1250); Band 3, Gotische Zeit (von etwa 1250 bis zum 1530); Band 4, "Renaissance" und Barock (von etwa 1530 bis um 1690); Band 5, Barock und Rokoko (von etwa 1690 bis um 1780); Band 6, Vom Ausgang des 18. Jahrhunderts bis zur Gegenwart. Bibliographies at end of each chapter. The standard history of Austrian art.

1245 Grimschitz, Bruno. Ars Austriae. Vienna, Wolfrum. 1960. 60p. (text); 244p. (illus.). index. LC A61-5108.

Pictorial survey of the art and architecture of Austria from the seventh century B.C. through the twentieth century. Introductory essay provides a brief historical survey supplemented by more detailed information in the notes to the plates. No bibliography. Popular survey in English for the general reader.

Neuwirth, Josef. Bildende Kunst in Österreich. Vienna, C. Fromme, 1918. 2v. illus. index.

Comprehensive history of art, exclusive of architecture, in Austria from prehistoric times to the early twentieth century. Contents: Band 1, Von der Urzeit bis zum Ausgange des Mittelalters; Band 2, Von der Renaissance bis zum Beginne des zwanzigsten Jahrhunderts. Occasional bibliographical footnotes.

Schaffran, Emerich. Kunstgeschichte Österreichs. Vienna, Hollinek, 1948. 443p. illus. (Bücherreihe Österreichische-Heimat, Band 11). LC 49-18170. Concise history of art and architecture in Austria from the early Middle Ages to the early twentieth century. "Lexikon der wichtigen bildenden Künstler Österreich" (pp. 353-423). Good classified bibliography of books and periodical articles (pp. 425-32).

Germany

Topographic Handbooks

Dehio, Georg. Handbuch der deutschen Kunstdenkmäler. New edition by the Vereinigung zur Herausgabe des Dehio-Handbuches. Munich, Deutscher Kunstverlag, 1964—. illus. index.

New, expanded, and rewritten edition of the original five-volume work published from 1900 to 1906. Comprehensive topographical handbook of the art and architecture of Germany from prehistoric times to the present. To date, the following volumes have appeared: *Baden-Württemberg*, by Friedrich Piel (1964); *Hamburg*; *Schleswig-Holstein*, by Johannes Habich (1971); *Hessen*, by Magnus Backes (1966);

Nordrhein-Westfalen. Erster Band: Rheinland, by Ruth Schmitz-Ehmke (1967); Nordrhein-Westfalen, Zweiter Band: Westfalen, by Dorothea Kluge and Wilfried Hansmann (1969); Rheinland-Pfalz, Saarland, by Hans Caspary, Ekkart Klinge, and Wolfgang Götz (1972); Bremen/Niedersachsen, by Gottfried Kiesow et al. (1977); Die Bezirke Dresden, Karl-Marx-Stadt, Leipzig (1965); Die Bezirke Neubrandenburg, Rostock, Schwerin (1968); Der Bezirk Magdeburg (1974); Der Bezirk Halle (1976). Additional volumes completing the coverage of both East and West Germany are in progress. Arranged by place, each volume provides an historical sketch of the place and a detailed description of the important buildings and their contents. Illustrated only with ground plans. No bibliography. A standard topographical handbook of German art and architecture.

1249 Hootz, Reinhardt. Deutsche Kunstdenkmäler: Ein Bildhandbuch.

Munich, Deutscher Kunstverlag, 1966-1974. 14v. illus. index. Illustrated handbook of the art and architecture of Germany consisting of separate volumes for each of the present states of both East and West Germany. Consists of the following volumes:

Baden-Württemberg (2nd ed., 1970)

Bayern nördlich der Donau (2nd ed., 1967)

Bayern südlich der Donau (2nd ed., 1967)

Bremen; Niedersachsen (2nd ed., 1974)

Hamburg; Schleswig-Holstein (2nd ed., 1968)

Hessen (2nd ed., 1974)

Niederrhein (2nd ed., 1966)

Rheinland-Pfalz und Saar (2nd ed., 1969)

Westfalen (2nd ed., 1972)

Thüringen (Bezirke Erfurt, Suhl, Gera) (1968)

Provinz Sachsen und Land Anhalt (Bezirke Halle, Magdeburg) (1968)

Sachsen (Bezirke Leipzig, Dresden, Karl-Marx-Stadt) (1968)

Mecklenburg (Bezirke Schwerin, Rostock, Neu-Brandenburg) (1971)

Mark Brandenburg und Berlin (Berzirke Potsdam, Frankfurt an der Oder, Cottbus, Berlin) (1971)

Each volume has an introductory essay that surveys the art history of the region, followed by an excellent collection of plates arranged by place, notes to the plates with plans and basic historical data, a chronological list of the works of art illustrated, and maps indicating the locations of the places. No bibliography. Although they do not substitute for the more intensive and extensive treatment of art and architectural monuments in the numerous official inventories, these volumes are handy, competent reference tools to the major works of art and architecture *in situ* in Germany. Their small size permits their use as field guides for intensive art travel.

1250 Reclams Kunstführer Deutschland. Stuttgart, Reclam, 1971—. illus. index. LC 68-110831.

Topographical guide to the art and architecture of West Germany and Berlin. Volumes covering East Germany are planned. To date, the following have appeared:

Band I, *Bayern* (8th ed., 1974)

Band II, Baden-Württemberg, Pfalz, Saarland (6th ed., 1971)

Band III, Rheinlande und Westfalen (5th ed., 1975)

Band IV, Niedersachsen, Hansestädte, Schleswig-Holstein, Hessen (5th ed., 1976)

Band VII, Berlin (1977)

Arranged by place or site. Each place is introduced by a brief historical sketch that precedes a thorough description of the major buildings and monuments, including their art contents and decoration. Modestly illustrated with plates, liberally provided with plans and diagrams, and well indexed. No bibliography.

Inventories of Art and Architecture

German art and architecture inventories present a complex bibliographical problem. Territorial changes after the two wars have broken the continuity of earlier series, changing their titles and scope, and have brought new series into being. To facilitate the use of these extremely valuable reference works for advanced study in German art history, they are arranged here under headings corresponding to major regions of Germany. The present-day territorial equivalents are given in parenthesis.

All of the inventories are thoroughly illustrated with plates, diagrams, and plans. Many provide old views of places and buildings. All follow a geographical arrangement by place within counties (*Kreise*). And all provide invaluable bibliographical references either in the form of footnotes or as separate bibliographies at the end of sections or volumes.

Bavaria (Land Bayern)

Die Kunstdenkmäler Bayerns. Munich, Oldenbourg, 1895—. illus. index.

Official inventory of art and architecture in Bavaria. The series is divided by the eight *Regierungsbezirke* and then by *Kreise*. To date, the following have appeared:

- I, Oberbayern
 - 1) Ingolstadt, Pfaffenhofen, Schrobenhausen, Aichach, Friedberg, Dachau, Freising, Bruck, Landsberg, Schongau, Garmisch, Tölz, Weilheim, München I und II (1895); 2) München Stadt, Erding, Ebersberg, Miesbach, Rosenheim, Traunstein, Wasserburg (1895); 3) Mühldorf, Alt-Ötting, Laufen, Berchtesgaden, Register zu Teil 1 [Index to section I] (1908).
- II, Oberpfalz und Regensburg
 - 1) Roding (1905); 2) Neuburg v. W. (1906); 3) Waldmünchen (1906); 4) Parsberg (1906); 5) Burglengenfeld (1906); 6) Cham (1906); 7) Oberviechtach (1906); 8) Vohenstrauss (1907); 9) Neustadt a. W. (1907); 10) Kemnath (1907); 11) Eschenbach (1909); 12) AG. Beilngries (1908); 13) AG. Riedenburg (1908); 14) Tirschenreuth (1908); 15) BA. Amberg (1909); 16) Stadt Amberg (1909); 17) Neumarkt (1909); 18) Nabburg (1910); 19) Sulzbach (1910); 20) Stadtamhof (1914); 21) BA. Regensburg (1910); 22) Stadt Regensburg (3v.; 1933).

III, Unterfranken und Aschaffenburg

1) Ochsenfurt (1911); 2) Kitzingen (1911); 3) Würzburg (1911);

4) Hassfurt (1912); 5) Hofheim (1912); 6) Karlstadt (1912);

7) Marktheidenfeld (1913); 8) Gerolzhofen (1913); 9) Lohr (1914);

10) Kissingen (1914); 11) Brückenau (1914); 12) Stadt Würzberg

(1915); 13) Königshofen (1915); 14) Hammelburg (1915); 15) Ebern

(1916): 16) Alzenau (1916): 17) BA. Schweinfurt (1917);

18) Miltenberg (1917); 19) Stadt Aschaffenburg (1918); 20) Gemünden (1920); 21) Mellrichstadt (1921); 22) Neustadt a. S.

(1922); 23) Obernburg (1925); 24) BA. Aschaffenburg (1927).

IV, Niederbayern

1) Dingolfing (1912); 2) BA. Landshut (1914); 3) Stadt Passau (1919); 4) BA. Passau (1920); 5) Vilsbiburg (1921); 6) Stadt Straubing (1921);

7) Kelheim (1922); 8) Eggenfelden (1923); 9) Kötzting (1922);

10) Pfarrkirchen (1923); 11) Wegscheid (1924); 12) BA. Straubing

(1925); 13) Landau a. I. (1926); 14) Vilshofen (1926); 15) Viechtach

(1926); 16) Stadt Landshut (1927); 17) Deggendorf (1928); 18)

Mainburg (1928); 19) Regen (1928); 20) Bogen (1929); 21) Griesbach

(1929); 22) Rottenburg (1930); 23) Wolfstein (1931); 24) Grafenau

(1939); 22) Rottenburg (1930); 23) Wolfstein (1931); 24) Grafenat (1933): 25) Mallersdorf (1936).

V. Mittelfranken

1) Stadt Eichstätt (1924); 2) BA; Eichstätt (1928); 3) BA. Hilpoltstein (1929); 4) Stadt Dinkelsbühl (1931); 5) Weissenburg (1932); 6) Gunzenhausen (1937); 7) Schwabach (1939); 8) Rothenburg o. T. kirchl. Bauten (1959); 10) Hersbruck (1959); 11) Landkreis Lauf an der Pegnitz (1966).

VII, Schwaben und Neuburg

1) BA. Nördlingen (1938); 2) Stadt Nördingen (1940); 3) LK. Donauwörth (1951); 4) Lindau (1954); 5) Neuburg/Donau (1958); 6) Stadt Dillingen (1964); 7) LK. Dillingen (1972); 8) LK. Sonthof

6) Stadt Dillingen (1964); 7) LK. Dillingen (1972); 8) LK. Sonthofen (1964).

VIII. Oberfranken

1) Wundsiedel und Stadt Marktredwitz (1954); 2) Pegnitz (1961).

Baden-Württemberg (Land Baden-Württemberg)

Die Kunstdenkmäler Badens. Various places and publishers. Presently:
Munich, Deutscher Kunstverlag. 1887— . illus. index. LC 53-23592.

Official inventory of the art and architecture in Baden. Until 1933, it was titled Die Kunstdenkmäler des Grossherzogthums Baden. To date, the following volumes have appeared:

Band 1: Kreis Konstanz; Band 2: Kreis Villingen; Band 3: Kreis Waldshut; Band 4, 1: Kreis Mosbach. Amtsbezirk Wertheim; Band 4, 2: Kreis Mosbach. Amtsbezirk Tauberbischofsheim; Band 4, 3: Kreis Mosbach. Amtsbezirke Buchen und Adelsheim; Band 4, 4: Kreis Mosbach. Amtsbezirke Mosbach und Eberbach; Band 5: Kreis Lörrach; Band 6, 1: Kreis Freiburg. Amtsbezirke Breisach, Emmendingen, Ettenheim, Freiburg Land,

Neustadt, Staufen und Waldkirch; Band 7: Kreis Offenburg; Band 8, 1: Kreis Heidelberg. Amtsbezirke Sinsheim, Eppingen und Weisloch; Band 8, 2: Kreis Heidelberg. Amtsbezirk Heidelberg; Band 9, 1: Kreis Karlsruhe. Amsbezirk Bretten; Band 9, 2: Kreis Karlsruhe. Amtsbezirk Bruchsal; Band 9, 3: Kreis Karlsruhe. Amtsbezirk Ettlingen; Band 9, 5: Kreis Karlsruhe. Amtsbezirk Karlsruhe Land; Band 9, 6: Kreis Karlsruhe. Amtsbezirk Pforzheim Stadt; Band 9, 7: Kreis Karlsruhe. Amtsbezirk Pforzheim Land; Band 10, 2: Kreis Mannheim. Stadt Schwetzingen; Band 10, 3: Kreis Mannheim. Landkreis Mannheim; Band 11, 1: Kreis Baden-Baden. Stadt Baden-Baden; Band 12, 1: Kreis Rastatt. Landkreis Rastatt.

1253 **Die Kunstdenkmäler Hohenzollerns.** Stuttgart, Spemann, 1939-1948. 2v. illus. index.

Official inventory of the art and architecture in the former province of Hohenzollern. Contents: Band 1, Kreis Hechingen (1939); Band 2, Kreis Sigmaringen (1948).

Die Kunst- und Altertumsdenkmale im Königreich Württemberg. Stuttgart, Deutsche Verlags-Anstalt, 1897-1914. 4v. illus. index.

Official inventory of the art and architecture in the former kingdom of Württemberg. Succeeded by *Die Kunst- und Altertumsdenkmale in Württemberg* (1255). Contents: Band 1, *Schwarzwaldkreis* (1897); Band 2, *Neckarkreis* (1889); Band 3, *Jagstkreis* (2v.: 1907-1913); Band 4, *Donaukreis I* (1914).

Die Kunst- und Altertumsdenkmale in Württemberg. Stuttgart, Deutsche Verlags-Anstalt, 1924-1936. 4v. illus. index.

Official inventory of the art and architecture in Württemberg. Succeeds *Die Kunst-* und Altertumsdenkmale im Königreich Württemberg (1254) and is succeeded by *Die Kunstdenkmäler in Württemberg* (1256). Contents: Band 1, *Donaukreis II* (1924); Band 2, *Oberamt Münsingen* (1926); Band 3, *Oberamt Ravensburg* (1931); Band 4, *Kreis Riedlingen* (1936).

1256 **Die Kunstdenkmäler in Württemberg.** Stuttgart, Deutsche Verlags-Anstalt, 1937–. illus. index. LC 38-8276 rev. 2.

Official inventory of art and architecture in the German Federal State of Württemberg. Succeeds *Die Kunst- und Altertumsdenkmale in Württemberg* (1255). To date the following volumes have appeared:

Band 1, Kreis Tettnang (1937)

Band 2, Kreis Saulgau (1938)

Band 3, Ehemaliger Kreis Waldsee (1943)

Band 4, Ehemaliger Kreis Wangen (1954)

Band 5, Ehemaliges Oberamt Künzelsau (1962)

Hesse (Land Hessen)

1257 Die Kunstdenkmäler im Grossherzogtum Hesse. Darmstadt, Bergsträsser, 1885-1934. 9v. illus. index.

Official inventory of the art and architecture in the former grand duchy of Hesse. In 1919, the title changed to *Die Kunstdenkmäler im Freistaat Hessen*; in 1933, to *Die Kunstdenkmäler im Volkstaat Hessen*. Succeeded by *Bau- und Kunstdenkmäler des Landes Hessen* (1258). Contents:

Provinz Starkenburg: Kreis Bensheim (1914)
Provinz Starkenburg: Kreis Offenbach (1885)
Provinz Starkenburg: Kreis Wimpfen (1898)
Provinz Starkenburg: Kreis Erbach (1891)
Provinz Oberhessen: Kreis Friedberg (1895)
Provinz Oberhessen: Kreis Büdingen (1890)
Provinz Oberhessen: Kreis Giessen. Band II (1919)

Provinz Rheinhessen: Stadt und Kreis Mainz (1919)

Provinz Rheinhessen: Kreis Bingen (1934)

1258 Die Bau- und Kunstdenkmäler des Landes Hessen. Munich, Berlin, Deutscher Kunstverlag, 1958—. illus. index.

Official inventory of the art and architecture in the German Federal State of Hessen. Succeeds *Die Kunstdenkmäler im Grossherzogtums Hessen* (1257). To date, the following volumes have appeared: Band 1, *Kreis Biedenkopf* (1958); Band 2 *Rheingau Kreis*; Band 3, *Kreis Bergstrasse* 2v.; 1969).

1259 **Die Bau- und Kunstdenkmäler im Regierungsbezirk Cassel.** Marburg, 1901-1939. 10v. illus. index.

Official inventory of the art and architecture in the former Prussian Regierungsbezirk Cassel. Today the territory is part of the German Federal State of Hessen. In 1937 it began a new series (Neue Folge) with its own volume numbers. Contents:

Band 1, Kreis Gelnhausen (1901)

Band II, Kreis Fritzlar (1909)

Band III, Kreis Grafschaft Schaumburg (1907)

Band IV, Kreis Cassel-Land (1910)

Band VI, Kreis Cassel-Stadt (1923)

Band VIII, Kreis Hofgeismar (1926)

Band VIII, Kreis Marburg-Stadt (1934)

Neue Folge (published in Kassel):

Band 1, Kreis Wolfhagen (1937)

Band 2, Kreis der Twiste (1938)

Band 3, Kreis des Eisenberges (1939)

Die Bau- und Kunstdenkmäler des Regierungsbezirks Wiesbaden. Frankfurt am Main, 1907-1921. 6v. illus. index. Reprint: Walluf, Sandig, 1973.
 5v.

Official inventory of the art and architecture in the former Prussian Regierungsbezirk Wiesbaden. The territory is today part of the German Federal State of Hessen. Contents:

Band I, Rheingau (1907)

Band II, Ost-Taunus (1905)

Band III, Lahngebiets (1908)

Band IV, Oberwesterwald. Westerburg (1910)

Band V, Nassauischen Kreise (1914)

Band VI, Nachlese zu Band I bis V (1921)

Die Baudenkmäler in Frankfurt am Main. Frankfurt/Main, 1896-1914.
3v. illus. index.

Official inventory of the art and architecture in the city of Frankfurt am Main.

Rhineland (Land Rheinland-Pfalz, Land Nordrhein)

Die Kunstdenkmäler der Pfalz. Munich, Oldenborg, 1926-1939. illus. index. 8v.

Official inventory of the art and architecture in the former Bavarian province of the Palatinate. Series consists of:

Band 1, Stadt und Bezirksamt Neustadt (Haardt) (1926)

Band 2, Stadt und Bezirksamt Landau (1928)

Band 3, Stadt und Bezirksamt Speyer (1934)

Band 4, Bezirksamt Bergzabern (1935)

Band 5, Bezirksamt Germersheim (1927)

Band 6, Stadt und Bezirksamt Ludwigshafen (1936)

Band 7, Bezirksamt Kircheimbolanden (1938)

Band 8, Stadt und Landkreis Frankenthal (1939)

1263 **Die Kunstdenkmäler der Rheinprovinz.** Düsseldorf, Schwann, 1891-1944, 19v. in 41. illus. index.

Official inventory of art and architecture in the former Prussian province of the Rhineland, which is today divided between the German Federal States of Nordrhein-Westfalen and Rheinland-Pfalz. For successor series, see (1264). The following volumes appeared:

Band 1, Kreis Kempen, Geldern, Moers, Kleve

Band 2, Kreis Rees, Duisburg, Mulheim, Ruhrort, Essen

Band 3, Kreis Düsseldorf, Barmen, Elberfeld, Remscheid, Lennep, Mettmann, Solingen, Neuss, M-Gladbach, Krefeld, Grevenbroich

Band 4, Landkreis Köln, Kreis Rheinbach, Bergheim, Euskirchen

Band 5, 1, Kreis Gummersbach, Waldrael, Wipperfurth

Band 5, 2, Kreis Mülheim am Rhein

Band 5, 3, Stadtkreis Bonn

Band 6, Stadt Köln (4v.)

Band 7, Stadt Köln (4v.)

Band 8, 1, Kreis Jülich

Band 8, 2, Kreis Erkeleuz und Geilenkirchen

Band 8, 3, Kreis Heinsburg Band 9, 1, Kreis Düren

Band 9, 2, Landkreis Aachen und Eupen

Band 10, Stadt Aachen (3v.)

Band 11, Monschau

Band 12, 1, Kreis Bitburg (1927)

Band 12, 2, Kreis Prüm (1927)

Band 12, 3, Kreis Daun (1928)

Band 12, 4, Kreis Wittlich (1934)

Band 13, Stadt Trier (2v.; 1938)

Band 15, 1, Kreis Bernkastel (1935)

Band 15, 2, Landkreis Trier (1936)

Band 15, 3, Kreis Saarburg (1939)

Band 16, 1, Kreis Altenkirchen (1935)

Band 16, 2, Kreis Neuwied (1940)

Band 16, 3, Landkreis Koblenz (1944)

Band 17, 1, Kreis Ahrweiler (1938)

Band 17, 2, Kreis Mayen (1941)

Band 18, 1, Kreis Kreuznach (1935)

Band 19, 3, Kreis Zell an der Mosel (1938)

Band 20, 1, Die kirchlichen Denkmäler der Stadt Koblenz (1937)

Die Kunstdenkmäler von Rheinland-Pfalz. Munich, Berlin, Deutscher Kunstverlag, 1954—. illus. index.

Official inventory of art and architecture in the German Federal State of Rheinland-Pfalz. In part, successor to the series *Die Kunstdenkmäler der Rheinprovinz* (1263) and *Die Kunstdenkmäler der Pfalz* (1262). To date, the following volumes have appeared:

Band I, Stadt Koblenz (1954)

Band II, Stadt und Landkreis Pirmasens (1957); reprinted 1974

Band III, Kreis Cochem (1959)

Band IV, Stadt Mainz

Band V, Der Dom zu Speyer. (3v., 1973)

Band VI, Ehemaliger Kreis Simmern (1977)

Westphalia (Land Westfalen)

1265 Die Bau- und Kunstdenkmäler von Westfalen. Münster, 1893— . illus. index.

Official inventory of art and architecture in Westphalia. Contents:

Kreis Ahaus (1900)
Kreis Altena (1911)

Kreis Herford (1908)
Kreis Hörde (1895)

Kreis Arnsberg (1906) Kreis Höxter (1914) Kreis Beckum (1897) Kreis Iserlohn (1900)

Bielefeld-Stadt (1906) Kreis Lippstadt (1911) Kreis Bielefeld-Land (1906) Kreis Lübbecke (1907) Stadt Bocholt (1931) Kreis Lüdinghausen (1893)

Bochum-Stadt (1906)

Kreis Bochum-Land (1907)

Kreis Meschede (1908)

Kreis Minden (1902)

Kreis Borken (1954)

Kreis Brilon (1952)

Stadt Münster (7v.; 1932-62)

Kreis Brilon (1952)

Kreis Münster-Land (1897)

Kreis Brilon (1952)
Kreis Büren (1926)
Kreis Coesfeld (1913)
Kreis Coesfeld (1913)

Kreis Paderborn (1899)

Dortmund-Stadt Kreis Recklinghausen (1929) Kreis Dortmund-Land (1895) Kreis Schwelm (1910)

Gelsenkirchen-Stadt (1908)

Hagen-Stadt (1910)

Kreis Hagen-Land (1910)

Stadt Hamm (1936)

Kreis Hagen-Land (1910)

Kreis Tecklenburg (1907)

Stadt Hamm (1936)
Kreis Halle (1908)
Kreis Hattingen (1909)
Kreis Hattingen (1909)
Kreis Warburg (1939)

Kreis Warendorf (1936) Kreis Wiedenbrück (1901) Witten-Stadt (1910) Kreis Wittgenstein (1903)

Lower Saxony (Land Niedersachsen, Land Bremen)

1266 **Die Kunstdenkmäler der Provinz Hannover.** Hanover, Provinzialverwaltung, 1899-1941. 25v. illus. index. LC 53-34984.

Official inventory of the art and architecture of the former province of Hanover, territory now part of the German Federal State of Niedersachsen. Succeeded by Die Kunstdenkmäler des Landes Niedersachsen (1268). Contents:

Band I, 1, Landkreise Hannover und Linden (1899)

Band I, 2, Stadt Hannover (in two parts; 1932)

Band I, 3, Kreis Springe (1941)

Band II, 1, Stadt Goslar (1901)

Band II, 2, Stadt Goslar (1901)

Band II, 3, Kreis Marienburg (1910)

Band II, 4, Stadt Hildesheim (in two parts; 1912)

Band II, 6, Kreis Alfeld (1929)

Band II, 7, Landkreis Goslar (1937)

Band II, 8, Kreis Peine (1938)

Band II, 9, Landkreis Hildesheim (1938)

Band II, 10, Kreis Alfeld II (1939)

Band III, 1, Kreise Burgdorf und Fallingbostel (1902)

Band III, 2, Stadt Lüneburg

Band III, 4, Kreis Gifhorn (1931)

Band III, 5, Stadt Celle (1937)

Band III, 6, Kreis Soltau (1939)

Band IV, 1, Stadt Osnabrück (1907)

Band IV, 2, Stadt Osnabrück (1907)

Band IV, 3, Kreise Wittlage und Bersenbrück (1915)

Band IV, 4, Kreise Lingen und Grafschaft Bentheim (1919)

Band V, 1, Kreise Verden, Rotenburg und Zeven (1908)

Band VI, 1, Stadt Emden (1927)

Band VI, 2, Stadt Emden (1927)

In 1939, two volumes not numbered with the above volumes appeared: *Die Kunstdenkmäler des Kreises Wesermünde. I: Die ehemalige Kreis Lehe* and *II: Der frühere Kreis Geestemünde.*

Die Bau- und Kunstdenkmäler des Herzogtums Braunschweig. Wölfenbüttel, various publishers, 1896-1922. 7v. illus. index.

Official inventory of art and architecture in the former duchy of Braunschweig, which is now part of the German Federal State of Niedersachsen. See (1268) for successor series. Contents:

Band I, Kreis Helmstedt (1896)

Band II, Kreis Braunschweig mit Ausschluss der Stadt Braunschweig (1900)

Band III, 1, Stadt Wölfenbüttel (1904)

Band III, 2, Die Ortschaften des Kreises Wölfenbüttel (1906)

Band IV, Kreis Holzminden (1907)

Band V, Kreis Gandersheim (1910)

Band VI, Kreis Blankenburg (1922)

Die Kunstdenkmäler des Landes Niedersachsens. Berlin and Munich, Deutscher Kunstverlag, 1956—. illus. index.

Official inventory of the art and architecture in the German Federal State of Niedersachsen. Successor to *Die Kunstdenkmäler der Provinz Hannover* (1266). To date, the following volumes have appeared:

Band I, 1, Land Hadeln und der Stadt Cuxhaven (2v.; 1956)

Band I, 2, Stadt Stade (1960)

Band I, 3, Landkreis Stade 2v.; 1965)

Band II, 1, Kreis Neustadt am Rübenberge (2v.; 1958)

Schleswig-Holstein (Land Schleswig-Holstein, Land Hamburg)

1269 Die Kunstdenkmäler der Provinz Schleswig-Holstein. Berlin, Deutscher Kunstverlag, 1939. 4v. illus. index.

Official inventory of the art and architecture in the former province of Schleswig-Holstein. Succeeded by *Die Kunstdenkmäler des Landes Schleswig-Holstein* (1270). Contents: Band 1, *Kreis Husum* (1939); Band 2, *Kreis Eiderstedt* (1939); Band 3, *Kreis Pinneberg* (1939); Band 4, *Kreis Südtondern* (1939).

1270 Die Kunstdenkmäler des Landes Schleswig-Holstein. Munich, Berlin, Deutscher Kunstverlag, 1950—. illus, index.

Official inventory of the art and architecture in the Federal German State of Schleswig-Holstein. Successor to *Die Kunstdenkmäler der Provinz Schleswig-Holstein* (1269), numbering its volumes together with the older series. To date, the following volumes have appeared: Band 5, *Kreis Eckenförde* (1950); Band 6, *Landkreis Flensburg* (1952); Band 7, *Stadt Flensburg* (1955); Band 8, *Landkreis Schleswig* (1957); Band 9, *Kreis Pinneberg* (1961); Band 10, 2, *Stadt Schleswig. Der Dom und ehemalige Dombezirk* (1966).

1271 **Die Bau- und Kunstdenkmäler der Hansestadt Lübeck**. Lübeck, 1906-1939. 6v. illus. index.

Official inventory of the art and architecture in the city and county of Lübeck. Contents:

Band I, Profane Denkmäler (1939)

Band II, Petrikirche, Marienkirche, Heilig-Geist Kirche (1906)

Band III, Der Dom (1919)

Band III, 2, Dom, Jakobikirche, Ägidienkirche (1920)

Band IV, 1, Die Klöster (1926)

Band IV, 2, Aussengebieten (1928)

New Series, Band 1, Rathaus und öffentliche Gebäude der Stadt Lübeck (1974)

Mecklenburg (Bezirke Neubrandenburg, Rostock, Schwerin)

Die Kunst- und Geschichtsdenkmäler des Grossherzogtums Mecklenburg-Schwerin. Schwerin, 1896-1902. 5v. illus. index.

Official inventory of art and architecture in the former grand duchy of Mecklenburg-Schwerin. The following volumes appeared:

- Band I, Amtsgerichtsbezirke Rostock, Ribnitz, Sülze-Marlow, Tessin, Laage, Gnoien. Dargun. Neukalen (1898)
- Band II, Amtsgerichtsbezirke Wismar, Grevesmühlen, Rehna, Gadebusch, Schwerin (1899)
- Band III, Amtsgerichtsbezirke Hagenow, Wittenburg, Boizenburg, Lübtheen, Dömitz, Grabow, Ludwigslust, Neustadt, Crivitz, Brüel, Warin, Neubukow, Kröpelin, Doberan (1900)
- Band IV, Amtsgerichtsbezirke Schwaan, Bützow, Sternberg, Güstrow, Krakow, Goldberg, Parchim, Lübz, Plau (1901)
- Band V, Amtsgerichtsbezirke Teterow, Malchin, Stavenhagen, Penzlin, Waren, Malchow, Röbel (1902).

1273 Kunst- und Geschichtsdenkmäler des Freistaates Mecklenburg-Strelitz. Neubrandenburg, various publishers, 1921-1934. 4v. illus. index.

Official inventory of the art and architecture in the former state of Mecklenburg-Strelitz. Successor to *Die Kunst- und Geschichtsdenkmäler des Grossherzogtums Mecklenburg-Schwerin* (1272). Contents:

- Band I, 1, Amtsgerichtsbezirke Neustrelitz, Strelitz, Mirow (1921)
- Band I, 2, Amtsgerichtsbezirke Fürtenberg, Feldberg, Woldegk, Friedland (Des Land Stargard) (1925)
- Band I, 3, Amtsgerichtsbezirke Friedland, Stargard, Neubrandenburg (1929)
- Band II, Das Land Ratzeburg (1934).

1274 Die Kunstdenkmäler im Bezirk Rostock. Leipzig, Seemann, 1963– . illus. index.

Official inventory of the art and architecture in the Bezirk Rostock of the German Democratic Republic (East Germany). To date, one volume has appeared: Band 1, *Kreis Rügen* (1963).

Thuringia (Bezirke Erfurt, Gera, Suhl, Halle, Magdeburg)

Die Bau- und Kunstdenkmäler der Provinz Sachsen. Halle, Historische Commission der Provinz Sachsen. Halle, 1879-1911. 29v. illus. index.

Official inventory of the art and architecture in the former Prussian province of Saxony. Succeeded by *Die Kunstdenkmäler der Provinz Sachsen* (1276). Contents:

- Band 1, Kreis Zeitz (1879)
- Band 2, Kreis Langensalza (1879)
- Band 3, Kreis Weissenfels (1880)
- Band 4, Kreis Mühlhausen (1881)
- Band 5, Kreis Sangerhausen (1881) Band 6, Kreis Weisensee (1882)
- Band 7, Grafschaft Wernigerode (1883)
- Band 8, Kreis Merseburg (1883)
- Band 9, Kreis Eckartsberga (1883)
- Band 10, Kreis Calbe (1885)
- Band 11, Stadt Nordhausen (1888)
- Band 12, Grafschaft Hohenstein (1889)
- Band 13, Stadt Erfurt und des Erfurter Landkreis (1890)

Band 14, Kreis Oschersleben (1891)

Band 15, Kreis Schweinitz (1891)

Band 16, Kreis Delitzsch (1892)

Band 17, Kreis Bitterfeld (1893)

Band 18, Mansfelder Gebirgskreises (1893)

Band 19, Mansfelder Seekreis (1895)

Band 20, Kreis Gardelegen (1897)

Band 21, Kreis Jerichow (1898)

Band 22, Kreis Ziegenrück und Schleusingen (1901)

Band 23, Halberstadt Land und Stadt (1902)

Band 24, Stadt Naumburg (1903)

Band 25, Stadt Aschersleben (1904)

Band 26, Kreis Naumburg (Land) (1905)

Band 27, Kreis Querfurt (1909)

Band 28, Kreis Heiligenstadt (1909)

Band 29, Kreis Wolmirstadt (1911)

Die Kunstdenkmäler der Provinz Sachsen. Burg, Hopfer, 1929-1938. 5v. illus. index. LC 50-47346.

Official inventory of the art and architecture in the former province of Saxony (Provinz Sachsen). Succeeds *Die Bau- und Kunstdenkmäler der Provinz Sachsen* (1275). Contents:

Band 1, Die Stadt Erfurt (1929)

Band 2, Die Stadt Erfurt (1931)

Band 2, 2, Die Stadt Erfurt (1932)

Band 3, Kreis Stendal Land (1933)

Band 4, Kreis Osterburg (1938)

1277 **Die Kunstdenkmäler im Bezirk Magdeburg.** Halle, Leipzig, Seemann, 1961–. illus. index.

Official inventory of the art and architecture in the Bezirk Magdeburg in the German Democratic Republic (East Germany). Bezirk Magdeburg is part of the old Freistaat and Königreich Sachsen. Successor to the series (1275) and (1276). To date, one volume has appeared: Band 1, Kreis Haldensleben (1961).

Saxony (Bezirke Dresden, Karl-Marx-Stadt, Leipzig)

Beschreibende Darstellung der älteren Bau- und Kunstdenkmäler des Königreichs Sachsen. Dresden, various publishers, 1882-1923. 42v. illus. index.

Official inventory of the art and architecture in the former kingdom of Saxony. Succeeded in 1929 by the series *Die Kunstdenkmäler des Freistaates Sachsen* (1279). Contents:

Heft 1, Amtshauptmannschaft Pirna (1882)

Heft 2, Amtshauptmannschaft Dippoldiswalde (1883)

Heft 3, Amtshauptmannschaft Freiberg (1884)

Heft 4, Amtshauptmannschaft Annaberg (1885)

Heft 5, Amtshauptmannschaft Marienberg (1886)

Heft 6, Amtshauptmannschaft Flöha (1886)

Heft 7, Amtshauptmannschaft Chemnitz (1886)

Heft 8, Amtshauptmannschaft Schwarzenberg (1887)

Heft 9, Amtshauptmannschaft Auerbach (1888)

Heft 10, Amtshauptmannschaft Oelnitz (1888)

Heft 11, Amtshauptmannschaft Plauen (1888)

Heft 12, Amtshauptmannschaft Zwickau (1889)

Heft 13, Amtshauptmannschaft Glauchau (1890)

Heft 14, Amtshauptmannschaft Rochlitz (1890)

Heft 15, Amtshauptmannschaft Borna (1891)

Heft 16, Amtshauptmannschaft Leipzig (1894)

Heft 17, Amtshauptmannschaft Stadt Leipzig (1895)

Heft 18, Amtshauptmannschaft Stadt Leipzig (1896)

Heft 19/20, Amtshauptmannschaft Grimma (1897)

Heft 21, Stadt Dresden (1909)

Heft 22, Stadt Dresden (1901)

Heft 23, Stadt Dresden (1903)

Heft 24, Amtshauptmannschaft Dresden-Alstadt (1904)

Heft 25, Amtshauptmannschaft Döbeln (1903)

Heft 26, Amtshauptmannschaft Dresden-Neustadt (1904)

Heft 27/28, Amtshauptmannschaft Oschatz (1905)

Heft 29, Amtshauptmannschaft Zittau (1906)

Heft 30, Stadt Zittau (1907)

Heft 31/32, Amtshauptmannschaft Bautzen (1908)

Heft 33, Stadt Bautzen (1909)

Heft 34, Amtshauptmannschaft Löbau (1910)

Heft 35, Amtshauptmannschaft Kamenz (1912)

Heft 36, Städte Kamenz und Pulsnitz (1912)

Heft 37, Amtshauptmannschaft Grossenhain (1914)

Heft 38, Städte Grossenhain, Radeburg und Riesa (1914)

Heft 39, Meissen (1917)

Heft 40, Meissen (Burgberge) (1919)

Heft 41, Meissen-Land (1923)

Erganzungsheft-Altenzella (1922)

1279 **Die Kunstdenkmäler des Freistaates Sachsen.** Dresden, 1929. illus. index. Official inventory of the art and architecture in the former free state of Sachsen (successor state to the kingdom of Saxony). Only one volume appeared: Band I, *Die Stadt Pirna* (Dresden, 1929).

Brandenburg (Bezirke Potsdam, Frankfurt an der Oder, Cottbus)

Die Kunstdenkmäler der Provinz Mark Brandenburg. Berlin, Deutscher Kunstverlag, 1907-1960. 21v. illus. index. LC 50-49544.

Official inventory of art and architecture in the former province of Brandenburg. Contents:

Band I, 1, Kreis Westpriegnitz (1909)

Band I, 2, Kreis Ostpriegnitz (1907)

Band I, 3, Kreis Ruppin (1914)

Band II, 1, Kreis Westhavelland (1913)

Band II, 3, Stadt und Dom Brandenburg (1912)

Band III, 1, Kreis Prenzlau (1921)

Band III, 2, Kreis Templin (1937)

Band III, 3, Kreis Angermünde (1934)

Band III, 4, Kreis Niederbarnim (1939)

Band IV, 1, Kreis Teltow (1941)

Band V, 1, Kreis Luckau (1917)

Band VI, 1, Kreis Lebus (1909)

Band VI, 2, Stadt Frankfurt a. Oder (1912)

Band VI, 3, Kreis Westernberg (1913)

Band VI, 4, Kreis Oststernberg (1960)

Band VI, 6, Kreis Crossen (1921)

Band VII, 1, Kreis Königsberg (1928)

Band VIII, 3, Kreis Landsberg (1937)

Silesia (now under Polish administration)

Verzeichnis der Kunstdenkmäler der Provinz Schlesien. Breslau, 1886-1903. 5v. illus. index.

Official inventory of art and architecture in the former German province of Silesia. Contents:

Band I, Die Stadt Breslau (1886)

Band II, Die Landkreis des Reg. Bezirks Breslau (1889)

Band III, Reg. Bezirk Liegnitz (1891)

Band IV, Reg. Bezirk Oppeln (1894)

Band V, Register [Index] (1903)

1282 Die Bau- und Kunstdenkmäler Schlesiens. Breslau, 1939-1943. 3v. illus. index.

Official inventory of the former German province of Silesia. Succeeded by Bauund Kunstdenkmäler des deutschen Ostens (1283). Contents: Band II, Kreis Namslau (1939); Band IV, Stadtkreis Oppeln (1939); Band V, Kreis Tost-Gleiwitz (1943).

Die Bau- und Kunstdenkmäler des deutschen Ostens. Stuttgart, Kohlhammer, 1957- . illus. index.

Inventory of art and architecture in the former German territories in Eastern Europe. To date, the following have appeared:

Reihe A. Stadt Danzig

Band I, Sankt Johann (1957)

Band II, Sankt Katharinen (1958)

Band III, Sankt Nikolai und andere Kirchen in Danzig (1959)

Band IV, Marienkirche (1963)

Band V, Kunstdenkmäler der Stadt Danzig (1972)

Reihe C. Schlesien

Band I, Landkreis Breslau (1965)

East and West Prussia (now under Polish administration)

1284 Die Bau- und Kunstdenkmäler der Provinz Westpreussen. Danzig,

Provinzial-Landtag, 1884-1919. 14v. illus. index.

Official inventory of art and architecture of the former German province of West Prussia. Contents:

Band I, 1, Kreis Carthaus, Berent und Neustadt (1885)

Band I, 2, Landkreis Danzig (1885)

Band I, 3, Kreis Pr. Stargard (1885)

Band I, 4, Kreis Marienwerder westl. der Weichsel, Schwetz, Konitz, Schlochau, Tuchel, Flatow, Deutsch Krone (1887)

Band II, 5, Kreis Kulm (1887)

Band II, 6, Kreis Thorn (1889)

Band II, 7, Stadt Thorn (1889)

Band II, 8, Kreis Strasburg (1891)

Band II, 9, Kreis Graudenz (1894)

Band II, 10, Kreis Löbau (1895)

Band III, 11, Kreis Marienwerder östl. der Weichsel (1898)

Band III, 12, Kreis Rosenberg (1906)

Band III, 13, Kreis Stuhm (1909)

Band IV, 14, Neuteich, Tiegenort und die ländlichen Ortschaften (1919)

1285 Die Bauwerke und Kunstdenkmäler von Berlin. Berlin, Mann, 1961-. Topographical inventory of the architecture and art of West Berlin. Thorough bibliographical references in the footnotes and introductions to the major buildings and monuments. Covers the art contents of buildings but not museums. To date, the following have appeared:

Bezirk Charlottenburg (2v., 1961)

Schloss Charlottenburg (2v., 1970)

Stadt und Bezirk Spandau (1971)

Histories

Art Treasures in Germany: Monuments, Masterpieces, Commissions, and Collections. General eds., Bernard S. Myers and Trewin Copplestone. New York and Toronto, McGraw-Hill, 1970. 196p. illus. index. LC 73-76759. Pictorial survey of architecture, painting, sculpture, and the decorative and minor arts in Germany from the time of the Celts (550 B.C.) to the present. Periods are treated by a variety of specialists. Contains maps and a glossary-index of museums and monuments, but no bibliography. For the general reader.

Dehio, Georg. Geschichte der deutschen Kunst... 3rd ed. Berlin and Leipzig, de Gruyter, 1923-1934. 4v. and atlas of plates. illus. index. Comprehensive history of art and architecture in Germany from time of the Germanic migrations through the early twentieth century. Volume four, covering nineteenth- and twentieth-century art and architecture, is written by Gustav Pauli. Separate volume of plates for each volume of text. No bibliography. An old, but classic history of German art.

1288 Günther, Hubertus. **Bruckmann's Handbuch der deutschen Kunst.** Munich, Bruckmann, 1975. 336p. illus. index. LC 75-507632.

Concise history of German art and architecture from Germanic times to the present. Chapters summarize the chief styles and periods of German art. Glossary of technical terms, chronological table and bibliography (pp. 329-34) of basic works in German.

Lindemann, Gottfried. History of German Art: Painting, Sculpture, Architecture. New York, Praeger, 1971. 228p. illus. index. LC 79-89605.

Survey history of art and architecture in Germany from the Carolingian period through the first half of the twentieth century. No bibliography.

1290 Pinder, Wilhelm. Von Wesen und Werden deutscher Formen . . . Leipzig, Seemann, 1937-1951. 4v. in 5. illus. index.

A new edition, edited by Georg Scheja, was published in 1957 (Frankfurt am Main, Menck) with four volumes of text and three volumes of illustrations. Comprehensive history of art and architecture in Germany from the Carolingian period through the middle of the sixteenth century. No bibliography. A standard history of German medieval and Renaissance art and architecture.

Vey, Horst, and Xavier de Salas. German and Spanish Art to 1900. New York, Franklin Watts, 1965. 307p. illus. index. LC 64-23687.

Pictorial survey of art and architecture in Germany and Spain from Carolingian times to 1900. Emphasis is on painting and sculpture. The introduction, which outlines the chief characteristics, schools, and artists of Germany and Spain, is followed by a substantial section devoted to artists' biographies. The work concludes with a brief historical sketch of the development of art and architecture in Germany and Spain. Well-illustrated. Brief and inadequate bibliographies of books in English are given at the end of the introduction and in some of the biographies. Awkwardly arranged, but the numerous illustrations and responsible, if too brief, text make it a useful survey for the general reader.

Weigert, Hans. **Geschichte der deutschen Kunst**. 2nd ed. Frankfurt am Main, Umschau, 1963. 2v. illus. index. LC 63-36375.

Concise history of art and architecture in Germany from paleolithic times through the early twentieth century. Selected bibliography (pp. 951-58). Reissue of an older, popular history of German art and architecture.

Switzerland

Topographic Handbooks

Deuchler, Florens. Reclams Kunstführer: Schweiz und Liechtenstein.
Stuttgart, Reclam, 1966. 905p. illus. index. LC 70-355052.
Topographical guide to the art and architecture in Switzerland and Liechtenstein.

Arranged alphabetically by place. Each city, town, or village is introduced with a historical sketch; for the major places, there are city plans, aerial views, and old views. Following the introduction, the various buildings and their artistic contents

are thoroughly discussed. The major works of art and architecture are illustrated by interspersed plates. The entries for the major cities provide a brief description of the art museums. Excellent glossary of terms; indexed by place and artists. Designed as a pocket-sized field guide, this work is remarkably thorough. As a ready source for information on Swiss art and architecture, its coverage is exceeded only by the official inventories (1296).

Hootz, Reinhardt. Kunstdenkmäler in der Schweiz: Ein Bildhandbuch. 1294 Munich, Deutscher Kunstverlag, 1969-1970. 2v. illus. index. LC 70-469028. Comprehensive illustrated handbook of the art and architecture in Switzerland arranged by canton then by location. Erster Band, Mit den Kantonen Aargau, Appenzell, Graubünden, Glarus, Luzern, St. Gallen, Schaffhausen, Schwyz, Thurgau, Unterwalden, Uri, Zürich, Zug: Zweiter Band, Mit den Kantonen Basel, Bern, Freiburg, Genf, Neuenburg, Solothurn, Tessin, Waadt, Wallis. Each volume provides an introductory essay that briefly sketches the history of art and architecture in the particular region. This is followed by a collection of excellent plates; concise and factual notes to the plates, with plans (but no bibliography); and a chronological list of the works illustrated at the end. Does not include works in museums. Although no substitute for the official inventory of art and architecture in Switzerland (1296), these volumes are a handy and competent reference tool to works of art in situ; their small size permits their use as field guides for intensive art travel.

Jenny, Hans. Kunstführer der Schweiz. 4th ed. Bern, Büchler, n.d. 637p. illus. LC 50-16474.

Comprehensive, pocket-size guide to the art and architecture of Switzerland. Geographical arrangement. Bibliography (pp. 635-36) of basic books.

Die Kunstdenkmäler der Schweiz. Les monuments d'art et d'histoire de la Suisse. Basel, Birkhäuser, 1927—. illus. index.

Official topographical inventory of the art and architecture in Switzerland and Liechtenstein. To date, the following have appeared:

Kanton Aargau (6v.; 1948-76)

Kanton Appenzell-Ausserhoden (1973)

Kanton Basel-Stadt (4v.; 1932-61)

Kanton Basel-Landschaft (2v.; 1974)

Kanton Bern (5v.; 1947-69)

Canton de Fribourg (3v.; 1956-57)

Kanton Graubünden (7v.; 1937-48)

Kanton Luzern (6v.; 1946-63)

Canton de Neuchâtel (3v.; 1955-68)

Kanton Schaffhausen (3v.; 1951-60)

Kanton Schwyz (3v.; 1927-78)

Kanton Solothurn (1v.; 1957)

Kanton St. Gallen (5v.; 1951-70)

Kanton Thurgau (3v.; 1950-62)

Cantone Ticino (1973)

Canton de Vaud (1v.; 1944)

Kanton Wallis (1976)

Kanton Zug (2v.; 1933-37) Kanton Zürich (7v.; 1938-78)

Fürstentum Liechtenstein (1v.; 1950)

Within the volumes, material is arranged by place. A thorough history of the place, with maps and old views, serves as an introduction. The important buildings and sites are thoroughly described and discussed, with footnotes referring to specialized literature. The art contents and decoration of the monuments are given extensive coverage. Well-illustrated. The epitome of a comprehensive and scholarly inventory of art and architecture. A basic reference and research tool.

Histories

Gantner, Joseph, and Adolf Reinle. Kunstgeschichte der Schweiz von den Anfängen bis zum Beginn des 20. Jahrhunderts. Frauenfeld, Huber, 1936-1962. 4v. illus. index. LC 38-8266 rev.

A second edition of volume I, completely rewritten by Adolf Reinle, appeared in 1968 (Huber). Comprehensive history of art and architecture in Switzerland from ancient Roman times to the end of the eighteenth century. Very well illustrated with plates, plans, and diagrams. Excellent bibliographies are given at the end of each chapter and throughout the text in footnotes. The standard history of Swiss art and architecture.

Ganz, Paul. Geschichte der Kunst in der Schweiz von den Anfängen bis zur Mitte des 17. Jahrhunderts. Basel, B. Schwabe, 1960. 646p. illus. index. LC A61-1709.

History of art and architecture in Switzerland from prehistoric times through the Renaissance. The minor arts are given particularly good treatment. Excellent selection of plates and good, classified bibliography (pp. 613-16). A standard history of old Swiss art and architecture.

Meyer, Peter. Schweizerische Stilkunde. 6th ed. Zürich, Spiegel, 1969. 288p. illus. index. LC 79-593833.

Concise history of art and architecture in Switzerland from prehistoric times to the present, with emphasis on the development of style. Well illustrated and provided with a bibliography (pp. 267-69) that lists major books in both German and French.

GREAT BRITAIN AND IRELAND

Topographic Handbooks

Royal Commission on the Ancient and Historical Monuments of England.

An Inventory of Ancient Monuments. London, H. M. Stationery Office,
1910—. illus. index.

Official inventory of art and architecture in England. Covers all major works from prehistory to the present. To date, the following have appeared:

Buckinghamshire (2v.; 1912-13) Cambridgeshire (2v.; 1968-72) City of Cambridge (2v.: 1959) Dorset (4v.; 1952-72)
Essex (4v.; 1916-23)
Gloucestershire (1976)
Herefordshire (3v.; 1931-34)
Hertfordshire (1910)
Huntingdonshire (1926)
London (5v.; 1924-30)
Middlesex (1937)
City of Oxford (1939)
Town of Stanford (1977)
Westmorland (1936)
City of York (4v.; 1962-75)

Within the volumes, the material is arranged by place. Following a brief history of the place, the major buildings, sites, monuments, etc., are described and discussed. Thorough reference to specialized literature is provided in the footnotes. Well illustrated with plates, maps, plans, and diagrams. Standard reference tool.

1301 Royal Commission on the Ancient and Historical Monuments in Scotland. An Inventory of Ancient Monuments. Edinburgh, H. M. Stationery Office, 1933—. illus. index.

Official inventory of art and architecture in Scotland. To date, the following have appeared:

Argyll (2v.; 1971-75)
County of Berwick (1915)
Caithness (1911)
County of Dumfries
East Lothian (1924)
City of Edinburgh (1951)

Fife, Kinross and Clackmannan (1933)

Galloway (2v.; 1912-14)

Midlothian and West Lothian (1929) Orkney and Shetland (3v.; 1946)

Outer Hebrides, Skye and the Small Isles (1928)

Peebleshire (2v.; 1967) Roxburghshire (2v.; 1956) Selkirkshire (1957) Stirlingshire (2v.; 1963) Sutherland (1911)

Within the volumes, the material is arranged by place. Following a history of the place are descriptions and discussions of the major buildings, their art contents, and their decoration. Archaeological sites are also covered. Specialized literature is referred to in the footnotes. Well illustrated with plates, maps, plans, and diagrams. Many volumes also provide a glossary of terms. Standard reference tool.

1302 Royal Commission on the Ancient and Historical Monuments of Wales.

An Inventory of Ancient Monuments. London, H. M. Stationery Office,
1911—. illus. index.

Official inventory of art and architecture in Wales. Covers all major works from prehistory to the present. To date, the following have appeared: Anglesey (1937)

Caernarvonshire (3v.; 1956-64)

Carmarthen (1917)

Denbigh (1914)

Flint (1912)

Glamorgan (1976)

Merioneth (1912)

Montgomery (1911)

Pembroke (1925)

Radnor (1913)

Within the volumes, material is arranged by place. Following a brief history of each place, its major buildings, sites, monuments, etc., are described and discussed. Thorough reference to specialized literature is provided in the footnotes. Wellillustrated with plates, maps, plans, and diagrams. Standard reference tool.

Histories

1303 Arnold, Bruce. A Concise History of Irish Art. Rev. ed. New York and Toronto, Oxford University Press, 1977. 180p. illus. index. Survey history of art and architecture in Ireland from the early Bronze Age through the twentieth century. Brief bibliography (pp. 206-207). A good survey history for the general reader.

1304 Art Treasures in the British Isles: Monuments, Masterpieces, Commissions, and Collections. General eds., Bernard S. Myers and Trewin Copplestone. New York and Toronto, McGraw-Hill, 1969. 176p. illus. index. LC 76-76757.

Pictorial survey of English painting, sculpture, architecture, and minor arts from prehistory to the present. Period sections are written by variety of specialists. Contains maps and a glossary-index of museums and monuments, but no bibliography.

1305 Boase, T. S. R. The Oxford History of English Art. Oxford, Clarendon, 1949- . illus. index.

Comprehensive history of art and architecture in England from prehistoric times to the present. It is planned for eleven volumes, of which the following have appeared to date:

Vol. II, English Art 871-1110, by D. Talbot Rice (1952)

Vol. III, English Art 1100-1216, by T. S. R. Boase (1953)

Vol. IV, English Art 1216-1307, by Peter Brieger (1957)

Vol. V, English Art 1307-1461, by Joan Evans (1949)

Vol. VII, English Art 1553-1625, by Eric Mercer (1962)

Vol. VIII, English Art 1625-1714, by Margaret Winney and Oliver Millar (1957)

Vol. IX, English Art 1714-1800, by John Burke (1976)

Vol. X, English Art 1800-1870, by T. S. R. Boase (1959)

Vol. XI, English Art 1870-1940, by Dennis Farr (1978)

Each volume is well illustrated with plates, plans, drawings and diagrams, and each has a thorough classified bibliography at the end. The standard history of English art and architecture.

1305a Finlay, Ian. Art in Scotland. London, Oxford University Press, 1948. 180p. illus. index.

Survey history of art and architecture in Scotland from Celtic times to the early twentieth century.

1306 Frey, Dagobert. Englisches Wesen in der bildenden Kunst. Stuttgart, Kohlhammer, 1942. 496p. illus.

Scholarly investigation of national character in English art and architecture from the Middle Ages to the end of the nineteenth century. Extensive bibliography in the notes (pp. 445-71) and list of source material (pp. 495-96). The work of a leading Austrian art historian, Frey's study is one of the best analyses of national art character. See also Pevsner (1310).

Garlick, Kenneth. British and North American Art to 1900. New York, Franklin Watts, 1965. 250p. illus. index. LC 65-10268 rev.

Survey history of the painting, drawing, and sculpture of Great Britain and North America from the sixteenth century to 1900. Following a succinct introduction, a biographical section treats the life and works of major British and American painters, with brief literature citations. Illustrated with color and black and white

plates.

Harbison, Peter, Homan Potterton, and Jeanne Sheehy. Irish Art and Architecture from Prehistory to the Present. London, Thames & Hudson, 1978. 272p. illus. index. LC 78-55034.

Illustrated survey of Irish art and architecture. Contents: I, From Prehistory to 1600; II, The Seventeenth and Eighteenth Centuries; III, The Nineteenth and Twentieth Centuries. Good classified bibliography of books and periodical articles (pp. 265-68).

Osmond, Edward. The Arts in Britain, from the Eighth to the Twentieth Centuries. London, Studio, 1961. 207p. illus. index. LC 62-52391. Survey history of art and architecture in the British Isles from early medieval times to the present. Good selection of illustrations.

Pevsner, Nikolaus. The Englishness of English Art. Harmondsworth, Penguin, 1964. 229p. illus. index. LC NUC65-77133.

Study of English national character in art and architecture from the Middle Ages through the nineteenth century; based on a series of radio lectures broadcast in 1955. Contents: 1, The Geography of Art; 2, Hogarth and Observed Life; 3, Reynolds and Detachment; 4, Perpendicular England; 5, Blake and the Flaming Line; 6, Constable and the Pursuit of Nature; 7, Picturesque England; 8, Conclusion. Bibliographical references in the notes (pp. 207-220). See Frey (1306) as well for a complementary study.

ITALY

Topographic Handbooks

Hootz, Reinhardt, ed. Kunstdenkmäler in Italien: Ein Bildhandbuch. Munich, Deutscher Kunstverlag, 1973—. LC 75-113560.

A comprehensive series of illustrated handbooks on the art and architecture of Italy. To date, these have appeared: Südtirol und Trentino (Trentino-Alto Adige) (1973); Venedig, Stadt und Provinz (1974); Venetien obne Venedig (1976). Volumes covering all the major regions of Italy are planned. When completed, it should provide a most needed topographical guide to art and architectural monuments in situ in Italy. Does not include works of art in museums. The introductory essay, which sketches the art history of the particular region, is followed by a collection of excellent plates, concise and factual notes on the plates (with plans), and a chronological list of the works illustrated at the end. No bibliography. This will be a valuable reference tool for the advanced student. The small size of the volumes permits their use as field guides for intensive art travel.

1312 Keller, Harald. Die Kunstlandschaften Italiens. Munich, Prestel, 1960. 387p. illus. index. LC A61-3518.

Handbook of the regional styles of Italian art and architecture. The art, history, and geography of the various regions of Italy are discussed and coordinated by the use of maps. The pocket edition, published in 1965 by the same publisher, provides a collection of plates as well. Extensive bibliography in the notes. A standard work in the field of art geography.

Ministero della Educazione Nazionale Direzione Generale delle Antichità e Belle Arti. Inventario degli oggetti d'arte d'Italia. Rome, La Libreria dello Stato, 1931-1938. 9v. illus. index.

Beginning of an official inventory of art objects in Italy. Does not include architecture. The series consists of:

Bergamo (1931)

Calabria (1932)

Parma (1934)

Aquila (1934)

Pola (1935) Mantua (1935)

Padua (1936)

Ancona, Ascoli Piceno (1936)

Sondrio (1938)

Within the volumes, objects are arranged by location. Fairly well illustrated, the volumes have descriptive and historical text, with reference in the footnotes to specialized literature.

Reclams Kunstführer Italien. Herausgegeben von Manfred Wundram. Stuttgart, Reclam, 1965—. illus. index. LC 72-460989.

Topographical guide to the art and architecture in Italy from prehistoric times to the present. To date, the following have appeared:

Band 2, 1, Venedig, Brenta-Villen, Chioggia, Murano, Torcello (2nd ed., 1974)

Band 2, 2, Südtirol, Trentino, Venezia-Giulia, Friaul, Veneto (2nd ed., 1972)

Band 3, Florenz (3rd ed., 1975)

Band 4, Emilia-Romagna, Marken, Umbrien (1971)

Band 5, Rom und Latium (3rd ed., 1974)

Band 6, Neapel und Umgebung (1971)

Arranged by place or site. A brief historical sketch precedes a thorough description of the major buildings and monuments, including their art contents and decoration. Modestly illustrated with plates, liberally provided with plans and diagrams, and well-indexed. No bibliography. The Reclam guides are intended as pocket guides for the serious art tourist, but their thoroughness makes them valuable reference works for the advanced student as well. This is especially so for Italy, where official inventories are lacking or inadequate.

Histories

1315 Alazard, Jean. L'art italien. Paris, H. Laurens, 1949-60. 4v. illus. index. LC A51-2809 rev.

Comprehensive history of art and architecture in Italy from earliest times through the nineteenth century. Contents: Vol. 1, Des origines à la fin du XIVe siècle; Vol. 2, Au XVe siècle, le quattrocento; Vol. 3, Au XVIe siècle; Vol 4, De l'ère baroque au XIXe siècle. Volumes are well illustrated, and there are bibliographies of major books at the end of each volume. A standard history of Italian art.

Ancona, Paolo d'. Storia dell'arte italiana. Florence, Marzocco, 1953-54. 3v. illus. index. LC 60-34627.

History of art and architecture in Italy from ancient Roman times to the present. Vol. 1, *Dall antichità classica al romanico*; Vol. 2, *L'arte gotica e il quattrocento*; Vol. 3, *Dal cinquecento all'arte contemporanea*. These well-illustrated volumes have responsible, factual text, with a bibliography at the end of each volume. A good general history of Italian art and architecture for beginning and advanced students.

Art Treasures in Italy: Monuments, Masterpieces, Commissions, and Collections. General eds., Bernard S. Myers and Trewin Copplestone. New York and Toronto, McGraw-Hill, 1969. 176p. illus. index. LC 72-76756. Pictorial survey of architecture, painting, sculpture, and the minor arts in Italy from prehistory to the present. Periods are treated by a variety of specialists. Contains maps and a glossary-index of museums and monuments, but no bibliography. For the general reader.

Baumgart, Fritz E. Italienische Kunst: Plastik, Zeichnung, Malerei. Berlin and Zurich, Atlantis, 1936. 171p. illus. LC 37-10460.

Forward by Paul Clemen. Pictorial survey of 128 masterpieces of Italian sculpture, painting, and drawing from the Renaissance through the eighteenth century. Descriptive notes. No bibliography.

Bottari, Stefano. **Storia dell'arte italiana**. Milan, Principato, 1955-57. 3v. illus. index. LC A55-10697.

History of art and architecture in Italy from ancient Roman times to the present. Vol. 1, Dall'antichità al trecento; Vol. 2, Il Rinascimento: L'arte del quattrocento; Vol. 3, Dal cinquecento ai nostri giorni. The good, classified bibliography (Volume 3, pp. 540-60) lists books in all languages.

- Carli, Enzo, and Gian Alberto Acqua. Profilo dell'arte italiana. Bergamo, Instituto Italiano d'Arte Grafiche, 1954-55. 2v. illus. index. LC 56-21289. Comprehensive history of Italian art and architecture from ancient Roman times to the mid-twentieth century. Selected bibliography of books and periodical articles (v. 2, pp. 647-66).
- 1321 Chastel, André. Italian Art. New York, T. Yoseloff, 1963. 526p. illus. index. LC 63-6134.

Concise history of art and architecture in Italy from the fifth century through the mid-twentieth century. Provides a good annotated and classified bibliography (pp. 403-422). Further specialized literature is given in the biographical and geographical indexes. The best history of Italian art in English.

Mazzariol, Giuseppe, and Terisio Pignatti. Storia dell'arte italiana. Milan, Mondadori, 1960-1961. 3v. illus. index. LC 66-34913.
 History of art and architecture in Italy from 2000 B.C. to the present. No bibliography. Popular survey history.

Monteverdi, Mario. Italian Art to 1850. New York, Franklin Watts, 1965. 433p. illus. index. LC 64-23685.

Pictorial survey of the art and architecture of Italy from the middle of the thirteenth century to 1850. Emphasis is on painting and sculpture. The introduction (which outlines the chief characteristics, schools, and artists) is followed by a substantial section devoted to artists' biographies. The work concludes with a historical sketch of the development of Italian art and architecture. Well illustrated. Brief and inadequate bibliographies at the end of the introduction and in some of the biographies. Awkwardly arranged, but the numerous illustrations and responsible (though somewhat too brief) text make it a useful survey for the general reader.

1324 Salmi, Mario. Arte italiana. Florence, Sansoni, 1953. 2v. illus. index. LC 50-55508.

Well-illustrated survey history of Italian art and architecture from ancient Roman times to the present. First volume covers the period from Early Christian times to the end of the Gothic; second volume treates the Renaissance to the present. Introduction in the first volume gives an extensive history of ancient art and architecture as a background to Italian art. Good bibliographies at the end of each chapter.

Toesca, Pietro. **Storia dell'arte italiana**. 2nd ed. Turin, Unione Torinese, 1965. 3v. illus. index. (Storia dell'Arte Classica e Italiana, v. 3). LC 67-117871.

Comprehensive history of art and architecture in Italy from the early Christian period through the fourteenth century. Well-illustrated with extensive bibliographical references in the footnotes. A standard, scholarly history of Italian medieval art and architecture.

Venturi, Adolfo. Storia dell'arte italiana. Milan, Hoepli, 1901-1940. 11v. illus. index. Repr.: New York, Kraus, 1967. 11v. in 25. LC 66-9698.
 Comprehensive history of art and architecture in Italy from the Early Christian period through the sixteenth century. Footnotes with bibliography. The standard history of Italian art. Index by J. D. Sisson, 2v., Nendeln, Kraus, 1975.

LOW COUNTRIES

General Works

Hammacher, A. M., and R. Hammacher Vandenbrande. Flemish and Dutch Art. New York, Franklin Watts, 1965. 316p. illus. index. LC 64-23686.

Pictorial survey of the art and architecture of the Low Countries from the thirteenth century through Post-Impressionism. Introduction outlines the major characteristics, schools, and artists. This is followed by a substantial section devoted to biographies of major artists. A concluding section, "Influences and Developments," ties the first two parts together in a brief history. Well illustrated. Brief, inadequate bibliographies are given at the end of the introduction and in some of the biographies. Awkwardly arranged, but the numerous illustrations and the responsible, if brief, text make it a useful survey for the general reader and beginning student.

Belgium

Topographic Handbooks and Inventories

Lemaire, Raymond M., ed. Le patrimoine monumentale de la Belgique. Liège and Brussels, Ministère de la Culture Française, 1971—. LC 72-363660.

Inventory of art and architecture of the French-speaking part of Belgium. References to specialized literature throughout. To date, the following have appeared:

Tome 1, Province de Brabant, Arrondissement de Louvain (1971)

Tome 2, Province de Brabant: Arrondissement de Nivelles (1974)

Tome 3, Province Liège: Arrondissement Liège (1974)

Tome 4, Province de Hainaut: Arrondissement de Mons (1975)

Tome 5, Province de Namur: Arrondissement de Namur (2v., 1975)

Antwerp

Donnet, Fernand, and G. Van Doorslaer. Inventaris der Kunstvoorwerpen bewaard in de openbare gestichten der Provincie Antwerpen. Antwerp, 1902-1940. 12v. illus. index.

Inventory of works of art in churches and other buildings open to the public in the Belgian province of Antwerp.

Brabant

1330 Province de Brabant: Inventaire des objets d'art. Brussels, 1904-1912. 3v. illus. index.

Inventory of art in the Belgian province of Brabant.

See also: Lemaire (1328).

East Flanders

Dhannens, Elisabeth. Inventaris van het Kunstpatrimonium van Oostvlaanderen. Ghent, 1951 – . illus. index.

Inventory of art and architecture in the Belgian province of Oostvlaanderen (East Flanders). Thorough reference to bibliography in the footnotes. Contents:

Vol. 1, Temse (1951)

Vol. 2, Kanton Kaprijke (1956)

Vol. 3, Sint-Niklaaskerk, Gent (1960)

Vol. 4, Dendermonde (1961)

Vol. 5, Sint-Baafskathedral, Gent (1965)

Vol. 6, Het retabel van het Lam Gods in de Sint-Baafskathedral te Gent(1965)

1332 Inventaire archéologique de Gand. Ghent, 1897-1915. 57v. in 3 series. illus. index.

Inventory of art and architecture in Ghent.

Oudheidkundig Inventaris van Oost Vlaanderen. Ghent, 1911-1915. 11v. illus. index.

Inventory of art and architecture in the Belgian province of East Flanders. In part, superseded by (1331).

Hainaut

1334 Inventaire des objets d'art et d'antiquité de la Province du Hainaut. Mons, 1923-41. 10v. illus. index.

Inventory of art and architecture in the Belgian province of Hainaut.

See also: Lemaire (1328).

Liège

1335 Inventaire des objets d'art et d'antiquité de la Province de Liège. Liège, 1911-1930. 2v. illus. index.

Inventory of art and architecture in the Belgian province of Liège.

See also: Lemaire (1328).

Limburg

Oudheidkundig Inventaris der Kunstvoorwerken in Kerken en openbare Gebouwen van de Provincie Limburg. Hasselt, 1916-35. 9v. illus. index. Inventory of art and architecture in the Belgian province of Limburg. Covers churches and other buildings open to the public. Includes only objects dating before 1830.

Namur

See: Lemaire (1328)

West Flanders

Devliegher, Luc. **Kunstpatrimonium van West-Vlaanderen**. Utrecht and Tielt, Lannoo, 1968– . LC 70-431740.

Inventory of art and architecture in West Flanders in Belgium. To date, the following have appeared:

Deel 2, De huizen te Brugge (1968)

Deel 3, De huizen te Brugge (1968)

Deel 4, De Zwinstreek (1970)

Deel 5, Damme (1971)

Deel 6, De Onze-Lieve-Vrouwkerk te Kortrijk (1973)

Histories

1338 Clemen, Paul. Belgische Kunstdenkmäler. Munich, Bruckmann, 1923. 2v. illus. index.

A collection of essays by various specialists (Clemen, Julius Baum, Greta Ring, etc.) on various aspects of the history of art and architecture in Belgium. Arrangement is chronological; volume one covers the ninth through fifteenth centuries, volume two covers the sixteenth through eighteenth centuries. Together they form a valuable history of art and architecture in Belgium.

Fierens, Paul. L'art en Belgique du Moyen Âge à nos jours. 3rd ed. Brussels, Renaissance du Livre, 1957. 535p. illus. index.

This history of art and architecture in Belgium is composed of essays, written by specialists, on the development of the various arts from the eleventh century through the early twentieth century. There are occasional footnotes with bibliography.

- 1340 Fierens, Paul. L'art flamand. Paris, Larousse, 1945. 164p. illus. index. Concise history of art and architecture in Belgium from the eleventh to the midtwentieth century. A useful, classified bibliography is included (pp. 156-59). A popular survey history for the general reader and the beginning student. A standard history of Flemish art and architecture.
- Francastel, Pierre, ed. L'art mosan. Paris, A. Colin, 1953. 227p. illus.

Collection of essays by European experts on aspects of medieval art and architecture in the Mosan region. Contents: La route de la Meuse et les relations lointaines des pays mosans entre le VIIIe et le XIe siècle (Maurice Lombard); Les arts du métal dans la vallée de la Meuse du Ier au Xe siècle (Faider-Feytmans); Ivoires mosans du haut moyen âge originaires de la région de la Meuse (W. F. Volbach); Les origines de la technique du bronze dans la vallée de la Meuse (Erich Meyer); Manuscrits pré-romans du pays mosan (André Boutemy); Les églises du haut moyen âge et le culte des anges (Paolo Verzone); La chronologie de la cathédrale de Tournai (Elie Lambert): La miniature dans le diocèse de Liège aux XIe et XIIe siècles (J. Stiennon); Les débuts du style roman dans l'art mosan (K. H. Usener); Quelques résultats des expositions de "L'art Mosan" à Liège, à Paris et à Rotterdam, 1951-1952 (J. de Borchgrave d'Altena); Orfèvrerie mosane-Orfèvrerie byzantine (André Grabar): Emaillerie mosane et emaillerie limousine aux XIIe et XIIIe siècles (S. Gauthier); Essai de groupement de quelques émaux autour de Godefroid de Huy (Hubert Landais); Le Chapiteau du pied de croix de Suger à l'abbaye de Saint-Denis (B. de Montesquiou-Fezensac); Influences mosanes dans les émaux anglais (C. Oman): A propos des vitraux de Châlons-sur-Marne, Deux points d'iconographie mosane (Louis Grodecki); L'iconographie du rétable typologique de Nicolas de Verdun à Klosterneubourg (L. Réau); La technique et le style du rétable de Klosterneubourg (Hans Hahnloser); Autour de Nicolas de Verdun (Otto Homburger); Oeuvres inédites d'art mosan en Pologne au XIIe siècle (Marjan Morelowski); La porte de bronze de Gniezno (P. Francastel); Orfèvrerie mosane et Orfèvrerie parisienne au XIIIe siècle (Pierre Verlet); Notes sur la vie et les oeuvres du sculpteur Jean de Liège (Pierre Pradel). Extensive bibliography in the footnotes.

Helbig, Jules, and Joseph Brassinne. L'art mosan depuis l'introduction du christianisme jusqu'à la fin du XVIII^e siècle. Brussels, Van Oest, 1906-1911. 2v. illus. index.

Comprehensive history of art and architecture in the Mosan region from the fifth century A.D. to the end of the eighteenth century. Tome 1: Des origines à fin du XV^e siècle; tome 2: Du début du XVI^e à la fin du XVIII^e siècle. Bibliographical footnotes.

1343 Leurs, Stan, ed. Geschiedenis van de Vlaamsche Kunst... Antwerp, de Sikkel, 1936-1940. 2v. illus. index.

A history of Flemish art and architecture from the early Middle Ages through the early twentieth century. Sections were written by various specialists, with bibliographies at the end of chapters. Well illustrated with plates, plans, and diagrams.

1344 Rooses, Max. Art in Flanders. New York, AMS Press, 1970. 341p. illus. index. LC 79-100819.

Pictorial history of art and architecture in Belgium from the late Middle Ages to the early twentieth century. For the general reader. Reprint of 1914 volume in the series: "Ars Una: Species Mille."

Netherlands

Topographic Handbooks

Hootz, Reinhardt. Kunstdenkmäler in den Niederlanden: Ein Bildhandbuch. Munich, Deutscher Kunstverlag, 1971. 421p. illus. index. LC 72-306403. Illustrated handbook of art and architecture in the Netherlands from the early Middle Ages through the present, arranged by place. An introductory essay sketching the art history of the Netherlands is followed by an excellent collection of plates, with informative notes to the plates (with plans). There is no bibliography. At the end of the volume is a useful chronological list of the works illustrated. Does not cover works of art in museums. Although it is not a substitute for the intensive and extensive coverage of art and architectural monuments in the official Dutch inventory (1346), this work is a most handy and competent reference tool and field guide to the art and architecture in situ in the Netherlands.

De Nederlandsche Monumenten vom Geschiedenis en Kunst. Utrecht, Oosthoek, 1912– . illus. index.

Official inventory of art and architecture in the Netherlands. To date, the following volumes have appeared:

Deel 1, De Provincie Noordbrabant. Part 1. Voormalige Baronie van Breda Deel 2, De Provincie Utrecht. Part 1. Gemeente Utrecht; Part 2. De Dom van Utrecht

Deel 3, De Provincie Gelderland. Part 1. Het Kwartier van Nijmegen (2v.); Part 2. Het Kwartier van Zutphen

Deel 4, De Provincie Overijsel. Part 1. Twente; Part 2. Zuid-Salland; Part 3. Noord-en Oost-Salland

Deel 5, De Provincie Limburg. Part 1. Gemeente Masstricht; Part 2. Noord-Limburg; Part 3. Zuid-Limburg

Deel 6, De Provincie Groningen. Part 1. Oost-Groningen

Deel 7, De Provincie Zuidholland. Part 1. Leiden en westelijk Rijnland

Deel 8, De Provincie Noordholland. Part 1. Waterland; Part 2.
Westfriesland; Part 3. De Gemeente Amsterdam

Histories

Gelder, Hendrik E. van, and J. Duverger. Kunstgeschiedenis der Nederlanden van de Middleleeuwen tot onze Tijd... 3rd ed. Utrecht, de Haan, 1954-1956. 3v. illus. index. LC 55-1363.

General history of art and architecture in the Netherlands and the Flemish part of Belgium from the early Middle Ages to modern times. Sections were written by various specialists. Bibliographical footnotes. Well illustrated. The standard history of Netherlandish art and architecture.

Guide to Dutch Art. 3rd rev. ed. The Hague, Government Printing and Publishing Office, 1961. 355p. illus. LC 62-5438.

Produced by the Netherlands Department van Onderwijs, Kunsten en Wetenschappen. Handbook to art and architecture in the Netherlands from the Carolingian period through the twentieth century. A historical introduction is followed by

essays on the development of the various arts, a good collection of plates, and a useful guide to the principal towns (with maps). Also included are a brief bibliography (pp. 95-96) and a list and description of notable museums (pp. 90-94). A useful handbook for the general reader, the tourist, and the beginning student.

Timmers, J. J. M. A History of Dutch Life and Art. Amsterdam, Elsevier, 1959. 201p. illus. index. LC 60-3972. British edition: London, Nelson, 1959. LC 60-427.

Concise survey of the art and architecture of the Netherlands from prehistory through the twentieth century. Although it is chiefly a history of art and architecture, each section is preceded by a brief cultural history of the period under consideration. Well illustrated, it has informative notes to the plates, but no bibliography. A good survey history for the general reader.

SCANDINAVIA

General Works

Kusch, Eugen. Ancient Art in Scandinavia. Nuremberg, Carl, 1965. 83p. (text); 176p. (illus.). Lc 71-8618.

Pictorial survey of the art and architecture in Denmark, Sweden, and Norway from the Viking period through the sixteenth century. Introductory essay provides a popular history of Scandinavian art, followed by more specific information in the notes to the plates. No bibliography.

Laurin, Carl, ed. Scandinavian Art. New York, American Scandinavian Foundation, 1922. 662p. illus. index. (Scandinavian Monographs, V). Collection of essays by specialists on various aspects of the history of art and architecture in Denmark, Sweden, and Norway from the early Middle Ages through the early twentieth century. Contents: "A Survey of Swedish Art," by Laurin; "Danish Art in the 19th Century," by Emil Hannover; "Modern Norwegian Art," by J. Thiis. No bibliography. Still a useful introduction for the general reader.

Denmark

Beckett, Francis. Danmarks Kunst. Copenhagen, Kappel, 1924-1926. 2v. illus. index.

Comprehensive history of Danish art and architecture from prehistoric times to the end of the Gothic period. Bibliographical footnotes and general bibliographies at the end of each volume. Contents: v. 1, *Del Oldtiden og den seldre middelalder*; v. 2, *Gotiken*.

- Laurin, Carl G. Nordisk konst; Danmarks och Norges konst fran 1880 till 1925. Stockholm, Norstedt, 1925. 413p. illus. index.
 History of art and architecture in Denmark and Norway from 1880 to 1925.
 Bibliographical footnotes.
- Nørlund, Poul. Danish Art through the Ages. Copenhagen, 1948. 90p. illus.

This history of Danish art and architecture consists of essays by specialists; coverage extends from the Romanesque period through the twentieth century. No bibliography.

Poulsen, Vagn. Danish Painting and Sculpture. Copenhagen, Det Danske Selskab, 1955. 196p. illus. index.

Concise history from the twelfth century to 1940, with emphasis on the nineteenth and twentieth centuries. No bibliography.

Poulsen, Vagn, ed. Dansk Kunsthistorie: Billedkunst og Skulptur. v. 1-. Copenhagen, Politiken, 1972-. illus. index. LC 73-327315.

History of painting and sculpture in Denmark from the Carolingian period to the middle of the nineteenth century. The fourth and final volume will cover the period 1850 to 1950. Well illustrated, but there is no bibliography and there are no footnotes. Text for the general reader and beginning student; plates useful to the advanced student.

Poulsen, Vagn. Illustrated Art Guide to Denmark. Copenhagen, Gyldendal, 1959. 84p. illus. index. LC 59-8958.

Pocket handbook of art and architecture in Denmark with a survey history of Danish art and architecture, a list of museums, and a collection of small illustrations. No bibliography. For the general reader and the tourist.

Zeitler, Rudolf. Reclams Kunstführer Dänemark. Stuttgart, Reclam, 1978.431p. illus. index.

Topographical guide to the art and architecture of Denmark from prehistoric times to the present. Arranged by place or site. Each place is introduced by a brief historical sketch that precedes a thorough description of the major buildings and monuments, including their art contents and decoration. Intended as a pocket guide for the serious art tourist, its thoroughness makes it a valuable reference work. No bibliography.

Finland

Hahm, Konrad. **Die Kunst Finnland**. Berlin, Deutscher Kunstverlag, 1933. 36p. illus.

Pictorial survey of art and architecture in Finland. Bibliography of basic books (p. 36).

Okkonen, Onni. Finnish Art. Porvoo, Söderström, 1946. 42p. text, 208 plates.

Pictorial survey of Finnish painting and sculpture from the Middle Ages to the twentieth century. Includes medieval architecture. No bibliography.

Iceland

Eldjárn, Kristján. **Icelandic Art.** New York, Abrams, 1961. 14p. (text); 80p. (illus.). LC 61-5785.

Pictorial survey of painting, sculpture, and the minor arts of Iceland from the twelfth century through the nineteenth century. Brief text sketches the main lines of artistic development in Iceland. No bibliography.

Norway

1362 Aars, Harald, et al. Norsk Kunsthistorie. Oslo, Gyldendal, 1925. 2v. illus. index.

This history of Norwegian art and architecture consists of essays, written by specialists, on various periods from prehistoric times to the twentieth century. The classified bibliography is arranged by chapters (pp. 661-72). A standard history of Norwegian art and architecture.

1363 Lexow, Einar Jacob. Norges Kunst. Oslo, Steenske, 1926. 342p. illus. Concise history of art and architecture in Norway from prehistoric times to the twentieth century. Brief bibliography of major works (pp. 340-42). No index. A popular history for the general reader.

Sweden

Topographic Handbooks

1364 Sveriges Kyrkor. Konsthistoriskt Inventarium. Stockholm, Generalstabers Litografiska Austalts Förlag, 1912—. illus. index.

Official inventory of art and architecture of the churches of Sweden. Summaries are given in English and German. Bibliographies in footnotes or at the ends of sections. In progress, 159 volumes to date (1975):

Blekinge

I, 1, Östra härad (1926)

I, 2, Medelsta härad (1932)

II, Bräkne härad och Listers härad (1941)

III, 1, Fredrikskyrkan i Karlskrona (1946)

III, 3, Amiralitetskyrkan i Karlskrona (1959)

IV, 1, Ronneby Kyrkor (1959)

IV, 2, Karlshamns Kyrkor (1960)

IV, 3, Sölvesborgs Kyrkor (1962)

V, 2, Generalregister till Blekinge Band I-V (1965)

Bohuslän

I, 1, Västra Hisings härad (1944)

I, 2, Kyrkor i Bohuslän. Inlands Sodre härad (1965)

I, 3, Ytterby, Kareby och Romelanda (1967)

II, 1, Kyrkor i Inlands Nordre härad, sodra Delen (1962)

III, 1, Hjärtums och Västerlanda Kyrkor (1968)

IV, 2, Kyrkor al Marstrand (1974)

IV, 3, Kungälvs Kyrkor, Inlands södre härad (1969)

Dalarne

I, 1, Kyrkor i Leksands och Gagnefs tingslag (1916)

I, 2, Kyrkor i Falu Domsagas norra tingslag (1920)

I, 3, Kyrkor i Falu Domsagas södra tingslag (1932)

II, 1, Falu stads Kyrkor (1940)

Dalsland

I, 1, Sundals härad (1931) Gastrikland (2v.; 1930-32)

Gotland

I, 1, Kyrkor i Lummelunda ting (1914)

I, 2, Tingstäde Kyrka (1925)

I, 3, Kyrkor i Bro ting (1929)

I, 4, Kyrkor i Erdre ting (1931)

I, 5, Kyrkor i Dede ting (1931)

II, Rute setting (1933)

III, Hejde setting (1942)

IV, 2, Kyrkor i Halla ting (1952)

IV, 4, Kyrkor i Kräklinge ting, nordvästra delen (1959)

IV, 5, Kyrkor i Kräklinge ting, sydöstra delen (1963)

IV, 6, Samt Register till Band IV

V, 1, Kyrkor pa Gotland; Garde ting, södra delen (1965)

V, 2, Alskogs kyrka, Garde ting (1908)

V, 3, Garde kyrka (1972)

VI, 1, Burs kyrka. Burs ting (1967)

VI, 2, Stånga kyrka. Burs ting (1968)

VI, 3, Hems Kyrkor, Hemse ting (1969)

VI, 4, Alva kyrka, Hemse ting (1970)

VI, 5, Rone kyrka (1973)

VI, 6, Eke kyrka, Hemse ting (1974)

Härjedalen

I, 1, Kyrkor i Svegs tingslag, norvästra delen (1961)

I, 2, Svegs tingslag södra delen (1965)

I, 3, Svegs tingslag östra delen (1966)

Lappland

I, 1, Kiruna kyrka (1973)

Medelpad

I, Njurunda och Sköns tingslag samt Sundsvalls stadt (1929)

II, Kyrkor i Ljustorps, Indals samt Medelpads Västra Domsagas tingslag (1939)

Närke

I, 1, Örebro stads kyrkor (1939)

I, 3, Kyrkor i Glanshammars härd, sydvästra delen (1961)

I, 4, Ödeby kyrka: Glanshammars härad (1969)

I, 5, Lillkyrka och Götlunda kyrkor (1971)

I, 6, Kyrkor i Närke (1972)

Öland

I, 1, Kyrkor pa Öland Inledning (1966)

I, 2, Böda och St. Olof: Akerbo härad (1968)

I, 3, Högby kyrkor: Akerbo härad (1968)

- I, 4, Källa kyrkor: Akerbo härad (1969)
- I, 5, Persnäs kyrkor: Akerbo härad (1970)
- I, 6, Föra kyrkor (1972)

Östergötland

- I, 1, 2, Kyrkor i bankekings härad, norra delen (1921)
- I, 3, Bankekings härad, mellersta delen (1963)
- II, Vreta Klosters kyrka (1935)
- II, 2, Langlöts kyrkor (1973)

Skäne

- I, 1, Kävlinge kyrkor i Harjagers härad (1932)
- I, 2, Barsebäcks och Hofterluds kyrkor (1972)
- I, 3, Löddeköping och Högs kyrkor (1972)
- II, 1, Luggude härad, sydvästra delen (1963)

Småland

- I, Jönköpings och Huskvarna kyrkor (1940)
- II, Kyrkorna i Sjösas uppvidinge härad (1967)
- II, 2, Drews och Hornaryds kyrkor (1968)
- II, 3, Dädesjö och Eke kyrkor: Uppvidinge härad (1969)
- II, 4, Granhutts och Nottebäcks kyrkor (1972)
- III, 1, Kalmar Slots kyrkor (1968)
- IV, 1, Växjö Domkyrka (1970)
- IV, 2, Växjö och öjaby kyrkor (1971)
- V, 1, Bergunda och Öja kyrkor. Kinnevalds härad (1970)
- VI, 1, Uppvidinge härad (1974)

Södermanland

- I, 1, 2, Strängnäs Domkyrka (1968-69)
- II, 1, Strängnäs domkyrka (1974)
- III, 1, Sorunda kyrka (1972)
- III, 2, Ösmo kyrka (1973)

Stockholms kyrkor

- I, 1, 2, 3, St. Nikolai eller Storkyrkan (1925-27)
- II, 1, 2, Riddarholmskyrkan (1928-37)
- III, 1, Ulrika Eleonara elle Kungsholm kyrka med St. Görans kapell (1915)
- III, 2, Hedvig Eleonara kyrka (1920)
- IV, 1, 2, S. Jakobs kyrka (1928-30)
- IV, 3, S. Johnnes kyrka och S. Stefans kapell (1934)
- V, 1, Adolf Fredriks kyrka och S. Olovs kapell (1924)
- V, 2, Gustav Vasa kyrka (1943)
- V, 3, Matteus kyrka (1946)
- VI, 1, 2, S. Klara kyrka (1927)
- VII, 1, S. Maria Magdalena kyrka (1934)
- VII, 2, Katarina kyrka (1944)
- VII, 3, Sofia kyrka (1961)
- VII, 4, Högalids kyrka (1966)
- VIII, 1, Bromma kyrka och Västerledskyrkan (1940)
- VIII, 2, Spanga och Hässelby kyrkor (1959)

VIII, 3, Brännkyrka, S. Sigfrids och Enskede kyrkor (1964)

IX, 1, Skeppsholmskyrkan elle Johans kyrka (1942)

Uppland

I, 1, 2, Kyrkor i Danderyds skepplag (1918-28)

I, 3, Kyrkor i Värmdo skeppslag (1949)

I, 4, Kyrkor i Akers skeppslag (1950)

II, 1, Kyrkor i Väddö och Haverö skeppslag (1918)

II, 2, Kyrkor i Bro och Vätö skeppslag (1940)

II, Halvband 2, Kyrkor i Frösakers härad (2v.; 1955-56)

II, 3, Kyrkor i Frötuna och Länna skeppslag (1945)

III, 1, 2, Kyrkor i Langshundra härad (1921-52)

III, 3, Kyrkor i Närdinghundra härad, västra delen (1953)

IV, 1, Kyrkor i Erlinghundra härad (1912)

IV, 2, Kyrkor i Seminghundra härad (1919)

V, 3, Kyrkor i Sjuhundra härad (1956)

V, 5, Kyrkor i Lyhundra härad (1961)

V, 6, Estuna och Söderby-Karls kyrkor i Uppland (1966)

V, 7, Karls Kyrkoruin (1967)

VI, 4, Kyrkor i Sollentuna härad, Södra delen (1958)

VI, 1-3, Kyrkor i Färentuna härad (1954-57)

VI, 5, Kyrkor i Sollentuna härad, norra delen (1958)

VII, 1, Kyrkor i Bro härad (1956)

VII, 2, Kyrkor i Habo härad, södra delen (1962)

VII, 3, Kyrkor i Habo härad, mellersta delen (1963)

VIII, 1, Trögds härad (1974)

IX, 1, Härkeberga kyrka: Trögds härad (1968)

IX, 2, Iitslena kyrka (1969)

XI, 1, Svinnegarns, Enköpings-Näs och Teda kyrkor (1966)

XI, 2, Tillinge kyrka: Asunda härad (1968)

XI, 3, Sparrsätra och Breds kyrkor: Asunda härad (1969)

XII, 2, Fittja kyrka: Lagunda härad (1970)

Värmland

I, 1, 2, Kyrkor i Grums härad (1924)

Västergotland

I, Kyrkor i Kallands härad (1913-22)

II, Habo kyrka, Vartofta härad (1970)

Histories

1365 Cornell, Henrik. Den svenska Konstens Historia. 2nd ed. Stockholm, Aldus/Bonnier, 1966. 2v. illus. index. LC 67-101872.

History of art and architecture in Sweden from the Viking period to about 1800. Supplementary chapter covers the graphic arts from 1600 to 1700. Bibliography (pp. 421-32) arranged by chapters. Excellent collection of plates, plans, and diagrams. A standard history of Swedish art, particularly good for the Middle Ages.

- Grate, Pontus, ed. Treasures of Swedish Art, from Pre-Historic Age to the 19th Century. Malmö, Allhem, 1965. 166p. illus. LC 66-51407. Pictorial survey of art and architecture in Sweden from prehistoric times to the nineteenth century. The brief introductory essay, which sketches the development of Swedish art, is followed by a collection of plates with informative notes.
- Lindblom, Andreas A. F. Svensk Konst; fran Stenaldern till Rymdaldern. Stockholm, Norstedt, 1960. 410p. illus. index. LC 60-32013.
 Concise history of art and architecture in Sweden from prehistoric times to the present. No bibliography. A well-illustrated recent survey history for the general reader and the beginning student.
- 1367a Lindblom, Andreas. Sveriges Konsthistoria från Forntid till Nutid.
 Stockholm, Nordisk Rotogravyr, 1944-1946. 3v. illus. index.
 Comprehensive history of art and architecture in Sweden from prehistoric times to the mid-twentieth century. Well-illustrated, but no bibliography. A standard history.
- Romdahl, Axel L., and Johnny Roosval. Svensk Konsthistoria. Stockholm, Aktienbolaget, 1913. 612p. illus. index.
 Comprehensive history of art and architecture in Sweden from the early Middle Ages to the end of the nineteenth century. Chapters are written by various Swedish experts and each has a brief bibliography at the end.
- Roosval, Johnny A. E. Swedish Art. Princeton, Princeton University Press, 1932. 77p. illus. (Princeton Monographs in Art and Archaeology, XVIII).

A collection of lectures given at Princeton in 1929 covering most aspects of the history of Swedish art and architecture (with the exception of the eighteenth century). Bibliography in the footnotes.

SPAIN AND PORTUGAL

Topographic Handbooks

- Gudiol i Ricart, Josep, and Santiago Alcolea. Hispania guia general del arte español. Barcolona, Argos, 1962. 2v. illus. index. Handbook of art and architecture of Spain, arranged by provinces. Includes the Canary Islands. No bibliography.
- 1371 Milicua, D. José. Guide artistique de l'Espagne. Paris, Tisne, 1967. 559p. illus. index.

Handbook of art and architecture in Spain arranged by place. Provides small illustrations and short descriptions, but no bibliography.

1372 Catálogo monumental de España. Madrid, Ministerio de Instrucción Pública y Bellas Artes, 1924—. illus. index.

Official inventory of art and architecture in Spain. Volumes are arranged by

province and city; to date, the following have appeared:

Provincia de Badajoz (3v.; 1925-26)

La Ciudad de Barcelona (1947)

Provincia de Cáceres (3v.; 1924)

Provincia de Cádiz (2v.; 1934)

Provincia de Leon (2v.; 1925)

Provincia de Palencia (4v.; 1946-51)

Provincia de Salamanca (2v.; 1967)

Zaragoza (2v.; 1957)

Provincia de Zamora (2v.; 1927)

Within volumes, material is arranged by chronological period. Reference to specialized literature is made in the footnotes. This is the standard topographical handbook of art and architecture *in situ* in Spain. It is not yet complete, however, and several regions have been inventorized by local groups; see below.

1373 Catalogo monumental de la provincia de Palencia. Palencia, Imprenta Provincial, 1939-1951. 4v. illus. index.

Topographical inventory of the art and architecture of the province of Palencia (North Central Spain). Emphasis is on architecture, but the chief works of art and decoration in the various buildings are also treated. Reference to specialized literature in the footnotes.

1374 Catálogo arqueológico y artístico de la Provincia de Sevilla. v. 1—. Seville, Servicio de Defensa del Patrimonio Artístico Nacional, 1939—. illus. index.

Topographical inventory of the art and architecture in the province of Seville, Spain. Arranged by place, it treats the major architectural monuments, archaeological sites, and the art contents and decorations of the major buildings in the province. Reference to specialized literature is found in the footnotes. Fills a gap, although incompletely, in the official inventory of Spanish art and architecture (1372).

1375 Catálogo monumental de la Provincia de Toledo, Toledo, Spain, Publicationes de la Excelentisma Diputación Provincial de Toledo, 1959. 413p. illus, index.

Topographical inventory of the art and architecture of the province of Toledo. Emphasis is on the architectural monuments, but the art contents and decoration of the major buildings are also covered. Reference to specialized literature is found in the footnotes. Fills a gap in the official inventory of Spanish art and architecture (1372).

1376 Catálogo monumental de la Provincia de Valladolid. Valladolid, Spain, Editado por la Excelentisma Diputación Provincial de Valladolid, 1960—. 5v. to date. illus. index.

Topographical inventory of the art and architecture in the province of Valladolid, Spain. Arranged by place, it emphasizes the architectural monuments, but the art contents and decoration of the major buildings are also covered. Reference to specialized literature is in the footnotes. Fills a gap in the official inventory of Spanish art and architecture (1372).

1377 Inventário artístico de Valladolid y su Provincia. Valladolid, Sever-Cuesta, 1970. 361 p. illus. index.

Author: Juan J. M. Gonzalez. Concise inventory of the art and architecture of the city and province of Valladolid. Emphasis is on architecture, with brief notices of works of art and decoration contained within the major buildings. No bibliography.

1378 Catálogo monumental Diócesis de Vitoria. Vitoria, Spain, 1967—. 4v. to date. illus. index. LC 71-234343.

Topographical inventory of the art and architecture in the diocese of Vitoria. Arranged by place, it emphasizes the buildings, but the art contents and decoration of the major structures are also covered. Well illustrated, with thorough reference to specialized literature in the footnotes. Fills a gap in the official inventory of Spanish art and architecture (1372).

- 1379 Catálogo de monumentos de Vizcaya. Bilbao, Spain, 1958. 2v. illus. index. Inventory of the art and architecture in the province of Vizcaya. Although the emphasis is on buildings, archaeological sites and the artistic contents of the buildings are also covered. Reference to specialized literature is in the footnotes. Arranged by place. Fills a gap in the official inventory of Spanish art and architecture (1372).
- 1380 **Inventário artístico de Portugal.** Lisbon, Academia Nacional de Bellas Artes, 1943—. illus. index.

Official inventory of art and architecture in Portugal. The first eight volumes are as follows:

I, Distrito de Portalegre (1943)

II, Cidade de Coimbra (1947)

III, Distrito de Santarém (1949)

IV, Distrito de Coimbra (1952)

V, Distrito de Leira (1955)

VI, Distrito de Aveiro (1959)

VII, Concelho de Évora (2v.; 1966)

VIII, Distrito de Évora (2v.; 1975)

Each volume is organized by place. A summary of the political and artistic history of the locality is followed by a detailed description of the major buildings and their contents. Specialized literature is referred to in the footnotes. Additional volumes are planned. A standard reference tool.

Histories

Art Treasures in Spain: Monuments, Masterpieces, Commissions, and Collections. General eds., Bernard S. Myers and Trewin Copplestone. New York and Toronto, McGraw-Hill, 1969. 175p. illus. index. LC 70-76758. Pictorial survey of the architecture, painting, sculpture, and the decorative arts in Spain from prehistory to the present. Sections were written by a variety of specialists. Contains maps and a glossary-index of museums and monuments, but no bibliography.

Barreira, João, ed. Arte portuguesa. Lisbon, Excelsior, n.d., 3v. in 4. illus. index.

Comprehensive history of Portuguese art and architecture from antiquity to the twentieth century. Tomo 1: *Arquitetura e escultura*; tomo 2: *Pintura*; tomo 3: *Artes decorativas*. Bibliographical footnotes.

- Cirici-Pellicer, Alejandro. Treasures of Spain from Charles V to Goya.
 Geneva, Skira; Cleveland, World, 1965. 236p. illus. index. LC 65-24418.
 Introduction by F. J. Sánchez Cantón. Pictorial survey of art and architecture in Spain from the sixteenth through the early nineteenth centuries. No bibliography. Excellent color plates.
- Dieulafoy, Marcel. Art in Spain and Portugal. London, Heinemann, 1913. 376p. illus. index.

In the series, "Ars Una: Species Mille." General survey of art and architecture in Spain and Portugal from Moorish times to the end of the nineteenth century. Has a long introduction tracing the development of Islamic art and architecture from Sassanian times to the conquest of Spain. Last chapter on Portuguese art. No bibliography.

Gaya Nuño, Juan A. **Historia del arte español**. Madrid, Editorial Plus-Ultra, 1946. 478p. illus. index.

Concise history of art and architecture in Spain from prehistoric times to the present. Provides a chronological table and a bibliography (pp. 448-50) that lists major books, chiefly in Spanish.

Gudiol i Ricart, Josep. **The Arts of Spain**. Garden City, N.Y., Doubleday, 1964. 318p. illus. index. LC 64-13731.

Survey history of art and architecture in Spain from prehistoric times to the present. Well illustrated and provided with a bibliography (pp. 305-307) of basic books in all languages. A good survey for the general reader.

- Gudiol i Ricart, Josep, ed. Ars Hispaniae: Historia universale del arte hispánico. Madrid, Plus-Ultra, 1947-1973. 21v. illus. index. LC 51-23057rev. Comprehensive history of art and architecture in Spain. Written by specialists, it covers the period from prehistoric art through the twentieth century. Volume XXI is a history of art and architecture in Latin America (exclusive of Brazil) and the Philippine Islands. Each volume has an excellent classified bibliography of books and periodical articles in all languages. Well illustrated. The standard history of Spanish art and architecture.
- Hagen, Oskar. Patterns and Principles of Spanish Art. Madison, University of Wisconsin Press, 1943. 2nd ed. 279p. illus. index.
 Concise history of Spanish art and architecture from prehistoric times to the present. Bibliographical references in footnotes. This is still a competent survey history for the general reader.
- Jiménez-Placer, Fernando, and Alejandro Cirici-Pellicer. Historia del arte español. Barcelona, Labor, 1955. 2v. illus. index.

History of art and architecture in Spain from Paleolithic times through the twentieth century. Well illustrated. No bibliography.

1390 Kehrer, Hugo. Spanische Kunst von Greco bis Goya. Munich, H. Schmidt, 1926. 364p. illus. index.

Well-illustrated survey of Spanish art and architecture from the sixteenth through the eighteenth century. Emphasis is on painting. Bibliographical footnotes.

1391 Kubler, George, and Martin Soria. Art and Architecture in Spain and Portugal and Their American Dominions: 1500 to 1800. Harmondsworth, Penguin, 1959. 445p. illus. index. (Pelican History of Art, Z17). LC 60-666.

Comprehensive and scholarly history of art and architecture in Spain, Portugal, and Latin America from 1500 to 1800. Excellent selection of plates, plans, and diagrams. Good classified bibliography of books and periodical articles (pp. 403-416), with further reference to more specialized literature in the extensive footnotes. A standard history of Spanish, Portuguese, and early Latin American art and architecture.

Lambert, Élie. L'art en Espagne et au Portugal. Paris, Larousse, 1945. 138p. illus. index. LC AF47-1595.

Concise history of art and architecture in Spain and Portugal from the early Middle Ages to the end of the nineteenth century. Bibliography of books in all languages (pp. 131-33). Series "Arts, Styles et Techniques."

Lozoya, Juan C. Historia del arte hispánico. Barcelona, Salvat, 1931-1949.
 5v. illus. index.

Comprehensive history of art and architecture in Spain from prehistoric times through the twentieth century. Well-illustrated with plates, plans, and diagrams. Good bibliographies at the end of each chapter, plus a supplementary bibliography for the entire work in volume 5 (pp. 671-83). A standard history.

Pita-Andrade, José M. Treasures of Spain from Altamira to the Catholic Kings. Geneva, Skira; Cleveland, World, 1967. 248p. illus. index. LC 67-25118.

Pictorial survey of art and architecture in Spain from prehistoric cave paintings through the fifteenth century. Introduction is by F. J. Sánchez Cantón. Excellent color plates. Popular text for the general reader; the plates are useful to beginning as well as advanced students.

Smith, Bradley. Spain: A History in Art. New York, Simon & Schuster, 1966. 296p. illus. LC 66-19432.

General survey of art in Spain, from prehistory to 1931, set in a cultural and historical context. Emphasis is on painting, with some sculpture and almost no architecture. Generously illustrated, all in color. General bibliography (pp.294-96).

1396 Lacerda, Aarao de, *et al.* **Historia da arte en Portugal.** Oporto, Portugal, 1943-53. 3v.

Comprehensive history of art and architecture in Portugal from prehistoric times through the nineteenth century. Volume 1 covers the period from prehistory through the fourteenth century; volume 2 treats the fifteenth and sixteenth centuries; volume 3 covers the seventeenth through nineteenth centuries. Only the first volume has a bibliography (pp. 555-60), which is a good classified list of books and periodical articles. A standard history of Portuguese art and architecture.

1397 Santos, Reynoldo dos. Historia del arte portugues. Barcelona, Labor, 1960. 383p. illus. index.

Concise history of art and architecture in Portugal from the pre-romanesque period through the twentieth century. No bibliography.

Smith, Robert Chester. The Art of Portugal, 1500-1800. New York, Meredith, 1968. 320p. illus. index. LC 68-31684.

Concise history of art and architecture in Portugal from 1500 to 1800. Well illustrated. Bibliography is provided in the notes to the text (pp. 313-16). A good general history of Portuguese art and architecture in English for the general reader and the beginning student.

See also: Vey and de Salas (1291).

EASTERN EUROPE

GENERAL WORKS

Rhodes, Anthony. Art Treasures of Eastern Europe. New York, Putnam, 1972. 280p. illus. index. LC 75-186798.

Pictorial survey of the art and architecture of Yugoslavia, Czechoslovakia, Poland, Hungary, Romania, and Bulgaria from prehistoric times to 1800. Provides a list of major museums in Eastern Europe, brief biographical notes on artists, and a bibliography of general books (p. 273). An attractive pictorial survey for the general reader.

CZECHOSLOVAKIA

1400 Prokop, August. Die Markgrafschaft M\u00e4hren in Kunstgeschichte Beziehung. Vienna, R. Spies, 1904. 4v. in 2. illus. index.

Illustrated handbook of art and architecture in Moravia from the Romanesque through the Baroque. Contents: 1, Das Zeitalter des romanischen Stils; 2, Das Zeitalter des gotischen Stils; 3, Das Zeitalter der Renaissance; 4, Das Zeitalter der Barocke. Illustrated with line drawings and lithographs.

Sourek, Karel, ed. Die Kunst in der Slowakei. Prague, Melantrich, 1939. 81p. text. 1330 plates.

Illustrated survey of art and architecture in Czechoslovakia from prehsitoric times to the end of the nineteenth century. Includes chapters on folk art. Brief introductory essay followed by good collection of plates with descriptive notes. A bibliography.

Wirth, Karel, et al. La richesse d'art de la Bohême. Prague, Stenc, 1913. 2v. illus.

Illustrated survey of art and architecture in Bohemia from prehistoric times to the end of the nineteenth century. Introductory text followed by extensive collection of plates, with descriptive notes containing bibliographical references.

BULGARIA

Bozhkov, Atanas. Bulgarian Art. Sofia, Foreign Language Press, 1964. 125p. illus. index. LC 64-56569.

Concise history of art and architecture in Bulgaria from the seventh through the twentieth century. No bibliography.

Filov, Bogdan D. Geschichte der altbulgarischen Kunst bis zur Eroberung des bulgarischen Reiches durch die Türken . . . Berlin, de Gruyter, 1932. 100p. illus. index. (Grundriss der slavischen Philologie und Kulturgeschichte, 10).

History of Bulgarian art and architecture from 679 to 1393. Bibliographies are given at the end of the chapters. This work, along with (1405), is a standard history of Bulgarian art and architecture.

Filov, Bogdan D. Geschichte der bulgarischen Kunst unter der türkischen Herrschaft und in der neueren Zeit . . . Berlin, de Gruyter, 1935. 94p. illus. index. (Grundriss der slavischen Philologie und Kulturgeschichte, 10).

History of Bulgarian art and architecture from 1393 to 1930. Bibliographies are given at the end of each chapter. Sequel to (1404); together they form a standard history of Bulgarian art and architecture.

HUNGARY

Divald, Kornel. **Old Hungarian Art.** London, Oxford University Press, 1931. 228p. illus. LC 32-13251.

General survey of Hungarian art and architecture from prehistoric times to the end of the nineteenth century. No bibliography.

1407 Hekler, Antal. Ungarische Kunstgeschichte. Berlin, Mann, 1937. 124p. illus. index. LC 38-11884.

Concise history of art and architecture in Hungary. Bibliography in notes (pp. 118-20).

Hootz, Reinhardt, ed. Kunstdenkmäler in Ungarn: Ein Bildhandbuch. Munich, Deutscher Kunstverlag, 1974. 480p. illus.

Illustrated, topographical handbook of the art and architecture of Hungary from prehistoric times to the present. The good collection of plates, arranged by place, contains informative notes as well as plans. A useful chronological list of the works illustrated concludes the volume. No bibliography. A most useful topographical handbook to art and architecture *in situ* in Hungary, especially considering the lack of an official inventory of art and architecture in that country. For the advanced student and the serious art tourist.

1409 Kampis, Antal. The History of Art in Hungary. London, Wellingborough, 1967. 400p. illus. index. LC 67-78512.

Concise history of art and architecture in Hungary from the ninth century through the first decade of the twentieth century. No bibliography.

Nemeth, Lajos. Modern Art in Hungary. Budapest, Corvina, 1969. 187p. illus. LC 72-9780.

Survey history of twentieth century art and architecture in Hungary. Bibliography (pp. 171-72) lists books and periodical articles in all languages.

POLAND

1411 Kuhn, Alfred. Die Polnische Kunst von 1800 bis zur Gegenwart. 2nd ed. Berlin, Klinkhardt & Biermann, 1937. 211p. illus.

Survey of Polish art and architecture of the nineteenth and early twentieth centuries. Bibliography of books in all languages (pp. 201-204).

Piotrowska, Irena. **The Art of Poland**. New York, Philosophical Library, 1947. 238p. illus. index. LC 47-3695.

Concise history of art and architecture in Poland from the early Middle Ages through the early twentieth century. Bibliography (pp. 227-28) lists major works in all languages.

1413 Topass, Jean. L'art et les artistes en Pologne. Paris, Félix, 1923-28. 3v. illus.

History of art and architecture in Poland from the beginning of the Middle Ages to circa 1920. Volume 1, Au moyen âge; volume 2, De la prime-renaissance au préromantisme; volume 3, Du romantisme à nos jours. Bibliographies given at the end of each volume list books in Polish, French, and German. Still one of the few histories of Polish art in a Western language.

ROMANIA

1414 Iorga, Nicolae, and G. Bals. Histoire de l'art roumain ancien. Paris, Boccard, 1922. 411p. illus.

History of art and architecture in Romania from the late Middle Ages through the nineteenth century. Contents: L'art roumain du XIVe au XIXe siècle-description et documentation historique; L'architecture religieuse moldave.

RUSSIA

1415 Ainalov, Demetrius. **Geschichte der russischen Monumentalkunst.** Leipzig, De Gruyter, 1932-33. 2v. illus. index.

In the series, "Grundriss der Slavischen Philologie und Kulturgeschichte." First volume is subtitled: Geschichte der russischen Monumentalkunst der vormoskovitischen Zeit; volume two: Geschichte der russischen Monumentalkunst zur Zeit der Grossfürstentums Moskau. Comprehensive, scholarly history of art and architecture in Russia from the tenth through the seventeenth century. Extensive bibliographical footnotes. Old, standard work.

1416 Alpatov, Mikhail V. Art Treasures of Russia. New York, Abrams, 1967. 178p. illus. index. LC 67-12683.

Lavishly illustrated general survey of Russian painting, sculpture, architecture, and liturgical arts from the Middle Ages through the nineteenth century. No bibliography.

Alpatov, Mikhail V., and Nikolai I. Brunov. Geschichte der altrussischen Kunst. Augsburg, Filser, 1932. 2v. illus. index. Repr.: New York, Johnson Reprint, 1969. 423p. illus. index. LC 69-19944.

Comprehensive history of art and architecture in Russia from the tenth century through the seventeenth century. Subjects are treated by type: Alpatov writes on architecture and Brunov, on the figurative arts. The reprint has a new preface in English by the authors. The bibliography for the architecture section is on pages 235 and 236; other bibliographies are at the end of the chapters. An old, but classic history of old Russian art and architecture; still valuable to the advanced student.

- Art Treasures in Russia: Monuments, Masterpieces, Commissions, and Collections. General eds., Bernard S. Myers and Trewin Copplestone. New York and Toronto, McGraw-Hill, 1970. 175p. illus. index. LC 71-101167.
 Pictorial survey of painting, sculpture, architecture, and the decorative and minor arts in Russia from 2500 B.C. to the present. The various epochs are treated by different specialists. Includes maps and a glossary-index of museums and monuments, but no bibliography.
- Blankoff, Jean. L'art de la Russie ancienne. Brussels, Centre National pour l'Étude des Etats de l'Est, 1963. 92p. text, 150 plates. index. LC 64-4041.

Concise history of art and architecture in Russia from the tenth century to the end of the seventeenth century. Contents: Introduction; La Russie de Kiev (Xe-XIIIes.); La Russie de Vladimir-Souzdal (XIIe-XIVes.); Novgorod et Pskov; La Russie moscovite (XIVe-XIIIes.); Conclusion. Bibliography (pp. 77-87) is a good list of books and articles, mostly in Russian with titles transliterated.

Bunt, Cyril G. E. Russian Art from Scyths to Soviets. London, Studio, 1946. 272p. illus. index.

Survey history of art and architecture from the pre-Christian period through World War II. Brief and inadequate bibliography (p. 268).

1421 Eliasberg, Alexander. Russische Kunst; ein Beitrag zur Charakteristik des Russentums. Munich, R. Piper, 1915. 118p. illus.

Concise history of art and architecture in Russia from the twelfth to the end of the nineteenth century. Contents: Einleitung; Architektur vom XII. bix zum XVII. Jahrhundert; Altrussische Malerei; Architektur im XVIII. und XIX. Jahrhundert; Die Malerei vom XVIII. Jahrhundert bis zur Gegenwart; Volkskunst. No bibliography. Introduction contains an important, early attempt to characterize Russian national style in the visual arts.

Geschichte der russischen Kunst. Dresden, Verlag der Kunst, 1957–.
 6v. to date. illus. index.

Collection of essays on various aspects of the art and architecture of Russia, written by Russian specialists and translated into German (Russian title: Istoriûa russkogo iskusstva). To date, it covers prehistory through the eighteenth century. Good bibliography, with German translations of Russian titles. A standard history of Russian art.

1423 Gibellino-Krasceninnicowa, Maria. Storia dell'arte russa. Rome, P. Maglione, 1935-1937. 2v. illus. index. LC 39-20014.

Comprehensive history of art and architecture in Russia from the eleventh century to the 1930s. Contents: tomo 1, Dal sècolo XI al sècolo XVII; tomo 2, Da Pietro il Grande ai tempi nostri. Bibliographies at the end of each volume.

Hamilton, George H. Art and Architecture of Russia. 2nd ed. London, Penguin, 1976. 342p. illus. index. (Pelican History of Art, Z6). LC 77-352526.

Comprehensive history of the art and architecture of Russia from the tenth through the twentieth century. Good selection of plates, plans, and diagrams. Bibliography (pp. 295-99) lists books chiefly in Western languages. Reference to further, more specialized literature is in the extensive footnotes. A standard history of Russian art and architecture.

- Hare, Richard. The Art and Artists of Russia. Greenwich, Conn., New York Graphic Society, 1966. 294p. illus. index. LC 66-16279. Survey of the history of painting and the minor arts in Russia from the fifteenth to the early twentieth century. Selected bibliography (pp. 282-86). Popular survey for the general reader and the collector.
- 1426 Kornilovich, Kira V. Arts of Russia. Cleveland, World, 1967-1968. 2v. illus. LC 67-24469 rev.

Pictorial survey of the art and architecture in Russia from the ancient Scythians through the eighteenth century. Popular text with good color plates. No bibliography.

1427 Matthey, Werner von. Russische Kunst. Einsiedln, Benzinger, 1948. 115p. illus. index.

Concise history of art and architecture in Russia from the early Middle Ages to the early twentieth century. Bibliography of general works in all languages (p. 110).

- Nemitz, Fritz. Die Kunst Russlands. Berlin, Hugo, 1940. 130p. illus. Concise history of architecture, painting, and sculpture in Russia from the eleventh through the nineteenth century. Contents: Einführung; Sakrale Baukunst; Das Wunder der Ikone; Russland und Europa. No bibliography.
- 1429 Réau, Louis. L'art russe. Verviers, Gerard, 1968. 2v. illus. index. LC 75-408686.

Reissue of the 1921-22 edition (Paris, Laurens). Survey of the art and architecture in Russia from the Greco-Scythian period through the Rococo. No bibliography,

but there is occasional reference to further literature in the footnotes. An old, standard history of Russian art and architecture.

1430 Rice, David T. Russian Art; An Introduction. London, Gurney and Jackson, 1935. 136p. illus.

Collection of essays by various scholars on aspects of Russian art and literature. Contents: 1, Russian Art—an Appreciation; 2, An Historical Survey; 3, The Periods and Schools of Early Russian Art; 4, Art in the Eighteenth Century; 5, Early Nineteenth Century Painting; 6, Decorative Art, Theatre and Ballet; 7, Textiles; 8, Metalwork and Enamels; 9, Art of the Book; 10, Porcelain. Table of emperors and dates. No bibliography.

Rice, Tamara T. A Concise History of Russian Art. New York, Praeger, 1963. 288p. illus. index. LC 63-16653.

Concise history of art and architecture in Russia from the tenth through the twentieth centuries. Provides a brief, unclassified bibliography (pp. 272-73). A good survey history of Russian art and architecture for the general reader.

Wulff, Oskar K. Die Neurussische Kunst im Rahmen der Kultur-Entwicklung Russlands von Peter dem Grossen bis zur Revolution. Augsburg, Filser, 1932. 2v. illus. index.

Comprehensive history of art and architecture in Russia from the eighteenth through the early twentieth century. Volume one, text; volume two, plates. Brief bibliography (p. 350).

YUGOSLAVIA

Bihalji-Merin, Oto, *et al.* Art Treasures of Yugoslavia. New York, Abrams, 1974. 445p. illus. index. LC 72-5237.

Well-illustrated history of art and architecture in Yugoslavia from prehistoric times to the present, consisting of essays by various Yugoslavian scholars. Bibliography (pp. 427-34) provides a good classified list of books and periodical articles in all languages.

1434 Kasanin, Milan. L'art yougoslave dès origines à nos jours. Belgrade, Musée du Prince Paul, 1939. 91p. illus.

Illustrated survey of art in Yugoslavia from prehistoric times to the early twentieth century. Bibliographical footnotes. Collection of plates illustrate works in the Belgrade Museum.

1435 Radojčic, Svetozar. Geschichte der serbischen Kunst; von den Anfängen bis zum Ende des Mittelalters. Berlin, De Gruyter, 1969. 126p. illus. index. LC 70-458515.

Concise history of art and architecture in Serbia from prehistoric times to the end of the Middle Ages. Contents: Die älteste serbische Kunst bis zum Ende des 12. Jahrhunderts; Die Anfänge der monumentalen Kunst in Raszien; Der reife raszische Stil (1200-1300); Die Serbische Kunst von Ende des 13. Jahrhunderts bis zur Schlacht an der Marica (1371); Die Kunst des Morava- und Donaugebietes von 1371 bis 1459. Extensive bibliographical footnotes.

CHAPTER TEN ORIENTAL ART

GENERAL WORKS

- 1436 Glaser, Kurt, et al. Die aussereuropäische Kunst. Leipzig, Kröner, 1929. 718p. illus. index. (Handbuch der Kunstgeschichte, Band VI). Comprehensive and scholarly history of the art and architecture of Asia, Oceania and pre-Columbian America. Bibliography of basic books (p. 694).
- Hallade, Madeleine. Arts de l'Asie ancienne. Thèmes et motifs. Paris, Presses Universitaires de France, 1954-1956. 3v. illus. index. (Publications du Musée Guimet. Recherches et Documents d'Art et d'Archéologie, Tome V).

Important, scholarly study of the development of the art and architecture of the Indian subcontinent, Southeast Asia, and China from the standpoint of iconography and function. Excellent bibliographies of specialized literature at the end of each chapter.

1438 La Plante, John D. Asian Art. Dubuque, Iowa, W. C. Brown, 1968. 185p. illus. index. LC 68-14575.

Survey of the art and architecture of India, China, and Japan from circa 2500 B.C. to the beginning of the twentieth century. Provides useful maps and a modest selection of illustrations in black and white. Bibliography (p. 177) lists major books in English. Designed as an inexpensive text for the beginning student.

Lee, Sherman E. A History of Far Eastern Art. Englewood Cliffs, N.J.,
 Prentice-Hall, 1964. 527p. illus. index. LC 64-11575.
 Concise history of art and architecture in India, China, Korea, Japan, Central Asia,
 Southeast Asia, and Indonesia. Excellent selection of plates, plans, and diagrams

Concise history of art and architecture in India, China, Korea, Japan, Central Asia, Southeast Asia, and Indonesia. Excellent selection of plates, plans, and diagrams covering works from the Stone Age through the eighteenth century. The good bibliography (pp. 499-511) of books and periodicals in all languages singles out those of special interest. The standard history of Far Eastern art and architecture.

Theile, Albert. Aussereuropäische Kunst von den Anfangen bis Heute: ein Überblick. Cologne, Seemann, 1956. 3v. illus. index. LC A57-4278.
 Concise history of non-Western art and architecture from prehistoric times to the present. Band 1, Die Kunst der Naturvölker: Die altere Kunst Amerikas; Band 2, Die neuere Kunst Amerikas; Kunst Australias; Indische Kunst; Die Kunst des

Islam; Band 3, Die Kunst des Fernen Ostens: China, Korea, Japan. General bibliography (vol. 3, pp. 274-78) lists major books in all languages. A standard German history of non-Western art and architecture.

ISLAMIC WORLD

GENERAL WORKS

Diez, Ernst. Kunst der islamischen Völker. Berlin, Athenaion, 1915. 218p. illus. index.

Concise but scholarly history of Islamic art and architecture from the beginnings through the eighteenth century. Bibliography given at the end of the chapters. A volume in the series, "Handbuch der Kunstwissenschaft." An old, but classic history, still of interest to the advanced student.

Glück, Heinrich, and Ernst Diez. Die Kunst des Islam. Berlin, Propyläen, 1925. 616p. illus. index. (Propyläen Kunstgeschichte, V). Comprehensive illustrated handbook of Islamic art and architecture. Introductory essays followed by good corpus of plates with descriptive notes. No bibliography.

Superseded by new Propyläen series (1456).

Grabar, Oleg. The Formation of Islamic Art. New Haven, Conn., Yale University Press, 1973. 233p. illus. index. LC 72-75193.
Scholarly study of Islamic art and architecture through the tenth century. Contents: 1, The Problem; 2, The Land of Early Islam; 3, The Symbolic Appropriation of the Land; 4, Islamic Attitudes toward the Arts; 5, Islamic Religious Art: the Mosque; 6, Islamic Secular Art: the Palace and City; 7, Early Islamic Decoration: the Arabesque; 8, The Formation of Islamic Art. Excellent annotated bibliography (pp. 217-27).

Grube, Ernst J. The World of Islam. New York and Toronto, McGraw-Hill, 1967. 176p. illus. index. LC 66-19271.

General pictorial survey of the architecture, sculpture, architectural decoration, metalwork, and minor and decorative arts throughout Islamic realms. Includes the arts of the Umayyads, Fatimids, Seljuk Turks in Anatolia and Iran, Atabeks, Ayyubids, Mongol period, Mamluk, Nasrid, Timurid, Ottoman Turks, Safavid Iran, and Islamic art in India. Includes maps, plans, and a brief bibliography (p. 171).

1445 Grousset, René, *et al.* Arts musulmans, Extrême-Orient. Paris, Colin, 1937. 496p. illus. index.

Concise history of the art and architecture of India, Indochina, Indonesia, China, Japan, Central Asia, and the Islamic world. Well illustrated. Bibliographies at the end of each section. An older but still valuable survey of Oriental art and architecture.

1446 Kühnel, Ernst. Islamic Art and Architecture. Ithaca, Cornell University Press, 1966. 200p. illus. index. LC 66-19223.

Concise history of art and architecture in the Muslim world from earliest times (Unmayyad style) to the twentieth century. Well illustrated with plates, plans, and diagrams. Provides a brief but good bibliography (pp. 185-89). Translation of *Die Kunst des Islam* (Stuttgart, 1963). A good survey history for the beginning student and the general reader.

Marcais, Georges. L'art musulman. Paris, Presses Universitaires de France, 1962. 186p. illus. index. LC 65-30614.

Concise history of Islamic art and architecture from the eighth century through the eighteenth century. First published in 1946 as *L'art de l'Islam*. Bibliography (pp. 184-86) lists books in all languages.

Migeon, Gaston. Les arts musulmans. Paris, Van Oest, 1926. 44p. text, 64 plates.

Pictorial survey of art and architecture in the Islamic world to the middle of the nineteenth century. Bibliography of basic works (p. 43).

Migeon, Gaston. Manuel d'art musulman: Arts plastiques et industriels. 2nd ed. Paris, Picard, 1927. 345p. illus. index.

Comprehensive handbook of Islamic painting, sculpture, applied, and decorative arts. Bibliographical footnotes.

Otto-Dorn, Katharina. L'art de l'Islam. Paris, Michel, 1967. 278p. illus. index. LC 67-107712.

Concise history of Islamic art and architecture from its beginnings through the eighteenth century. Provides glossary of terms, chronological table, and bibliography (pp. 270-75), which lists books in all languages. French edition of the series, "Art of the World."

Papadopoulo, Alexandre. L'Islam et d'art musulman. Paris, Mazenod, 1976. 611p. illus. index. LC 78-341485.

Sumptuously illustrated survey of Islamic art and architecture. Chapter on the chief sites of Islamic art. Bibliography (pp. 598-602) provides a good, classified list of books and periodical articles in all languages.

Pijoán y Soteras, José. Arte islámico. Madrid, Espasa-Culpe, 1949. 625p. illus. index. (Summa Artis, Historia General del Arte, XII).

Comprehensive history of Islamic art and architecture. Introduction discusses the background of Islamic art, and subsequent chapters are devoted to major periods and nations of Islam, including a lenghthy chapter on Islamic art in Spain. Bibliography of basic books (pp. 597-99).

1453 Raymond, Alexandre M. L'art islamique en Orient. Paris, Librarie Raymond, 1923. 2v. illus.

Contents: 1 partie: Vielles faiences turques en Asie-mineure et à Constantinople; 2 partie: Fragments d'architecture religieuse et civile. Bibliographical footnotes.

1454 Rice, David T. Islamic Art. New York, Praeger, 1965. 286p. illus. index. LC 65-10179.

Concise history of art and architecture in the Muslim world from the seventh through the seventeenth century. Good selection of plates; bibliography (pp. 261-63) lists chief books in English, French, and German.

Ry van Beest Holle, Carel J. du. Art of Islam. New York, Abrams, 1971. 263p. illus. index. LC 72-92914.

Survey history of the art and architecture of the Islamic world from the time of the Umayyad dynasty through the Safavid dynasty. Includes a chapter of Islamic art of India (Moghul India). The illustrations are well chosen, and the balanced bibliography (pp. 256-58) lists books in all languages. A good survey for the general reader.

Sourdel-Thomine, Janine, and Bertold Spuler. Die Kunst des Islam. Berlin, Propyläen, 1973. 426p. (text); 416p. (illus.). index. (Propyläen Kunstgeschichte, Band 4). LC 74-310053.

Comprehensive, illustrated handbook of the art and architecture of the Islamic world from its beginnings through the eighteenth century. Also covers the art and architecture of Persia from the sixth century B.C. to the rise of Islam. The introductory essay characterizing and sketching the history of Islamic art and architecture is followed by a corpus of excellent plates. Separate essays by a group of international specialists discuss in greater detail the development of the various arts and national styles. Notes to the plates provide basic information and reference to specialized literature. The volume concludes with a very good classified bibliography (pp. 401-417) that lists books and periodical articles in all languages. A chronological table coordinates political, religious, cultural, and artistic events in the various regions. A standard handbook.

EGYPT

Brunner-Traut, Emma and Vera Hell. Ägypten: Kunst und Reiseführer mit Landeskunde. 3rd ed. Stuttgart, Kohlhammer, 1978. 784p. illus. index.

Exceptionally complete pocket-sized guide book to the art historical sites of Egypt. Introductory chapters survey geography, history, religion, language, culture, and art in ancient times, Coptic and Islamic culture. These are followed by a thorough description of major sites, arranged by broad regions, then by place. Covers the neighboring regions of Libya, Sinai, and Nubia. Chronological table, list of major museums of Egyptian art, and basic bibliography of books in all languages. Also provides helpful practical hints for the modern traveler to Egypt. An admirable art-tourist guide book.

IRAN AND AFGHANISTAN

Auboyer, Jeannine. L'Afghanistan et son art. Paris, Cercle d'Art, 1968. 172p. illus. index.

Concise survey of the art and architecture of Afghanistan from prehistoric times to the fifteenth century. A brief introductory essay traces the development; this is followed by a good collection of plates, with informative notes. Bibliography (pp. 167-72) lists major books in all languages.

Belloni, Gian Guido, and Liliana Fedi Dall'Asèn. Iranian Art. New York, Praeger, 1969. 29p. (text); 101p. (illus.). LC 70-81992.

Pictorial guide to the art and architecture of Iran from prehistoric times to the seventeenth century. Brief introduction traces the history of art and architecture in Iran with the help of maps and a chronological table; this is followed by a good selection of plates with informative captions. Bibliography (p. 29) lists major books in all languages.

1460 Godard, André. The Art of Iran. New York, Praeger, 1965. 358p. illus. index. LC 65-11169.

Comprehensive history of art and architecture in Iran from 2400 B.C. through the first half of the nineteenth century. Well illustrated with plates, plans, diagrams, and useful maps; good classified bibliography (pp. 339-45) lists books and periodical articles in all languages. Scholarly but readable text. Standard history of Iranian art and architecture.

1461 Pope, Arthur U. An Introduction to Persian Art Since the Seventh Century A.D. New York, Scribner's, 1931, 256p. illus.

Concise history of art and architecture in Persia from the seventh through the twentieth century. Provides a list of the principal monuments and a brief bibliography (pp. 252-56). An old, general survey history of Persian art and architecture by a leading expert; still useful reading for the general reader.

Pope, Arthur U., and Phyllis Ackerman, eds. Survey of Persian Art from Prehistoric Times to the Present. London, Oxford University Press, 1965. 14v. illus. index. LC NUC67-61802.

Collection of essays by specialists covering all aspects of Persian art from prehistory to the present. Volume 14 contains "New Studies 1938-1960: The Proceedings of the International Congress of Iranian Art and Archaeology, 1960, Part A." Bibliography is in the footnotes. These authoritative, scholarly essays form a standard history of Persian art and architecture.

TURKEY

1463 Akurgal, Ekrem, *et al.* Treasures of Turkey. Geneva, Skira, 1967. 253p. illus. index. LC 66-22488.

Pictorial survey of art and architecture in Turkey from the earliest civilizations of Anatolia through the Islamic period. Excellent color plates. No bibliography. Popular text for the general reader.

Aslanapa, Oktay. **Turkish Art and Architecture**. New York, Praeger, 1971. 422p. illus. index. LC 72-144222.

Concise history of art and architecture in Turkey from pre-Islamic times through the Ottoman period. Well illustrated. Bibliography (pp. 355-99) is an excellent classified list of books and periodical articles in all languages. A standard history of Turkish art and architecture.

Levey, Michael. The World of Ottoman Art. New York, Scribner's, 1977. 152p. illus. index. LC 76-40383.

Concise history of Ottoman art and architecture in Turkey. Contents: 1, Early Cities and Style; 2, Istanbul: Creation of a New Capital; 3, The Age of Sinan; 4, Achievement Amid Decline; 5, Intimations of Rococo; 6, The Exotic West. Glossary of terms, brief historical outline, and bibliography (p. 149) of books, chiefly in English.

Restle, Marcell. Istanbul. Bursa, Edirne, Iznik. Baudenkmäler und Museen. Stuttgart, Reclam, 1976. 632p. illus. index.

Pocket-sized handbook of the architectural monuments and museums of the Turkish cities of Istanbul (Constantinople), Bursa (Brusa), Edirne (Adrianople), and Iznik (Nicaea). Emphasis is on architecture, but major works of painting and mosaic are mentioned, and the collections of major museums are described. Glossary of terms. Bibliography of books in all languages (pp. 551-57). In the series, "Reclams Kunstführer." Excellent guide for the art tourist but thorough enough for reference work, especially considering the lack of topographic studies for this important ancient, Byzantine, and Islamic region.

INDIA AND CEYLON

Abbate, Francesco, ed. Indian Art and the Art of Ceylon, Central and South-East Asia. London and New York, Octopus, 1972. 158p. illus. LC 73-151958.

Brief, pictorial survey of the art and architecture of India, Ceylon, Afghanistan, Nepal, Tibet, Siam, Burma, Cambodia, Vietnam, and Indonesia. Popular text. Brief bibliography (p. 154) and chronological table.

Ahmed, Jalal U. Art in Pakistan. 2nd ed. Karachi, Pakistan Publications, 1962. 151p. illus. index. LC SA64-1479.

Brief history of art and architecture in Pakistan from the beginning of the Islamic period to the present. No bibliography.

- Bussagli, Mario, and C. Sivaramamurti. 5,000 Years of the Art of India. New York, Abrams, 1971. 355p. illus. index. LC 78-133846.

 Illustrated handbook of art and architecture in India from prehistoric times to the present. Excellent plates. For the general reader and beginning student. The corpus of illustrations is useful for the advanced student.
- 1470 Coomaraswamy, Ananda K. History of Indian and Indonesian Art. New York, Dover, 1965. 295p. illus. index. Reprint of 1927 edition.

 Concise history of art and architecture in India, Nepal, Tibet, Turkestan, Ceylon, and Indonesia from pre-Mauryan times through the Indian medieval. Bibliography (pp. 214-29) provides a good listing of older books and periodical articles. An older, standard history.
- 1471 Craven, Roy C. A Concise History of Indian Art. New York, Praeger, 1976. 252p. illus. index. LC 76-363147.

Contents: I, Harappan Culture: Beginnings on the Indus; II, Historical and Religious Origins; III, The Mauryan Period; IV, The Shunga Dynasty; V, The Andhra Period; VI, The Kushan Period; VII, The Gupta and Post-Gupta Periods; VIII,

South India; IX, The Medieval Period in North India; X, Islamic India; XI, Jain, Rajusthani and Pahari Painting. Good classified bibliography (pp. 246-48).

1472 Diez, Ernst. Die Kunst Indiens. Berlin, Athenaion, 1925. 194p. illus. index.

History of art and architecture in ancient and medieval India and of Indian colonial art of the same time in Ceylon, Java, Burma, Cambodia, Thailand, and Laos. Bibliographies at the end of the chapters. A volume in the "Handbuch der Kunstwissenschaft" series. An old, but classic scholarly history of Indian art.

1473 Fischer, Klaus. Schöpfungen indischer Kunst... Cologne, DuMont-Schauberg, 1959. 412p. illus. index. LC A60-1155.

Illustrated handbook of ancient and medieval art and architecture in India. Good classified bibliography of books and periodical articles in all languages

(pp. 353-84).

1474 Franz, Heinrich G. Buddhistische Kunst Indiens. Leipzig, Seemann, 1965. 382p. illus. index. LC 66-75937.

Scholarly history of Buddhist art and architecture in India. Important for its thorough examination of the cult function of Buddhist art and architecture. General works cited (p. 162) and extensive bibliographies of specialized literature at the end of each chapter.

1475 Goetz, Hermann. The Art of India: Five Thousand Years of Indian Art. New York, Crown, 1962. 280p. illus. index. LC 59-13434.

Concise history of art and architecture in India from prehistoric times to the present. Provides a glossary of terms, a chronological table, a map, and a good,

select bibliography (pp. 263-69) of books and periodical articles in English. A good survey history for the beginning student and the general reader.

Grünwedel, Albert. **Buddhist Art in India.** London, Quaritch, 1901. 228p. illus. index.

Concise history of Buddhist art and architecture in India. Contents: Introduction; II, Early-Indian Style; III, The Gandhara Sculpture; IV, Representation of Buddha and Bodhisattva. Bibliography (p. 218) lists books and periodical articles. A pioneering history of Indian Buddhist art.

Härtel, Herbert, and Jeannine Auboyer. Indien und Südostasien. Berlin, Propyläen, 1971. 408p. (text); 369p. (illus.). index. (Propyläen Kunstgeschichte, Band 16). LC 71-889568.

Comprehensive, illustrated handbook of the art and architecture of India and Southeast Asia from 3000 B.C. to 1700 A.D. Covers also Afghanistan, East Turkestan, and Central Asia. Introductory essay is followed by a corpus of excellent plates, notes to the plates that provide basic information and specialized bibliography, and separate essays on the development of the various media and national styles by a group of specialists. Provides an excellent, comprehensive bibliography (pp. 330-45) that lists books and periodical articles in all languages and a useful chronological table that coordinates the artistic, political, religious, and general cultural events in the various countries. A basic handbook.

Havell, Ernest B. A Handbook of Indian Art. New York, Dutton, 1920. 222p. illus. index.

Survey of Indian art and architecture from the earliest times to the nineteenth century. Bibliographical footnotes.

Havell, Ernest B. The Ideals of Indian Art. London, Murray, 1916. 188p. illus. index.

History of Indian art, exclusive of architecture. Contents: I, Origin of Indian Art—the Vedic Period; II, The Eclectic or Transition Period; III, The Universities of Northern India and Their Influence on Asiatic Art; IV, The Development of the Divine-Ideal; V, The Trimurti; VI, The Feminine Ideal; VII, The Three Paths; VIII, Historical Development of Indian Art. Bibliographical footnotes.

Iyer, K. Bharatha. Indian Art: A Short Introduction. Bombay, Asia Publishing House, 1958. 87p. illus. index. LC 60-2779.
 Brief history of art and architecture in India from earliest times through the eighteenth century. Brief bibliography (pp. 79-80).

1481 Kramrisch, Stella. **The Art of India.** 3rd ed. New York, Phaidon, 1965. 230p. illus. LC 65-28967.

Survey of the art and architecture of ancient and medieval India. Well illustrated, the text concentrates on concepts and characteristics of Indian art. Bibliography (pp. 230-31) lists major works, catalogs of exhibitions, and journals. A good introduction for the general reader.

1482 Kramrisch, Stella. **Grundzüge der indischen Kunst.** Helleran bei Dresden, Avalun-Verlag, 1924. 141p. illus. index.

Concise history of Indian art, with emphasis on sculpture. Contents: Mythus und Form; Natur; Raum; Rhythmus; Entwicklungsmomente. Bibliography of books in all languages (pp. 131-33).

Mukerjee, Radhakamal. The Culture and Art of India. New York, Praeger, 1959. 432p. illus. index. LC 59-7976.

History of Indian art, exclusive of architecture, from earliest times to the end of the nineteenth century, with emphasis on the general cultural context. Time chart of Indian civilization. Bibliography of books and periodical articles, (pp. 387-94).

- Rawson, Philip. Indian Art. New York, Dutton, 1972. 159p. illus. index. Survey history of art and architecture in India from prehistoric times through the twentieth century. Well illustrated, it provides a brief bibliography (p. 157) of popular works in English.
- Rivière, Jean R. El arte de la India. Madrid, Espasa-Calpe, 1964. 803p. illus. index. (Summa Artis, Historia General del Arte, XIX). LC NUC65-94883.

Comprehensive history of art and architecture in India from prehistoric times to the end of the Mughal period. Bibliographies at the end of each chapter.

Rowland, Benjamin, Jr. The Art and Architecture of India: Buddhist, Hindu, Jain. 3rd ed. rev. London, Penguin, 1967. 314p. illus. index. (Pelican History of Art, Z2). LC 67-4077.

Comprehensive history of art and architecture in India from prehistoric times through the period of the Hindu dynasties (nineteenth century). Also covers the Romano-Indian art and architecture in Afghanistan, Turkestan, and Kashmir, and the Indian art and architecture in Ceylon, Siam, Burma, and Java. Provides a good selection of plates, useful maps, plans, diagrams, a glossary of terms, and a good, classified bibliography (pp. 486-92), which lists books and periodicals in all languages. Reference to specialized literature is in the extensive footnotes. A standard history of Indian art and architecture.

Smith, Vincent A. A History of Art in India and Ceylon. 2nd ed., rev. by
 K. de B. Codrington. 3rd rev. and enl. ed. by Karl Khandalavala. Bombay,
 D. B. Taraporevala, 1962. 219p. illus. index. LC SA62-809.

Concise history of art and architecture in India and Ceylon from the Mauryan period to modern times. Covers Indian-inspired art in Central Asia, Tibet, Nepal, and Java. Bibliography (pp. 209-210) lists books in English. Reissue of an older general history.

- Sundaram, K. Monumental Art and Architecture of India. Bombay, Taraporevala, 1974. 106p. illus. index. LC 75-901577.
 Concise survey of Indian architecture and sculpture. Bibliography of basic books (pp. 103-104).
- Winstedt, Richard, ed. Indian Art. London, Faber and Faber, 1947. 200p. illus. index.

Survey of the art and architecture of India during the ancient and medieval periods. Introductory essay giving the historical background by H. G. Rowlinson. Popular text. No bibliography.

Zimmer, Heinrich R. The Art of Indian Asia: Its Mythology and Transformation. 2nd ed. Princeton, Princeton University Press, 1955. 2v. illus. index.

A comprehensive conceptual and historical study of the art and architecture of India and Indian Asia from prehistoric times to 1850. Volume one, text; volume two, plates. Provided with maps and a chronological table. Thorough reference to specialized literature is in the notes. A standard work on Indian art and architecture, especially for its chapters on symbolism.

CENTRAL ASIA

Dagyab, Lodan Sharap. **Tibetan Religious Art**. Wiesbaden, Harrassowitz, 1977. 386p. illus. index. (Asiatische Forschungen, Band 52). LC 78-347988.

Scholarly study of Tibetan painting and sculpture, with reference to source of imagery and usage in sacred texts of Tibetan Buddhism. Bibliographical footnotes.

Gordon, Antoinette K. **Tibetan Religious Art**. 2nd ed. New York, Paragon, 1963. 104p. illus. index. LC 63-22167.

Concise history of Tibetan painting, sculpture, and the minor arts. Provides bibliography (pp. 99-100) of books and periodical articles in English.

Hrbas, Miloš, and Edgar Knobloch. The Art of Central Asia. London, Hamlyn, 1965. 140p. illus. LC 66-71049.

Pictorial survey with brief introductory essay. Bibliography (p. 27) lists works in German and Czech.

Hummel, Siegbert. Geschichte der tibetischen Kunst. Leipzig, Harrassowitz, 1953. 123p. (text); 124p. (illus.).

History of art and architecture in Tibet from prehistory to the present. Provides maps, a good selection of plates, and a bibliography (pp. 113-17) that lists books and periodical articles in all languages. A standard history of Tibetan art and architecture.

Pal, Pratapaditya. The Arts of Nepal. Leiden, Brill, 1974—. v. 1—. illus. index. LC 75-500108.

Comprehensive history of the art and architecture of Nepal. To date, volume one, covering sculpture, has appeared. Bibliographical footnotes.

Rice, Tamara T. Ancient Arts of Central Asia. New York, Praeger, 1965. 288p. illus. index. LC 65-19586.

Concise survey of the art and architecture of Central Asia, including the greater Caucasian area, Russian Central Asia, Afghanistan, and parts of Northern India. Provides a chronological table and a brief bibliography arranged by chapters (pp. 263-64).

1497 Singh, Madanjeet. Himalayan Art . . . New York, Macmillan, 1971. 287p. illus. LC 68-28652.

Survey history of painting and sculpture in the Himalayas including Nepal, Bhutan, Sikkim, and the Siwalik Ranges. Bibliography (pp. 281-82) lists general books in English.

Waldschmidt, Ernst, and Rose Leonore Waldschmidt. Nepal: Art Treasures from the Himalayas. New York, Universe, 1970. 160p. illus. index. LC 72-96964.

Pictorial survey of the art and architecture of Nepal from circa 400 A.D. through the eighteenth century. Brief introduction characterizes the geography, people, and religion of Nepal and provides a short sketch of the art history. Excellent collection of plates with informative captions and a brief but useful note (p. 159) referring to the chief sources for bibliography on Nepal.

SOUTHEAST ASIA

GENERAL WORKS

- Griswold, Alexander B., and Peter H. Pott. The Art of Burma, Korea, Tibet. New York, Crown, 1964. 277p. illus. index. LC 63-20855. Concise history of the art and architecture of Burma, Korea, and Tibet from 200 B.C. to the nineteenth century. Provides maps, a chronological table, and a good bibliography of books in all languages (pp. 255-63).
- Groslier, Bernard Philippe. The Art of Indochina, including Thailand, Vietnam, Laos and Cambodia. New York, Crown, 1962. 261p. illus. index. LC 62-11805.

Concise history of art and architecture in Southeast Asia from prehistory to circa 1900. Emphasis is on the architecture and sculpture of the great temples. Provides a useful glossary, a guide to the pronunciation of names, a list of the names of kings, and a bibliography (pp. 240-45) of major books and periodical articles in all languages.

Rawson, Philip S. The Art of Southeast Asia: Cambodia, Vietnam, Thailand, Laos, Burma, Java, Bali. New York, Praeger, 1967. illus. index. LC 67-29399.

Survey history of the art and architecture of Cambodia, Vietnam, Laos, Thailand, Burma, Java, and Bali from earliest times to the modern age. Provides a glossary of terms and a select bibliography of books in all languages (pp. 278-83).

INDOCHINA

1502 Bezacier, Louis. L'art vietnamien. Paris, Union Française, 1955. 233p. illus. index.

History of art and architecture in Vietnam from prehistoric times to the nineteenth century. Poor illustrations. Bibliography (pp. 211-13) lists books and periodicals, chiefly in French.

Das, Ram R. Art Traditions of Cambodia. Calcutta, Mukhopadhyay, 1974. 208p. illus. index.

History of art and architecture in Cambodia. Based upon the premise that India was a chief influence. Bibliography of basic works (pp. i-vi).

- 1504 Hetjzlar, J. The Art of Vietnam. London, Hamlyn, 1973. 262p. illus. Popular, pictorial survey of art and architecture in Vietnam. One-page bibliography of general works.
- Lunet de Lajonquière, Etienne E. Inventaire descriptif des monuments du Cambodge. Paris, Leroux, 1902-11. 3v. illus, index.

Geographical inventory of architecture and sculpture in Cambodia. Arrangement by provinces. Occasional bibliographical footnotes. Well illustrated with plans, elevations, and other drawings.

- 1506 Parmentier, Henri. L'art khmer classique; monuments du quadrant nord-est... Paris, Les Éditions d'Art et d'Histoire, 1939. 2v. illus. index. Comprehensive handbook of Khmer art and architecture from the ninth to the fifteenth century. Geographical arrangement. Glossary of terms and chronological table of major monuments. Bibliographical footnotes. Together with (1507), a standard reference to Cambodian art and architecture.
- Parmentier, Henri. L'art khmer primitif. Paris, Les Éditions d'Art et Histoire, 1927. 2v. illus. index.
 Comprehensive handbook of Khmer art and architecture from the seventh to the ninth century A.D. Geographical arrangement. Glossary of terms. Chronological table of monuments. A standard reference work.
- Parmentier, Henri. **L'art du Laos**. Paris, École Française d'Extrême-Orient, 1954. 2v. illus. index. (Publications de l'École Française d'Extrême-Orient, volume XXXV).

Comprehensive history of art and architecture in Laos. Following introductory chapters is a thorough geographical inventory of the major sites. Summary takes the form of a general survey of the historical development of Laotian art and architecture. Bibliography (pp. 347-48) lists books and periodical articles. Glossary of Laotian terms. A standard work.

INDONESIA

- Bernet Kempers, August J. Ancient Indonesian Art. Cambridge, Harvard University Press, 1959. 124p. (text); 353p. (illus.). LC 59-4979. Comprehensive study of art and architecture in Indonesia from mesolithic times through the early Islamic period (circa 1650). Brief introduction tracing the development is followed by an excellent corpus of illustrations, with detailed and informative notes. Provides an excellent but unclassified bibliography (pp. 109-114) of books and periodical articles in all languages. A standard history of Indonesian art and architecture.
- Bezemer, T. J. Indonesian Arts and Crafts. The Hague, Ten Hagen, 1931.
 168p. illus.
 Pictorial survey of Indonesian sculpture, painting, and decorative arts. No bibliography.
- Bodrogi, Tibor. Art of Indonesia. Greenwich, Conn., New York Graphic Society, 1972. 140p. (text); 157p. (illus.). LC 76-154331.
 Well-illustrated survey of the art and architecture of Indonesia from paleolithic times to the present. Provides a good bibliography (pp. 109-115) listing books and periodical articles in all languages. A good survey history of Indonesian art for the general reader.
- Holt, Claire. Art in Indonesia: Continuities and Change. Ithaca, New York, Cornell University Press, 1967. 355p. illus. index. LC 66-19222. Concise history of art and architecture in Indonesia from prehistoric times to the modern age. Discussion of the legends and literature expressed in the fine arts of

Indonesia are discussed in the appendices. Bibliography (pp. 331-38) is an unclassified list of books chiefly in English.

- Jasper, J. E., and Mas Pirngadie. De inlandsche kunstnijverheid in Nederlandsch-Indie. The Hague, Mouton, 1912-1930. 5v. illus. index.
 Comprehensive handbook of the arts and crafts of Indonesia. Contents: I, Het Vlechtwerk (1912); II, De Weefkunst (1912); III, De Batikkunst (1912); IV, De Goud en Zilversmeed Kunst (1930); V, De Bewerking van Niet-edele Metalen (1930). Extensive treatment of techniques and materials. Bibliographical footnotes. A standard work.
- Loèber, Johannes. Geillustreerde beschrijvingen van indische kunstnijverheid. Amsterdam, J. H. de Bussy, 1903-1916. 8v. illus.

 Early illustrated handbook of the arts and crafts of Indonesia. Contents: 1, Het weven in Nederlandsch-Indie; 2, Bamboe in Nederlandsch-Indie; 3, Het schelpenen-Kratenwerk in Nederlandsch-Indie; 4, Het bladwerk en zijn versiering in Nederlandsch-Indie; 5, Textiele versieringen in Nederlandsch-Indie; 6, Leder-en perkamentwerk, schorsbereiding en aardewerk in Nederlandsch-Indie; 7, Beenhoornen schildpadbewerking en het vlechtwerk in Nederlandsch-Indie; 8, Houtsnijwerk en metaalbewerking in Nederlandsch-Indie.
- Wagner, Frits A. Indonesia: The Art of an Island Group. New York, McGraw-Hill, 1959. 256p. illus. index. LC 59-13943.
 History of art and architecture in Indonesia from the neolithic age through the twentieth century. Excellent chapters on the impact of Indian and Islamic culture on the culture of Indonesia precede the discussion of the major epochs of Indonesian art and architecture. Provides a useful glossary, a chronological table, and a bibliography (pp. 243-45) of books and periodical articles in all languages. An excellent history of Indonesian art and architecture for beginning and advanced students.

THAILAND

Döhring, Karl S. Kunst und Kunstgewerbe in Siam. Berlin, Band, 1925. 2v. illus.

Pictorial survey of art in Thailand, with emphasis on works in lacquer. Volume of text and volume of plates. No bibliography.

Le May, Reginald S. A Concise History of Buddhist Art in Siam. 2nd ed. Rutland, Vt., Tuttle, 1963. 169p. illus. LC 62-18359.
Originally published in 1938, this is a survey history of art and architecture in Thailand from the Dvāravatī period through the schools of Lopburi and Ayadhya. Bibliography (pp. 155-57) lists major books and periodical articles in all languages.

FAR EAST

GENERAL WORKS

Fontein, Jan, and Rose Hempel. China, Korea, Japan. Berlin, Propyläen, 1968. 362p. (text); 256p. (illus.). index. (Propyläen Kunstgeschichte, Band 17). LC 70-426900.

Comprehensive, illustrated handbook of art and architecture of China, Japan, and Korea from 1000 B.C. to the middle of the nineteenth century. Introductory essays on the development of the various arts in the three countries are followed by an excellent corpus of plates. The very informative notes also supply bibliographical references to specialized literature. The volume concludes with an excellent comprehensive bibliography (pp. 318-37) of books and periodical articles in all languages and a thorough chronological table that coordinates artistic events in the three countries with philosophical, political, religious, and general cultural happenings. The standard illustrated handbook of Far Eastern art.

Kümmel, Otto. Die Kunst Chinas, Japans und Koreas. Wildpark-Potsdam, Athenaion, 1929. 198p. illus. index.

Concise history of art and architecture in China, Japan, and Korea from prehistoric times to the Ching and Tokugawa periods. Bibliography is given at the end of the chapters. An old, but scholarly history, still of interest to the advanced student. Part of the series, "Handbuch der Kunstwissenschaft."

Munsterberg, Hugo. Art of the Far East. New York, Abrams, 1971. 264p. illus. index. LC 68-26866.

Survey history of art and architecture in China, Korea, and Japan from prehistoric times to the present. Well-chosen illustrations but no plans for the architectural examples. Bibliography (pp. 260-62) lists books in all languages.

Shoten, Kadokawa, ed. A Pictorial Encyclopedia of the Oriental Arts. New York, Crown, 1969. 7v. illus. LC 70-93408.

Illustrated handbook of Far Eastern art and architecture, divided by country; two volumes are devoted to China, four to Japan, and one to Korea. Provides broad essays on periods of art and architecture, followed by an extensive collection of plates. No bibliographies. A useful collection of illustrations.

CHINA

- 1522 Arts of China. Tokyo, Kodansha International, 1968-1970. 3v. illus. index. Illustrated history of Chinese art and architecture, with emphasis on discoveries since the Second World War. Volume 1: Neolithic Cultures to the T'ang Dynasty, by T. Akiyama, et al.; volume two: Buddhist Cave Temples; Recent Discoveries, by T. Akiyama; volume three: Paintings in Chinese Museums; New Collections, by Y. Yonezawa and M. Kanakita.
- 1523 Ashton, Leigh, and Basil Gray. Chinese Art. London, Faber, 1935. 375p. illus. index.

Concise history of art, exclusive of architecture, in China from the pre-Han period (3000 B.C.) to the end of the Ching dynasty. Emphasis is on the minor arts. Bibliography (pp. 360-62) lists major books in English. An old, but valuable survey by leading English scholars. For the beginning student and the collector.

Bachhofer, Ludwig. A Short History of Chinese Art. New York, Pantheon, 1946. 139p. illus. index.

Concise history of art and architecture in China from the neolithic period through the eighteenth century. Bibliography is provided in the form of notes to the text (pp. 129-31).

Buhot, Jean. Chinese and Japanese Art, with Sections on Korea and Vietnam. New York, Praeger, 1967. 428p. illus. index. LC 67-9244.

Concise history of Chinese and Japanese art and architecture with briefer sections on Korea and Vietnam from prehistoric times through the eighteenth century. Classified bibliography (pp. 335-43), mostly of works in French.

Fenollosa, Ernest F. Epochs of Chinese and Japanese Art: An Outline History of East Asiatic Design. New and rev. ed. with copious notes by Professor Petrucci. New York, Dover, 1963. 2v. illus. LC 63-5655.

Reprint of the 1921 edition, first published in 1912. Concise history of art and architecture in China and Japan from prehistoric times through the nineteenth century. Provides a glossary of proper names and some bibliographical references in the footnotes. Early pioneering history of Far Eastern art.

1527 Grousset, René. Chinese Art and Culture. New York, Orion Press, 1959. 331p. illus. index. LC 59-13323.

Translation of *La Chine et son art* (Paris, Plon, 1951). Concise history of art and architecture in China from prehistoric times through the Ching dynasty. Sets the arts within the development of Chinese culture. Bibliographical footnotes. A good introduction to Chinese art and its cultural context for the general reader and the beginning student.

1528 Jenyns, R. Soame, ed. Chinese Art. New York, Universe, 1960-1965. 4v. illus. LC 60-12415.

Illustrated handbook of Chinese art, exclusive of architecture, covering the period from neolithic times to the end of the Ching dynasty. The volumes consist of a brief introductory essay followed by a good collection of plates. Bibliographies are given at the end of volumes 1, 3, and 4. Contents:

Vol. 1, Lion, Daisy, and Jean Claude Moreau-Gebard. Bronze, Jade, Sculpture, Ceramics (1960)

Vol. 2, Watson, William, and R. Soame Jenyns. Gold, Silver, Bronze, Cloisonné, Cantonese Enamel, Lacquer, Furniture, Wood (1962)

Vol. 3, Speiser, Werner, Roger Goeppe, and Jean Fribourg. *Painting, Calligraphy, Stone Rubbing, Wood Engraving* (1964)

Vol. 4, Jenyns, R. Soame. Textiles, Glass and Painting on Glass, Carvings in Ivory and Rhinoceros Horn, Carvings in Hardstones, Snuff Bottles, Inkcakes and Inkstones (1965).

Good collection of plates for the collector and advanced student.

Medley, Margaret. A Handbook of Chinese Art for Collectors and Students. London, G. Bell, 1964. 140p. illus. index. LC 64-54900. Repr.: New York and Evanston, Harper & Row, n.d. LC 74-6765.

Dictionary handbook of Chinese art, exclusive of architecture. Sections cover bronzes, ceramics, decoration, jade and hardstones, and painting. Each section has a brief introduction and a dictionary of terms. Brief bibliographies at the end of each section list books in English. General bibliography (pp. 131-32) lists books in English. Appendix lists societies devoted to the study of Chinese art and culture and chief collections of Chinese art. Useful handbook for the beginning student and the collector.

Munsterberg, Hugo. The Arts of China. Rutland, Vt., Tuttle, 1972. 234p. illus. index. LC 70-188012.

Concise history of art and architecture in China from prehistory through the Ching period. Bibliography (pp. 221-23) lists major books in English.

Munsterberg, Hugo. A Short History of Chinese Art. New York, Greenwood, 1969. 225p. illus. index. LC 70-88990.

Reprint of 1949 edition. General history of Chinese art and architecture from prehistoric times through the Ching dynasty. Bibliography (pp. 213-17) lists major works in English.

Prodan, Mario. Chinese Art: An Introduction. New York, Pantheon, 1958. 220p. illus. index. LC 58-11711.

Concise history of Chinese art, exclusive of architecture, from prehistoric times through the Ching dynasty. Chapters on bronzes, ceramics, sculpture, painting, ivories, jade, lacquer, textiles, and jewelry. Bibliography (pp. 209-213) is a classified list of books in all languages. A sensitively written survey for the general reader and the collector.

Rivière, Jean R. El arte de la China. Madrid, Espasa-Calpe, 1966. 626p. illus. index. (Summa Artis, Historia General del Arte, XX). LC NUC67-61954.

Comprehensive history of art and architecture in China from prehistoric times to the end of the Manchu dynasty. Good coverage of the applied and decorative arts. No bibliography.

Sickman, Laurence C. S., and Alexander Soper. The Art and Architecture of China. 3rd ed. Harmondsworth, Penguin, 1968. 350p. illus. index. LC 75-422837. (Pelican History of Art, Z10).

Comprehensive history of art and architecture (treated in separate sections) of China from prehistoric times to the early twentieth century. Excellent selection of plates, maps, plans, and diagrams. Two-part bibliography (pp. 327-34) lists major works in all languages, with an additional note on works that have appeared since the first edition. Further reference to specialized literature is found in the extensive footnotes. Useful glossary of terms. The standard history of Chinese art and architecture.

1535 Silcock, Arnold. Introduction to Chinese Art and History. New York, Oxford University Press, 1948. 256p. illus. index.

Concise survey of Chinese art and architecture cast within the general historical development of the country. Provides maps, chronological table of events in China and the West, guide to the pronunciation of Chinese names, and a brief bibliography listing major books and periodicals in English (pp. 244-46). Still a useful survey for the general reader.

1536 Sirén, Osvald. A History of Early Chinese Art. London, Benn, 1929-30. 4v. illus. index.

Comprehensive history of art and architecture in China through the T'ang dynasty. Contents of vol. I: Prehistoric Introduction; the Yin Period; the Chou Period; the Ch'u and Ch'in Period; vol. II: The Han Period; the Chin and Six Dynasties Period; vol. III: Sculpture; vol. IV: Architecture. Bibliographical footnotes. An older, standard work.

1537 Smith, Bradley, and Wan-go Weng. China: A History in Art. Garden City, N.Y., Doubleday, 1973. 296p. illus. index. LC 72-76978.

Elaborately illustrated cultural history of China from ancient times to the present, as illustrated in works of art and architecture. Bibliography, (pp. 293-94) lists books in English and Chinese.

Speiser, Werner. **The Art of China: Spirit and Society.** New York, Crown, 1961. 258p. illus. index. LC 61-10700.

Survey history of art and architecture in China from the Shang dynasty to the twentieth century. Provides glossary of terms, chronological table, and bibliography (pp. 247-48) of books in all languages (those works that have bibliographies are singled out).

Sullivan, Michael. The Arts of China. Rev. ed. Berkeley and Los Angeles, University of California Press, 1977. 286p. illus. index. LC 76-44639. New edition of the author's *A Short History of Chinese Art* (1967). Concise history of the art and architecture of China from prehistory through the twentieth century. Good selection of plates, useful chronological table, and bibliography (pp. 271-73) of major works in English. An excellent survey history for the general reader and the beginning student.

Sullivan, Michael. Chinese and Japanese Art. New York, Franklin Watts, 1965. 302p. illus. index. LC 65-10271.

A concise history of Chinese and Japanese painting, sculpture, and architecture. Includes an interesting section on influences. Illustrated with color plates and black and white illustrations. A good introduction for beginning students and general readers.

Swann, Peter C. Art of China, Korea and Japan. New York, Praeger, 1963. 285p. illus. index. LC 63-18836.

Concise survey of the art and architecture of the Far East from circa 1550 B.C. to the present. Bibliography (pp. 274-81) lists books in English.

Watson, William. Style in the Arts of China. New York, Universe, 1975. 126p. illus. index. LC 74-193821.

Concise history of art and architecture in China from prehistoric times through the nineteenth century. Brief text with emphasis on stylistic development. Good selection of plates with informative, descriptive captions. Brief bibliography of books in all languages. Series: "Universe History of Art."

1543 Willetts, William. Chinese Art. London, Penguin, 1958. 2v. illus. index. LC 59-12349.

History of art and architecture in China from prehistoric times to the present. After an introduction that covers the geography of China and that provides a short history of the country, there are chapters on prehistoric civilization. The rest of the work is divided into sections on the major media. Bibliographical references are in the footnotes. A good history of Chinese art and architecture, in part superseded by the author's later work (1544).

Willetts, William. Foundations of Chinese Art from Neolithic Pottery to Modern Architecture. New York, McGraw-Hill, 1965. 456p. illus. index. LC 64-66127.

Illustrated history of art and architecture in China from the neolithic to the present. The text is a revised, abridged, and extensively rewritten version of the author's *Chinese Art* (London, Penguin, 1958. 2v.). Provides a very good selection of plates, plans, and diagrams and a good classified bibliography (pp. 437-41). A good survey history of Chinese art and architecture for beginning and advanced students.

JAPAN

Abbate, Francesco, ed. Japanese and Korean Art. London and New York, Octopus, 1972. 158p. illus. LC 72-17182.

Pictorial survey of the art and architecture of Japan and Korea from the seventh century A.D. to the beginning of the twentieth century. All illustrations are in color, but some are poorly reproduced. Inadequate one-page bibliography.

1546 Arts of Japan. Vol. 1—. New York and Tokyo, Weatherhill/Shibundo, 1972—. illus.

Pictorial survey of the pictorial and applied and decorative arts of Japan. Each volume is topical and written by a Japanese expert on the subject. To date, the following have appeared:

- 1, Design Motifs
- 2, Kyoto Ceramics
- 3, Tea Ceremony Utensils
- 4, The Arts of Shinto
- 5, Narrative Picture Scrolls
- 6, Meiji Western Painting
- 7, Ink Painting

Some have been adapted from the original Japanese series (Nihon no Bijutsu) by individual translators. No bibliographies.

Boger, H. Batterson. The Traditional Arts of Japan: A Complete Illustrated Guide. Garden City, N.Y., Bonanza, 1964. 351p. illus. index. LC 64-11726. Comprehensive survey of the many arts of Japan, including painting, sculpture, architecture, landscape design, floral arrangement, tea ceremony and ceremonial objects, pottery, porcelain, lacquerware, and others. Generously illustrated with black and white illustrations plus a color plate section. Includes maps, chronological outline, and a bibliography (pp. 339-40). A good, sensitive survey for beginning and advanced students.

Buhot, Jean. Histoire des arts du Japon. I. Des origines à 1350. Paris, Vanoest, 1949. 270p. illus. index. (Annales du Musée Guimet, Nouv. série, V).

Comprehensive and scholarly history of the art and architecture of Japan from prehistoric times to 1350. Provides good selection of plates, diagrams, and maps, with thorough reference to specialized literature in the extensive footnotes. A standard history of early Japanese art and architecture.

Gutiérrez, Fernando G. El arte de Japòn. Madrid, Espasa-Calpe, 1967.
 567p. illus. index. (Summa Artis, Historia General del Arte, XXI).
 LC NUC68-44791.

Comprehensive history of art and architecture in Japan from pre-Buddhist times to 1926. Glossary of technical terms in Japanese and bibliography of basic books (pp. 547-48).

Heibonsha Survey of Japanese Art. Vol. 1—. New York and Tokyo, Weatherhill, 1972—. illus.

Comprehensive history of Japanese art, architecture, and the applied arts, consisting of volumes devoted to specific subjects. To date, the following have appeared:

- 1, Major Themes in Japanese Art
- 2, The Beginnings of Japanese Art
- 3, Shinto Art: Ise and Izumo Shrines
- 4, Asunka Buddhist Art
- 5, Nara Buddhist Art
- 6, The Silk Road and Shoso-in
- 7, Temples of Nara and Their Art
- 8, Art in Japanese Esoteric Buddhism
- 9, Heian Temples: Byodo-in and Chuson-ji
- 10, Painting in the Yamato Style
- 11, Sculpture of the Kamakura Period
- 12, Japanese Ink Painting; Shubun to Sesshu
- 13, Feudal Architecture of Japan
- 14, Momoyama Decorative Painting
- 15, Japanese Arts and the Tea Ceremony
- 16, Japanese Costume and Textile Arts
- 17, Momoyama Genre Painting
- 18, Edo Painting: Sotatsu and Korin
- 19, The Namban Art of Japan
- 20, Edo Architecture
- 21, Traditional Domestic Architecture

- 22, Traditional Woodblock Prints of Japan
- 23, Japanese Painting in the Literati Style
- 24, Modern Currents in Japanese Art
- 25, Japanese Art in World Perspective
- 26, Folk Arts and Crafts of Japan
- 27, The Art of Japanese Calligraphy
- 28, The Garden Art of Japan
- 29, The Art of Japanese Ceramics

Each volume is written by a Japanese expert and contains bibliographical references.

Newman, Alexander R., and Egerton Ryerson. Japanese Art: A Collector's Guide. London, Bell, 1964. 271p. illus. index. LC 65-83470.

Handbook of Japanese art containing chapters on various media (books, ceramics, clocks, etc.) and a section on Japanese dating and periods of art history. Good bibliographies are provided at the end of chapters and sections. A good guide to Japanese art, especially the minor arts of interest to collectors.

Noma, Seiroku. The Arts of Japan. Tokyo, Kodansha International, 1966-67. 2v. illus. LC 65-19186 rev.

Illustrated history of art and architecture in Japan from prehistory to the present day. Vol. I: *Ancient and Medieval*; vol. II: *Late Medieval to Modern*. Short essays sketch the development of art and architecture by periods; there are excellent color plates with informative captions. A bibliography of works in English is at the end of each volume. An excellent survey for the general reader.

- The Pageant of Japanese Art. Tokyo, Toto Bunka, 1957-1958. 6v. illus. Comprehensive history of Japanese art and architecture to the early twentieth century. Contents: v. 1-2, Painting; v. 3, Sculpture; v. 4, Ceramics and Metalwork; v. 5, Textiles and Lacquer; v. 6, Architecture and Gardens. Each volume contains a text tracing the development of the medium, a collection of plates with descriptive notes, a glossary of Japanese terms, and explanatory drawings and diagrams. No bibliography.
- Paine, Robert T., and Alexander C. Soper. Art and Architecture of Japan. 2nd ed. London, Penguin, 1974. 328p. illus. index. (Pelican History of Art, Z8). LC 74-186336.

Comprehensive and scholarly history of art and architecture in Japan from the archaic period to the mid-nineteenth century. Excellent selection of plates, glossary, maps, diagrams, and plans. Bibliography (pp. 293-306) is divided into sections on architecture and art; the first part lists only books in English, while the second part has sections for books in Western languages and those in Japanese. Thorough reference to more specialized literature in the extensive footnotes. The standard history of Japanese art and architecture in English.

Smith, Bradley. Japan. A History in Art. Garden City, Coubleday, 1964. 295p. illus. LC 64-21410.

Elaborately illustrated cultural history of Japan from the earliest times to the present. One-page bibliography of general books in English.

1556 Swann, Peter C. An Introduction to the Art of Japan. Oxford, Cassirer, 1958. 220p. illus. index. LC 58-12088.

Concise history of the art, exclusive of the architecture, of Japan from prehistoric times to the Edo period. Bibliography (p. 216) lists books in English.

1557 Swann, Peter C. The Art of Japan: From Joman to the Tokugawa Period. New York, Crown, 1966. 238p. illus. index. LC 66-22128.

Concise history of art and architecture in Japan from neolithic times to the midnineteenth century. Good selection of color plates, modest supplement of black and white plates; liberally provided with plans and diagrams. Provides useful maps, a chronological table, and a bibliography (pp. 226-28) that lists major works in all languages.

Tsuda, Noritake. Handbook of Japanese Art. Tokyo, Sanseido, 1935. 525p. illus. index.

History and handbook of Japanese art and architecture covering the period from prehistoric times to the twentieth century. Text is arranged by periods. Part II provides a useful topographical guide to temples and museums in Japan. Bibliography (pp. 505-508) lists only books in English. An older history, still useful to the advanced student.

1559 Tsudzumi, Tsuneyoshi. Die Kunst Japans. Leipzig, Insel, 1929. 341p. illus. index.

Comprehensive history of art and architecture in Japan from a poetic and aesthetic point of view. Contents: Einleitung; Die Rahmenlosigkeit als Grundbegriff des Japanischen Kunststils; Kunst der Naturgestaltung; Religiöse Kunst; Kunst der Lebengestaltung. No bibliography. Important contribution towards the definition of national character in Japanese art history, albeit from a nationalistic vantage point.

Warner, Langdon. The Enduring Art of Japan. Cambridge, Mass., Harvard University Press, 1952. 125p. illus. index.

Concise history of Japanese art and architecture from 794 to circa 1750. Consists of chapters on the major periods of Japanese art and architecture. Bibliography (pp. 111-13) provides a list of major books in English. A useful introduction to the broad outlines of Japanese art history.

1561 Yashiro, Yukio, ed. **Art Treasures of Japan**. Tokyo, Kokusai Bunka Shinkokai, 1969. 2v. illus. LC 63-2165.

Illustrated handbook of Japanese art, exclusive of architecture, from prehistoric times to the present. Consists of essays on the various periods by Japanese specialists, followed by an excellent corpus of illustrations with descriptive notes. Provides a useful chronological chart of the periods of Oriental art history. A standard handbook of Japanese art.

1562 Yashiro, Yukio. 2000 Years of Japanese Art. New York, Abrams, 1958. 268p. illus. index. LC 58-13478.

Illustrated survey of the art of Japan from prehistoric times to the present, exclusive of architecture. The introductory essay, which characterizes the chief epochs

of Japanese art, is followed by a collection of excellent plates with informative captions. No bibliography. A good survey for the general reader.

KOREA

Eckardt, Andreas. A History of Korean Art. London, Goldston, 1929. 225p. illus. index.

Concise history of art and architecture in Korea from earliest times to the twentieth century. A bibliography is given at the beginning of each section. An older survey history of Korean art and architecture.

1564 Kim, Chae-won. Treasures of Korean Art: 2000 Years of Ceramics, Sculpture and Jeweled Arts. New York, Abrams, 1966. 283p. illus. index. LC 66-23402.

Illustrated history of sculpture and the minor arts in Korea from prehistoric times to the middle of the nineteenth century. Bibliography (pp. 261-63) is an unclassified list of major works; further literature is mentioned in the notes to the text. Excellent illustrations, and good (if brief) text. A good survey of the arts of Korea for the beginning student and the collector.

McCune, Evelyn. The Arts of Korea: An Illustrated History. Tokyo and Rutland, Vt., Tuttle, 1961. 452p. illus. index. LC 61-11122.
 Concise history of the art and architecture of Korea from prehistoric times through the pineteenth century. Good selection of illustrations, abronalogical table and

the nineteenth century. Good selection of illustrations, chronological table, and brief but well-selected bibliography (pp. 439-42). A standard history of Korean art and architecture.

CHAPTER ELEVEN NEW WORLD ART

PRE-COLUMBIAN AMERICA

GENERAL WORKS

Anton, Ferdinand, and Frederick J. Dockstader. Pre-Columbian Art and Later Indian Tribal Arts. New York, Abrams, 1968. 264p. illus. index. LC 68-11509.

Survey of the art and architecture of pre-Columbian Mexico, Central and South America, and the later tribal arts of the North American Indian. Good choice of illustrations. Bibliography (pp. 258-61) lists books in all languages.

Bushnell, G. H. S. Ancient Arts of the Americas. New York, Praeger, 1965. 287p. illus. index. LC 65-20077.

Concise history of the arts of pre-Columbian civilizations of North and South America. Emphasis is on the ancient civilizations of Mexico, Central America, and northern South America, with only brief mention of North American Indian art. Good selection of plates, with maps, a chronological table, and a bibliography (pp. 267-68) of works in English.

Disselhoff, Hans-Dietrich, and Sigvald Linné. The Art of Ancient America: Civilizations of Central and South America. New York, Crown, 1966. illus. index. LC 61-16973.

Concise history of pre-Columbian art and architecture covering Mexico, Central America, the Andean lands, greater Peru, Colombia, and San Agustín from prehistory to the Spanish Conquest. Provides useful chronological tables, glossary of terms, good selection of color plates, and modest supplement of black and white plates. Bibliography (pp. 263-66) lists books and periodical articles in all languages. A good survey of pre-Columbian art and architecture for the beginning student.

Emmerich, André. Art before Columbus. New York, Simon and Schuster, 1963. 256p. illus. index. LC 63-16027.

Pictorial survey of the art and architecture in Latin America from the second millennium B.C. to the Spanish Conquest. The brief text is accompanied by a good selection of color and black and white plates. Provides a useful glossary of terms and a good bibliography (pp. 245-47) of books in all languages.

1570 Kelemen, Pál. Art of the Americas, Ancient and Hispanic, with a Comparative Chapter on the Philippines. New York, Crowell, 1969. 402p. illus. index. LC 72-87163.

Concise history of art and architecture in Central and South America from prehistoric times through the Colonial period. Contains a chapter on art and architecture in the Colonial Philippines. Provides maps, a good selection of plates, and a bibliography (pp. 359-61) that lists books and periodical articles in English.

1571 Kelemen, Pál. Medieval American Art. New York, Macmillan, 1943; repr. New York, Dover, 1969. 2v. illus. index.

Comprehensive history of the art and architecture of Mexico, Central America, and the Andean region of South America from circa 100 A.D. to the Spanish Conquest. Good selection of plates, plus maps, plans, diagrams, and a chronological table. Bibliography (pp. 385-405) is an unclassified list of books and periodical articles. A dated, but classic treatment of pre-Columbian art and architecture.

1572 Kubler, George. Art and Architecture of Ancient America. 2nd ed. London, Penguin, 1976. 421p. illus. index. (Pelican History of Art, Z21). LC 77-352362.

Comprehensive history of art and architecture in pre-Columbian South and Central America. Covers the civilizations of the Mexican, Mayan, and Andean regions from 1500 B.C. to the Spanish Conquest. Provides good selection of plates, maps, plans, diagrams, and an excellent bibliography (pp. 385-402) that lists the major books and periodical articles in all languages. A standard, scholarly history of ancient American art and architecture.

Lapiner, Alan. Pre-Columbian Art of South America. New York, Abrams, 1976. 460p. illus. LC 75-1016.

Illustrated handbook of art and architecture in Peru, Ecuador, Colombia, Venezuela, Bolivia, Argentina, Chile, and Brazil before the Spanish Conquest. Chronological tables, maps, glossary and bibliography of books and periodical articles in all languages (pp. 455-59).

Lothrop, S. K. Treasures of Ancient America: The Arts of the Pre-Columbian Civilizations from Mexico to Peru. Geneva, Skira, 1964. 230p. illus. index. LC 64-23255.

Pictorial survey of the art (exclusive of the architecture) of the ancient civilizations of Mexico, Central America, and the Andean region of South America, from pre-Classical times to the Spanish Conquest. The brief text is accompanied by excellent color plates and commentaries. No bibliography.

- Pijoán y Soteras, José. Arte precolombiano Mexicana y Maya. Madrid, Espasa-Calpe, 1946. 606p. (Summa Artis, Historia General del Arte, X). Comprehensive history of art and architecture in pre-Columbian Mexico and Central America. Chapters are devoted to individual sites. Bibliography (pp. 585-87) lists general books in all languages.
- Willey, Gordon, ed. Das Alte America. Berlin, Propyläen, 1974. 392p. text, 228 plates. (Propyläen Kunstgeschichte, XVIII). LC 75-568149.

Comprehensive, illustrated handbook of pre-Columbian art and architecture. Introductory essays by various experts examine the development in major regions and are followed by a good corpus of plates with descriptive notes containing specialized bibliographies. Bibliography (pp. 367-85) is an excellent classified list of books and periodical articles in all languages.

MESOAMERICA AND MEXICO

1577 Anton, Ferdinand. Ancient Mexican Art. New York, Putnam, 1969. 309p. illus. index. LC 77-75212.

Illustrated history of art and architecture in Mexico from circa 1500 B.C. to the Spanish Conquest. Brief introductory essay is followed by a good selection of plates and commentaries. Provides a useful chronological table, a map, and a bibliography (pp. 299-301) that lists books and periodical articles in all languages. Good survey history for the general reader and beginning student. Plates form a valuable handbook for the advanced student.

1578 Anton, Ferdinand. Die Kunst der Goldländer zwischen Mexiko und Peru. Leipzig, Seemann, 1974. 314p. illus. LC 75-528638.

Illustrated handbook of the art, exclusive of architecture, of pre-Columbian Nicaragua, Costa Rica, Panama, northern Colombia and Venezuela, and pre-Inca Ecuador. Chronological table and bibliography of basic books in all languages (pp. 313-14).

1579 Covarrubias, Miguel. Indian Art of Mexico and Central America. New York, Knopf, 1957. 360p. illus. index. LC 57-59203.

History of the art and architecture of the pre-Columbian civilizations of Mexico and Central America, from the Olmec empire through the Aztec empire. Bibliography (pp. 335-60) lists books and periodical articles. Somewhat out of date, but still useful for the advanced student.

Dockstader, Frederick J. Indian Art in Middle America. Greenwich,
Conn., New York Graphic Society, 1964. 221p. illus. LC 64-21815.

Illustrated handbook of the arts of Central America from earliest times to the present. Covers the ancient cultures of the Aztecs and Mayas as well as the arts of present-day Indians in Central America. Brief introduction sketches the history of art, followed by more detailed comments on the excellent plates. There are maps, a chronological table, and a bibliography (pp. 217-21). Text is directed to the general reader and the beginning student. Plates, especially when combined with the other works by Dockstader (1587, 1591), form a valuable illustrated handbook of Indian art for the advanced student.

Feuchtwanger, Franz. Art of Ancient Mexico. London and New York, Thames and Hudson, 1954. 125p. illus. index.

Pictorial survey of the art and architecture of ancient Mexico from 1521 B.C. to 1500 A.D. Brief text with good plates, a map, and a chronological table. No bibliography.

Medioni, Gilbert. Art Maya du Mexique et du Guatémala. Paris, Éditions de la Cyme, 1950. 113p. illus.

Scholarly history of art and architecture of the ancient Mayas. Excellent maps, detailed chronological tables, and a bibliography (pp. 109-112).

Spinden, Herbert J. A Study of Maya Art. Its Subject Matter and Historical Development. Cambridge, Mass., Peabody Museum, 1913. 285p. illus. index. Reprint: ("With introduction and bibliography by J. E. S. Thompson") New York, Dover, 1975. 285p. illus. index. LC 74-20300.

An old, standard handbook of Maya art and architecture. Contents: Introduction; I, General Consideration of Maya Art—the Human Form, the Serpent, the Serpent and Geometric Art, the Serpent in Some of Its Religious Aspects, Other Subjects; II, Consideration of the Material Arts—Architecture, Minor Arts; III, Chronological Sequence; Table of Nomenclature. Bibliography (pp. 263-76) is a list of works cited in the 1913 edition. Bibliography by Thompson in reprint consists of brief list of works by Spinden at end of biographical introduction.

Toscano, Salvador. Arte Pre-Columbino de México y de la América Central. 2nd ed. Mexico City, Inst. de Invest. Estéticas, 1952. 2v. illus. index. Comprehensive history of art and architecture of pre-Columbian Mexico and Central America from circa 1500 B.C. to the Spanish Conquest. Good bibliographies are given at the end of the chapters. An older but standard history of ancient Maya and Aztec art and architecture.

Winning, Hasso von. **Pre-Columbian Art of Mexico and Central America**. New York, Abrams, 1968. 388p. illus. LC 65-13065.

Illustrated history of art and architecture in Mexico and Central America from circa 1500 B.C. to the Spanish Conquest. Brief text sketching the history of art and architecture is accompanied by excellent plates, commentaries on the plates, chronological tables, maps, and a bibliography (pp. 386-88), which lists books and periodical articles in all languages. A well-illustrated and concise survey for the general reader.

SOUTH AMERICA

1586 Anton, Ferdinand. Alt Peru und seine Kunst. Leipzig, Seemann, 1962. 127p. illus. LC 62-47873.

Pictorial survey of the art and architecture of ancient Peru from 3000 B.C. to 1500 A.D. Excellent plates, maps, brief unclassified bibliography (pp. 99-100) of books and periodical articles in all languages. Further literature is mentioned in the footnotes.

Dockstader, Frederick J. Indian Art in South America: Pre-Columbian and Contemporary Arts and Crafts. Greenwich, Conn., New York Graphic Society, 1967. 222p. illus. LC 67-19372.

Illustrated handbook of the arts and crafts of the Indian societies of South America from earliest times to the present. Includes ancient Inca civilizations. Brief introduction, commentaries on the excellent plates, maps, chronological table, and bibliography (pp. 219-22). Text is directed to the general reader and the

beginning student. Especially when combined with the other works by Dockstader (1580, 1591), the plates form a valuable illustrated handbook of Indian art for the advanced student.

Lehmann, Walter, and Heinrich Ubbelohde-Doering. The Art of Old Peru. 2nd ed. London, Benn, 1957. 68p. (text); 128p. (illus.). Reprint: New York, Hacker, 1975.

Illustrated survey of pre-Columbian art and architecture with a brief introduction and notes to the good plates. Bibliography (pp. 66-68) lists major works in all languages. First published in 1924. Once a standard work, it is now out of date in several respects; nevertheless, it is still a valuable collection of plates.

1589 Ubbelohde-Doering, Heinrich. The Art of Ancient Peru. New York, Praeger, 1952. 240p. illus. LC 52-7489.

Illustrated survey of the arts of ancient Peru. A brief introductory essay sketching the history of ancient Peruvian art is followed by a good selection of plates and a bibliography (pp. 53-55) that lists books and articles in all languages. Still useful for its plates.

NORTH AMERICAN INDIAN

1590 Covarrubias, Miguel. The Eagle, the Jaguar, and the Serpent: Indian Art of the Americas. New York, Knopf, 1954. 314p. illus. index. LC 52-6415.

History-study of the arts of the North American Indians covering Alaska, Canada, and the United States. Chapters sketch the history of North American Indian art, discuss its techniques and aesthetics, and describe the various Indian societies. Bibliography (pp. 298-314) is an unclassified list of:books and periodical articles in English. An older, classic study of Indian art, still useful to the advanced student.

- Dockstader, Frederick J. Indian Art in America. 3rd ed. Greenwich, Conn., New York Graphic Society, 1966. 224p. illus. LC NUC67-88306.
 Survey of the arts of the North American Indian. Well illustrated, it also has a good bibliography (pp. 222-24), which lists books in all languages. A good pictorial survey for the general reader.
- 1592 Feder, Norman. American Indian Art. New York, Abrams, 1971. 446p. illus. LC 69-12484.

Illustrated survey of the arts of the North American Indian. Part I deals with the origins, materials, and techniques of the Indian artists; part II discusses the arts by culture areas. Covers Indians of the plains, the Southwest, California, the Northwest, the Eastern woodlands, and the Arctic coasts. Excellent plates and a good bibliography (pp. 439-46) that lists major books. A standard illustrated handbook.

1593 Feder, Norman. Two Hundred Years of North American Indian Art. New York, Praeger, 1971. 128p. illus. LC 70-176395.

Pictorial survey of the arts of the North American Indian based on an exhibition held at the Whitney Museum of American Art. Brief introduction discusses the Indian artists, the function of Indian art, and techniques and materials.

Well-illustrated. Provides a good but unclassified bibliography (pp. 121-24). For the general reader and the beginning student.

Haberland, Wolfgang. The Art of North America. New York, Crown, 1964. 251p. illus. index. LC 68-15660.

Survey of the arts of the Indians of the United States, Canada, Alaska, and Greenland. Initial chapters treat the Paleo-Indian art of North America; the rest of the work is devoted to an examination of the arts of the American Indian by region. Provides a useful group of five chronological tables, maps, and a good classified bibliography (pp. 212-20), which lists books and periodical articles in all languages. A good survey of North American Indian art for the general reader. Series: "Art of the World."

Vaillant, George C. Indian Arts in North America . . . New York and London, Harper, 1939. 63p. illus.

Survey of North American Indian art. Selected bibliography (pp. 55-63) is arranged by chapters and lists major books and periodical articles. An old, but solid introduction to American Indian art.

NATIONAL HISTORIES AND HANDBOOKS

LATIN AMERICA

General Works

Angulo Iñiguez, Diego, Enrique M. Dorta, and Mario J. Buschiazzo. Historia del arte Hispano-Americano. Barcelona, Salvat, 1945-56. 3v. illus. index.

Comprehensive history of art and architecture in Latin America from the time of the Spanish conquests to the present. Bibliographies are at the end of each volume. Well-illustrated. Standard history of Latin American art and architecture.

- 1597 Cali, Francis. L'art des conquistadors. Paris, Arthaud, 1960. 294p. illus. Pictorial survey of the art and architecture of Latin America from the conquests by the Spanish until the end of the eighteenth century. No bibliography.
- Castedo, Leopoldo. A History of Latin American Art and Architecture from Pre-Columbian Times to the Present. New York, Praeger, 1969. 320p. illus. index. LC 69-13421.

Survey history of art and architecture in Latin America from the ancient Toltecs to the present. Fine selection of plates and maps, and a good selected bibliography (pp. 297-99). A good survey of Latin American art and architecture for the general reader.

1599 Kelemen, Pál. Baroque and Rococo in Latin America. New York, Macmillan, 1951. 302p. illus. index.

History of art and architecture in Latin America during the colonial period (seventeenth and eighteenth centuries). Good selection of plates, although they are poorly reproduced; the excellent bibliography (pp. 286-94) lists books and

periodical articles in all languages. A somewhat out-of-date, but classic history of Colonial Latin American art and architecture.

Solá, Miguel. Historia del arte hispano-americano. Barcelona, Labor, 1935. 341p. (text); 51p. (illus.). index.

Concise history of art and architecture in colonial Latin America (sixteenth through eighteenth centuries). Good selection of poorly reproduced plates. Bibliography (pp. 331-34) lists chiefly Spanish books. This old, general history of colonial Latin American art and architecture is still a useful source of information.

Argentina

- Brughetti, Rommaldo. Historia de arte en Argentina. Mexico City, Pormaca, 1965. 223p. illus. (Colección Pormaca, 17). LC 67-38174.
 Concise survey of art and architecture in Argentina from pre-Hispanic times to the present. Nineteenth and twentieth centuries are treated in a series of chapters devoted to major artists. No bibliography.
- Pagano, José León. El arte de los argentinos. Buenos Aires, Edicion del Autor, 1937-1940. 3v. illus. index. LC 40-2745.

Comprehensive history of art and architecture in Argentina from prehistoric times to the early twentieth century. Contents: I, Desde los arborigenes el periodo de los organizadores; II, Desde la acción innovadora der "Nexus" hasta neustros dias; III, Desde la pintura en Córdoba hasta las expresiones mas recientes; pintura, escultura, gravado.

Pagano, José León. Historia del arte Argentino. Buenos Aires, L'Amateur, 1944. 507p. illus. index.

Concise history of art and architecture in Argentina from the pre-Hispanic aborigines to the present. Bibliography is found in the footnotes. A good general history of art and architecture in Argentina.

1604 Schiaffino, Eduardo. La pintura y la escultura en Argentina. Buenos Aires, Edicion del Autor, 1933. 418p. illus.

Survey of painting and sculpture in Argentina from the coming of the Spanish to the end of the nineteenth century. Bibliographical footnotes.

Brazil

Acquarone, Francisco. **Historia da arte no Brasil**. Rio de Janeiro, Mano, 1939. 276p. illus. LC 40-14555 rev.

Popular account of Brazilian painting and sculpture from colonial times until the 1930s. No bibliography.

Bardi, P. M. História da arte brasileira. Pintura, escultura, arquitetura, outras artes. Sao Paolo, Melhoramentos, 1975. 228p. illus. index. Pictorial history of fine and decorative arts in Brazil from prehistoric and primitive cultures to the present. No bibliography.

1607 Mattos, Anibal. Historia de arte brasileira. Bela Horizonte, Edicões Apollo, 1937. 2v. in 1.

History of art and architecture in Brazil. Contents: I, Das origens da arte brasileira; II, Arte colonial brasileira. No bibliography.

Colombia

Arbeláez-Camacho, Carlos, and F. Sebastian. El arte colonial en Colombia. Bogota, Sol y Luna, 1968. 223p. illus. LC 78-424470.

Survey history of architecture, sculpture, painting, furniture, and jewelry in Colombia from the sixteenth through the early nineteenth centuries. Bibliographical footnotes and general bibliography (pp. 209-233) lists books and periodical articles.

Barney, Cabrera Eugenio. Temas para la historia del arte en Colombia. Bogotá, Universidad Nacional de Colombia, 1970. 210p. illus. LC 72-317694.

Concise history of art and architecture in Colombia from 1500 to the present. Poor illustrations. Bibliography (pp. 142-43).

Cuba

1610 Castro, Martha de. **El arte en Cuba**. Miami, Ediciones Universal, 1970. 151p. illus. index. LC 72-19190.

Survey of art and architecture in Cuba from early colonial times to the present. Bibliographies are at the end of chapters.

Ecuador

Vargas, José Maria. El arte ecuatoriano. Puebla and Mexico City, Cajica, 1959. 581p. illus. index. LC 61-20250.

History of art and architecture in Ecuador from the sixteenth century through the nineteenth century. No bibliography. A standard history of Ecuadorian art and architecture.

Guatemala

1612 Chinchilla, Aguilar E. **Historia del arte en Guatemala 1524-1962: arquitectura, pintura y escultura.** 2nd ed. Guatemala City, Ministerio de Educacion Publica, 1965. 261p. illus. index. LC 63-59236.

Concise history of art and architecture in Guatemala from 1524 to 1962. Provides an unclassified bibliography (pp. 183-87).

1613 Diaz, Victor M. Las bellas artes en Guatemala. Guatemala City, Tipografia Nacional, 1934. 600p. illus.

History of art, architecture, theater, dance and music in Guatemala from early colonial times to the late nineteenth century. No bibliography.

Mexico

1614 Enciclopedia Mexicana del arte. Mexico City, Ediciones Mexicanas, 1950-1951. 15 parts. illus.

Collection of essays by various Mexican scholars on aspects of Mexican art and architecture from pre-Columbian times to the early twentieth century. Occasional bibliographical footnotes.

Fernandez, Justino. A Guide to Mexican Art, from its Beginning to the Present. Chicago, University of Chicago Press, 1969. 398p. illus. index. LC 69-16773.

Concise history of Mexican art and architecture from the time of the ancient Toltecs to the present. There are good bibliographies at the ends of the chapters. A good survey for the general reader.

Rojas, Pedro. The Art and Architecture of Mexico. London, Hamlyn, 1968. 71p. (text); 146p. (illus.). LC 79-379618.

Pictorial survey of the art and architecture of Mexico from 10,000 B.C. to the present. Provides a chronological table, a map, and notes to the plates. No bibliography.

Rojas, Pedro, ed. Historia general del arte mexicano. Mexico, Editorial Hermes, 1962-64. 3v. illus, index. LC 64-54702.

Comprehensive history of art and architecture in Mexico from pre-Columbian times to the present. Vol. I: Época Prehispánica, by R. Guerrero; vol. 2: Época Colonial, by P. Rojas; vol. 3: Época Moderna Y Contemporánea, by R. Tibol. There are extensive bibliographies at the end of each volume. Well illustrated. The standard history of Mexican art and architecture.

Smith, Bradley. Mexico: A History in Art. New York, Harper & Row, 1968. 296p. illus. index. Reprint: New York, Crowell, 1975. LC 75-6016.

Pictorial history of the art of Mexico, exclusive of architecture, from prehistoric times (1700 B.C.) to 1940. Well illustrated. Provides a bibliography (pp. 294-95) that lists major books.

Tablada, José L. Historia del arte en Mexico. Mexico City, "Aguilas," 1927. 255p. illus.

Concise history of art and architecture in Mexico from pre-Columbian times through the nineteenth century. No bibliography.

Toussaint, Manuel. Colonial Art in Mexico. Austin, Texas, University of Texas, 1967. 493p. illus. index. LC 66-15696.

Translation of Arte Colonial en México (Mexico City, 1962). Important, comprehensive history of art and architecture in Mexico from the Spanish Conquest to 1821. Extensive bibliography of books and periodical articles (pp. 461-76). A standard work.

Westheim, Paul, et al. Prehispanic Mexican Art. New York, Putnam, 1972. 447p. illus. index. LC 70-142463.

Illustrated survey of art and architecture of Prehispanic Mexico. Contents: Artistic Creation in Ancient Mexico, by Paul Westheim; The Art of Ancient Mexico in Time and Space, by A. Ruz; Volume and Form in Native Art, by P. Armillas; Prehispanic Architecture, by R. de Robina; Painting in Mesoamerica, by A. Caso. Chronological table, site plans, maps and bibliography of prehispanic codices. Bibliography (397) lists books in all languages.

Peru

1622 Cossio del Pomar, Felipe. Arte del Perú colonial. Mexico City, Buenos Aires, Fondo de Cultura Economica, 1958. 153p. illus. index. LC 59-22919.

History of architecture and art in Peru from the sixteenth through the early nineteenth century. Bibliographies of specialized literature at the end of each chapter.

Wethey, Harold. Colonial Architecture and Sculpture in Peru. Cambridge, Mass., Harvard University Press, 1949. 317p. illus. index.

Scholarly study of architecture and sculpture in Peru during the sixteenth and seventeenth centuries. Bibliographical footnotes and bibliography of books and periodical articles (pp. 281-86). Catalogue of monuments in Lima (pp. 246-78).

Venezuela

1624 Calzadilla, Juan, ed. El arte en Venezuela. Caracas, Circulo Musical, 1967. 239p. illus. LC 67-98176.

Concise history of art and architecture in Venezuela from pre-Spanish aboriginal art to the present. Provides an appendix with biographies of artists and architects (pp. 196-239). No bibliography. The standard history of art and architecture for Venezuela.

UNITED STATES

Brown, Milton W. American Art to 1900. New York, Abrams, 1977. 631p. illus. index. LC 72-99241.

Comprehensive history of American art from early colonial times to 1900. Architecture, painting, and sculpture are treated together in four parts: The Colonial Period, The Early Republic, The Jacksonian Era, and Civil War to 1900. Chapter on art associations and museums and one on patronage and the art union are of special interest. Good classified bibliography (pp. 611-17).

1626 Cahill, Holger, and Alfred Barr, eds. Art in America: A Complete Survey . . . New York, Halcyon, 1939. 162p. illus.

Brief survey of art and architecture in America from colonial times to the early twentieth century. Consists of essays written by various specialists. Bibliography (pp. 153-62) lists major books and periodical articles. Still a useful survey for the general reader.

- 1627 Chase, Judith W. Afro-American Art and Craft. New York, Cincinnati, and Toronto, Van Nostrand, 1972. 271p. illus. index. LC 76-163485. Survey of Afro-American painting, sculpture, and minor arts. Introductory chapter discusses the African background and early history of Afro-American art. Bibliography (pp. 138-39) provides a classified list of major books. For the general reader and the beginning student.
- Dunlap, William. A History of the Rise and Progress of the Arts of Design in the United States . . . New edition, illustrated, edited, with additions by Frank W. Bayley and Charles E. Goodspeed . . . Boston, Goodspeed, 1918. 3v. illus. First published in 1834 (Reprint: New York, Dover, 1969. LC 69-16810).

History of art and architecture in the United States from early colonial times to the end of the Federal period. Emphasis is on painting. Chapters are chiefly concerned with lives and works of major artists. Bibliography in volume three (pp. 346-77) was compiled by the editors and lists books and periodical articles. A standard early chronicle of the arts in the United States.

Goodrich, Lloyd. **Three Centuries of American Art.** New York, Praeger, 1967. 145p. illus. index. LC 66-26551.

Pictorial survey of art and architecture in America from colonial times to the present. Brief introductory text accompanies a good selection of plates. No bibliography. For the general reader.

Green, Samuel M. American Art: A Historical Survey. New York, Ronald Press, 1966. 706p. illus. index. LC 66-16844.

Comprehensive history of art and architecture in America from colonial times to circa 1960. Fairly well illustrated; has a good glossary of terms, informative notes to the text, and a good classified bibliography (pp. 663-68). Balanced, unbiased text. An excellent survey history of American art and architecture.

LaFollette, Suzanne. Art in America. New York, Harper & Row, 1968. 361p. illus. index. LC 72-2187.

Reprint of 1929 edition. Survey history of art and architecture in America from colonial times to the early twentieth century. No bibliography. For the general reader.

- Larkin, Oliver W. Art and Life in America. Rev. and enl. ed. New York, Holt, Rinehart and Winston, 1960. 559p. illus. index. LC 60-6491.
 General history of art and architecture in America from circa 1600 to the present. Emphasis is on the cultural context of the fine arts. Thorough and useful bibliographical notes (pp. 491-525). For the general reader and the beginning student.
- McLanathan, Richard. The American Tradition in the Arts. New York, Harcourt, Brace, & World, 1968. 492p. illus. index. LC 65-21032. History of art and architecture in America from colonial times to the mid-twentieth century. Well illustrated. A classified list of major books is provided in the bibliography (pp. 471-78). For the general reader and the beginning student.

- McLanathan, Richard. Art in America: A Brief History. New York, Harcourt Brace Jovanovich, 1973. 216p. illus. index. LC 72-92358.
 Concise history of art and architecture in America from colonial times to the present. Good selection of plates. Good, partially annotated bibliography of books and periodical articles (pp. 211-12). A good survey for the general reader.
- Mather, Frank J., Charles R. Morey, and William J. Henderson. The American Spirit in Art. New Haven, Yale University Press, 1927. 354p. illus. index. (Pageant of America, v. 12).
 Illustrated survey of music and the figurative arts in the United States from

Illustrated survey of music and the figurative arts in the United States from colonial times to the early twentieth century.

- Mendelowitz, Daniel M. A History of American Art. 2nd ed. New York, Holt, Rinehart and Winston, 1970. 521p. illus. index. LC 71-111303.
 History of art and architecture in America beginning with American Indian art and concluding with American art of the present. Well illustrated. Bibliography (pp. 510-12) lists basic books. A standard history of American art and architecture for the general reader and the beginning student.
- Myron, Robert, and Abner Sundell. Art in America: From Colonial Days through the Nineteenth Century. New York, Crowell-Collier, 1969. 186p. illus. index. LC 69-10347.

Survey history of art and architecture in America from colonial times to the end of the nineteenth century. Brief bibliography (p. 183). For the general reader and the beginning student.

- Neuhaus, Eugen. The History & Ideals of American Art... Stanford, Calif., Stanford University Press, 1931. 444p. illus. index.

 Survey of art and architecture in the United States from colonial times to the early twentieth century. Biographical notes for major artists are provided at the end of each chapter. Bibliography of basic works (pp. 427-38).
- Pierson, William H., Jr., and Martha Davidson, eds. Arts of the United States: A Pictorial Survey. New York, McGraw-Hill, 1960. 452p. illus. LC 60-9855.

Brief survey of art and architecture in America from colonial times to the present. The eighteen brief essays on various arts at different periods are by a number of specialists. Conceived as an accompaniment to a slide collection at the University of Georgia, the illustrations are postage-stamp-size reproductions of the slides. No bibliography. With the slides, this is a valuable teaching tool directed to the general reader and the beginning student.

Richardson, Edgar P. The Way of Western Art, 1776-1914. Cambridge, Mass., Harvard University Press, 1939; repr. New York, Cooper Square, 1969. 204p. illus. index. LC 73-79604.

Survey history of art and architecture in America and Western Europe in the period 1776 to 1914, with emphasis on the interrelationships between European and American art and architecture. No bibliography. Still a valuable study for beginning and advanced students.

Taylor, Joshua C. America as Art. Washington, D.C., Smithsonian Institution Press, 1976. 320p. illus. LC 76-4482.

An examination of the changing interpretation of American life in art from colonial times to the present. Contents: America as Symbol; The American Cousin, the Virtue of American Nature; The Frontier and the Native American; The Image of Urban Optimism; The Folk and the Masses; A Center of Art; Identity from Uniformity.

Wilmerding, John. American Art. Harmondsworth, Penguin, 1976. 322p. illus. index. LC 75-18755. (Pelican History of Art, Z40).
 Scholarly history of American art from 1564 to 1976. Chapters are devoted to the

Scholarly history of American art from 1564 to 1976. Chapters are devoted to the chronological examination of major periods. Specialized literature cited in the footnotes. Bibliography (pp. 271-302) is a good, classified list of books and articles including a section of selected monographs on artists.

Wright, Louis, ed. The Arts in America: The Colonial Period. New York, Scribner's, 1966. 360p. illus. index. LC 66-12921.

History of architecture, painting and the decorative arts in the United States up to independence. Introductory essay discusses the general cultural and political background. Bibliography (pp. 353-57) is a classified list of books.

CANADA

1644 Colgate, William G. Canadian Art, Its Origin and Development. Toronto, Ryerson, 1943. 278p. illus. index.

Concise survey of the history of art in Canada, exclusive of architecture, from 1820 to 1940. Bibliography (pp. 267-70) provides a useful list of primary sources as well as major books and articles. A good survey history of Canadian national art. For the general reader and beginning student. The bibliography will be of use to the advanced student.

Hubbard, Robert H. An Anthology of Canadian Art. Toronto, Oxford University Press, 1960. 187p. illus. LC 60-52060 rev.

Concise history of art and architecture in Canada from the founding of New France to the present. Well illustrated. Brief introduction traces the history of art and architecture in Canada, followed by more detailed notes to the plates, a section of artists' biographies, and useful bibliographical notes (pp. 167-69), which evaluate the state of art historical scholarship in Canadian art. A good survey history of Canadian art and architecture for the general reader and beginning student.

- Hubbard, R. H. The Development of Canadian Art. Ottawa, National Gallery of Canada, 1967. 137p. illus. index. LC NUC64-19658.

 Survey history of Canadian art and architecture from the foundation of New France to the present. Compiled from a series of lectures delivered at the National Gallery in Ottawa. Well illustrated. No bibliography. A good survey of Canadian art and architecture by a leading specialist. For the general reader and the beginning student.
- 1647 McInnes, Graham C. Canadian Art. Toronto, Macmillan, 1950. 140p. illus. index. LC 52-6306 rev.

318 | New World Art

Survey of the history of art in Canada, exclusive of architecture, beginning with Indian art and ending in 1933. Appendices give lists of principal events in Canadian history, art institutes and museums, and Canadian artists. No bibliography. A balanced if cursory history of Canadian art for the general reader.

CHAPTER TWELVE

ART OF AFRICA AND OCEANIA (WITH AUSTRALIA)

GENERAL WORKS

Abbate, Francesco, ed. African Art and Oceanic Art. London and New York, Octopus, 1972. 158p. illus. LC 72-172111.

Very brief pictorial survey of both sub-Saharan African and Oceanian art, most of which is sculpture. All color illustrations. Weak one-page bibliography. For the general reader.

Trowell, Kathleen M., and Hans Nevermann. African and Oceanic Art. New York, Abrams, 1968. 263p. illus. index. LC 68-16798.

Pictorial survey of the arts of sub-Saharan Africa and primitive Oceania, in the latter case consisting of New Guinea, Melanesia, Micronesia, and Polynesia. The section on Africa is treated according to modes or types of art, with a chapter on the sculpture of some ancient African kingdoms. The art of Oceania is treated by region. Provided with maps and good photographs showing African artists at work. Bibliography (pp. 259-60) lists books and some periodical articles in all languages. For the general reader and the beginning student.

AFRICA

Bascom, William. African Art in Cultural Perspective: An Introduction. New York, Norton, 1973. 196p. illus. index. LC 73-4680.

Survey of the traditional art of Africa, with emphasis on the general anthropological context. There is a brief chapter on Egypt and North Africa, though the bulk of the work is devoted to sub-Saharan Africa. Useful maps, rather poorly reproduced; well-chosen illustrations. Bibliography (pp. 189-91) lists books in all languages. A good introduction for the beginning student.

Bodrogi, Tibor. Art in Africa. New York, McGraw-Hill, 1968. 131p. illus. LC 68-12065.

Introduction to the traditional arts of sub-Saharan Africa. The brief text is followed by a selection of plates and a bibliography (pp. 97-101). For the general reader.

Berman, Esmé. Art and Artists of South Africa: An Illustrated Biographical Dictionary and Historical Survey of Painters and Graphic Artists since 1875. Cape Town, A. A. Balkema, 1970. 368p. illus. index. LC 75-54902.

Two-part handbook of painters and graphic artists in South Africa since 1875. The entries in the first part, the biographical dictionary, give basic biographical information, list of major exhibitions, collections that own the artist's work, and (for the major artists) reference to further literature. The second part is a historical survey of painting and graphic art in South Africa since circa 1850. Basic reference tool to art of South Africa.

Delange, Jacqueline. The Art and Peoples of Black Africa. New York, Dutton, 1974. 354p. illus. index. LC 74-1179.

Comprehensive survey of sub-Saharan art and architecture. Contents: Upper and Middle Niger; The Volta Peoples; The Coastal Peoples of Guinea; The Southwest of the Sudanese Savanna and the West Coast of the Atlantic Forest; The Akan; Dahomey; Nigeria; The Fulani; Central and Western Cameroun; The Western Congo; The Central Congo; The Eastern Congo; East Africa; South Africa. Excellent bibliography, by Alexandra Darkowska-Nidzgorska (pp. 315-44) lists books and periodical articles. First published in Paris (Gallimard) in 1967.

1654 Laude, Jean. The Arts of Black Africa. Berkeley, University of California Press, 1971. 289p. illus. index. LC 71-125165.

Concise history of the arts of sub-Saharan Africa treating both historical and contemporary traditional arts. Provides a useful comparative chronological table of artistic and cultural events in Africa and Western Europe. Bibliography (pp. 279-84) lists books in all languages. For the beginning student.

Leiris, Michel, and Jacqueline Delange. African Art. London, Thames and Hudson, 1968. 460p. illus. index. (The Arts of Mankind, 11). LC 73-353276.

Comprehensive handbook of the traditional arts of sub-Saharan Africa. Well illustrated with plates, plans, and diagrams. Provided with maps, glossary, and bibliography (pp. 385-408), which lists books and periodical articles in all languages. Although the bibliography is unclassified, it is extensive, and the most important works are marked with an asterisk. For beginning and advanced students.

Leuzinger, Elsy. The Art of Black Africa. Greenwich, Conn., New York Graphic Society, 1972. 378p. illus. index. LC 72-172085.

Pictorial handbook of the arts of sub-Saharan Africa. Introduction discusses the geography, function, materials, and techniques of art in Africa. This is followed by an excellent collection of plates arranged according to stylistic regions; there is a map and a succinct summary introduction for each region. The select bibliography (pp. 363-69) is an excellent classified list of books and periodical articles in all languages. A good introduction for the general reader and the beginning student. The excellent plates make it of value to the advanced student as well.

1657 Leuzinger, Elsy. Africa: The Art of the Negro Peoples. 2nd ed. New York, Crown, 1967. 247p. illus. index. LC 60-13819.

Concise study of the traditional arts of sub-Saharan Africa. Part one gives a general introduction; part two discusses the regional styles of African art. Includes useful maps, a table of cultures, a glossary of terms, and a good selected bibliography

(pp. 228-32) of books and periodical articles. A good survey for the general reader and the beginning student.

Rachewiltz, Boris de. Introduction to African Art. New York, New American Library, 1966. 200p. illus. index. LC 66-18260.

Concise survey and history of sub-Saharan African art from prehistoric times to the present. Provides a good, classified bibliography (pp. 161-92). For the general reader and the beginning student.

Wassing, René S. African Art, Its Background and Traditions. New York, Abrams, 1968. 285p. illus. index. LC 68-28387.

The traditional arts of sub-Saharan Africa are covered, with emphasis on their relationship to social life, economics, religion, and technology. Introductory chapter: "The African and His Environment." Well illustrated. Bibliography (pp. 274-75) is a brief alphabetical listing of major books. For the general reader and the beginning student.

Willett, Frank. African Art: An Introduction. New York, Praeger, 1971. 288p. illus. index. LC 76-117394.

Concise history of the art and architecture of sub-Saharan Africa from the earliest times to the present. Provides a good selection of plates, many useful maps, diagrams, and a few plans. Bibliography (pp. 275-79) is an unclassified list of major books and periodical articles in all languages. The footnotes provide further reference to specialized literature. A good general survey for the beginning student and the general reader.

OCEANIA

Ambesi, Alberto C. Oceanic Art. Feltham, England, Hamlyn, 1970. 159p. illus. index. LC 78-563041.

Pictorial survey of the arts of Melanesia, Micronesia, Polynesia, New Zealand, and Hawaii. No bibliography. For the general reader.

Barrow, Tui T. Art and Life in Polynesia. Wellington, Auckland, Sydney, A.H. & A.W. Reed, 1972. 191p. illus. index. LC 72-77509.

Well-illustrated handbook of Polynesian art. Part one is devoted to the cultural background with many illustrations of historical significance; part two is a catalogue of works of art arranged by geographical centers. Glossary of Polynesian terms, maps, and bibliography (pp. 181-84) listing recent works in English.

1663 Bodrogi, Tibor. Oceanian Art. Budapest, Corvina, 1959. 43p. (text); 170p. (illus.). LC 60-36105.

Pictorial survey of the arts of Melanesia, Micronesia, Polynesia, and Indonesia. Illustrations of works in the Ethnographical Museum in Budapest. Provides a list of principal collectors and collections of Oceanic art, and a brief bibliography (pp. 39-40) of major works in all languages. For the general reader.

Bühler, Alfred, Terry Barrow, and Charles P. Mountford. The Art of the South Sea Islands, including Australia and New Zealand. New York, Crown, 1962. 249p. illus. index. LC 62-11806.

Survey of the arts of Melanesia, Micronesia, Polynesia, as well as the aboriginal arts of Australia and the Maori art of New Zealand. Introductory chapters discuss the geographical setting and the religious, social, and technological factors. These chapters are followed by excellent characterizations of the major regional styles. Bibliography (pp. 235-40) provides a thorough list of major books and periodical articles in all languages. A good survey for beginning and advanced students.

- Chauvet, Stephen. Les arts indigènes en Nouvelle-Guinée. Paris, Société d'Éditions Géographiques Maritimes et Coloniales, 1930. 350p. illus. Comprehensive handbook of the arts of the indigenous peoples of New Guinea, arranged by the old colonial divisions. Bibliographical footnotes to specialized literature and general bibliography (pp. 314-16). A standard work.
- Guiart, Jean. The Arts of the South Pacific. New York, Golden Press, 1963. 461p. illus. index. (The Arts of Mankind, 4). LC 63-7331.

 Well-illustrated study of the native arts of Australia, Torres Straits, New Guinea, Melanesia, Micronesia, Polynesia, and Hawaii. Provided are a glossary-index, maps, and a bibliography (pp. 419-38), which is an alphabetical list of major books and periodical articles in all languages. A good illustrated handbook for beginning and advanced students.
- 1667 Kooijman, S. De Kunst van Nieuw-Guinea. The Hague, Servire, 1955. 135p. illus. index.

Concise survey of the arts of New Guinea. Arrangement is by regions. Bibliography (pp. 125-30) is a thorough, classified list of books and periodical articles in all languages.

- Schmitz, Carl A. Oceanic Art: Myth, Man and Image in the South Seas.
 New York, Abrams, 1971. 405p. illus. index. LC 69-12797.
 Comprehensive study of the native arts of New Guinea, Melanesia, Polynesia, and Micronesia. The general introduction sketches the history of art in Oceania from prehistoric time to the present. Sumptuously illustrated. Bibliography (pp. 402-405) lists books and periodical articles. For the general reader and the beginning student.
- Smith, Bernard W. Place, Taste, and Tradition: A Study of Australian
 Art since 1788. Sydney, Smith, 1945. 287p. illus. index. LC 46-1408 rev.
 Concise history of art and architecture in Australia in the nineteenth and twentieth centuries. Emphasis is on the general cultural climate. Bibliography (pp. 272-75) lists books and periodical articles. For the general reader and the beginning student.
- 1670 Tischner, Herbert. Oceanic Art. New York, Pantheon, 1954. 32p. (text); 96p. (illus.).

Pictorial survey of the arts of Melanesia, Micronesia, Polynesia, and New Zealand. Brief text, with notes to the plates. Bibliography (pp. 17-20) lists books and periodical articles. For the general reader and the beginning student.

Wingert, Paul S. Art of the South Pacific Islands. New York, Beechhurst, 1953. 64p. illus.

Brief survey of the arts of Melanesia, Micronesia, Polynesia, New Zealand, and Hawaii. Short bibliography (p. 46) of major books. For the beginning student.

Wingert, Paul S. An Outline of the Art of the South Pacific. New York, Columbia University Press, 1946. 61p. illus.

Brief guide to the art of Melanesia, Micronesia, Polynesia, Australia, and New Zealand. Text is in outline form. Appendix gives lists of American museums that have collections of Oceanic art. Good classified bibliography of books and articles (pp. 45-57). An older, but useful introduction for the beginning student.

AUSTRALIA

Berndt, Ronald M., ed. Australian Aboriginal Art. New York, Macmillan, 1964. 117p. illus. index. LC 64-12214.

This survey of the art of the Australian aborigines deals with pre-colonial rock paintings as well as with the more recent traditional aboriginal arts. Consists of a collection of essays by specialists. Well-chosen illustrations and a good bibliography (pp. 108-112), which lists books and periodical articles in all languages. A good introduction for the general reader and the beginning student.

Hughes, Robert. **The Art of Australia**. Rev. ed. Harmondsworth, Penguin, 1970. 331p. illus. index. LC 72-18946.

History of art and architecture in Australia from prehistoric times to the present. Well illustrated. Bibliography (pp. 317-20) is a good list of books and periodical articles. A standard history of Australian art and architecture for the general reader and the beginning student.

Moore, William. The Story of Australian Art, from the Earliest Known Art of the Continent to the Art of Today. Sydney, Angus & Robertson, 1934. 2v. illus. index.

Survey of art and architecture in Australia from prehistoric times to the early twentieth century. Provides a dictionary of Australian artists (pp. 155-234). For the general reader and the beginning student.

The state of the s

reported to the state of the st

AUTHOR/TITLE/SUBJECT INDEX

References are to item number, not page number. The numbering sequence includes subscript letters. Title entries are included only for those publications that are main entries in the bibliography and for major series.

A.L.A. Portrait Index, 206 Aargau (Switzerland), Canton, art in, 1294, 1296 Aars, H., 1362 Abastado, C., 1203, 1204 Abbate, F., 1159, 1467, 1545, 1648 Abstract art, 1188-1190, 1192 Academie Royale des Beaux-Arts et École des Arts Decoratifs, Brussels, Catalogue annoté de la Bibliothèque, 171 Accademia Toscana di Scienze e Lettere "La Colombaria," Studi, 932 Achaemenian art, 600 Ackere, J. van, 1017 Ackerman, P., 1462 Acquarone, F., 1605 Adam, L., 514 Adama van Scheltema, F., 717, 918 Adeline, J., 253 Aegean art, 616-626 Aeschlimann, E., 103 Afghanistan, art in, 1458 Africa, art in, 540-543, 1648-1660 bibliographies, 162-163b Afro-American artists, dictionary, 406 Ahlers-Hestermann, F., 1160 Ahmed, J., 1468 Aiges-Mortes (France), Canton, art in, 1225 Ainalov, D., 1415 Akurgal, E., 604, 605, 637, 1463 Alazard, J., 1315 Aldred, C., 552 Alizeri, F., 351 Allen, J., 718 Allen, J. S., 62 Alpatov, M., 114, 1416, 1417 Alsace, art in, 1225, 1249 Alsatian artists, dictionary, 331

Amaya, M., 1161

Ambesi, A., 1661 American Architects Directory, 222 American art See United States, art in American Art Directory, 223 American artists, dictionaries, 405-417 American Indian art, 541-543, 1590-1595 bibliography, 148, 149 American School of Classical Studies at Athens, Genadius Library, Catalogue, 181 Amsterdam, Rijksmuseum, Kunsthistorische Bibliotheek, Catalogus, 170 Amsterdam, Stedelijk Museum, Bibliotheek, Catalogus 187 Ancient People and Places, 714 Ancona, P. d', 1316 Ancona (Italy), art in, 1313 Andersen, L., 976 Andersson, A., 751 Andorfer, E., 1238 Andrade, A. S. de, 374 Andrea, W., 565 Andreae, B., 688 Andreoli-de Villers, J., 74 Angevin (France) artists, dictionary, 334 Anglesey (Wales), art in, 1302 Anglo-Saxon art (medieval), 835, 838, 839 Angulo Iñiguez, D., 1596 Angyal, E., 1023 Anker, P., 751 Annales du Musée Guimet, 1548 Anhalt (Germany), art in, 1249 Annual Bibliography of Indian Archaeology, 131 Annual Egyptological Bibliography, 40 Annuario bibliografico di storia dell'arte, 177 The Antiquarian Library, 449 Anton, F., 1566, 1577, 1578, 1586 Antwerp, art in, 1329 Antwerp, artists of, dictionary, 371

"Aportaciones recientes a la historia del arte español," 115 Appenzell (Switzerland), Canton, art in, 1294, 1296 Aquila (Italy), art in, 1313 Arbeitsgemeinschaft für Forschung des Landes Nordrhein-Westfalen, Geisteswissenschaft, Abhandlung, 711 Arbeláez-Camacho, C., 1608 Archaic Greek art, 646, 655, 658, 660 Archäologischer Anzeiger zum Jahrbuch des Archäologischen Instituts, 41 Archäologische Bibliographie, 41 Archivo español del Arte, 115 Aressy, P., 299 Argan, G., 1050, 1124 Argentina, art in, 1601-1604 bibliography, 152 dictionaries, 401 Argyll (Scotland), County, art in, 1301 Arias, P., 638 Arnason, H., 1026 Arnold, B., 1303 Arntz-Bulletin, 75 Ars Una: Species Mille, 1230, 1344, 1384 Art and Architecture Bibliographies, 81 Art and Architecture Book Guide, 168 Art and Architecture Information Guide Series, 159 Art Bibliographies Current Titles, 191 Art Bibliographies Modern, 76 Art Deco, bibliography, 77 Art historians, dictionary, 271 Art in mid-century, 1219-1222 Art Index, 192 Art/Kunst, 22 Art Libraries Society of North America, Directory of Art Libraries, 224 Art Nouveau, 1159-1170 bibliographies, 80, 81 Art Treasures in France, 1229 Art Treasures in Germany, 1286 Art Treasures in Italy, 1317 Art Treasures in Spain, 1381 Art Treasures in the British Isles, 1304 Artamonov, M., 609 Arte Veneta, 102 Arts of China, 1522 Arts of Japan, 1546 The Arts of Mankind, 591, 600, 601, 618, 646-648, 692, 693, 765, 795, 837, 852, 872, 1655, 1666 Arts, Styles et Techniques, 970, 1006, 1007 Aschaffenburg (Germany), art in, 1251 Ascoli (Italy), art in, 1313 Ashmole, B., 546, 639 Ashton, L., 1523 Asiatische Forschungen, 1491

Aslanapa, O., 1464

Assyrian art, 589, 590, 592-594, 596, 637 bibliography, 42, 45 dictionary, 291 Asunka Buddhist art, 1550 Athens, American School of Classical Studies at Athens, Genadius Library, Catalogue, 181 Das Atlantisbuch der Kunst, 235 Aubert, M., 856, 857, 886 Auboyer, J., 1458, 1477 Audin, M., 327 Augustan Roman art, 696 Aurenhammer, H., 439 Australia, art in, 1440, 1673-1675 Australian artists, dictionary, 419 Austria, art in, 853, 973, 973a, 1009, 1011, 1044-1046, 1070, 1142, 1238-1247 bibliographies, 87-89 Austrian artists, dictionary, 319, 320 Auvergne, art in, bibliography, 1225 Aveiro (Portugal), Distrito, art in, 1380 Avery, C., 287, 308 Avery Architectural Library Catalog, 165 Index to Architectural Periodicals, 194 Obituary Index to Architects and Artists, 204

Babylonian art, 589, 592-594, 637 Bachhofer, L., 1524 Bachmann, D., 6 Bachmann, E., 887 Backes, M., 818, 1248 Badajoz (Spain), Provincia de, art in, 1372 Baden (Austria), Bezirk, art in, 1240 Baden-Württemberg (Germany), art in, 1248-1250, 1252-1256 Badstübner, E., 91, 464 Baldass, L., 858 Baldass, P. von, 973 Bals, G., 1414 Bandi, H., 521, 531 Bandinelli, R., 672, 692, 693 Banerjea, J., 494 Barbaric art See Migrations, art of the Barbier de Montault, X., 440 Barcelona, art in, 1372 Bardi, P., 1606 Barilli, R., 1162 Barney, C., 1609 Baroque art, 976-1001 in Austria, 1008-1012, 1244 in France, 1002-1007 in Germany, 1008-1012 in Italy, 1013-1016, 1316 in the Low Countries, 1017-1019 in Slavic countries, 1023-1025 in Spain, 1020-1022 Barr, A., 1060, 1175, 1205

Benesch, O., 961, 1242

Barreira, J., 1382 Barrow, T., 1662, 1664 Bascom, W., 1650 Basel (Switzerland), Canton, art in, 1294, 1296 Batterberry, M., 540, 634, 919, 1125 Battisti, E., 920, 934 Die Bau- und Kunstdenkmäler der deutschen Ostens, 1283 Die Bau- und Kunstdenkmäler der Hansestadt Lübeck, 1271 Die Bau- und Kunstdenkmäler der Provinz Sachsen, 1275 Die Bau- und Kunstdenkmäler der Provinz Westpreussen, 1284 Die Bau- und Kunstdenkmäler des Herzogthums Braunschweig, 1267 Die Bau- und Kunstdenkmäler des Landes Hessen, 1258 Die Bau- und Kunstdenkmäler des Regierungsbezirk Cassel, 1259 Die Bau- und Kunstdenkmäler des Regierungsbezirks Wiesbaden, 1260 Die Bau- und Kunstdenkmäler Schlesiens, 1282 Die Bau- und Kunstdenkmäler von Westfalen, 1265 Die Baudenkmäler in Frankfurt am Main, 1261 Baumgart, F., 921, 1318 Baumgarth, C., 1193 Baur, J., 1155, 1156 Die Bauwerke und Kunstdenkmäler von Berlin, 1285 Bavaria, art in, 1248-1251 bibliographies, 97, 98 Bayern See Bavaria Bayet, C., 785 Bayley, F., 1628 Bazin, G., 977 Beauvais, artists of, 333 Beazley, J., 639 Becatti, G., 627, 689 Becker, F., 276 Beckett, F., 1352 Beckwith, J., 757, 786, 847 Beenken, H., 1074 Beier, U., 1141 Belfort, A., 326 Belgian artists, dictionaries, 368-373 Belgium, art in, 171, 863, 864, 916, 1017, 1018, 1046a, 1047, 1071, 1072, 1327-1344 bibliography, 83, 171 Belle-Ile-en-Mer (France), Canton, art in, 1225 Bellier de Chavignerie, E., 324 Belloni, G., 1459

Ben-Amos, P., 39

Bénézit, E., 268 Benin art, bibliography, 39 Benoit, F., 1080 Bérard, A., 325 Berenson Library, Villa i Tatti, Catalog, 184 Bergamo (Italy), art in, 1313 Berghe, L., 42 Berlin, art in, 1249, 1250, 1285 bibliography, 91 Berman, E., 1652 Bern (Switzerland), Canton, art in, 1294, 1296 Bernal, I., 144 Berndt, R., 1673 Bernen, R., 424 Bernet, K., 1509 Bernier, R., 135 Bertman, S., 690 Bertran, M., 207 Berwick (Scotland), County, art in, 1301 Beschreibende Darstellung der älteren Bau- und Kunstdenkmäler des Konigreichs Sachsen, 1278 Bessone-Aureli, A., 352 Besterman, T., 7 Bettini, S., 691 Beyrodt, W., 90 Bezacier, L., 1502 Bezemer, T., 1510 Bhattacharyya, B., 495 Bialostocki, J., 888, 975 Bibliografi over Dansk Kunst, 84 Bibliografia del libro d'arte italiano, 103 Bibliografia dell'arte veneta, 102 Bibliografie del Ventennio, 108 Bibliografisch Overzicht van in Nederland in 1966-versehenen Publicaties, 109 Bibliographic Guide to Art and Architecture, Bibliographical dictionaries, 202, 268-277 Bibliographie analytique del'Assyriologie, 42 Bibliographie annuelle de l'âge de la pierre taillée, 32 Bibliographie de l'art byzantin et post-byzantin, Bibliographie de l'histoire de l'art national, 83 Bibliographie étrusque, 44 Bibliographie 1925, 77 Bibliographie zum Jahrbuch del Archäologischen Instituts, 41 Bibliographie zur Kunstgeschichte Österreichs, Bibliographie zur Kunstgeschichtlichedn Literatur in slawischen Zeitschriften, 23 Bibliographies See Chapter One Bibliographies of bibliographies, 7 Bibliography of Standard Reference Books of Japanese Studies, 141

Boutemy, A., 1341

Bibliography of the Netherlands Institute Bowness, A., 1027, 1114 for Art History, 111 Bozhkov, A., 1403 Biblioteca Balear, 381 Bozzella, A., 1200 Biblioteca Bibliografica Italica, 105 Brabant (Belgium), art in, 1328, 1330 Bibliotheca Bibliographica Aureliana, 421 Brandenburg (Germany), art in, 1249, 1280 Bibliothèque Forney, Paris Brassinne, J., 1342 Catalog of Periodical Articles on Braun, E., 229 the Decorative Arts, 195 Braun, J., 470 Catalogue des catalogues de ventes Braunau (Austria), Bezirk, art in, 1240 d'art, 178 Braunfels, W., 848 Catalogue matièrs, 179 Braunschweig (Germany), art in, 1267 Bihalji-Merin, O., 1433 Brazil, art in, 1605-1607 Bilzer, B., 254 bibliography, 153 Biró, B., 100 Brazilian artists, dictionaries, 399, 403 Bittel, K., 606 Breda (Netherlands), art in, 1346 Blankoff, J., 1419 Bréhier, L., 789, 819, 860 Blazicek, O., 1024 Bremen (Germany), art in, 1248, 1249, 1250 Blekinge (Sweden), art in, 1364 Brenzoni, R., 354 Bloch, P., 872 Brescia, artists of, dictionary, 361 Bloch, R., 673 Bretagne (France): Morbihan, Canton Belle-Blok, C., 1188 Ile-en-Mer, art in, 1225 Blunt, A., 968 Bretagne (France): Morbihan, Cantons Le Boardman, J., 616, 640, 641 Faouet et Gourin, art in, 1225 Boas, F., 541 Brieger, P., 1305 Boase, T., 1305 Brilliant, R., 642, 694 Bode, W. von, 935 Brinckmann, A., 978 Bodelsen, M., 85 Brion, M., 1093, 1094, 1189, 1219 Bodrogi, T., 1511, 1651, 1663 Britannica Encyclopedia of American Art, 405 Boethius, A., 712 British art Boger, H., 1547 See Great Britain Bohemia, art in, 1402 British artists, dictionaries, 343-347, 350 See also Czechoslovakia British Honduras, Pre-Columbian art in, Bohemian artists, dictionary, 321 bibliography, 145 Bohr, R., 628 Brizio, A., 1028 Bohuslän (Sweden), art, 1364 Brommer, F., 486, 487 Böing-Hausgen, U., 239 Brown, G., 522, 835 Boletin Bibliográfico de Antropologia Brown, M., 1625 Americana, 147 Brughetti, R., 1601 Bolio, M., 155 Brulliot, F., 278 Bologna, artists of, dictionary, 353 Brun, C., 393 Bolletino Bibliografico, 104 Brunet, J., 21 Bolling, P., 149 Brunn, H., 643, 644 Bollingen Series, 524, 875 Brunne, Abbé Paul, 327 Bolognini Amorini, A., 353 Brunner-Traut, E., 1457 Bon, A., 788 Brunov, N., 114, 1417 Bonet, B., 859 Brussels, Académie Royal des Beaux-Arts Bonet Correa, A., 1020 et Ecole des Arts Decoratifs, Catalogue, 171 Bonnet, H., 495a Brussels, artists of, dictionary, 368 Bonser, W., 33, 61 Bücherreihe Österriechische-Heimat, 1247 Bony, J., 732 Buchowiecki, B., 858 Borchgrave d'Altena, J. de, 1341 Buckinghamshire (England), art in, 1300 Borovka, G., 610 Bugara, W., 306 Borroni, F., 105 Bühler, A., 1669 Borton, H., 138 Buhot, J., 1525, 1548 Boschot, A., 1095 Bulgaria, art in, 810, 1403-1405 Boskovits, M., 101 bibliographies, 60, 63, 64, 67 Bossert, H., 573, 607, 617 Bulletin of the Institute of Classical Studies, Bottari, S., 1319 University of London, Supplement, 53 Bouffard, P., 889

Bulletin Signalétique: Série 521: Sociologie-Carpenter, R., 649 Ethnologie, 37 Carrara, artists of, dictionary, 357 Bulletin Signalétique: Série 525: Pré-Carrick, N., 1 histoire, 34 Carrieri, R., 1051, 1194 Bulletin Signalétique: Série 526: Art et Carroll, D., 1126 Archeologie: Poche-Orient, Asie, Caso, A., 1621 Amerique, 123 Caspary, H., 1248 Burgenland (Austria), art in, 1239, 1241 Cassel (Germany), Regierungsbezirk, art in, Burke, J., 1305 1259 Burney, C., 574 Castedo, L., 1598 Bursa (Turkey), art in, 1466 Castro, M., 1610 Burt Franklin Bibliography and Reference Catálogo arqueológico y artístico de la Provin-Series, 147 cia de Sevilla, 1374 Busch, H., 674, 820, 861, 890 Catálogo monumental de España, 1372 Buschiazzo, M., 152, 1596 Catálogo monumental de la Provincia de Palen-Bushnell, G., 1567 cia, 1373 Bussagli, M., 1469 Catálogo monumental de la Provincia de Toledo, Busse, J., 309 1375 Byvanck, A. W., 544 Catálogo monumental de la Provincia de Valla-Byzantine art, 733, 735, 741, 757, 759, 766, dolid, 1376 768, 779, 784, 785-810 Catálogo monumental Diocesis de Vitoria, 1378 bibliographies, 60, 62, 69, 71, 73, 181, Catálogo de monumentos de Vizcaya, 1379 Cavalcanti, C., 399 dictionaries and encyclopedias, 307 Cave art, 522, 523, 529, 538 Byzantinische Zeitschrift, 62 Ceán Bermúdez, J., 379 Ceci, G., 106 Cederholm, T., 406 Cabrol, F., 300 Celtic art, 718-721, 723, 724, 726, 730, 836, Cáceres (Spain), Provincia, art in, 1372 845, 850 Cadiz (Spain), Provincia, art in, 1372 Centofanti, L., 358 Caernarvonshire (Wales), art in, 1302 Central Asia, art in, 1491-1498 Cahier, C., 471 bibliographies, 135-137 Cahill, H., 1060, 1626 Chamberlin, M., 8 Caithness (Scotland), County, art in, 1301 Chamoux, F., 645 Calabria (Italy), art in, 1313, 1314 Champeaux, G. de, 441 Cali, F., 1597 Champigneulle, B., 1163 Calzadilla, J., 1624 Chapot, V., 695 Camard, J., 326 Charbonneaux, J., 646-648, 696 Cambodia, art in, 1503, 1505-1507 Charmet, R., 310 Cambridge (England), art in, 1300 Charrière, G., 611 Cambridge, Mass. Harvard University, Cata-Chase, F., 157 logue of Harvard University Fine Arts Chase, J., 1627 Library, 164 Chastel, A., 936, 937, 1321 Cambridgeshire (England), art in, 1300 Chauvet, S., 1665 Campori, G., 356, 357 Cheney, S., 1183 Campoy, A., 378 Chevrette, V., 39 Canada, art in, 169, 1644-1647 Chicago, Art Institute, Ryerson Library, Index Canaday, J., 1029 to Art Periodicals, 193 Canadian artists, dictionaries, 407, 412 Child, H., 442 Capart, J., 553, 554, 555 China, art in, 1436-1440, 1518-1521, 1522-Caplan, H., 279 1544 Carhaix-Plouguer (France), Canton, art bibliographies, 140, 143 in, 1225 dictionaries and encyclopedias, 396, 397 Carinthia (Austria), art in, 1238, 1239, 1241 China Society Sinological Series, 396 Carli, E., 1320 Chinchilla, A., 1612 Carmarthen (Wales), art in, 1302 Chipiez, C., 550 Carolingian art, 847, 848, 851, 852, 854, Christensen, E., 515 855 Christian, V., 575 bibliographies, 68, 72 Il Cicognara, 105

Cimmerian art, 612, 615

Cirici-Pellicer, A., 1383 Cirker, B., 208 Cirker, H., 208 Cirlot, J., 425, 1127 Clackmannan (Scotland), County, art in, Clapp, J., 197, 201, 209, 210 Classical art, 627-636 See also Etruscan art, Greek art, Roman bibliographies, 41, 43, 44, 46, 47-53, dictionaries and encyclopedias, 287-290, 292, 294-298 Classified Directory of Artists' Signatures, Symbols and Monograms, 279 Clay, J., 1115 Clemen, P., 1338 Clement, C. See Waters, C. Clough, R., 1195, 1196 Coddé, P., 359 Cohen, G., 743 Coimbra (Portugal), Cidade and Distrito, art in, 1380 Colas, R., 862 Cole, H., 39 Colección de documentos inéditos para la historia España, 386 Colección Pormaca, 1601 Colgate, W., 1644 Collection Art et Paysages, 792 Collection Latomus, 44, 700 Colledge, M., 597 Colles, D., 442 Collon-Gevaert, S., 863 Cologne, artists of, dictionary, 336 Colombia, art in, 1608, 1609 bibliographies, 154 Colombian artists, dictionary, 402 Colombier, P. du, 969, 970 Color Reproductions, 207 Columbia University, Avery Architectural Library, Avery Index to Architectural Periodicals, 194 Columbia University, Avery Architectural Library, Catalog of the Avery Memorial

University, 165

Constructivism, 1191

Contenau, G., 576-578

American Indian Heye Foundation, 148

104

Cook, R., 650

Architectural Library of Columbia Columbia University, Avery Memorial Architectural Library, Avery Obituary Index of Architects and Artists, 204 Commentari, "Bollenttino bibliografico," Contributions from the Museums of the

Coomaraswamy, A., 132, 496, 1470 Cooper, J., 426 Coppleston, T., 1229, 1286, 1317, 1381 Coptic art, 757, 758, 784, 810, 811-817, 1457 bibliographies, 66, 73 Corna, A., 360 Cornell, H., 1365 Cossio, M., 516, 523, 556, 579, 651, 697, 759 Cossio del Pomar, F., 1622 Costa Rica, Pre-Columbian art in, bibliography, 145 Côte d'Azur (France), art in, 1228 Côte d'Or (France), art in, 1225 Coulson, W., 43 Courtens, A., 864 Covarrubias, M., 1579, 1590 Craven, R., 1471 Creative Canada: A Biographical Dictionary of Twentieth-Century Creative and Performing Artists, 407 Cremona, I., 1164 Crespelle, J., 1171 Creswell, K., 125 Crouslé, M., 9 Crozet, R., 865 Cuba, art in, 1610 Cubism, 1175-1182 Cummings, P., 408 Cunningham, A., 343 Curtius, L., 545 Cycladic art, 624, 626 Cyprus, art in, 623 Czechoslovakia, artin, 876, 975, 1144, 1400-1402 Czechoslovakian artists, dictionary, 321

Dada, 1205, 1214, 1217 Dagyab, L., 1491 Dalarne (Sweden), art in, 1364 Dall'Asèn, L., 1459 Dalsland (Sweden), art in, 1364 Dalton, O., 790, 1791 Daniel, H., 427 Danish artists, dictionaries, 322, 323 Dansk Kunsthistorisk Bibliografi, 85 Danzig, art in, 1283 Daremberg, C., 289 Darkowska-Nidzgorska, A., 1653 Darmstaedter, R., 269 Das, R., 1503 Dauphiné (France), art in, 1228 Davidson, M., 1639 Davies, H., 1213 Dawdy, D., 148, 409 Déchelette, J., 719 Decker, Hans, 866 Decker, Heinrich, 891, 938 Defosse, P., 44 Dehio, G., 1238, 1248

Dörig, J., 641 Dehio-Handbuch, Österreich, 1238 (Deutsch-Dorset (England), art in, 1300 land, 1248) Delange, J., 1653 Dorta, E., 1596 Delevoy, R., 1128 Dove, J., 10 Delogu, G., 24 Drake, M., 472 Delvoye, C., 792 Dresden (Germany), Bezirk, art in, 1248 Demargne, P., 618 Dreyfous, M., 1081 Driot, E., 557 Demmin, A., 236 Denbigh (Wales), art in, 1302 Droulers, E., 428 Dube, W., 1184 Dendermonde (Belgium), art in, 1331 Du Bourguet, P., 760, 812 Denmark, art in, 725, 727, 731, 751, 839, Ducati, P., 629, 676, 698 840, 884, 1073, 1352-1358 bibliographies, 84, 85 Dumbarton Oaks Bibliographies Based on De Stijl, 1201, 1202 "Byzantinische Zeitschrift," 62 Detzel, H., 443 Dumbarton Oaks Research Library, Dictionary Deuchler, F., 892, 1293 Catalog, 183 Deutsche Akademie der Wissenschaft zu Dumbries (Scotland), County, art in, 1301 Berlin, Schriften zur Kunstgeschichte, Dunlap, W., 1628 91 Du Peloux de Saint Romain, C., 311, 328 Deutsche Kunstgeschichte, 1235 Duplessis, G., 11 Deutsche Kunst und Kultur, 1116, 1117 Dürer-Bibliographie, 98 Deutscher Beiträge zur Altertumswissen-Durliat, M., 867 Du Ry, C. schaft, 673 Deutscher Kunstrat, Schrifttum zur See Ry van Beest deutschen Kunst des 20. Jahrhun-Dussieux, L., 329 derts, 92 Dutch artists, dictionaries, 369, 370, 372, 373 Deutsches Archaologisches Institut, Rome, Duval, P., 720 Bibliothek, Kataloge, 182 Duverger, J., 368 Devliegher, L., 1337 Dvorak, M., 939 Dhannens, E., 1331 Diaz, V., 1613 Dictionaries Early Books on art (before 1870), 19, 21 See Chapter Five Early Christian art, 757-784 bibliographies, 73 Dictionary of Ancient Greek Civilization, dictionaries and encyc., 300, 302-304 Dictionary of British Artists 1880-1940, 344 Early Medieval art, 818-834 Dictionnaire d'archéologie chrétienne, 300 bibliographies, 61, 68, 70, 72 Dictionnaire des artistes et ouvriers d'art de in England, 1305 la France, 327 in France, 819, 825, 828 Dictionnaire des civilisations africaines, 418 See also Carolingian art Dictionnaire des égiles de France, 1223 in Germany, 832 Didron, A., 444 See also Carolingian art, Ottonian art Diehl, C., 793 in Ireland, 829, 836, 845, 850 Dieulafoy, M., 598, 1384 in Italy, 826, 846 Diez, E., 599, 1441, 1472 in Spain, 831, 842, 843 Directories East Flanders (Belgium), art in, 1331 See Chapter Four East Lothian (Scotland), County, art in, 1301 Disselhoff, H-D., 1568 East Prussia, art in, bibliography, 95 Dittich, E., 139, 140 East Prussia, artists of, 340 Divald, K., 1406 Ebeling, E., 291 Dlabač, J., 321 Ebert, M., 285 Dockstader, F., 1580, 1587, 1591 Eckardt, A., 1563 Doering, O., 445 Ecuador, art in, 1611 Dohme, W., 1236 Edinburgh, art in, 1301 Döhring, K., 1516 Edirne (Turkey), art in, 1466 Dohrn, T., 675 Edo art and architecture, 1550 Dölling, R., 818 Edouard-Joseph, R., 312 Donin, R., 1238 Edwards, H., 78 Donnet, F., 1329 Effenberger, A., 813 Doorslaer, G. van, 1329

Eggers, H., 721

332 | Author/Title/Subject Index

Eglinski, E., 940 Far Eastern art, 1518-1521 Egyptian art, 552-572, 1457 bibliographies, 142 bibliographies, 40, 54 Farr, D., 1305 dictionaries and encyclopedias, 293 Ehresmann, J., 255 Eighteenth century art, 984, 985, 991, 992, Fauvism, 1171-1174 Feder, N., 1592, 1593 Einleitung in die Altertumswissenschaft, 633 Einstein, C., 1129 Fenaroli, S., 361 Eisenstadt (Austria), Bezirk, art in, 1240 Fenollosa, E., 1526 Ekdahl, J., 159 Ferguson, G., 446 El Salvador, Pre-Columbian art in, bibliography, 145 Elamite art, 589, 591, 593, 602 Fettich, N., 722 Elbern, V., 854 Eldjárn, K., 1361 Feuchtwanger, F., 1581 Elias de Molins, A., 380 Feuerstein, G., 1142 Eliasberg, A., 1421 Feulner, A., 1008, 1235 Ellis, J., 211 Fielding, M., 410 Ellis, R., 45 Fierens, P., 1339, 1340 Éluard, P., 1213 Emblemata, dictionary, 431 Filip, J., 286, 532 Emmerich, E., 1569 Fillitz, H., 821 Enciclopedia Biografia e Bibliographia Filov, B., 63, 1404, 1405 "Italiana," 271 Enciclopedia de arte en America, 400 Enciclopedia dell'arte antica, 288 art in, 1225 Enciclopedia Mexicana del Arte, 1614 Encyclopedia of Islam, 395 Finlay, L., 723, 1305a Encyclopedia of World Art, 237 Fischer, F., 893 Encyclopedias Fischer, K., 1473 See Chapter Five Fischer, O., 1235 Encyclopédie théologique, 473 Fischer, W., 1132 Englestoff, P., 323 England, art in, 747, 748, 835, 839, 963, Flint (Wales), art in, 1302 1148, 1149, 1300, 1305, 1306, 1310 Florén Lozano, L., 156 bibliography, 99 Florence (Italy), art in, 1314 Engman, B., 390 Eppel, F., 35 Errera, I., 429 Catalog, 185 Essen, C. C. van, 699, 700 Focillon, H., 732 Essex (England), art in, 1300 Fontaine, A., 1046a Este (Italy), artists of, 356 Fontein, J., 1518 Etruscan art, 672-687 Forstner, D., 447 bibliographies, 41, 44, 46, 48, 52, 182 Francastel, P., 1082, 1341 Ettingshausen, R., 126 Evans, J., 742, 1305 Evers, H. G., 1030 Evora (Portugal), Concelho and Distrito, art in, 1380 Exhibition catalogs, 5, 24, 27, 28, 30, 31 Francia, E., 761 Expressionism, 1183-1187 Frankfort, H., 580 Faenza, artists of, 366 Franz, H., 868, 1474

Fakes and forgeries, 17 Faider-Fertmans, M., 1341 Fairholt, F., 256 Falke, J. von, 1236 Le Faouet (France), Canton, art in, 1225

Fasti Archaeologici . . . Annual Bulletin of Classical Archaeology, 46 Feldkirch (Austria), Bezirk, art in, 1240 Fernández, J., 1055, 1076, 1615 Festschriften, bibliography of, 205 Feuchtmüller, R., 973, 1009, 1044, 1243 Fife (Scotland), County, art in, 1301 Fine Art Reproductions, 220 Finistère (France), Canton Carhaix-Plouguer, Finland, art in, 752, 1359, 1360 Flanders (Belgium), art in, 1331, 1337 Florence, Berenson Library, Catalogues, 184 Florence, Kunsthistoriseles Institut, Bibliothek, France, art in, 742, 743, 819, 825, 828, 856, 857, 860, 865, 869, 874, 875, 900, 902, 907, 968-972, 1002-1007, 1048, 1223-1234 bibliographies, 27, 86, 1225 Franche-Comté, artists of, 327 Frankfurt (Germany), art in, 1261 Frankfurt (Germany), artists of, 342 Fraser, D., 39, 542 French artists, dictionaries, 324-335 Frey, D., 1306 Fribourg, T., 1528 Fribourg (Switz.), Canton, art in, 1294, 1296

Friesland (Netherlands), art in, 1346	Geschichte der deutschen Kunst, 1236
Frova, A., 677, 701	Geschichte der Kunst, 745
Fründt, E., 91	Geschichte der Modernen Kunst, 1070
Fry, E., 1176	Geschichte der russischen Kunst, 1422
Fuchs, W., 641	Gestoso y Pérez, J., 382
Furió, A., 381	Getty, A., 497
Futurism, 1193-1200	Ghent (Belgium), art in, 1331, 1332
bibliography, 74	Ghirshman, R., 600, 601
	Gibellino-Krasceninnicowa, M., 1423
	Giedion, S., 524
Gabet, C., 330	Giglioli, G., 678
Gallo-roman art, 719, 724	Gilbert, C., 922
Galloway, J., 519	Ginhart, K., 1238, 1244
Galloway, J. C., 1031	Giraldo Jaramillo, G., 154
Galloway (Scotland), art in, 1301	Girard, H., 1095
Gand (Belgium), art in, 1331, 1332	Giraudet, E., 332
Gantner, J., 869, 1297	Giuliano, A., 672
Ganz, P., 1298	Glamorgan (Wales), art in, 1302
Garbini, G., 581	Glaser, K., 1436
Gard (France), Canton Aigues-Mortes, art	Glossarium Artis. Deutsch-Französisches Wör
in, 1225	terbuch zur Kunst, 257
Garland Reference Library of the Humani-	Gloucestershire (England), art in, 1300
ties, 43, 415	Glück, G., 962, 1442
Garlick, K., 1307	Godard, A., 1460
Garrett, W., 158, 1079	그는 이유 내용에 하면 이 그런 사이가 살아왔다면 보다 보는 것이 되는 것이 없는데 그 그 것이다. 이번 그 것은
Garrucci, R., 762	Goeppe, R., 1528 Goetz, H., 1475
Gascoyne, D., 1206	
Gaskin, G., 162	Golding, J., 1177
Gaunt, W., 1207	Goldman, B., 2
Gauthier, S., 1341	Goldsmith, E., 448
Gay, V., 301	Goldstein, F., 280
Gaya, A., 814	Golzio, V., 1013
Gazette de Beaux-Arts, 86	Gomez Moreno, M., 870
Gebelin, F., 971	Gonzalez, J., 1377
Geck, F., 107	Goodrich, L., 1156, 1629
Gegenswart Kunst, 1045	Goodspeed, C., 1628
Gelder, H. E. van, 1347	Goossens, G., 582
Gelderland (Netherlands), Provincie, art in,	Gopinātha Rau, T., 498
1346	Gordon, A., 1492, 1499
Gelsted, O., 322	Gordon, I., 1215
	Gothic art, 886-917
Genadius Library, Athens, Catalog, 181	in Belgium, 916
Geometric Style Greek art, 658, 668, 670	in Bohemia, 887
Gérard, C., 331	in France, 900-902, 907, 908
Gerke, F., 763	in Germany, 890
German art, 728, 744, 745, 832, 853, 861,	in Ireland, 912
890, 961-967, 973, 973a, 1008-1012,	in Italy, 891, 904, 910, 1316
1049, 1074, 1145-1147, 1235-1237,	in Spain, 899
1248-1292	in Switzerland, 889
bibliographies, 87, 88, 90-98	Gotland (Sweden), art in, 1364
dictionaries and encyc. 338, 341	Götz, W., 1248
German artists, dictionaries, 336-342	Gough, M., 764
German Democratic Republic, art in, bibliog-	Gourin (France), Canton, art in, 1225
raphies, 91, 94	Grabar, A., 64, 754, 765, 794, 795, 1341
Germanic art, 717-731, 832, 833, 837, 846	Grabar, O., 1443
German-speaking countries, art in, 1235-1299	Grady, J., 80
Germany, art in, 1248-1292	Grand, P., 525
bibliographies, 87, 88, 90-98	Grant, M., 488
Gershman, H., 79	Grate, P., 1366
Gerson, H., 1018	Graubünden (Switzerland), Canton, art in,
Geschichte der bildenden Kunst, 882, 914, 915	1294, 1296

334 | Author/Title/Subject Index

Habich, J., 1248

Hackin, J., 502 Graves, A., 345 Gray, B., 1523 Haendcke, B., 121 Gray, C., 1057 Hafner, G., 619, 702 Graziosi, P., 526 Haftmann, W., 1145, 1220 Great Britain, art in, 747, 748, 835, 839, Hagen, O., 1388 963, 1148, 1149, 1300-1310 Haggar, R., 258 bibliographies, 99, 174-176 The Hague, Koninklijke Bibliotheek, Cata-Greek art (ancient), 637-671 logus, 172 bibliographies, 41, 43, 46, 47, 56, Hahm, K., 1359 181, 182 Hahnloser, H., 1341 dictionaries, 287-293 Hainisch, E., 1238 Greek art (Medieval) Hall, H., 110 See Byzantine art Hall, H. C., 346 Green, S., 1630 Hallade, M., 1437 Grenier, A., 724 Hallein (Austria), Bezirk, art in, 1240 Grey, L., 500 Hamann, R., 558, 652, 1116, 1117 Grimal, P., 489 Hamilton, G., 1032, 1033 Grimschitz, B., 1009, 1245 Hammacher, A., 1327 Grisebach, A., 1237 Hammer, H., 1238 Griseri, A., 1014 Hammond, N., 292 Grisons Handbook of Latin American Studies, 150 See Graubünden Handbuch der Altertumswissenschaft, 549 Griswold, A., 1499 Handbuch der Kunstgeschichte, 1436 Groce, G., 411 Handbuch der Kunstwissenschaft, 545, 1008, Grodecki, L., 820, 849, 1341 1034, 1441, 1519 Groenewegen-Frankfort, H., 546 Hanfmann, G., 703 Grohmann, W., 1130 Hannover, E., 1073, 1351 Groningen (Netherlands), Provincie, art in, Hansen, H. J., 1062 1346 Hansford, S., 396 Groslier, B., 1500 Hansmann, W., 1248 Grosse Kulturen der Frühzeit, 592 Harbison, P., 1308 Grousset, R., 1445, 1527 Harding, A., 149 Grube, E., 1444 Hare, R., 1425 Gruhn, H., 93 Härjedalen (Sweden), art in, 1364 Grundriss der Kunstgeschichte, 657, 709, Harkesen, S., 91 987, 1037 Harpers's Encyclopedia of Art, 238 Grundriss der slavischen Philologie und Kul-Hartel, H., 1477 turgeschichte, 1404, 1405 Hartt, F., 941 Grüneisen, W. de, 815 Harvard List of Books on Art, 12 Grünwedel, A., 1476 Harvard-Radcliffe Fine Arts Series, 13 Guatemala, art in, 1612, 1613 Harvard University, Catalogue of the Harvard bibliography, 145 University Fine Arts Library, 164 Gubernatis, A., 362 Harvard University Center for Italian Renais-Guénebault, L., 302, 473 sance Studies, Catalogues of the Berenson Gudiol i Ricart, J., 1370, 1386, 1387 Library, 184 Guebwiller (France), Canton, art in, 1225 Harvey, J., 894 Guerrero, R., 1617 Haselberger, H., 38 Guiart, J., 1666 Haslam, M., 281, 1208 Guide artistique de France, 1224 Hassel, H., 163 Hausenstein, W., 979 Guide to Dutch Art, 1348 Günther, H., 1288 Hauser, A., 929 Gupte, R., 501 Haussig, H., 503 Gurlitt, C., 1049 Hante Normandie (France), Eure, Canton Lyon-Gutiérrez, F., 1549 la-Forêt, art in, 1225 Hautecoeur, L., 980, 1083, 1095 Hautmann, M., 822 Haack, F., 1037, 1131 Haut-Rhin (France), Canton Guebwiller, art Habasque, G., 1178 in, 1225 Haberland, W., 1594

Havell, E., 1478, 1479

Havelock, C., 653

Havlice, P., 202, 212 Hubbard, R., 1645, 1646 Hazel, J., 488 Hubert, J., 825, 828, 837, 852 Heian temples, 1550 Hudson, K., 225 Heibonsha Survey of Japanese Art, 1550 Hughes, R., 1674 Hugnet, G., 1213 Heintze, H. von, 704 Heise, C., 1132 Hulme, F., 449 Hejzlar, J., 1504 Hummel, S., 1494 Hekler, A., 1407 Hungary, art in, 722, 729, 1406-1410 Helbig, J., 1342 bibliographies, 100, 101 Helck, W., 293 Hunger, H., 490 Held, J., 981 Hunter, S., 1133, 1157, 1221 Hempel, E., 1010, 1235, 1238 Huntingdonshire (England), art in, 1300 Hempel, R., 1518 Hürlimann, M., 685 Henderson, G., 823, 895 Husarski, V., 1096 Henderson, W., 1635 Husenbeth, F., 475 Henkel, A., 431 Hutter, I., 766 Henry, F., 836, 850, 871 Huyghe, R., 547, 733, 923, 1035, 1036 Hentschel, W., 91 Hymanns, H., 1071 Herder Lexikon: Kunst, 239 Herefordshire (England), art in, 1300 Hermand, J., 1116, 1117 Iceland, art in, 1361 Hertfordshire (England), art in, 1300 Iconography, 419a-513 Hess, R., 679 ancient, 423 Hevesi, L., 1070 bibliographies, 419-423 Hewett-Woodmere Public Library, Index Buddhist, 496, 497, 499, 501, 506, 508, to Art Reproductions, 213 510 Heydenreich, L., 942, 948 Chinese, 512, 513 Heyne Bücher, 260 Christian, 439-469 classical, 486-493 Hiburno-Saxon art, 835, 836, 838, 845 Higgins, R., 620 dictionaries, 425-438 Hildebrandt, E., 1002 Egyptian, 495a, 503, 507 Hildebrant, H., 1034 Hindu, 494, 495, 498, 501, 505, 510, Hill, A., 252 Hinks, R., 851 Jainist, 501, 505 Hirmer, M., 559, 593, 621, 641 Japanese, 504 Histoire de l'art, 830, 905, 947, 948, 963, Lamaist, 499 990, 991, 1040 non-Western, 494-513 Hittite art, 604, 606, 608 Oriental, 500, 502, 503, 509 Hocke, G., 930 profane, 484, 485 Hoernes, M., 527 saints, of, 470-483 Hoffmann, H., 944 Iconclass, an Iconographic Classification Sys-Hofmann, W., 1063 tem, 419a Hofstätter, H., 896 Il'in, N., 65 Hohenzollern (Germany), art in, 1253 Illustrations, indexes to, 206-221 Holländer, H., 824 Immerzeel, J., 369 Holloway, R., 654 Impressionism, 1114-1123 Holmqvist, W., 725 Indexes Holt, C., 1512 See Chapter Three Holweck, F., 474 India, art in, 1467-1490 Homann-Wedeking, E., 655 bibliographies, 131-134 Homburger, O., 1341 Indochina, art in, 1502-1508 Honduras, Pre-Columbian art in, bibliog-Indonesia, art in, 1509-1515 raphy, 145 Innsbruck (Austria), art in, 1240 Honour, H., 1084 International Directory of Photographic Hootz, R., 1239, 1249, 1294, 1311, 1345, Archives of Works of Art, 232 International Who's Who in Art and Antiques, Horn (Austria), Bezirk, art in, 1240 Hourticq, L., 1230 Internationale Bibliographie der Fertschriften, Hrbas, M., 1493 Hubala, E., 982

Jantzen, H., 853, 897

Internationale Bibliographie der Kunst-Japan, art in, 1545-1562 wissenschaft, 25 bibliographies, 138, 139, 141 Internationales Kunst-Adressbuch, 226 Japanese artists, dictionary, 397 Introductions à la nuit des temps, 441 Jasper, J., 1513 Inventaire archéologizue de Gand, 1332 Jenny, H., 1295 Inventaire des objets d'art et d'antiquité Jenyns, R., 1528 de la Province de Liège, 1335 Jettmarr, K., 136, 612 Inventaire des objets d'art et d'antiquité Jewish art, bibliography, 15 de la Province du Hainaut, 1334 Jiménez-Placer, F., 1389 Inventaire général des monuments et des Jobes, G., 432 richesses artistiques de la France, 1225 Joly, H., 504 Inventario artistico de Portugal, 1380 Jones, J., 39 Inventario artistico de Valladolid y su Jones, L., 3 Provincia, 1377 Joubin, A., 1095 Inventario deglia oggetti d'arte d'Italia, 1313 Journal of Soc. of Archi'tl. Historians, 80 Inventories, artistic Austria, 1240 Belgium, 1328-1337 Kaftal, G., 476, 477 France, 1225 Kähler, H., 705 Germany, 1251-1285 Kalnein, W. von, 1003 Great Britain, 1300-1302 Kaltenbach, G., 270 Italy, 1313 Kamakura period sculpture, 1550 Low Countries, 1328-1337, 1346 Kampis, A., 1409 Portugal, 1380 Kanakita, M., 1522 Spain, 1370-1379 Karlinger, H., 898 Sweden, 1364 Karl-Marx-Stadt, art in, 1248 Switzerland, 1296 Kärnten (Austria), art in, 1238, 1239, 1241 Iorga, N., 1414 Karpel, B., 1157 Iran, art in, 1459-1462 Karpfen, F., 1045 Iranian art (ancient), 597-603 Kasanin, M., 1434 Irish art, 829, 836, 850, 1303, 1308 Kaschnitz von Weinberg, G., 706 See also Celtic art Kasper, W., 630 Irish artists, dictionary, 349 Kaufmann, G., 924 Irwin, D., 1085 Kayser, F., 826 Ise ed Izumo Shrines, 1550 Keaveney, S., 159 Islamic art, 1441-1456 Kehrer, H., 1390 bibliographies, 125-130 Kelemen, P., 1570, 1571, 1599 dictionaries and encyclopedias, 395 Keller, Harald, 945, 984, 1227, 1312 Istanbul, art in, 1466 Keller, Hiltgart, 454 Instituto Nazional per le Relazioni Culturali Kempton, R., 81 con l'Estero, Archeologia, arti figurative, Kendall, A., 145, 146 musica, 108 Kendrick, T., 838, 839 Italian artists, dictionaries, 351-367 Kenner, H., 47-51 Italian Renaissance art, 934-960 Kersten, W., 1153 Italy, art in, 749, 750, 846, 866, 891, 910, Kidson, P., 734 934-960, 1013-1016, 1050-1053, 1075, Kiesow, G., 1248 1311-1326 Kim, C., 1564 bibliographies, 138, 139, 141 Kimball, S., 985 Iyer, K., 1480 Kinross (Scotland), County, art in, 1301 Iznik (Turkey), art in, 1466 Kirfel, W., 505, 506 Kirschbaum, E., 455 Kitson, M., 986 Kitzinger, E., 796 Jacobsthal, P., 726 Jacobus, J., 1133 Kjellberg, E., 631 Klauser, T., 303 Jaffe, H., 1201 Klein, W., 656 Jahn, J., 240, 973a Jameson, A., 451, 452, 453 Klindt Jensen, O., 840 Klinge, E., 1248 Jamot, P., 1095 Janitschek, H., 1236 Kloster, G., 228

Kluge, D., 1248

Knipping, J., 456 Knobloch, E., 1493 Koch, H., 707 Koch, W., 433 Kohlhaussen, H., 1235 Kokusai Bunka Shinkokai, Bibliography of Standard Reference Books of Japanese Studies, 141 Koninklijke Bibliotheek, The Hague, Catalogus, 172 Konsthistorisk Tidskrift, 120 Kooijman, S., 1667 Korea, art in, 1563-1565 Kornilovich, K., 1426 Kozakiewiczowie, H. and S., 975a Kozloff, M., 1179 Kramm, C., 370 Kramrisch, S., 1481, 1482 Kraus, T., 708 Krautheimer, R., 757 Krems (Austria), Bezirk, art in, 1240 Krienke, G., 94 Kritische Berichte zur Kunstgeschichtlichen Literatur, 26 Kubach, H., 854, 872 Kubler, G., 1391, 1572 Kügler, H., 95 Kühn, A., 1411 Kuhn C., 1185 Kühn, H., 517, 528, 728 Kühnel, E., 127, 1446

Kuile, E. H. ter, 1018 Kümmel, O., 1519 Kung, D., 1151 Kungl, Vitterhets Historie och Antikvitets Akadiemiens Handlingar, 725

Die Kunst des Abendlandes, 918 Die Kunst des Ostens, 603

Die Kunst- und Altertumsdenkmale im Königreich Württemberg, 1254 Kunst- und Geschichtsdenkmäler des

Freistaates Mecklenburg-Strelitz, 1273 Die Kunst- und Geschichtsdenkmaler des

Grossherzogtums Mecklenburg-Schwerin, 1272 Die Kunstdenkmäler Badens, 1252 Die Kunstdenkmäler Bayerns, 1251

Die Kunstdenkmäler der Pfalz, 1262 Die Kunstdenkmäler der Provinz Hannover, 1266

Die Kunstdenkmäler der Provinz Mark Brandenburg, 1280

Die Kunstdenkmäler der Provinz Schleswig-Holstein, 1269

Die Kunstdenkmäler der Rheinprovinz, 1263 Die Kunstdenkmäler der Schweiz, 1296

Die Kunstdenkmäler des Freistaates Sachsen, 1279

Die Kunstdenkmäler des Landes Niedersachsens, 1268

Die Kunstdenkmäler des Landes Schleswig-Holstein, 1270 Die Kunstdenkmäler Hohenzollerns, 1253 Die Kunstdenkmäler im Bezirk Magdeburg,

Die Kunstdenkmäler im Bezirk Rostock, 1274 Die Kunstdenkmäler im Grossherzogtum Hesse, 1257

Die Kunstdenkmäler in Wurttemberg, 1256 Die Kunstdenkmäler von Rheinland-Pfalz, 1264 Kunstgeschichtliche Anzeigen, 26

Kunsthistorisches Institut, Bibliothek, Catalog of the Institute for the History of Art, Florence, Italy, 185

Künstle, K., 457 Künstler, G., 873 Die Kunstliteratur, 19 Kurz, O., 15, 19 Kusch, E., 1350 Kutzli, R., 841 Kyoto ceramics, 1546

Laag, D., 304 Lacerda, A. de, 1396 Laclotte, M., 1231 LaFollette, S., 1631 Lafond, L., 900 La Fontaine-Dosgne, J., 810 Lajonquière, L. de, 1505, 1506 Lambach (Austria), Bezirk, art in, 1240 Lambert, E., 1392 Lambert, J., 198, 899, 1341 Lambotte, P., 1047 Lamer, H., 294 Laming-Emperaire, A., 529

Lampe, L., 282

Landais, H., 1341

Landes (France), Canton Peyrehorade, art in, 1225

Landsberger, F., 1086 Lange, K., 559

Languedoc, art in, bibliography, 1225

Langui, E., 1134 Lankheit, K., 1064 Lanson, R., 1095 Lantier, R., 828 Laos, art in, 1508 Lapiner, A., 1573 La Plante, J., 1438

Lappland (Sweden), art in, 1364

Larkin, O., 1632 Lasko, P., 827 Lassus, J., 768 László, G., 729

Late Gothic art, 893, 913, 915 Late Roman art, 691, 693, 710, 711

Latin American art, 1596-1600 Limburg (Netherlands), Provincie, art in, 1346 bibliographies, 150, 151 dictionaries and encyclopedias, 400, Latium, art in, 1314 Laude, J., 1654 Laurent, M., 769 Laurin, C., 1351, 1353 Lavagnino, E., 749, 1052 Lebel, G., 86 Leblond, V., 333 Lebov, L., 39 Leclercq, H., 770 Lee, C., 214 Lee, S., 1439 Lees-Milne, J., 1015, 1021 Lefrançois-Pillon, L., 874, 900 Lehmann, W., 1588 Leiden (Netherlands), art in, 1346 Leipzig, Austalt für Kunst und Literatur, Kunstcatalog, 173 Leipzig (Germany), Bezirk, art in, 1248, 1278 Leira (Portugal), Distrito, art in, 1380 Leiris, M., 1655 Leistner, O., 205 Le Mage, R., 265 Lemaire, R. de, 1328 Le May, R., 1517 Lemerle, P., 797 Lemke, A., 259 Lenning, H., 1165 Leon (Spain), Provincia, art in, 1372 Lerius, T. van, 371 Leroi-Gourhan, A., 530 Leroy, A., 548, 771 Lethaby, W., 735 Leurs, S., 1343 Leuzinger, E., 1656, 1657 Levey, M., 946, 1003, 1465 Lexikon der Agyptologie, 293 Lexikon der alten Welt, 295 Lexikon der Kunst, 241 Lexikon des Mittelalters, 305 Lexow, E., 1363 Leymarie, J., 1118, 1172 Libraries, art, 8, 164-190, 224, 226 Library catalogs See Chapter Two Library manuals, 1-6 Libya, art in, 1457 Liechtenstein, art in, 1294, 1296 Liège (Belgium), Pronvince, art in, 1328, 1335 Lietzmann, H., 82 1296 Life Magazine, art in, 209 Liguria (Italy), artists of, 351 Limburg (Belgium), Provincie, art in, 1336

Limousin, art in, bibliography, 1225 Linz (Austria), Bezirk, art in, 1240 Lion, D., 1528 Lipffert, K., 458 Lippold, G., 549 "Literaturbericht zur Kunstgeschichte," 31 Literaturbericht zur Kunstgeschichte: deutschsprachige Periodika, 87 Lloyd, S., 583 Lodovici, S., 271 Loèber, J., 1514 Lohse, B., 820 L.O.M.A. Literature on Modern Art, 76 Lombard, M., 1341 Lombardic art, 826, 841, 844 Lommel, A., 518, 519 London, art in, 1300 London, Royal Institute of British Architects, Library, Catalogue of the Library, 174 London, Victoria and Albert Museum, National Art Gallery Library Catalogue, 176 London, University, Courtauld Institute of Art, Annual Bibliography of the History of British Art, 99 London, University, Library, Catalogue of Books on Archaeology and Art and Cognate Works Belonging to the Preedy Memorial Library, London, Warburg Institute, Catalogue, 186 Loosjes-Terpstra, A., 1154 López, Serrano, M., 116 Lopez Pegna, M., 52 Lorraine (France), art in, bibliography, 1225 Lothrop, S., 1574 Low Countries, art in, 1327 See also Belgium, Netherlands Lower Austria, art in, 1238, 1239, 1241 Lower Bavaria, art in, 1251 Lower Franconia, art in, 1251 Lower Saxony, art in, 1248-1250, 1266-1268 Lowrie, W., 772 Lozoya, J., 1393 Lübeck (Germany), art in, 1271 Lübke, W., 657, 709, 987, 1037 Lucas, E., 12-14 Lucie-Smith, E., 1119, 1135, 1222 Lugt, F., 203 Lundqvist, M., 119 Lunet de Lajonquiere, E., 1505 Lurker, M., 420, 421, 459, 507 Lutzler, H., 261 Lutzow, C. von, 1236 Luzern (Switzerland), Canton, art in, 1294, Lydian art, 605 Lynton, N., 1038 Lyon-la-Forêt (France), Canton, art in, 1225 Lyonnais, artists of, dictionary, 327

Medieval art, 732-741 Maastricht (Netherlands), Gemeente, art in, See also Carolingian art, Early Medieval art, 1346 Gothic art, Ottonian art, Pre-Carolingian art, Maatschappij der Antwerpsche Bibliog-Romanesque art philen, 371 bibliographies, 61, 68, 70, 72 McCausland, E., 160 dictionaries, 299-301, 305, 306 McCulloch, A., 419 in Belgium, 1341 McCune, E., 1565 in France, 742, 743, 1234 McInnes, G., 1647 in Germany, 744-746, 1244, 1287, 1290 McLanathan, R., 1633, 1634 in Great Britain, 747, 748, 1305 MacCulloch, J., 500 in Ireland, 836, 850, 871 Macdonald, C., 412 in Italy, 749, 750, 1315, 1316 Machado, C., 375 in Portugal, 1396 Madsen, S., 1166 in Scandinavia, 751-753, 1365, 1367a Maetzke, G., 682 Magdeburg (Germany), Bezirk, art in, 1248 in Slavic countries, 754-756, 1404, 1413, 1415, 1417, 1422, 1432, 1435 1277 in Spain, 1387 Mahr, A., 829 Medioni, G., 1582 Maillard, R., 313 Mâle, E., 736, 744, 875, 901, 902, 988, 1232 Medley, M., 1529 Mallett, D., 413 Meer, F. van der, 774 Megaw, J., 730 Maltese, C., 1053 Meier-Graefe, J., 1039 Malvasia, C., 353 Meiji Western painting, 1546 Mannerist art, 921, 927, 929-933 Meissner, B., 291 Mansuelli, G., 680 Mantua (Italy), art in, 1313 Melk (Austria), Bezirk, art in, 1240 Mellink, M., 532 Mantua, artists of, dictionary, 359 Mendelowitz, D., 1636 Manzano, C., 389 Marcais, G., 1447 Menghin, O., 527 Mensching, G., 508 Marcus, A., 85 Menzies, L., 478 Marinatos, S., 621 Mercer, E., 1305 Maringer, J., 531 Merhautova-Livorova, A., 876 Marks and signatures, dictionaries, 278-284 Merioneth (Wales), art in, 1302 Marle, R. van, 484 Merlino, A., 401 Martha, J., 681 Merlo, J., 336 Martin, F., 1238 Merovingian art, 819, 825, 828 Martin, J., 989 Mesoamerican art, 1577-1585 Martin, M., 1197 Mesopotamian art, 589-596 Martin, R., 646, 647, 648 bibliographies, 42, 45, 59 Martindale, A., 903, 925 Messerer, W., 855 Marucchi, O., 773 Mexico, art in, 1577-1585, 1614-1621 Masciotta, M., 262 bibliographies, 145, 146, 155 Maspero, G., 560 Meyer, E., 1341 Mather, F., 1635 Meyer, J., 272 Mathew, G., 798 Meyer, P., 1299 Mathey, F., 1120 Michalowski, K., 561 Matt, L. von, 682 Michel, A., 830, 905, 947, 948, 963, 990, 991, Matthey, W. von, 1427 Mattos, A., 1607 1040 Micheles, P., 799 Matz, F., 622, 658 Middlesex (England), art in, 1300 Mauricheau-Beaupré, C., 1004 Midlothian (Scotland), County, art in, 1301 Mayan art, 1580, 1582-1585 bibliographies, 144, 145, 146, 147 Migeon, G., 1449 Migrations, art of the, 717-731, 832, 833, 846 Mayer, A., 905 Mijatev, K., 64 Mayer, L., 15, 128 Milan, artists of, dictionary, 355 Mazzariol, G., 1322 Milicua, D., 1371 Mecklenburg (Germany), art in, 1249, 1272, Millar, O., 1305 1273 Millen, R., 927 bibliographies, 91 Medelpad (Sweden), art in, 1364 Millet, G., 65, 755, 948

Ministero della Educazione Direzione Mühlestein, H., 683 Generale delle Antichita e Belle Arti. Mukerjee, R., 1483 Inventario degli oggetti d'arte d'Italia. Müller, H., 273, 338 Muller, J., 1173 Minoan art, 616-622, 625 Müller, T., 1235 Mirvish, D., 163a Müller-Karpe, H., 533 Mithoff, H., 337 Mütherich, F., 849 Mitra, H., 133 Munro, I., 216, 217 Mitteilungen der Gesellschalt für verg-Munsterberg, H., 1054, 1520, 1530, 1531 leichende Kunstforschung in Wien, 89 Murau (Austria), Bezirk, art in, 1240 Möbius, H., 91 Murray, L., 242, 949, 950, 951 Modern art, 1026-1043 Murray, P., 242, 951 See also Nineteenth century art, Twen-Muser, C., 398 tieth century art Museu do Estado da Bahia Publicação, 153 bibliographies, 75, 76, 82, 188 Museum directories, 223, 225, 226, 228 dictionaries, 309-318 Museum Media, 199 in Africa, 1191 Museum publications, indexes, 5, 27, 28, 30, in Austria, 1044-1046, 1142 31, 197-200 in Belgium, 1046a, 1047 Museums of the World/Museen der Welt, 229 in China, 1143 Mycenean art, 616-622 in Czechoslovakia, 1144 Myers, B., 243, 314, 1186 in France, 1048 Myers, S., 243 in Germany, 1049, 1145-1147, 1287 Myron, R., 1061, 1637 in Great Britain, 1148, 1149 in Hungary, 1150 Nadeau, M., 1209 in Italy, 1050-1053 Nagel, G., 339 in Japan, 1054, 1151 Nagler, G., 274, 283 in Mexico, 1055, 1152, 1617 Namban art, 1550 in Netherlands, 1153, 1154 Namur (Belgium), art in, 1328 in Poland, 1411, 1413 Naples (Italy), art in, 1314 in Russia, 1057, 1058, 1422, 1423, Nara Buddhist art and architecture, 1550 1424, 1432 Närke (Sweden), art in, 1364 in Spain, 1387, 1390, 1391 National Gallery of Canada, Catalogue of the in Sweden, 1059, 1367a Library, 169 in the United States, 1060, 1061, Naturalism, 1117 1155-1158, 1642 Naylor, C., 315 Modern artists, dictionaries, 309-318 Nebeskýi, V., 1144 Mollett, J., 264 De Nederlansche Monumenten vom Geschiede-Molsdorf, W., 460 nis en Kunst, 1346 Momoyama painting, 1550 Németh, L., 1150, 1410 Monmouthshire (England), art in, 1300 Nemitz, F., 1428 Monneret de Villard, U., 66 Nepal, art in, 1495, 1497, 1498 Monograms, artists', dictionaries, 278-284 bibliographies, 135-137 Monographs, artists, bibliographies, 6, 9, 11 Netherlandish artists, dictionaries, 369, 370, Montesquiou-Fezensac, B. de, 1341 372, 373 Monteverdi, M., 363, 1323 Netherlands, art in, 172, 893, 961-967. Montgomery (Wales), art in, 1302 1019, 1153, 1154, 1345-1349 Moon, B., 53 bibliographies, 109-113 Moore, W., 1675 Netherlands. Rijksbureau voor Kunsthistorische Moortgat, A., 589 Documentatie. Bibliography of the Nether-Moreau-Gebard, J., 1528 lands Institute for Art History, 111 Morelowski, M., 1341 Neubauer, E., 91 Moretti, M., 682 Neubrandenburg (Ger.), Bezirk, art in, 1248, 1272 Morey, C., 737, 775, 1635 Neuburg (Germany), art in, 1251 Morse, J., 215 Neuchatel (Switz.), Canton, art in, 1294, 1296 Moss, R., 54 Neufville, J., 308 Mothes, O., 338 Neuhaus, E., 1638 Mountford, C., 1664 Neumann, H., 464 Mrazek, W., 858, 973, 1009, 1044 Neumann, W., 340 Muehsam, G., 4

Neuss, W., 776

Neuwirth, J., 1246 Nevermann, H., 1649 New Century Handbook of Greek Art and Architecture, 287 New Century Italian Renaissance Encyclopedia, 308 New Guinea, art in, 1665, 1667 New International Illustrated Encyclopedia of Art. 244 New York City, Columbia University, Avery Architectural Library, Catalog, 165 New York City, Columbia University, Avery Architectural Library, Index, 194 New York City, Columbia University, Avery Architectural Library, Obituary Index, New York City, Metropolitan Museum of Art, Library, Catalog, 166 New York City, Museum of Modern Art, Catalog of the Library, 188 New York City, Museum of Primitive Art. Library, Primitive Art Bibliographies, 39 New York City, Research Libraries of the New York Public Library, A Dictionary Catalogue of the Art and Architecture Division, 167, 168 Newald, R., 423 Newhall, B., 1175 Newman, A., 1551 Newton, D., 39 Newton, E., 1097 Nicaea (Turkey), art in, 1466 Nicaragua, Pre-Columbian art in, bibliography, 145 Nichols, A., 225 Niederbayern (Germany), art in, 1251 Niederösterreich (Austria), art in, 1239, 1241 Niederrhein (Germany), art in, 1249, 1263 Niedersachsen (Germany), art in, 1248, 1250, 1268 Niedersachsen (Germany), artists of, dictionary, 337 Nijmegen (Netherlands), art in, 1346 Nineteenth century art, 1062-1069 bibliographies, 82 dictionaries, 309, 318, 330 in Austria, 1070, 1244, 1246 in Belgium, 1071, 1072 in Denmark, 1073 in England, 1305 in Germany, 1074, 1287, 1292 in Italy, 1075, 1315, 1316, 1319 in Mexico, 1076, 1617 in Poland, 1411, 1413 in Sweden, 1077, 1078, 1367a in the United States, 1079, 1642 Nochlin, L., 1112 Noma, S., 1552

Noordbrabant (Netherlands), Provincie, art in. 1346 Noordholland (Netherlands), Provincie, art in. 1346 Nordensvan, G., 1077, 1078 Nordrhein-Westfalen (Germany), art in, 1248-1250, 1263 Nørlund, P., 1354 North American Indian art, 1590-1595 North Brabant (Netherlands), art in, 1346 North Holland (Netherlands), art in, 1346 Northern Renaissance Art, 961-967 Northwest Coast Indian art, 541, 542 bibliography, 39 Norway, art in, 753, 1362, 1363 Nottingham, artists of, dictionary, 346 Nougier, L., 534 Novotny, F., 1065

Nubian art, 810, 1457

Oberbayern (Germany), art in, 1251 Oberfranken (Germany), art in, 1251 Oberösterreich (Austria), art in, 1239-1241 Oberpfalz (Germany), art in, 1251 Oberwalt (Austria), Bezirk, art in, 1240 Oberwölz (Austria), Bezirk, art in, 1240 Obituary index of artists, 204 Ocampo, M., 155 Oceania, art in, 540, 542, 543, 1661-1671 O'Dwyer, J., 265 Oettinger, K., 1241 Official Museum Directory, United States and Canada, 230 Okkonen, O., 1360 Oland (Sweden), art in, 1364 Old World Bibliography. Recent Publications Mainly in Old World Palaeolithic Archaeology and Paleo-Anthropology, 36 Oliveira, A. H. de, 117 Olivier-Michel, F., 1226 Olmec sculpture, bibliography, 39 Oman, C., 1341 Oostvlaanderen (Belgium), art in, 1331, 1333 Oprescu, G., 1056 Orellana, M. A. de, 383 Orient et Byzance, 60, 64, 65, 67 Oriental art See Chapter Ten bibliographies, 122-124, 189 Oriental Art, "Bibliography" in, 122 Orkney (Scotland), County, art in, 1301 Ortega Ricuarte, C., 402 Orthmann, W., 584 Osborne, H., 245 Osmond, E., 1309 Ossorio y Bernard, M., 384 Osten, G. von, 964 Östergötland (Sweden), art in, 1364

342 | Author/Title/Subject Index

Österrichische Zeitschrift fur Kunst und Denkmalpflege, 89 Ostmärkische Knusttopagraphie, 1240 Otto, E., 293 Otto, W., 549 Otto-Dorn, K., 1450 Ottonian art, 849, 853, 854 Ottowa, Ontario, National Gallery of Art Catalogue of the Library, 169 Oudheidkundig Inventaris der Kunstvoorwerken in Kerken en openbare Gebouwen van de Provincie Limburg, 1336 Oudheidkundig Inventaris van Oost Vlaanderen, 1333 Outer Hebrides, art in, 1301 Overbeck, J., 491 Overijsel (Neth.), Provincie, art in, 1346 Overy, P., 1202 Oxford (England), art in, 1300

Paatz, W., 952 Pacey, P., 5 Padovano, E., 364 Padua (Italy), art in, 1313 Pagano, J., 1603 Pageant of America, 1635 Pageant of Japanese Art, 1553 Paine, R., 1554 Paintings, indexes to, 215-217 Pal, P., 1495 Palatinate (Germany), art in, 1262-1264 Palencia (Spain), Provincia, art in, 1372 Pallas Library of Art, 525 Pallottino, M., 684, 685 Palol Salellas, P. de, 842 Pamplona, F. de, 376 Panama, Pre-Columbian art in, bibliography, Papadopoulo, A., 1451 Pappenheim, H., 246 Paris, art in, 1228 Paris, Bibliothèque Forney. Catalogue d'articles des periodiques-arts decoratifs et beaux-arts, 195 Paris, Bibliothèque Forney. Catalogue des catalogues de ventes d'art, 178 Paris, Bibliothèque Forney. Catalogue matières: arts-decoratifs, beaux-arts métiers, techniques, 179 Pariset, F., 1087 Parma (Italy), art in, 1313 Parmentier, H., 1506, 1507, 1508 Parow, R., 246 Parrot, A., 591 Parthian art, 597, 601 Passavant, G., 943 Passeron, R., 1210 Pauli, G., 1088 Pauly, A. F. von, 296

Pauly-Wissowa, Real-Encyclopädie der classichen Altertumswissenschaft, 296 Peeblesshire (Scotland), art in, 1301 Peirce, H., 800 Pelican History of Art, 536, 566, 680, 712, 757, 827, 958, 964, 1003, 1010, 1016, 1018, 1019, 1065, 1391, 1486, 1534, 1554, 1642 Pembroke (Wales), art in, 1302 Penguin Reference Books, 242 Pericot-Garcia, L., 519 Periodicals, art, bibliographies, 2, 5, 8, 19, 20, 25-28, 31, 191-195 Pernice, E., 657, 709 Perrot, G., 550 Persian art (ancient), 598-603 Persian art (Islamic), 1459-1462 Peru, art in, 1622, 1623 Pevsner, N., 1310 Peyrehorade (France), Canton, art in, 1225 Pfalz (Germany), art in, 1262-1264 Phaidon Dict. of Twentieth Century Art, 316 Phaidon Encyclopedia of Art and Artists, 247 Phoenician art, 637 Phrygian art, 605 Picon, G., 1211 Picton, H., 832 Piedmont, artists of, dictionary, 365 Piel, F., 1248 Pierce, H., 800 Pierce, J., 248 Pierre, J., 1180, 1212 Pierson, W., 1639 Pigler, A., 434 Pignatti, T., 992, 1322 Pijoán y Soteras, J., 516, 523, 556, 579, 651. 697, 759, 833, 877, 906, 953, 954, 965, 993, 1041, 1452, 1575 Piland, S., 6 Pinder, W., 1290 Piotrowska, I., 1412 Pirngadie, M., 1513 Pisa, artists of, dictionary, 358 Pita-Andrade, J., 1394 Platte, H., 1132 Pleiss, R., 259 Ploetz, G., 231 Plüss, E., 394 Pobé, M., 869 Podszus, C., 16 Poensgen, G., 1190 Pöggstall (Austria), Bezirk, art in, 1240 Poitou-Charentes (France), art in, bibliog., 1225 Pola (Italy), art in, 1313 Poland, art in, 975a, 1411-1413 Pollitt, J., 659 Pontual, R., 403 Pool, P., 1121 Pope, A., 1461, 1462 Porada, E., 602 Porcher, J., 837, 852

Port, C., 334 Radnor (Wales), art in, 1302 Portal, C., 335 Radojcic, S., 1435 Portalegre (Portugal), Distrito, art in, 1380 Rafols, J., 385, 1098 Ramiréz de Arellano, R., 386 Porter, B., 54 Portraits, indexes to, 206, 208, 214, 221 Rau, H., 134, 137 Portugal, art in, 879, 1021, 1380, 1382. Rave, P., 205 1384, 1391, 1392, 1396-1398 Rawson, P., 1484, 1501 bibliographies, 117 Raymond, A., 1453 Portuguese artists, dictionaries, 374-377 Read, H., 1148, 1213 Pöschl, V., 422 Reader's Guide Series, 10, 18 Posner, D., 981 Realism, 1112, 1113 Post-impressionism, 1114, 1123 Reallexikon der Assyriologie, 291 Potratz, J., 585 Reallexikon für Antike und Christentum, 303 Pott, P., 1499 Reallexikon zur byzantinischen Kunst. 307 Poulsen, V., 562, 1355-1357 Reallexikon zur deutschen Kunstgeschicte, 341 Powell, A., 551 Réau, L., 266, 461, 743, 907, 1005, 1099, Powell, T., 535 1233, 1341, 1429 Pradel, P., 1341 Reclams Kunstführer Dänemark, 1358 Praeger Encyclopedia of Ancient Greek Reclams Kunstführer Deutschland, 1250 Civilization, 297 Reclams Kunstführer Frankreich, 1228 Praeger Encyclopedia of Art, 249, 297 Reclams Kunstführer Italien, 1314 Prause, M., 196 Reclams Lexikon der Heillgen und Biblischen Praz, M., 1089 Gestalten, 454 Pre-Carolingian art, 835-846 Reclams Universal-Bibliothek, 636 bibliographies, 144-147 Redgrave, S., 347 Preedy Memorial Library, University of Rees, T., 348 London, Catalogue, 175 Regensburg (Germany), art in, 1251 Prehistoric art, 521-543 Région Nord (France), art in, bibliography, bibliographies, 32-36 1225 dictionaries and encyclopedias, Reinach, S., 218, 219 285, 286 Reinle, A., 1297 Primitive art, 514-520, 540-543 Reisner, R., 17 See also Africa, Oceania, Pre-Colum-Renaissance art, 918-928 bian art (Chapter Eleven) See also Italian Renaissance art, Northern bibliographies, 37-39 Renaissance art Primitive Art Bibliographies, 39 bibliographies, 184-186 Princeton Monographs in Art and Archaein Austria, 1244 ology, 614, 1369 in England, 1305 Prodan, M., 1532 in France, 962, 968-972, 1234 Prokop, A., 1400 in Germany, 961, 964, 973, 973a, 1287, Propyläen Kunstgeschichte, 532, 565, 567, 1290 584, 665, 708, 728, 758, 810, 821, 822, in Italy, 934-960, 1315, 1319, 1326 898, 911, 924, 935, 955, 962, 978, 984, in Slavic countries, 975, 975a, 1417, 1001, 1069, 1088, 1113, 1124, 1442, 1422 1456, 1477, 1518, 1576 in Spain, 974, 1387 Provence, art in, 1228 in Sweden, 1367a Provence, artists of, dictionary, 326 Répertoire d'art et d'archéologie, 27, 28 Provincie de Brabant. Inventaire des objets Répertoire des inventaires, 1225 d'art, 1330 Repertoire international des archives photo-Publications de l'École Française d'Extreme graphiques d'oeuvres d'art, 232 Orient, 1508, Repertorium betreffende Nederlandse Monu-Pückler-Limpurg, S., 1090 menten van Geschiedenis en Kunst, 112 Puig y Cadafalch, J., 843 Repertorium van Boekwerken betreffende Pylkkänen, R., 752 Nederlandse Monumenten van Geschiedenis en Kunst, 113 Repertory of the Literature of Art, 28 RAA, 27, 28 Reproductions, indexes to, 207, 210, 211, 213, Rachewiltz, B. de, 563, 1658 220, 231, 232

Restle, M., 1466

Racz, I., 752, 753

Raczynski, A., 377

Revue belge d'archéologie et d'histoire de	Romanesque art (cont'd)
l'art, "Bibliographie de l'histoire de l'art	in Portugal, 897, 1396
national," 83	in Scandinavia, 884
Rewald, J., 1122, 1123, 1174	in Slavic countries, 876
Rey, R., 878	in Spain, 859, 867, 870, 1387
Reynolds, Mary, 78	Romania, art in, 754, 755, 810, 1414
Rheims, M., 1167	bibliographies, 60, 67
Rheinland-Pfalz (Germany), art in,	Romanticism, 1093-1111
1248-1250, 1264	Romdahl, A., 1368
Rheinprovinz (Germany), art in, 1263	Rome, art in, 1314
Rhineland, art in, 1248-1250, 1262-1264	Rome, Deutsches Archaologisches Institut. Kat
bibliographies, 96	loge der Bibliothek, 182
Rhodes, A., 1399	Ronchetti, G., 435
Rhône valley (France), art in, 1228	Rooses, M., 1344
Ricci, E., 479	Roosval, J., 1368, 1369
Rice, D., 777, 801-803, 1305, 1430, 1454	Roscher, W., 492
Rice, T., 613, 1431, 1496	Rose, B., 1158
Richardson, E. H., 686	Rosenberg, J., 1019
Richardson, E. P., 1640	Rosenblum, R., 1091, 1181
Richardson, T., 1136, 1640	Rosenfeld, A., 538
Richter, G., 660, 661	Rosenthal, L., 1095
Richter, H., 1214	Rosenthal, T., 18
Rickey, G., 1191	Ross, N., 509
Riegl, A., 706, 710	Rostovtsev, M., 614, 615
Riesenhuber, M., 1011	Rotenberg, J., 994
Riis, P., 687	Rothenstein, J., 1149
RILA. Repertoire international de la lit-	
térature de l'art, 28	Roussillon (France), art in, bibliography, 1225 Rowland, B., 124, 1486
Ris-Paquot, O., 284	Rowland, K., 1137
Robina, Rde, 1621	Rowlinson, H., 1489
Rococo art, 976-979, 981, 982, 984, 985,	Roxburgshire (Scotland), art in, 1301
987, 988, 991, 992, 995-998	Royal Commission on the Ancient and His-
in Austria, 1008-1012	torical Monuments
in Belgium, 1017, 1018	of England, An Inventory of Ancient
in France, 1002-1007	Monuments, 1300
in Germany, 1008-1012	of Scotland, An Inventory of Ancient
in Italy, 1013, 1016	Monuments, 1301
in the Netherlands, 1019	of Wales, An Inventory of Ancient
in Slavic countries, 1023-1025, 1417,	Monuments, 1302
1422	Rubin, W., 1215
in Spain and Portugal, 1020-1022	Rudel, J., 1036
Rodenwaldt, G., 632	Rumpf, A., 549, 633, 711
Roeder, H., 480	Runciman, S., 804
Roh, F., 1146, 1235	Ruskin, A., 540, 634, 926, 995
Rohault de Fleury, C., 462, 463, 481	Russia, art in, 756, 810, 975, 1023, 1057, 1058
Rojas, P., 1616, 1617	1415-1432
Roman art, 688-716	bibliographies, 60, 65, 114
bibliographies, 41, 43, 46, 49-51,	Rust (Austria), Bezirk, art in, 1240
57, 58, 182	Ruz, A., 1621
dictionaries and encyclopedias, 288,	Ry van Beest Holle, C. J. du, 586, 1455
289, 292, 294-296	Rye, J., 1198
Romanesque art, 821, 823, 827, 856-885	Ryerson, E., 1551
dictionaries, 299, 301, 305, 306	Ryerson Library Art Institute of Chicago, Index
in Austria, 858, 1243, 1244, 1246	to Periodicals, 193
in Belgium, 863, 864, 1341	
in England, 1305	Saarland (Germany), art in, 1248, 1249
in France, 856, 857, 860, 862, 865,	Sachs, H., 464
869, 874, 875, 878	Sachsen (Germany), Provinz, art in, 1249, 1276
in Germany, 861, 868, 872, 873,	Säfflund, G., 631
1287, 1290	Saglio, E., 289
in Italy, 866, 1316	Jugito, 1., 207

Schmitz, C., 1668

Sahai, B., 510 St. Gallen (Switzerland), Canton, art in, 1294, 1296 St. Paul in Lavnattal (Austria), art in, 1240 Salamanca (Spain), Provincia, art in, 1372 Salas, X. de, 1291 Sales catalogs, 5, 24, 164, 166, 178, 203 Salet, F., 908 Salin, B., 731 Salis, A. von, 663 Salland (Netherlands), art in, 1346 Salmi, M., 1324 Saló Marco, A., 974 Saltillo, M. de, 387 Salzburg (Austria), art in, 1239-1241 Samuels, H., 414 Samuels, P., 414 Sandars, N., 536 Santarém (Portugal), Distrito, art in, 1380 Santo Domingo, art in, bibliography, 156 Santos, R. dos, 879, 1397 Sarmatian art, 612, 614, 615 Sarne, B., 55 Sarre, F., 603 Sas-Zaloziecky, W., 778, 805 Sassanian art, 601, 602 Saunders, O., 747 Saxon art See Anglo-Saxon art Saxony (Germany), art in, 1249, 1278, 1279 bibliographies, 91 Scandinavia, art in, 725, 727, 731, 751, 1350-1351 See also Denmark, Finland, Iceland, Norway, Sweden Schäfer, H., 564, 656 Schaffhausen (Switzerland), Canton, art in, 1294, 1296 Schaffran, E., 250, 844, 1247 Schärding (Austria), Bezirk, art in, 1240 Schardt, A., 745 Schede Vesme, 365 Scheen, P., 372 Scheffler, K., 909, 1066 Schefold, K., 664, 665 Scheja, G., 1290 Scheltema, F. Adama von, 717, 918 Schiaffino, E., 1604 Schiller, G., 465 Schlegelmilch, G., 91 Schlesische Bibliographie, 93 Schleswig-Holstein (Germany), art in, 1248-1250, 1269, 1270 Schlosser, J. von, 19, 738 Schmarsow, A., 910 Schmeckebier, L., 1152 Schmidt, J., 1238 Schmidt, R., 319

Schmitt, O., 341

Schmitz, H., 746, 1012 Schmitz-Ehmke, R., 1248 Schmörkel, H., 592 Schmutzler, R., 1168 Schneede, U., 1216 Schneider, R., 1234 Schoder, R., 666 Schönberger, A., 997 Schöne, A., 431 Schriften zur Kunstgeschichte, 911 Schriften zur Kunstgeschite Südösteuropas, 722 Schrifttum zur deutschen Kunst, 88 Schrifttum zur deutschen Kunst des 20. Jahrhundert, 92 Schrifttum zur rheinischen Kunst von den Anfängen bis 1935, 96 Schubring, P., 955 Schuchhardt, W., 667 Schug, A., 1138 Schug-Wille, C., 806 Schultze, J., 1067 Schwab, A., 415 Schwaben (Germany), art in, 1251 Schwartz, P., 1182 Schweinfurth, P., 807 Schweitzer, B., 668 Schwerin (Germany), Bezirk, art in, 1248, 1272 Schwyz (Switz.), Canton, art in, 1294, 1296 Scotland, art in, 1301, 1305a Scullard, H., 292 Scythian art, 609-615 Sebastian, F., 1608 Seling, H., 1169 Selkirkshire (Scotland), art in, 1301 Seltman, C., 669 Selz, P., 1170 Semrau, M., 987 Sepik district art, bibliography, 39 Sepp, H., 97 Serbian art, 1435 Sevilla (Spain), Provincia, art in, 1374 Sewter, A., 996 Shearman, J., 931 Sheehy, J., 1308 Shetland (Scotland), County, art in, 1301 Shinto art, 1546, 1550 Shoten, K., 1521 Sickman, L., 1534 Signatures, artists', dictionaries, 278-284 Silcock, A., 1535 Silesia, art in, 1281-1283 bibliographies, 93 Sill, G., 466 Simiolus, "Bibliographisch Overzicht van in Nederland in 1966-verschenen Publicaties," 109 Simson, O. von, 911 Sinai, art in the, 1457

Singer, H., 221, 273 Stedlijk Museum, Amsterdam, Bibliotheck, Singh, M., 1497 Catalogue, 187 Sirén, O., 1536 Steiermark (Austria), art in, 1239, 1241 Sisson, J., 1326 Steiermark (Austria), artists of, dictionary, 320 Skäne (Sweden), art in, 1364 Stein, F., 68 Skye (Scotland), art in, 1301 Stein, H., 301 Slavic countries, art in, 754, 755, 808, 834, Stern, H., 808 1399-1435 Stiennon, J., 1341 Slavic languages literature on art, bibliog-Stillwell, R., 298 raphy, 23, 24 Stinson, R., 998 Slive, S., 1019 Stirling-Maxwell, W., 388 Småland (Sweden), art in, 1364 Stirlingshire (Scotland), art in, 1301 Smart, A., 956, 966 Stockholm (Sweden), art in, 1364 Smith, Bernard W., 1669 Stockholm Studies in History of Art, 119 Smith, Bradley, 1395, 1537, 1555, 1618 Stokes, A., 957 Smith, N., 739 Stokes, M., 845 Smith, Ralph, 416 Stokstad, M., 967 Smith, Robert, 151, 1398 Stoll, R., 748 Smith, V., 1487 Storia dell'arte classica e italiana, 629, 749, Smith, W., 566 1013, 1052, 1325 Smithsonian Institution, Freer Gallery of Storia universale dell'arte, 638, 701, 1028 Art, Dictionary Catalogue of the Library Strickland, W., 349 of the Freer Gallery of Art, 189 Strömböm, S., 1059 Södermanland (Sweden), art in, 1364 Strommenger, E., 593 Soehner, H., 997 Strong, D., 635, 712, 740 Sokol, D., 161 Strong, E., 713 Sola, M., 1600 Stryzygowski, J., 779, 809, 834 Solothurn (Switzerland), Canton, art in, Studien zur deutschen Kunstgeschichte, 97 1294, 1296 Studien zur Kunst des neunzehnten Jahrhun-Sombernon (France), Canton, art in, 1225 derts, 82 Sondrio (Italy), art in, 1313 Stutley, M., 511 Soper, A., 1534, 1554 Style and Civilization, 616, 823, 895, 946, Soria, M., 1391 1084, 1112 Sormani, G., 251 Styria Sotiriou, G., 67 See Steiermark Sotriffer, K., 1046 Subsidios para a historia de arte portuguesa, 375 Souchal, F., 880 Sullivan, M., 1143, 1539, 1540 Sourdel-Thomine, J., 1456 Sumerian art, 589, 591-593, 595, 596 Sourek, K., 1401 Summa Artis, Historia General del Arte, 516, South Holland (Netherlands), Provincie, 523, 556, 579, 651, 697, 759, 833, 877, art in, 1346 906, 953, 954, 965, 993, 1041, 1452, 1485, South Pacific Islands, art of, 1662-1664, 1533, 1549, 1575 1668, 1670-72 Sundaram, K., 1488 South Tirol, art in, 1311, 1314 Sundell, A., 1061, 1637 Southeast Asia, art in, 1499-1501 Surrealism, 1203-1213, 1215, 1216, 1218 See also Indochina, Indonesia, Thailand bibliographies, 78, 79 Spain, art in, 831, 1370-1379, 1381, 1383-Survival of the classics, bibliography of, 423 1391, 1393-1395 Sutherland (Scotland), County, art in, 1301 bibliographies, 115, 116, 118 Svensk Konsthistorisk Bibliografi, 120 Spanish artists, dictionaries, 378-389 Svenska konstnärer; biografisk handbok, 392 Speiser, W., 587, 1528, 1538 Svensk Konstnärs Lexikon, 391 Spinden, H., 1583 Sveriges Kyrkor, 1364 Spiteris, T., 623 Swedish artists, dictionaries, 390-392 Spooner, S., 275 Swiss artists, dictionaries, 393-394 Spuler, B., 1456 Switzerland, art in, 889, 1008-1010, 1293-1299 Stalley, R., 912 bibliographies, 87, 88, 121 Stanford (England), art in, 1300 Swoboda, K., 56-59, 69-72, 129, 130, 142, 882, Stangos, N., 1136 914, 915, 1025 Sybel, L. von, 780, 781

Sydow, E. von, 520, 1092

Sylvester, D., 1139 Symbolik der Religionen, 505, 506 Symbolism, art style, 1119 Syndicus, E., 782 Syrian art (ancient), 637, 809, 810

Tablada, J., 1619 Tamsweg (Austria), Bezirk, art in, 1240 Tapie, V., 999 Tarn (France), artists of, dictionary, 335 Tavel, H., 394 Taylor, J., 1199, 1641 Techniques artistic, 4, 235, 237, 239, 242-245, 252-255, 258, 259, 263 Temse (Belgium), art in, 1331 Terms, art, dictionaries, 253-267 Tervarent, G. de, 485 Thailand, art in, 1516, 1517 Theile, A., 1440 Theime, U., 276 Thieme-Becker, 276 Thiis, J., 1351 Thimme, J., 624 Thoene, P., 1147 Thomas, K., 1140 Thompson, R. F., 39 Thurgau (Switzerland), Canton, art in, 1294, 1296 Thuringia (Ger.), art in, 1249, 1275-1277 Tibet, art in, 1491, 1492, 1494 Tibol, R., 1617 Ticino (Switz.), Canton, art in, 1294, 1296 Tietze, H., 1238 Time Magazine, art in, 212 Timmers, J., 469, 883, 893, 1349 Timmling, W., 20 Tirol (Austria), art in, 1239, 1241 Tischner, H., 1670 Tisdall, C., 1200 Todd, A., 436 Toesca, P., 1325 Toledo (Spain), Provincia, art in, 1375 Topass, J., 1413 Topographical Bibliography of Ancient Egyptian Hieroglyphic Texts, 54 Torbrügge, E., 537 Torres Strait art, bibliography, 39 Toscano, S., 1584

Torses Strait art, bibliography, 39
Toscano, S., 1584
Tours (France), artists of, dictionary, 332
Toussaint, M., 1620
Toynbee, J., 714
Trent (Italy), art in, 1311, 1314
Tripp, E., 493
Trowell, K., 1649
Tsuda, N., 1558
Tsudzumi, T., 1559
Tümmers, H., 200
Tuulse, A., 884
Twente (Netherlands), art in, 1346

Twentieth century art, 1124-1140 bibliographies, 75, 76, 92 dictionaries and encyclopedias, 310, 312-317 in Africa, 1141 in Austria, 1142 in China, 1143 in Czechoslovakia, 1144 in Germany, 92, 1145-1147 in Hungary, 1150 in Japan, 1151 in Mexico, 1152 in the Netherlands, 1153, 1154 in the United States, 1155-1158 Twentieth century artists, dictionaries, 310, 312-317 Twentieth Century Encyclopedia of Catholicism, 782 Tyler, R., 800

Ubbelohde-Doering, H., 1588, 1589 Ucko, P., 538 Ullstein Kunstgeschichte, 778, 805 UNESCO. Répertoire international des archives photographiques d'oeuvres d'art, 232 Unger, E., 594 United States, art in the, 1625-1643 bibliographies, 157-161, 190 dictionaries, 405-417 U.S. Library of Congress Latin American Series, 151 L'Universe des formes, 606, 849, 872 Universe History of Art, 885, 892, 928, 982, 1068, 1542 Unterfranken (German), art in, 1251 Upper Austria, art in, 1239, 1241 Upper Bavaria, art in, 1251 Upper Palatinate (Germany), art in, 1251 Uppland (Sweden), art in, 1364 Urartian art, 605, 607 Urech, E., 467 Usener, K., 1341 Utrecht (Netherlands), Provincie, art in, 1346

Vaillant, G., 1595
Valgimigli, G., 366
Valladares, J., 153
Valladolid (Spain), Provincia, art in, 1376, 1377
Valle, R., 147
Vallier, D., 1192
Van de Walle, A., 916
Vandenbrande, R. H., 1327
Vandersleyen, C., 567
Vanderstappen, H., 143
Vandier, J., 568
Vanzype, G., 1072
Vargas, J., 1611
Vargas, U., 404

Värmland (Sweden), art in, 1364 Västergotland (Sweden), art in, 1364 Vaud (Switzerland), Canton, art in, 1294, 1296 Vaughan, W., 1111 Venezuela, art in, 1624 Venice (Italy), art in, 1311, 1314 bibliography, 102 Venice, artists of, dictionary, 354 Venturi, A., 1326 Verkauf, W., 1217 Verlet, P., 1006, 1341 Vermeule, E., 670 Verona, artists of, dictionary, 367 Versailles (France), art in, 1228 Verzeichnis der Kataloge und Führer Kunstund Kultur-geschichtlicher Museen in der Bundesrepublik Deutschland und in Berlin (West), 200 Verzeichnis der Kunstdenkmäler der Provinz Schlesien, 1281 Verzone, P., 846, 1341 Vey, H., 1291 Vial, E., 327 Vienna (Austria), art in, 1238-1241 Vienna, Osterreichisches Museum für Kunst und Industrie. Bibliothek, Catalog, 180 Vietnam, art in, 1502, 1504 Vieyra, M., 608 Viking art, 725, 731, 839, 840 Villard, F., 646-648 Villegas, V., 1020 Viñaza, C., 389 Vinet, E., 21 Visigothic art, 842, 843 Visual Dictionary of Art, 252 Vitoria (Spain), diocese, art in, 1378 Vitzthum, G., 750 Vizcaya (Spain), Provincia, art in, 1379 Vogt, A., 1068 Vogüe, M. de, 306 Volbach, W., 750, 783, 810, 837, 852, 1341 Vollmer, H., 317

Waage, F., 539
Wagner, E., 820
Wagner, F., 1515
Waidhofen (Austria), Bezirk, art in, 1240
Waldberg, P., 1218
Waldmann, E., 1113
Waldschmidt, E., 1498
Waldschmidt, R., 1498
Wales, art in, 1302
Wales, artists of, dictionary, 348
Walker, J., 267
Wallace, D., 411
Walle, A. J. L. van de, 916

Vorarlberg (Austria), art in, 1239, 1241

Voyce, A., 756

Wallis (Switzerland), Canton, art in, 1294, 1296 Wan-go Weng, 1537 Warburg Institute, A Bibliography of the Survival of the Classics, 423 Warburg Institute, Library, Catalogue, 186 Ward-Perkins, J., 712 Wardwell, A., 39 Warner, L., 1560 Washington, D.C., Smithsonian Institution. Freer Gallery of Art. Dictionary Catalogue of the Library of the Freer Gallery of Art, 189 Wassing, R., 1659 Wastler, J., 320 Waterland (Netherlands), art in, 1346 Waters, C., 277, 318, 437, 482 Waters, G., 350 Watson, W., 1528, 1542 Webber, F., 468 Webster, T., 671 Weese, A., 972 Weigel, R., 173 Weigert, H., 1292 Weigert, R., 1007 Weilbach, P., 323 Weisbach, W., 1000, 1001, 1022 Weisbord, D., 436 Weise, G., 932 Welsh artists, dictionary, 348 Werkkataloge zur Kunst des 20. Jahrhunderts, 75 Werner, E., 512 Wessel, K., 307, 817 West Flanders (Belgium), art in, 1337 West Indies, Pre-Columbian art in, bibliography, 39 West Prussia, art in, 1284 Westendorf, W., 569 Western, D., 163b Westfalen (Germany), art in, 1248-1250, 1265 Westfriesland (Netherlands), art in, 1346 Westheim, P., 1621 Westmoreland (England), art in, 1300 Westphalia (Germany), art in, 1248-1250, 1265 bibliography, 90 Westphalia (Germany), artists of, dictionary, 337 Wethey, H., 1623 Wheeler, R., 715 White, H., 958 Whitehill, W., 158 Whittlesey, E., 438 Who's Who in American Art, 233 Who's Who in Art, 234 Wichmann, H., 98 Wickhoff, F., 716

Wiesbaden (Germany), Regierungsbezirk, art

in, 1260

Wilder, E., 151 Wilenski, R., 1042 Will, E., 721 Willard, A., 1075 Willey, G., 1576 Willet, F., 1660 Willett, J., 1187 Willetts, W., 1544 Williams, C., 513 Wilmerding, J., 1642 Wilson, D., 840 Wimmer, O., 483 Wingert, P., 543, 1671, 1672 Winney, M., 1305 Winning, H. von, 1583 Winstedt, R., 1489 Winterthur Museum Libraries Collection of Printed Books and Periodicals, 190 Wirth, K., 1402 Wissowa, G., 296 Wittkower, R., 1016 Wodehouse, L., 159 Woldering, I., 570 Wolf, R., 927 Wölfflin, H., 959, 960 Women artists bibliography, 6 dictionary, 277 Woolley, C., 588, 595 World Bibliography of Bibliographies, 7 Worldwide Art Book Syllabus, 29 Worldwide Art Catalogue Bulletin, 30 Worringer, W., 917 Wright, L., 1643 Wulff, O., 73, 784, 1432 Wundram, M., 928, 1228, 1314

Zeitschrift für Kunstgeschichte, "Literaturberricht zur Kunstgeschichte," 31 Zeitschrift für salvische Philologie, 114 Zell am See (Austria), Bezirk, art in, 1240 Zervos, C., 596, 625, 626, 1043 Zimmer, H., 1490 Zinserling, G., 636 Zoomorphic style, 731 Zug (Switzerland), Canton, art in, 1294, 1296 Zuidholland (Netherlands), Provincie, art in, Zuid-Salland (Netherlands), art in, 1346 Zülch, W., 342 Zürich (Switzerland), Canton, art in, 1294, 1296 Zutphen (Netherlands), art in, 1346 Zwettl (Austria), Bezirk, art in, 1240 Zwischen den Beiden Kriegen, 1130

Yamato style painting, 1550 Yashiro, Y., 1561, 1562 Yonezawa, Y., 1522 York (England), art in, 1300 Yoruba sculpture, bibliography, 39 Young, W., 417 Yuan, T., 143 Yugoslavia, art in, 754, 755, 810, 1433-1435

Württemberg (Germany), art in, 1254-1256

Würtenberger, F., 933

Wurzbach, A., 373

Zahn, L., 1190
Zalosser, H., 816
Zamora (Spain), Provincia, art in, 1372
Zamora Lucas, F., 118
Zannandreis, D., 367
Zaragoza (Spain), art in, 1372
Zarnecki, G., 741, 885
Zeitler, R., 1069, 1358

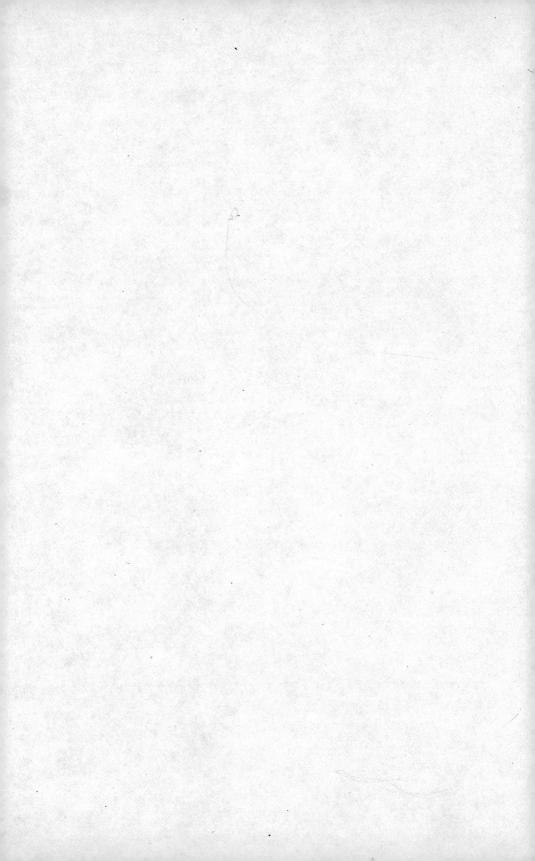